The Moment of
Self-Portraiture
in German
Renaissance Art

Joseph Leo Koerner

The University of Chicago Press

Chicago and London

Joseph Leo Koerner is professor of fine arts at Harvard University. He is the author of *Die Suche nach dem Labyrinth, Caspar David Friedrich and the Subject of Landscape,* and (with Rainer Crone) *Paul Klee: Legends of the Sign.*

Frontispiece: Albrecht Dürer, *Self-Portrait*, 1500, oil on panel, Alte Pinakothek, Munich (photo courtesy of Artothek).

The University of Chicago Press, Chicago 60637
The University of Chicago Press, Ltd., London
© 1993 by The University of Chicago
All rights reserved. Published 1993
Printed in the United States of America

02 01 00 99 98 97 96 95 94 93 5 4 3 2 1

ISBN: 0-226-44997-1

Library of Congress Cataloging-in-Publication Data

Koerner, Joseph Leo.
 The moment of self-portraiture in German Renaissance art / Joseph
Leo Koerner.
 p. cm.
 Includes bibliographical references (p.) and index.
 1. Dürer, Albrecht, 1471–1528—Self-portraits. 2. Dürer,
Albrecht, 1471–1528—Criticism and interpretation. 3. Baldung,
Hans, d. 1545—Self-portraits. 4. Baldung, Hans, d. 1545—Criticism
and interpretation. 5. Portrait painting, Renaissance—Germany.
6. Portrait painting, German. I. Title.
ND588.D9K82 1993
759.3—dc20 92-15135
 CIP

This book is printed on acid-free paper.

till min Betta

Contents

PART TWO: *The Mortification of the Image: Hans Baldung Grien*

Illustrations

Preface

A preface to the study of Albrecht Dürer's self-portraits effects special tautologies. This is not only because, like all prefaces, it will at once restate and presage arguments made within the study itself, or because it will shatter the beautiful illusion that art history really can be heuristic, a discourse that originates from the object and is shared between the author and the reader.[1] Dürer constructs his self-portraits as *themselves* prefaces, announcing and projecting in them an idea of art, a regimen of vision, a history of reception, and an epoch of history.

In his most truly programmatic likeness, the famous 1500 *Self-Portrait* now in Munich, Dürer displays and centers all codes of authorship, publication, and intent that usually inhabit the frames of images or the front matter of books (frontispiece and fig. 21). The artist has painted his likeness with the symmetry and formality of a funeral effigy, his en face posture eliminating all contingencies of movement and viewpoint that might temporalize or localize his display. Prepared for posterity, Dürer looks ready to serve as a frontispiece for some future biography or "collected works." Framing this face are the marks of its authorship inscribed in gold: to the right, in Latin, Dürer's name, city, and age (twenty-eight years); to the left, the AD monogram; and above the monogram, the picture's moment, 1500, the year of the new century. Date, proper name, and artist's likeness together publish that it is from here—from this historical moment, this place, this artist, this very body—that the art of Albrecht Dürer originates. The always prefatory nature of self-portraiture is encoded even in the physical format of the Munich panel's inscription. For as recent scholarship has shown, its Roman lettering and symmetrical arrangement imitate the title-page design of certain exemplary humanist books published at Nuremberg in 1500.[2]

One of my aims in this book is to recover the preface that Dürer wrote for himself, to voice proleptically those statements and predictions that the 1500 *Self-Portrait* already made about Dürer's art as a whole and about the futures that would respond to it. At the start of a half-millennium that we are now seeing to an end, and as an origin of our own

torial style, and grasp of character. And if the sitters exhibit distinct characters, are these both not Dürer's creation and therefore primarily testimonies to his art? The 1500 likeness thus becomes a tautology of authorship, repeating what we would already know about Dürer's art by 1499. Absorbed into the oeuvre of their maker, like a preface into a text it seems to introduce, Dürer's self-portraits cannot claim to be, in any privileged way, images *about* Dürer's art.

Bakhtin's skepticism toward self-portraiture's special status emerges from his general theory of authorship, formulated in the early 1920s.[7] Just as the author's image is reintegrated into the community of his works, so too the author, whom the romantics elevated above all ordinary beings and hypostatized as autonomous from the world of social exchange, emerges for Bakhtin only within a dialogue with the reader. Yet for the self-portrait to be thus absorbed into the oeuvre, as one author-image among many, the oeuvre itself must already be read as the product of a person. Such a reading is not natural, but historical. And for northern art this history begins with Dürer and the moment of self-portraiture. The 1500 *Self-Portrait*, I will argue, is a statement less about Dürer's person than about his art. It proclaims that art and artist are consubstantial; that the value and meaning of an image derives from its being *by* someone; that the artist paints, as Dürer himself writes, to "make himself seen in his works"; and that every signed picture is in some sense a self-portrait. This explains the panel's character as frontispiece to an oeuvre and an epoch. Artist's face, signature, date, and city, like the front matter of a published book, propose a contract or "pact" between the painter and the viewer.[8] This pact, which guarantees that the image is both *by* and *of* Dürer, will determine our viewing of this and all other works signed by the artist, as well as of all authored works generally that follow in the tradition. That Dürer's contract has precise legal and economic dimensions will become apparent in chapter 10, "The Law of Authorship."

Understood as a pact between artist and viewer, self-portraiture complicates the distinction between production and reception. Dürer's 1500 *Self-Portrait* might be its epoch's emblem of the divine creativity of the artist. It might mythicize itself as self-produced, self-sustained. Yet it does this in order to draft a viewing contract valid for the artist's oeuvre as a whole. Self-portraiture as image of origin has as its end a regimen of response, and this regimen occurs *as* the history of self-portraiture's reception. Baldung, conversely, might stand for the entirety of this reception, cheerfully imitating, parodying, and disfiguring Dürer's art. As the embodiment of what Bakhtin terms the "dialogic," he might speak in the travestied voice of the artistic other (Dürer), thereby exposing the false singularity of origin, self, and canon. Yet Baldung's art also depends on its own viewing contract, which it proposes through bizarre instances of self-denomination and self-portraiture. My argument therefore circulates continuously between the poles of production and reception, artist and viewer, master and epigone. I commence with the rise of the Renaissance artist at the moment of self-portraiture, recover the viewing pact thus drafted, observe its effects within Baldung's reception, then circle back to self-portraiture at the end of the German Renaissance. There Baldung presages, through likenesses of himself, the death of the artist.

Dürer proposes himself as origin; and in placing him at the start, indeed in arguing that he has already prefaced what I shall say about him, I underwrite his proposal. The history of this book tells a different story, however. My research on German Renaissance art began in an encounter with a newly discovered single-leaf woodcut by Baldung, which James Marrow brought to my attention (fig. 140). I wanted to understand the image as aimed at each particular viewer, warning of impending death. I therefore tried not to submerge its message in the familiar, tired, and generalizing history of *vanitas* symbolism. What struck me most about Baldung's print was the curious interval between the scene's gruesome event, in which a knight is about to be toppled by a mounted cadaver, and the knight's sad glance toward the beholder, which suggests that the woodcut is really about ourselves. In a 1985 article I argued that Baldung designed this and other macabre images less as meditations on death than as demonstrations of the nature of visual meaning itself as it is experienced and understood by the image's "fallen" audience.[9]

Baldung's art occasioned, in my analysis, a methodological shift from *what* images mean to *how* they mean. And it raised a historical question about why, in the early sixteenth century, German artists wanted to thematize the activity of viewing and interpreting works of art in the particular ways they did. Turning to the history of modern hermeneutics, I found that German philosophers and theologians, from Wilhelm Dilthey to Walter Benjamin, Hans-Georg Gadamer, Gerhard Ebeling, and Hans Blumenberg, traced the origins of their own hermeneutic theory to the age of Luther. I proposed that a "crisis of interpretation," evident in many spheres of German culture on the eve of the Reformation, motivated Baldung's art as well. To widen this historical context, I investigated images that had as their explicit subject the new hermeneutic method of Luther and thereby registered the changing status of interpretation and of self. Whereas my work on Lucas Cranach the Elder's images of the law and the gospel studied the "rise of the viewer" from the perspective of pragmatic history (that is, the events and human decisions of the Reformation), I discovered that the pictorial strategies of Baldung and Cranach belonged to a different kind of history, one played out between artists within a pictorial tradition—what the Russian formalists termed the "succession of systems."[10] I was thus led to the creative source of this pictorial tradition, Albrecht Dürer, and to the emblems of his originality: his self-portraits produced between 1491 and 1500.[11] I presented my initial work on Dürer at the 1986 St. Louis Symposium on German Literature at Washington University.[12] My ideas on the relation between Dürer's general aesthetic and the legal status of the artist's monogram were developed in a paper delivered at the Arbeitsgruppe Poetik und Hermeneutik in Bad Homburg in October 1987.[13] Paralleling my work on Dürer, I examined modes of artistic self-representation in Baldung (monograms, coats of arms, and oblique self-portraits), observing how they disfigure Dürer's original project of self-portraiture. This research was first presented in 1988, in lectures at Northwestern University and at the Twenty-third International Congress on Medieval Studies in Kalamazoo, Michigan; and it was developed at the conference "Traditionsbewußtsein und Traditionsverhalten," organized by Walter Haug and Burghard Wachin-

ger and held at the Reisensburg in 1989.[14] This book also revises my 1988 University of California at Berkeley dissertation, *Self Portraiture and the Crisis of Interpretation in German Renaissance Art: Albrecht Dürer, Hans Baldung Grien, Lucas Cranach the Elder.*[15]

Paul Valéry wrote, "There is no theory that is not a fragment, carefully prepared, of some autobiography."[16] One function of prefaces is to propose a link between the book and its author, to affirm a single voice and a single intention behind the text that will follow. This book, however, grew from dialogues with friends and teachers, and it speaks in many voices. It began in conversations with fellow graduate students, in particular in the Department of the History of Art at Berkeley: Kay Cashman, Martha Hollander, and Wendy Ruppel. It depended, throughout, on the advice, ideas, and support of many people, especially Paul Beutel, Sarah Cahill, Cynthia Chase, Juliet Fleming, Stephen Greenblatt, Moshe Halberthal, Walter Haug, Reiner Haussherr, Chris Hummel, Joan Koerner, Leslie Kurke, Margaretta Lovell, Steven Owen, Steven Ozment, Peter Parshall, Frank Schirrmacher, Seth Schwarz, Jane Selby, Natasha Staller, Michael Stolleis, Jurij Striedter, and O. K. Werckmeister. It was shaped, early on, in seminars with Svetlana Alpers, who guided my dissertation to its completion, and who kindly nominated me to the Society of Fellows at Harvard University. The society gave me three precious years of unstructured time and provided the most supportive, stimulating, and intellectually spacious environment imaginable. I also owe thanks to my mentor from my undergraduate years at Yale: Harold Bloom introduced me to the question of artistic influence, and his own influence remains pervasive and deep. At Harvard, John Shearman and Geraldine Johnson helped in crucial ways, reading and commenting on the entire manuscript. This book would be diminished without them. Benjamin Binstock offered important comments on a late draft of the book and prodded certain arguments to their conclusion. I owe special thanks to my adviser James Marrow, who taught me what to ask of northern Renaissance art, and whose experience, inspiration, support, and technical advice helped me at every step of the way. Finally and most of all, my father Henry Koerner taught me the thought unique to painters; this book is one reception of his great originality.

This book was written in a time not of inwardness, but of love. If it is the fragment of an autobiography, then it is a marriage portrait dedicated to my wife Lisbet.

Prologue

1

Prosopopoeia

What is the moment of self-portraiture? At what point in history, at what juncture in their tradition or their biography, do artists set about fashioning images of their own physical appearance? And what instant in the bodily life of the artist will these images articulate? In an ink drawing produced about 1491 and preserved now in Erlangen, the twenty-year-old Albrecht Dürer peers out at us from the moment of self-portraiture. His furrowed brow and the squint of his asymmetrical eyes register the strain of someone seeing in order to draw (fig. 1; W. 26).[1] Ourselves now fixed in the artist's gaze, we behold not simply Dürer's likeness, but rather something temporally more specific: Dürer as he appeared "just then," in the instant of the drawing's production, absorbed in the act of observing and sketching himself. Before we can write its history or motivate its context, the Erlangen *Self-Portrait* draws us toward the *Augenblick* of its own making. As a document of the artist's struggle to perceive and to capture himself as the visual image's origin, the sketch can be for us the lapidary starting point for understanding the moment of Dürer's self-portraits.

The Erlangen drawing reads less as a picture of Dürer's physical appearance than as the study sheet of a body at work. With the help of a convex mirror (flat mirrors were not yet available to Dürer),[2] the artist observes himself performing a reflexive operation that can be described only in awkward, involuted phrases: Dürer drawing himself drawing—or seeing himself drawing himself drawing. Unwilling simply to portray his body isolated from the activity that occupies it, his struggle will continually compound itself. For the more Dürer strains to behold and to represent his mirrored likeness, the more the strain of looking will alter the features of his face. Thus confounded by the essential mutability of his subject, it is no wonder the artist looks troubled as he gazes toward us at the end of his labors. There is something unsettled and unsettling, for example, about that right eye[3] that, looking straight out of the picture, represents Dürer's active eye. As if to represent with his pen the activity of looking—as if, that is, to render his gaze visible to our sight—Dürer concentrates on his eye's material contours, laboring over

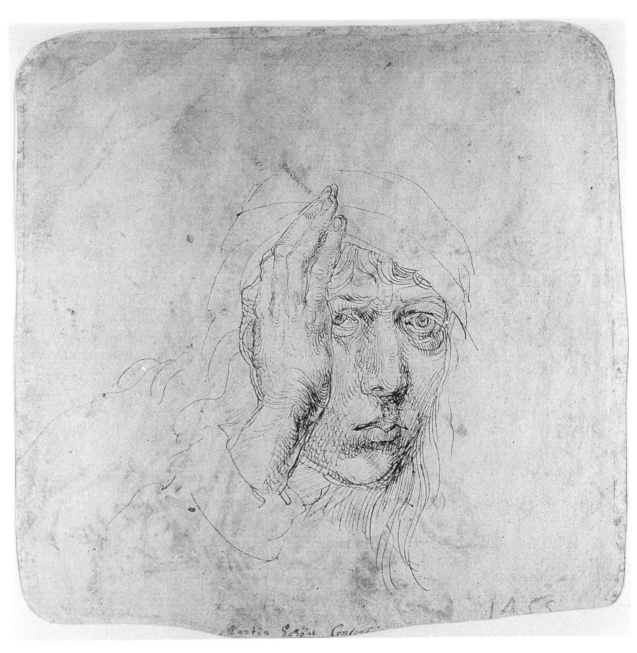

1. Albrecht Dürer, *Self-Portrait*, c. 1491, pen and dark brown ink, Universitätsbibliothek, Erlangen.

its shadows and encircling its limits so that it seems finally to stand out from the rest of the face. This dense concatenation of lines, as well as representing an eye, thus chronicles a pursuit: the artist's hand seeking to capture its controlling agent, the originary and seeing eye.

Perhaps the most striking feature of the Erlangen *Self-Portrait* is its deft formal conjunction of hand and eye. Dürer's highly evocative gesture of propping his head against

his hand so that his left pupil just borders on the edge of his palm relates in part to the difficult operation of self-portraiture. As his own model, the artist must maintain a still pose even as parts of his body are actively observing and sketching. Dürer himself complained of an "unrest in painting" caused by the mobility of an artist's gaze, which can never observe anything from a fixed point.[4] Such motion would frustrate self-portraiture particularly, since here the artist cannot move his eye without also altering his object. In the Erlangen drawing Dürer seems to solve this problem by holding his head in place with his hand, steadying thereby both his gaze and its object. Dürer is not disturbed that his hand, pressed firmly against the skin of his cheek, has obscured and even distorted features of his face. For what occupies him is not a flawless rendition of his likeness, but rather the anatomy of tensions and relations that attend the double activity of looking and representing. The Erlangen drawing is perhaps the first self-portrait to thus celebrate the moment and conditions of its making.

This is not to say that Dürer's *Self-Portrait* wholly *explains* those conditions. The artist attends to the two traditional centers of pictorial interest in portraiture, the face and the hand, conjoining them at the center of his sheet. Yet he leaves the rest of his body unfinished and omits altogether any indication of surrounding space. We are left to guess, for example, whether Dürer's left elbow really rests on some supporting surface, as his raised shoulder suggests, or whether he holds his hand up to his face to observe a particular conjunction that interests him visually. This uncertainty raises difficult questions about the occasion of the Erlangen sheet. Did Dürer begin his sketch as a self-portrait, depicting his likeness conveniently supported by his left hand? Or was it rather his hand's interaction with his cheek that he first studied, the self-portrait being merely a fortuitous afterthought? It is not enough to say that both may have been intended, or that Dürer's original intention is of no importance to us today. For as we shall see, the interpretation of Dürer's drawing will already rest on how we read this gesture—how, that is, we come to terms with the privileged and, at 1491, novel practice of self-portraiture.

Dürer presses palm against cheek, yet the hand does not integrate itself easily into the self-portrait. The dark line indicating the hand's contour on the right, passing down the length of Dürer's face and silhouetted against the merest indication of hair and hat, stands out from the drawing. Although it is difficult to view Dürer's face without perceiving the hand that frames it, the hand is easily discernible as a discrete object, disconnected from the face it overlaps. This results in part from a disparity in the drawing's graphic style, which delineates the face more loosely and informally than the carefully outlined hand. The imaginable disjunction between hand and face anticipates Dürer's slightly later *Self-Portrait* drawing, now in the Metropolitan Museum in New York (fig. 2; W. 27). Here the abrupt juxtaposition of portrait likeness and hand, stationed above a crumpled pillow, registers not only two separate body parts depicted as mere objects in different scales, but also two distinct methods by which an artist can view his own person. Whereas Dürer observes his face in a mirror, he draws his left hand directly, holding it in position before him. What jars us most in the Metropolitan *Self-Portrait* is that this hand, really Dürer's left, reads like a greatly magnified image of his right hand as it would be seen beside his

face and reflected in a mirror. Its size suggesting proximity to the mirror or the picture plane, the hand would mime what will always escape self-portraiture: the artist's active right hand wielding a pen between thumb and fingers.

In the Erlangen drawing, Dürer checks the hand's ambiguity in the specular moment of self-portraiture, its capacity to be represented both directly and through a mirror, by insisting that it made physical contact with his face. The fold of skin pushed up just below his left eye attests to a real dialogue of Dürer's body with itself. Even if Dürer's hand may block, distort, or overpower his likeness, this fold, represented by a line barely larger than a comma, provides testimony that the image we see is all of one flesh.

Self-portraiture is a bodily activity here. At the very center of the visual field, Dürer conjoins hand and eye as tools of the artist's trade. They recall a deeper conjunction we cannot see: the relation between Dürer's active right eye and his right hand that has fashioned the image before us. The always mobile right hand constitutes a lacuna in self-portraiture, for in it the artist's two roles of maker and model become irreconcilable. In the Erlangen drawing, Dürer resurrects his hand in its works. In the drawing's loose, spontaneous style, in the equal handling of outlines and modeling, the artist insists that his right hand show itself within the visible marks that make up the image. This will be true of Dürer's graphic style generally: the pen's free play on the page has value because, by registering the actual bodily and temporal event of human making, it attests to the authentic presence of the artist in the work of art.[5] We need only compare the Erlangen *Self-Portrait* with drawings by other German masters of an earlier generation to discern the novelty of the young Dürer's style.[6] In Hans Holbein the Elder's (c. 1460–1524) drawing of *Kungspergs Niclas,* for example, produced in Augsburg as part of a sketchbook of portrait likenesses, every line rendering the boy's likeness is set down to be final and true (fig. 3).[7] The finished sketch is made to betray no evidence of the human and therefore fallible labor that went into it. Once established, the body's contours will only be traced and retraced until they are veritably etched into the white prepared ground—note the scratched surface around the heavy outline of the boy's chin and jaw, as well as his whole right contour. Holbein controls the calligraphic potential of his line even in rendering the boy's hair. Restricted to outlining individual locks, his silverpoint studiously avoids ever interweaving its lines. When the artist wavers, as he does in rendering the position of the bent forefinger at the right and in outlining the sitter's collar, he takes care to conceal this process under dense hatching.

Dürer, on the other hand, utilizes the effects of error, allowing all lines, failed and successful, to energize his self-portrait. The several lines that differently render his thumb, or the dense jumbles of marks that describe his chin and wrist, make Dürer's likeness mobile and alive. These many lines, read together, document the *work* of representation. They are an intrinsic part of that project, enacted also in the posture and expression of the represented sitter: Dürer representing his body in labor and motion, sketching himself in the act of sketching. Self-portraiture takes place here as much in the spontaneous activity of the artist's right hand as in the likeness steadied by the left. Dürer unites his roles of maker and model within one irreducible moment.

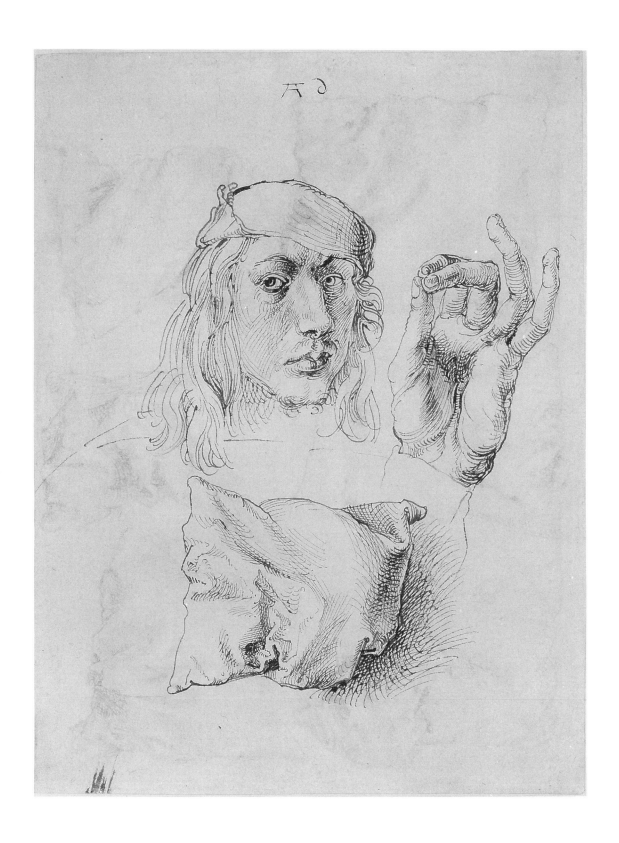

2. Albrecht Dürer, *Self-Portrait at Age Twenty-two*, c. 1493, pen and brown ink, Robert Lehman Collection, Metropolitan Museum, New York.

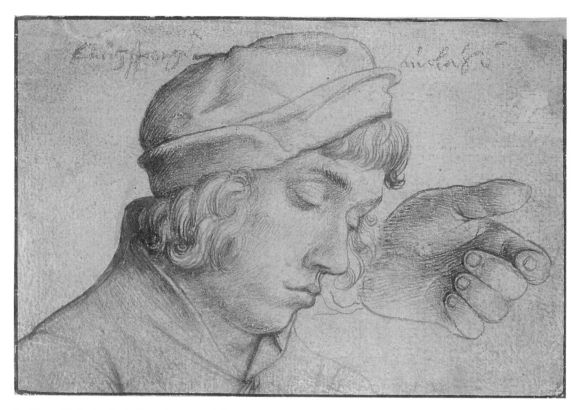

3. Hans Holbein the Elder, *Portrait of Kungspergs Niclas*, c. 1511, silverpoint on white grounded paper with gray ink wash, Kupferstichkabinett, Staatliche Museen Preußischer Kulturbesitz, Berlin.

In his important 1934 monograph on Dürer's self-portraits, Hugo Kehrer discovers in the Erlangen drawing a "moment" of a very different kind. For Kehrer, the drawing represents "more than an individual likeness. This representation of the I is at once a spiritual self-analysis and self-dissection. One could say, in that hour of Dürerian self-observation the German Renaissance awoke."[8] In Kehrer's reading, representative of nearly all scholarly accounts of Dürer's self-portraits, the moment of self-portraiture has been elevated to an epochal turning point in the history of Western culture. The particular arena of change the Erlangen drawing inaugurates is that of an emergent self-consciousness. Dürer's momentous celebration of what Kehrer calls "the limitless abundance of a most intricate and polymorphic inner life" makes him a precocious representative of the modern age. We need not yet address Kehrer's assertion that Dürer observes and anatomizes his "inner" self in the Erlangen sketch. It is a view shared by most of the drawing's interpreters, from Heinrich Wölfflin and Wilhelm Waetzoldt to Erwin Panofsky,[9] and it belongs to a tradition of historiography reaching back through Jacob Burckhardt to Jules Michelet and Hegel, which celebrates the modernity of the Renaissance in its discovery of the individual self.[10] What interests us here is the particular hyperbole with which Kehrer expresses the *originality* of Dürer's drawing: "In that

hour of Dürerian self-observation the German Renaissance awoke." In the tense features of Dürer's face, and in the nervous lines that render the likeness, we are asked to discern not only the heightened temporality of an artist capturing his own body in labor, but also the very instant in which the Renaissance, which is to say modernity, first occurs in Germany. So new, so original is that moment of self-portraiture that Dürer performs in it the start of our age.

Kehrer's interpretation of the Erlangen *Self-Portrait* makes at least two extravagant claims. First, by narrowing the inception of the German Renaissance to a singular "hour" of one painter's practice, Kehrer hyperbolizes the belief that historical epochs have precisely datable beginnings. The Erlangen drawing becomes a momentous demonstration of Western history in the making. In it Dürer launches the Renaissance with a flourish of his pen. Second, by locating the start of the Renaissance in one painter's self-portrait, Kehrer valorizes the individual human self, most fully embodied in a great artist like Dürer, as history's prime mover. In the radical disparity between the little sketch in Erlangen, produced by one person and intended for a very limited audience, and its colossal historical significance, Kehrer underscores the absolute sovereignty of the artistic self.

It would be easy to historicize Kehrer's own position, to regard it, say, as a belated expression of the romantic cult of genius. Yet I am convinced that the sources for Kehrer's notion of self and epochality also lead back to Dürer and to the culture of the German Renaissance. Dürer, we shall see, proclaims himself the incarnation of a new era in his monumental *Self-Portrait* of 1500. And it is Dürer, in what he himself calls his "strange saying,"[11] who first proclaims that a small, quick sketch of a great master is far more important than a year's labor of a lesser talent. It makes little sense today to argue, with Kehrer, that Dürer's self-portraits inaugurate the Renaissance in Germany. Yet as representational practice, self-portraiture provided a place wherein such a nascent conviction as the self's sovereignty, or a culture's epochality, could be reified, celebrated, questioned, or dismissed.

Certainly the plot of self-portrayal can celebrate the originary powers of the human subject. In the specular moment of fashioning one's own likeness, one installs oneself at once as viewing subject and as thing viewed, as representation's origin as well as end. The picture can therefore claim autochthony, isolating itself from any source, human, historical, or divine, beyond what it already represents. Self-portraits can exemplify the notion of an "autonomous" likeness, such as was being theorized for painting during the Renaissance. In his treatise *De sculptura* from 1504, the Paduan humanist Pomponius Gauricus wrote that a portrait must depict its subject *ex se,* out of itself.[12] Portraiture must renounce a referentiality that would turn the sitter into a mere representation of something other or more general than himself.[13] This fiction of autonomy is heightened in a painting in which the represented person is also the work's creator. For in the self-portrait, the *uomo singulare* has himself given rise to his own likeness *ex se.* Displayed in

both his appearance and his works, the artist stands self-contained and complete, freed of any functions or references beyond self-denomination.

Such a picture presents the interpreter with a problem. How can we motivate a suitable context for self-portraiture? How, that is, can we write its history without threatening an autochthony that the image might propose about itself? Kehrer's exaggeration of the epochality and self-assertion of the Erlangen drawing articulates what self-portraiture might well write about itself: the individual self, master of its representations, is in command of a history that it alone inaugurates. Thus far my account of the Erlangen sketch has followed this plot. It introduces my study of self-portraiture neither because it exemplifies my methods nor because it surveys my material, but because it allows Dürer's drawing to articulate itself fully *as* introduction: introduction to the project of self-portraiture and its epoch, the Renaissance in Germany. How true is this reading, though, to the moment of self-portraiture?

On the recto of the Erlangen *Self-Portrait*, Dürer has drawn a very different work: the Virgin, seated on a bench, cradles the Christ child while Joseph peers at them from behind, supported by a cane (fig. 4, W. 25). The Holy Family was a popular motif in late fifteenth-century German art, partly because it expressed the sacred in terms of a domestic intimacy that appealed to a predominantly bourgeois audience. Dürer produced at least three drawings of the Holy Family during his travels as a journeyman (1490–1494).[14] In the Erlangen drawing Dürer embroiders this traditional scene with a subtly construed Joseph, articulating in his stooped but agitated form an old man's feelings of bafflement mixed with wonder. But Dürer's interest in this drawing is less in the gestures of subjectivity than in the formal qualities of an elaborately crumpled drapery. Garments dominate the composition, creating a relief surface that cascades diagonally down the sheet and gathers in deep hairpin folds at the lower right. Outlined in heavy, aggressive lines and modeled in an ordered system of hatching, each fold becomes a unique and fully architectural object in shallow space. Compared with this, Dürer's treatment of the Virgin's face and the Christ child appears awkward and summary. One would imagine, for example, that the artist who could so elegantly construct the gothic twirl of cloth above the Virgin's right knee would take more care in depicting Christ's right arm. The Erlangen *Holy Family*, however, has a more narrowly defined focus. The young Dürer is building his decorative repertoire by concentrating on the free play of a bent, folded, and twisted surface.[15]

Although the folded garments themselves appear unpredictable in their configurations, Dürer's graphic style is highly controlled and systematic throughout. The movement that animates the Virgin's robe is conveyed by measured and stiff pen strokes, some of which appear to have been made with a straightedge. We are far from the calligraphic style of Dürer's *Self-Portrait* on the verso, where accidents of line occur not in the represented object, but in the spontaneous movement of the artist's pen. The drapery in the *Holy Family* stands closer to the studied manner of Holbein's *Kungspergs Niclas* (fig. 3), in which outlines are clean, final, and without visible error. Some scholars regard the Erlangen *Holy Family* as the copy of a lost work by Martin Schongauer.[16] This might explain

4. Albrecht Dürer, *Holy Family*, c. 1491, pen and dark brown ink, Universitätsbibliothek, Erlangen.

Dürer's cautious draftsmanship. Whereas in the *Self-Portrait* on the verso his hand freely traces the lines of his own body, in the *Holy Family* he is struggling to learn the line of his predecessors.

Differences between the two sides of the Erlangen sheet reflect the range of pictorial exercises out of which Dürer's famous likeness emerged. Self-portraiture begins within a highly varied practice. The young artist sketches both from nature and from earlier art, experimenting all along with different graphic styles and pictorial formats.[17] Much later, in his theoretical writings, Dürer affirms the importance of drawing to an artist's work and training. A sketch can provide the model for a finished composition, enabling the

artist to foresee and, if necessary, correct his final work: "In order to portray such things [as the specific appearance of people] it is useful, before one starts a work, to sketch with outlines the picture as one intends it to be, so that one can see if there is something in the figures that might be improved."[18] But even before that, drawing is central to an artist's education. By learning to translate any object, in whatever position it shows itself, into a convincing and pleasing likeness, the aspiring painter can acquire the manual dexterity and visual acuteness necessary for producing finished works of art: "That is why it is necessary for every artist to learn to draw well. For this is useful beyond measure in many arts, and much depends upon it."[19] Here the individual sketch functions not as a preparatory model for a finished painting, but rather as an exercise to train the hand and eye generally. The goal of this pedagogy is the "free, practiced hand,"[20] a hand so trained that it can accurately paint anything the artist sees without need for a preparatory sketch.[21]

The verso of Dürer's *Self-Portrait* in the Metropolitan Museum displays an extraordinary example of the young Dürer's diligence as an aspiring artist (fig. 5; W. 32). The artist has filled the sheet with six studies of crumpled pillows. Except for the top two, no pillow overlaps another, nor do they cast shadows on any surface outside their own. Unadorned and silhouetted against a neutral ground, each pillow is captured in its volume and coherency as a separate object, even as it is distorted from its essential square form. A pillow is the simplest of things: two surfaces enclosing a volume. Yet Dürer delights in the passage from simple to complex, from smooth to tortuous, as he pens the structural logic of his motif. Far more than in the drapery of the earlier *Holy Family* drawing in Erlangen, we sense the artist's bodily relation both to his object and to his work. One supposes that the six pillows are really permutations of a single pillow that has been punched, twisted, and arranged by the artist himself. And once created, these pillow sculptures will be rendered in supple lines expressive of the twisting movement of sketching itself. Note the impossible little spiral fold at the left edge of the pillow at center left. Contours have been transformed into flourishes, pillows into paraphs, in the attempt to render the pure object in line.

In *Six Pillows*, Dürer learns to master the thing in itself—here the unformed clump potentially infinite in variation—by translating its shape into the movements of his pen. The recto of the sheet charts this operation (fig. 2). The artist's gaze, depicted in the self-portrait, conjoins with his hand (here Dürer's left hand projected to the right) to confront and represent an object: the crumpled pillow below. This pillow may well have been the first of the series. It still has commerce with its surroundings, balancing oddly on some curved surface that appears to slope upward to the right. By the time he sketches the seventh pillow at the base of the sheet's verso, Dürer has learned to isolate his object, depicting the pillow as a volume that, however complex, remains legible, stable, and self-contained. Viewed thus as the chronicle of a movement from face to pillow and from subject to object, the Metropolitan sheet tells a story of the self's mastery over things seen.

And yet the work can sustain quite the opposite reading. Dürer's likeness, arranged

4. Albrecht Dürer, *Holy Family*, c. 1491, pen and dark brown ink, Universitätsbibliothek, Erlangen.

Dürer's cautious draftsmanship. Whereas in the *Self-Portrait* on the verso his hand freely traces the lines of his own body, in the *Holy Family* he is struggling to learn the line of his predecessors.

Differences between the two sides of the Erlangen sheet reflect the range of pictorial exercises out of which Dürer's famous likeness emerged. Self-portraiture begins within a highly varied practice. The young artist sketches both from nature and from earlier art, experimenting all along with different graphic styles and pictorial formats.[17] Much later, in his theoretical writings, Dürer affirms the importance of drawing to an artist's work and training. A sketch can provide the model for a finished composition, enabling the

artist to foresee and, if necessary, correct his final work: "In order to portray such things [as the specific appearance of people] it is useful, before one starts a work, to sketch with outlines the picture as one intends it to be, so that one can see if there is something in the figures that might be improved."[18] But even before that, drawing is central to an artist's education. By learning to translate any object, in whatever position it shows itself, into a convincing and pleasing likeness, the aspiring painter can acquire the manual dexterity and visual acuteness necessary for producing finished works of art: "That is why it is necessary for every artist to learn to draw well. For this is useful beyond measure in many arts, and much depends upon it."[19] Here the individual sketch functions not as a preparatory model for a finished painting, but rather as an exercise to train the hand and eye generally. The goal of this pedagogy is the "free, practiced hand,"[20] a hand so trained that it can accurately paint anything the artist sees without need for a preparatory sketch.[21]

The verso of Dürer's *Self-Portrait* in the Metropolitan Museum displays an extraordinary example of the young Dürer's diligence as an aspiring artist (fig. 5; W. 32). The artist has filled the sheet with six studies of crumpled pillows. Except for the top two, no pillow overlaps another, nor do they cast shadows on any surface outside their own. Unadorned and silhouetted against a neutral ground, each pillow is captured in its volume and coherency as a separate object, even as it is distorted from its essential square form. A pillow is the simplest of things: two surfaces enclosing a volume. Yet Dürer delights in the passage from simple to complex, from smooth to tortuous, as he pens the structural logic of his motif. Far more than in the drapery of the earlier *Holy Family* drawing in Erlangen, we sense the artist's bodily relation both to his object and to his work. One supposes that the six pillows are really permutations of a single pillow that has been punched, twisted, and arranged by the artist himself. And once created, these pillow sculptures will be rendered in supple lines expressive of the twisting movement of sketching itself. Note the impossible little spiral fold at the left edge of the pillow at center left. Contours have been transformed into flourishes, pillows into paraphs, in the attempt to render the pure object in line.

In *Six Pillows,* Dürer learns to master the thing in itself—here the unformed clump potentially infinite in variation—by translating its shape into the movements of his pen. The recto of the sheet charts this operation (fig. 2). The artist's gaze, depicted in the self-portrait, conjoins with his hand (here Dürer's left hand projected to the right) to confront and represent an object: the crumpled pillow below. This pillow may well have been the first of the series. It still has commerce with its surroundings, balancing oddly on some curved surface that appears to slope upward to the right. By the time he sketches the seventh pillow at the base of the sheet's verso, Dürer has learned to isolate his object, depicting the pillow as a volume that, however complex, remains legible, stable, and self-contained. Viewed thus as the chronicle of a movement from face to pillow and from subject to object, the Metropolitan sheet tells a story of the self's mastery over things seen.

And yet the work can sustain quite the opposite reading. Dürer's likeness, arranged

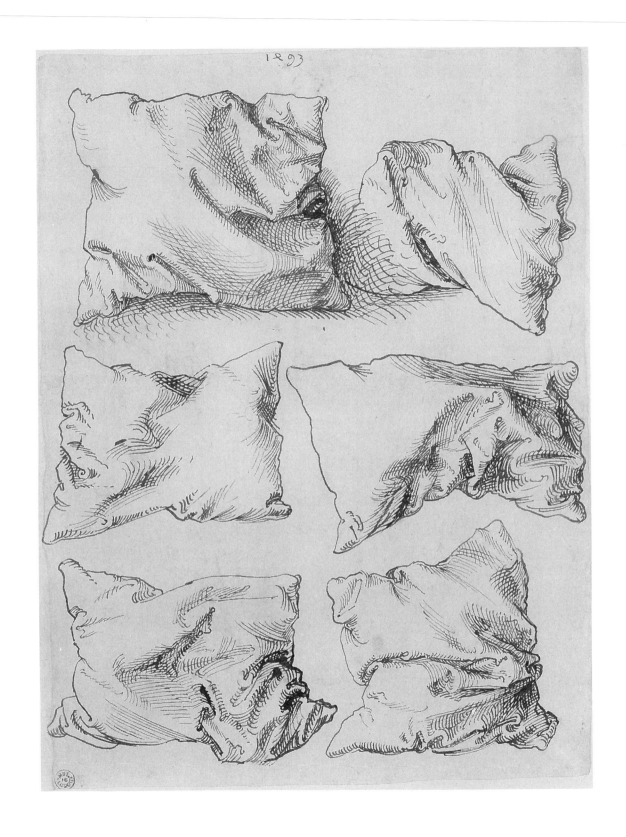

5. Albrecht Dürer, *Six Pillows*, c. 1493, pen and ink, Robert Lehman Collection, Metropolitan Museum, New York.

on the page with a pillow and a hand, has been reduced to a thing among things. In his own features the artist has discovered merely another appearance to master, another surface whose folds and contours he can control with his pen. And from the looks of it, Dürer found his own face less interesting than the dumb folds of the pillows that hold his attention through six sketches on the verso. We are far from Kehrer's account of the moment of self-portraiture. The artist's face is merely another available object for training his visual and manual skills.

But let us return now to the Erlangen *Self-Portrait* and work out its place within the young artist's practices as draftsman. I hypothesized earlier that Dürer's interest in this drawing lies less in rendering clearly his own characteristic features than in studying a face (which just happens to be his own face) in a particular attitude and posture. As in the sketch of *Six Pillows*, the Erlangen drawing studies specifically a folded and distorted object: the flesh of Dürer's cheek pressed up against the edge of his palm. Dürer's attention to this specific subject may involve more than a random appetite for difficult pictorial tasks. For in a slightly later drawing of the *Holy Family*, now in Berlin, this motif appears copied in the figure of Joseph at the right (fig. 6; W. 30).[22] With his head propped against his hand, Joseph can lean toward the seated Virgin and child while still maintaining his distance. This separation is meaningful, for as the garden wall in the middle ground at the left and the closed gate at the right suggest, Mary's virginity is expressed in an image of closure, here the *hortus conclusus*. Joseph's hand, together with the grassy bench and the hem of Mary's garments, acts as a visual barrier between himself and the Virgin and suggests the isolating psychic state of inward contemplation or sleep. The Berlin drawing thus relates to problems already raised by the *Holy Family* on the recto of the Erlangen *Self-Portrait*, in which Joseph, again separated from the Virgin by the bench and by an extension of drapery, retains an enigmatic relation to the mystery of Christ's birth through gesture and pose. In the Berlin drawing, and later in the pen and watercolor sketch of the *Madonna with a Multitude of Animals*, the Christ child points his right index finger at Joseph as if to reiterate the mystery of his paternity. For Joseph is both a father and not a father, a human origin that has been elided by the Virgin birth. Dürer himself practiced this pose in his earliest extant work, the silverpoint *Self-Portrait* from 1484 (fig. 19). The pointing finger responds here to the hand of Dürer's own father, which, in the silverpoint *Self-Portrait of Dürer the Elder* (fig. 22), holds the product of its labor: a silver statuette.

Working on the Erlangen *Holy Family*, Dürer confronted the figure of Joseph in all its semantic complexity, as model of piety and as cuckold, as player in biblical history, as extraneous observer, and as mere illusion of origins. In drawing his own self-portrait on the verso of the sheet, the artist perhaps sought to devise a more effective visual formula for Joseph, invoking the interiorizing gesture of a head propped up by hand. Having performed and observed this gesture himself, Dürer was then able to use his sketch for other drawings. We can observe such a practice in one of Dürer's very earliest extant works: the *Virgin and Child* now in the British Museum (fig. 7; W. 22). Mary's right hand, supporting the Christ child from below, is somewhat clumsily drawn, and Dürer seems

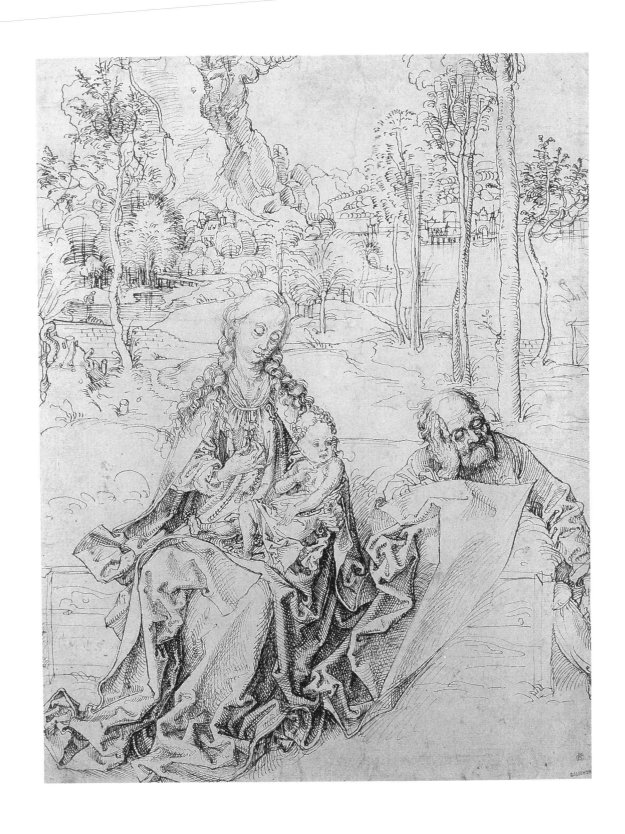

6. Albrecht Dürer, *Holy Family*, c. 1492–1493, pen and ink, Kupferstichkabinett, Staatliche Museen Preußischer Kulturbesitz, Berlin.

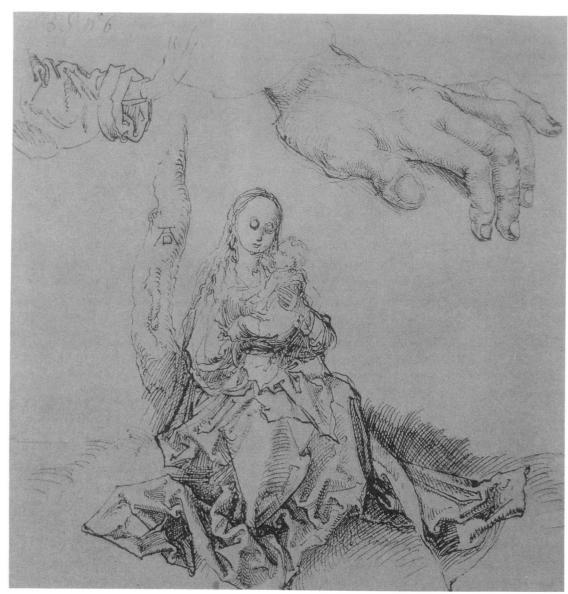

7. Albrecht Dürer, *Study Sheet with the Virgin and Child*, c. 1491, pen and ink,
British Museum, London.

to have practiced this form in a separate sketch at the sheet's upper left. The drawing of
a hand at the upper right might have had a similar function, although it solves different
formal problems and might belong to another project. The position of the wrist, the
slightly splayed minimus, and the direction of the arm suggest that this could be Dürer's
own left hand twisted in toward himself.[23] Taken as a whole, the sheet proposes a fluid
process of creation, in which work on a traditional motif, here the Virgin and child,
presents certain pictorial difficulties that Dürer solves in separate studies, always ready

to use his own body as a model. Similarly, in the Berlin *Holy Family*, the "representation of the I" (Kehrer) of the Erlangen *Self-Portrait* is transferred to a more traditional image, serving there to express a subjective relation—Joseph's—to the epochal event par excellence, the birth of Christ.

In his 1514 preface to the illustrated prose history of Emperor Maximilian I, Max Treitzsaurwein describes the book's unfinished state in terms instructive to our understanding of Dürer's drawings. Treitzsaurwein, who was secretary to the emperor and editor of the *Weiß Kunig*, explains that the book collects autobiographical passages by Maximilian himself that still await revision: "This book is now only material [*ain materi*] and an incomplete work and nothing else. It is a form that the most all-illuminating . . . emperor Maximilian has preliminarily supplied, in order that out of it, through the delightful eloquence of the German language, through the proper order of human reason, and with all the trimmings necessary for the royal truth, a completed work can be made."[24] In the *Weiß Kunig*, as in all the emperor's literary projects, autobiography provides merely the raw material out of which a fictionalized and partly allegorical biography will later be fashioned. Dürer's Erlangen *Self-Portrait* represents, similarly, an "incomplete work." The *materi* it provides finds its way into other, more "complete" creations. We have observed this in the Berlin *Holy Family*, where all that remains of the moment of self-portraiture is Joseph's hand. And it occurs again in a small panel of the *Man of Sorrows* dating from very early in Dürer's career, in which Christ gazes out at the viewer, chin propped in hand (fig. 8). The particular distortion of Christ's cheek, as well as many features of his face (his left eye and the shape of his mouth), bears a close resemblance to Dürer's Erlangen likeness. Far from capturing the whole personality and appearance of the sitter *ex se*, then, the Erlangen *Self-Portrait* functions as preliminary sketch for details in more traditional works.

Such a reading transforms our original visual experience, shifting our attention away from the image's aspect as self-portrait. The picture no longer seems to emanate from the artist's originary gaze as represented in his likeness. Rather, the darkly outlined hand asserts its priority within the genesis of the image, and Dürer's face consequently appears merely as a belated appendage. The drawing falls among the artist's many hand studies from this period, such as the *Study of Three Hands* in the Albertina (W. 47) and the sketch at the top of the London *Virgin and Child* (fig. 7), only in the Erlangen sheet has Dürer chosen to depict his object in context, pressed against the surface of a face. Thus interpreted, thus itself contextualized within Dürer's practice as a late medieval painter, the moment of self-portraiture appears as happenstance within more traditional artistic projects. Where at first we had discovered in Dürer's face the radically originary power of the self, now we find only an afterthought of pictorial attention.

And yet the gesture that Dürer performs, observes, and draws in the Erlangen sheet connotes a state of heightened subjectivity. Resting his head against his hand, the artist strikes the pose, present in art from antiquity to the present day, of someone absorbed

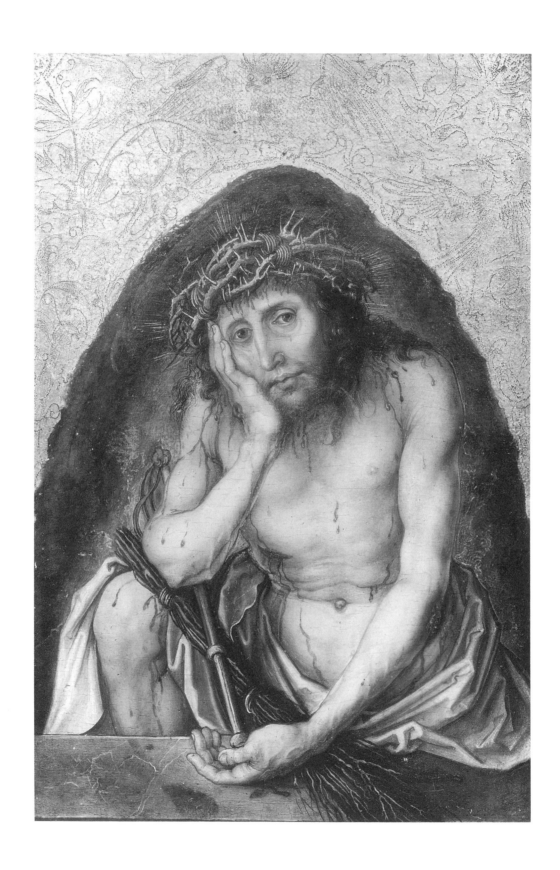

8. Albrecht Dürer, *Christ as Man of Sorrows*, c. 1494, oil on panel, Staatliche Kunsthalle, Karlsruhe.

9. *Job on a Dungheap*, illumination from *Dialogus de laudibus sanctae crucis*, c. 1170–1175, pen and ink on parchment, Bayerische Staatsbibliothek, Munich, Clm. 14159.

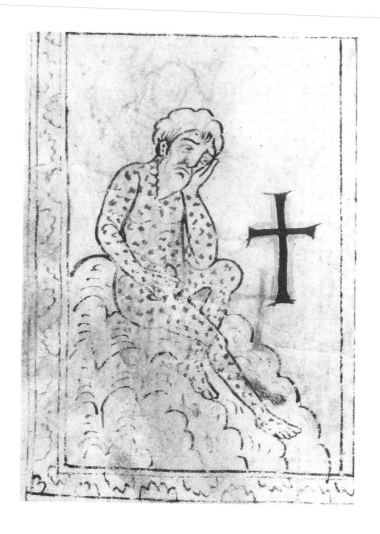

in himself. The suffering Job often assumes this posture, as in a twelfth-century illumination from Regensburg (fig. 9)[25] and an exterior panel of Dürer's own *Jabach Altarpiece,* now in Frankfurt (fig. 10). Closely related are the images of Christ in distress, such as Dürer's Karlsruhe picture (fig. 8), in which Christ, submitting himself wholly to his torments, sits as the emblem of patience.[26] While Christ's posture suggests a moment of rest within the Passion, the stigmata and side wound indicate that the Crucifixion has already occurred. Christ's meditative attitude, isolated from any single narrative context and expressed fully in his pose, exemplifies the self's properly inward response to the entire Passion. Gazing out of the picture, Christ appeals directly to us as viewers in the here and now, encouraging us not only to observe, but also to include ourselves in the subjective experience of suffering.[27] Read in conjunction with the Erlangen *Self-Portrait* upon which it is partially modeled, the posture of Dürer's *Schmerzensmann* becomes invested with a new, personal dimension. The interiority projected onto the viewer originates from the artist as he gazes at himself.[28] And given Dürer's subsequent habit of represent-

10. Albrecht Dürer, *Job Castigated by His Wife*, 1503–1504,
 exterior of right wing of *Jabach Altarpiece*, oil on panel,
 Städelsches Kunstinstitut, Frankfurt.

ing himself as Christ, the Karlsruhe panel begins to read less as a conventional religious image for which the Erlangen sheet was but a preparatory sketch than as the radical extension of the project of self-portraiture into the domain of devotional art.[29]

The meaning and function of Dürer's posture in the Erlangen *Self-Portrait* varies from context to context. When applied to the figure of Joseph in the Berlin *Holy Family*, it couples physical presence with spiritual absence or suggests Joseph's distress and doubt concerning the Virgin Birth. This is also true for Dürer's sketch of an old man in a margin of the *Prayer Book* of Maximilian I (fig. 11).[30] This figure, probably representing Joseph, embodies simultaneously the oblivion of the just man to physical hardship, as described in Psalm 46 printed on the same page, and the *tribulatio*, successfully withstood, of spiritual doubt.[31] In Dürer's woodcut *Design of a Monument to the Peasants*, made in 1525 after the great Peasants' War, the farmer ornamenting the column's top assumes a similar posture, now as the bathetic emblem of defeat or betrayal (fig. 118; Kn. 369).[32] And in Dürer's 1521 *St. Jerome*, the aged church father rests head on hand to express his knowledge and contemplation of the vanity of the world (fig. 12).[33] Most centrally, however, the gesture of resting one's chin in one's hand, as sign of inwardness or subjectivity, belongs to the established iconography of melancholy. It appears, for example, in a Frankish woodcut *Acedia* from about 1490 (fig. 13); and it is monumentalized in the winged angel of Dürer's famous *Melencolia* engraving of 1514 (fig. 14; Kn. 74).

One might assume that Dürer, sketching his own mirrored likeness on the Erlangen sheet, strikes his pose because "melancholy" appropriately names that condition where the self, turned inward upon itself, becomes absorbed in, and paralyzed by, its own reflection. The moment of self-portraiture appears suddenly more modern, more familiar. It becomes the premonition of romanticism's myth of genius: the artist as a sad, frail, inward-turned individual, tragically distanced from his life, his surroundings, his society, and his epoch, such as we see him in a *Self-Portrait* by the German romantic painter Caspar David Friedrich, dating from about 1802 (fig. 15).[34] Whether they acknowledge it or not, interpreters of Dürer's Erlangen *Self-Portrait* read the artist's likeness through this gaze of romantic melancholy. Waetzoldt sees the sketch as "melancholy self-brooding"; Helmut Theodor Musper observes a "presentiment of tragedy"; and the catalog of the great 1971 Dürer exhibition in Nuremberg refers to a loss of "spiritual equilibrium" in the artist's features.[35] Others have found evidence of physical frailty. Thus Friedrich Winkler writes, "It is indeed a bandage that the artist wears, and it suggests that Dürer perceived himself as an invalid."[36] This identification of Dürer's headgear is probably fanciful, yet it underscores the inclination of interpreters to decipher self in the Erlangen sketch as troubled or suffering. This is the consequence of Dürer's gesture. Fitted with melancholy's attribute, the artist's likeness conveys a general inwardness that will be read according to whatever model of character is current in the interpreter's own culture.

This sense of familiarity is fleeting, however. The idea of melancholy as it was inherited and revised by Dürer depends on notions of self and image that remain radically alien to us today. And the unresolved and centuries-old debate on the meaning of Dürer's *Melencolia* engraving hardly recommends applying the print as an iconographic key to the

Eus noster refugiũ et virtus: adiutor in tribulatiõibus: que inuenerũt nos nimis. Propterea non timebimus dum turbabitur terra: et transferentur mõtes in cor maris. Sonuerunt et turbate sunt aque eorum: conturbati sunt montes in fortitudine eius. Fluminis impetus letificat ciuitatem dei: sanctificauit tabernaculum suum altissimus. Deus in medio eius non commouebitur: ad

11. Albrecht Dürer, decorated page of the *Prayer Book of Maximilian*, 1515, pen and ink on parchment, Staatsbibliothek, Munich, L. impr. membr. 64, fol. 45.

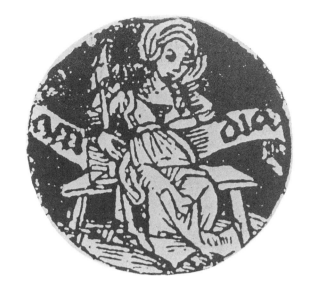

12. (*left*) Albrecht Dürer, *St. Jerome*, 1521, oil on panel, Museu de Arte Antiqua, Lisbon.

13. (*above*) *Acedia,* c. 1490, Frankish woodcut.

Erlangen *Self-Portrait*.[37] The engraving's obscurity is partly the artist's intention. Dürer invokes diverse areas of thought, from medicine, astrology, and numerology to geometry, theology, and art theory, in order to make a statement about or, perhaps more basically, to cause his viewers to think upon the work of the human mind per se.[38] The vast effort of subsequent interpreters, in all their industry and error, testifies to the efficacy of the print as an occasion for thought. Instead of mediating *a* meaning, *Melencolia* seems designed to generate multiple and contradictory readings, to clue its viewers to an endless exegetical labor until, exhausted in the end, they discover their own portrait in Dürer's sleepless, inactive personification of melancholy.[39] Interpreting the engraving itself becomes a detour to self-reflection, just as all the arts and sciences whose tools clutter the print's foreground finally return their practitioners to the state of a mind absorbed in itself. This links *Melencolia* to Dürer's two other "master engravings" of 1514, *St. Jerome in His Study* (Kn. 73) and *Knight, Death, and the Devil* (fig. 144; Kn. 72).[40] Each print pictures a relation of the self to itself, inflected variously in intellectual, spiritual, and moral labor and enacted always against the temporalizing horizon of death (the ubiquitous hourglass).

Yet if these three engravings invite us to attend to ourselves as *inner*, if they are indeed instruments of the Delphic injunction, reiterated for Dürer's culture by Erasmus, to "know thyself,"[41] the self envisioned in *Melencolia* is of a mixed pedigree. Melancholy, as defined by the medieval theory of humors, is black bile, a substance concentrated in the

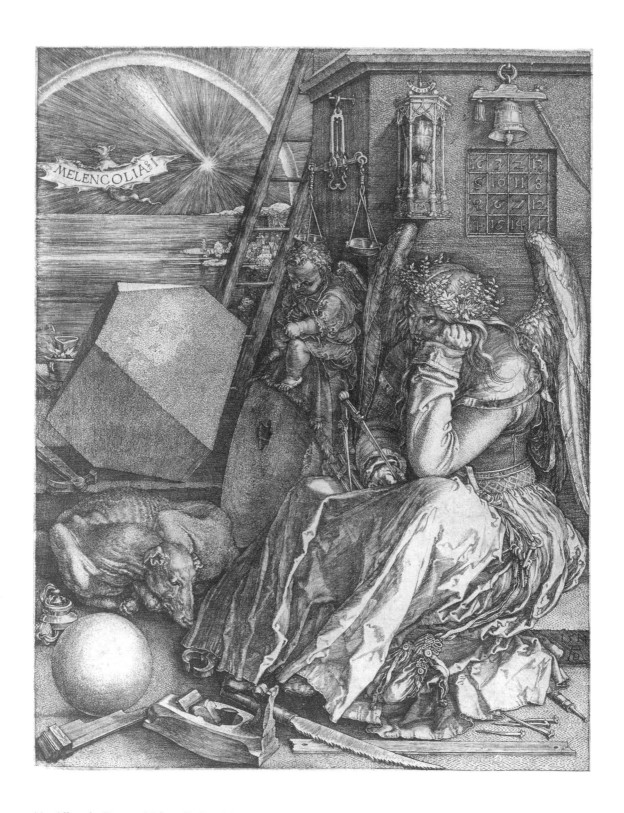

14. Albrecht Dürer, *Melencolia I*, 1514, engraving.

15. Caspar David Friedrich,
 Self-Portrait with Supporting Arm,
 c. 1802, pen and ink,
 Kunsthalle, Hamburg.

human spleen or kidneys. Excess bile makes a person sad and introverted not simply because, as substance, bile causes this mood *in them,* but because melancholy resides *in the bile,* as a psychic manifestation of what, ontologically, bile is. Charles Taylor has emphasized that the theory of humors differs from modern notions of self in this localization. Inwardness as melancholy proposes a protean relation of inner to outer, self to substance, subject to object, one that is foreign to us who feel our moods and selves to be somehow our own.[42] A reading of the Erlangen sheet through the medieval theory of melancholy might thus historicize the self depicted: self-portrayal would record less Dürer's unique and innermost being than melancholy's self-manifestation through the medium of the artist's body.

Medieval medical theory maintained that a person's character is formed by the influence of the humors and the planets and predetermined by the catastrophe in Eden. Adam, striving to be equal to God, ate the apple and fell into a state of existential deficiency whose chief symptom is melancholy and whose consequence is death. The self, heir to Adam, strives ever toward mastery, equating its powers with God's, but falls into a gloom that is the body's bitterness.[43] In their influential 1923 study of the *Melencolia* engraving, Erwin Panofsky and Fritz Saxl argued that Dürer superimposed upon this

older theory of the humors a new glorification of melancholy as the distinguishing characteristic of genius.[44] According to a strain of Renaissance humanism current in Germany at 1514, great artists, born under the sign of Saturn and constituted as melancholic types, create their works in alternating fits of divine frenzy and despondency. This creativity, more abstract and speculative than manual labor, elevates artists to a status akin to God's; hence the compass in Dürer's print as traditional attribute of God as *deus artifex* (fig. 16). The *Melencholia* engraving thus seems to articulate a pivotal moment in the history of subjectivity. Where the Middle Ages substantialized inwardness as the excess of black bile and moralized that excess as the deadly sin of acedia, the Renaissance abstracted inwardness as an inherent quality of creative genius and valorized its effects in the originality of the artist, whose works are wholly his own.

Following this clue, Panofsky and Saxl pressed their modernizing account further, locating the meaning of the 1514 engraving in the person of Albrecht Dürer. The print, we learn, is "a spiritual self-portrait," in which the artist declares himself to be "'inspired' by celestial influences and eternal ideas, but suffers all the more deeply from his human frailty and intellectual finiteness."[45] This interpretative shift from artwork to artist has been criticized as overly "romantic."[46] And indeed the reading of the *Melencolia* as a self-portrait has important precedents in the writings of Caspar David Friedrich's friend and

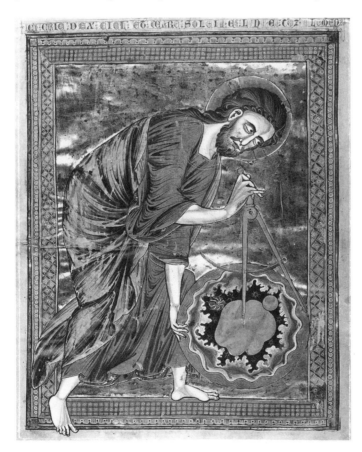

16. *God as Deus Artifex*, illumination from the *Bible moralisée,* 1220–1230, Vienna, Nationalbibliothek, Cod. 2554.

follower the Dresden romantic Carl Gustav Carus, as well as in an 1834 poem by Théophile Gautier.[47] Historical support for Panofsky and Saxl's argument remains rather scant: the *Self-Portrait of the Sick Dürer* in Bremen, in which the artist points to his spleen as the seat of his malady (fig. 91; W. 482); Philipp Melanchthon's (1497–1560) reference to Dürer's "most noble and magnanimous" melancholy; the artist's own belief, articulated in his theoretical writings, that painters' apprentices should be of a melancholy temperament; and Dürer's melancholy pose in the Erlangen drawing.[48] For our present purposes, however, the account of the 1514 engraving as a self-portrait is illuminating, for it remains consistent with a notion of melancholy as the dangerous foregrounding of self. Dürer's pensive angel, assuming a posture of inwardness that she shares with the artist in the *Self-Portrait* in Erlangen, provides the occasion wherein, exemplarily, the historiography of art can link the visual image to the person of the artist.[49] Undecipherable according to any single preexisting code, *Melencolia* draws its viewers into an ever-narrower locus of reference until the image becomes wholly the product and reflection of the unique, creative self of Albrecht Dürer. Even the winged spirit seated on the millstone carries a possible reference to the artist. Crouching over an object shaped like the monogrammed tablets of the *Jerome* and *Knight, Death, and the Devil* engravings, and wielding what might be a burin, the putto could even engrave the AD initials of Dürer's authorship.

Earlier in my account of the Erlangen *Self-Portrait*, I traced very different trajectories for Dürer's melancholy pose: as practical device for steadying the artist's gaze while he draws himself in the mirror; as mere formal problem to be mastered, like the folds of a pillow; as preparatory model for other works of art. In returning Dürer's pose to his practices as a draftsman, and in observing its subsequent itinerary in other works of art, we are led away from self-portraiture as a portrayal of self. From this perspective, the Erlangen drawing acts as a curious "source" for the *Melencolia* engraving and all its interpretative complexities. The artist has observed and represented himself only so that, once his pose is subtracted from the specificity and implied subjectivity of a self-portrait, it can enter into more impersonal works of art. Yet once invested with his likeness—once linked, however obliquely, to the moment of self-portraiture—that pose will carry with it the face of its maker. Thus it is that, without any recognizable likeness of Dürer himself, the *Melencolia* engraving can be called a self-portrait. What we are approaching here is neither an iconographic nor a historical problem, but a general phenomenon of signification: How is it that *things* (objects as well as works of art) are linked to *meanings* through the agency of the face-as-self?

The discovery of the artist in his works, or more generally the passage from object to self enacted in interpretation, finds a useful demonstration in Dürer's *Six Pillows* (fig. 5). Earlier I suggested that Dürer's study sheet, while containing a self-portrait on its recto (fig. 2), had as its goal the apprehension of the pure object, isolated from its context and reduced to an abstract play of outline and modeling. This movement from face to thing, however, tells only half the story. For as commentators have long noted, the pillows

themselves contain hidden faces in their folds and indentations.[50] For example, the curious spiral on the left edge of the pillow at center left acts as a possible eye for faces discoverable in the lower left corner and, upside down, at the upper left. Similarly, faces appear at the far edge of the pillow just to the right; the curved horizontal fold just below center reads both as the mouth of one face whose nose is the pillow's upper corner, and as the nose and eye of a smaller face in the lower corner. Once set in motion, this game of "seeing as" can be played indefinitely, transforming corners into noses, chins, or satyrs' horns, and creases into mouths and brows, until each pillow is animated by a number of hypothetical masks frowning, laughing, fretting, and speaking.[51] None of these faces, it is true, can be posited with certainty as really being there, nor do they remain stable for us. We lose one possible physiognomy once we discover another that overlaps with it. Yet even the skeptic will admit that the pillows, arranged in pairs and gesturing dynamically, have been rendered animate, if not anthropomorphic, by the artist's pen. These drawings exercise the visual fantasy not only of the artist inventing these grotesque physiognomies, but also of the viewer discovering faces that others might miss.

A pillow is an appropriate place to hide faces. As indicated by the German word *Kopfkissen* (literally "head cushion"), pillows are the head's support in sleep. In Dürer's *Dream of the Doctor* engraving of 1498, a head at rest on a pillow spawns lurid phantasms (fig. 17; Kn. 22). Once used, the pillow preserves in its indented shape a loose impression of the sleeper. In the Metropolitan study sheet, the hidden faces in the pillows merge imaginary sleepers with their place of rest, transforming the amorphous indentations of fabric into twisted, phantasmagoric countenances. We have already observed Dürer's interest in distorted physiognomies. The Erlangen *Self-Portrait* studies the artist's own altered features as he rests his face against his hand. Now, as I noted earlier, Dürer's punched pillows, as well as the calligraphic lines that rendered them, are themselves marks of Dürer as maker. It is appropriate, then, that the first face on the sheet's recto should be the artist's own: Dürer's self-portrait, reversed and subtly distorted through the convex mirror.[52] The Metropolitan sheet charts a movement from face to pillow, self to object, and back again. The artist's likeness may indeed be displayed as a thing among things, as just another exercise within the objective practice of an artist, yet "things" themselves have here been given faces and are invested now with a character that potentially can be read. Who can say which is more expressive, the artist's likeness gazing out at us at the top of the recto, or the histrionic, eyeless physiognomy of the pillow, whose upper left corner reads like a triumphant nose (note the mark, unrelated to the logic of the pillow's folds, indicating a nostril) and whose chin is the pillow's lower left corner? The historiographical uncertainty whether Dürer's early drawings of his own features are "self"-portraits or whether Dürer merely studies his face as just another object to be mastered by his pen is an aporia already staged by the material itself. For objects themselves have been inscribed with faces and are empowered to speak as subjects through the agency of pictorial prosopopoeia.

In his theoretical writings, Dürer terms an artist's object, that is, his visual model as it appears in nature, either a *gegen würff*, which simply translates the Latin *objectum*,

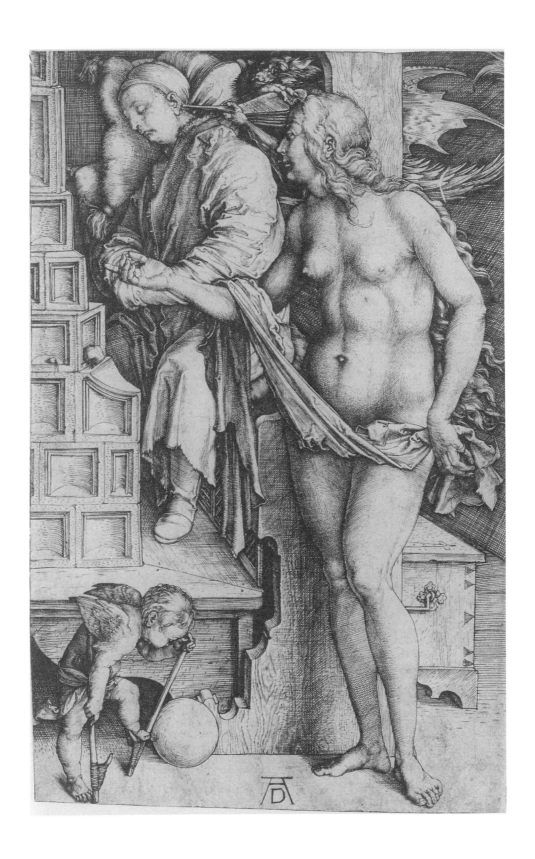

17. Albrecht Dürer, *Dream of the Doctor*, 1498, engraving.

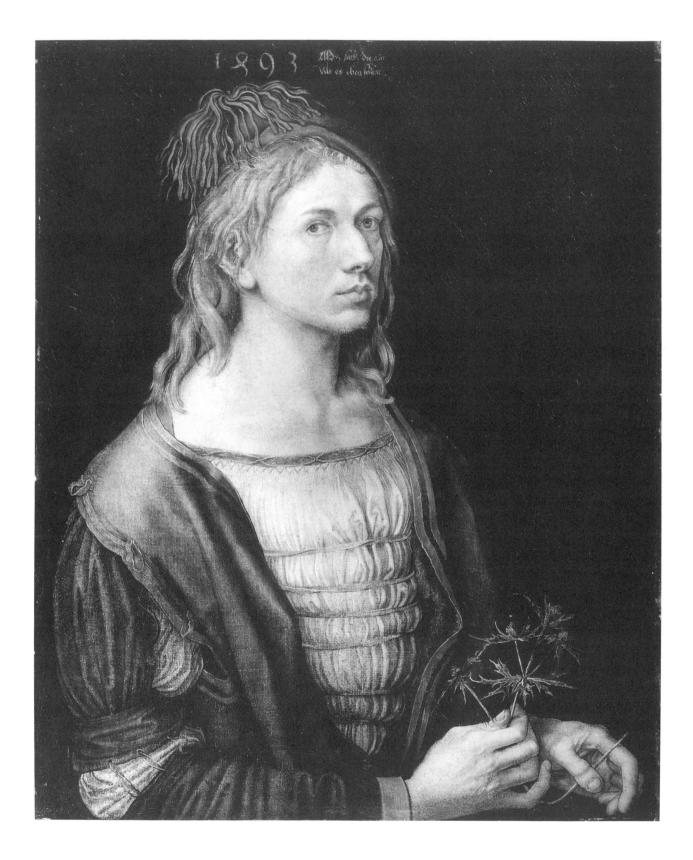

18. Albrecht Dürer, *Self-Portrait*, 1493, oil, transferred from
 vellum to linen, Louvre, Paris.

or more tellingly, a *gegen gesicht,* which means literally "before (or against) the face."[53] Once themselves endowed with faces, and therefore with character and subjectivity, the pillows change their appearance and orientation, twisting, turning, and grimacing according to the individual viewer's fancy. The pillows are subjected to *our* thought, appropriated by our desire to find meaning in them by rendering them homologous to ourselves. Recent interpretations of the Metropolitan sheet bear witness to this. George Szabo, for example, has linked the pillows to Dürer's personal life at 1493. According to him, the Metropolitan sheet, produced during Dürer's engagement to Agnes Frey (c. 1475–1539), assembles a group of images all associated with love and marriage.[54] The likeness on the recto served as a preliminary sketch for Dürer's earliest surviving painted *Self-Portrait,* the 1493 panel in the Louvre, which the artist seems to have presented to Agnes as a token of their impending betrothal (fig. 18).[55] The sketch of his hand at the right of the sheet might also belong to this project. It offers an alternative formula for the gesture in the Louvre picture, where Dürer holds in his fingers a sprig of sea holly or *Eryngium.* Szabo also links the motif of the pillow to marriage, for according to a medieval custom, if a bridegroom sleeps on a pillow filled with magical herbs on St. John's Day (June 24), he will be able to see into the future. Szabo speculates: "Might the anxious young Dürer, on the eve of his marriage, have attempted to risk a glance at his future with the help of one or more pillows? Are the hidden faces the visions he saw in his troubled sleep?"[56]

Fanciful though this reading might be, it is useful to pursue it a bit further and to consider how it may have been occasioned by Dürer's drawing itself. It is true that in his Louvre engagement portrait the artist gathers around him objects and sayings designed to ward off bad luck in marriage. In the motto at the top of the panel—"My affairs fare as ordained from above"[57]—Dürer resigns his future to the stars, expressing his powerlessness against fortune. The *Eryngium,* associated in folklore of the period with success in love, and often used as an aphrodisiac, is included to magically assist Dürer's impending sexual union.[58] Given what we know about Dürer's unhappy, childless marriage and about his possible attraction to boys,[59] his precautions in the Louvre *Self-Portrait* were perhaps meant apotropaically, against what he already knew about himself. The pillows, while employed to help him into matrimony, would then display in their grimacing features and their arrangement in pairs a nightmare vision of the marriage bed. Included on a sheet containing his self-portrait, the Metropolitan pillows betray the artist's anxiety about sexual coupling born from a fundamental narcissism evinced in the project of self-portraiture itself. The movement charted from his own likeness to the pillow, from self to other, and from narcissism to the conjugal bed discovers at its end grotesque faces, which is to say visions of a disfigured self.

I have pursued this reading of the Metropolitan sheet not because I believe, as Szabo does, that the pillows can best be explained biographically. Rather, interpreting the pillows as expressions of an anxiety about coupling continues an operation begun in Dürer's drawing. For in the juxtaposition of portrait and pillow, and in the carefully devised folds of the pillows, the artist himself couples object with face, picture with person. Dürer's

pillows are prosopopoeias, conferments (*poien*) of a face or mask (*prosopon*) on a thing.[60] As such, they emblematize the operation of any biographical reading, whose business is to make a work of art intelligible and memorable by conferring upon it a face or subjectivity, however phantasmagoric.

The artist's likeness is profoundly suited to appear together with these pillows, for like the faces hidden in the pillows' folds, self-portraiture elicits a mode of interpretation that will always move from image to person, work to artist, so that any further production can appear as some form of "spiritual self-portrait." The Erlangen drawing, then, with its emphasis on depicting and demonstrating the moment of its making, is nothing less than the conferment of a face, and therefore a subjectivity, on the process of representation itself. The drawing's conjunction of hand and likeness, present both in the artist's posture and in his graphic style, merely renders explicit a more primary coupling. For self-portrayal couples the body that draws with the object of its representation: the artist as his own *gegen gesicht*, whose work will be meaningful only as face. This prosopopoeia of representation, however, may never fully be "self"-portraiture, because it always marks only the transition from objects to subjects, things to signifiers. It is in part this transition that I call here the moment of self-portraiture.

The moment of self-portraiture in Dürer's early drawings turns out to be two-faced, hinging, as it were, on an uncertainty observable in the shape of our own interpretation. On the one hand, if I behold the Erlangen sheet according to its traditional title, that is, as "self-portrait," my experience of the work will be determined by my prior expectations of this privileged genre in Western art. My eye is first of all drawn into a special commerce with the sitter's gaze, and confronted by what I believe to be the face of the artist, I settle into a dialogue of self with self. Soon I discover a center of gravity and point of origin: Dürer's active eye at the right of the sheet, from which his vision seems to extend. Everything else follows from here. The artist's hand reads as a stabilizing device for the eye (or else as an attribute of Dürer's troubled psyche); the tensions and distortions of the likeness become embodiments of the work of seeing; and the drawing's agitated line testifies to the authenticity of our encounter, asserting that the eye we see was sketched at the very moment when it returns our gaze. And if I go then to place the drawing in history, I will be apt to celebrate it as a totally new departure in German art. Convinced that in the artist's sketched eye we are witness to the origin and starting point of his labor, I will (as indeed Kehrer does) regard the sketch as a radical rupture with the past, hypostatizing the discovery of the self, and with it the birth of an epoch, in the moment of Dürer's self-portrayal. My interpretation thus returns to the beginning, to the "self-portrait" at *its* historical beginning as a genre, even though it is doubtful that Dürer could have set out with a knowledge of what, if anything, self-portraiture might possibly be.

If, on the other hand, I forget the modern title of the Erlangen sheet and instead place the work in the context of Dürer's general pictorial practices as a journeyman in the early 1490s, then the entire character and orientation of the sheet changes. Linked to works

like the Berlin *Holy Family* and the *Schmerzensmann* in Karlsruhe, as well as to the artist's many studies of hands, arms, and objects in difficult or distorted positions, the sheet appears to have begun with Dürer's observing the hand's, any hand's, interaction with the cheek. That is, before the self-portrait and its seemingly originary gaze, Dürer established his object on the page; and only belatedly, perhaps through sheer visual appetite, did he decide to carry his sketch across the sheet, reaching at the right his active eye. Our eye fixed on the hand at the sheet's center, we experience the likeness as a detour, and with this shift in the picture's moment our whole interpretation changes. Dürer portrays his body as a thing among things, and his project is placed not at the historical start of a new genre or a new epoch, but at the close of medieval model-book tradition, in which the journeyman gathers visual material where he can find it, in order then to produce finished images of traditional subjects—Holy Family, Man of Sorrows, personification of the humors, or what you will.

It is possible to combine these two readings into a single hypothetical plot. Dürer began his Erlangen sketch as a preparatory drawing, but in contemplating the original motif (his hand) he shifted his attention to a new object (his own face). This would occupy him increasingly during the next decade and, through his foundational efforts as self-portraitist par excellence in the Renaissance tradition, would establish what all future viewers mean when they view the Erlangen sketch *as* a self-portrait. It should be noted that the "traditional" projects that might have initiated his hand study were themselves concerned with questions of self: in the figure of Joseph, human doubt vis-à-vis divinity; in the Man of Sorrows, the inwardness of meditation; and in melancholy, a period model of interiority itself. In one form or another, self-portraiture will have been already implied in the practices out of which the Erlangen sketch emerged. Finally, the Metropolitan pillows demonstrate that the "mere" object, insofar as it is represented in Dürer's art, becomes invested with a face, and that consequently our response to it will be *as* toward a human subject. We must attend to these passages in Dürer's art where pillows pass over into masks, where the mere hand opens onto the face of the artist, and where the artwork starts claiming a relation to the body and mind of its maker. For it is in that interstice, both spatial and historical in nature, between an object and an emergent self that the moment of self-portraiture erupts into Dürer's art, in advance of any intention or project or theory that might explain it.

2

Self and Epoch

The Erlangen *Self-Portrait* has demonstrated how difficult it is to place Dürer's self-portraits in history. If, with Kehrer and others, we station the work at the beginning of the modern era, then its history can only be the new that it alone inaugurates and determines. The work will be, by definition, different from the tradition out of which it originated and, isolated from any contemporary point of comparison or elucidation, will risk simply reflecting the culture that interprets it. Yet if we push the self-portrait back into older pictorial practices that might have occasioned it, we risk concealing the work's originary power. This origination may occur outside any prior intention of the artist, taking place within the very moment and logic of the work's production: the marks that make up the Erlangen sketch themselves instantiate the passage from study sheet to self-portrait. It would be misleading to contextualize this passage within, say, the expectations of a contemporary "public": the only beholder for which the drawing would have at first been intended was the journeyman Albrecht Dürer, who would have copied its details in a finished, salable work. The fact of the drawing's preservation, and with it our own situation as viewers, belongs to a later context and history.

In Germany the taste for artists' sketches, predicated on a new estimation of the value and uniqueness of the individual self, really emerges only in the years following the Erlangen sketch.[1] Far from catering to a current taste, far from mirroring the demands of a public, Dürer's *Self-Portrait* helped fashion the conditions under which such a taste and a public could possibly emerge. In his open-ended practice as a young artist, in which he trains his pen to move freely from object to object, Dürer arrives at the new motif of self-portraiture.[2] Once established within his repertoire, though, this motif will become both the keystone of his art and the exemplary expression of what his future viewers will come to believe a work of art is: the display of the individual self in its works.

Again, the Erlangen sketch stands at the horizon of our assumptions and expectations concerning self-portraiture: such is Dürer's modernity that our own interpretation becomes conditioned by the very tradition his sketch inaugurated.[3] It is possible, of course,

to vacillate between a reading that stresses the newness of Dürer's art and one that contextualizes it in late medieval pictorial practice, therefore distancing it from ourselves. My purpose here is to sketch out, not to adjudicate, these two trajectories. The play between modernity and alterity does not emerge out of any lack of historical or textual evidence that, if recovered, would decide the case once and for all.[4] Rather, it reflects a hermeneutical problem underlying the apprehension of originality or historical rupture generally.

Historiography tends to privilege certain tangible divisions in its material—certain turning points where one age seems to give way, finally and irreversibly, to another. The belief that at some particular and experienceable moment in time a new epoch is born is, of course, less a description of the way history is actually lived than a symptom of the need to find sense in history. To identify, for example, Columbus's discovery of America as "the beginning of the modern era"[5] is not only to affirm that the actions of certain people led, and therefore still can lead, to a change in the essential conditions of the world, but also that in affecting those conditions they divide history into a before and an after—into discrete epochs, each with its own unique character. The particular event a historian singles out to call an epochal threshold is a good index of the brand of history being engaged in: show me when you think the modern age begins, and I will tell you who you are. Yet whether the turning point turns out to be a natural disaster, a moment of social upheaval, a mythically suggestive coincidence,[6] the succession of rulers, the deliberate action of a "great man," or the production of a particular work of art, the very impulse to find a threshold at all represents a desire at the heart of writing history. The historian will always search for some evidence, some principle of self-demarcation within the historical material itself, to legitimate the underlying assumption of historiography: that change is real and that it has meaning.[7]

Within the discipline of art history, the self-portraits of Albrecht Dürer represent a group of objects that have been singled out again and again to document profound changes in the European pictorial tradition. They have functioned as quintessential epoch-making works, explicating and affirming the reigning historical constructions of the discipline. For over two centuries, they have been placed at the origin of everything from the German character[8] to the modern self, and they have served to demonstrate a range of historical ruptures in the pictorial tradition, such as the end of Gothic and the beginning of Renaissance painting,[9] or the transformation of sacred into secular art.[10] These are the images that feature as frontispieces and cover illustrations for surveys of northern Renaissance art.[11] Their importance lies less in their imagined aesthetic value, or even in their exemplarity for the values and spirit of their age, than in their ability to mark a beginning and thus to legitimate the divisions that govern the scope and character of art historical surveys.

Each of Dürer's self-portraits has been granted the status of an epochal beginning. The silverpoint drawing in the Albertina, for example, executed in 1484 when the artist was still a boy, is regarded not only as the earliest self-portrait in Germany in which an artist appears isolated from any other scene or decorative program,[12] but also as Western art's most precocious self-portrait (fig. 19; W. 1). As Waetzoldt wrote in 1938, "No one had

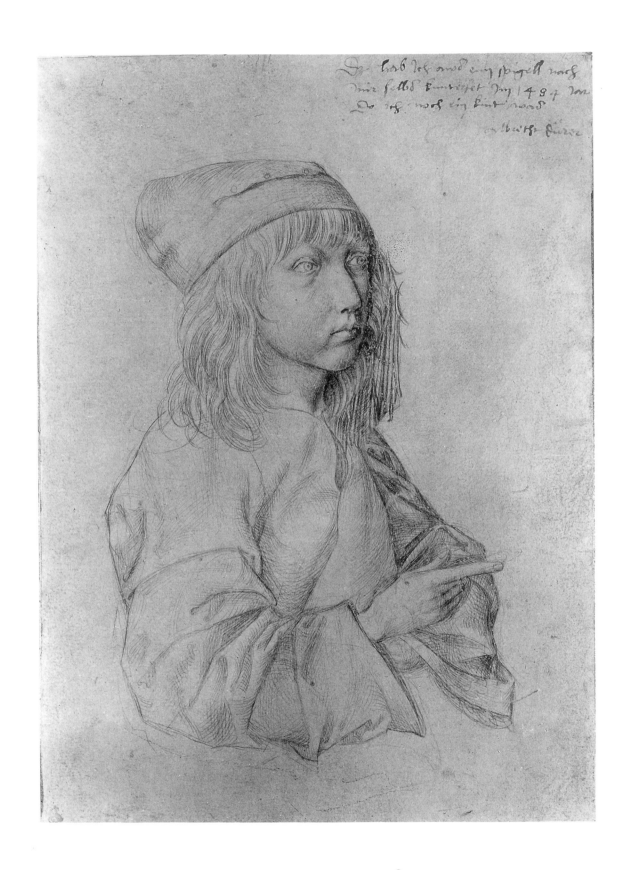

19. Albrecht Dürer, *Self-Portrait*, 1484, silverpoint on prepared paper,
Graphische Sammlung Albertina, Vienna.

ever started to portray himself earlier than Dürer—at thirteen years of age";[13] to which could be added that the surviving oeuvre of very few artists reach back this far in their careers. The Albertina silverpoint is the earliest extant Dürer. It inaugurates his artistic biography as we know it. We shall see that this fortuitous coincidence between self-portraiture and a personal artistic beginning may have been engineered, retrospectively, by the mature Dürer himself, who was the first person to collect and to label the sketch.

Dürer's next self-portrait, the Erlangen sketch of 1491, has marked a beginning of an even more momentous kind. It has been termed the first "modern" self-portrait, because for the first time the artist seems to depict not only his physical appearance, but also his unique inner self. For Kehrer, this originality placed the drawing as the start of the German Renaissance. The litany of Dürer's priority does not stop here, however. The 1493 Louvre *Self-Portrait* has been called the earliest example of an autonomous self-portrait executed in paint (fig. 18).[14] Max Friedländer declares it to be "the oldest true artist's portrait, at least in the North," as do the editors of the 1971 Nuremberg Dürer catalog; and Kehrer describes it as being of "epoch-making significance."[15] Even clearer in its intention as self-portrait fashioned for posterity, and therefore more novel in its conception, is Dürer's 1498 panel in the Prado, which Panofsky called "the first independent self-portrait ever produced" (fig. 20).[16] The artist not only dated and monogrammed[17] this work but also included a lengthy inscription that cites his own age and full name and attests unequivocally to the panel's status as self-portrait: "This I painted after my own image, / I was twenty-six years old."[18] Declaring the artist and the sitter to be identical, this label determines the way the painting will be viewed and creates the effects that, attributed to the painted likeness itself, define it as self-portrait.[19]

In the Louvre painting the artist appears like any young, middle-class Nuremberg burgher, outfitted with attributes of a fiancé and placed within the common German pictorial type of the betrothal portrait. In the Prado panel, perhaps for the first time in the history of art, self-portraiture distinguishes itself from other kinds of portraits.[20] Dressed in lavish and festive clothing of modish taste and design,[21] and wearing the expensive doeskin gloves that were a Nuremberg specialty, Dürer elevates himself above the modest social rank into which he was born, above even the apparent status of his patrician sitters the Tuchers and the Krels, whom he portrayed in far less ostentatious and cosmopolitan garb and setting.[22] Italian aspects of the painting's execution—its soft modeling, stable architectonic construction, and atmospheric landscape passage—bear witness to foreign sources of the artist's conception of himself. For it is in Italy, during his first trip there in 1494–1495, that he encountered a new, humanistic conception of the sovereignty of the artist, a conception that he recognized was missing in his own native Germany; hence his famous remark to his friend Willibald Pirckheimer in a 1506 letter written from Venice: "Here I am a gentleman, at home only a parasite [*schmarotzer*]."[23] The Prado panel combines artistic pride, evident in the daring of its pictorial invention and voiced in its inscription, with Dürer's personal pride in who he is, how he looks, where he has been, and what he is worth. It celebrates the power of the individual and elevates what self-portraiture is intended to depict: not merely the look and status of its maker, but the underlying idea of painting itself.

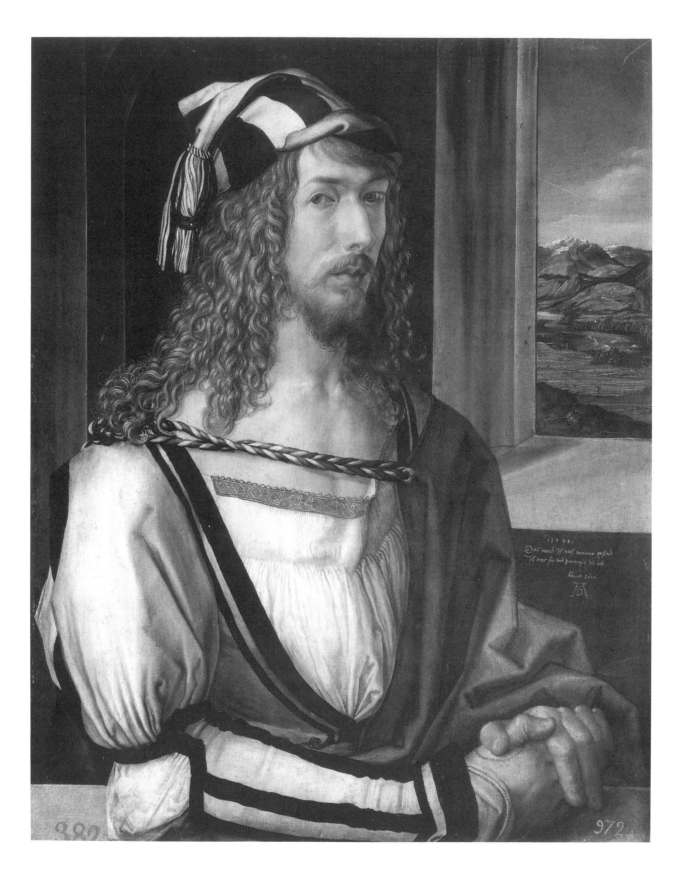

20. Albrecht Dürer, *Self-Portrait*, 1498, oil on panel, Prado, Madrid.

Whether these claims concerning Dürer's newness are historically accurate, whether the Prado panel expresses—and for the first time—the painter as representative self, is not at issue here. In the litany of beginnings that surround Dürer's self-portraits, what strikes us most is the art historian's faith in the originary power of art—a faith that assumes an almost religious character when what is at stake is the historical source of the self. Therefore there is something encouraging about Dürer's great 1500 *Self-Portrait*, now in the Pinakothek in Munich (fig. 21 and frontispiece). In the sheer monumentality of the picture's design, in the fearful symmetry and directness of address that solemnize our encounter with the artist's likeness, Dürer seems to affirm and sanctify the epochal change that his self-portraits are believed, in retrospect, to instantiate. Here is a painting that appears wholly to validate the belief that Dürer's self-portraits represent a passage from one age to another.[24] The panel's date of 1500 takes on special importance, and not only because its round number cannot but be regarded as epochal. In its prominent placement near the center of the darkened visual field at the upper left, one also senses that the artist has fashioned the moment of his painting as a point of passage, indeed, that his self-portrait is the appropriate emblem of that great year. As we shall see, the Munich panel may have been produced as part of a larger celebration of the saeculum staged by German humanists in the circle of Conrad Celtis (1459–1508). Celtis fashioned the year 1500 into a symbol of his own culture's momentous advance over the past, thereby inscribing the process of history into a secular myth of progress. The 1500 *Self-Portrait* is Dürer's pictorial response to this project of self-presentation mixed with historical consciousness.

To put it another way: Dürer's panel will always convince us that it was made to stand as frontispiece for surveys of northern Renaissance art. For the kind of thinking that produces such surveys, dividing time into clear-cut eras and emblematizing them with a single representative work of art, has a true precursor in the self-historicizing gesture of the Munich panel. Whether the painting is monumental because of its date or whether the date is monumental because of the painting's emerging vision of history that monumentalizes dates remains an unresolvable question. For like the art history that will interpret it, Dürer's 1500 *Self-Portrait* affirms its ability to mark a great moment in history at the same time as it maintains that the moment's importance lies in its being greater than any particular work, act, or event.

If art history regards the Erlangen *Self-Portrait* as epochal because of the notions of art and self that the 1491 sketch presages, then the Munich panel, linking self-portraiture with the festive demarcation of a new epoch, already fulfills this prophecy. Dürer's originality consists of more than merely making the work we see, more even than inventing a new pictorial invention or genre. In his idea of himself as artist that the Munich panel implies, as well as in his own apparent conviction that this idea is historically original to himself, Dürer founds categories upon which later German art, and later understandings of that art, will from now on be based—categories such as self, history, art, and man. In confronting the art of Hans Baldung Grien and of Lucas Cranach, we shall learn that Dürer represents for painting what Michel Foucault calls an "initiator of discourse." Not

merely original *within* a tradition, Dürer produces the very possibility of, and rules of formation for, the subsequent German pictorial tradition. As Foucault writes in "What Is an Author?" the act of initiation "is such, in its essence, that it is inevitably subjected to its own distortion; that which displays this act and derives from it is, at the same time, the root of its divergences and travesties."[25] What Dürer's self-portrait commences is the very idea of the self's originary and epochal power; and the attendant distortions will become visible in works that will be enabled by it. Thus Baldung and Cranach will be for us the eloquent evidence and critique of what Dürer does or does not initiate in his Munich panel and related works.

Critiques of origination are familiar enough. Contemporary historical disciplines tend to resist the concept of an epochal work of art, partly because they object to its implied vision of sudden rupture in history, and partly because they resist regarding the artist, or indeed any individual, as autonomous from his public or culture. It is as if the process of historical cognition, which from the early modern period to the historicism of the nineteenth century had described the shape of change and demonstrated the reality of epochs as discrete and authentic formations in history, today seeks to dismantle its own description, assembling in its place a narrative uninterrupted by mythicized turning points.[26] A rigorously historicist art history might regard with suspicion any claim that in the 1500 *Self-Portrait* we observe the epiphany of the artist at the start of our own age. For historical cognition does not have to credit epochality even when it is pretended by the material itself. One familiar impulse would be to reveal how deeply a postromantic conception of art and self colors our viewing of a work so very distant and foreign to us. Against older interpretations celebrating the firstness of each of Dürer's self-portraits, there would now be a tendency to demystify those claims of originality by discovering Dürer's art to be anticipated by earlier artists and older traditions of expression. The search for pictorial and textual precedents, the mainstay of art historical discourse, would thus reintegrate the self-portrait into a historical continuity by pushing it back into the Middle Ages.

Having dismantled self-portraiture's claim to epochality by contextualizing Dürer's painting within the very period it itself had marked as already over, a historicist reading might then seek to estrange us from self-portraiture's object. The spectacle of self in Dürer's art would be distanced in two ways: first, by emphasizing the differences between early modern notions of the human subject and our own; and second, by undermining the monolithic nature of the self in Dürer's self-portraits and in his culture as a whole. If we think we recognize a deeply modern replacement of love of God with love of self in the 1500 *Self-Portrait*, a historicist account would problematize this familiarity by setting the work within ever more unfamiliar contexts.[27] Historians would thereby secure for themselves priesthood in a domain of exegesis without which the painting is deemed illegible. Such a rigorously demystifying reading would indeed preserve the pastness of the past, yet it would do so by effacing something essential about its object: On the one hand, it would disregard the possible claim Dürer himself might be making that his work represents a radical break from the past, that his art is self-consciously in advance of his culture, and that 1500 has become, indeed partly through his art, the threshold of a new

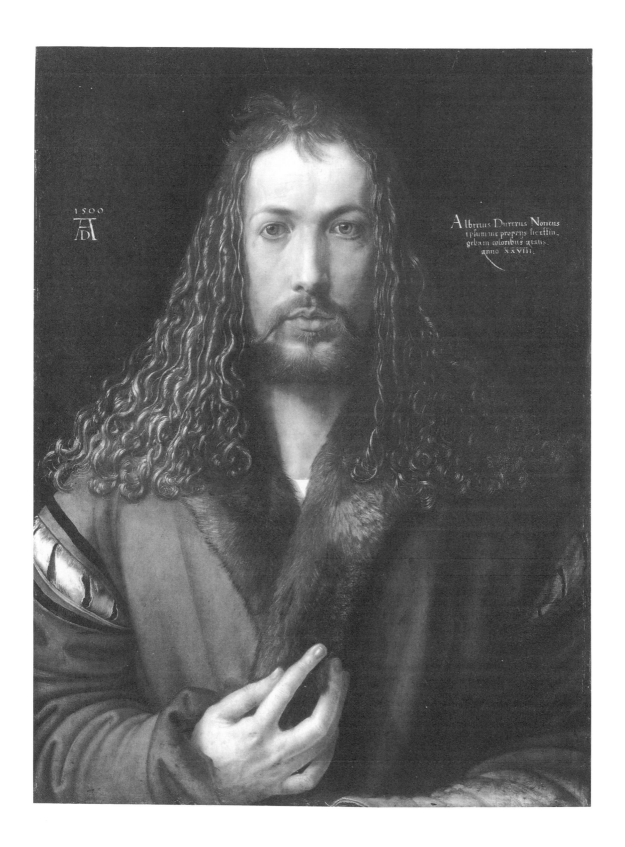

21. Albrecht Dürer, *Self-Portrait*, 1500, oil on panel, Alte Pinakothek, Munich.

era. On the other hand, it would rule out the possibility that what we deemed was modern or "like ourselves" in the Munich panel was really there, indeed that our recognition of modernity stemmed from an authentic match between the forward-looking intentions of Dürer and our own embeddedness in an era whose beginning is marked by Dürer. As Hans Blumenberg has argued in the *Legitimacy of the Modern Age*, it is precisely at the point where a work of art explicitly affirms its own modernity and we, cheerfully and correctly, embrace an anticipation of ourselves in the past that historicism reaches its limits.

Friedrich Nietzsche recognized this failure of historical cognition to acknowledge the truly new, this tendency to push everything back into an ever more distant past, when he lamented that the Germans, in their intoxication with historicism, succeeded in eradicating the Renaissance as a viable division. In an 1888 letter to Georg Brandes he wrote, "The Germans have it . . . on their conscience that they deprived the last *great* age of history, the Renaissance, of its meaning."[28] Nietzsche was canny enough not to dismantle the modernity of the Renaissance and its works. In interpreting Dürer's 1500 *Self-Portrait*, we are faced with a paradigmatic dilemma in the interpretation of art today. Our object is a work that seems to embody, overtly, everything that is transformative about the German Renaissance; and yet our discipline is steeped in a historicism (itself a German legacy) that, if pursued to its logical end, will work to efface the reality of epochal thinking even where it is present in its object. How then do we recover the originality of Dürer's self-portraits without discovering in them merely the likeness of ourselves?

Dürer documents his own response to the earliness of one of his self-portraits. The Albertina silverpoint consists of two parts separated by a lifetime: at the center of the sheet, a likeness of the young artist sketched by himself when he was only thirteen; at the upper right, an inscription to that effect written by Dürer sometime during the last eight years of his life (fig. 19).[29]

The self-portrait likeness dates from before the beginning of Dürer's career as an artist.[30] As we learn from his family chronicle, composed in 1523, Dürer began his apprenticeship as a painter only in 1486, having "lost time" training to be a goldsmith in the shop of his father, Albrecht Dürer the Elder.[31] Yet the sketch already exhibits ambition in both its subject matter and its technique. The young Dürer's task of drawing himself from a mirror not only is unusual, if not novel, at 1484 but is also technically difficult. For as the Erlangen sheet demonstrated, a self-portraitist must constantly juggle his two roles as maker and model. He pursues a mobile object with an eye and a hand that must try to stay still, for they are part of their object. In the Albertina sketch, Dürer accomplishes this with agility and precision, taking care to conceal any evidence that his body is engaged in labor. He appears to look off to the right, even though his eyes must actually have been fixed on the mirror straight ahead, and he lets his active right hand disappear, although somewhat awkwardly, behind his left sleeve. And the treatment of volume and proportion in the upper body seems unaffected by the distorting effects of a mirror, per-

haps because the artist fashioned his likeness only partly from his reflected image. Dürer accomplishes his study, with all its subtle adjustments and detailed focus, in a particularly exacting medium. Silverpoint is executed with a silver stylus on a surface (paper, parchment, or vellum) coated with a burnished prepared ground. The resulting line is the product of a chemical reaction between stylus and ground that intensifies with time. As Panofsky notes, this medium "permits neither corrections nor emphasis by mere pressure, and thus demands an unusual degree of assurance, precision and sensibility."[32] In the Albertina sheet, self-portraiture is an astonishing trick, a display of precociousness itself, in which Dürer demonstrates a mature technical virtuosity within a likeness that reveals him to be still a boy.

It would be fascinating to explore the conditions under which, at 1484, such a study could have been produced. In his family chronicle, Dürer recounts how his father had encouraged him to practice his skills and how he had impressed his father with his industry: "And my father took special pleasure in me because he saw that I was diligent in exercising to learn."[33] The Albertina *Self-Portrait* is evidence of the application and aptitude that earned the young Dürer his father's approval. As an exercise, moreover, the sketch may have been motivated by his father. In a silverpoint drawing now in Vienna, the elder Dürer seems to have fashioned a portrait of himself strikingly similar to the 1484 sheet in technique and arrangement (fig. 22; W. 3).[34] Here again we encounter a meticulous, detailed likeness executed in the difficult medium of silverpoint; again the artist delights in folded garments and in the calligraphic potential of hair and hides his right hand behind his left sleeve, a conceit best explained if the drawing is a self-portrait. If this is a self-portrait of Dürer the Elder, rather than a portrait by the young Dürer of his father, as some commentators believe,[35] self-portraiture does not emerge in Germany single-handedly in the art of Dürer the Younger, but rather is a practice shared by a Nuremberg goldsmith and his son, perhaps as a means for developing their manual and visual skills. Where the father holds a silver statuette in his hand, the product of his profession as goldsmith, the son displays a pointing finger, suggesting either that he has as yet no trade and therefore is without attribute or perhaps that his tool, as painter-to-be, is the hand itself. In any case, father and son would have assumed for these drawings an audience no larger than their immediate family and shop. Nor would they have regarded their works as particularly epochal.

Yet when the mature Dürer came upon his 1484 *Self-Portrait* some forty years later, he chose to frame it for posterity with an inscription penned boldly at the top of the sheet: "This I fashioned after myself out of a mirror in the year 1484 when I was still a child. Albrecht Dürer."[36] Written by an older man separated from his childhood likeness, the demonstrative "this" (*Dz*) brackets off the silverpoint sketch for commentary. It points to and encircles the image, speaking from a "now" anterior to the moment of self-portraiture in order to address a future for which that moment, long past, will be deemed meaningful. The deictic *Dz*, as if to repeat that curious pointing gesture performed by the sitter's left hand in the sketch, functions to tell us what it is that this self-portrait shows.

What do the Albertina *Self-Portrait* and its inscription show? Most simply, the likeness

22. Albrecht Dürer the Elder, *Self-Portrait*, 1484, silverpoint on prepared paper, Graphische Sammlung Albertina, Vienna.

records the artist's physical appearance as a child, and the inscription, naming the sitter and guaranteeing the likeness's accuracy through its having been made "out of a mirror," drafts the autobiographical pact that will determine all future viewing. Labeling his juvenalia, the artist prepares it for posterity, for as the text of the German Renaissance's most ambitious literary project of remembrance, Maximilian's *Weiß Kunig*, puts it: "He who, during his lifetime, makes no memorial [*gedächtnus*] will not be remembered after his death and will be forgotten when the bell tolls."[37] In the Albertina sheet, memory has already intervened. Before passing his youthful portrait on to us, the aging Dürer remembers it in the inscription he composes.[38] Image and word represent the confrontation of future with past such as shall be replayed in countless acts of *gedächtnus*.

The Albertina sheet remembers more than the artist's bodily being, however, for it also records the precociousness of his art. The inscription's demonstrative *Dz* points to the silverpoint less as an image *of* Dürer than as an image *by* himself. It seems to say, "This is how well I could draw when I was but a child, and this is how clever I was, how advanced my thinking, that I should draw myself out of a mirror already in 1484!" Precocity would have had special significance for the Dürer of the 1520s. In the earliest drafts

of his planned magnum opus, titled "Food for the Young Painter" (*Ein Spies der Maler-knabe*), Dürer argued that although instruction and practice could perfect art, great painters (Dürer calls them "powerful artists" [*gewaltzsamen künstner*]) were born with an innate talent that could not be learned.[39] In a manuscript dated 1512, Dürer notes painting's benefits for mankind and asserts: "It is difficult to acquire the art of painting well. Therefore whosoever finds himself unfit for it should not presume to try. For it comes alone from inspiration from above."[40] Dürer derives the phrase "inspiration from above" (*öberen ein gissungen*) from the language of the German mystics, where it refers to a mystical union of God with the elect.[41] By discovering the source of inborn talent in God, Dürer not only legitimates his profession theologically but also elevates the artist above other men. For, as he goes on to say, the mighty kings of antiquity had bestowed honor and wealth on their painters, recognizing in these men a godlike sensibility: "They esteemed such inventiveness as a creation in the likeness of God."[42] What proves that the painter is fashioned in God's image is his ability to fashion, in turn, things never seen before: "from his inward 'ideas,' which Plato speaks of, the artist would always have something new to bring forth through his work."[43] Originality is the measure of art's divine economy, which receives *ein gissungen* from above in order to bring forth (*aws zwgissen*) a reflection of divinity in the form of the new (*ettwas news*).

We shall examine later how the concept of the artist as *imago Dei* becomes a controlling motif in Dürer's mature self-portraits. The Albertina likeness is surely innocent of such lofty pretensions. Yet combined with the inscription that interprets it in retrospect, this innocence would have been for the artist a demonstration of his divinity. Produced in 1484, before Dürer entered formal training as a painter, the self-portrait likeness testifies precisely to the child's inborn aptitude as a painter—what the classical rhetoricians called *ingenium*.[44] One might even speculate, following Dürer's own account of his early career, that the Albertina silverpoint was what convinced Dürer the Elder to let his son change his trade. Self-taught and blindingly original in his creation, at 1484, of a self-portrait, Dürer as *Malerknabe* reveals himself to be a mirror of the divine, an *imago Dei*, by creating himself as *ettwas news* through the agency, appropriately, of a mirror.

In the Albertina sketch's juxtaposition of likeness and framing inscription, in its play between an image and its retrospective interpretation, we witness the emergence of self-portraiture within a reception posterior to its originary moment. When the thirteen-year-old Dürer sketched himself, his goal was to fashion an image that would closely resemble the physical appearance of its maker. Working within a medium that permitted no corrections, he trained himself to work carefully and without revision, avoiding error and regarding every line as final. He was mindful, as well, to conceal how the body he sketched was entangled in the originary act of sketching—hence the elided right hand and the doll-like eyes. For he sought to produce an image transparent to its model, uncontaminated by any intervening signs of labor. In doing this, the young Dürer may *also* have evinced talent and diligence; yet the drawing's initial value, indeed its index of skill, rested in its faithfulness to its model such as he would appear outside the acts and marks of representation.

When the mature Dürer of the 1520s comes upon this sketch among his possessions, however, its value for him has changed. Rather than showing how he looked as a child, the silverpoint demonstrates how he drew in 1484, before he became a painter. Its reference and source of value is not the objective order of the world, but the totality of works that the artist subsequently produced. And where the young boy concealed the mechanics and gestures of labor, the mature Dürer labels the drawing by naming the temporal moment and technical exigencies of its making. The inscription thus registers a new conjuncture of values. It links a work of child, which would be anonymous to posterity, to a name, the famous Albrecht Dürer. Integrated into the artist's oeuvre, and inaugurating that oeuvre with what Dürer has come to regard as an exemplary act (self-portraiture), the silverpoint has value because of who produced it and what it presages about him. Self-portraiture, collapsing the distinction between model and maker, functions here to negotiate fundamental shifts in pictorial reference, from the adherence to a model to the singular expression of an artist in his gesture, and from the representation of the world to the integration into an oeuvre.[45] It exemplifies the irreducible relation between image and maker upon which a new notion of the value and meaning of art was being founded by Dürer for his public.

When Dürer penned his inscription, his culture was only beginning to think about works of art as belonging to an oeuvre. Previously the value of an image rested either in *what* was represented (a sacred person, a significant legend, a rare prodigy, etc.) or in *how* it was represented (costliness of materials used, labor expended in production, beauty or mimetic accuracy of the finished product, etc.). In Germany it is only in the sixteenth century that some collectors, mostly humanist scholars, start to order their possessions according to artist—the more common practice being an encyclopedic arrangement by topic or subject matter.[46] In a 1588 inventory of the Imhoff collection in Nuremberg, into which the Albertina drawing passed after Dürer's death, authorship of a drawing or print is more important than subject, and copies are distinguished from originals.[47] For the Imhoffs, moreover, as for most northern collectors of the sixteenth and seventeenth centuries, Dürer holds pride of place, being represented by a complete collection of his prints and probably the largest group of his drawings gathered anywhere. We shall examine later how Dürer, more than anyone else in this period, inspires the production and collection of graphic art, having demonstrated and subsequently theorized that the value of an artwork lies primarily in its having been made or invented by an individual artist of genius. Such thinking is at work in the Albertina drawing. Labeling his likeness as he does, the artist, who is also the drawing's first collector, evaluates it less according to the object it depicts than to its originary place within the totality of his own creative production. To put it simply, the Albertina sheet then and now is valuable because it is "a Dürer." In the self-portrait's fortuitous conjunction of artist and artwork, Dürer can inaugurate his oeuvre with an image already identical to himself.[48]

The Albertina sheet suggests that, at its origin, self-portraiture becomes meaningful only within its later reception. The artist's likeness functioned differently for the Dürer of 1484 and the Dürer of 1520. To return the work to its "original" historical context would

mean stripping it of its inscription and therefore of much of its significance *as* self-portrait. An episode in the later fate of Dürer's Albertina sheet clarifies what is at stake in a historical interpretation of self-portraiture. In the print room of the British Museum there exists an accurate copy of Dürer's 1484 drawing (fig. 23).[49] The likeness, rather pale in its present state, is executed in silverpoint on a sheet quite similar in size to the Albertina original (262 × 195 mm compared with 275 × 196). A strip of paper has been attached at the base, on which is inscribed: "On February 4, 1576, I made this portrait [*Conterfect*] after that which the far-famed Albrecht Dürer made with his own hand and added in his own writing." Then, in a different, more "gothic" script approximating that of Dürer, "This I fashioned after myself out of a mirror in the year 1484 when I was still a child. Albrecht Dürer."[50] Self-portraiture appears embedded in a many-layered history of reception. Dürer's name, wrapped in a calligraphic paraph, undersigns the copy in the manner of a legal document. Rather than testifying to the sheet's authenticity as an original Dürer, however, the signature, together with Dürer's own inscription of about 1520 that had authenticated the 1484 likeness, has been placed in quotation marks, as it were. Reduced to a citation and framing the copy of the Albertina likeness, Dürer's first-person text is itself framed by the voice of the copyist. And the copyist, also speaking in the first person and dating his labors, asserts authorship of all we see, while indicating his model's authenticity through the Dürer citation. What has become of the self-portrait likeness itself?

The copyist has kept close to the 1484 original. He has not corrected the awkward passages in his model, where the tassels of Dürer's hat hang illogically in space at the right, or where his right arm passes behind his left sleeve. Admittedly, the copyist has omitted some minor errors. He has clarified the contour of the boy's index finger and right forearm and left out the tentative initial outlines that, set down at the start of Dürer's labor, remain still visible at the finished horizons of the original likeness. But what is astonishing in the London sheet is how it imitates the style and medium of the early Dürer. To a sophisticated professional artist working in Germany at 1576—which the copyist must have been—the Albertina sheet would have appeared both archaic and artistically immature. The stiff and angular folds of the garments, modeled in a loose, inconsistent hatching, are conventions particular to late Gothic northern art, as are the likeness's irrational proportions and its overall flatness, its decorative pattern on the picture plane. After 1500 and largely through the influence of Dürer himself, German artists systematized hatching and proportion and celebrated volume and space over surface patterning. By 1576 no one, not even the most provincial painter, would have sketched in the manner of the Albertina sheet.[51] In Dürer's *Self-Portrait*, a late Gothic style is practiced by the untutored hand of a child, resulting in a faint naïveté evident if we set this likeness against the silverpoint *Self-Portrait* of Dürer the Elder from the same period (fig. 22).

The London copy represents a complex act of remembrance. The medium of silverpoint, rarely used by 1576, expresses an antiquarian's insistence on fidelity to the Dürer original. Tracing the lines of the Albertina sketch, replicating the very signature of the hairs on the sitter's head, the copyist transports his craft back to an earlier moment in art

23. Hans Hoffman (attributed to), *Copy of Dürer's Self-Portrait as a Thirteen-Year-Old Boy*, silverpoint, British Museum, London.

history, when Dürer had not yet fashioned the visual idiom that would dominate German art well into the sixteenth century. This archaism is the curious outcome of that new coupling of self and art that Dürer himself devised and appended to his youthful sketch in the inscription of about 1520. Rather than fashioning a contemporary portrait of the thirteen-year-old *Malerknabe* on the basis of the Albertina sheet,[52] the copyist portrays Dürer's drawing itself. The term *Conterfect* in the inscription sustains this doubling of the likeness of a sitter (portrait) with the replica of his art (counterfeit). Of course, it is in the nature of self-portraiture that the self should be made visible in its works. But in the London copy, and before that in Dürer's own project of self-portraiture, this coincidence will negotiate a more general displacement: the work of art as fundamentally an inscription of self. That this should appear within a *copy* of a self-portrait, indeed that anyone should want to *imitate* the singularity of the artist in his appearance and gesture, reflects a certain instability at the heart of Dürer's project.

The London copy belongs to the "Dürer renaissance" that spread through south Germany and the Habsburg territories in the last quarter of the sixteenth century. At the courts of Ferdinand of Tyrol and Maximilian I of Bavaria in Munich, in the houses of wealthy Nuremberg patricians like Willibald Imhoff, and above all in Emperor Rudolf II's Prague court, Dürer's paintings, prints, and drawings were acquired and passionately admired, forming the aesthetic core of the northern Renaissance art collection or *Kunstkammer*.[53] When collectors did not possess the particular Dürer they desired, they often commissioned a copy from one of the many painters of the period skilled in this trade. Copying (*ritrarre*) passed easily into imitation (*imitare*), and a fashion arose for images in the general style of Dürer.[54] It is likely that the London copy of the 1484 *Self-Portrait* was made by the greatest of all Dürer imitators and the central figure of the Dürer renaissance in Prague, the Nuremberg-born painter Hans Hoffmann (1530 to c. 1591).[55] At 1576, Hoffmann was a friend of the then owner of the original silverpoint, Willibald Imhoff, and he copied a number of other Dürers in Imhoff's *Kunstkammer*.[56] Sometimes signing his copy with his own personal Hh mark, sometimes including in his own work the original Dürer monogram and date, Hoffmann's art shifts troublingly between facsimile and what we today would call forgery. For while his copies and even his Dürerian affectation of a personal monogram celebrate Dürer's original genius, Hoffmann wholly subsumed himself under the style of another, thereby calling into question the presumed unity of art and artist that grounds the notion of an "original."

In the culture for which the London copy was made, Dürer's art came to be treated with an almost cultic veneration. A famous instance of this developed around Dürer's 1509 *Heller Altarpiece,* which stood in the Dominican church in Frankfurt until 1614.[57] So popular was this work that the monks charged substantial fees for opening it to visitors on weekdays, a practice usually reserved for the ostension of religious relics. Writing about the *Heller Altarpiece* in 1604, Carel van Mander finds it "almost unbelievable how much money this painting yields yearly to the monks of the monastery, through the tips given and the drinks bought by gentlemen, merchants, travelers, and others interested in art to whom this painting is disclosed."[58] Similarly, when Rudolf II brought Dürer's

great *Feast of the Rose Garlands* (1506) from Venice to Prague, he treated it like a virtual relic, transporting it "carefully wrapped in rugs and much cotton-wool and baled in a waxed cloth. At the Emperor's orders it was carried on poles by a group of strong men all the way to the Imperial Residence at Prague."[59] Contemporaries were quick to recognize the blurring of boundaries between cultic worship and the appreciation of Dürer's art. Thus Matthias von Kinckelbach, in an account of the history of German art appended to his *Teutscher Nation Herligkeitt* of 1609, describes the veneration of Dürer in purely religious terms: "His manuscripts and other plainly designed drawings on paper and parchment are regarded by artists and other admirers as holy things; his panels and paintings are displayed and preserved as the highest and noblest relics [*Kleinoder*], so that, for several, one must pay money simply to see and scrutinize [*abspiculiren*] them."[60] A simple sketch by Dürer is deemed sacred because, as something by the master's hand, it has the character of a bodily relic and should be venerated as such. To view it, therefore, is to receive some profit, hence the verb *abspiculiren*, which suggests the reception, through sight itself, of an aesthetic benediction for which one is willing to pay. When the copyist of the Albertina silverpoint traces with his own hand the precious lines of Dürer's self-portrait and its later inscription (or "manuscript"), he participates in this very cult. The relic he venerates is doubly sacred: a drawing of and by the artist as a young boy. Testifying through its precocity to the inbornness of Dürer's genius, this self-portrait might be the holiest of holies, the site wherein the yet unformed artistic self, before training or tradition, leaves us its first autochthonous and originary mark.

The meaning of Dürer's first self-portrait unfolds within its subsequent receptions. Dürer's inscription on the sheet represents only the first of these, when the 1484 likeness acquires its public character as self-portrait. The Dürer of 1520 assumed that posterity would care how he looked and drew before he became an artist. Hans Hoffmann, or whoever copied the sheet for a culture obsessed with its past, proved him right. The copyist, subsuming his own personal and period style under the style of the original, elevates the past artist to the status of universal exemplar. The archaism of the Dürer Renaissance, its veneration of Dürer as Great Original, participates in a cult of genius that will dominate the interpretation of art until our century. The Albertina sheet and its receptions thus uncover the prehistory of our own response to the moment of self-portraiture. It would be simplistic to regard this history as a deviation from Dürer's original intentions at 1484. For the moment of self-portraiture exceeds the horizon of expectations out of which it was produced. Dürer's earlier self-portraits are paradigmatic instances of what might be called the noncontemporaneity of the contemporaneous.[61] So new are their visions, and so foundational are their functions to our present horizon, that as a result of their existence their original historical context becomes more remote to its subsequent interpreters. If the Erlangen *Self-Portrait* demonstrates for us the artist's own modernity and helped to determine it for Dürer, it also distances, dialectically, the past

from which it distinguishes itself. A historicist account that seeks to push the work back into that past ignores the continuum of response that leads forward to us.

This is not to say that the meaning of Dürer's self-portraits was the same for him as it is for us. Indeed, the earliest reception history of the Albertina sheet suggested that Dürer regarded his silverpoint likeness differently when he made it and when he prepared it for posterity. And the London copy questions the very possibility of self-portraiture after Dürer. Although the late sixteenth-century imitation and sacralization of Dürer as representative artist may be a consequence of the claims his self-portraits make about his art, self-portraiture has become difficult for those who would follow him. The self subsumed in the London copy is only an extreme case of the problem Dürer will pose to artists living in his shadow. Even though their influence is formidable, Dürer's self-portraits have no real successors. In the art of Baldung, self-portraiture as a project will either be overturned or be radically circumscribed, and in its place will arise quite different figurations of self in the work of art. Reception here is anything but the mirroring of what Dürer may or may not have originally meant. It is rather the necessarily disfiguring response to origination itself.

3

Organa of History

In a 1931 essay on the future of literary history, Walter Benjamin warns against a historicism that regards the reconstructed past as the primary interpretative context for the work of literature: "For it is not a question of representing works of literature in relation to their own time, but rather of bringing into representation the time that knows them—which is our own time—in the time when they came into being. Literature becomes thus an organon of history. And to make it this is the task of literary history—and not to make of literature the stuff of history."[1] Extricated from antiquarianism and from a position auxiliary to the writing of general history, the study of literature should disclose the prehistory of our *present* experience of a work. And this disclosure should not simply supply material toward a reconstructed historical past—what Benjamin terms *Historie*—but ought to be a medium whereby a culture learns to think about history per se, about its inner logic, its dependence on literary modes of narrative, and its entanglement in the needs of the present. Today we may be more skeptical about art's capacity to be the "organon of history," yet Benjamin's emphasis on the contemporary, and on the path that leads backward from ourselves to our historical horizon in the work of art, is useful for confronting the self-conscious and troubled originality of German Renaissance art.

In my account of Dürer's earliest self-portraits in Vienna, Erlangen, and New York, I have traced each image's historical trajectory: as chance product of older, more traditional practices; as instrumental turning point of a new project of art; and as material for the artist's own nascent conception of the historicity of his art. I have introduced self-portraiture before establishing either a methodology that might interpret it or a single history that might contain it. Instead, the Erlangen and Albertina sketches themselves function as prefaces to—or organa of—the kind of history that can be written about self-portraiture generally. This heuristic approach, suggested to me by the prefatory character of Dürer's 1500 *Self-Portrait*, shows that the meaning of self-portraiture emerges in retrospect, through successive acts of reception, interpretation, and revision, and that the suitable historical contexts in which to set Dürer's project might emerge only at the end

of the tradition it initiates. The path from the precocious silverpoint of 1484 through its inscription by the mature Dürer to its replication by a copyist of the Dürer renaissance exemplifies the dialectical process whereby innovation founds tradition and tradition recasts its original innovation. The two-part structure of the present book follows from this example. Pairing Dürer and Baldung heuristically as original and epigone, as producer and receiver, I interpret self-portraiture in its specific modernity within exemplary acts of pictorial response.

Part 1, "The Project of Self-Portraiture," centers on Dürer's 1500 *Self-Portrait* as emblem of the originary and productive power of the artist (fig. 21). Here is condensed, in one panel, the whole by now familiar, domesticated, discredited, and estranged discourse of the "dignity of man." Dürer's airtight placement at the center of the visual field, which allows not so much as a single hair to stray out of representation, affirms the consubstantiality of product and producer. His erect, en face posture dramatizes the personal force of the artist as representative man. Dürer stands dressed in the fur-trimmed coat worn by patricians and humanists; he demonstrates his learning at once in the geometry of the image and in the difficult Latin of his inscriptions; all in order to assert, once and for all, the Renaissance painter's ascent from craftsman to artist, from manual to intellectual laborer. This elevation is interpreted in the panel's controlling figure. Dürer, as we shall see, fashions his likeness after icons of Christ. In analogizing artist's portrait and cult image of God, in celebrating his art as the *vera icon* of personal skill and genius, Dürer realigns the terms of artistic and human self-understanding. He leaves behind centuries of image production in which authorship either was not registered or else was framed in postures of submission, as in the self-portrait of the thirteenth-century chronicler and illuminator Matthew Paris crouched beneath the Virgin in the *bas-de-page* (fig. 24).

What Dürer reifies here no longer seems as "natural" today as it did a few decades ago. Categories like self, man, art, modernity, genius, and labor now appear to many of us as fictions whose historicity and ideological motivation have been the subject of much recent scholarship on the Renaissance.[2] My intention in this book is not so much to dismantle Dürer's project myself as to let one artist working in his shadow do my work for me. In part 2, "The Mortification of the Image," I study how one artist, Hans Baldung Grien, interprets and disfigures Dürer's project of self-portraiture. Self-portraits proper occupy a marginal place in Baldung's oeuvre. The figure of self takes other forms here: as parodies of Dürer's image of the artist; as debased artist's monograms; as the ambivalent relation between the me and the not-me elicited by the sight of a corpse or a nude female body; as baleful mirrors that reflect the beholder in a state of ongoing corruption, bewitchment, or fracture. These heterogeneous portraits of self—or better, to borrow Foucault's phrase—these visual "technologies of self,"[3] reveal the unstable claims of Dürer's self-portraits and adumbrate one of their motivating historical conditions: what I call in my final chapters the "crisis of interpretation."

"What the father kept silent," wrote Nietzsche, "comes in the son to speech; and often I found the son to be the father's disclosed secret."[4] Baldung does not simply revise the art of his teacher by proposing an alternative vision. In his images of death and fallen

sexuality, he reveals that Dürer's self-portraits are themselves structured as systems of inclusions and exclusions and that the totality of this system, as well as its historical conditions, becomes apparent only in the alternatives of its reception. History, observed in this briefest of genealogies, has the character of what the Russian formalists termed the "succession of systems" or the "dialectical self-production of new forms."[5] Each artwork proposes its own regimen of production and response and depends for its effects upon a relation to earlier and later regimens within a tradition. Just as, on a local level, a viewer takes part in the image and completes its meaning, so too the epigone as representative viewer (here Baldung) completes his inheritance. To regard the moment of self-portraiture in this history, however, is not the same as seeing it in history proper, that is,

24. Matthew Paris, *Virgin and Child with Author's Self-Portrait*, illuminated page from the *Historia Anglorum*, 1250–1259, London, British Library MS. Royal 14 c. vii, fol. 232.

in the historical horizon of its origination, social function, and larger cultural motivation.[6] What kind of history, then, am I writing?

This book does not offer a historical explanation of the moment of self-portraiture. It does not, that is, propose a diachronic *causal* answer to the question, What brought about Dürer's likenesses of himself? One can imagine a wide range of answers, each plausible but insufficient in itself. One could cite certain artistic and cultural influences as precipitating conditions: The Renaissance ideology of the dignity of man, first established in Italy during the fifteenth century, arrived in Germany through Dürer and occasioned his self-celebrations; new styles of piety, caused by broad changes in society, redefined the function of images, and Dürer's self-portraits are one response to this new function; an intensified interest in self-control and self-exploration, evident in all spheres of culture, affected the art of Dürer and his heirs. Or one could propose broader social or economic causes: The breakdown of feudal modes of production and the rise of merchant capitalism in German imperial cities at the eve of the Reformation, along with attendant changes in the legal and economic construction of the individual, precipitated innovations in artistic self-definition. The technology of printing, together with the development of an art market, required individual artists to signal what was theirs in more compelling and totalizing ways. A successful, literate, urban middle class initiated new patterns of patronage to which self-portraiture catered in complex but definable ways. A new, meritocratic administrative class, supported by Emperor Maximilian I, found emblems of the value of personal talent in Dürer's portrait likenesses. Changing power relations between individuals and larger societal structures (formations of family, gender, class, and state) necessitated new models of identity that Dürer's pictures could provide. Such lists could be expanded indefinitely until the epochality of Dürer's self-portraits, and of their curious aftermath, is perfectly matched by a contextual sublime.

This book, however, poses a different question, more interpretative than explanatory. Answering it involves accounting for the appeal of self-portraiture in this period, its *idées-forces*, to use a term of Charles Taylor's.[7] This question might be phrased: What functions did Dürer's likenesses serve in the creation and reception of the rest of his works? What aesthetic, theological, and economic obstacles did they navigate, and how successful were their tactics? To understand the "force" of self-portraiture, of course, it will be necessary to draw on some of the contexts listed above. Yet the direction of inquiry will be toward working out what Dürer's self-portraits, in the first place, are and say. And more than anything else, it seems to me, these images are a *means by which art symbolizes its tasks;* and what they say is that *art is an image of its maker.*

Dürer's 1500 *Self-Portrait,* as well as the Christian *vera icon* it is based on; Baldung's images of death, witches, fallen spectators, and the debased artist; and Cranach's allegories of the law and the gospels all model the nature and function of visual images. They are not theories of the image but something more internal, like the famous mirror in Jan van Eyck's *Arnolfini Portrait* (fig. 25).[8] We feel confident that here, where the artist's sig-

nature (the words *Jan de Eyck fuit hic* inscribed in chancery script on the wall above the mirror) and self-portrait (visible in the mirror) combine to verify the contract of matrimony, Van Eyck has made a statement "about" the nature of his art. This statement may not be the painting's primary message. Relationships between painting and patron, or between the sitters Giovanni Arnolfini and Giovanna Cenami, were surely of more interest to the work's original audience. Yet whether as centerpiece or as supplement, the mirror and its signs of authorship propose themselves as an image of the image, as a metapicture whose potential as interpretative key has fueled an art historical industry.[9]

For André Gide, such mirrors in Netherlandish painting were a primary instance of what he termed the *mise en abyme*, that is, "an aspect enclosed within a work that shows a similarity with the work that contains it."[10] The term itself derives from heraldry, where *abîme* ("abyss") means the heart of the shield, and where *mise en abyme* would have meant, to Gide, the image of a shield containing, at its center, a miniature replica of itself.[11] A convex mirror in a painting, like *Hamlet*'s play within the play, constitutes an interpretation of the work from within, the work's own model of itself. Gide finally rejects the Eyckian mirror as his example, because it always represents a different and distorted view of what we see in the panel before us. What he desires is that the moment of the work's production, the encounter between artist and work, be repeated within (or indeed *as*) the work: a reflection occurring not at the far end of represented space, but at the point where the picture is made or perceived; a mirror consubstantial with the picture. Dürer's self-portraits, drawn "out of a mirror," occupy this notional space. They station us in the position of Albrecht Dürer contemplating the mirror that will be his painting.

What, as a preliminary, can such a picture say about its image? It proposes art as the spectacle of the producer's body and talent, a proposition theorized by Dürer under the notion of a personal and inimitable graphic style. And it presages and determines the image's reception by linking what we see to the person of the artist. The enigma surrounding a work like the *Melencolia* engraving is more than just the consequence of Renaissance humanist arcana whose code is yet to be cracked. It depends as well on a unique and personal inflection of a code, and therefore on the phantasm of a self (the artist's self) behind the work, and even of the work as an allegory of selfhood. The conflict between romantic and historicizing accounts of the engraving, between calling the print "a spiritual self-portrait" and calling it a "compendium of knowledge," cannot be resolved wholly outside Dürer's pact of self-portraiture, which will have said, for Dürer's oeuvre, that all the images we see are at bottom displays of the artist. This raises the historical question not only of why the *self* is granted this privileged status at 1500, but also of why specifically *art* is given the task of idealizing the relation between the self and its products, the individual and its labor.

For it might well have been otherwise. In Nicholas of Cusa's dialogue *De mente* from 1450, the figure of the Idiota demonstrates his own self-understanding and asserts his self-worth by explicating the nature of his lowly trade: the craft of carving spoons.[12] According to the Idiota, unlike the arts of poetry and painting, which imitate nature, the labor of the spoonmaker, which brings forth something entirely new, imitates the *ars*

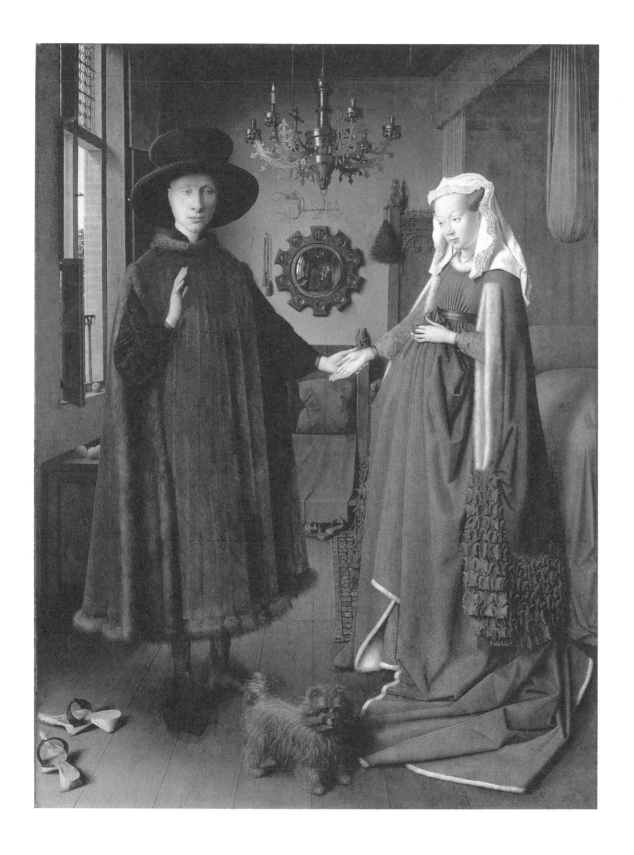

25. Jan van Eyck, *Double Portrait of Giovanni di Arrigo Arnolfini and Giovanna Née Cenami*, 1434, oil on panel, National Gallery, London.

minati:tunc imaculatus ero:
et emundabor a delicto maxi-
mo.Et erunt vt complaceant
eloquia oris mei:et meditatio
cordis mei in cõspectu tuo sem
per.Domine adiutor meus et
redemptor meus. Gloria.An
tiphona. Sicut mirra electa
odorem dedisti suauitat sancta
tta dei genitrix. Antiphona.
Ante thorum. Psalmus.
Omini est terra:et ple-
nitudo eius orbis terra
rum:et vniuersi qui habitant

41

26. Albrecht Dürer, decorated page of the *Prayer Book of Maximilian,* 1515, pen and violet ink on parchment, Staatsbibliothek, Munich, L. impr. membr. 64, fol. 41.

infinita of God. I am reminded here of Dürer's little sketch of an exotic spoon supporting a native, perhaps of the New World (fig. 26). The spoon probably represents an object like the ones Dürer saw in Brussels in 1523, when he was shown, in his own words, "things that had been brought to the king from the new land of gold," from America, and where he admired "the subtle *ingenium* of people in foreign lands."[13] In *De mente*, the Idiota forges a link between a craftsman's accomplishments and a new mode of self-consciousness, in which individuals regard their works as evidence of their autonomous, and therefore quasi-divine, creative powers. It is an argument about the importance of man's productive capabilities, his *poietic* rather than *mimetic* powers, that is so central to the rise of modern identity. Nicholas of Cusa's example of the craftsman who creates new things by means of an artisanal technology will soon be supplanted in the West by the artist as example of the creative individual. Why it is the poets and painters, rather than the spoonmakers, who become our culture's privileged embodiments of the self's productive capabilities; why it is the work of art that comes to speak about itself, offering its reflexivity as *the* model for human labor per se: these are still open questions, despite the work of, among others, Michel Foucault and Hans Blumenberg.

One possible answer might lie in the theory of ideology. The historical moment of self-portraiture was contemporaneous with a commercial revolution in German cities, fueled variously by the activities of capital, by new technology, and by expanded private and communal demand. One-person, one-product labor was replaced by manufacture on an ever-increasing scale.[14] This was particularly true for the painter's trade. The production of works for an art market by large, specialized, and stratified workshops, together with the medium of printing, which separated the designing artist from the men and machines making the individual impressions, altered the relation between picture and person. Wedged in the widening gap between individual and product, and between intellectual and manual laborer, Dürer's art offered its vision of the self present in its own works as a social ideal. Ideology, as Louis Althusser wrote, is "a 'representation' of the imaginary relationship of individuals to their real conditions of existence."[15] Dürer's self-portraits represent art as the image of its maker, and as the perfect union of head and hand. They could therefore function as imaginary solutions to real splits between product and laborer, and between intellectual and manual labor, occurring elsewhere in the culture.[16] At the horizon of this present study there appear faint outlines of this past and present motivation.

The Project of Self-Portraiture

ALBRECHT DÜRER

Le sot projet qu'il a de se peindre.
—Pascal on Montaigne

4

The Artist as Christie

The distance that separates Dürer's 1500 *Self-Portrait* from his Erlangen likeness is too great to be attributed simply to distinctions of media (figs. 1 and 21). Whereas in the drawing the artist displays himself in the act of sketching, thereby celebrating the distortions and accidents of posture attendant on this labor, in the Munich panel Dürer sublimates his body from all work and motion, positioning it full face before the viewer and establishing it as the central vertical axis of the visual field. This is neither Dürer's body as it appeared to him in a mirror at the moment of the picture's creation nor even, as in the Prado *Self-Portrait* (fig. 20), his body as he wished it to appear to his public, projected into the garb, setting, and social status to which he aspired. Formalized so as to display its underlying construction almost in the manner of an architectural front elevation, and set off against a neutral ground, the 1500 likeness is less a body in a setting, capable of movement elsewhere, than a principle of pictorial order consubstantial with the visual image itself. The painted panel has become pure face.

The visitor to the Pinakothek in Munich experiences it at once: in its frontality, symmetry, and isolation, in its sheer confrontality with the viewer, Dürer's *Self-Portrait* of 1500 hardly looks like a portrait at all. Consider Dürer's earlier likeness in the Prado. The artist has positioned his body within a margin of space between a foreground parapet and the rear wall of a vaulted room. This setting frames and stabilizes the portrait likeness. The arrangement of the back wall, ordered by the window opening, conforms to the general L shape of the sitter's bust and arm, as does the combination of parapet and pillar at the far left. The arch at the upper left similarly adumbrates the curve of the artist's cap. The human figure does not, however, wholly determine or dominate its setting. At the right, following a portrait convention established first in the Netherlands, Dürer opens up the interior space of his portrait with a window overlooking a landscape. Probably inspired by the artist's own experience of crossing the Alps in 1494–1495, it advertises Dürer's unique worldliness. Such a trip was virtually unheard of before 1500 for aspiring painters in the North, whose travels as journeymen were confined to Germany

and the Low Countries. By visiting Italy, Dürer shared an experience with only the most cosmopolitan Germans: the sons of the great urban merchant families, young men who journeyed south to study at the Italian universities or to acquire business experience abroad. The mountainous landscape of the Prado panel at once signals the artist's kinship with this elite and places the portrait likeness vigorously in the world. Closed off on one side by window's edge and on the other by the panel's limits, the landscape situates the viewer's gaze at a single, contingent point in space. Dürer's whole scene has the character of a view through a window. The parapet, extending across the painting's lower edge as an internal frame, accommodates the actual limits of the picture plane to the architecture of represented space while echoing the form of the windowsill. Even the painting's inscription obeys this illusory order. Rather than placing his signs of authorship on the painting's frame, or simply in neutral zone on the surface of the panel, Dürer makes his inscription, with its name, date, and monogram, appear as if it were internal to the represented world, a text applied to the framing windowsill and obedient to the laws of three-dimensional space.

In the 1500 *Self-Portrait*, space has been reduced to the volume displaced by the artist's body. Casting no shadow on the flat, dark ground against which it is silhouetted, Dürer's likeness emerges out of nothing, pressing itself flat against the picture plane. The sense of setting has been further undermined by the form and placement of the prominent inscriptions. Stationed symmetrically on either side of Dürer's likeness, they adhere to the picture plane, drawing the dark ground on which they are written (a ground ostensibly "behind" the sitter) up toward the surface of the panel.[1] And this panel is precisely sized to the limits of the sitter's body. Dürer's locks flow to the very edge without so much as a single hair passing outside the visual field. Appearing without foreground or background in a space exclusively his own, Dürer seems no longer quite of this world.

The only extant German portrait before Dürer's 1500 *Self-Portrait* that depicts its sitter en face is a posthumous likeness. In the Nuremberg miniaturist Jakob Elsner's (d. 1517) panel *Thomas Reuss*, dating from about 1486, the sitter, a participant in the Council of Constance (1414), faces forward, silhouetted against a dark ground upon which are inscribed his name and coat of arms (fig. 27).[2] The panel belongs to a series of posthumous portraits by Elsner. The en face arrangement indicates, first, that the picture represents someone already dead; and second, that its main function was less the accurate depiction of the sitter's individual features than his representation as ideal type or *uomo famosi*. I shall have more to say about the deeper religious precedents for Dürer's frontality in the Munich panel. Seen within the tradition of German portraiture alone, the *Self-Portrait* reads like a proleptic epitaph. Extracting himself from the movements and contingencies of the world, Dürer offers to posterity a perfect and timeless likeness of the "world famous" artist. We are a very long way from the Erlangen drawing's spontaneous moment of self-portraiture, when self was revealed only in the temporal and historical act of making.

But then, much had happened in the nine years separating these two works. By 1500, largely through his vastly influential woodcut series the *Apocalypse* (begun in 1496 and

27. Jakob Elsner, *Posthumous Portrait of Thomas Reuss*, c. 1486, oil on panel, private collection, Germany.

published in 1498), Dürer had achieved an international fame unknown to any German painter before him. Within Germany he had served as portraitist to wealthy Nuremberg patricians like the Tuchers, the Imhoffs, and the Krels, had received commissions from territorial princes like Frederick the Wise, elector of Saxony,[3] was close to many of Germany's greatest scholars and humanists, and had established a lucrative trade in engravings and woodcuts that he designed, cut, and printed on his own press. Through his first trip to Italy in 1494–1495 and his continuing contact with painters from Venice and Bologna, Dürer introduced into his work classical motifs and a pictorial manner that would, almost single-handedly, alter the whole course of painting in the North. Moreover, his contact with Italian humanism had instilled in him a new conception of the status and mission of the individual artist, one he began to articulate already by 1498 in the novel form of an independent self-portrait panel.

In 1500 Dürer would have seen himself at the height of his powers. The Munich picture's inscription, which gives the sitter's age as "aetatis anno xxviii," places the sitter at his biographical apogee. For in the traditional medieval division of the stages of life, this represents the moment of transition between youth and maturity. According to Isidore of

28. Viet Thiem, *Luther Triptych*, 1572, oil on panel, City Church of SS. Peter and Paul, Weimar.

Seville, it is at twenty-eight that a man, having passed through youth but suffered no decline, possesses his greatest strength, intellect, moral rectitude, and physical beauty and can enter the public world for honor and fame.[4] The Munich *Self-Portrait*, prominently dated 1500, combines the artist's biological passage into adulthood with the epochal transition of the saeculum. Dürer enters the new half-millennium at the moment of his own perfection, elevated from the temporality of both growth and decay. Made in the fullness of time, the *Self-Portrait* submits to the future the entelechy of Dürer's person revealed in the perfection of his body and his art. This explains the panel's quality as epitaph. Having become the best he will ever be, such that any future likeness will represent but a devolution from this exemplary state, Dürer makes final his effigy, stripping it of all contingencies of movement, spatial setting, and point of view. In fact, after the 1500 panel Dürer was to live another twenty-eight years exactly. In that second half of his life he produced no more independent self-portrait panels (although, as we shall see, his personal relation to Raphael occasioned, about 1515, a pseudomagical likeness of himself fashioned on linen).

Our account thus far has assumed one thing: the Munich panel's intended function was to preserve for posterity one self that is uniquely Dürer's. A glance at the artist's earlier likenesses, however, complicates our ideas about the unity and function of the self

in self-portraiture at 1500. Viewed in succession, these works chronicle not so much one person's physical and artistic maturation as a sequence of roles enacted by the artist for a variety of occasions. In the Louvre panel of 1493 (fig. 18) Dürer outfits himself dutifully as lover and as husband; in the Prado portrait he appears as worldly *gentilhuomo;* and in the Munich picture he is something more lofty and audacious, a being fashioned in the image of God. If we sense the person "Dürer" behind this change of costumes, it is only in the gap between, on the one hand, the garb that fixes the sitter into his various roles and, on the other hand, the sitter's face that, remaining constant through the panels, gazes out of the picture with a conviction and an immediacy at odds with the variously clothed body. Thus in the Louvre *Self-Portrait,* a spruce and eager Dürer, wielding his medicine against impotence, presents himself to his fiancée. And yet the attention and flattery he lavishes on his own appearance, the strong sense we have of Dürer relishing the specular act of self-portraiture itself, complicates the apparent direction of his desires. Here the self of self-portraiture would be the artist's narcissism at odds with his role. In the Prado panel, Dürer's familiar face peers out at the modern viewer as if somehow mocked by his own costume. This does not tell us what Dürer was "really" like, only perhaps what we hope he was *not* like. And in the 1500 *Self-Portrait,* as we shall see, Dürer thematizes the unbridgeable rift between himself, in all his vanity, narcissism, and specificity, and the higher role to which he aspires. Dürer presents himself *as* Christ but reveals himself to be mere man. My point here is not to decipher an inner subjectivity that is constant in all Dürer's self-portraits, but rather to demonstrate how, to a modern sensibility, these works are strangely anonymous. What we think should be their subject, Dürer, emerges only negatively, at a distance from a role and therefore from the initial function of the panel.

This effect should not surprise any modern student of the sixteenth century. As Stephen Greenblatt has argued in his now-classic study of psychic mobility in the Renaissance, during this period "there appeared to be an increased self-consciousness about the fashioning of human identity as a manipulable, artful process."[5] Dürer can style himself as lover or as Italian gentleman, just as later he will fashion himself as Christ and as Adam, celebrating all the while his own capacity to mold himself in whatever manner he chooses. An interesting example of the potential multiplicity of identities within a single work occurs in a strange painting by the Saxon court painter Veit Thiem, dated 1572 (fig. 28). Martin Luther is portrayed posthumously in three likenesses forming a triptych. Extensive inscriptions at the base of each panel describe, in doggerel, the main events of the Reformer's life. Produced during the bitter conflict between the Wittenburg and Jena factions of German Protestantism, the panels take to an extreme a general tendency in this period to sanctify the person Luther as supreme authority and example in all matters of faith, politics, and dogma.[6] The triptych format itself carries strong cultic associations and is somewhat rare in later Reformation art.[7] Each of Thiem's panels copies a well-known likeness by the greatest of all Saxon court painters, Lucas Cranach the Elder, and each depicts Luther in a phase of his career in which he assumes a role representative of some sphere of human action. At the left, *Luther as Augustinian Monk,* derived from an

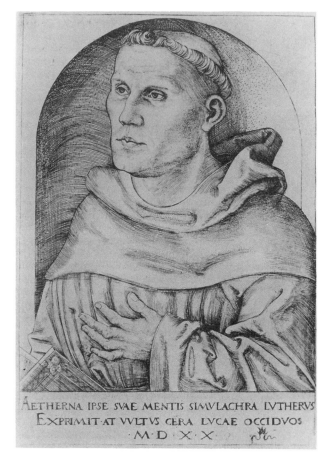

AETHERNA IPSE SVAE MENTIS SIMVLACHRA LVTHERVS
EXPRIMIT AT VVLTVS CERA LVCAE OCCIDVOS
· M · D · X · X ·

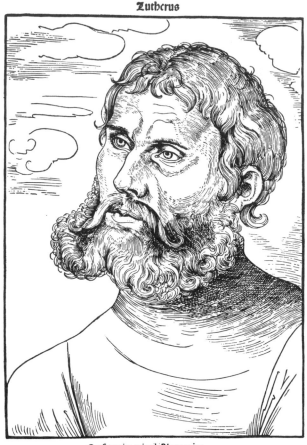

Zutherus

Quæſitus toties, toties tibi Rhoma petitus
En ego per Chriſtum viuo Lutherus adhuc
Vna mihi ſpes eſt, quo non fraudabor, Ieſus
Hunc mihi dum teneam perfida Rhoma vale.

influential 1520 engraving by Cranach's shop (fig. 29; J. 210)[8] and representing the young Luther before his emergence as evangelical leader, emphasizes the sitter's saintly aspect as divinely inspired man of Christ.[9] *Luther as "Junker Jörg,"* at the right, adapting a Cranach woodcut from 1522 (fig. 30; J. 405),[10] refers to the Reformer's 1521–1522 concealment in the Wartburg castle and presents him as a German nobleman. And the central panel, *Luther as Reformer,* culled from several Cranach panels,[11] depicts the sitter gesturing toward Scripture as sole authority for the new evangelical faith. That the panels, read left to right, disagree with the biographical sequence given in doggerel below (*Luther the Reformer* comes after, and therefore should appear to the left of, *Junker Jörg*) only confirms the ensemble's symbolic order, which, like earlier Christian triptychs, flanks an iconic image with preliminary narratives. Taken as a whole, the triptych thus functions as a memorial or *Gedenkbild* in which the Reformer, within his multiple roles as saint, statesman, and religious leader, can be venerated as at once a spiritual, political, and theological authority.

29. (*facing page, right*) Lucas Cranach the Elder (shop), *Luther as Augustinian Monk*, 1520, engraving.

30. (*facing page right*) Lucas Cranach the Elder, *Luther as "Junker Jörg,"* 1522, woodcut.

31. (*right*) Hans Brosamer, *Luther as Seven-Headed Monster*, woodcut title-page illustration for Johannes Cochlaeus's *Sieben Köpffe Martini Luthers* (Leipzig: Valentin Schumann, 1529).

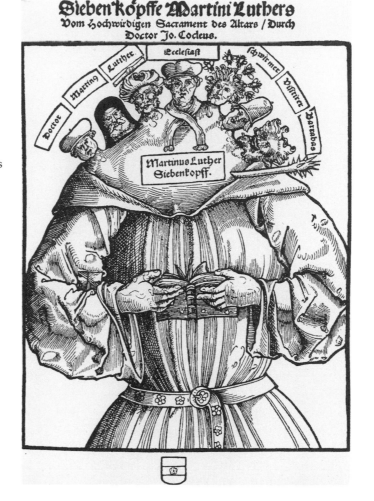

Although celebrated in Thiem's triptych, Luther's ability to play many roles became, for his opponents, proof of his hypocrisy and self-contradiction. In a title-page illustration for Johannes Cochlaeus's *Sieben Köpffe Martini Luthers*, published in Leipzig in 1529 by Valentin Schumann and attributed to Hans Brosamer (1500–1552), the Reformer appears as the seven-headed monster of Revelation, preaching "what the masses want to hear" (fig. 31).[12] He appears in many guises—as doctor, saint, infidel, priest, fanatic, loutish bureaucrat, and Barabbas—and therefore can be many things to many people, yet he is himself without a stable identity. In Thiem's *Luther Triptych*, again, the Reformer's three faces underscore his unifying role as leader and exemplar to a Reformation now in the throes of factionalism. The triptych format, used throughout the Middle Ages because of its association with the Trinity, now functions within the secular context of memorial portraiture, sanctifying the unified allegiance of Luther's person to his faith, his state, and his church. The central panel articulates this unity's source: the open book as the Lutheran hermeneutical principle of *sola scriptura*. Brosamer's hydra, on the other

hand, presents Luther as a body with too many heads, a being who indeed reads from a single book, but whose readings are multiple, conflicting, and in the language of Babel. Against the *sola scriptura*, Luther's Catholic opponents set the dangerous polyvalence of a Bible read without the authority of tradition and the Fathers. Against the heroism of a man aspiring to speak to all men, they set an apocalyptic monster of confusion: the man without qualities.

The iconography of Luther introduces problems about the self of portraiture in the sixteenth century. In his various self-portraits, Dürer expresses confidence that he can fashion himself at will, aspire to positions above his estate, and, all along, be representative for all men. Yet he, and even more his artistic followers, will also experience the self as lack, as deviation from the exemplum, and as fall into relative truth and into the particularity of character. The 1500 *Self-Portrait* is Dürer's most ambitious and complex expression of this problem. Less a reflection of the artist's particular subjectivity, it pictures through the example of the "artist" the troubled Renaissance dream of the completed, finished, and representative person.

Representative to whom and for what end? We know neither the occasion of production nor the original place of display for the Munich panel. The work's immediate audience was certainly wider than Dürer's family or shop. As Dieter Wuttke has shown, the poet laureate of Germany, Conrad Celtis, had already composed an epigram on the *Self-Portrait* by the end of 1500.[13] This suggests that the painting was known by, or perhaps even produced in dialogue with, the circle of Nuremberg humanists calling itself the Sodalitas Celtica.[14] Whether Celtis saw the painting in Dürer's shop or whether it was displayed elsewhere remains unclear. The panel's original frame has been lost, along with its rear surface,[15] making it even more difficult to determine the *Self-Portrait*'s intended setting. It is quite possible that the Munich panel was not meant to be displayed on a wall; fitted with shutters (as in Dürer's 1499 *Portrait of Oswolt Krel*, fig. 86) or with a protective cover (as in Dürer's *Portrait of Hieronymus Holzschuher* of 1526, now in Berlin), it could have been kept in a cabinet and viewed only occasionally.[16] By the time of the artist's death in 1528, it is probable that it was displayed in a public setting, most likely the city hall in Nuremberg. Helius Eobanus Hessus (1488–1540), in his epicedium for Dürer, writes that the artist's memory was preserved in a self-portrait likeness kept in "official or ministerial hands" (*officiosa manus*), a phrase Hans Rupprich reads as referring specifically to the Nuremberg Rat.[17] The artist might have either sold or donated work to the city fathers, as he did the *Apostles* panels of 1526, now in Munich. In 1577 Carel van Mander came across a self-portrait "painted by Dürer in 1500" hanging in the city hall in Nuremberg.[18] In 1611, during the remodeling of the building's *Regimentsstube*, mention is made of a "small portrait [*conterfect*] of the artful and world-famous painter Albrecht Dürer" hanging alongside his *Adam* and *Eve* panels of 1507, now in the Prado (fig. 133).[19] In his *Teutsche Akademie*, published in Nuremberg in 1675, Joachim Sandrart refers to Dürer's *Contrafät* displayed "among other rarities in the city hall of his birthplace."[20] And by the eighteenth century, documents describe a panel identical to the Munich *Self-Portrait* hanging in the "Silver Room" of the city hall.[21]

32. Georg Vischer, *Christ and the Woman Taken in Adultery*, 1637, oil on panel, Bayerische Staatsgemäldesammlung, Munich.

This history tells us little about the initial function and occasion of the *Self-Portrait*, however, except that the panel came to serve a public function in the self-representation of the city of Nuremberg. Yet as seen in my introductory remarks, the question of an "original" meaning of a self-portrait is ill posed in Dürer's case. I shall therefore turn to subsequent receptions of the 1500 panel and examine the contexts in which the work traditionally has been placed, as well as the complex ways the work continues to reflect, transform, and subvert those contexts.

One fascinating pictorial response to the 1500 *Self-Portrait* belongs to a late phase of the Dürer renaissance in Bavaria. In a panel of *Christ and the Woman Taken in Adultery* from 1637, now in Munich, Georg Vischer, court painter to Maximilian I of Bavaria, assembles a group of half-length figures, each copied or adapted from some earlier work of art (fig. 32), to depict the episode in John 8.[22] The face gazing out of the picture at the upper right replicates a figure in Robert Walker's (1607–1658) *Card Players* now in Donzdorf;[23] the man carrying the stones in the foreground derives from Titian's *Parable of the Tribute Money*, known from an engraving by Martino Rota;[24] and at the exact center of the panel,

the likeness of Christ surrounded by an aureole copies Dürer's Munich *Self-Portrait*.[25] Vischer has altered certain details of the 1500 original, adding Christ's robes and repositioning his hand, and he has generally softened Dürer's lighting and line. All in all, however, *Christ and the Woman Taken in Adultery* reproduces Dürer's portrait with a precision akin to the 1576 copy after the Albertina silverpoint (fig. 23). We have examined the aesthetic that informs such a copy in European courts about 1600. The cult of Dürer, fostered through collecting, replicating, and imitating his works, and foundational to the development of the early *Kunstkammer,* stands as an important and recurrent episode in the rise of "art" as a secular religion. In Vischer's 1637 panel, Dürer's sanctification is explicit. Copying the 1500 likeness for the face of Christ, Vischer fashions an apotheosis of the individual artist in his art: Dürer's *Self-Portrait,* venerated in the retrospective act of imitation itself, is transformed into a holy icon. Needless to say, such a transformation also involves a secularization of the religious image. *Christ and the Woman Taken in Adultery* functions neither as altarpiece nor as cult image, but rather as an *exemplum* of virtue to be displayed in a gallery of mostly secular pictures decorating Maximilian's court in Munich. And for the culture of the Dürer renaissance, Albrecht Dürer had become nearly as viable an example of personal virtue as was Christ in the episode in the Gospel of John.

All this is but part of the story. Vischer's transformation of Dürer into Christ not only belongs to the Munich panel's later reception but constitutes the work's own controlling allusion. For Dürer fashions his own *Self-Portrait* after the face of Christ as it appears in images of the Holy Face. A comparison between the 1500 self-portrait and a version of the *Holy Face* attributed to Jan van Eyck from about 1440 reveals that Dürer not only reproduced the pictorial format of earlier portraits of Christ—their strict frontality, hieratic symmetry, and systematized proportionality—he also modified the physical features of his own face so that it more closely resembles Christ's physiognomy (fig. 33). Whereas Dürer is dark blond in his Louvre and Prado self-portraits and in his various *in assistenza* likenesses of 1506–1511,[26] his Munich panel depicts him with the hazelnut-colored hair of Christ, known from numerous apocryphal descriptions.[27]

The Christomorphic aspect of Dürer's *Self-Portrait* has been recognized in the literature since Moriz Thausing's 1876 monograph on the artist,[28] although the 1637 Vischer panel demonstrates that the portrait's *pictorial* reception had already articulated this point about 250 years earlier. Some scholars have remained skeptical about the presence of the allusion,[29] and there is nothing in Dürer's picture itself, apart from formal similarities to panels of Christ, that can certify the allusion's presence. Nor can we be helped here by visual antecedents or successors within a tradition of self-portraiture, for the work neither belongs to nor engenders anything like a "tradition." The likelihood that Dürer intended his *Self-Portrait* to evoke the Holy Face can be demonstrated circumstantially. First, frontal portraits of this kind are so rare in Germany in the fifteenth century, and Holy Faces so popular, that a contemporary viewer would have more easily discerned the reference to Christ than recognized the panel as a "portrait" of Dürer. Second, in his writings, and in later self-portraits, Dürer continues to make analogies between the artist and Christ. And third, Vischer, an artist of the Dürer renaissance and thus closer to 1500 than to ourselves,

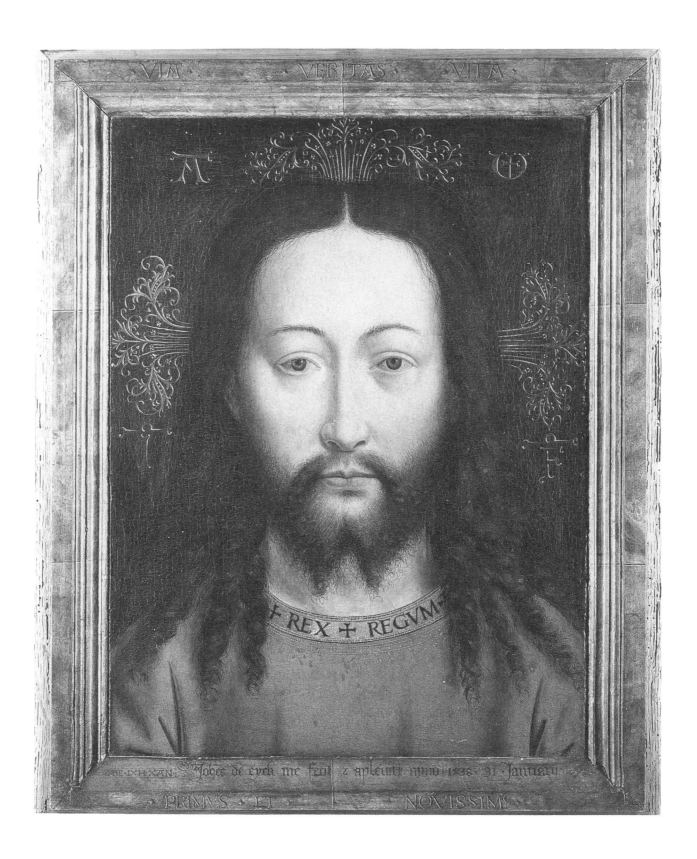

33. Jan van Eyck (copy after?), *Holy Face*, 1440, panel, Staatliche Museen
Preußischer Kulturbesitz, Berlin.

cheerfully utilized the allusion. All these points, however, and indeed whatever else I shall bring to bear on the allusion, do not constitute proof. This uncertainty is not born of either a lack of historical evidence or an obscurity of artistic intention but belongs to the message of the allusion itself. Christ is present in Dürer's likeness only as *analogy*, that is, as similarity through proportion.[30] The *Self-Portrait* will remain only potentially related to the Holy Face, because by refusing an open identification with its model it can generalize Christian anthropology, which always places the human in relation to the divine through some form of analogism. What will concern us is the meaning and function of the *analogon*, as well as its instantiation as a pictorial image—that is, as a representation that has its relation to a model through resemblance or analogy. As Dürer himself writes in his *Instruction Book of Painting*, "There is to be found a great likeness in unlike things."[31]

Thausing's mention of the *Self-Portrait*'s Christomorphic dimension appears in his remarkable summary of the artist's historical importance. By making explicit what in the panel remains only a shadowy allusion, by articulating the *Self-Portrait*'s dependency on the "old Oriental Christ type,"[32] he pushes the meaning of Dürer's panel in a specific direction. Thausing concludes that, just as according to Xenophanes men create their gods in their own image, so too the creative artist will fashion the divine (and indeed anything else he creates) as a likeness of himself: "It is the total subjectification of the object, the consumption of the master in the material of his images. Dürer's Christ is no different from Goethe's Werther or Faust."[33] Thausing accomplishes this movement from the general principle of the anthropomorphism of the gods to the specific example of Dürer's self-portrait through a notion of the great artist as cultural mediator: "The widespread opinion that Dürer's own face resembled Christ's is founded therefore on wholly correct observation. Only it is a *hysteron proteron*, whose framework, after more careful deduction, should be reversed: it is precisely our modern image of Christ that carries the features of Dürer." Dürer not only fashions his particular god in his own image but, through the influence of his art and the exemplarity of his person ("he is a model person among visual artists as Goethe is among the poets"), he imprints his own face onto our collective picture of Christ. Steeped in the nineteenth-century cult of genius, Thausing's reading might itself sound today like an anachronism or *hysteron proteron*. Is Dürer really fashioning God in his own image? Or is he rather reflecting merely the theological anthropocentrism of the Renaissance—that man was created in the image of God? I suggest that this uncertainty as to the direction of the *analogon* has been built into Dürer's panel from the start.

Thausing's reading is pursued to its limits in a title-page illustration by Max Seliger (1865–1920) for an 1898 issue of the German art monthly *Kunstgewerbeblatt* (fig. 34). Placed within a classicizing aedicula, the 1500 *Self-Portrait* has become a cult object on the altar of Art. At the left, Painting, personified by a woman with an artist's palette, steps toward Dürer's panel to light her candle from one of the attendant flames. Seliger allegorizes modern art's proper relation to tradition, in which the present draws its strength from preserving and imitating past genius, here embodied in Dürer. The commandment inscribed below the *Self-Portrait*, quoted from Germany's literary "model person" Goethe,

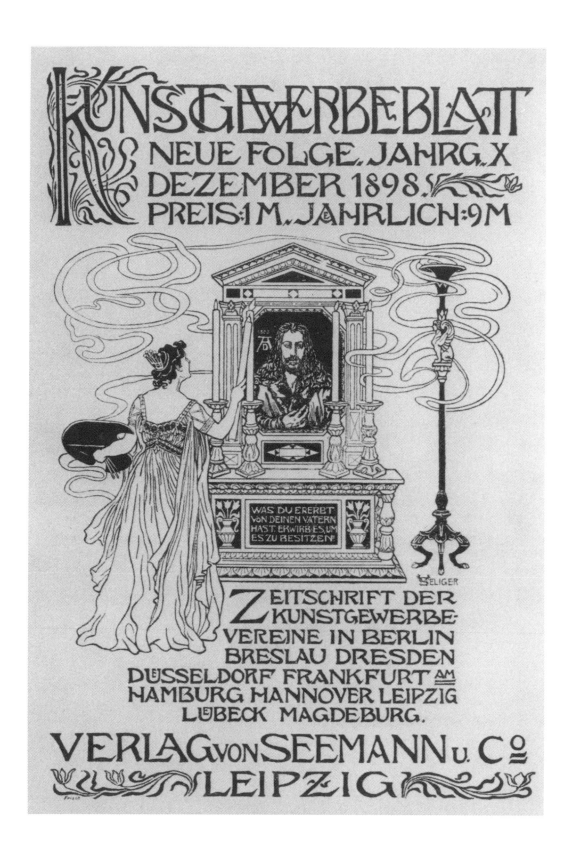

34. Max Seliger, *Dürer's Self-Portrait Adored by the Personification of Art*, title-page illustration for *Kunstgewerbeblatt*, December 1898.

spells out this relation: "What you have inherited from your fathers you should earn in order to possess." The usefulness of past art depends on its active and worthy appropriation by the present. Dürer may be modern German painting's inheritance, but in order for us to possess him, we must "earn" (*erwerben*) it through labor and industry. *Erwerben* comes from the Gothic *wairban*, which means to change or turn, hence words like *Wirbel* ("whirl") and *Gewerbe* ("industry"), as in the journal title, *Kunstgewerbe* ("art industry" or "applied arts"). For Painting to receive the inspiring flame, she must make tradition her own. Seliger appropriates, uses, and transforms the art of the fathers—synecdochally represented in his depiction of the Munich panel with a greatly magnified Dürer monogram—by framing it in the trappings of a religion. That such a placement might subvert Dürer's original intentions is of no special concern. Painting wields her candle like a paintbrush and could as well be producing an altarpiece to the fathers as receiving from it inspiring light. Moreover, the illustration fits the logic of Dürer's original panel and its subsequent reception: we merely pass from Dürer's own self-fashioning as Christ, through Vischer's Christ with the features of Dürer, to the Christ's replacement as cult object by Dürer, magically present in the sacred relic.[34]

Such a trajectory would support Dürer's modernity, yet for historians of the Christian Renaissance it raises questions about the artist's faith. As Erwin Panofsky asked in 1943, "How could so pious and humble an artist as Dürer resort to a procedure which less religious men would have considered blasphemous?"[35] Since Panofsky, most scholarship on the panel has been devoted to defending Dürer against the charge of blasphemy. Historians have generally legitimized the Christomorphic dimension of the Munich panel by linking it to features of late medieval piety. Panofsky, for example, argued that in fashioning his portrait after Christ's likeness, Dürer expresses the doctrine of the *imitatio Christi*: the belief, that is, professed by St. Francis and popularized in the North by Thomas à Kempis, that to follow Christ is to become like him, to humbly take up the cross and share in his Passion.[36] Dürer invokes this belief frequently in his writings. In a famous passage from his Netherlands diary of 1521, the artist responds to rumors about Martin Luther's arrest for treason. Dürer writes that Luther "was a follower of Christ [*nachfolger Christi*]" and urges Erasmus to rise to the Reformer's defense and prove himself too to be "of the likeness of your master Christ."[37] Dürer goes on to metaphorize Luther's persecution in terms of the Passion: "But Lord, before you judge, we pray you will it that, as your son Jesus Christ had to die at the hands of the priests and rise from the dead and afterward ascend to heaven, so too in a like manner [*gleichförmig*] it should be with your follower Martin Luther, whose death the pope with his money, and against God, contrives; him you will quicken again."[38] And in two late sketches now in the British Museum, Dürer represents the *imitatio* explicitly, portraying an individual—probably Lazarus Spengler[39]—with a cross on his shoulders following in the footsteps of Christ of the Passion (fig. 35); W. 925–926).

Such comparisons between the individual and Christ, however, are distinct from the Christomorphism of the 1500 *Self-Portrait*. They link self to exemplar not through physical appearance, but through a virtuous and ascetic life. And the object of their imitation is

The Project of Self-Portraiture: Albrecht Dürer

35. Albrecht Dürer, *Christ Carrying Cross* and *Christian Bearing His Cross*, c. 1523, ink on parchment, British Museum, London.

Christ's Passion, not his beauty and majesty. Other scholars, aware of the absence of Passion imagery (or indeed of any narrativity) in the Munich panel, amend Panofsky and suggest that the painting visualizes the doctrine that "God created man in his own image" (Gen. 1:27).[40] The beauty and proportion of Dürer's likeness, the argument goes, are not an expression of narcissism, but rather testimony to the Creator, who revealed himself most perfectly in his only son Christ, "who is the most beautiful in all the world" (Dürer).[41] Bestowing upon himself the *pulchritudo Christi,* Dürer resurrects man's original, but now fallen, appearance as an *imago* akin to Christ. And in fashioning the 1500 panel itself, the artist displays his own inborn talent as creator and, through the allusion to Christ, acknowledges the source of his talent in God. Dürer's idealizing *Self-Portrait* becomes the perfect demonstration of man as *imago Dei,* for it can reflect divinity doubly. On one hand, as model, as beautiful object of painting, Dürer the person reveals himself to be *created* in the image of God; on the other hand, as maker, as creative artist, he shows through his art that he can *create* in a manner akin to God. The panel thus instantiates the controlling fiction of Renaissance humanist aesthetics and its foundation in the doc-

trine of the dignity of man—the analogy between God as *deus artifex* and man as potentially *divina artista*.[42]

What all these recent interpretations of Dürer's *Self-Portrait* share, in comparison with the earlier responses of Thausing and Seliger, is a tendency to normalize the work's Christomorphic dimension by emptying it of controversy and by situating it in what is assumed to be the monolithic context of late medieval and Renaissance Christianity. Instead of heralding the modern age, Dürer's painting becomes the illustration of venerable, pious ideas whose Latin-sounding names—*imitatio Christi, imago Dei, divina artista*— assure us of their provenance in an epoch different from our own and therefore of their proper historicity as interpretative keys. I do not doubt that these ideas inform Dürer's producing and legitimating his *Self-Portrait*. What I am skeptical about is, first, the closure of these ideas at 1500, and therefore their capacity to serve as stabilizing explanations for Dürer's work; and second, their use in addressing the panel's specifically pictorial concerns—in apprehending, that is, Dürer's image *as image*.

In his exhaustive history of the *imago Dei* concept during the Italian Renaissance, Charles Trinkaus has shown that the theme of the physical beauty and creative power of man emerged originally as a pendant to the more widespread medieval theme of contempt for the world. Even after the dignity of man was celebrated by humanists like Petrarch, Giannozzo Manetti, and Giovanni Pico della Mirandola, it never became universal to all brands of humanism.[43] Humanism north of the Alps, shaped by a renascence of Augustinianism, was particularly apt to stress man's weakness and misery; and insofar as there did emerge a new concept of man's freedom and perfectibility, it was mixed with doubts and anxieties that could be resolved only through a more radical break with the past. William Bouwsma, sensitive to the deeply unstable ideology of northern humanism at the eve of the Reformation, places the topos of the dignity of man not within the context of normative Christianity, but precisely within a religious crisis whose resolution marks a decisive break with the medieval Christian past.[44] Discovering in Dürer's *Self-Portrait* an affirmation of man as *imago Dei* thus does not rest the case concerning the work's potentially subversive modernity or its spiritual blasphemy. For the *imago* itself is not a stable concept, nor is its affirmation unchallenged by contradictory messages in the *Self-Portrait*. We therefore cannot accept Panofsky's reassurance that "the reproach of self-glorification is less justified in connection with Dürer's Self-Portrait in the guise of Christ than it is in connection with his Self-Portrait in the guise of a *gentilhuomo*. It is no longer a challenge, but a confession and a sermon. It states, not what the artist claims to be, but what he must humbly endeavor to become."[45] As the religious polemic at the eve of the Reformation amply demonstrates, "confession" and "sermon" are potential loci for self-glorification, and a mere conviction of personal piety is not the same as true humility.[46] Dürer's Christianizing defenders not only obscure the *Self-Portrait* by emptying it of a modernity that links it to ourselves, they also overlook the tensions and ambivalences within Christianity itself at 1500. To put it simply, the Latin terms that seem to explain Dürer's intentions are no less opaque, no less multivalent, than his painting itself.

My more fundamental reservation about the prevailing accounts of the 1500 *Self-*

Portrait concerns their interpretive focus. Recent scholarship on the panel is unified in its willingness to accept Dürer's self-comparison at face value. Taken in by the sheer realism of the painting and its prototypes in Netherlandish art, and fooled perhaps by the extraordinary sense that portrait likenesses of Dürer and of Christ have accurately recorded, down to the minutest details, the authentic look of their models, commentators assume that the two fundamental terms in Dürer's allusion are, on the one hand, Dürer as human being, as empirical subject who looks and paints in a particular way, manipulating as he does so certain ideologies for personal ends, and on the other hand, Christ as the image of God on earth. I am convinced, however, that the 1500 *Self-Portrait* can be approached more meaningfully if we locate its controlling allusion at a very different level. Dürer's *analogon* is not primarily between himself and Christ, but between two kinds of pictorial representation. On one hand there is the image of Christ's face, a visual formula that has a long and complex history and that raises essential questions about the status of pictorial representation in the West; on the other hand there is the autonomous self-portrait, a subject of painting that Dürer can be said to have invented for the North and that became, in the course of the next half-millennium, one of the most representative modes of expression in European art. In fashioning his own most monumental likeness after the cultic image of the Holy Face, Dürer makes particular claims for the art of painting. By transferring the attributes of imagistic authority and quasi-magical power once associated with the true and sacred image of God to the novel subject of self-portraiture, Dürer legitimates his radically new notion of art, one based on the irreducible relation between the self and the work of art.

Focusing attention on the Munich panel *as image,* we shall observe how the "self" of Dürer's self-portraits functions within a larger argument concerning the status of the visual image at 1500. It is within this argument, internal and specific to painting, and not within the debate over Dürer's personal piety, that the play between tradition and innovation, history and modernity, religion and art is properly staged.

5

Not Made by Human Hands

The Munich *Self-Portrait* sets an artist's likeness in the format of an icon. To understand the full complexity of this conceit it is necessary first to explore the image of the Holy Face itself and to trace its reception in the art and theology of the northern Renaissance. For by the late fifteenth century the Holy Face had already mobilized, within its innumerable variations and interpretations, the central terms of Dürer's conceit: icon, portrait, self-portrait, and artist's signature. This prehistory determined how Dürer's person was at once inscribed in, and resistant toward, his *Self-Portrait*'s controlling allusion. And it will help distinguish for us the specific circumstances of artistic production and reception that occasioned this allusion at 1500.

Jan van Eyck's portrait panel of Christ (fig. 33) is a distant ancestor of the so-called *acheiropoetoi*, the "images not made by human hands" (Greek: *a* = without + *cheir* = hand + *poiein* = to make; Latin: *non manufactum*) mentioned in early Christian literature and associated mainly, but not exclusively, with the devotional practices of the Eastern church.[1] In these miraculous images, the face of Christ was believed to have left behind its authentic likeness in the form of a perfect imprint. The original function of these images was at least double: not manufactured, they elevated the cult image of Christ above artificially fashioned pagan idols; and divine in origin, they linked back to, and transumed, similar heaven-sent images of pre-Christian gods—for example, the *diipetes*, objects (often meteorites) believed to be statues of Athena or Artemis cast to earth by Zeus. The reception history of the *acheiropoetos*, stretching from the rise of the Christian cult of images to the sixteenth century and later, articulates the changing functions, values, and perceived origins of the visual image within the Eastern and Western churches. Dürer was fairly sophisticated in his knowledge of this history. Invoking the Holy Face, he writes his novel project of self-portraiture into this history, thereby linking himself and his art back to the Christian image par excellence, the miraculous self-portrait of Christ.

One of the earliest written accounts of an *acheiropoetos* concerns a portrait of Christ

brought to Constantinople from the Cappadocian town of Camulia in 574. According to sixth-century sources, a pagan woman named Hypatia swore she could not believe in Jesus unless she saw him herself. One day she discovered in a pond a canvas painted with Christ's likeness. She removed it from the water and found it dry; and when it spontaneously replicated itself on her garments, she converted to the Christian faith.[2] Here the *acheiropoetos* functions as theophany: the pagan demand for the material presence of the divine is simultaneously fulfilled and overturned. A more famous story surrounds an image from northern Syria. According to a sixth-century legend, King Abgar Ukamâ of Edessa fell ill.[3] Hearing about a healer named Jesus, he sent for the holy man and promised to become his follower. Christ learned of this and praised Abgar for having faith without visual evidence. Unable to travel to Edessa, Christ sent a likeness of himself produced miraculously on a cloth or mandylion (from Arabic *mandil*, "veil," and Latin *mantele*, "towel" or "napkin"). Abgar was cured, and the mandylion remained in Edessa until 544, when its magic turned back the invading Persians from the gates of the now-Christian city.[4] In 944, after it had worked many more miracles, Emperor Constantine VII Porphyrogenitus transferred the mandylion to Constantinople. After being conveyed around the city like a visiting monarch, indeed like the returned Christ, the image was established in the palace chapel, where it was worshiped above all the icons and relics of Byzantium. A triptych wing from about 950 shows the event of the *acheiropoetos*'s reception by Abgar, here depicted with the features of Constantine Porphyrogenitus (fig. 36).[5] The relic disappeared in the fall of Constantinople in 1204. The Latin emperor Baldwin II probably sent it to King Louis IX in France, where it remained until 1749; other ancient images extant in Rome (S. Silvestro in Capite) and in Genoa (S. Bartolomeo degli Armeni) still claim to be the authentic mandylion.[6]

The Western church's most famous image not made by human hands was the so-called sudarium (from Latin *suder*, "sweat") of St. Veronica.[7] Its histories were multiple and highly obscure, in part because it consisted of both an object and a legend, each with its own separate provenance. The object, a 40 by 37 centimeter likeness, was first recorded in the eleventh century, when it was kept in the upper story of a six-columned ciborium at St. Peter's, in the Oratory of John VII (Sta. Maria ad Praesepe).[8] Called the Veronica after its original owner, it was at first believed to preserve Christ's likeness at the start of his Passion, when he sweat blood on the Mount of Olives.[9] The effigy's fame escalated during the papacy of Innocent III. According to the *Chronica majora* of Matthew Paris (after 1245), during a regular ostension of the sudarium in 1216, the likeness miraculously turned itself upside down before a procession of torch-bearing worshipers. Pope Innocent, "believing that a foreboding prophecy had occurred," composed a prayer in honor of the effigy and promised ten days' remittance of sins to anyone who read it before the Holy Face.[10] Only in the early fourteenth century, however, does the sudarium find a stable place within the Passion narrative. According to the Bible of Rogier of Argenteuil, a pagan woman named Veronica saw the tortured Christ on the road to Calvary. Pitying him, she wiped the sweat and blood from his face with a cloth she had planned to sell at the market. To reward her compassion, Christ left on Veronica's cloth a perfect imprint

of his features. The cloth itself was termed the Veronica partly because of a felicitous homonymy. As Gerald of Wales writes in his *Speculum ecclesiae* (c. 1215), "Some say that Veronica signifies, in a play on words [*vocabulo alludentes*], simultaneously the true icon [*veram iconiam*]."[11] Regarded as the most sacred relic in Western Christendom, the Veronica was the most important prototype for all the so-called Holy Faces produced in the North.[12] The relic was lost in the sack of Rome in 1527, when, as one contemporary lamented, "it was passed from hand to hand in all the taverns of Rome" by Lutheran soldiers in the pay of Charles V.[13] It was only one of the Western church's many "true icons," however. An ancient image of Christ kept in the Sancta Sanctorum chapel in the Lateran, for example, was sometimes referred to as the Veronica and regarded as an

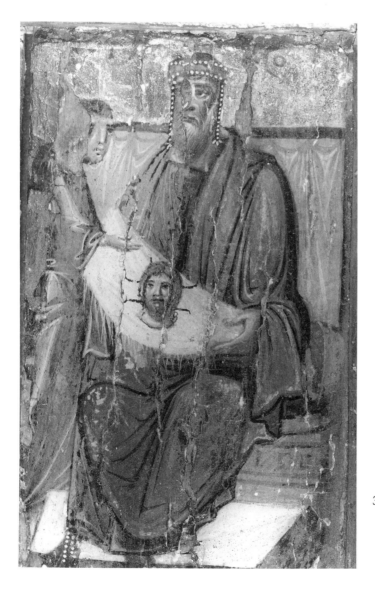

36. *King Abgar Receiving the Mandylion,* Constantinople after 944, tempera on panel, St. Catherine's Monastery, Sinai.

acheiropoetos. The proliferation of such images could be explained by further miracles of unmediated reproduction, in which a cloth or a parchment covering the original likeness would be imprinted with an equally authentic Holy Face, or in which the original was folded so that its likeness permeated all layers of the fabric, multiplying itself by powers of two and three.[14] All such images were believed to possess miraculous powers to heal or to harm their viewers and were counted among the most sacred relics of the churches that housed them.

It is enormously difficult to summarize the range of meanings invested in the *acheiropoetoi*. Theology, variously supporting, explaining, utilizing, rejecting, or prohibiting these objects, tells only a partial story. Its discourse is frequently reactive: a retrospective exegesis of preexistent popular beliefs in—or better, practices surrounding—certain images deemed divine in origin and efficacious in people's present lives. At one level, the myth of miraculous production simply explained certain real pictures of great antiquity around which local cults had grown. The *non manufactum* belonged to the reception of powerful images of the past. It was invoked frequently at the end of the Middle Ages, when the reception of Byzantine icons, stylistically distant from Western images of the time, renewed accounts of divine origins and saintly authorship.[15] At another level, the images of Camulia and Edessa, as well as the sudarium of St. Veronica, functioned like the graves and relics of the saints.[16] Through the material *praesentia* of his imprinted face, the power of one historical miracle worker, Christ, was conducted into the midst of a particular community. *Acheiropoetoi* were "contact relics" of Christ, material remnants of him whose grave lay empty and whose corpse was fully resurrected after death.[17] Created by Christ himself and therefore exempt from the rites of consecration whereby ordinary icons were empowered, they circumvented the authority of priest and theologian.[18] In the course of their history, however, as they survived and functioned within successive communities and cultures, the *acheiropoetoi* also motivated complex theological interpretations. Although these were often attempts to explain and therefore control cult practices existing outside the domain of organized theology, they illuminate the *acheiropoetos* as it was passed to the West in the Middle Ages.

Early in their history, miraculous likenesses of Christ were placed at the service of specific theologies. They functioned, for example, to support the Eastern church's central doctrine of the Incarnation as it was defined against the Monophysite heresy of the fifth and sixth centuries. The *acheiropoetos,* recording the earthly appearance of Christ as body, testified that God became fully human, while its status as produced without human hands affirmed, by analogy to the Virgin Birth, the status of the divine Word as "without beginning" and unutterable by man.[19] Ernst von Dobschütz, in his classic study of legends of the image of Christ, argued that what distinguished the Christian *acheiropoetos* from its pagan ancestors was its origin in an imprint, in a quasi-physical contact of original with likeness. Although miraculously produced and linked to eternity, the likeness of Christ also recorded one person's body at a singular moment in time, thereby affirming history as a central reality of the Christian faith. The *acheiropoetos,* like the Gospels, was at once a miracle worker in an ongoing present and the token of an apostolic past.

The most important theological inflection of the *acheiropoetoi,* however, was their place within arguments on the status of the image.[20] Cult images were legitimated neither by the Gospels nor by the early Fathers. Christian martyrs, heirs to the Mosaic interdict against pictures, died for refusing to bow to the emperor's effigy. When a Christian cult of images did develop in the period around 400, it had both to circumvent the aniconism of the Old Testament and to distinguish itself from pagan idolatry. Early in this struggle, and during the great iconoclastic controversies of the Byzantine church (726–842), the *acheiropoetoi* supported iconophile positions in various ways. Most simply, that Christ imprinted his own likeness and imparted it to his followers spoke for his acceptance of holy icons generally, and it invalidated any claims that Christ as son of God could not be portrayed in his body. For just as God created Christ as his perfect image and likeness, as "the icon of the invisible God" (Col. 1:15), so too Christ created the *acheiropoetos* as his perfect icon. The image not made by human hands thus simultaneously supported and was interpreted by the doctrine of the Incarnation. As the poet George Pisides wrote, celebrating the mandylion borne into battle by the troops of Emperor Heraclius in 622, Christ and his portrait, "both formations of the Word," together "confirm faith in the Incarnation against the errors of the fantasts."[21] The power of the icon to save or damn, to protect or destroy, derives from its place within a hierarchy of images (from God through Christ to the *acheiropoetos*), each linked to the next through the medium of resemblance. This hierarchy explained the general economy of image worship as it was classically defined by St. John of Damascus (730): "The honor shown to the image is transferred to the prototype, and whoever honors the image honors the person represented by it."[22] Later theologians in the iconoclastic controversy would elaborate this relationship between image and prototype. In the complex early ninth-century formulations of Theodore Studites and Nicephorus of Constantinople, the image was always already latent in its prototype, and to destroy the icons of Christ (as the iconoclasts did) was the same as denying his reality. Portraiture, according to this model, was therefore not dependent on the will or talent of the painter alone, but was motivated *ex se,* as it were, by the sitters themselves: a likeness that not only looked like, but was product and property of its prototype.[23]

What knits together the various theological interpretations of the *acheiropoetos,* and what motivates its invocation by Dürer in his *Self-Portrait,* is its myth of representation. The idea that Christ produced his authentic self-portrait without the agency of human hands expresses the dream of an autonomous, self-created image, a picture produced instantly in its perfect totality, outside the bodily conditions of human making that are embedded in the fallen dimension of time. Through its mode of production, what is fashioned without hands enters into a special, elevated status among things in the world. St. Paul speaks of Christ's priesthood as "a greater and more perfect one, not made by men's hands [*ou acheiropoetos*], that is, not belonging to this created world" (Heb. 9:11). In the Platonic and Philonic tradition of early Christianity, the divine prototypes of all earthly things were called *acheiropoetoi.* Thus man as mere *image* of God was sometimes distinguished from his divine model by being termed *cheiropoetos.*[24] In the Septuagint this

latter term denoted pagan idols, indicating their falsehood through their mode of production: "Their idols are silver and gold, the work of men's hands" (Ps. 115:4).[25] The image as *acheiropoetos* is antithetical to the idol, and devotion to it is the privileged movement from likeness to prototype and from earthly to divine. George Pisides compared the *acheiropoetos* to Christ not simply because it bore his true appearance in its likeness, but also because its origination was as pure and miraculous as Christ's. It was made "without inscription and formation—just as he had been fashioned without human semen—through the art of God."[26] Through its mode of production the *acheiropoetos* enters into a series of oppositions that define it: *vera icon* versus false idol, original versus copy, divine insemination versus sexual procreation, impure versus pure. And as the icon of icons, as the mimetic ideal toward which all pictures should aspire, it sanctifies the labor of all human painters of Christ: "The work of iconography is divine action."[27]

At first sight, the kind of painting represented by Dürer's Munich *Self-Portrait* is precisely one in which the visible signs of human making—for example, brushwork and the material presence of paint—are all but imperceptible. Nor does the artist-as-sitter appear to be engaged physically in the act of fashioning his likeness. Dürer gazes out at us from a completed world in which every hair, every visible surface, is wholly accounted for—as if the moment of self-portraiture had indeed been the total and instant doubling of the living subject onto the blank surface of the panel. The inscription painted at the upper right supports this idea. Dürer proclaims that he has fashioned his likeness with *propriis coloribus*, a complex phrase meaning not only "eternal" or "permanent" colors, but also colors that are Dürer's very own—colors that are somehow magically consubstantial with the thing they represent.[28] Through the visual allusion to the *vera icon*, Dürer can raise to a higher register this conceit of a perfect equivalence between image and model by comparing his work to the miraculous self-portraits of Christ. Thus mythicized, the artist's concealment of all signs of manual labor asserts, through the old analogy of the *acheiropoetos* to the Virgin Birth, a purity of origination comparable to an Immaculate Conception. This will be of interest to us later when we examine Dürer's intimations of a fallenness intrinsic to human creativity, a fallenness that Baldung will explore as the secret link between art and sexuality and between painting and ejaculation. At this point it is sufficient to say that Dürer finds in the *acheiropoetos* an idealizing model of self-portraiture. The 1500 panel claims to be produced *ex se*, thus bolstering Dürer's claim to the legitimacy, sanctity, and metaphysical originality of his art.

Against the legend of the *acheiropoetos* we could set Dürer's Erlangen drawing, in which self-portraiture was precisely the unique and characteristic activity of the artist's hand. Dürer's troubled physiognomy and cramped gestures, as well as the hasty lines that rendered them, testified to the temporal and bodily conditions of human making. In the Munich *Self-Portrait*, Dürer suppresses precisely such human conditions. One could argue, of course, that working in oil rather than in pen and ink, Dürer was bound by tradition to conceal the evidence of labor. To discover how the 1500 *Self-Portrait* thematizes precisely this painterly tradition by analogizing it to the *acheiropoetos*, we shall examine the evolution of the Holy Face in northern art before Dürer.

At the end of the Middle Ages, images of the Holy Face became ubiquitous throughout Europe, enjoying a special popularity in Germany and the Low Countries by the fifteenth century. The church, we recall, had encouraged devotion to the Roman Veronica since at least 1216, when Innocent III granted remittance of sins to anyone who read his prayer, the *Salve sancta facies*, to the Holy Face.[29] By about 1245, Matthew Paris could report that many people recited this prayer from memory before replicas of the Veronica. The person would "cross himself [*signans se*], say 'The light of your visage, Lord, appeared [*signatum*] over us,'" recite the *Salve sancta facies*, and then pray: "Lord, as your memorial you have left us—we who are marked [*signatis*] by the light of your face—the image imprinted on the sweat cloth of Veronica. For the sake of your Passion and the cross, grant that just as we on earth are permitted to worship and venerate these in mirror and in likeness, we will someday, on the good side, behold you as judge face to face."[30] The Veronica brings forth a theology of the sign. The Holy Face, as true icon of Christ and therefore as perfect match between image and model, *signum* and *res*, resembles the original divine signature on the face of man, as a being made in the image and likeness of God. To venerate the Veronica, believers sign themselves with the cross (the sign of signs), so that the Incarnation of God in the suffering Christ is met by the *imitatio* of his Passion in Christian piety. The end point of this growing proximity of signs to their referents, this sublimation of likeness into identity, is the unmediated vision of God, the "face to face" of 1 Cor. 13:12. The Veronica prepares believers for this movement from mirror to reality, *signum* to *res*, by aiding their future recognition of the face of faces. It is already clear why Dürer, an artist obsessed with signatures, mirrors, and likenesses, would prepare himself for this passage after death by intensifying the signature of God upon his own lighted face in his Christomorphic *Self-Portrait*. We in turn see the living artist mirrored "through a glass, darkly," but also, after death, face to face with God.

Devotion to the Holy Face was not only a metaphysical procedure, however. It had its practical rewards, which contributed to the popularity of the *vera icon* in the late Middle Ages. The sudarium in Rome was the earliest and most important indulgenced image in Christendom. After 1215 the church raised this promise of indulgence from ten to ten thousand days, and then to three thousand, nine thousand, twelve thousand, and (by 1370) twenty thousand years, with the result that the Veronica became the most popular relic for pilgrims traveling to Rome.[31] During the Jubilee Year of 1350, when more than a million pilgrims visited the city,[32] the sudarium was frequently displayed to huge crowds in the Vatican. A woodcut from the incunabulum *Mirabilia Romae*, produced for the Jubilee of 1475, illustrates the ostension of the relic, which took place regularly on Fridays and on all high holidays of the church (fig. 37).[33] Another woodcut from the same book shows the relic held by angels and surmounting the escutcheons of Rome and of Pope Sixtus IV, suggesting that by about 1500 the cloth had become the veritable emblem of *Roma christiana* (fig. 44).[34]

A brisk trade in souvenirs developed around the Veronica and its cult. The Holy Face was painted, etched, printed, or stamped on badges that visitors could attach to their garments as talismans and as tokens confirming their meritorious journey and earned

37. *Ostension of Vera Icon in Rome,* c. 1475, block-book illustration of *Miribilia Romae.*

38. Quentin Massys, *St. Roche Resting on His Return from Rome,* c. 1518–1520, panel, right wing of *Rem Altarpiece,* Alte Pinakothek, Munich.

39. Petrus Christus, *Portrait of a Young Man*, 1462, oil on panel, National Gallery, London.

indulgences. In a side panel from Quentin Massys's *Rem Altarpiece* of 1518–20, the suffering St. Roch appears resting on his homeward journey from Rome. The brim of his hat is decorated with signs of his pilgrimage: the keys of St. Peter cast in tin and a painted Veronica badge (fig. 38).[35] Owing partly to the proliferation of these images, mass-produced and sold by specialized *pictores Veronicarum* and *mercanti di Veronichi*, respectively, the particular features of the Holy Face in St. Peter's spread through Europe, to be copied and imitated by local artists in an enormous variety of media.[36] During the fourteenth and fifteenth centuries, en face representations of Christ appeared everywhere from altarpiece panels and the keystones of cathedrals to woodcuts, engravings, tapestries, and the final leaves of manuscripts.[37] By Dürer's time nearly every church in Europe had at least one image of the Veronica in its possession.[38] Sometimes these images were outfitted with the *Salve sancta facies,* so that the individual believer could benefit from the Holy Face's redemptive powers without having to make the journey to Rome. In a portrait by Petrus Christus (active 1444–1473) dating from about 1462, now in London, a painted parchment of the *vera icon* inscribed with a Latin hymn to St. Veronica appears on the wall behind the sitter (fig. 39).[39] Placed within a domestic setting, the *acheiropoetos* functions as a private devotional image or *Andachtsbild*.[40] We shall see later how the Holy Face served a new and specifically subjective piety in the North at the eve of the Reformation.

The Veronica took special forms in German painting during the century before Dürer. Unlike the Netherlandish Holy Face as formulated by Jan van Eyck (fig. 33) and Rogier van der Weyden (fig. 66), in which Christ is represented *en buste,* as if in a contemporary portrait likeness, the German *vera icon* generally shows a disembodied head silhouetted against a white cloth. Christ usually wears the crown of thorns, and his features betray the agony of his Passion, as in the name piece of the Master of St. Veronica (active in Cologne 1395–1415), now in Munich (fig. 40).[41] Sometimes, though, he appears serene and unwounded, as in a small panel by the same artist from about 1410, now in London (fig. 41).[42] The *acheiropoetos,* here lifted from all contexts, spatial or temporal, distances itself from the events of the Passion and from its origin in Veronica's pity. Imprinted at the absolute foreground of the painting, it causes everything else in the visual field—the saint, her cloth, the gold ground behind, and the illusion of pictorial space itself—to shrink back from it, as if all were just so many illusions attendant upon the totalizing reality and presence of the Face.

Cologne painting in the fifteenth century was especially well suited to elevate the sacred image above all earthly appearances. Whereas local traditions elsewhere in Germany attempted to assimilate the veristic *ars nova* of the Netherlands, the anonymous artists of Cologne remained willfully conservative, looking backward to the international courtly Gothic style of about 1400 and perfecting this delicate but hieratic pictorial mode. They stressed the value of the plane and avoided illusions of space, fashioning symmetrical images whose surfaces were patterned as flat areas of pure, rather than local, color. The use of gold as a backdrop continued in Cologne until the early sixteenth century, producing works in which a landscape rendered properly in perspective ends abruptly at a gilded sky (fig. 201).[43] Already in the London *St. Veronica,* the function of gold is appar-

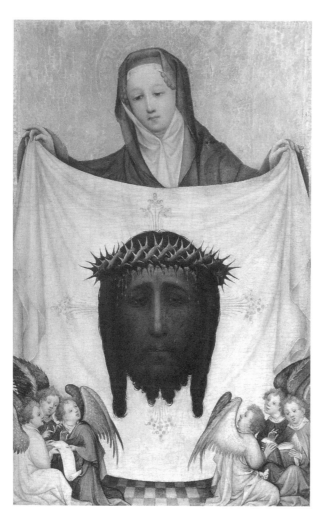

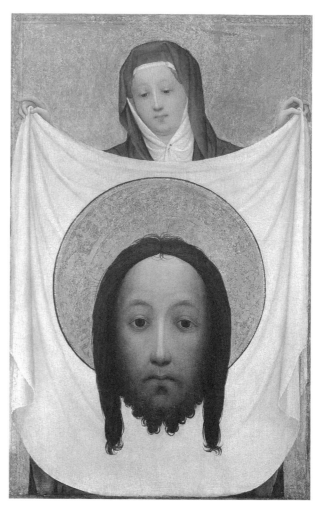

40. Master of St. Veronica, *St. Veronica with the Sudarium*, c. 1415, oil on panel, Alte Pinakothek, Munich.

41. Master of St. Veronica, *St. Veronica with the Sudarium*, c. 1415, oil on panel, National Gallery, London.

ent: echoing the supernatural luster of the Holy Face's halo, the gilding celebrates and sanctifies the painted panel *as object*. Instead of allowing the picture plane to vanish into the illusion of a represented scene, as Jan van Eyck does about 1440, the Cologne master keeps the eye fixed on the tooled surface of the panel, on its material presence. And since the absolute "foreground" of this image is constituted by the *vera icon* itself, the whole work of art becomes consubstantial with its magical subject, aspiring thereby to the status of the relic itself.

In its treatment of the visual image as inseparable from its material support, the Veronica Master's name piece is characteristic not only of Cologne painting but of most German art of the period. For as art historians from Heinrich Wölfflin to Otto Pächt have noted, German painters before Dürer, in spite of their reception of the Netherlandish

42. Friedrich Herlin, *Sudarium*, 1466, oil on panel, rear predella of high altar of St. Jacob's Church, Rothenburg on the Tauber.

tradition, never quite embraced an illusionism that would fully emancipate the visual image from its apparent adherence to the picture plane. Instead, they achieved an uneasy but often expressive tension between represented space and the two-dimensional reality of the art object itself.[44] This stylistic tendency informs the particular shape of the German *vera icon*. The overwhelming majority of Holy Faces produced in Germany before Dürer, whether in devotional panels, in retable altarpieces (fig. 42), or in woodcuts and engravings, agree in their general arrangement with the early panels by the Veronica Master.[45] Pächt wrote of this tradition:

> If one were to imagine a fitting myth of origin for German painting and the concept of the image it documents, it would be closest to the wonderful legend, told in the late Middle Ages, of the sweat cloth of St. Veronica. . . . The supple cloth molds the three-dimensional object, but when it is again spread out as a plane surface, it shows the object's impression as a picture. This is what is odd in the Christian legend and what cannot be explained through recourse to nature.[46]

The *vera icon* is simultaneously a cult object and an implicit aesthetic, what Hans Belting could call a theory of the image before the era of art. It articulates for German painters their constant struggle with surface and depth and with the altarpiece's sacred material reality and representation's convincing illusions.

Dürer produced several Veronicas in this style, including the 1513 engraving *Sudarium Held by Two Angels* (fig. 43; Kn. 71), probably based on a block-book illustration like the one on the end page of the *Mirabilia Romae* (fig. 44); a remarkable etched *Sudarium* of 1516 (fig. 49); a *vera icon* in pen and green ink on a page of the *Prayer Book of Maximilian* from 1515 (fig. 45); and the *Sudarium with SS. Veronica, Peter, and Paul* from the *Small Passion* of 1510 (Kn. 276), which punctuates the narrative flow of the woodcut series.[47] He also made numerous paintings of the sudarium. The 1588 inventory of the Imhoff collection records two such "panels,"[48] and in his Netherlands diary Dürer mentions four given as gifts. These were valued, one would assume, not as cult images, but as tokens of Dürer's

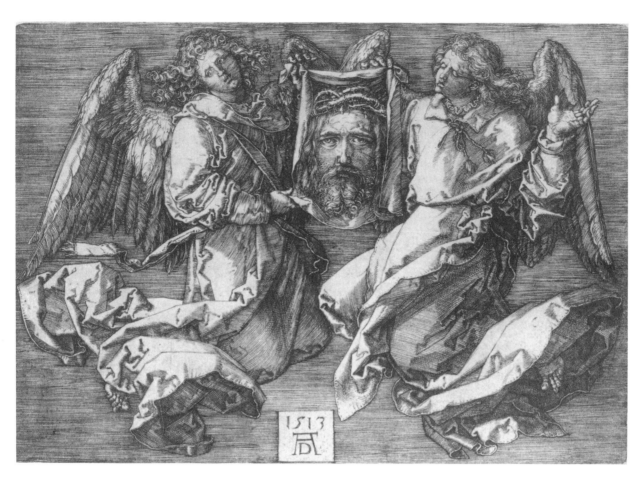

43. Albrecht Dürer, *Sudarium Held by Two Angels*, 1513, engraving.

friendship and artistry, autographs of skill executed swiftly during his travels, which he could present to admirers on foreign soil: "a painted Veronica face" to Jacob Panisio; another to "Jan the Goldsmith."[49] Dürer distinguishes each according to its artistic quality. To Francisco, factor of Portugal, he gives a "good Veronica face made with oil colors, which is worth twelve gulden"; and to Brandon, factor of Portugal, he gives "a better one." There is also evidence that Dürer produced a more elaborate painting of the *vera icon* in the period around 1500. In a letter to a prospective buyer, the painter Friedrich von Falkenburg describes and illustrates a triptych of the Holy Face (fig. 46).[50] Falkenburg, who copied Dürer's *Heller Altarpiece* for Archduke Maximilian of Austria about 1600, calls the Holy Face "a panel in oil paint by AD (the monogram of Dürer)" and identifies the portraits on the wings as Jacob Heller and Katherina Mühlheim. On the inner frame above and below the Holy Face itself, Falkenburg has indicated a long inscription, probably a version of the *Sancta salves facies* or some theological text, like the words on Antoniazzo Romano's *Holy Face* triptych alluding to Christ's archetypal beauty (fig. 47).[51]

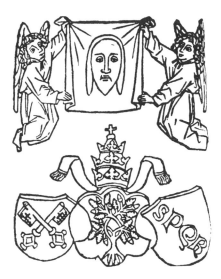

44. *Sudarium Held by Angels*,
c. 1475, block-book illustration
of *Miribilia Romae*.

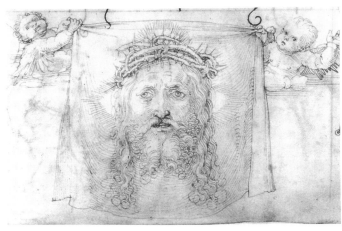

45. Albrecht Dürer, *Sudarium* from the *Prayer Book of
Maximilian*, 1515, pen and olive green ink on parchment
(detail of fig. 114 below), Staatsbibliothek, Munich,
L. impr. membr. 64, fol. 56.

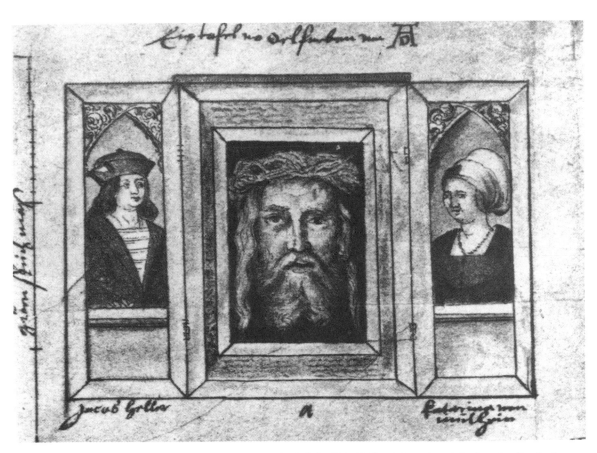

46. Friedrich von Falkenburg, letter (c. 1600) to Archduke Friedrich of Austria with sketch after lost
Dürer *Triptych of Vera Icon with Jacob Heller and Katharina von Mühlheim*.

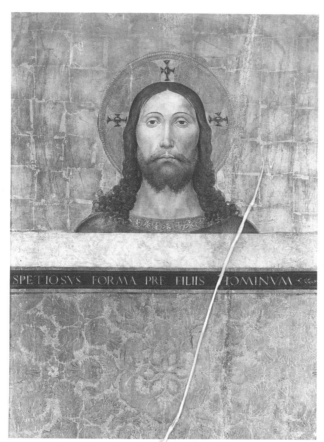

47. Antoniazzo Romano, *Triptych with SS. John the Baptist, Peter, and Holy Face,*
 c. 1485, panel, Prado, Madrid.

Although none of Dürer's Veronica panels survive, a large woodcut *Holy Face* from
about 1528, attributed to Dürer's student Hans Sebald Beham, preserves the arrangement
of the type (fig. 48).[52] The German *vera icon* is here translated into Dürer's graphic style
and achieves a new relation to its material support. Emerging as pure line from the blank
surface of the page, its beard a series of calligraphic flourishes seemingly independent of
any "body," the Holy Face appears strangely immaterial, almost diaphanous, as if the
print depicts not merely the image *on* the sudarium, but also the magically transparent
quality of the cloth itself, or as if the *acheiropoetos* of the Cologne Master of St. Veronica,
floating in an impossible space before the saint and her cloth, had been further purified.
Like the *acheiropoetos* it represents, Beham's woodcut is the impression of an object: the
imprint of the carved surface of the ink-covered woodblock. Although supple in their
contours, the lines that constitute the image do not appear like pen lines made individu-
ally and uniquely by a human hand. Their paths are interrupted here and there by minute
gaps of white, where the paper was creased or the block was chipped or unevenly inked.
Beham's printed Christ, filling the whole sheet with its monumental form, may thus cele-

The Project of Self-Portraiture: Albrecht Dürer

48. Hans Sebald Beham, *Holy Face*, 1528, woodcut.

brate the value of lines laid down freely by the draftsman's hand, yet it also distances us from that moment of activity through the agency of mechanical reproduction. The Holy Face here does not appear quite "on" the sheet, nor does it even hover "above" it, as in the Veronica Master. Rather, it arrives as if from nowhere, an afterimage in whose play of presence and absence the magic of the *acheiropoetos* is restaged.

According to Giorgio Vasari, Dürer produced a self-portrait of analogously magical qualities.[53] In the "Life of Raphael of Urbino," we learn that Dürer sent Raphael

> his own self-portrait. This was a head executed in gouache on transparent cambric, so that the design appeared the same on both sides. He used watercolors for the ground and colors, and the white of the cloth to provide the lights. Raphael considered this a wonderful [*maravigliosa*] work, and in return sent several of his own drawings which Dürer kept and treasured. (The head used to be among the belongings of Giulio Romano, Raphael's heir, in Mantua.)[54]

Dürer's translucent and reversible self-portrait invited the viewer to hold the fine linen image up to light and discover the artist's likeness as if freed from any material support.

The portrait did not appear built up on a surface, as in the Veronica Master's panel, or established as a body represented illusionistically "behind" the picture plane, as if through a window, in the manner of Jan van Eyck's *Holy Face*. Rather, the artist's face hovered miraculously in space, its highlights not *representing* light, but actually *being* the light that passes through the linen. It is likely that the exchange of works between Dürer and Raphael took place about 1515, for Dürer inscribed a sketch by the Italian master that he had in his possession as follows: "1515 Raphael of Urbino, who had been so highly regarded by the pope, made this nude picture and sent it to Albrecht Dürer of Nuremberg to show him his hand."[55] The past tense "had been" suggests that the inscription itself was fashioned after Raphael's death in 1520, in the period when Dürer labeled so many of the drawings in his possession. The date 1515 therefore dates the drawing's reception in Nuremberg.[56] Dürer interprets his colleague's gift as an attempt "to show him his hand," that is, as a demonstration of individual skill within the specificity of a personal graphic style. Dürer's transparent likeness on cambric and the Raphael sketch amount to tokens of self, gifts wherein the bodies of the painters are, each in its own way, made visible in their works. Each will treat the other's product as a relic, outfitting it for posterity with an inscription or bestowing it upon an artistic heir (Giulio Romano). In the specific form that Dürer's *Self-Portrait* for Raphael took—a "marvelous"[57] likeness fashioned on a diaphanous cloth of fine white linen—it is very difficult not to discern an allusion to the portrait-memento par excellence, the sudarium of Christ.

In an etching produced in 1516, the year after Dürer and Raphael exchanged gifts, the sudarium appears at the top of the sheet spread against the sky by an angel. The angel floats in clouds above the other *arma Christi* and views the relic from below (fig. 49). What we behold is an upside-down likeness scarcely legible behind the parallel hatchings that render both the sky and the shadowed underside of the cloth. It is only the direction of the angel's gaze, combined with a highlighted edge of the sudarium and a subtle curvature of hatchings on its surface, that alerts us to the presence of the Holy Face. Once recognized, Christ's dematerialized portrait appears as if etched in air. To admire its delicately rendered features, the viewer will want to hold Dürer's print upside down, or assume the angel's position under the relic. The angel lifts the relic as if to offer it to heaven or to allow heaven's light to pass through its surface. This gesture—elevating or reversing the cloth and peering through it—recalls the response Dürer's *maravigliosa* self-portrait elicited in Raphael's shop. And in the 1516 etching, as in most of Dürer's Holy Faces after 1500, the likeness of Christ recalls Dürer's en face, Christomorphic *Self-Portrait* in Munich.

It is also tempting to see in Dürer's etching a reflection of another portrait: the face of Christ as it appears on the vaulting and keystones of medieval German cathedrals, where it interprets church space as the mystical image of heaven.[58] These elevated Christ images, deriving from both the *Maiestas Domini* of Romanesque apse and typanum decoration and the Christ Pantocrator of Byzantine domes, propose a complex metaphysics of the face applicable to Dürer's etching. As John Shearman has recently shown, the Byzantine Pantocrator, usually shown half-length in a disk (fig. 50), was sometimes explained

49. Albrecht Dürer, *Angel with the Sudarium*, 1516, etching.

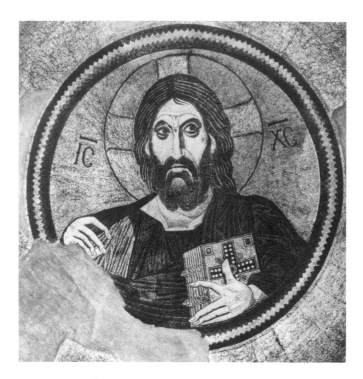

by the opening pages of Acts, in which two angels appear to the apostles after Christ's ascent and ask: "Ye men of Galilee, why stand ye gazing up into heaven? This same Jesus, which is taken up from you into heaven, shall so come in like manner as ye have seen him go into heaven" (Acts 1:11).[59] The face of Christ on the dome envisions, to the viewer below, Christ returning as judge in the circle of heaven. Dürer's sudarium, held by an angel, might likewise represent Christ's ascent and Second Coming—a conflation appropriate to the reversible transparent relic itself.

In a description of the Church of the Holy Apostles in Constantinople, written just before 1204, Nicolaus Mesarites interprets the Pantocrator of the dome thus:

> The dome shows in pictured form the God-Man Christ, leaning and gazing out as though from the rim of Heaven, the rim at the point where the curve of the dome begins, looking toward the floor of the church and everything in it. . . . Wherefore one can see Him, to use the words of the Song [of Solomon 2:8–9], looking forth at the windows, leaning out as far as His navel through the lattice at the summit of the dome like an earnest and vehement lover. . . . His look is gentle and wholly mild, turning neither to the left nor the right, but wholly directed toward all at once and at the same time toward each individually.[60]

In Dürer, the rim of heaven might be the upper edge of the painted sheet, cleverly doubled in the highlighted corner of the sudarium. And the figure of divine omnivoyance has been spread out on heaven's dome, as a likeness barely distinguishable from the texture of the sky. The source for Dürer's conceit, of course, is not Nicolaus Mesarites,

but it may well be an intermediary interpreter of divine omnivoyance, Nicholas of Cusa, whose text on the Holy Face we shall consult in the next chapter.

Thus far our survey of the *acheiropoetos* suggests that Dürer's allusion to the sudarium in his 1500 *Self-Portrait* links his work not only to a particular tradition of Christian images, but also to an array of theological readings and cult practices associated with those images. As proof of Christ's miraculous power (what the language of relics called *virtus*), and as the indulgenced image par excellence, remitting purgatorial punishment for sinners who have confessed their sins, the *vera icon* is a site of Christ's full *praesentia* in the world. Dürer places his own likeness at this heart of the sacred, fashioning himself after an image that not only looks like God but, in its sustaining myths of self-creation, perfect representation, and magical efficacy in atonement, has the powers and attributes of God.

We have examined the specifically German *vera icon* as it developed in the fifteenth century and entered the work of Dürer and his students: an image that refuses to be materialized within the representation of earthly space. Earlier I noted that the 1500 *Self-Portrait*, with its shadowless dark ground, gold inscriptions, and strict frontality, appeared flat in comparison with the earlier Louvre and Prado panels. At the same time, however, the Munich *Self-Portrait* shows Dürer's body itself in full relief, its every contour modeled by sharp light from the left and its lower extremities passing out of the picture, as if into a space beyond the rectangle of the panel. If this is a version of the *acheiropoetos*, it is a very different one from that of the Veronica Master, or Beham, or Dürer himself in his 1516 etching. Dürer's model is not the German sudarium (see fig. 51), but the *acheiropoetos* in its specifically Netherlandish variety, such as Jan van Eyck's portrait of Christ (fig. 33).[61] By linking his *Self-Portrait* to this tradition, Dürer can fashion for his own art a distinguished pedigree reaching back to the founding masters of the northern tradition. It is therefore to these Flemish portraits of Christ that we now turn.

On the frame of an inferior copy of the Eyckian Holy Face, now in Bruges, appears the inscription: "Johes de eyck Inventor anno 1440 30 January—als ikh kan."[62] As Friedländer noted, "Inventor" might signal that Jan van Eyck was the originator of the composition but did not himself execute the particular panel now in Bruges.[63] What was this invention, such that a later copyist would have wanted to acknowledge his dependency on it? If we compare the Berlin *Holy Face* with Christ as depicted some thirty years earlier by the Veronica Master (fig. 41), we observe that the Flemish painter has removed the en face likeness from the surface of the sudarium, refiguring it as a short bust clothed in royal red (the collar of his garment is inscribed with the title *Rex regum*), and allowed it to dwell in a space separated from our world by the picture's frame. In other words, Jan van Eyck has translated the *acheiropoetos* into an individual portrait likeness, a genre he himself was formulating for northern art of the fifteenth century.[64] This formula is at once so convincing and so foundational to our understanding of what a picture is that, after Van Eyck, it is difficult for us to think of it as an "invented" formula at all. The artist labors to replicate the unique appearance of his sitter, as much as he is visible to us, down to chance lip

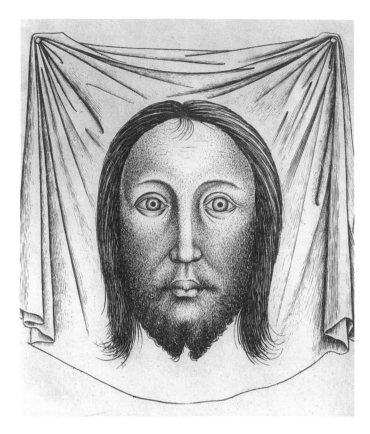

51. Master of the Playing Cards,
Vera Icon, c. 1440, engraving,
Germanisches Nationalmuseum,
Nuremberg.

lines and the individual hairs of his beard, locks, and eyebrows. Each part of the human body—hair, skin, eyes, fingernails—has not only its own shape and color, but also its characteristic material surface that the artist imitates by concocting with his oils an analogous surface, or better: a surface upon which light will behave much as it would on the substance represented.[65] And these "parts," gathered together, occupy a space invoked both through the modeling of the likeness in light and dark (note how the locks of Christ's hair cast shadows on his garments) and through the controlling agency of the frame, which closes off the visual field as if it were a scene observed through a window.[66] Once established, this space will join our world to the fictive domain of the portrait, assuring us that the laws of objects abiding with us will be followed also beyond the frame, and convincing us therefore that what we see is one specific body of one specific person: not *the* face, but *this* face.

When the Veronica Master establishes the Holy Face in front of St. Veronica and her cloth, he takes care *not* to integrate it into the shallow space behind. Although the white cloth itself has visible folds undulating its surface, these do not affect Christ's features of the imprint. Nor does the face cast any shadow on the cloth, as it would were it really to hover before the white surface. But then the German painter seeks to establish a hierarchy of appearances, distinguishing the sphere of earthly reality, embodied in the picture's

piccemeal naturalism, from the higher truth of Christ's authentic and perfect likeness. The Holy Face is thus not an attribute carried by St. Veronica in illusionistic space; rather, the oversize face of Christ appears with the saint and space in tow, as attributes of *its* greater reality. Later German artists will preserve this separation of cloth and face even as they describe each in an increasingly illusionistic style. In a print from the 1460s, the Master E. S. exploits the plastic potential of the engraved image to set a fully volumetric likeness of Christ undisturbed before a deeply folded cloth (fig. 52).[67] Christ's nimbus transcends the limits of the sudarium, and the gaze of the attendant angels, who are shown in profile and three-quarters, locates the face somewhere forward of the saint and her sudarium.

When Jan van Eyck depicts Christ's nimbus in the Berlin *Holy Face*, he is compelled to integrate it fully into the fabric of the represented world. The three rays of light issuing from Christ's head, the visible elements of a cruciform nimbus, are clusters of wrought gold filigree—real objects with a luster specific to their material and to their exact position relative to the portrait's light source. One has the sense that if Van Eyck's Christ were suddenly to turn and walk away from the picture, he would leave his nimbus behind as a fixed backdrop, or else we would glimpse some neat contraption whereby the halo was wired to his hair. Even the two letters below the rays at both sides of his head do not simply float in space; they appear to hang from the lower curl of the rays, as if attached by a thread too thin to see. Thus all aspects of Christ's likeness, even the letters *I* (= *initium*) and *F* (= *finis*) denoting Christ's infinity and therefore divinity, must be rendered in earthly terms.

All this does not mean that Netherlandish naturalism is incapable of depicting the *acheiropoetos* as a miraculous projection of Christ's face onto the two-dimensional surface of St. Veronica's cloth. In a panel from about 1432, attributed to Robert Campin (c. 1378–1444) and now in Frankfurt, an aged Veronica holds up a diaphanous veil imprinted with Christ's face (fig. 53).[68] Yet the relic's mystery is here subsumed by an even more amazing magic. The artist has displayed the sudarium parallel to the picture plane, its imprinted face rendered as if in low relief, while at the same time, through the miracle of his craft, he has allowed us to peer through its surface to the saint's luxurious garments. More astonishing than the likeness on Veronica's veil is Campin's likeness of this likeness. For as well as rendering both what is on and what is behind the veil, and as well as sustaining, as the Veronica Master had done, the distinction between the creased surface of the sudarium and the portrait face of Christ, Campin has made the materiality of his own image (oil on panel) wholly transparent to its object. Christ's face not only hovers before the veil, but with the saint and her world, it hovers absolutely behind the picture plane. However we choose to interpret this conceit, the image not made by human hands has here become an occasion for displaying and mythicizing the power of the human hand to conceal altogether its means and its labor.

When Jan van Eyck incarnates the *acheiropoetos* as a volumetric portrait likeness enclosed within an illusion of space, he does so at once to found the *vera icon*'s veracity on a new idea of pictorial truth and to fashion the Holy Face as the true icon of his own

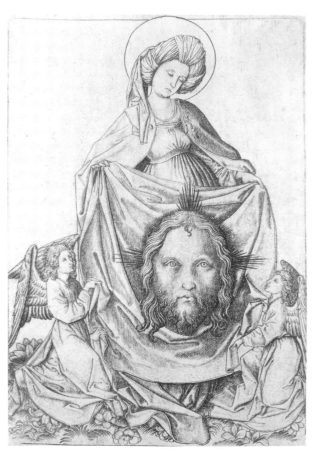

52. Master E. S., *St. Veronica with Sudarium and Angels*, c. 1467, engraving, Kupferstichkabinett, Staatliche Museen Preußischer Kulturbesitz, Berlin.

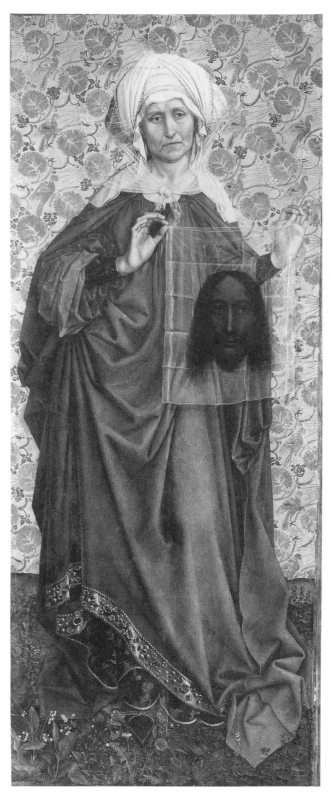

53. Robert Campin, *St. Veronica with Sudarium*, c. 1432, oil on panel, Städelsches Kunstinstitut, Frankfurt.

craft. That the Berlin *Holy Face* was originally meant as a version of the miraculous likeness imprinted on St. Veronica's cloth in St. Peter's is supported by the panel's immediate reception. In the background of the *Portrait of a Young Man* by Jan van Eyck's successor in Bruges, Petrus Christus, the miniature heading a text of the *Salve sancta facies* is a modified version of the Eyckian Christ portrait (fig. 39). More strikingly, in the *Llangattock Hours* of 1445, as well as in a Book of Hours of the same period made in Tournai, now at the Pierpont Morgan Library, an almost exact copy of Jan van Eyck's panel appears in miniature introducing prayers to the Veronica in Rome.[69] We have explored the myths that guaranteed the Roman relic's authenticity. According to the legend of the *non manufactum*, the likeness we see is not merely a perfect replica of Christ as he actually appeared. It also repeats, through its miraculous self-origination, its divine prototype's very mode of being: as something not made by human hands. But what about the tens of thousands of painted, printed, stamped, or sculpted images that claimed to replicate the *acheiropoetos* by Van Eyck's time? What guaranteed the veracity of these products of human labor and industry?

In the first two centuries of the *vera icon*'s proliferation in the West, artists made little effort to reproduce accurately the features of a "prototype." It was enough that the viewer recognize the image to be a Veronica for it to work the magic of the original. In the course of the fifteenth century, however, painters made new claims about the authenticity of their likenesses of Christ, forging analogies between the *non manufactum* of the icon and the miracle of their art. This was partly the consequence of a broader cultural interest in the facts of Christ's appearance.

The famous Lentulus letter attests to this attention.[70] This short Latin description of Christ, a product of monastic culture of about 1300, was originally intended as a meditative exercise in visualizing the Passion. In the early fifteenth century it was mistaken for (or rewritten as) a letter composed by Publius Lentulus, Pontius Pilate's predecessor as governor of Roman Judea. Humanistic scholars like Lorenzo Valla, attracted to the letter perhaps because of its emphasis on Christ's physical beauty, constructed optimistic provenances for the text. By Dürer's time the *Epistula Lentuli* was believed to be perfectly authentic and had helped establish Christ's physiognomy for artists working north and south of the Alps. Jan van Eyck's image of Christ agrees with the Lentulus description, as does, for that matter, Dürer's own likeness in Munich. Both show their sitter with hair

the color of ripe hazel-nut. It falls straight almost to the level of his ears; from there down it curls thickly and is rather more luxuriant, and this hangs down to his shoulders. In front his hair is parted into two, with the parting in the center in the Nazarene manner. His forehead is wide, smooth and serene, and his face is without wrinkles or any marks. It is graced by a slightly reddish tinge, a faint color. His nose and mouth are faultless. His beard is thick and like a young man's first beard, of the same color as his hair; it is not particularly long and is parted in the middle. His aspect is simple and mature. His eyes are brilliant, mobile, clear, splendid. . . . He is broad in chest and upstanding. . . . He is the most beautiful among the children of men.[71]

How do painted likenesses of Christ assert their message of "authenticity," however, aside from their adherence to the basic facts of his appearance as established by such texts as the Lentulus letter?

In the Veronica Master, authenticity is registered mostly in the formal beauty of his painted sudaria—their symmetry, regularity, grace, and purity of color, material, and proportion—for Christ was himself the most perfect of men, a being of archetypal beauty, *archetypia tou kallous,* as one Byzantine source puts it.[72] Christ's dark complexion, too, might be a gesture toward historical veracity, reflecting either the coloristic idiom of Eastern icons, or the supposed racial type of Christ,[73] or the effects of Palestine's sun, stressed by early thirteenth-century texts. Yet the truth value of the likeness here is finally dependent not on such principles of imitation, but rather on invoking and expressly articulating the *acheiropoetos* myth itself. The German *vera icon* captures the reality of the Holy Face by representing it precisely in an unreal manner. The outsize, disembodied head hovers over, but refuses to adhere to, the sweat cloth; and in this refusal of ordinary veracity it elevates the status of the painted panel itself to the level of a holy relic. The sanctity of the art object is made tangible through the lavish use of gold, while the work's status as "not made by human hands" is maintained by the anonymity of its producer. For it is not a coincidence that Cologne painters of the late Middle Ages remain largely nameless to posterity. Within the conservative aesthetic of this ecclesiastical center, every work of art has as its true maker not the individual artist but God, whose divine creativity the artist serves merely to mediate.[74] The German *vera icon's* truth works on principles of *theomimesis:* the *acheiropoetos* as self-portrait of God; art as a mirror of the divine.

But what of Dürer's more immediate prototype, the portrait panel of Christ by Jan van Eyck? As we have noted, Christ's physiognomy closely follows the Lentulus description, down to the particular brown of his hair and his rosy complexion.[75] And Van Eyck submits his likeness to a strict canon of proportion, so that it can embody that ideal of physical beauty that the *Epistula* attributes to Christ as "the most beautiful among the children of men" (fig. 54).[76] What is most astonishing about the *Holy Face,* however, is the way the artist's archaeological interest in Christ's specific appearance as historical individual gets transposed into a new idiom of pictorial veracity. Van Eyck does not reproduce the image-relic of Christ in Rome. By depicting Christ as a body in full space, and by integrating that body as part of a world fully homologous to our own, he claims to show us Christ himself as a living prototype. With this he transumes the entire tradition of Christian images before him.

Kurt Bauch wrote that all pictures by Jan van Eyck aspire to the condition of portraiture. Through his art "even the holy personages appear largely portraitlike."[77] This is especially true of his *Holy Face,* for in it he produces a picture of Christ virtually identical in format and style to his portraits of contemporary burghers of Bruges. We are meant to feel as if we encounter Christ as a real, fleshly, and specific person in the here and now of our experience, unmediated by any "image." That Van Eyck takes for his model not the *vera icon* but its prototype is only a consequence of the artist's working procedure, which is always to conceal any signs that what we see is paint applied manually to panel.

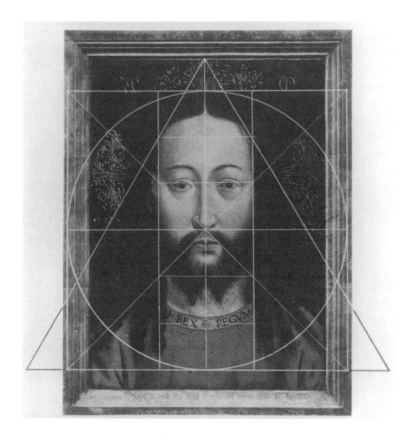

54. Jan van Eyck, *Holy Face*, Berlin, with system of proportions (after Winzinger).

For this procedure to be effective, there must be a mechanism for negotiating the transition from the visual image to things around it. In Van Eyck it is the picture frame that constitutes that horizon between work and world, being the last object the eye sees before passing into the *illusion* of objects. That is one reason he frequently hypostatizes the materiality of his frame, painting false finishes on its surfaces, fashioning illusionistic inscriptions that appear to be cut into its very substance, echoing its form through false frames within the image proper, and sometimes marbleizing the rear of the picture panel.[78] Whereas in the painting proper Van Eyck conceals the materiality of his medium and makes paint on panel disappear into the objects it represents, in the panel's boundaries and back, those hybrid zones that are at once inside and outside the work (zones Immanuel Kant will theorize as the *parergon*),[79] he celebrates the materiality of the thing he paints on. But he does so only by transforming it into *his* own terms, by refiguring all the objects we see in and around the work into illusory supports for other painted objects.

To discern fully the divide between the Berlin *Holy Face* and the Veronica Master's London *Sudarium*, we need only fix our gaze on the *parergon*, here the lower framing edges. In the London panel the edge coincides with the bottom border of the sweat cloth itself, so that the picture plane can read as coextensive with the surface of the sudarium.

The Holy Face, hovering "before" this surface, is thus projected into our space as a ghostly apparition. In Van Eyck the lower edge is a barrier rising up between ourselves and the sitter's flesh. Not quite outside the work, because pressed right up against the work, it conveys an interim of space before the sitter, therefore guaranteeing the spatiality of the body of Christ. This fictional gap, impossible not to see, erases the materiality of the painted image and installs in its place the fiction of a self-contained totality behind the picture plane. The German *vera icon* sought to break down the closure of the images, projecting the miraculous face of Christ into our midst and consecrating the material surface of the panel through the sanctity of the subject. Van Eyck, on the other hand, institutes boundaries around his image, at once accrediting and negotiating a series of oppositions that will command the northern pictorial tradition as well as the very concept of the "work of art": inside and outside, work and world, content and container, signified and signifier.[80]

Once freed from its material support, the image is experienced as an autonomous reality, in which Van Eyck can establish a new *acheiropoetos*. It is new because it can capture the prototype himself, fashioning him to appear as if in the present; and it is an *acheiropoetos* because the disappearance of the picture plane also conceals the signs of painterly manufacture. The myth of an image "not made by human hands" serves here to articulate an idea of the quasi-divine powers of the individual artist. It is therefore appropriate that on the surface of the lower frame, at that horizon between the world of things and the work of art, there should appear the name of the artist himself: "Johes de eyck me fecit et apleviit anno 1438, 31 January," and to the left his famous motto, written in Greek letters: "ΑΛΣ·ΙΧΗ·ΧΑΝ" (*als ikh kan*, "as I can"). The formula is not original to Jan van Eyck, nor is it, within his oeuvre, unique to the *Holy Face*. Already in the early thirteenth century, certain artists of central Italy were labeling cross-shaped crucifixes with their own names followed by the phrase *me fecit*, although the practice had no northern imitators before Van Eyck.[81] And though at least ten of Van Eyck's extant panels are outfitted with a version of this formula, his contemporaries and followers did not take up the practice, and one must wait until Albrecht Dürer to find another northern master as obsessed with signatures and other signs of authorship. What interests us here, however, is not Van Eyck's place in the history of artists' signatures, but how, through the agency of the signature, he transforms the meaning of the Holy Face. For by fashioning the picture to say of itself, "Johannes van Eyck made and completed me on January 31, 1438," the artist overturns the traditional account of the *acheiropoetos*'s magical origins.

The anonymity of medieval artists was at least in part a function of the Christian theology of images.[82] As we have seen, the production of icons of Christ was founded in, and legitimated by, the doctrine of the Incarnation: "without human hands" God was made man. If Scripture maintained that idols were "the work of men's hands" (Ps. 115:4) and that "all things were made by him; and without him was not any thing made that was made" (John 1:3), then artists were advised to efface the fact of their artistry or to couch their activity in modesty formulas and protestations of incapacity.[83] The *acheiropoetos* in St. Peter's simply offered a controlling narrative for what was true of all pictures of

Christ, that they should at once reflect the fact of his Incarnation and attribute their ultimate authorship to God. It would be contradictory to the message of the Veronica Master's *Sudarium* for his name to appear within the visual field, since the work's power and authenticity derived from its mythic link to Christ, the creator of the *acheiropoetos* itself. In Van Eyck, the source of the image's authority has changed radically. Instead of evoking a mythic origin in the most distant past, the Berlin *Holy Face* asserts that it was produced, like ordinary portraits, at a precise moment in recent historical time. The very precision of this date of completion—31 January 1438—hyperbolizes the new magic of purely human creation, which can boast of producing such a detailed panel in a single day. And instead of founding its veracity upon a fiction of divine authorship, Van Eyck's signature asserts that pictorial accuracy is based on the skill and knowledge of the individual human creator.

This attitude of self-assertion becomes clearest in the artist's motto and its format. At one level, *als ikh kan* belongs to the repertoire of medieval modesty formulas, in which the person of an artist, poet, copyist, or amender enters the work only within an apology for the work's imperfections.[84] In the colophons of corrected manuscripts we often find the phrase *ut potui (non sicut volui)*,[85] which is a rhetorical antecedent to Van Eyck's *als ikh kan*. Yet within the ambitious project of a new *vera icon* of Christ, authenticated by artistic skill, the motto reads rather differently. *Kan*, here, comes from the Gothic and Middle Dutch *kunnen*, "to know" and is related to the German *kunst*, "art." The "I" and its powers dominate the inscription, transforming the panel from a portrait of Christ to a demonstration of Jan van Eyck's personal knowledge and skill. Moreover, the artist's particular choice of Greek letters, his preference for the chi (X) over the equally functional kappa (K) in rendering the words *ikh* and *kan* (which we, in turn, could transpose into the terms "self" and "art"), suggests a self-conscious imitation of the monogram of Christ—IHC XPC or simply IC XC—such as appears on Byzantine icons of the Holy Face.[86] The portrait itself has its own fair share of Christological initials (alpha and omega, *I* and *F*) that document the artist's awareness of such monograms. Now in the Eastern icon, the abbreviated name of the represented holy person was much more than a label. It referred to the magical bond between the image and its prototype by being the very *logos* that commands the world of appearances. Monograms guaranteed the authenticity and therefore power of the image by linking it to its sacred source and referent. The event of their inscription on the icon was a sacral occasion.[87]

Van Eyck's inscriptions below the *Holy Face* panel perform an analogous function. They too link picture to person, although this time not to Christ, but to his representer, the artist Jan van Eyck. Instead of guaranteeing the relation of icon to prototype, they forge an indissoluble link between the artistic self and his works. That Van Eyck's "I" (IXH) is analogized with his subject Christ (XC) only strengthens this. It repeats the analogy between self and God present in Van Eyck's revision of the *acheiropoetos* itself. Instead of a miraculous self-portrait of Christ we have an image produced by one man in history (hence the panel's insistence on date), an image that, however, through the magic of the artist's *kunnen* appears to be "made without human hands."[88]

We are nearing Dürer's Christomorphic *Self-Portrait* of 1500, in which the image of the artist himself is fashioned after the *acheiropoetos* of Christ. Note that in addition to his novel practice of inscribing the fact of his authorship on all of his works, sacred or profane, Jan van Eyck also seems to have produced several self-portraits. The *Man in a Turban* from 1433, now in London, is usually regarded as self-portrait and is outfitted with a monumental version of the artist's motto at the top of the frame (fig. 55);[89] in his *Arnolfini Marriage Portrait* (1434) in London, his *Madonna of Canon George van der Paele* (c. 1436) in Bruges,[90] and his *Ghent Altarpiece*, Jan van Eyck's likeness appears reflected on surfaces within the painted world; and in the *Madonna of Chancellor Rolin*, the turned figure of a red-turbaned man in the middle ground may be a self-portrait. Thus Van Eyck already engages the terms of Dürer's analogy in the Munich panel.

And these terms are also current in the pictorial culture out of which the Netherlandish painter fashioned his Berlin *Holy Face*. In his monumental exhibition catalog *Die Parler und der Schöne Stil*, Anton Legner analyzed a complex pattern of responses by northern artists at 1400 to Eastern icons.[91] Under the powerful rule of Emperor Charles IV of the house of Luxembourg, the court city of Prague, which traditionally had been oriented toward Constantinople, became an important conduit to the West for Byzantine art—in particular, to the courts of Charles V of France and his brothers the dukes of Berry and Burgundy. Eastern icons were not simply absorbed or copied by the northern painters; they gave rise to hybrid forms, in which the elevated and historically distanced icon would be juxtaposed to, or installed within, pictures fashioned in the new naturalistic idiom of the North. One expression of this, according to Legner, is the devotional diptych. Here the donor and the object of his or her devotion are portrayed not only in separate panels, but also in different pictorial styles. The holy figure, often rendered in a deliberately archaic manner, is both a person and an icon of a person; devotion to it is simultaneously to its image and to its prototype.[92] In the "Bronnbach Stone," a wall epitaph dating from about 1350 and now in the Liebieghaus in Frankfurt, we can observe an early version of this logic (fig. 56). A deceased couple kneels above their grave, praying to a sudarium held between them by an angel. The Holy Face, smaller in scale than the two portrait likenesses, is thus depicted together with the act of its veneration. This new combination of the *acheiropoetos* with its reception at once elevates the individual sitters to a higher sphere, where the sacred is fully present to them as a vision, and humanizes the relics as object of a piety enacted in the present. As viewers we in turn are confronted not with the presence of Christ, but with an exemplary scene of personal devotion: a self's *response* to the *acheiropoetos*.[93] Thus Dürer's *Self-Portrait* is in part simply an idiosyncratic expression of the desire, central to northern art by 1500, to combine the sacred icon with the subjective moment of its reception in a single image. The juxtapositions of narrative event and affective response as objects of equal pictorial attention (as in Rogier van der Weyden's Philadelphia diptych *Crucifixion with the Virgin and Child*) or the synthesis of cult image with individual portrait likeness within a unified domestic space (as in many of Jan van Eyck's Marian panels or, most powerfully, in a work like Hans Memling's

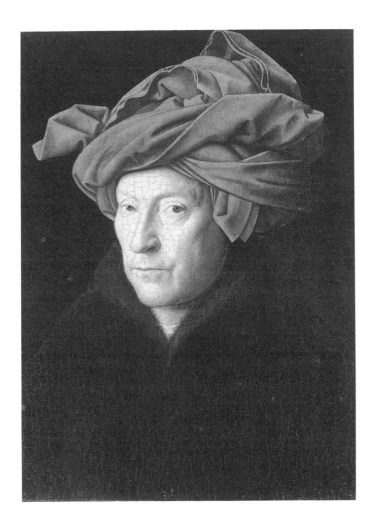

55. Jan van Eyck, *Man in a Turban*,
 1433, oil on panel,
 National Gallery, London.

Diptych of Martin Nieuwenhove, now in Bruges) prepare the way for Dürer's conceit of placing his own portrait in the format of a private devotional image.[94]

It is not coincidental that in the period of the devotional diptych we begin to find depictions of the human production of holy icons. In an illustration from a French manuscript of Boccaccio's *De mulieribus claris*, completed by 1404, the legendary Roman painter Irene appears fashioning a diptych with the Holy Face (fig. 57).[95] We can observe her working procedure, how she mixes her paints on a hand-held palette and applies them to the icon. Yet the focus of the image is less on the particularities of a painter's practice than on an interplay staged within the miniature itself, between the Roman painter's beautiful portrait of Christ and the French miniaturist's delicate likeness of Irene herself. Irene's production of the Holy Face appears here as an act of devotion, in which she envisions the God within herself in order to present it to her audience.[96] The icon, no longer *non manufactum*, is installed in the earthly setting of a painter's shop and impli-

cated in the temporal process of its own production, as a personal statement of belief. When compared with this illumination from 1404, Jan van Eyck's signed and dated portrait panel of Christ no longer seems quite so strange.

Another manuscript of *De mulieribus claris* from the same period and by the same shop shows the painter Marcia at work on a self-portrait (fig. 58).[97] Even more than in the *Irene* illumination, the entire process of artistic creation is assembled for the viewer. Brushes, palette, and paints in various jars and seashells lie around the painter as she studies her likeness in a tiny oval mirror (Boccaccio calls it, appropriately, Marcia's *consiglio*),[98] while with her right hand she places the final strokes on her life-size self-portrait. All three images of Marcia—her reflection in the mirror, her painted self-portrait, and Marcia herself—are rendered by the French miniaturist in the same naturalistic manner. Reflection, portrait, and person become interchangeable, and it is possible to mistake the scene for a skewed image of a woman at her toilet, applying cosmetics to her face, not colors to a panel. Taken as a whole, the illumination celebrates the magic of portraiture or, more accurately, self-portraiture exemplifies the powers of art and of human making. And since

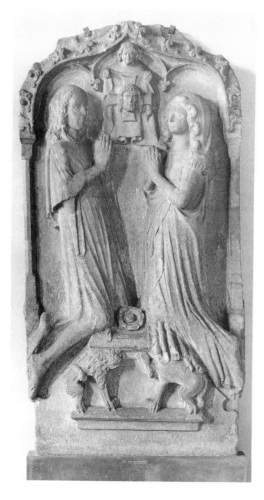

56. *Deceased Couple Praying to Vera Icon* "Bronnbach Stone"), c. 1350, wall monument in gray sandstone, Liebieghaus, Frankfurt.

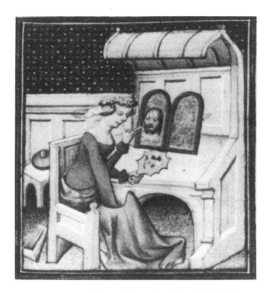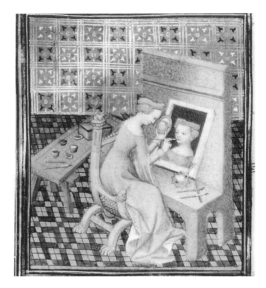

57. *Irene Painting a Diptych with the Holy Face,* 1404, miniature from *Des cleres et nobles femmes,* Paris, Bibliothèque Nationale, Fr. 598, fol. 92.

58. Coronation Master (?), *Marcia Painting Her Self-Portrait,* 1403, miniature from *Des cleres et nobles femmes,* Paris, Bibliothèque Nationale, Fr. 12420, fol. 101ᵛ.

the scene of *Marcia Painting Her Self-Portrait* appears in the same manuscript with similarly arranged scenes of *Irene Polychroming a "Beautiful Madonna"* (fol. 92ᵛ), *Thamyris Painting a Virgin and Child* (fol. 86), and in the slightly later Boccaccio manuscript, *Irene Painting a Diptych with the Holy Face* (fig. 57), self-portraiture stands in direct analogy to iconography. We shall examine later a theology that underwrites the link between icon and self. At this point it is enough to say that, within the visual culture of French illuminators around 1400 (a culture that exerted enormous influence on Jan van Eyck), the *acheiropoetos* has been humanized as a production of artisanal labor, and the self-portrait finds a place within the traditional repertoire of cultic images.[99]

What is it about self-portraiture that makes it exemplary of human labor? In Van Eyck, and even more clearly in Dürer, it emerges within a more general practice of the artist's signaling his authorship within the work of art. When Van Eyck inscribes his name at the base of the Berlin *Holy Face* and dates the work to a moment in his own bodily life, he constructs an interpretative perspective from which everything we see—the frame, the image, indeed the represented body of Christ himself—appears to some degree "Jan van Eyck." Modifying Paul de Man's account of autobiography, one could say that the specular relation between the artist and his image in self-portraiture is already implied, to some degree, in any work that posits itself as having a human maker. Self-portraiture merely renders explicit the wider claim to authorship that takes place whenever an image "is stated to be *by* someone and assumed to be understandable to the extent that this is the case."[100] Dürer's 1500 panel and, indeed, all his late self-portraits have as part of

their function making visible, once and for all, the fact of authorship that the artist signals throughout his oeuvre, in all his monograms, signatures, and inscriptions. Self-portraiture belongs to Dürer's more general aesthetics, which locates the value and meaning of a work of art in the way it manifests the style, talent, and body of the particular artist. And it supports his new business practices as a producer, who will be paid according to his inimitable authorship rather than the labor he expends.

Dürer visualizes this link between self-portraiture and signature in four important religious paintings produced between 1506 and 1511.[101] In these panels the artist depicts himself with a narrative scene, supporting an inscription with his name and the panel's date. Examples of artists portraying themselves as participants in, or observers of, a sacred drama are common in Italy in the fifteenth century and occur, as well, in contemporary German and Netherlandish paintings.[102] Besides registering authorship, these self-portraits *in assistenza* can articulate an artist's corporate identity (his allegiance to family, church, confraternity, guild, or patron), becoming therefore scarcely indistinguishable from donor portraits. In his great religious paintings, Dürer isolates and privileges his portrait likeness in a unique way, combining what in Italian painting appear as alternative sites of artistic self-denomination: self-portrait likeness and inscribed tablet or *cartellino*.[103]

In the last work with this double device, the Vienna *Adoration of the Holy Trinity*, commissioned by Matthäus Landauer for an All Saints chapel of a refuge for old artisans in Nuremberg and completed in 1511, Dürer and his tablet of authorship appear at the lower right of the painting (fig. 59). Far more radically than Jan van Eyck in his *Holy Face* inscription, the artist frames the image with signs of his person, linking the sacred subject to the agency of human art. Dürer stands at the edge of two worlds, or of two models of the world. To the left, the earth is represented in a vast panorama of landscape, city, and sea stretching to the horizon—a *bas-de-page* for the painting's central vision of God. And above, the cosmos is a sphere inscribed in the All Saints scene, its upper surface being the panel's arched top, its lower surface the landscape's flanking hills, and its equator the curved line shaped by the heads of the assembled saints in the Adoration's lower register. Friderike Klauner has argued convincingly that the place occupied by Dürer's self-portrait has special valences in medieval diagrams of the cosmos.[104] In a woodcut from Hartmann Schedel's 1493 *Nuremberg Chronicle* (a book Dürer may have helped illustrate), the hand of God appears in the upper left of a scene of Creation (fig. 75). The terrestrial world (again, a landscape bisected by a waterway) emerges in the central circle upside down, placing God's hand at the landscape's lower left. Perhaps closer to Dürer's self-portraits *in assistenza* are images of visionaries to whom the world's mystery appears unlocked. In an illumination from a twelfth-century codex of Hildegard of Bingen's *Liber divinorum operum*, the author sits in the lower-right corner of a vision of "Cosmic Christ" (fig. 60).[105] Circumscribed by concentric spheres, Hildegard's Adam-Christ is a perfectly proportioned Vitruvian man, in whom God perfects his creation (*omnia opera sua perfecit*).[106] Dürer constructs a similarly idealized Christ in the *Landauer Altarpiece*'s "Throne of Mercy," implying that perfection appears both in Christ and in Dürer's painting of Christ. That is

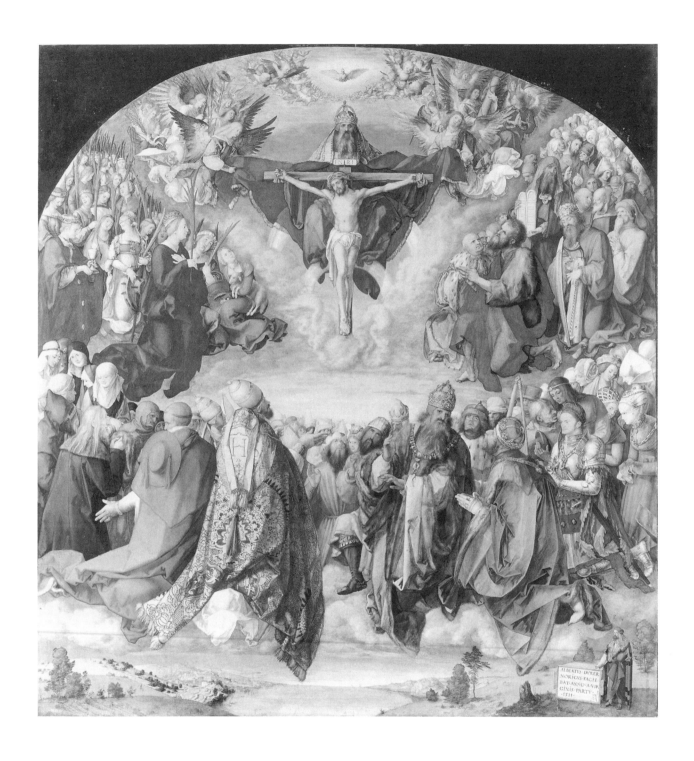

59. Albrecht Dürer, *Adoration of the Holy Trinity* ("*Landauer Altarpiece*"), 1511, oil on panel, Kunsthistorisches Museum, Vienna.

one reason the artist can occupy a position in the cosmos reserved for inspired seers or divine creators.

Dürer's self-portraits *in assistenza* clearly idealize authorship. What remains to be seen is exactly why, at 1500, this artist modeled his most monumental self-portrait, and therefore his most ambitious account of artistic making, after an image alleged not really to have been "made" at all. Jan van Eyck's transformation of the *acheiropoetos,* Dürer's closest antecedent, suggested that art could be placed in analogy to (or even in competition with) Christ's miraculous self-portraiture. And Legner's account of the interplay between icon and portrait at 1400 provides a broader context for this analogy. The influx of Byzantine icons into a visual culture increasingly concerned with pictorial veracity occasioned new, hybrid models of authenticity. But what of Dürer? Whence came this interest in the *acheiropoetos?* And why did he choose as his specific model its Eyckian incarnation?

In Germany at the eve of the Reformation there arose a renewed interest in both the style and the symbolism of Byzantine icons.[107] A famous example of this is the develop-

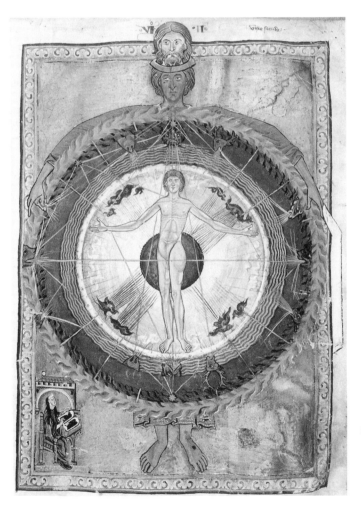

60. *Cosmic Man,* illustration from Hildegard of Bingen's *Liber divinorum operum,* c. 1160, Lucca, Biblioteca Governativa di Lucca, Cod. lat. 1942.

61. Hans Holbein the Elder, *Virgin and Child*, 1493, oil on panel, Pfarrkirche, Bad Oberdorf.

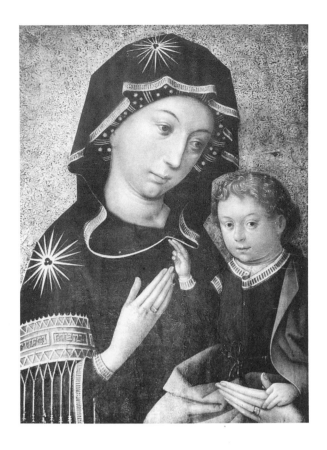

ment of the so-called *Lukasmadonna.* This popular iconographic type, known in numerous southern German paintings, sculptures, and woodcuts from about 1500, was modeled after what was believed to be an authentic portrait of the Virgin executed by St. Luke.[108] A panel from 1493 by Hans Holbein the Elder is the earliest German example of this new, self-consciously Byzantinizing image (fig. 61). St. Luke painting the Virgin was a common subject in fifteenth-century northern art. Before Holbein, however, painters of this primal scene of iconography neither modified their pictorial style nor introduced into their art any willfully foreign elements that would code their vision as particularly ancient. Indeed, the veracity of their pictures rested primarily in their resemblance to ordinary, contemporary reality. In paintings by Rogier van der Weyden, Derik Baegert, and the Master of the Holy Blood, for example, St. Luke paints the Virgin as any northern artist of the fifteenth century would paint any woman. Holbein's Virgin, on the other hand, wears a special fringed and starred paenula or *maphorion* found only in Eastern and Italo-Byzantine icons of the type known as the "Hodigitria-Psychosostria." She lies somewhere between a loose copy of a venerable icon-relic and a quasi-archaeological reconstruction of the original appearance of the Virgin.[109] In a number of statues of the *Lukasmadonna* by the sculptor Hans Leinberger, this exotic garb is coupled with archaizing treatments of drapery and of the Virgin's physiognomy.[110]

The new interest in discovering, replicating, and imitating ancient and therefore more "authentic" images was not limited to pictures of the Virgin. The proliferation of manuscript and printed versions of the Lentulus letter around 1500, especially among humanists in Augsburg and Nuremberg, attests to a lively concern with Christ's true physical appearance. Dürer's closest friend Willibald Pirckheimer possessed a complete manuscript copy of the letter, which he kept in his library until his death.[111] In 1491 the *Epistula* was published in a Nuremberg edition of the works of Anselm of Canterbury, printed on the press of Johannes Löffelholz.[112] In 1500 Pope Alexander sent a lavish illuminated text of the Lentulus letter to Dürer's patron, Frederick the Wise of Saxony;[113] in the same year the printer Erhart Rotdolt published a full German translation on his Augsburg press; and in 1511 the humanist press of Johannes Weissenburger in Nuremberg reprinted this translation as part of a schoolbook and included a woodcut *vera icon* of Christ in profile by Hans Burgkmair (fig. 62).[114] The text gained such authority that it was even appended to certain Latin manuscripts of the Gospel.[115] Its appeal was at least twofold. It supported the humanists' celebration of man's physical perfection (the 1500 Augsburg translation concludes that Christ was "the most beautifully constructed [*allerwolgestaltigst*] of all sons of men"); and it satisfied a new, almost evangelical desire to renew the Christian faith by returning to original sources (the Hebrew and Greek Bible, the texts of the early Fathers, etc.). Regina Dölling writes of the German fascination with the *vera icon:* "Perhaps it represents, in the visual arts, a search for authenticity similar to Luther's spiritual struggle for the pure Word of Scripture, and for a human posture and devotion to God that is free of regimentation and intermediaries."[116]

One fascinating instance of this evangelical interest in the authentic portrait of Christ is a broadsheet by Lucas Cranach the Younger entitled *The Form of the Body of Our Lord Jesus,* published in Wittenberg in 1553 (fig. 63).[117] Accompanying the woodcut portrait is a text by a certain Nicephorus, a preacher from Constantinople, describing Jesus' physical appearance in detail. Nicephorus's authority rested on his familiarity with Eastern icons claiming to have been made during Christ's lifetime, while the attention, in Wittenberg, to an exiled Byzantine preacher probably reflects the tentative alliance, proposed first by Melanchthon, between the reformed faith and the Eastern church against their common Roman enemy.[118] What commentators on the broadsheet have generally overlooked, however, is that the portrait of Christ is neither an imitation of a Byzantine icon nor a free rendition after Nicephorus, but rather a close copy of a panel by the itinerant Italian painter Jacopo de' Barbari (fig. 64). Jacopo's *Blessing Christ,* now in Dresden, was produced in Wittenberg in 1503 and was originally owned by Cranach the Elder.[119] In its thin application of paint and its virtuoso treatment of Christ's hair and beard, the panel is clearly indebted to Dürer, whom Jacopo visited in Nuremberg about 1500.[120] It is even possible that this portrait, registering authenticity through the Hebrew letters on Christ's garments and believed, by 1553, to be a historical document of Christ's true appearance, originated as a response to Dürer's 1500 *Self-Portrait.* It was through Jacopo, I would note, that Dürer first became acquainted with an antique canon of human proportions, which led to his lifelong preoccupation with the question of beauty. Whether or not it is directly

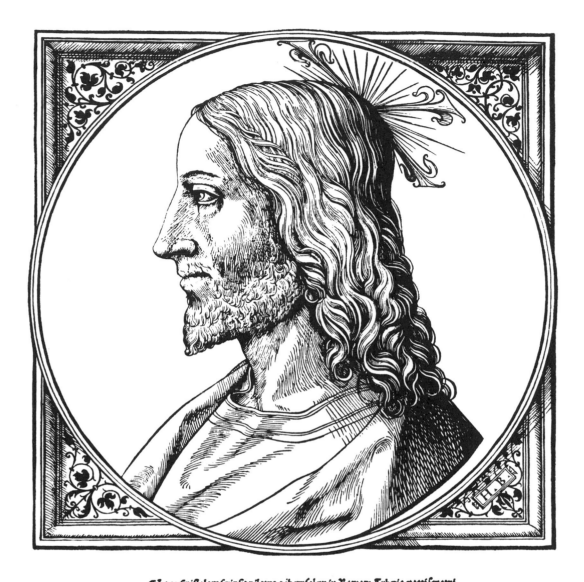

¶Hane Epistolam scripsit pilatus a jherusalem in Remam Tyberio et toti senatui

Pparuit temporibus nostris et ad huc est Homo magne virtutis: cui nomen est cristus jesus: suscitans mortuos: et sanans langnores: Qui dicitur propheta veritatis: quem discipuli eius vocant filium dei: Homo quidé statura procerus et spectabilis: vultum habens venerabilem .quem intuentes possunt diligere et formidare: capillos habens coloris nucis auela ne premature planos vere vsqʒ ad aures: ab auribus vero crispos aliquantū et ceruliores et fulgentiores ab humeris ventilantes: discrimen habene iī medio capitis iuxta morem nazarenéium: faciem habens sine ruga aliqua et macula: quā rubor moderate venustat.nasi et oris nulla precisus est reprehensio: oculis rariis glancis et claris eī istiti ue Barbā habens copiosam et nen longam: saliicet capillis concoloré et impuberem sed in medio bifurcata manus habens et brachia visu delectabilia in emvpatiene terribilis. in ammonitione placidus et amabilis: hylaris serua ta granitæqui nuquā visus est ridere: flere autem: Siein celle quio tatue et medesius. speciosus inter filios hominum:

¶Disen brieff vnd Epestel schraib pilatus võ Jherusalem gen Rom dé kaiser tiberio vnd gemaincklichen den eltisten senatoribus vñ der ganzé maiserschaffi des rumischen velcks

zū vnsern zeiten erschinen vñ noch ist am mensch grosser tugent der gemeuet ist Christus Jesus: erkuckē die toten vñ hailmachend die kranckhait; der di gehaissen witt ain prophet der warhait: welche seine jungern ı enen gottes sun: Nempt war ain mensch langer masse vnd gar lieplich emon zūsehen haben ain eerwirdiges angesicht: welches die: die es ansehen lieb habē miigen vnd furd ten: har habent varb ainer überzeitigen haselnus: rund sd led nahend bis auff die oin: aber von den oin kruaß ains tails: vnd gelbleter vñ liachter bis auff die achseln sich wendent: habend ain sd aitel iı mittel de haubts nach gewonhait der nazareischen: habent ain angesicht en ainicherlay runzel vñ mackel welchs ain māssige rete gesiert: der nasen vnnd iı iı des ist genzlich kain vngestalt: mit gezierten augen praunen vñ klarem wesend habend ainen dicken part vndtt lang den haubtes haren gleich ger a jūnglich Egestalt vñ zwyfilatenhend vnd arm habend lieplich an zūsehen: in derstraff erschreckenlich é: in der vern ai ur g geufllig vñ lieplich: It ı ıc doch mit behaltung der tapffrhait: der nye gesehen ist lachen: besunder tr ainen: im gespiach seltzam vnd māssiger: vnd der aller rrelgestaltigst ı ı ıwdi den sūnen der menschen

¶Dise h , e vnden getruckte linie zū ro : n ален gemessen ist die leng rpi jhesit:

62. Hans Burgkmair, *Profile of Holy Face,* woodcut illustration to "Lentulus Letter" (Nuremberg: Johannes Weißenburger, 1511).

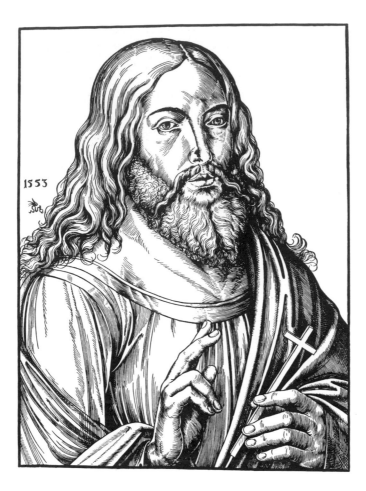

related to the Munich *Self-Portrait,* Jacopo's *Blessing Christ* does suggest that, at 1500, authentic portraits of Christ were of interest to painters working in Germany and that this interest was bound up for them with the Renaissance aesthetics of the beautiful.

Of course, such things are familiar to us from our encounter with Jan van Eyck's *Holy Face.* This is partly because Dürer fashions his *Self-Portrait* as retrospective toward two kinds of images: on the one hand, the *vera icon* itself, with its myths of miraculous representation, its cultic resonance, and its privileged place in German painting of an earlier era; on the other hand, the *vera icon*'s reincarnation as portrait likeness through the new veristic idiom of early Netherlandish painting. Dürer could have known Jan van Eyck's *Holy Face* composition either from a possible visit to the Lowlands during his travels as journeyman[121] or from versions of the Eyckian type that had reached Germany. A drawing by the Colmar artist Martin Schongauer, whose shop Dürer visited in the year following the master's death in 1491, documents the reception of the Netherlandish Holy Face in the upper Rhine (fig. 65). Schongauer's half-length portrait includes Christ's blessing hand and thus lies closer to Dürer's *Self-Portrait* than to Van Eyck's *Holy Face.* The drawing

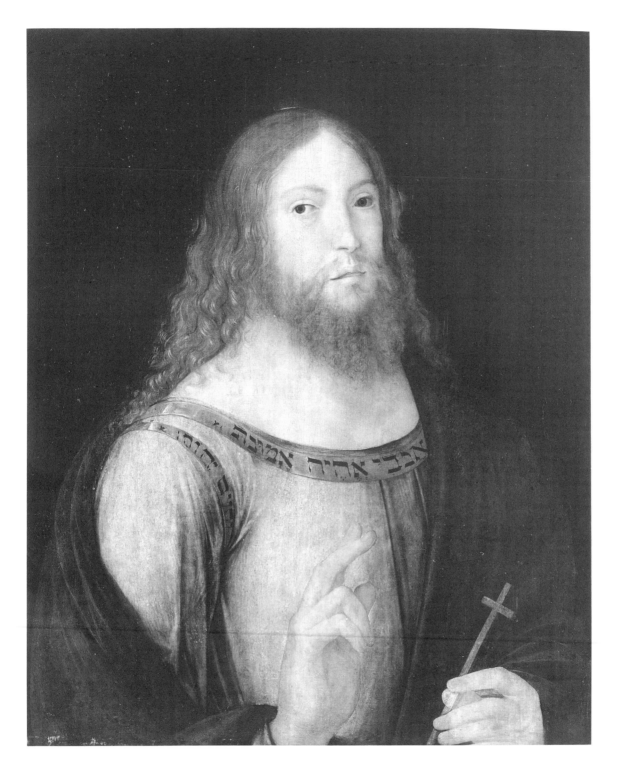

64. Jacopo de' Barbari, *Blessing Christ*, 1503, oil on panel transferred to canvas, Staatliche Kunstsammlungen, Gemäldegalerie, Dresden.

is probably based on a composition by Rogier van der Weyden, known to us from various Flemish and Rhenish copies.[122] The closest extant example by Rogier is the central figure of the Blessing Christ in the Louvre *Altarpiece of Jehan Braque* (c. 1450; fig. 66). Otto Pächt argued that the addition of hands to the Eyckian *Schulterbrüste* reflects the assimilation of another Eastern icon type to the northern Holy Face—an assimilation that Jan van Eyck characteristically avoids.[123] A more plausible source for Rogier's Blessing Christ, however, would be a portrait type, current in Italy since the early fourteenth century, that includes a sitter's hands, sometimes in a gesture of benediction.[124]

It is not of great importance whether Dürer's 1500 *Self-Portrait* relies specifically on an Eyckian panel or on one by Rogier or by Schongauer. It is in Jan van Eyck that the portrait likeness of Christ achieves its most original expression and is combined with a new inscription of authorship similar to Dürer's. To reiterate, Van Eyck already transformed the

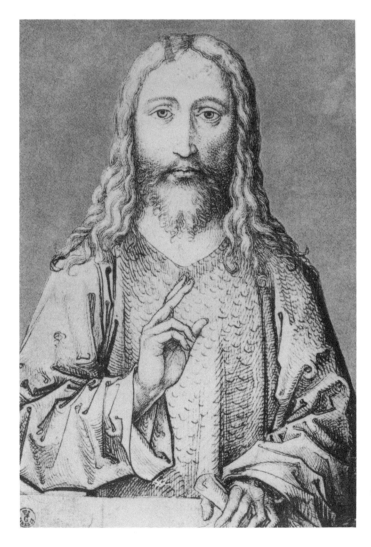

65. Martin Schongauer, *Blessing Christ*, c. 1467, pen and ink, Uffizi, Florence.

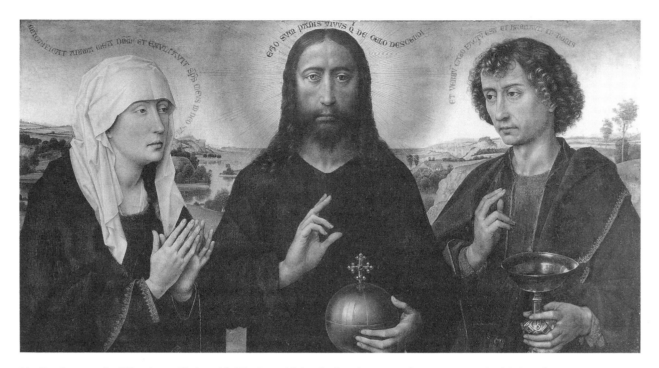

66. Rogier van der Weyden, *Christ with Virgin and John the Baptist*, central interior panel of *Triptych Epitaph for Jehan Braque*, c. 1452, oil on panel, Louvre, Paris.

cult image, whose authority rested in its miraculous origins in sacred time, into the new idiom of portraiture, whose authority rested more in its mimetic accuracy and its human origins in historical time. Dürer's *Self-Portrait* is simply a logical conclusion of the Eyckian project. Where the Netherlandish artist only exemplified his personal skill in painting Christ's face, Dürer also projects his own person into that painting.

In constructing this narrative, we easily lose sight of the distance separating Van Eyck from Dürer. It is true that the Flemish painter includes his own likeness in certain of his works, and that he inscribes his frames with signatures, mottoes, and devices. Yet these representations of self remain peripheral to the work of art itself, occurring either outside the panel, on surfaces separating work from world, or else as reflections of the artist's body cast from this side of the painted image on certain shiny objects beyond: a mirror behind Giovanni Arnolfini and Giovanna Cenami (fig. 25) or the armor of St. George behind Canon van der Paele. Far from making the artist the subject of his art, these anamorphic self-portraits subsume the self under a technique of total representation from which there is no escape. By including the artist *in* his work, they deprivilege his central place *before* the work. For in their curved and happenstance surfaces, these reflections undermine the absolute fixity of the artist's, and by extension the viewer's, seeing eye.[125] The centrality of the self-portrait *in assistenza* in, say, Dürer's *Martyrdom of the Ten Thousand* (fig. 67), is simply unimaginable in Jan van Eyck, as is, finally, the conceit of trans-

forming the sacred center of religious imagery, the Holy Face, into an image of the artist. The continuum we have constructed, from the *vera icon* to Van Eyck to Dürer, is less an extension of the logic of fifteenth-century Netherlandish painting than the teleology of a northern tradition that Dürer has consciously fashioned. The 1500 *Self-Portrait* enacts a kind of Copernican revolution of the image, where what was peripheral in painting becomes central. Yet by invoking the *vera icon* and its Eyckian revision, Dürer also links his art to a past whose logic and trajectory he himself will define. As interpreters, we must at once recover the prehistory that Dürer's likeness fashions for itself and gauge the scope of the self-portrait's modernity.

The retrospective quality of the Munich *Self-Portrait*, the claim it makes to a distinguished artistic and cultic pedigree, is not unique to Dürer in this period. What Panofsky and others term "archaism of about 1500" characterizes much of the art of Flemish masters like Gerard David, Quentin Massys, Jan Gossaert, and Joos van Cleve.[126] It is evinced both in copies after Van Eyck, Rogier, and Campin made by major northern masters of the first decade of the sixteenth century and in numerous archaizing reconstructions of earlier Flemish masterpieces. The panels after Jan van Eyck's Berlin *Madonna in the Church* of about 1438 (itself a creative reformulation of fourteenth-century Marian cult statues) by Gossaert and the Bruges Master of 1499 are but two examples of this complex mixture of imitation and emulation.[127] For if at 1420 to 1440 ambitious northern artists invoked and rephrased certain ancient and miraculous cult images still efficacious in their culture, by 1500 artists turned to the generation of 1420 for examples of authority and visionary power, with the result that Jan van Eyck's paintings, and not merely their sacred subjects, become the object of a new kind of veneration.

In Germany this retrospective tendency is apparent in the dominant artistic genre: the retable altarpiece. As Bernhard Decker has demonstrated in his remarkable study of the late medieval cult image, religious sculpture in Germany after 1500 often tries to invoke not simply the personages of sacred narrative, but also a sacral *style* of representation. This style it finds in the recent past of its tradition: the "soft style" sculptures from about 1420–1440.[128] Decker argues that this archaism, which includes both the imitation of an earlier style and the integration of actual older cult statues into new ensembles, is radically different from both the Renaissance revival of antiquity and the invocation of Eastern icons by fourteenth- and fifteenth-century Western artists. For in imitating works produced less than a century before, German art at 1500 evinces a consciousness of its own comparatively *recent* history, preparing the way for a new, distinctly modern cultification of art and its tradition. Dürer, working always outside the dominant genre of the retable altarpiece, finds an alternative tradition in Netherlandish painting, which can function as a more appropriate locus of self-definition. What is important here is that Dürer's *Self-Portrait* appears at a moment when the German pictorial tradition generally begins to think of itself as a tradition, and therefore as something with a history.

It is not surprising that the first history of art written in Germany should date to the decade of Dürer's *Self-Portrait*. In the *Book of Famous Painters*, dated 1505 and addressed to an illuminator named Sister Gertrude of the Benedictine convent of Nonnenwert, Jo-

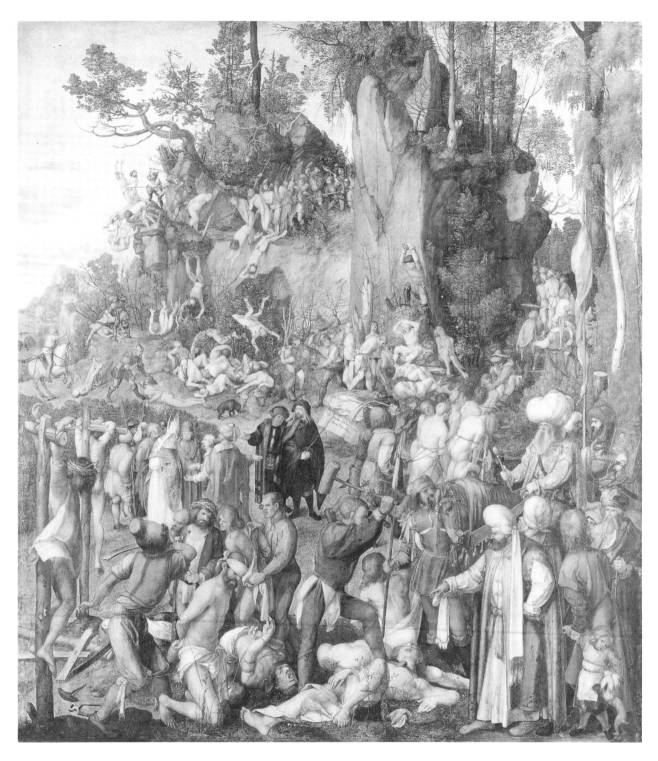

67. Albrecht Dürer, *Martyrdom of the Ten Thousand*, 1508, oil on panel,
Kunsthistorisches Museum, Vienna.

hannes Butzbach composes a brief chronicle of great artists from antiquity to his own day.[129] Butzbach (1478–1526) was prior of the cloister of Maria-Laach and is better known for his autobiographical *Odeporicom* of 1506.[130] He culled his art history mainly from Pliny and from Italian humanist sources,[131] yet his focus remains essentially theological. Celebrating the superiority of Christian painters over all pagan masters, he elevates Sister Gertrude, by virtue of her faith, above Apelles and Phidias. The *Book of Famous Painters* is divided into two parts: a list of painters of antiquity, with special emphasis on women painters who can serve as exempla for his female readers, and an account of Christian art that begins with the creation of the world, explicates the legitimacy of Christian images, and concludes by naming a few German painters of the recent past. The centerpieces of these two sections are a self-portrait and the *vera icon*, respectively.

Self-portraiture appears here where it had in the Boccaccio manuscripts, in the story of Marcia fashioning "a self-portrait, which she drew with the help of a mirror. In its lines and colors, as well as in its general construction of the face, the portrait was so like its model that no contemporary who knew Marcia was in any doubt who was represented in it."[132] As well as exemplifying the veracity of her art, Marcia's self-portrait functions within Butzbach's larger argument concerning chastity. Marcia, a virgin, became a painter to avoid the "usual feminine occupation." The description of her self-portrait is followed by a paean to her personal modesty:

> It is said that she preferred painting and sculpting women rather than men. The cause of this habit lay in her bashfulness. For although in antiquity nudes and seminude figures were generally not uncommon, Marcia found it more decorous, more appropriate to her virginity, to represent only the upper body of her sitters, leaving out the lower half. That way she did not have to busy herself with the lewd [*impudica*] parts of men. For if she had depicted men in their entirety, she would have been open to the reproach that she had damaged her virginal feelings of shame. To escape such an unfavorable judgment, she found it smarter to hold back.[133]

It remains unclear whether Marcia refuses to depict male bodies below the waist because of her own modesty or because she did not want viewers to imagine her observing those "lewd parts." At any rate, self-portraiture is her proper occupation, since she can practice it alone and without impropriety. I suspect, too, that Marcia's mirror is also meant symbolically, through the venerable metaphor of the Virgin as *speculum sine macula*.[134] Butzbach emphasizes that Marcia's chastity was not imposed on her, by the pagan cult of Diana, say, but arose "through her own inner purity." Self-portraiture thus becomes the emblem of this personal virtue, which likewise is self-fashioned: the pictorial equivalent of a virgin birth. However we wish to read this conceit, Butzbach certainly regards an artist's self-portrait as a powerful metaphor that can say things about the nature of art and of sexuality.

Marcia's virtue could only be self-begotten, since she was born *ante Christi nativitatem*,[135] that is, before the era when chastity could have come to her as a gift from Christ. Had she lived later, Butzbach tells us, she would have left "beautiful examples of her art and her own holiness." Here Marcia's art is compromised by its place in salvation history.

The whole thrust of the *Libellus* is ethical and theological rather than aesthetic. Antique painters are examples less in their art than in their moral character as revealed in anecdotes about their lives. This enables Butzbach to legitimate painting as an essentially virtuous activity. It is a strategy found later in the writings of Dürer, who defends his profession against moralistic detractors thus: "When an artistic person is by nature pious, he avoids what is evil and effects the good. That is the function of art, for it makes known good and evil."[136] In Butzbach the stress on virtue also serves a polemic end, demonstrating the necessary superiority of the modern painters over the ancients. Butzbach can thus say of an obscure monk who decorates the *Libellus* manuscript with some flowers, "Brother, in your presence the fame of Apelles' art vanishes; neither Parrhasius nor Zeuxis stands before you."[137] For the monk was born *sub gratia*, under grace, and, spiritually superior, will therefore be greater than the greatest of the pagans.

Butzbach's account of "our painters, who are far more famous" than the ancients, does not begin with the earliest artists born after Christ. Rather, he turns to the "first artist, our Lord and Savior Jesus Christ" at the moment of Creation, when Adam was made "in his image and likeness, and endowed with chastity and innocence, and all other good virtues."[138] Butzbach's descriptions of the *imago Dei* status of the soul, the beauty of the world, and the perfection of man's physical being (in particular his face) are all controlled by the metaphor of God as *deus artifex*. God is "the most miraculous artificer, or to speak in the manner of my theme [the Latin is *propositum*, meaning the first premise of a syllogism]: the most accomplished painter and sculptor."[139] With God as the first Christian painter, the cards are clearly stacked in favor of the *moderni*. And when Butzbach finally begins the actual chronicle of painters living *sub gratia*, he does so with Christ:

> While he [God in his aspect as *deus artifex*] who is our savior Jesus Christ was led to his death, he pressed the image of his face upon the veil of Veronica at her bidding. It is said that he did the same for an emissary of King Abgar, who was unable to capture in paint the divine radiance of Christ's face. There you see the work of a great painter! No wonder! For out of nothing he created, with a nod, everything that is. He speaks and it is done; he commands and it is created.[140]

In a sense Butzbach needs to invoke Christ as painter because there simply was no canon yet of famous Christian painters. Besides Christ and St. Luke, Butzbach can name only seven, and only three of these (Giotto, Israel van Meckenem, and Konrad Witz) are known outside the author's immediate circle in Maria-Laach. Nor are these painters remembered in anecdotes or praised for any specific works. The entire passage on the *moderni* proper, which concludes Butzbach's text, fills scarcely one-twentieth of his little book. His final example is typical of this limited repertoire: Brother Heinrich, erstwhile cantor, now barber, glazier, and supervisor of the vestments in Butzbach's cloister, distinguishes himself by fashioning "many decorative initials, sweetly ornamented with flowers and leaves, in the cloister's hymnals."[141]

One thing that distinguishes Butzbach's history of art from all others written in the North afterward is the absence of any reference to the one German painter who will be remembered and canonized like the ancients: Dürer. In the same year Butzbach's *Libellus*

appeared, the Strasbourg humanist Jacob Wimpfeling (1450–1528) published a brief description of recent German painting as part of his patriotic history, *Epithoma rerum Germanicarum usque ad noster tempora* (1505).[142] Wimpfeling's account culminates with Dürer, whose works are said to be brought by merchants to Italy and valued "as highly as the paintings of Parrhasius and Apelles."[143] From Wimpfeling on through the eighteenth century, Dürer will make it possible to write a proper "history" of German painting, providing posterity both with a body of works, identifiable through marks of authorship, and with a repertoire of anecdotes that grow up around Dürer even during his lifetime. Butzbach's *Libellus* is at once the first history of German art and the last that does not celebrate Dürer.

By following his account of the *antiqui* with a chronicle of Christian art that commences with Creation, Butzbach writes a history still medieval in character, in which the individual talent, embodied in a canon of "famous painters," counts for little compared with the works of God and the commanding divisions of salvation history. Wimpfeling has a very different agenda. He seeks to establish the parity of German and Italian painting (hence the detail about Dürer's works' being purchased in Italy) by overleaping the whole anonymous Christian tradition through the comparison between Dürer and his only named rivals, the painters of pagan antiquity. Yet if we compare Wimpfeling's secularizing and protonationalistic account of Dürer's place in history with the account that the 1500 *Self-Portrait* writes about itself, the Nuremberg painter seems to construct art history rather in Butzbach's mode. Here the Christian artist finds the source of his tradition in the *vera icon* of Christ, and the activity of painting is legitimated not only by magical likenesses of Christ, but also because these likenesses reflect God's status as *deus artifex* and man's as *imago Dei*. Butzbach is also useful in assembling, alongside the myth of the *vera icon*, a metaphorical understanding of self-portraiture itself in the story of Marcia. Against the assumption that fashioning one's own image is merely a mode of self-celebration, the Marcia anecdote interprets self-portraiture as a chaste act: thus can an artist produce a portrait *ex se*, without having to gaze at any model or at any male organ of sexual procreation, just as virtue arises autochthonous in a pagan heart. It is a parable not easily transferred to Dürer's Munich likeness, yet it instructs us that the very operation of self-portraiture could, by 1500, be invested with complex symbolic significance.

What remains to be clarified is how Dürer places self-portraiture in an analogy to images not made by human hands. There is much about the *vera icon* itself as a devotional image that would legitimate, or at least explain, its transformation into an artist's likeness. In a number of fifteenth-century texts, the Holy Face occupies a central place in defining the relation between self and God. Observing how this relation is theologically construed, we can discern the constitution and instability of "self" in the moment of self-portraiture.

6

Figures of Omnivoyance

We possess an important text that explores the status of the self through the theology of the Holy Face. In *De visione Dei sive de icon liber,* completed in 1453, Nicholas of Cusa (1401–1464) explicates God's nature by meditating on the face as it is represented in works of art.[1] Cusanus's starting point is a simple effect of visual representation: when a person is portrayed as gazing directly out of a picture, beholders will always feel themselves watched and followed by the represented person's gaze. The illusion of an all-seeing eye has been observed and analyzed since antiquity. Ptolemy discusses it in his *Optics;* Pliny the Elder praises its effects in his account of the painter Famulus; Nicolaus Mesarites, we recall, observes it in the Christ Pantocrator and reads it as analogous to God's vision ("wholly directed toward all at once and at the same time toward each individually"); and Jacobus de Voragine, in his *Legenda aurea* (1275), tells of a scribe who visits the Hagia Sophia and finds himself followed by the eyes of the Savior represented in the dome.[2] Sometimes the illusion is interpreted as the magical property of an image. In a famous account from 1013, Bernard of Angers, a cleric from Chartres, describes a miraculous gold cult statue in Conques (Aveyron). The effigy's head was the gilded and bejeweled skull of an early Christian martyr named St. Foy; it had a "face so animated by lifelike expression that its eyes seemed to fix upon us, and the people read from its gaze whether their prayers had been heard."[3] Bernard encounters the cult image first as a skeptic, regarding its illiterate devotees as pagan idolators; in the end, however, he learns to trust in its power to work miracles.

Cusanus submits the illusion of omnivoyance to a number of different metaphorizations, transforming it into a complex figure of God and thereby transporting his readers "by human means unto divine things."[4] And because human thought can approach God only through a concrete image, Cusanus insists that his readers place before them an example of such an all-seeing picture: "So that you not be lacking in practical experience, which requires a sensible figure, I am sending Your Love a painting that I was able to acquire. It contains the figure of an omnivoyant . . . ; and I call it the 'icon of God.'"[5]

Several of the early manuscripts of *De visione Dei* included an actual painted or woodcut version of the Veronica,[6] which readers were instructed to "hang . . . somewhere . . . [and] stand around it, at a short distance from it, and observe it."[7] Such a practice is suggested by Petrus Christus's panel discussed earlier, in which a parchment of the Holy Face is affixed to the wall behind the sitter (fig. 39). In pictures like these the "vision of God" appears doubly, as that which *sees* (God's absolute vision figured as omnivoyance) and as that which *is seen* (the *vera icon* testifying to God's physical appearance in the world). Appearing always to look at me *in particular,* addressing me in my individuality, it hails me as subject. By subject I mean, on the one hand, a free subjectivity and center of initiatives and movement and, on the other, a subjected being, one who submits to a higher moral and ontological authority. The omnivoyant icon interpellates me as the God of Genesis did Moses, who replied to God's call on Sinai: "It is I! I am Moses thy servant." And because it looks at me in my singularity and simultaneously sees everyone around me, the omnivoyant is itself more than simply *a* subject. It is the subject par excellence: the self-generated and self-sustained pictorial equivalent of Yahweh's words: "I am that I am." I would note, from the outset, that this logic of an absolute gaze, which Louis Althusser interprets as the mechanism of ideology, is appropriated by Dürer for himself in the 1500 likeness.[8] Self-portraiture, which can say of itself "I am who painted me," and which proclaims the sovereignty and godlike status of the painter, proposes the creative artist as himself unique, absolute subject, in whose omnivoyant gaze all viewers are interpellated in their individuality.

Now Cusanus does not claim that the picture has to represent the face of Christ for it to figure divine omnivoyance. Included in the Cusan's list of examples of the "icon of God" is a face "by the preeminent painter Rogier in his priceless painting in the city hall at Brussels."[9] Scholars have identified this picture as the *Justice of Trajan*, painted by Rogier van der Weyden for the Brussels town hall in 1438.[10] Although Rogier's painting was destroyed in 1695, a tapestry (now in Bern) after the original reveals that the one face that seems to gaze out at us is a small self-portrait of Rogier (fig. 68).[11] According to an early seventeenth-century account of Rogier's *Justice*, this cameo self-portrait was a famous curiosity in Brussels.[12] Cusanus's seemingly casual association here between a self-portrait and the *vera icon* will become, in the course of the *Vision of God*, a controlling motif.

Before turning to the Cusan's treatment of the *vera icon* and its relation to human subjectivity, I should say a word about the author and his possible connections to Dürer. In an obituary written in 1469, Giovanni Andrea Bussi, bishop of Aleria, described Cusanus as, among other things, a great connoisseur of the "Middle Ages." Paul Lehmann noted that this expression—*media tempestas*—represents the earliest use anywhere of the term "Middle Ages" to describe the period between antiquity and the present epoch.[13] By thus naming the historical epoch of which the Cusan is a connoisseur, the epithet at once links him to an earlier era (one between antiquity and the modern age) and distances him from it. In most recent literature on his thought, Cusanus represents a figure paradigmatically balanced on the threshold of our era: from Ernst Cassirer, Karl Jaspers, and Alexander

68. Tapestry copy after Rogier van der Weyden, *Justice of Trajan*, late fifteenth century, detail of *Self-Portrait*, Historisches Museum, Bern.

Koyré to Hans Blumenberg and Amos Funkenstein, the Cusan is regarded as a Janus-faced figure who, while dedicated to the basic theological aims of medieval thought, develops ideas and methods that prefigure modern cosmology and anthropology.[14] As Blumenberg puts it, Cusanus's work attempts to "save the Middle Ages out of the substance and with the spiritual means of the epoch itself," yet in the process he invents a method of procedure that will speed the epoch to a close.[15] Bringing Cusanus to bear on Dürer can therefore help us not only in analyzing the thematics of the Holy Face, but also in gauging the 1500 *Self-Portrait*'s fusion of medieval piety and modern self-consciousness.

It seems likely that Dürer could have read or at least known of Cusanus's text. Willibald Pirckheimer's great uncle Thomas Pirckheimer and his grandfather Hans Pirckheimer II were close associates of Cusanus,[16] and we know that Hans II educated Willibald's sister Caritas Pirckheimer. Hartmann Schedel, the important Nuremberg writer and humanist who arranged for the printing of some of Dürer's early woodcuts, possessed Cusanus's complete works.[17] The lively interest in the Cusan in Dürer's time is further evidenced by new editions of his work, including an *omnia opera*, published in the early years of the sixteenth century.[18] In 1500, as part of the monumental publishing project staged to commemorate the half-millennium, Conrad Celtis printed his own *Carmen saeculare* in a

volume together with Cusanus's late *De non aliud*.[19] If, as Wuttke has suggested, Dürer actually produced his 1500 *Self-Portrait* as part of the same celebration of the saeculum, then it is possible that the ideas of the Cusan could have been integrated into Dürer's painting. The basic conceit of the *Vision of God*—the all-seeing face as metaphor for the relation between the individual and God—is of such simplicity that Dürer need only have heard of it to understand its possible implications for his art. And this conceit did not have to come directly from Cusanus; it was available to Dürer and his circle in a number of popular devotional tracts dependent upon the Cusan. We shall examine one such text later. The usefulness of *De visione Dei* to our understanding of the Munich panel does not anyway depend on direct influence. It functions for us as a fitting proof text of the shifting status of "self" within the culture out of which Dürer emerges.

In the *Vision of God*'s play of conjecture,[20] the apparent paradox of a face that seems to follow the viewer with its eyes generates diverse metaphors for the paradox of the hidden God. For example, that the image's eyes appear to move with the beholder even though they actually remain fixed, as two-dimensional areas of paint, serves as a figure for how God does not see things in movement or succession but regards the events of history from a point outside time. And the inescapability of the image's gaze, the disturbing sense that no matter where viewers travel it will remain fixed upon them, becomes proof that everything exists only through the will of God. I shall focus on one central reading of the face in Cusanus that is particularly relevant to Dürer's *Self-Portrait:* namely, how the figure of the omnivoyant manifests and finally resolves the dialectic between our love for ourselves and God's love for us. It may be useful to consult the particularly mesmerizing example of the Holy Face by the Master of the Playing Cards, a work roughly contemporary with *The Vision of God* and probably close in style to the images attached to Cusanus's original manuscript (fig. 51).

The Cusan's metaphor of the icon's gaze as God's love rests on a simple analogy: "O Lord, Your seeing is loving; and just as Your gaze regards me so attentively that it never turns away from me, so neither does Your love."[21] Cusanus instructs his readers, the monks of Tegernsee, to assemble in one room and together view the icon. Although each monk feels that the icon's gaze rests on him alone, he will learn that everyone in the room shared the same experience. In this staged confrontation between the viewpoint of the individual and the consensus of the community, Cusanus deduces God's love for man: while each one of us experiences God's love as a gift bestowed specifically on ourselves alone, from a higher, collective vantage point God's love embraces all people equally and at all times. Cusanus's exercise thus enables a transition from relative to absolute vision, from the self's limited and often deluded perspective to a viewpoint that can, like the figure of the omnivoyant itself, encompass all individual perspectives.[22]

This does not mean, however, that the communal vision negates the individual's experience in revealing it to be illusory. For Cusanus, the icon's value as an object of meditation lies precisely in its capacity to demonstrate and to justify the self's irreducibly

egocentric perspective on the world: "For You who are the Absolute Being of all things are present to each thing as if You were concerned about no other thing at all. (Consequently, there is no thing which does not prefer its own being to all the modes of being of other things; and each thing so cherishes its own being that it would let the being of all other things perish rather than its own.)"[23] It is self-love, not pious devotion, that is the first principle in an individual's reading of the icon. When I experience myself as the constant center and focus of the picture's gaze, my own overweening self-regard is merely confirmed. I am unable to imagine that I share that gaze with anyone. The icon appears to have eyes for me alone and thus acts as a mirror reflecting back to me my narcissistic gaze. Cusanus does not regret this. For it is only through our primary narcissism that we can grasp the magnitude of God's love. God's attention to us is "so strong that the one who is being looked upon cannot even imagine that the icon is concerned for another."[24] Our inability to "imagine" that the love we experience could be shared may be a token of our deepest narcissism, yet as such it can also function as our truest index of value.

The notion that self-love should be the first step to the love of, and likeness to, God is not new to Cusanus but appears already in twelfth-century writers like Bernard of Clairvaux.[25] What is new about the argument of *The Vision of God,* and what makes the Cusan such a pivotal figure in the rise of modern self-consciousness is the way the self begins to color the object of its devotion, acquiring the attributes of the God it claims to worship. It is after all human viewers who, believing they are being seen by the icon, invest it with a fictive gaze that can trope for the vision of God. Cusanus reverses the relation between human and divine, endowing the viewer with that sight-giving power formerly invested in the God pictured in the image.

Nowhere is Cusanus's subjectivism as extreme as when he tries to define the visible form of the icon. Although he supplies his readers with an actual picture of the *vera icon,* Cusanus continually undermines the objective status of the image.[26] He notes, for example, that "every face that can look at Your Face sees nothing that is *other* than itself or *different* from itself, because it sees its own Truth."[27] Although the underlying doctrine here is that of man as *imago Dei,*[28] the equation can also be reversed. Man creates God in his own image: "O Lord, how admirable is Your Face! If a youth wished to conceive of it, he would envision it as youthful; if an adult wished to conceive it, he would envision it as adult; and someone elderly would envision it as elderly."[29] The *vera icon* does not merely look *at* its viewer, but will always, to human eyes, look *like* its viewer. Again, Cusanus does not worry about the unusual status he has afforded the self here. By appealing to our narcissism, by fashioning his own true icon as "a mirror, an icon, a symbolism,"[30] God ensures our continued devotion to himself: "O inexplicable Graciousness, to him who looks unto You You give Yourself as if You received being from him; and You conform Yourself to him, in order that the more You appear to be like him, the more he will love You. For we cannot hate ourselves. . . . [W]e embrace our likeness, because we are shown ourselves in an image, and we love ourselves therein."[31] Here Cusanus has shifted from the painted image of God to God's living incarnation in Christ. What concerns us, however, is how the face of Christ has become a portrait of the viewer, how the

icon has become a mirror. Dürer's conceit of fashioning his own likeness after the icon of God no longer seems strange. For one thing, we need not defend Dürer against charges of hubris or narcissism, as if self-love were the antithesis of devotion. Cusanus's omnivoyant teaches that the starting point for man's contemplation of the divine is the radically subjective perspective of the individual, and that the final measure of one's devotion remains one's own narcissistic regard for oneself. Regarded in this light, the 1500 *Self-Portrait* not only is a Christomorphic likeness of the artist, it is also Dürer's most personal *vera icon.*

Given such important analogies between Cusanus and Dürer, it is not surprising that *The Vision of God* closes with the metaphor of self-portraiture. Cusanus describes how each one of us must fulfill the particular spiritual destiny for which we were created. All these unique destinies, though, together form one image wherein God views his own grandeur. To express this idea of divine self-reflexiveness, Cusanus constructs the following figure:

> You, O Lord, who work all things for Your own sake, created this whole world on account of the intellectual nature. You created as if You were a Painter who mixes different colors in order, at length, to be able to paint Himself—to the end that He may have an image of Himself wherein He Himself may take delight and His artistry may rest. Although the Divine Painter is one and is not multipliable, He can nevertheless be multiplied in the way in which this is possible: viz., in a very close likeness.[32]

Although in the mid-fifteenth century the autonomous self-portrait was virtually an unknown product in the North, the *process* of an artist's making and retaining his own likeness is here already invested with complex metaphorical dimensions and situated within the culture's deepest ontological concerns. Dürer's self-portraits, too, will be symbolic not merely as products, but as processes. They are exemplary forms of human labor, expressions of man's privileged place in the cosmos, as a being empowered both to create himself in whatever shape he chooses (Pico della Mirandola's famous formulation)[33] and to imitate God's divine self-reflective purpose in creating the universe.

Now, in Cusanus's metaphor each brushstroke an artist places on his canvas is like one individual self within God's cosmic composite self-portrait. In his *Idiote de mente*, Cusanus metaphorizes the individual as a kind of self-portrait of God, in which the likeness is capable of growing more and more like its model.[34] From this perspective, Dürer's Munich panel becomes a most pious work. Fashioning an image that is both self-portrait and *vera icon*, Dürer fulfills his spiritual vocation through the perfection of his particular craft, and in so doing he offers up a reflection of God in whose image he was created. The panel's mimesis becomes multiple and complexly construed. It is at once the replication of the artist's body, the emblem of the artist's pious imitation of Christ, the reflection of Christ's physical appearance in the idealized portrait of Dürer, and the participation of human making—here the art of painting—in divine creation. Mimesis, linking not only two *created* natures (Dürer as mortal and his likeness in the self-portrait) but also two *creative* natures (God and the artist), celebrates the power of human poiesis. Here self, as

in so much of Renaissance culture, is identified with its products, with its capacity for production.[35] In Dürer, as in Cusanus, the play of likeness becomes finally a spectacle God stages in order to behold himself.[36] As we read in a draft of Dürer's prologue to the *Lehrbuch*, the art of painting "is useful because God is honored when one observes that He has conferred such reason upon a creature who has such art in him."[37] And again, in a later manuscript dated 1513, "through art, we become ever more like the divine portrait."[38] God takes pleasure in his self-portrait when it grows ever more like himself.

The spiritual economy between man and God as explicated through an image of the Holy Face was popularized in a text written under the influence of Cusanus: the so-called *Pilgrim Tract of Nicholas of Flüe*.[39] Anonymously published in Augsburg and Nuremberg between 1486 and 1489, the work seems to have been composed by the Freiburg rhetorician Heinrich Gundelfingen (c. 1440–1490). Dürer would have known this text, for the Nuremberg edition (published in 1488 by Markus Ayrer) was illustrated by artists of Michael Wolgemut's shop. Indeed, certain woodcuts have been attributed to the young Dürer.[40] The narrator of the text, calling himself a pilgrim, describes his encounter with the legendary hermit "Brother Claus" (Nicholas of Flüe), who sets forth his mystical theology by interpreting a certain image in his possession. The painting exists today in the parish church in Sachseln (fig. 69), and woodcut versions were included in the early editions of the *Pilgrim Tract* (fig. 70). Modern scholars have dated the Sachseln panel back to 1460–1470,[41] suggesting that Gundelfingen's text represents the interpretation of this already existing image. Written in the vernacular and in a style and terminology far less demanding than Cusanus's *De visione Dei*, the *Pilgrim Tract* documents the reception of the Holy Face in popular piety of the late fifteenth century. Moreover, as an extended period reading of an actual work of art, it demonstrates the extraordinary interpretative pressures that could be placed on an image in the culture just before Dürer. Images, even of a popular variety, were sites of an open-ended labor far more theoretical than what is often practiced as art history today.

Brother Claus's image is what Martin Luther calls a *Denkbild* or *Merkbild*, that is, a diagrammatic representation of a difficult theological point for the purpose of instruction or meditation. Brother Claus terms his picture variously "my *book*," "a figure in the likeness of a *wheel* with six spokes," and the "*clear mirror of the true living God*"—shifting denominations that, like the protean figure of thought at the heart of Cusanus's *Vision of God*, destabilize the image as simple *object* given to sight. A central en face head confronts the viewer, circumscribed by two concentric rings. Its beard and physiognomy identify the face as Christ's such as it appears in northern representations of the *vera icon*, and its crown celebrates God's triune aspect as *totius medius Trinitatus*.[42] Brother Claus calls the face itself "the divine being" and "the undivided Godhood, in whom all saints rejoice."[43] Around this figure are assembled six scenes in interlocking rings, and at the four corners are the emblems of the evangelists. Each of the ringed scenes connects to the center through a raylike device that alternately flows inward toward the Holy Face from an apex

in the peripheral medallion and emerges from an apex somewhere on the face. Note that the three rays that originate at the "undivided Godhood" do so from his mouth, eye, and ear, expressing thereby the threefold manifestation of God in the world: at the upper left, God the father in the act of creation; at the upper right, Christ crucified; at the bottom, appropriately linked to his mouth, the annunciation to the Virgin through the Holy Spirit. Alternating with these are images of what man returns to God: above, Judas's

69. *Meditational Image of Brother Claus*, Swiss, 1460–1470, panel, Parish Church, Sachseln.

betrayal; lower right, the sacrament of the Eucharist; and lower left, the adoration of Christ. Added to the economy of things returning to God are six works of human charity: a mantle for "clothing the naked," a coffin for "burying the dead," loaves, wine, and fishes for "feeding the hungry," and so on.

Brother Claus metaphorizes this inward-outward movement between God and man through the symbol of the "divine mirror." God reveals himself in the world through the

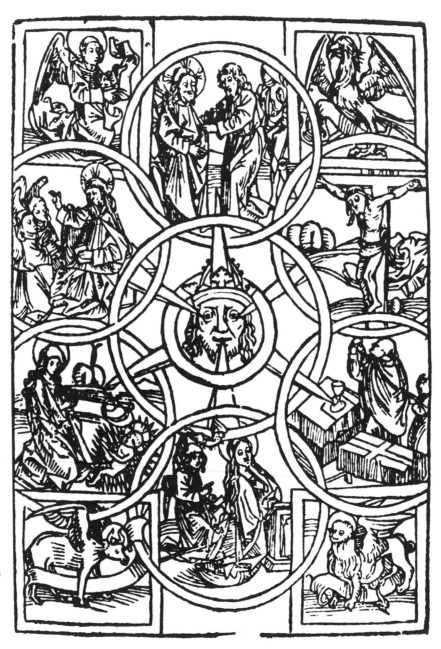

70. *Meditational Image of Brother Claus,* woodcut illustration for the *Pilgrim Tract* (Nuremberg: Markus Ayrer, 1488).

Creation, Incarnation, and Crucifixion and beholds himself reflected in those human works that imitate God's mercy. Man, in turn, fulfilling his status as *imago Dei* with good works, discovers at the horizon of his labors the human face of God. In a sense, the six surrounding medallions only diagram, as sacrament, works, and history, the more immediate act of mirroring that should take place in the here and now, between the viewer gazing at the image and the omnivoyant Holy Face. The dialectic between seeing and being seen is more intense in the Sachseln panel than in the woodcut, for there the central roundel has been fashioned as an all-seeing eye.[44] The image thus pictorializes what Cusanus and the mystics call the Vision of God, where "vision" doubles as the faculty of sight and the thing seen and as what God sees and what man sees of God.

Throughout the *Pilgrim Tract*, the text shifts between three voices: the pilgrim-narrator who encounters Brother Claus and records the hermit's teachings; Brother Claus himself, who speaks of the Sachseln panel as if he were its maker;[45] and a third voice, ostensibly Claus's yet colored by the pilgrim's uncertainty, who regards the image as a riddle still to be deciphered. Thus the hermit explains how he "placed" at the center of the panel a Holy Face: "The . . . divine mirror I see here in the form of an image of man."[46] But then he suddenly voices uncertainty: "Why this is is not really solidly known to me."[47] He installs in his panel a God in the form of man only to wonder what such an anthropomorphism might *mean*. This aporia concerns less the interpretation of the Sachseln panel than the deeper mystery of theophany itself, a mystery made apparent to the hermit in his act of fashioning a visual image. The hermit asks why God appears to us in the form of a man. In the reception of Dürer's Christomorphic *Self-Portrait* we heard the inverse question: Why should a man, Dürer, represent himself as God? To which Moriz Thausing in the late nineteenth century replied: Because God is only the projection of the self.

Brother Claus answers differently, and the image he makes and interprets is his response. "Yet I also see that the Lord spoke: We want to make a man after our likeness and image, although one wishes to attempt this by another path. Yet I say that God descended from heaven and took upon himself a human image."[48] The phrase "we want to make a man after our likeness and image" echoes Gen. 1:26, in which man in general is fashioned in God's image. And the following sentence interprets God's incarnation as the new Adam or Christ, who is the true *imago Dei*.[49] The hermit thus asserts the absolute priority of God in any analogy between the human and the divine. God may have a human face, but only because it was he who first created man in his own image, and because he mercifully descended to us again in the form of the Universal Man. At the same time, though, the *Pilgrim Tract* also closes the gap between God and man to forge an equivalency between man created in the image of God and man's free self-elevation through works into a being *quasi alius deus*—like another god. The statement "we want to make a man after our likeness and image" simultaneously paraphrases God's fiat and articulates the hermit's own creative intentions in fashioning the devotional panel itself. Beyond all the works of charity emblematized in the picture's six peripheral roundels, Claus's artisanal labor of making a picture itself mirrors the Godhead according to the venerable analogy between God as artificer and the artist as divine.

I have focused on the analogy between man and God as it is constructed in the *Pilgrim Tract* and in its chief theological model, Cusanus's *Vision of God*, for I believe that the Christomorphic dimension of Dürer's *Self-Portrait* emerged, at least in part, from discourses of piety in Germany in the late fifteenth century. The basic terms of Dürer's pictorial meditation on the interrelationships between self, image, God, and art are all prefigured in popular and elite texts about the Holy Face. The apparent disparity, in the Munich panel, between the narcissism of self-portraiture and the devotion to the icon disappears when we regard the new roles afforded the self in the more advanced thought on the eve of the Reformation. The moment of self-portraiture represents here less Burckhardt's notion of an awakening to or a discovery of self than the self's reinvention within changing paradigms of religious experience.

This does not mean, however, that Cusanus and Gundelfingen fully *explain* the 1500 *Self-Portrait*. Their texts stage the analogy between God and man precisely as a difficult problem—indeed, as a paradox that, while worthy of intense scrutiny, does not solve but rather expresses and preserves the mystery of human/divine equivalence. At one level, therefore, these texts simply situate Dürer's panel within certain interpretative practices current in late fifteenth-century German piety. The dialogue between Brother Claus and the pilgrim-narrator foreshadows terms and arguments Dürer might have used to explain his own *speculum* to, say, a visiting humanist. At a deeper level, though, the *Pilgrim Tract* and *De visione Dei* focus on visual images that are fundamentally distinct from Dürer's *Self-Portrait*. Cusanus may say that the Holy Face is like a mirror image of its individual viewer, yet he never erases the qualifying *figurality* of such a statement. He will never propose Dürer's equation, where self-portrait *is* Holy Face. However much his text fashions an experiential meeting place between self and God, it also insists on the absolute distinction between the two. As Blumenberg has argued, Cusanus's philosophy remains "medieval" precisely to the extent that it maintains a rigorous distinction between, on the one hand, man's likeness to God, justified by Scripture, evidenced in the arts of man, and expressed in the lapidary formula *quasi alius Deus,* and on the other, the radical *velle se esse Deum* or "wanting to be God oneself," which is human sinfulness itself.[50] It is at the moment when the quasi-divinity of man is established not on the proposition "man is great because his God is great," but instead on the marks of actual personal accomplishment that we enter the modern period.

Viewing the 1500 *Self-Portrait* within a tradition that includes the *acheiropoetos*, the northern portrait panels of Christ, Cusanus's meditation on the icon, and the popular *Pilgrim Tract*, we may be struck by the overwhelming historical logic of Dürer's conceit. What indeed were the rays passing in and out of Christ's face in the Sachseln panel but diagrams of the passage between self and God? This passage was already traversed in Dürer's *Self-Portrait:* the individual self offering to God a good work that perfectly mirrors both artist and divine maker. Yet the same logic that integrates Dürer into the Middle Ages and domesticates his message as a version of orthodox piety also obscures the very foundations of the artist's self-identification with God, namely, the *originality* that the artist himself claims for his art. In the painted inscriptions and monograms that docu-

ment his authorship, in the panel's date (1500), expressive of the beginning of a new saeculum, and in the likeness itself, which is rendered as if consubstantial with the painting's specific and originary body, Dürer asserts that what we see is irreducibly and unrepeatably *his own*.

Or to put it into the idiom of vision: when Cusanus instructs the monks of Tegernsee to assemble in a room where each experiences himself as the sole object of the icon's attention, he intends to lead them beyond this local interpellation of self to an awareness that the vision of God looks the same to all people and that each person is equally an *imago Dei*. The monk, that is, whose very name denotes "one who lives alone" (from greek *monos*), transcends personal uniqueness and finds community in and through God. Dürer, on the other hand, may liken himself to Christ as Universal Man. He may claim to imitate Christ's example. Yet the ultimate purpose of his *Self-Portrait* is to proclaim what is different, what is inimitable about Dürer as person and as producer. The body, talent, style, and invention that are the panel's spectacle are things that precisely will not be found within the self of Dürer's viewers. And as we shall see, Dürer will do everything in his power to protect what is his and his alone from all who would share in his originality, be they collaborators, students, or imitators.

Dürer grounded the artist's quasi-divine status upon the radical originality of his productions. In various drafts of his *Lehrbuch*, we recall, Dürer told how painters were held in high esteem by the kings of antiquity, who recognized "that the most understanding artists are similar to God, as one finds written. A good painter is inwardly full of figures. And were it possible for him to live forever, he would have from his inward ideas, whereof Plato writes, always something new to pour forth through his work."[51] This "something new" (elsewhere Dürer calls it "die newe creatur," meaning "the new creature" or second creation)[52] stands in opposition to the entire tradition of medieval anthropology and aesthetics from St. Augustine and Peter Damian to Thomas Aquinas, which asserts categorically that *solus creator est Deus*.[53] Scholars have found antecedents for Dürer's statement of artistic originality in Seneca, where it is applied only to God ("God has within himself these models of all things. . . . He is full of these figures, which Plato calls 'ideas'"), and in Marsilio Ficino's *De vita triplici*, where it is applied to the melancholic poet ("filled with divine influences and oracles from on high, he [the melancholic] always devises something new and unusual and foretells the future").[54] Yet Dürer is the first Western writer to apply it to painters and to envision it not as a special state of artistic afflatus, but as a general characteristic of all art. At the moment when an artist asserts that he not only imitates the natural, God-created world but also produces something totally new, he elevates himself from the secondary status as image of God to become truly another god, an *alter deus*. We must therefore attend to "something new" in Dürer's *Self-Portrait*, bearing in mind that this claim to originality might threaten the carefully constructed boundary between man and God constructed by the theology legitimating Dürer's project. The new here is self-portraiture itself, and it is to this that we now return.

7

The Divine Hand

How easily does Dürer's likeness rest within the compositional formula of the Holy Face? The 1500 *Self-Portrait* aspires to appear as if fashioned "without hands": the activity of human making is visible neither in the marks that make up the image nor in the physical posture of the maker himself. And yet there is something unsettling about the way Dürer's extreme painterly accuracy boasts that the image has accounted for literally every hair of its model while, at the same time, the painting's composition demands that this manifold detail be subordinated to a hieratic symmetry and otherworldly stasis. The result, to me, is a sense of stiffness or strain that permeates the represented body. I feel as if the sitter had to struggle to hold himself in place, or as if the pose that endows his likeness with the proportionality and balance of the *vera icon* was achieved only through a constant expenditure of energy.

Dürer's figure does not possess, for example, that sense of sublime calm characteristic of earlier German pictures of the Holy Face, in which Christ's face seems to float on the sweat cloth as if it were a reality independent of the world that supports or beholds it (figs. 40, 41, 42, and 51). Nor is Dürer's framed body comparable to the Eyckian *en buste* portraits of Christ (fig. 33) or to their variant, the Rogierian Blessing Christ that influenced German painting (figs. 65 and 66). It is true that, whereas the German sudaria construct their likeness so that it appears to transcend all externals (scale, frame, the rule of space, etc.), Jan van Eyck's portrait likeness already compromises the absolute autarky of Christ's appearance. The portrait convention, after all, depends upon the fiction that we see the sitter as if in a space "behind" the frame and therefore that our visual access to him will be contingent upon his and our positions relative to the reality of that frame. Yet when Van Eyck applies this convention to the frontal portrait of Christ, such contingencies are invested with a new meaning. Precisely because we feel as if the sitter could at any moment vacate the visual field, his presence, directed immediately and only toward us through his outward gaze, appears as an act of will. In the Veronica Master, we look at the likeness of Christ as it appears deposited on, or even floating before, the

sudarium; in Jan van Eyck, Christ appears to have himself chosen, within a freedom of movement implied by the surrounding space, to look at us and, almost secondarily, to let us behold him. The Holy Face appears less as relic than as epiphany. This holds true for the Rogierian Blessing Christ as well, in which the sitter's presence and outward gaze are combined with the gesture of benediction meant potentially for each individual viewer. Northern painters did not altogether solve the problem of representing Christ within the conventions of secular, bourgeois portraiture. In the Rogierian type—a version of the kit-cat portrait—Christ's left hand rests on a parapet that is one with the lower edge of the panel, as if it were necessary to stabilize the holy portrait by anchoring it to that point of passage between work and world: the picture frame. Dürer, we shall see, not only forgoes but indeed subverts any such simple closure at his image's base.

Earlier we noted how the use of the frame in the 1500 *Self-Portrait* heightens the likeness's symmetry, proportionality, and order. Dürer's locks, for example, may be infinitely varied in configuration and sheen as they fall to his shoulders at both sides of his likeness. Yet when they reach the panel's edges not a single hair is allowed to pass out of the picture. In this perfect fit between the visual field and the artist's body, the edges appear as rules to which the human sitter must accommodate himself, rather than as extensions of a measured body's *own* perfect construction. This is partly due to certain lapses in the likeness's symmetry, certain passages where attention to detail contradicts the picture's rage for order. Dürer depicts himself gazing out of the picture, yet such is the artist's naturalism that only one eye, his active right eye, is shown looking straight out at us. Perhaps what we experience as strain in the sitter's body as he fits himself into the space and order of the panel is nothing but the consequence of our foreknowledge, imposed on us by the picture's inscription, that we behold a self-portrait. From the moment we regard the represented body as identical to the person who produced the image, we start searching for signs of the physical movement that would have been necessary for the portrait to have come about.

Dürer's likeness conveys an uneasy doubleness. Beyond the essential duplicity of any self-portrait, in which the subject must be at once maker and model, representer and represented—beyond even the dualities introduced by the Christ allusion, which define the panel as both portrait and *vera icon* and the sitter as potentially both man and God—Dürer's 1500 *Self-Portrait* stages a drama of the seen and the unseen, one that enacts some of the deepest ambivalences of his art and of his epoch. This stillness, symmetry, and painterly finish of Dürer's likeness may erase the signs of its making, yet the artist's active right hand, conspicuously absent below the base of the frame, suggests an anxious possibility of movement and labor underneath the visual field. Of course it is next to impossible for one to paint one's active hand "from life." Of all the parts of the human body, with the possible exception of the binocular gaze, it is only the working hand that cannot pose for the artist, that cannot at once represent and be represented.

Dürer is perfectly able to construct poses that mask this necessary absence. In his self-portraits of 1493 and 1498, he makes his left hand read as if it were his right and adds a manufactured, but visibly awkward, fictive left hand (figs. 18 and 20). This is simple to

71. Albrecht Dürer, *Self-Portrait*, 1500, Munich, detail of right cuff.

do, for we face a portrait as if it were a person, and the right side of a person who faces us appears naturally on *our* left. In his self-portraits, however, Dürer's body has been reversed in the mirror, and his real right side will face us at our right. This explains Dürer's relaxed pose in the Prado panel. Leaning his arm (really his left) on the foreground parapet and clasping his hand with another hand emerging uneasily at the panel's lower left,[1] Dürer appears at rest, complete, and (all hands accounted for) elevated above the manual labor of painting. This particular inflection of the *non manufactum* serves well the social pretensions of this image. We see Dürer not as artist, but as *gentilhuomo* and highborn sitter. Sublimating his trade, Dürer installs himself as patron of a portraitist as great as he—a man who can employ rather than himself supply artistic talent.

In one sense the 1500 *Self-Portrait*, in its stillness and formality, its evocation of the *acheiropoetos*, and its self-comparison with God, should represent the apotheosis of the artist freed from servile labor. Yet Dürer insists on complicating the picture. He purposely lets his likeness vanish precisely at the point where his active right hand should be. This elision is neither casual nor in any way concealed, but is rather fully represented. The frame cuts precisely between the two-ply cuff of Dürer's sleeve and the flesh of his hand, which remains hidden (fig. 71). It covers the action of making that is antithetical to the claims of the *acheiropoetos*. Traditionally, a portrait's lower framing edge assembles the conventions of closure. For example, the picture's actual base will be doubled or tripled within the painted world by analogous structures—a stone parapet, tabletop, window ledge, or whatever. Or as in a kit-cat portrait or a Blessing Christ, the sitter will appear to rest a hand at the picture's base, so that the frame itself appears as a reality shared between ourselves and the painted world. Dürer overturns such conventions in the Munich panel. Not only does his hand disappear conspicuously beneath the frame, from the position of the cuff and the proximity between the sitter's body and the plane of the picture, it seems that this hand, were it visible, would also extend forward beyond the

surface of the panel and into our own space. Dürer invites us to conjure up the following vision: while his upper body is kept rigid in the act of posing, the artist works away with his right hand on a panel positioned approximately where the viewer stands. It cannot be simply by chance that Dürer should allow this cuff, with its fabric depicted in cross section, to peek above the base of the frame into our visual field, reminding us of the hand it would surround. Deliberately, but as yet inexplicably, Dürer signals in this minute detail an absence within, and therefore perhaps the incompleteness of, his *vera icon*.

As if to make up for the troubling void he creates at the picture's base, Dürer invests his left hand with extraordinary pictorial interest. In the play of light that models it, Dürer stages a complex drama of spatial relations and endows his object with a sense of volume and presence far beyond its relative size. Indeed, the hand contributes much to the painting's overall feeling of space, for without its sculpted form the portrait would appear flat. And to a viewer not initiated into the special properties of self-portraiture, this hand will read as Dürer's active right and can therefore function to celebrate the creative "tool of his trade."

In the "Aesthetic Excursus" of his treatise on human proportion, published posthumously in 1528, Dürer writes that artists ought to be meticulous in their depiction of *all* parts of the human body, down to the most seemingly peripheral, rendering every surface of their object in the minutest detail possible: "Then one should further take care that one puts together diligently, and down to the last detail, the breast, belly, the back and behind, the legs, feet, arms, and hands with all that they contain. And these things should also be fashioned within the work in the clearest and most meticulous manner, and the tiniest wrinkle and speck should not be omitted insofar as this is possible."[2] At the base of his Munich panel, Dürer articulates every vein, every "wrinkle and speck" of his hand, offering pleasurable surprises along the way—for example, the spot of light on the little finger that causes the wrinkles around its knuckle to stand out, or the two highlights at the tip of his index finger, articulating through their different luster whether they reflect off Dürer's skin or nail. The veins that appear beneath the translucent skin are at once a triumph of the artist's complex use of glazes and layered pigment and a demonstration of his power of observation and knowledge of human anatomy. One feels as if Dürer did not depict his hand as it appeared to him from outside, as reflected in the mirror; rather, he seems to have built it up from the inside out, starting from the bone and laying on painted versions of muscle, veins, skin, and finally the variegated play of surface light. It is unclear at first what this left hand is actually doing here below the center of Dürer's chest. It neither properly grasps an object, nor engages in a characteristic activity, nor simply rests while the artist paints and poses. Dürer's hand is simultaneously stiff and energized, as if flexing itself before his body to display the very materiality and density of the human flesh.

In the various biographies and eulogies written about Dürer after his death, the physical perfection of his hands was a recurrent theme. It was invoked as the centerpiece of

larger paeans to his beautiful appearance as a man. Thus the great philologist Joachim Camerarius (1500–1574) writes in the preface to his 1532 Latin translation of Dürer's *Proportionslehre*: "Nature bestowed on him a body remarkable in build and stature and not unworthy of the noble mind it contained. . . . His head was intelligent, his eyes flashing, his nose nobly formed and, as the Greeks say *tetragonon*. His neck was rather long, his chest broad, his body not too stout, his thighs muscular, his legs firm and steady. But his fingers—you would vow you had never seen anything more elegant."[3] At one level such praise of Dürer's appearance merely repeats the traditional Christian metaphysics of beauty, which equates the beautiful with the good and true and the ugly with the evil and false.[4] Yet Camerarius's preface is more than simply an idealized character portrait of Dürer. The description of the artist's looks is the first term of an argument that proceeds ineluctably from the perfection of his body, through the nobility of his character, to the perfection of his art. The aim of this is to establish the unity of the artist and his works, a unity affirmed by Camerarius in the very act of writing an artist's biography (a novel project in Germany at 1532) and emblematized by Dürer *as* self-portraiture.

"The nature of a man," Camerarius writes, "is never more certainly and definitely shown than in the works he produces as the fruits of his art. What single painter has there ever been who did not reveal his character in his works?"[5] According to this account, any work of art will be a kind of self-portrait. If pictures are "obscene" (*obscenitate pingendi*), so too were the "minds and fingers [that] made such works." If the art is beautiful and perfect, as in Dürer's case, then its maker himself was morally and physically beautiful. In Camerarius, the artist's hand is the privileged site of such interpretive displacements, such movements from art to artist, from created object to creative subject, for it is here that the artist's body engages physically with the thing it produces. When Camerarius deduces that a painter's "fingers" were "obscene," he turns the painting's subject matter, its indecent spectacle, back onto its maker through that bodily conduit between work and author. The artist's very flesh is implicated in the things it produces.

During this period, there are artists who themselves assert an equivalence between a corrupt scene they depict and the corruption they are. Baldung's macabre and erotic art is one example, and we shall explore its links to Dürer's self-proclaimed perfection. Another example is a chalk drawing of a dying woman from about 1518 by the Swiss artist Niklaus Manuel Deutsch (1484–1530; fig. 72). The wound on the woman's breast, possibly identifying her as Lucretia, is linked through her gaze, and through a lock of her hair, to a dagger or *Schweizerdolch* at the upper right, which is Manuel's own personal device.[6] Lucretia committed suicide after she was raped.[7] Given the obvious sexual associations of the dagger and the vertical wound, it seems that Manuel, present both in his personal device and in his monogram (NMD to the left of the dagger), has deliberately implicated himself in the story he depicts. The specific plot of this entanglement of the artist in his image does not yet concern us. I would note, however, that the *physical* link between the woman and Manuel's dagger—the animated lock of hair—reads also as an extended calligraphic flourish below the artist's name, and that Manuel's *Schweizerdolch* appears as the sketching instrument. The graphic mark, in whose specific signature the hand of the

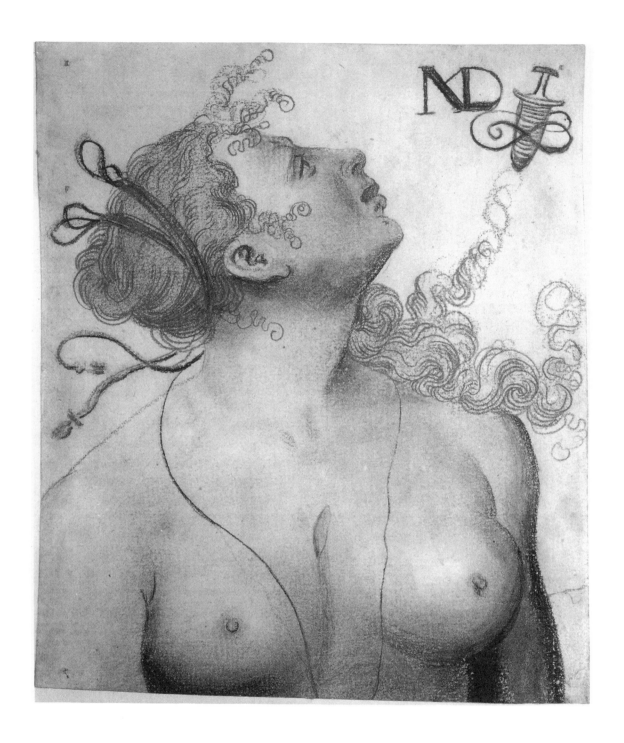

72. Niklaus Manuel Deutsch, *Bust of Dying Woman (Lucretia?)*, c. 1518, colored chalk and charcoal, Kupferstichkabinett, Kunstmuseum, Basel.

individual artist is manifested, connects the work of art to its maker. In German and Swiss art of the early sixteenth century, this connection has its formal source and theoretical exposition in Albrecht Dürer. Manuel's sketch is a sexualized and perhaps even comically exaggerated version of Dürerian self-portraiture and graphic style.

Camerarius follows his description of the physical beauty of Dürer's hand with a statement of its skill in executing works of art: "What shall I say of the steadiness and exactitude of his hand? You might swear that rule, square, or compasses had been employed to draw lines, which he, in fact, drew with the brush, or very often with pencil or pen, unaided by artificial means, to the great marvel of those who watched him."[8] The ability to draw straight lines and perfect circles without artificial aids is a common topos of artists' biographies, appearing in legends of figures as diverse as Giotto, Beccafumi, and Wu Tao-tzu.[9] It often asserts that the artist possesses a certain personal, quasi-magical power (Dürer calls it *gwalt*, or "power")[10] that can be neither learned nor imitated. In Camerarius, anecdotes of Dürer's manual dexterity function to extol Dürer's particular qualities as an artist: "Why should I tell how his hand so closely followed the ideas of his mind that, in a moment, he often dashed upon paper, or, as painters say, composed, sketches of every kind of thing with pencil or pen." This ideal of sketching quickly and accurately anything one sees belongs, we recall, to Dürer's reassessment of the role of drawing in the painter's craft. Dürer recommends that aspiring artists sketch from life in order to achieve "a hand practiced to almost perfect freedom,"[11] by which he means a body perfectly trained and obedient to what the artist sees and thinks. Camerarius's description of the artist sketching what he invents in his imagination also echoes Dürer's celebration of art as "pour[ing] forth . . . something new,"[12] and anticipates mannerist art theory, with its stress on personal interpretation of nature over slavish imitation.[13] And by observing how Dürer's pen perfectly expresses his mind, Camerarius celebrates in a new way the capacity of the artist's hand to reveal his person. Drawing freehand, without artificial aid, previous sketch, or natural model, is more than simply a display of skill. It is a mode of self-revelation. Just as the physical beauty of Dürer's hand revealed and glorified the artist's person, so too shall the beautiful works of that hand.

Camerarius's interest in the dexterity of Dürer's hand, and therefore in his particular strength as a draftsman, is predicated on a new taste in the North for artist's sketches as independent, and therefore collectible, works of art. Dürer theorized this taste earlier than anyone when he declared, in his "Aesthetic Excursus," that the hasty drawing of a great master is worth more than the most meticulously finished panel painting.[14] What is valued in something "dashed on paper," as Camerarius puts it, is that in the freedom and spontaneity of the artist's hand, the inimitable and specific talent of the painter emerges in the form of a personal style. In Camerarius this aesthetic belongs not only to drawing, but also to painting:

> This consummate artist's mind, endowed with all knowledge and understanding of the truth and of the agreement of the parts one with another, governed and guided his hand and bade it trust to itself without any other aids. With like accuracy he held the brush, wherewith he drew the smallest things on canvas or wood without sketching them in beforehand, so that, far from giving ground for blame, they always won the highest praise.

A painting fashioned without previous sketches or underdrawings wins praise not because of the time and labor expended in making it, but because of the skill required to produce an image quickly, correctly, and effortlessly, without the toil that lesser talents make visible in their works.[15]

As well as articulating an aesthetic and cultural ideal, Camerarius refers here to a specific technique of painting practiced intermittently in the North in the fifteenth and sixteenth centuries: namely, the *alla prima* method, in which a picture's visible surface is completed in one session and with such opacity that whatever lies beneath, as underpainting or preparatory sketch, will not modify the picture's final effect. Because it was less time consuming than building a surface of multiple, overlayered transparent glazes on a ground of color and outline (the technique of *Feinmalerei* evident, say, in Jan van Eyck) *alla prima* painting was sometimes used in subordinate surfaces of a large work (e.g., the rear, outer wings, or frame of a retable altarpiece) or else in certain painted passages meant to be distinguished, for one reason or another, from the rest of the work. In the great *Coronation of the Virgin* from 1454, now in Villeneuve-lès-Avignon, Enguerrand Charonton (c. 1410–1461) depicts the three zones of the world through three different scales and painterly modes (fig. 73). At the top, the monumental group of Mary and the Trinity is fashioned in broad areas of basic colors against a sacral gold ground; in the middle register, figures of saints above an earthly landscape appear rendered in more variegated colors and without the gold; and below, as the cosmic underside and *bas-de-page*, the tiny figures in hell and purgatory are painted *alla prima*,[16] as if expressing their ontological emptiness in the thinness of their painted likeness. Hieronymus Bosch, the master of hellish drollery, worked almost exclusively *alla prima*. This had to do with both his artistic beginnings in the craft of manuscript illumination and his radical revision of the techniques and subjects of northern Netherlandish panel painting.[17] *Alla prima* painting functions to destabilize and dematerialize the forms Bosch portrays. And as a "base" form of painterly labor put to a lofty end, it belongs to Bosch's general tactics of inversion, in which the high is rendered in a humble style and the low (demonic drollery, popular wisdom, and the domain of the body) is elevated to the privileged center of art: the retable altarpiece.

In the story of Dürer's painting directly on panel or canvas, Camerarius grants the *alla prima* method a specific significance. Because it is quick and spontaneous, such painting demonstrates that the artist's creative hand is guided by neither previous models nor sketches nor artificial aids, but rather by his internalized knowledge of truth (*cognatione et intelligentia veritatis*). Where previously peripheral surfaces had been painted *alla prima*, for Camerarius's Dürer this method becomes a vehicle of self-display. The spontaneous marks of paint preserve the history of the artist's bodily gestures as they are commanded by his mind. Far more than *Feinmalerei*, which conceals this history under layers and layers of glazes, painting *alla prima* reveals "the nature of the man." This is useful for Camerarius, who himself writes in a genre—artist's biography—that usually assumes that art can be understood as the expression of an artist's person. In my account of the Erlangen *Self-Portrait* (fig. 1), I observed how this idea of the presence of the self in its

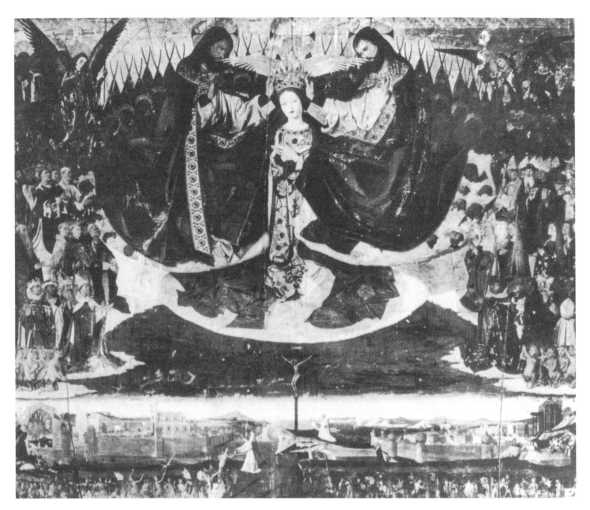

73. Enguerrand Charonton, *Coronation of the Virgin*, 1454, oil on panel, Musée de l'Hospice, Villeneuve-lès-Avignon.

works emerged, in German art, within Dürer's practice as a draftsman, and further, how self-portraiture became a reification of this idea. This all informs Camerarius's emphasis on draftsmanship and his thematization of the artist's hand. But what of Dürer's actual practice as a painter?

Unlike the Erlangen sheet, which celebrates the gestural quality of the line, the 1500 *Self-Portrait* carefully conceals brushwork, displaying to the viewer a smooth, uniform surface magically transparent to its subject. In its proportioned and geometrical composition, Dürer's likeness is the veritable antithesis of painting without plan, prefiguring instead his later labored constructions of the idealized nude drawn, as he puts it, "with ruler and compass." Moreover, in *alla prima* painting as described by Camerarius, the image displays its manufacture by human hands. The Munich panel's allusion to the

acheiropoetos contradicts this aesthetic of the spontaneous line. And Dürer's actual painting technique follows the laborious procedures of *Feinmalerei* as established in German and Netherlandish shops by the end of the fifteenth century.[18] In this procedure a panel was first prepared with a thick layer of gesso and inscribed with ink or black tempera indicating the main contours of the image. Over this was placed a resinous oil and often another underpainting, again in tempera. Then came a full tempera underpainting to establish the sculptural forms. Finally the artist applied the thin glaze priming or *imprimatura* upon which layer after layer of transparent oil pigments would be placed.

Dürer executed virtually all of his extant panel paintings in this time-consuming fashion, but in the decade following the 1500 *Self-Portrait* he began to find such labor burdensome and unprofitable. Dürer's letters of 1508–1509 to his patron Jacob Heller document the artist's growing resistance to the traditional demands of his trade. Responding to charges that he has breached his promise to paint an altarpiece for Heller, Dürer writes: "You further accuse me of having pledged to you that I should make the panel for you with the greatest possible diligence that ever I could. This I certainly did not say, unless I was out of my mind. For I hardly trust myself to finish such a thing during my whole lifetime. With such great care I can barely finish one face in half a year. And your picture has one hundred faces in it, not counting drapery, landscape, and other things that are in it."[19] Although elsewhere he advises young artists to work "diligently" (*fleysig*) on all areas of a painting, Dürer here concludes, hyperbolically, that to fulfill his patron's demand for "greatest possible diligence" (*allerhöchsten fleiß*) he would have to spend more than a lifetime on that single job. Taking literally his patron's loosely meant superlative *allerhöchsten*, Dürer voices sarcastically his irritation with painting on commission. Nevertheless, in the months following this letter, he successfully completes Heller's altarpiece and soon begins work on an even more ambitious panel, the *Landauer Altarpiece*, commissioned in 1508 and completed in 1511 (fig. 49). Both these paintings are executed in the usual laborious technique of *Feinmalerei*. The 1500 *Self-Portrait* lies presumably in the very highest range of Dürer's personal scale of painterly care and would therefore have taken something under "a half year" to complete. In other words, anything but a work produced *alla prima*.

There are areas of Dürer's output where he demonstrates the values of quickness and spontaneity celebrated by Camerarius. Images executed in watercolor and body color on paper are one important example.[20] In the *Pond in the Woods* from about 1496, in the British Museum, Dürer applies his brush directly to the sheet largely without any previous sketch or preparatory ground (fig. 74). This allows him to rethink his composition in the midst of his labors. Dürer planned a group of trees at the left of the scene. Yet these were abandoned when, while he painted, there suddenly appeared the dramatic spectacle of orange and blue clouds.[21] Instead of executing the second group of conifers that would properly balance his composition, Dürer opened the left side of his sheet to a sky rendered in loose, broad strokes. Here, as in most of his watercolors, painting aspires to the freedom and spontaneity of drawing.

Other artists working under the spell of Dürer's early graphic style (known chiefly

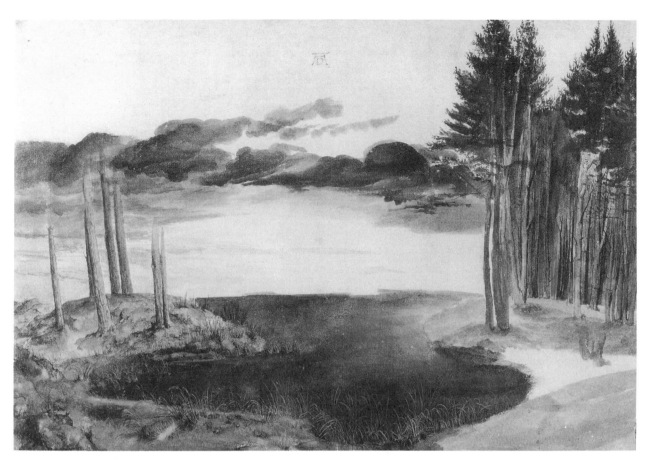

74. Albrecht Dürer, *Pond in the Woods*, 1496, watercolor and body color, British Museum, London.

from his woodcuts and engravings) produced panel paintings in this manner. Lucas Cranach the Elder, during his youthful Sturm und Drang period in Vienna (1502–1504); Albrecht Altdorfer from about 1506 to 1518; Wolf Huber and many other painters of the "Danube school"; Swiss masters like Urs Graf, Niklaus Manuel Deutsch, and Hans Leu the Younger; and Baldung, in certain of his works—all work *alla prima* in oil on panel. And all cultivate their spontaneous painterly manner in other new and suitably calligraphic media such as color-ground drawing and watercolor on parchment.[22] Theirs is the real revolution in German Renaissance panel painting, in which the medieval workshop practice of *Feinmalerei* is replaced by a gestural and highly personal oil painting style akin to sketching. Although Dürer is absolutely foundational to the style and the artistic careers of these masters, he himself executes his panels in a more traditional manner.

Camerarius, however, writes a different story of Dürer's painting technique:

Almost in awe have we gazed upon the bearded face of the man, drawn by himself, in the manner we have described, with the brush on the canvas and without previous sketch. The locks of the beard are almost a cubit long, and so exquisitely and cleverly drawn, at such regular distances

and in so exact a manner that the better anyone understands art the more he would admire it and the more certain would he deem it that in fashioning these locks the hand had employed artificial aid.[23]

Camerarius refers here to nothing other than the 1500 *Self-Portrait*, which by 1532 was probably displayed in the Nuremberg town hall. Leaving aside his perceptive remarks about hair in Dürer's panel, it seems that Camerarius believes—or wants us to believe—that this painting, so clearly the product of meticulous planning and *allerhöchsten fleiß*, was produced spontaneously and "without any previous sketch." Indeed the *Self-Portrait* stands as Camerarius's only example of the *alla prima* technique deemed central to Dürer's achievement. This is the consequence less of the actual nature of Dürer's panel than of Camerarius's larger argument concerning the relation between artist and work as mediated by the agency of the hand. Rather like the Erlangen *Self-Portrait*, the Munich panel seems to conjoin, for Camerarius, the "bearded face of the man" with the originary power of his hand. The painting, combining face and hand, artist and work, becomes the prosopopoeia for Dürer's art as a whole. In it "the nature of [the] man is never more certainly and definitely shown."

To the myth of representation afforded by the *acheiropoetos*, we must thus add another legend: Camerarius's account of the *Self-Portrait* produced without the preparatory labor expended by lesser talents. The two myths are complementary. Camerarius notes that "to anyone who understands art," the panel would appear to be fashioned with "artificial aid." Yet by asserting its origin in a free, mobile, hand-held brush, he hyperbolizes its sole source in Dürer's body. What is magical about the *Self-Portrait* is that while it may appear as if "made without human hands," it is quintessentially *cheiropoetos*. By insisting on the immediacy of Dürer's relation to his product, Camerarius proclaims a deeper kind of *praesentia* for the artist in his work. The *Self-Portrait* not only represents the artist's appearance as the artist but will be somehow his body's own characteristic deposit or imprint—a contact relic akin to the sudarium itself. And in Camerarius, as in myths of the *vera icon*, the body's synecdoche is the hand.

Some years later, Camerarius invoked Dürer's hand to make an even more extravagant claim for the artist. In the *Elementa rhetoricae*, published in 1541 and intended as a textbook for students in Tübingen, he set forth some twenty categories of rhetoric through a series of literary *exempla* either culled from ancient sources or composed by himself.[24] One example, clarifying the concept of *descriptio* or *ecphrasis*, takes the form of a short essay on Dürer's 1514 *Melencolia* engraving (fig. 14). Camerarius's description begins: "Albrecht Dürer, the most accomplished artist, from whose divine hand [*diuina manus*] many immortal works still exist, represented in the following manner the emotions of a deep and thoughtful mind which are called melancholic."[25] Praise of an artist's hand is original neither to Camerarius nor to the Renaissance. Already in the twelfth century, Abbot Wilbald of Stablo could hurry a sluggish goldsmith by flattering his genius and the skill and fame of his hands: "your well-known genius, your lively and illustrious hands."[26] Camerarius transforms this commonplace by his use of the adjective "divine," which links

75. Michael Wolgemut (shop), *Fourth Day of Creation,* woodcut illustration from Hartmann Schedel, *Nuremberg Chronicle* (Nuremberg: Anton Coberger, 1493), fol 4.

Dürer's hand to the hand of God. The *divina manus* as instrument of creation is represented frequently in medieval art, often appearing from the cloud of heaven, as in the woodcut illustration of Schedel's *Nuremberg Chronicles* discussed in chapter 5 (fig. 75).[27] Camerarius's analogy between God's hand and the *divina manus* of the artist, however, is without precedent. Indeed while the phrase *divinus poeta* occurs occasionally in classical and medieval literature, as far as I know, painters are never termed "divine" before about 1500.[28] William Heckscher has emphasized that the Dürer epithet in Camerarius's *Elementa rhetoricae* predates most Italian instances of this adjective as applied to painters and is the first time Dürer is thus described.[29] Of course Camerarius's sentiment was already expressed visually by Dürer's 1500 *Self-Portrait*, which represents the artist in the image of God and displays at the base of his panel the tool of his divine trade. Let us dwell on Dürer's hand a moment longer, though, and consider arguments for its divinity.

Dürer's hand plays an important figurative role in a long funerary poem by the neo-Latin poet Helius Eobanus Hessus (1488–1540), composed only days after the artist's death.[30] *In funere Alberti Dureri Norici* is an epicedium, a song of mourning in praise of the dead, sung as if in the presence of the corpse. Near the beginning of the poem, Hessus turns to the cadaverous hand of Dürer and addresses it thus:

> Horribly discolored lies now the hand that completely understood
> All that color can do, all that one can teach about color.
> Now faded are the fingers that once had the hue of roses,
> Roses that, when it was pleasing, these fingers could apply to ivory.

Who now, O Albrecht, could equal what you have painted?
Who will it be who will be capable of being your successor?
Nature itself, it seems, mourns your death,
Nature whom you were virtually able to renew with your learned hand [*docta . . . manus*]![31]

Speaking from a position at the threshold, as a living voice to the corpse of the deceased, Hessus constructs his apostrophe as passages between life and death, art and nature, beauty and ugliness. The poet laments that Dürer's hand lies dead, yet he attributes to it a renovative power, for it can make mortal nature into eternal art. This is the primal myth of the Renaissance: Dürer, of whom Hessus can say, "Artifice Albertus maior Apelle manu" (1.14), revives antiquity by resurrecting nature through his art.[32] Hessus's own artistry in the epicedium will itself be guided by this principle, seeking to resurrect its object (Dürer) through immortal poesy.

The passage on Dürer's hand imagines rebirth in the figure of ivory roses. Dürer's living fingers, the color of roses, once themselves fashioned roses on ivory, which is to say, mortal nature in eternal art. Hessus's poem lets all that hands can do or know reflect back upon the hand itself. In the deceased artist's "pale" fingers we discover another work of art: Dürer's once rosy hand refashioned in ivory. White and hard, ivory is akin to bone and to the cadaver. It is also a symbol of Christ, referring to the incorruptibility of his body in the tomb, hence the custom of carving crucifixes in ivory. In Hessus it becomes the perfect image of transfiguration from abject corpse to beautiful and indestructible art: the artist's cadaverous hand is replicated in ivory as a kind of relic. Dürer, of course, had already thus embalmed his hand in *propriis coloribus* at the base of his proleptic epitaph, the 1500 *Self-Portrait*.

Hessus monumentalizes Dürer's hand because of its creative powers. Able to renew nature, it imitates God's divine hand, which is what Camerarius asserts some thirteen years later in his *Melencolia* interpretation. What is fascinating in Hessus is how the metaphorization of the hand is carried out in the presence of the Dürer's decomposing corpse. What is asserted for this macabre, "horribly discolored" hand? Essentially, that it was once beautiful, with fingers the color of roses, and that it could, in turn, create beauty, knowing all that color can do. More powerfully even than Camerarius, Hessus conceives of the artist's hand as the site of an exchange. Stationed as bodily medium between artist and work, the hand negotiates between Dürer as subject who *knows beauty* and his art, which *is beautiful*. Appropriately enough, therefore, Dürer's hand is itself ideally beautiful, just as it is also possessed of the idea of the beautiful.[33]

Dürer contemplated his own hand in a similar fashion. In a sketch from about 1513, the artist draws, measures, and calculates the proportions of his left hand as it lies flat with its fingers extended (fig. 76).[34] The work belongs to a large group of preparatory drawings for Dürer's treatise on human proportion, which were bound in an album and are kept now in Dresden. The *Left Hand* is thus part of the project that occupied Dürer from about 1500 until his death, namely, the measurement and construction of ideal human figures as embodiments of beauty. The Munich *Self-Portrait*, based as it is on the proportions of the northern Holy Face[35] and endowed with the *pulchritudo* of Christ,

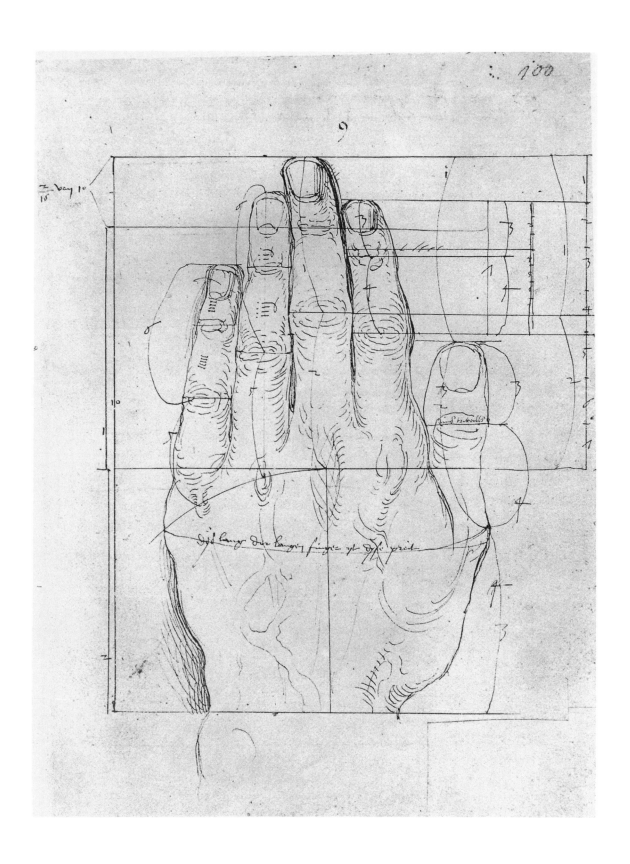

76. Albrecht Dürer, *Dürer's Left Hand*, 1513, pen and ink, from "Dresden Sketchbook,"
Dresden, Sächsische Landesbibliothek, MS. R-147, fol. 100r.

represents an inauguration of Dürer's interest in callistics and anthropometry. After 1500 the artist shifts from idealizing real models (especially his own person) to fabricating more abstract, generalized human "types," as in his late woodcut illustration for the *Four Books on Human Proportion* (fig. 77).[36] The Dresden *Hand* appears as a curious intrusion of the artist's own body into what had become, by 1513, an intentionally depersonalizing, departicularizing project.

The sheet takes the form of a contour drawing embellished with indications of surface detail and overlaid by measurements: ruled and divided lines, numbered units, and two brief inscriptions summarizing the proportions of the hand. This is nothing like the hands of the Erlangen and Metropolitan sheets—those fully three-dimensional objects held at an angle to the eye and articulating an eccentric pose (figs. 1 and 2). The Dresden sketch depicts Dürer's hand less as it is *seen* than as it might be *traced*, lying flat on the page. We know of such images from cave paintings, children's art, and the walls of public places. One hand, placed flat against a surface, is outlined by some writing instrument wielded in the other, creating an image by touch, not sight. Afterward internal details may be added, such as nails, wrinkles, and veins. Yet these belong to a mode of depiction different from the original tracing of the hand. A hand silhouette is less a picture than a primal imprint of the body onto the world. In C. S. Peirce's terms, it is simultaneously an *icon* resembling its object and an *index* causally connected to that object it resembles.[37] This gives it its meaning. As signature, autograph, or affirmation of presence, it says, "I was here." Perhaps that is why, more than any of his self-portrait likenesses, Dürer's Dresden *Hand* appears uncannily like a physical relic of the artist. His meticulous attention to the free margin, nail, lunule, and cuticle at the end of each finger, for example, appears as work performed directly *on* the body: drawing as adornment of the hand; visual detail as cosmetic. How does Dürer's work on his hand serve the larger project of human proportion?

For one thing, variations among the fingers themselves, their different sizes, shapes, and wrinkle patterns, prove a point about the individuality of each particular hand, and therefore of each particular body and person. In his *Four Books on Human Proportion* (1528), Dürer writes: "It is to be noted that in the hand no two fingers have the same form. Anyone who observes people will find this is so. I have also proved that if the hand is stretched out, the fingers do not stand straight beside each other, but shift themselves outward at the little finger."[38] Dürer's own hand demonstrates that the index and middle fingers can point inward slightly—a peculiarity already visible in the artist's left hand as it appears in the 1500 *Self-Portrait*. Beyond teaching the structure of specific hands and bodies, however, the *Proportionslehre* struggles with the problem of specificity per se. By observing individual bodies, Dürer learns that, like the fingers of a hand, no two persons are ever alike. This heterogeneity, this fall into the particular, threatens any system that seeks to generalize human proportion from specific cases. Throughout his writings, Dürer observes this threat on the twin fronts of object and subject. No single person's body can *be* representative of a type, and therefore there is no living embodiment of the beautiful, for all particular cases are divergences from an ideal. And no one will ever *know*

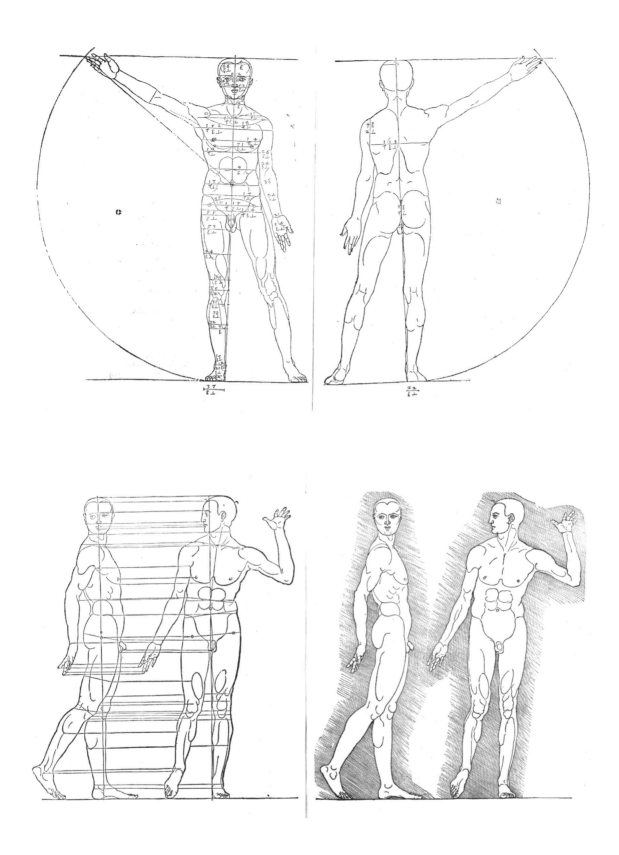

77. Albrecht Dürer, *Constructed Nude,* woodcut illustration for *Vier pucher von menschlicher proportion* (Nuremberg: Hieronymus Andreae, 1528).

beauty absolutely, for each person has only a limited, relative access to the ideal. As Dürer himself puts it most succinctly: "There lives on earth not one beautiful person who could not be more beautiful. There also lives on earth no one who can say or show how the most beautiful form of a person should look."[39] Dürer explains this absence of absolute beauty as a consequence of the Fall. In the "Aesthetic Excursus" he writes: "For the deception is in our cognition, and darkness lies so stubbornly within that our feeble gropings also fail."[40] This is the pessimism that Panofsky regarded as the tragic under-song of the *Melencolia* engraving (fig. 14).[41] The beautiful is, and always shall be, inaccessible to man; and artists can only offer relative improvements, better things that will never be the best. Hence Dürer's lapidary statement: "What beauty is, however, I do not know.[42]

And yet, introducing his own left hand into the project of idealized man, Dürer seems to counteract such pessimism. Superimposed upon the outlined hand in the Dresden sheet are a number of lines, all drawn with a ruler, that locate and measure the hand's main structural units. These markings themselves already presuppose abstraction, since many define units that have no correlation with the body's own division.[43] Thus, over the sketchy lines and hatchings that render each knuckle, Dürer draws a short line hypothesizing a center point. Having established this marker, he can measure its distance from other such markers and calculate size relations among the various parts. Dürer practices on his own hand the venerable science of anthropometry, known to the West at least since Polyclitus, practiced throughout the Middle Ages (e.g., Villard de Honnecourt), and established on new theoretical grounds by Italian theorists like Leon Battista Alberti and Leonardo da Vinci. Dürer seeks, that is, to establish "the mathematical relations between the various members of a living creature, in particular of human beings, in so far as these are thought of as subjects of artistic representation."[44] Founding the fundamental unit of measure in the proportion of his own fingers, he can transfer it from finger to hand and from hand to forearm, and so on until he has constructed an entire body.

In another drawing, Dürer constructs a smaller hand with the same proportions as his own hand in the Dresden sheet (fig. 78).[45] This time, though, the body exhibits a far more abstract quality: the artist's hand has been elevated to a rule. Indeed, as Kurt Gerstenberg has shown, the drawing *Dürer's Left Hand* (fig. 76) will serve as an essential measure for all bodies published in the *Proportionslehre* of 1528, even though its proportions are rather anomalous.[46] The artist discovers, for example, that the width of his hand is equal to the length of the middle finger (hence the inscription on the back of the hand: "This length of the long finger is this width"),[47] an arrangement found only in exceptionally long-fingered persons. And his remark on the width of his thumb—"This is three units"—holds true only for large-jointed fingers. Yet these are precisely the proportions that determine the measurements of all Dürer's ideal, "beautiful" types.

Represented, measured, and abstracted, Dürer's hand enters into a canon of beauty. That it is specifically his *hand* that should thus circulate as measure follows from its mediative position between artist and work. The myth of Dürer's hands as beautiful and beauty-creating creations emerges within the painter's own desire to unite himself with

his productions, to render the individual person one with his labor. This desire motivates Dürer's inscription on his Raphael drawing, where he asserts that the Italian master sent him his work "to show him his hand." And it is mirrored in the new aesthetic, interpreting the nascent taste for artists' sketches, which determines the value and meaning of a work according to the individual who made it, and who, in making, reveals himself. As we shall see, Dürer's desire also responds to changes in the real conditions of artistic labor at 1500. The development of an art market transforms the way Dürer's society values a painter's work as well as how artists organize themselves as workers, producers,

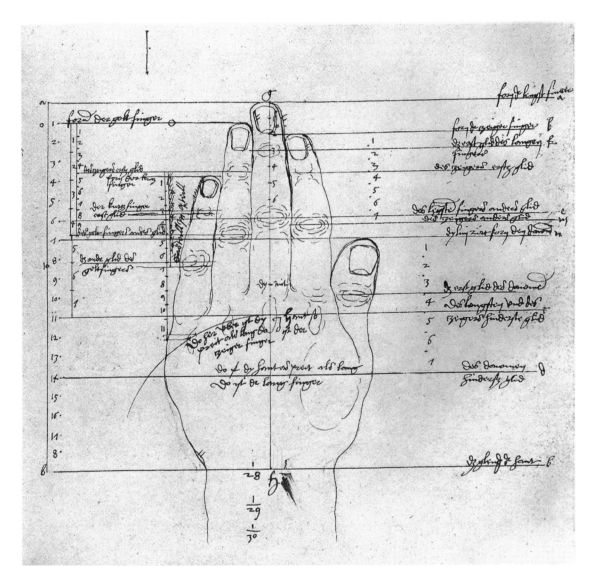

78. Albrecht Dürer, *Constructed Hand*, 1513, pen and ink, from "Dresden Sketchbook," Dresden, Sächsische Landesbibliothek, MS. R-147, fol. 96.

and entrepreneurs; and the technology of printing, allowing German painters new economic and artistic opportunities, alters the way the artist's hand is present in its products and refigures relations between image and maker, producer and public. Dürer not only experiences and reacts to these broader changes, to a surprising degree he also personally shapes their manifestation, and their future vicissitudes, in German art production. What I wish to emphasize here, however, is that celebrations of Dürer's hand are also partly models of labor. They idealize the exchange between person and product for a new era of merchant capitalism in Germany. To say of Dürer's hand that it both *is* beautiful and *makes* beauty is at once to transform Dürer's body into a work of art and to insist that his art be read as the immediate product of the body.

The unity of artist and image, of course, is self-portraiture's general claim, and it finds its most monumental instance in Dürer's 1500 panel. At once man and god, *imago* and creative prototype, representation and representer, the artist establishes himself as beautiful object. Where in the Dresden *Hand* the particularity of Dürer's real body is measured and installed within a general canon of beauty, here Dürer subsumes his real body under

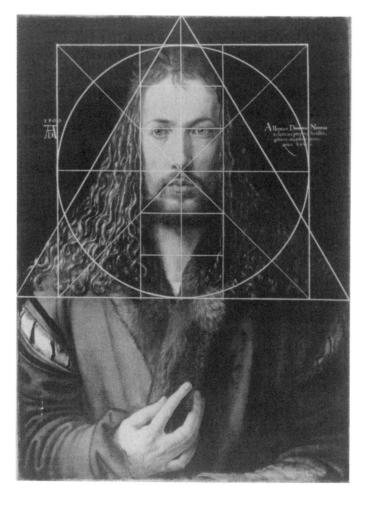

79. Albrecht Dürer, *Self-Portrait,*
1500, with system of proportions
(after Winzinger).

a traditional system of ideal proportions. The particulars of this system have already been worked out by other scholars, so I need not rehearse them in detail here. Suffice it to say, Dürer's likeness adheres to a geometric scheme established for portraits of Christ such as we saw in Jan van Eyck's *Holy Face.* Dürer transfers Christ's proportions to his own person in order to express his status as *imago Dei* (figs. 54 and 79).[48] This procedure threatens the panel's simpler status as portrait. For the more Dürer submits his painted likeness to a universal *exemplum*, the less it will resemble himself. In the 1500 *Self-Portrait*, in fact, Dürer looks less like his likenesses in the Louvre, the Prado, Erlangen, and the Metropolitan than all these earlier likenesses look like each other. And when critics discover Dürer's face in his various post-1500 pictures of Christ, one wonders whether this is simply because the Munich panel is already so little Albrecht Dürer and so much a Holy Face. The payoff of this exchange of mimetic accuracy for self-flattery is clear. The analogy between self and God rests on the double status of the *imago:* as subject capable of perfect creation and as perfectly fashioned creature.

The question of the boundary between the creator and his image is raised at the painting's lower edge. Dürer's right hand may indeed be absent from the image, vanishing where it would emerge from the picture's space into our world. And if we follow closely the visual plot of the *Self-Portrait*, this hand should be busy at work fashioning the panel we see before us—a *divina manus* that, instead of descending into sight from behind a covering cloud (fig. 75), disappears into our world below the painting's illusion. Yet Dürer's hand, absent from the visual field, is present *as* the 1500 *Self-Portrait.* This resurrection of the hand in its works is literalized in the prominently displayed left hand that lifts itself as beautiful object above the void at the picture's base. One could say, then, that in this panel Dürer "shows [us] his hand." Yet through the magic of his art, which conceals all signs of human making, he also makes that hand disappear. This play of presence and absence, or *cheiropoetos* and *acheiropoetos*, is staged for us in the caesura at the picture's base, at the image's clean cut between Dürer's right and left hands and between his two aspects as creator and creature.

8

The Hairy, Bearded Painter

Dürer does not simply display his left hand at the center of his chest. The index and middle fingers turn inward toward his body, pushing up between them a small tuft of fur from the lining of Dürer's elegant coat or *Schaube* (fig. 80). This tuft, returning the touch of the artist's exploring fingers and silhouetted against their flesh, is the climax of Dürer's painting. There is nothing quite so alien to the kind of image mythicized by the *vera icon* as this sensual episode of exploration, this little adventure of the represented body into the material of its world. The very possibility that this lapse of symmetry and total visibility might have occurred "by chance" only intensifies the *Self-Portrait's* divergence, here, from the hieratic order of the cult image. To imagine that the hand, resting against the sitter's body, has unintentionally displaced the tuft of fur is to introduce into the moment of self-portraiture an element of contingency. At the very least, it gives us occasion to distinguish between Dürer as human sitter, idly fingering the fur of his coat as he tries to maintain his stiff pose, and Dürer as emblem of the *imago Dei*.

Dürer's fingers seem to touch or rest against the fur but not quite grasp it. This indeterminacy destabilizes all lines of force within the painted world. In our initial encounter with the Munich panel, we feel ourselves addressed directly by the artist's gaze. Once we notice the tuft of fur, however, and entertain the notion that Dürer is absorbed not in what he sees but in what he touches, that gaze will draw away from us, becoming a blanker stare. Touching the fur signals the sitter's interiority; it draws him inward toward his body as into his "self." His attention no longer seems focused on us as viewers or, within the plot of self-portraiture, on himself in the mirror. It is fixed on something within: the heart, perhaps, whose location within Dürer's models of human proportion corresponds to the tip of his outstretched index finger in the Munich panel.

There would be sense in this referent. As Klaus Jürgens has argued in his excellent analysis of the geometry of the 1500 *Self-Portrait*, the distance from the bottom of Dürer's chin to his finger/heart equals that from his chin to the top of his face; and the finger/heart marks the lowest point of a perfect hexagram whose upper intersecting equilateral

triangle is defined by the outlines of Dürer's hair (see fig. 68). Jürgens explains Dürer's conceit through passages in Exodus, in which God endows the artisans of the tabernacle and the ark with wisdom, understanding, and skill, placing these powers "in the heart" (*in corde*; Exod. 31:6; 33:34; 36:2). Dürer pictured such an infusion in his title-page woodcut for Celtis's *Quatuor libri amorum* (Nuremberg, 1502). There a scroll with Greek letters—culminating in the AD monogram—unrolls from the heart of the enthroned, en face Philosophia, who in a verse inscription says of herself that fire, earth, air, and water, and everything that is done by man and God, are "all encompassed in my breast." By including his monogram on Philosophia's scroll, Jürgens concludes, and by designing his Munich *Self-Portrait* around his own heart, Dürer claims his art to be similarly God-given and all-encompassing. One could take this argument a step further and invoke a central passage in Dürer's theoretical work where he refers to the divine contents of his heart. In the "Aesthetic Excursus," Dürer writes that "art" (*Kunst*), understood as theoretical know-how, lies embedded in, and therefore must be extracted from, nature—hence the importance of sketching from life. Geometry can determine much in a work, but the work's success depends finally on its truth to nature. And anyway nothing can be made except what God, in his creative nature (*natura naturans*, as it were) has already allowed. For this reason

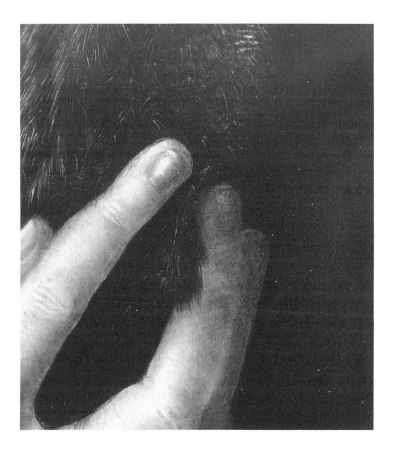

80. Albrecht Dürer, *Self-Portrait*, 1500, detail of hand and fur.

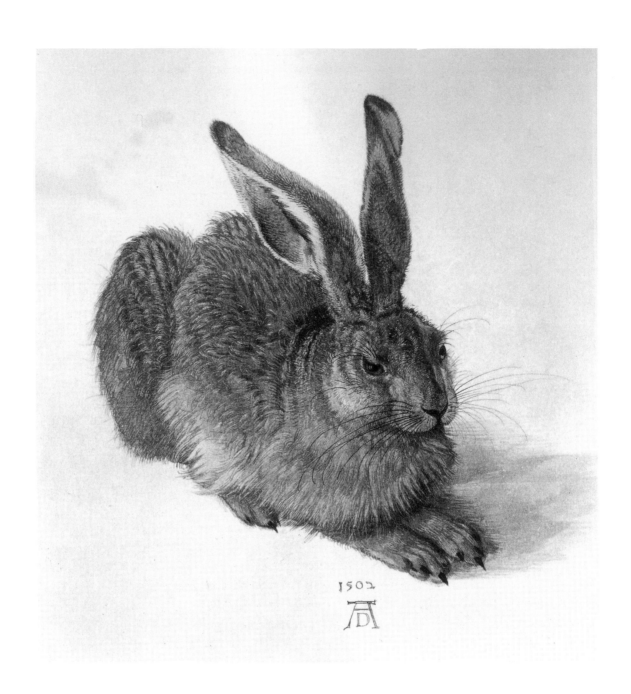

81. Albrecht Dürer, *A Young Hare*, 1502,
watercolor and body color heightened with white,
Graphische Sammlung Albertina, Vienna.

it is determined that no man can ever again make a beautiful image from his own thoughts, unless he has filled his mind with such things through much copying [from nature]. This is then no longer to be called his own but has become acquired and learned art [*kunst*], which sows, waxes, and bears fruit after its own kind. Out of this the gathered, secret treasure of the heart [*der versamlet heymlich schatz des hertzen*] will be revealed through the work, through the new creature which a person creates in his heart in the form of a thing.[1]

The heart is a treasure chest or *Schatzkammer* wherein nature, internalized in the draftsman's work, is distilled and abstracted as art. The artist's secret, therefore, lies neither in external nature nor in the laws of geometry but in the innermost core of self, where practice and theory, perception and imagination are uniquely mediated. In the 1500 *Self-Portrait*, then, a work that combines geometry and naturalism to celebrate the originary power of born genius, Dürer's finger aims at this heart whose secret treasure romanticism will learn to call "experience" (*Erlebnis*).

There are, of course, simpler readings of the gesture. In the fur that his finger displaces, Dürer dazzles us with his attention to the visible surface of things. Not only does he capture the subtle play of tones generated by the fur as it is seen at different angles; the fur, highly variegated in color, thickness, and texture, conveys fully the sense that it has been taken from some particular animal with a particular anatomy. In this the Munich *Self-Portrait* belongs to Dürer's animal and plant studies, such as the famous *Hare*, dated 1502 and now in the Albertina (fig. 81; W. 238). In the *Self-Portrait*, Dürer allows his own hand to manipulate the fur, thereby fulfilling the impulse of a viewer who, astonished by the picture's naturalism, might wish to reach out and touch the represented object. The trompe l'oeil aspect of the Munich panel is celebrated in a contemporary anecdote. In the *Libellus de laudibus Germaniae et ducum Saxoniae* from 1508, Christoph Scheurl describes how another furry beast, Dürer's dog, mistook the *Self-Portrait* for his master, defacing it with his tongue. Scheurl asserts that "one can still see marks of this [on the panel], as I can prove."[2] Dürer's own gesture within the Munich panel, augmenting our sense of sight with a vision of touch, celebrates the magical presence or quiddity of the painted world.

The tuft of fur functions as a synecdoche for the *Self-Portrait*'s veracity. Perhaps nowhere is Dürer's naturalism displayed so ostentatiously as in the virtuoso treatment of his *own* hair and beard (fig. 82). We recall that it was this aspect of the *Self-Portrait* that Camerarius singled out for comment, describing how viewers of the work could not believe that such long and regular tresses were painted freehand. And in his life of Dürer from 1604, Carel van Mander, too, foregrounds this aspect of the *Self-Portrait*. Remembering the panel from his visit to Nuremberg in 1577, van Mander writes: "Dürer painted his face with long hair on it, hanging down. Some of the hair intertwines, and some is traced in gold very effectively. I can remember this well."[3] There is, in fact, no gold in the hair of the Munich panel—although it is, interestingly, a common feature of Christ's hair as represented in the Byzantine mandylion.[4] Yet van Mander's mistaken recollection is appropriate to the experience of Dürer's *Self-Portrait*. The wonderful nimbus of hair that frames the face functions like the sacral gold of an icon. It testifies to the otherworldly power of the represented person, which in Dürer's case is a power manifested precisely *as* his ability to endow his human hair with a transcendent, chrysographic glow.

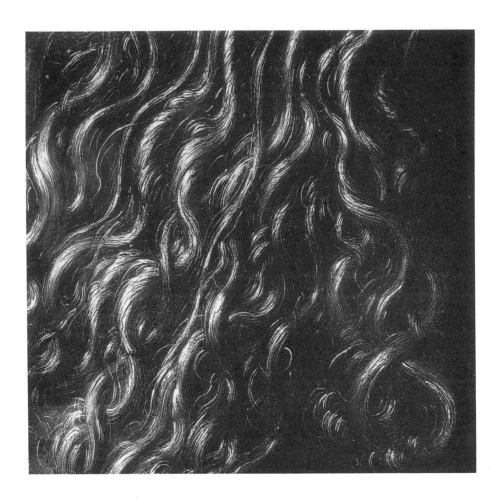

To capture every hair on his head in paint, Dürer must attend to at least three different aspects of the visual phenomenon. First, he must trace with his brush the course of individual hairs as they twist around other hairs, spinning themselves into strands or thin tresses and curling up calligraphically at their free ends. Second, he must work out the spatial logic of the entangled tresses themselves, reproducing a concatenation of strands in three dimensions—a pictorial task akin to designing an ornamental knot, like Dürer's 1507 woodcut *Knot with Seven Plexuses* (fig. 83; Kn. 249).[5] Finally, he must register the play of light over this fantastically complex structure, preserving the coherence of both individual hairs and curling tresses even as he renders them in constantly varying tones. The sheer amount of *work* Dürer expends in observing and representing his own body becomes an integral part of the viewer's experience of the panel. In the "labor of love" invested in his locks (and in the way his left hand turns inward toward his body as if to touch himself), it is difficult not to see a hint of narcissism. One result of the artist's almost fetishistic desire to capture in paint every hair on his head is that, when viewed close up, the symmetry that rules the painting's overall composition vanishes. Dürer's finer optic, endowing each individual hair with a shape, thickness, and color all its own, cele-

82. (*facing page*) Albrecht Dürer, *Self-Portrait,* 1500, Munich, detail of hair.

83. Albrecht Dürer, *Knot with Seven Plexuses,* 1507, woodcut.

brates the wild heterogeneity of the small. In rendering, for example, that marvelous cluster of hair below his lower lip, Dürer's brush cheerfully allows each hair to follow its own rules and stand out from the face in any direction (fig. 84). The whole cluster achieves an uncanny effect of presence as hairs overlap and hide the skin under the lip, as if the delicate paint lines that render these hairs had become consubstantial with their object, or as if the painter's brush, itself a cluster of hairs, had given birth to its own image.

We can see this kind of visual thinking at work in Dürer's famous nature study the *Great Turf* from 1503 (fig. 85; W. 346). Here the artist presents a worm's-eye view of heterogeneous nature, organizing what seems to be a random assemblage of concatenated plants and grasses, rather monotonous in color, into a monumental whole. Such portrait-like depictions of plants are common in the tradition of Frankish painting that preceded Dürer, where they adorned the base and margins of larger compositions, acting as naturalistic frames for scenes of sacred narrative.[6] In the *Great Turf,* however, what was peripheral now fills the whole visual field, creating an image curiously without center and boundaries. In the middle of the sheet our eye finds only an impenetrable density of plants, and at the edges the grass passes haphazardly out of the composition, emphasiz-

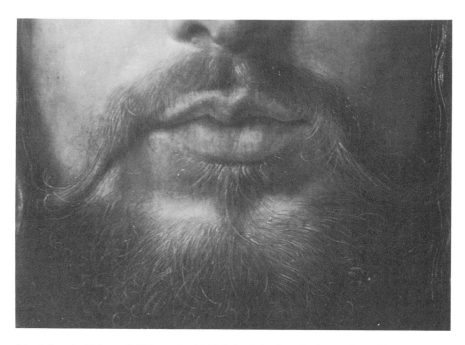

84. Albrecht Dürer, *Self-Portrait*, 1500, Munich, detail of mouth and beard.

ing the narrowness of our gaze. In place of a formal unity based on pictorial closure and hierarchical composition, however, Dürer has founded his whole upon "things in themselves." In the lower third of the image, the soil gives way to what appears to be a watery pool. Here the artist exploits the special properties of his mixed medium. He utilizes watercolor's inherent transparency to dematerialize the very ground upon which the plants are resting; and with thin body color and colored pen lines, he establishes the delicate opacity, bordering on translucence, of the living plants themselves. Able thus to peer into the earth to the network of roots and rhizomes, we see each plant as a whole, from the tips of its leaves silhouetted against the unprepared surface of the sheet to its base in the aqueous ground. And there within transparent soil we discover another sign of closure: at the base of the sheet, right of center, Dürer has written the date of the image's completion—1503—in pen and ink.[7] Dürer, earlier than any other northern artist, regarded such a nature study as a finished and therefore collectible work of art. Hidden appropriately among the grasses' roots, the picture's date returns the image to *its* source in human making. It therefore interprets the seemingly random spectacle as a unity by referring it back not to a totality of things in nature, but to the singular, irreversible gesture of the artist in history.

Dürer enables our gaze to tunnel to the *Ding an sich*. This is made easier by an equivalence between the artist's graphic medium (the calligraphic line) and the object it depicts. Leaves of grass, as well as their pale roots, are essentially linear forms and thus appear

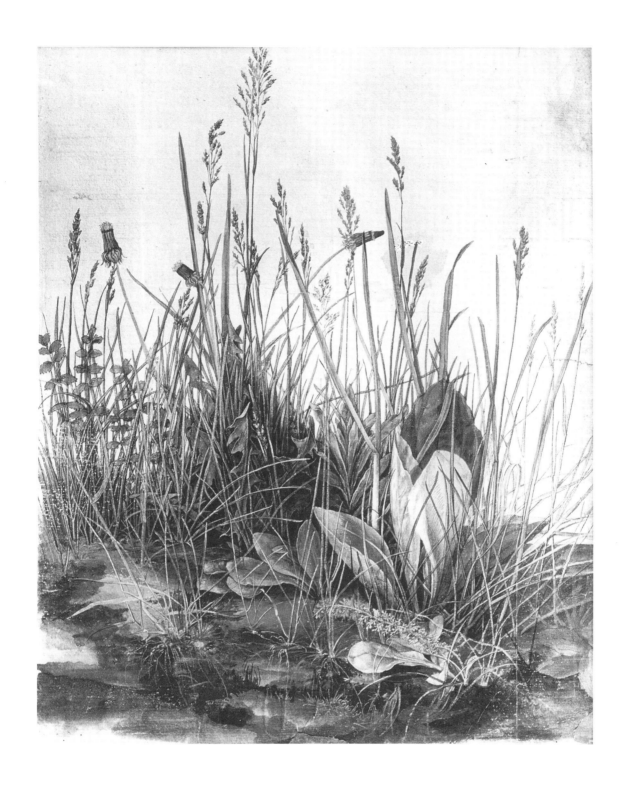

85. Albrecht Dürer, *Great Turf*, 1503, watercolor, body color, and pen heightened with white, Graphische Sammlung Albertina, Vienna.

fully captured by the single strokes of paint with which the artist "draws" them. This is true also for Dürer's hair and beard in the Munich panel, as well as for the fur trimming on his collar and for virtually the whole of the *Hare* watercolor. At the lower limit of his microscopic gaze, Dürer discovers the smallest indivisible particle of the visible world to be nothing other than the calligraphic line. Dürer builds his "new creature" out of myriad self-portraits of his brush.[8]

The relation between Dürer's virtuoso depiction of hair and the actual hair of his brush is the subject of an anecdote about the artist. In his Preface to the *Proportionslehre*, Camerarius illustrates his point about the "steadiness and exactitude of [Dürer's] hand" through a story about Dürer in Italy. The great Italian master Giovanni Bellini (c. 1430–1516), Dürer's elder by about forty-one years, was said to have so admired Dürer's "fineness and delicacy" in executing human hair that, when the two artists met in Venice, Bellini asked to see one of the young German's paintbrushes.[9] He believed that Dürer used special brushes to produce such marvelously regular locks, brushes "with which you can draw several hairs with one stroke." When Dürer drew forth only an ordinary artist's brush, Bellini was incredulous. It seemed impossible that anyone could produce such "very long and wavy tresses . . . in the most regular order and symmetry" without any "artificial aid." Bellini was satisfied only when Dürer actually demonstrated his manual technique. The point of this anecdote is multiple. It testifies to the magical quality of Dürer's art, the viewer's real sense that such painting, like the *acheiropoetoi*, could not have been fashioned by human hands. Yet, while affirming the human hand of the maker behind the work of art, it also reveals Dürer's magic to be a matter of personal, bodily skill—what Dürer in his theoretical writings will call "practice," or *Brauch*.[10] Finally, Dürer's performance stages the parity, or even the superiority, of German painting vis-à-vis Italian. In Venice, the home ground of his older rival, Dürer demonstrates his genius in precisely that area where German artists were generally thought to excel: the expressive and rhythmic *line* produced freely and spontaneously by the practiced hand of the individual master.

Camerarius's anecdote recalls a specific passage from Pliny the Elder, in which the artists Apelles and Protogenes compete over who can draw the thinnest line. Apelles wins by placing his line inside a line fashioned by Protogenes, which itself had been drawn within one made originally by Apelles.[11] By modeling his anecdote after this classical agon, Camerarius implicitly compares Dürer to Apelles—an analogy that plays through the whole Preface and takes its lead from Conrad Celtis's 1500 epigram "Ad Pictorem Albertum Durer Nurnbergensum," which refers to the German artist as *alter Apelles*.[12] Desiderius Erasmus, too, praised Dürer's graphic style through a comparison to the mythic Greek painter. In the *laudatio* for Dürer included in his *Dialogus de recta latini graecique sermonis pronunciatione* from 1528, the Dutch humanist notes that everything Apelles could depict with color, Dürer equals or surpasses with black lines alone:

> Shade, light, radiance, projections, depression. Moreover, from one object [he derives] more than the one aspect which offers itself to the beholder's eye. He accurately observes proportions and

harmonies. He even depicts what can not be depicted: fire; rays of light; thunderstorms; sheet lightning; thunderbolts; or even, as the phrase goes, the clouds upon a wall [*nebulae in pariete*]; characters and emotions—in fine, the whole of man as it shines forth from the appearance of the body, and almost the very voice. These things he places before our eyes by the most felicitous lines, black ones at that. . . . And is it not more wonderful to accomplish without the blandishment of colours what Apelles accomplished only with their aid.[13]

Erasmus's praise here refers specifically to woodcuts and engravings; yet as Camerarius's anecdote demonstrates, Dürer's essentially linear style was felt in his panel paintings as well. When, in the 1500 *Self-Portrait*, the artist gestures toward the fur of his *Schaube*, marvelously depicted in lines of paint, he thus conjoins the instrument of his practice with the emblem of his art. The artist's *hand*, that is, depicted as a beautiful object at the base of the page, gestures toward its exemplary product: hair rendered consubstantial with the calligraphic line.

We know that hair played an important part in Dürer's own perception and cultivation of his physical being. His friends called him *barbatus* and mocked him for the excessive care he lavished on his locks.[14] Sebastian Brant satirized such affectations in his enormously popular *Ship of Fools* of 1494. The chapter "On New Fashions" condemns the excessive attention men pay to their clothes (including furs, which Brant calls *wild kappen*)[15] and hair:

> With sulfur and resin one puffs one's hair
> And then whips in an egg white,
> So that it curls in the basket-dish.
> One man hangs his head out of the window;
> Another bleaches his hair with sun and fire:
> Under such the lice are plentiful.[16]

In a letter of March 19, 1507, the canon Lorenz Beheim joked to Pirckheimer about their common friend ("our Albrecht") and his beard: "The obstacle is his pointed beard [*barba bechina*], which doubtless has to be waved and curled every single day. But his boy, I know, loathes his beard [*Ma il gerzone sue abhorret, scio, la barba suu*]; thus he had better be careful to shave."[17] At 1500 in Germany, young and middle-aged men normally did not wear beards, and even most elderly men were clean-shaven.[18] Dürer's well-groomed facial hair must have seemed like an eccentric and dandyish anachronism. Social anthropologists have taught us that people's hair, a private asset, is also a potent public symbol. As an integral part of people's bodies, but capable of infinite variation, hair functions as a visible index of their personality and makes statements "about their conception of their role, their social position, and changes in these."[19] From this perspective, the 1500 *Self-Portrait* displays the sitter as already a work of art with social, sexual, and religious dimensions. It is the portrait of a portrait of self encoded in an especially cared-for body.[20]

The issue of hair arises most tellingly in Dürer's famous literary feud with Lazarus Spengler, first secretary to the city council of Nuremberg. Dürer wrote and published several long and rather bad poems in the years 1509–1510, possibly the result of his

association with the short-lived School for Poets (1498–1509), founded by Johannes Pirckheimer to civilize Nuremberg's elite.[21] In a satirical poem or *Spottgedicht*, Spengler mocks Dürer's verses and advises him to stick to painting. To illustrate the point, Spengler tells the story of Apelles and the cobbler, in which the painter accepts with equanimity the craftsman's advice on how to render shoes but chides him when he criticizes other parts of a painting.[22] Spengler concludes: "Thus I say to this man that / While he can do the painter's craft [*maler handtwerck*], / He should then stay with the same / So that he doesn't make himself the butt of someone's joke."[23] By comparing the artist both to Apelles and, implicitly, to the cobbler, he undercuts Dürer's ambition, embodied in his literary efforts themselves, to elevate painting from manual to intellectual labor. Dürer, in response, also fires off a *Spottgedicht* defending his desire to make himself a total man, or what the Italians call *l'uomo universale*. Of course, as Jacob Burckhardt demonstrated long ago, Renaissance self-assertion and pride often occasioned a healthy, corrective laughter from society.[24] Yet in the thrust and parry of this literary exchange, Spengler hit his mark. At a moment of wounded narcissism, in which the artist is caught between vanity and shame, failed head work and mere *handtwerck*, Dürer names himself in a telling epithet. His verse defense concludes: "Still I want to make rhymes / Even if the secretary laughs more / Spake the hairy, bearded painter / To the mocking secretary."[25] There is, I believe, a note of this ambivalence already in the 1500 *Self-Portrait*. The fur Dürer fingers, as a displaced version of the hair with which he identifies himself, is a way of associating himself not with the God whose feature he shares, but with the beasts of the earth.

In Dürer's *Portrait of Oswolt Krel*, dated 1499 and now in Munich, the fur collar invests the sitter with a potential animality (fig. 86). On the portrait's right inner wing, Krel's coat of arms is held by a wild man who, in the position of his head and direction of his eyes and in his general physiognomy, bears a resemblance to the sitter.[26] Wild men were a popular motif in German panel paintings and prints of the early sixteenth century and had been common in tapestry, decorative arts, and heraldry throughout the late Middle Ages.[27] They had multiple associations of primitive power, sexual lust, fallenness, and pugnacity. And after 1500 they began to picture a new, heroic ideal appropriate to Germany, transforming Cisalpine notions of northern barbarism into a positive virtue.[28] The wild men on the *Krel* portrait wings, expressing their aggressive nature in their animated gestures, might refer to the specific character of Dürer's sitter. Oswolt Krel, depicted here with a fierce demeanor and set against a red background, was both a powerful force in Nuremberg commerce and a notable rowdy, once imprisoned for his unruly behavior at a *Fastnachtspiel*. I suggest that the wild man, covered with hair from head to foot, acts as a foil for the clean-shaven but potentially aggressive Krel. The fur of Krel's coat (what Brant disapprovingly termed a *wild kappen*) echoes the shape of the two flanking wild men in its curved form and reads like a displaced version of the sitter's body hair. Krel clutches his fur in a manner suggesting not only the sitter's victory over his baser instincts, but also his lingering alliance with these powers of the earth.

Throughout the Middle Ages and into the Renaissance, animal fur was a profoundly ambiguous and symbolically charged material.[29] On the one hand, it was the garb of

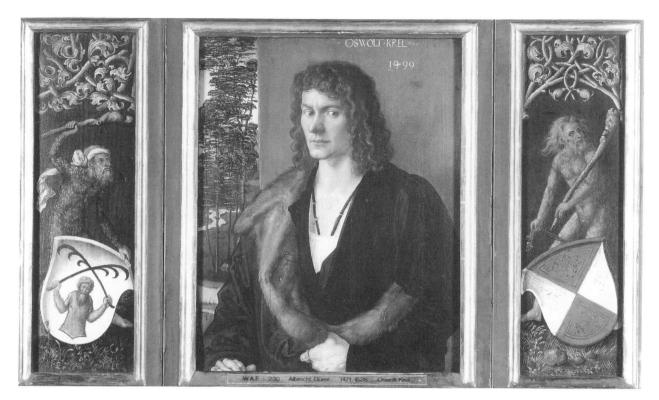

86. Albrecht Dürer, *Portrait of Oswolt Krel*, 1499, panel, Alte Pinakothek, Munich.

Adam and Eve after the Fall. For Isidore of Seville, therefore, wearing fur denoted the sinfulness and bestiality of man.[30] On the other hand, fur was also associated with the innocence of the Golden Age, when people were neither totally naked nor clothed in woven, artificial garments. Between culture and nature, the home and the forest (hence, perhaps, the sylvan landscape behind Krel), fur could itself be deceptive, trimming stylish garments but appearing to line them throughout. These various ambiguities, nicely condensed in the French word *doublure*, meaning both "lining" and "stand-in," made fur an apt metaphor for the doubleness of man as body and soul, inner and outer.[31] Around 1400 in the courts of France and Burgundy, and throughout the urban culture of the late fifteenth century, fur, especially rare and exotic varieties, became an increasingly coveted mark of social distinction, and its usage was regulated by sumptuary laws. For an artisan like Dürer to wear fur was a statement about status, a badge of wealth, power, and distinction far removed from the hair shirts of ascetic imitators of Christ.

Thus in Dürer's Christomorphic likeness, even more than in the *Krel* portrait, the fur-lined coat conveys a heightened ambivalence. The animal hair to which the artist gestures with his left hand is perhaps an emblem of his own bodily being, even as it is the index of his painterly craft. When regarded in this light, Dürer's hand gesture represents a complex mode of self-reference. It is a version of the common portrait convention of

depicting the sitter with some trinket in his hand—a flower, a ring, a tool of his trade—representative of who he is. Specifically, the fur completes the Munich *Self-Portrait* by introducing into the Christomorphic likeness certain mixed references to Dürer's humanness. I say "mixed," for as an emblem of painterly craft the fur reminds us that the image was fashioned by human hands even as it appears to be magically generated, while as a symbol of Dürer's bodily being, the fur relates to the sitter's proximity to the beasts even as it expresses his carnal beauty and attendant narcissism.

A drawing by the Nuremberg sculptor and designer Peter Vischer the Younger (1487–1528) glosses the ambivalence, felt in German culture at 1500, about the beauty of the human body (fig. 87).[32] The lovely nymph Scylla squats in a pool while contemplating herself in a mirror that she dangles from her hand. Below the looking glass, at the edge of the pond, are instruments of her toilet: an ointment jar and a body brush. According to the legend as recounted by Ovid, Scylla was bewitched by the sorceress Circe, who, jealous of the nymph's beauty, transformed her into a monster by poisoning the pool where she bathed.[33] Vischer portrays the moment of transformation, in which the nymph's lower parts grow hairy around the hips, sprouting a snakelike tail and the webbed feet of a frog. Her upper body, meanwhile, remains beautiful as she observes her reflected image. The German artist thus superimposes upon the classical myth of metamorphosis a moralizing admonishment against vanity, typical of northern approaches to the nude. Whereas Renaissance art in Italy, through its reception of the classical nude, rehabilitated the human body as an indivisible whole, worthy of full representation, the northern tradition remained more committed to the medieval Christian condemnation of sensuality and bodily pleasure. Although classicizing nudes entered German art about 1500, largely through the influence of Dürer, they were usually placed within a didactic narrative that qualified or overturned the visual and erotic responses aroused within the viewer. In Vischer, Scylla's beauty becomes an attribute of her aspect as *superbia*, self-love, signaled by the mirror. And her disfiguration into a monster is rewritten as punishment for the vice she embodies. The viewer, in turn, may be offered a last glimpse of the nymph's original charms, yet whatever pleasures he[34] might feel will be overturned by the abjection and sexual horror invoked by her grotesque lower body.

Peter Vischer the Younger, perhaps the most deeply classicizing of all German artists of the period, still depicts the antique tale through a medieval geography of the body that posits a radical caesura between the head or upper body, seat of the soul or spirit, and the area below the waist, seat of sexuality and the fallen instincts of the flesh. It was to this geography that Butzbach appealed when he commended the chaste painter Marcia for representing men only above the waist. And I believe it is also subtly operative in Dürer's 1500 *Self-Portrait*. Cutting off his image at precisely the point where we would observe the artist's working hand, his panel represses the fact of human production, which, as we remember from accounts of the *cheiropoetos* as idol, is associated with sexual generation. And though he conceals these manipulations below the panel's edge, his gesture toward the fur, however much it asserts the magic of Dürer's art, also has darker messages of vanity and bestiality. It must be admitted that these are finally overruled by

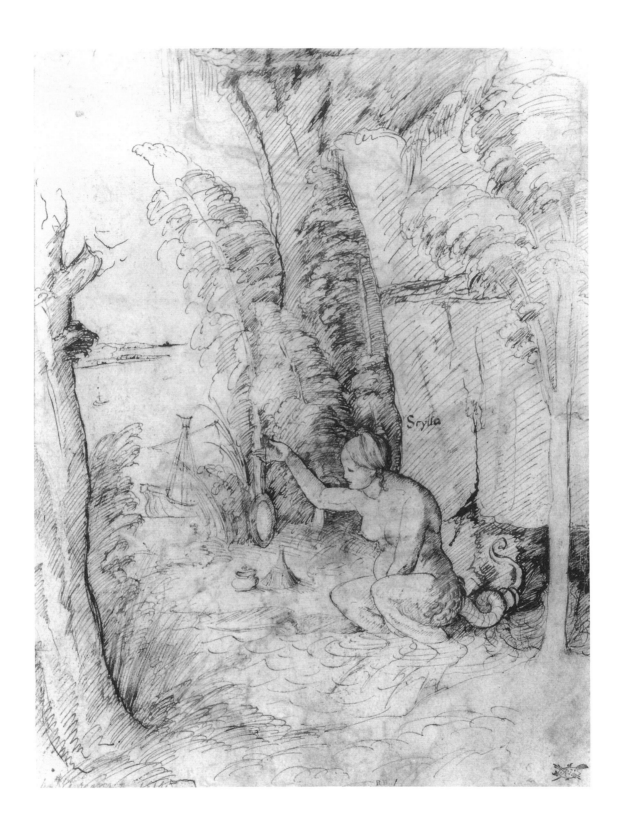

87. Peter Vischer the Younger, *Scylla*, 1514, pen and brown ink,
 Germanisches Nationalmuseum, Nuremberg.

the affirmation of the divinity and perfection of the body and self of the artist. Yet they point to certain fundamental instabilities in Dürer's project of self-portraiture, instabilities whose meaning and consequences will determine the art of Baldung.

Hegel once wrote of the impossibility of self-reference: "When I say, 'I,' I *mean* myself *as this* to the exclusion of all others; but what I say, I, is precisely anyone."[35] Once submitted to representation, the "I" becomes general and anonymous and fails to refer back to the subject in its absolute uniqueness. Dürer's hand gesture in the 1500 *Self-Portrait* is an epochal instance of self-reference: the artist, present at once in his name, his likeness, and his artistry, turns his body back upon itself as if to say "I *myself*." What appears signaled at the end of his straightened index finger, however, is disconcertingly open. Does this finger, like the rest of his hand, *display* its perfect form as emblem of a body at once beautiful and beauty-creating? Does it, together with the middle finger, *grasp* the tuft of fur as emblem of the sitter's bodily and artistic being? Or does it rather *point* to the heart, which Dürer's anatomy locates at the "middle of the chest,"[36] and which his aesthetics metaphorized as the secret coincidence of theory and practice, geometry and nature study? Wilhelm Vöge wrote of medieval portraiture: "The attribute makes the man an apostle or a saint. This was an idea familiar to the Middle Ages, for to the Middle Ages the outer sign was already the essence."[37] Dürer's personal attribute in the Munich panel, existing within an uncertainty whether there is any attribute present at all, is finally that of the self-portraitist per se: Dürer is that man whose "impossible project" (Pascal) it is to show himself.

It would not be hard to relate Dürer's specific hand gesture to certain established poses within the Western pictorial tradition. It recalls the arrangement of Rogierian *Blessing Christ* panels, in which the Savior raises his right hand at the center of his chest in a gesture of benediction (fig. 66). In these pictures the cultic power of the *vera icon* is made plain. As indulgenced image, it is an instrument of atonement, blessing the beholder in the here and now and promising a speedier path to heaven. In Dürer's panel, the hand turns back on itself. Instead of conducting redemptive love to the viewer, this likeness enacts self-love or narcissism, one might argue, aiming to consecrate the artist's person magically present in his image. Closer formal analogies to Dürer's hand gesture exist in certain Eastern icons, in which Christ's right hand is displayed similarly turned toward his chest, with thumb opposed to index and ring fingers (fig. 88).[38] In a mosaic of this type from the early twelfth century, now in Berlin, the inscription names Christ "merciful" (*eleemon*). His gesture is that of "the Son of God, revealed and self-sustained in the truth of the Word."[39] Dürer's left hand, modifying this posture by pointing toward his body, would similarly testify to his own *praesentia,* not by means of the Word, but by means of the image "self-sustained" by the artist's hand.

In neither the Rogierian *Blessing Christ* nor the *Christ Eleemon* does the gesturing hand actually point inward toward the body of the sitter. If Dürer's hand stands in an analogy to the hand of certain Christ types, then it does so mainly to evoke an *aura* of cultic

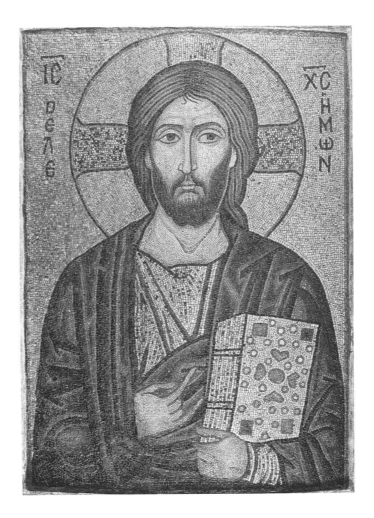

88. *Christ Eleemon,* Constantinople, 1100–1150, mosaic, Staatliche Museen Preußischer Kulturbesitz, Berlin.

significance, not to denote exactly what that significance is. As with so many aspects of the *Self-Portrait,* Dürer's left hand reoccupies earlier pictorial signs—here the language of sacramental gesture—without ever settling on a traditional referent. At one level Dürer's gesture belongs to the repertoire of secular portraiture, where a sitter will point toward his body as if to say: "This is me." Thus in Jörg Syrlin the Elder's 1474 bust of a man holding a bundle of laurels (one of many such carvings decorating the Ulm Minster choir stalls), the subject points his index finger at his chest (fig. 89).[40] In Italian portraits after 1500, similar gestures become conventional, as we can see from Lorenzo Lotto's *Portrait of a Man of Thirty-seven Years* from about 1535, now in Rome (fig. 90).[41] This conceit belongs to the general evolution of Renaissance portraiture toward a representation of the individual *ex se* and *per se* (Gauricus). In place of an objective attribute that would establish the meaning of a likeness by pointing elsewhere to other meanings or images, the gesture toward the body expresses a dream of pure self-reference in and through the sitter's likeness alone.

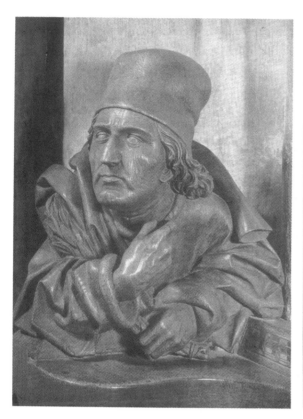
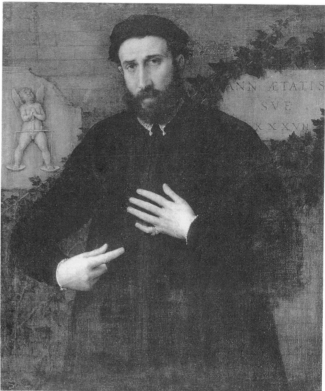

At another level, the ghost of an older theology still haunts Dürer's posture and likeness. The *Self-Portrait* may aspire to capture the artist in all his singularity as body, down to the shape of the individual hairs of his beard. Through the myth of the *acheiropoetos*, and through the conceit of allowing Dürer's active hand to pass out of the picture, only to be resurrected in its image and work, the picture may also assert that it was produced *ex se*, out of itself. Yet at the point where the panel makes its most audacious claim to autarky—that is, in its analogy to the truly self-originated, self-sufficient *uomo singolare*, Christ[42]—it also abandons the purity of its self-reference. The aspect of Dürer's likeness as a universal exemplum blunts the self-referential force of his hand gesture. The artist wants at once to point to his body in the new manner of Syrlin and Lotto and to infuse that gesture with a sacramental aura through visual echoes of the Christ icon. He wants, in Hegel's terms, to be both "I" and "everyone." The irreducible indirection of Dürer's deictic hand thus does not stem from our uncertainty about its iconography or about Dürer's intention. It is rather the consequence of a historical moment in the history of reference, in which the modern impulse toward self-display reoccupies the spectacle of theophany.

Dürer's gesture of pointing to his body appears again in the *Self-Portrait of the Sick Dürer*, dating from about 1512 and kept now in Bremen (fig. 91; W. 482).[43] Dürer made

89. (*facing page left*) Jörg Syrlin the Elder, *Bust of Virgil* (?), c. 1469–1474, oak from choir stalls, Ulm Minster.

90. (*facing page right*) Lorenzo Lotto, *Portrait of a Man of Thirty-seven Years*, 1535, oil on canvas, Palazzo Doria Pamphilii, Rome.

91. (*right*) Albrecht Dürer, *Self-Portrait of the Sick Dürer*, c. 1512–1513, pen and ink with watercolor, Kunsthalle, Bremen.

this small sketch as a means of describing the symptoms of his illness to a doctor. Yet the care with which the artist has drawn and modeled his likeness with delicate touches of watercolor suggests a wider function for the work. In his penetrating gaze, the sick Dürer addresses us as viewers, inviting us to witness not merely the symptoms of an illness, but the whole afflicted person. The artist assembles all possible modes of signification to refer to, and specify, his pain: language, in the inscription heading the page ("There where the yellow spot is and the finger points, there it hurts me");[44] bodily symptom, in the yellow spot portrayed on likeness's side; pictorial mimesis, in the self-portrait proper; gesture, in the index finger that points to the trouble; and diagrammatic mark, in the circle that delimits the hurt. In these multiple signs, we sense not so much the efficacy of the deictic in Dürer's art as its inadequacy for articulating what ails him. For the hurt itself, that experience toward which all representations refer, remains quintessentially accessible only to the body in pain.

A similar constellation appears in a work produced in Nuremberg in the orbit of Dürer and Jacopo de' Barbari. In an allegorical statue from a bronze table fountain, now in Florence, a nude Venus stands atop a globe, gesturing toward her breast and groin (fig. 92).[45] Around the globe is written in large letters: "Where the hand is, there is the pain" (*Ubi Manus ibi Dolor*). The tone here is comic. Venus wears the headgear of a

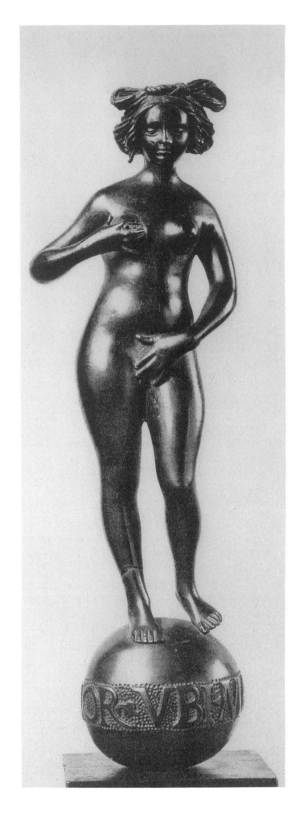

92. (*left*) *Venus*, Nuremberg, c. 1520–1530, bronze statue from table fountain, Museo Nazional, Florence.

93. (*above*) Albrecht Dürer, *Christ as Man of Sorrows*, c. 1510, pen and ink, British Museum, London.

Nuremberg *Badstubenmädchen* in a manner recalling Dürer's own *Large Fortune* engraving of about 1501 (Kn. 36; fig. 198).[46] She gestures toward her erogenous zones as if they were sources of affliction. Physical hurt translates a psychological state of mind. This might also be at work in the Bremen *Sick Dürer*. For as many commentators have noted, the "yellow spot" in the Bremen *Self-Portrait* is around the spleen, believed to be the seat of melancholy. Dürer's pain articulates a subjective state *and* the constitution of his character.

There is another aspect of the Bremen *Self-Portrait* that could not have been overlooked by a contemporary viewer of the sketch. Pointing to his side and gazing out of the picture, Dürer assumes the traditional pose of Christ as Man of Sorrows, displaying his wounds to the viewer. Dürer himself depicted the *ostentatio vulnerum* in a sketch roughly contemporary with the Bremen sheet (fig. 93; W. 476).[47] Christ's sidewound was an object of special devotion in the Middle Ages. Interpreting a passage in the Gospel of John, in which a soldier stabs Christ's corpse with a lance and releases "a flow of blood and water" (John 19:34), theologians since the sixth century had regarded the wound as sign of the redemptive power of the Word and as fountain of life.[48] Dürer illustrated this in the first sheet of his *Engraved Passion* (fig. 94; Kn. 51). Two streams of blood spout from the *Schmerzensmann*'s wound directly onto the heads of the Virgin and John the Evangelist. The *ostentatio* of the wound, in which the risen Christ gestures with his finger toward his wound or allows his thumb and index finger to frame and display its limits, refers at once to the redemptive power of his sacrifice and to Christ's incarnation as man. German art of the fifteenth century often stressed the sheer physicality of the wound, as when, in a panel from about 1495 by the Cologne Master of St. Bartholomew, the doubting apostle Thomas forces two fingers into Christ's flesh up to the third knuckle, stretching the skin around the wound (fig. 95). By enacting the gesture of *ostentatio* in his Bremen *Self-Portrait*, Dürer can relate his own illness to the Passion, thereby assuming the pious attitude of *conformitas Christi* and invoking, for his aid, the healing power of Christ's wounds.[49] Both of Dürer's other autonomous self-portraits produced after 1500 include similar conceits. In the *Self-Portrait as Man of Sorrows* from 1522, formerly in Bremen, Dürer, nude to the waist, bears the scourge and whip of the Passion (fig. 96; W. 886);[50] and in the *Nude Self-Portrait* from about 1503, he adds to his frank depiction of his body the barest indication of a side wound, just below his ribs on the left (fig. 120; W. 267).[51] Of course, Christomorphic self-portraiture is already established in Dürer's 1500 panel, although not through a display of wounds, but through a spectacle of artistic perfection. Yet by deepening the illusion of materiality in the represented world and by foregrounding certain human aspects of Dürer's human character, the *ostentatio* of painted fur heightens our sense of the artist's incarnality, as well as of his vanity, self-love, and fallenness.

Self-love and love of God exist in an uneasy symbiosis in pre-Reformation piety. Nicholas of Cusa, we recall, regards narcissism as the starting point for devotion. We embrace God, in whose image we are made, not initially because we recognize him as our creator, but because we see his face as a reflection of our own, which we love above all else. Xenophanes' account of the origin of the gods in man, invoked by Thausing to explain the modernity of Dürer's *Self-Portrait*, finds an echo in Cusanus when he asserts that the

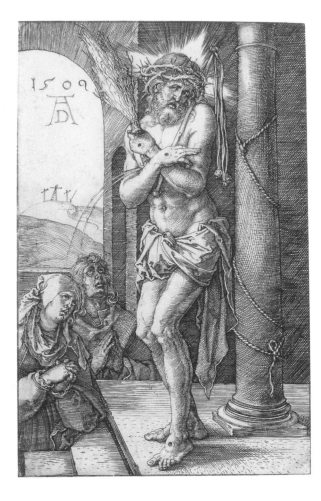

94. Albrecht Dürer, *Man of Sorrows with Virgin and John the Evangelist*, 1509, engraving from the *Engraved Passion*.

anthropomorphism of the Christian God is a consequence of the humanity of believers.[52] Yet here the elevation of self to the status of "another god" always meets a restriction that distinguishes Cusanus's position from Dürer's. Man is great only because God is great; the artist is "divine" only because God is *deus artifex*; man can create "new creatures," rather than simply imitate created things, only because he imitates the creation of the world. No matter how much power and centrality Cusanus accords the self, his syllogisms have as their ineluctable final term the absolute priority and originality of God. Thus any analogy between man and God will remain mere trope, operating through the connector "like" or "quasi" and aimed at staging man's full *imago* status within a spectacle intended for God.

The risk is that self-love and self-assertion for their own sake are opposed to devotion, being the *velle se esse deum*, the will to be god, of sin itself. Indeed, one traditional allegory of the Fall has it that Adam's primary sin was neither disobedience to God nor sexual trespass, but rather self-love, or *superbia*. As the *Theologia deutsch* states, the Fall occurs when "man considers himself to be something and believes that he is, knows, and can

95. Master of St. Bartholomew, *Doubting Thomas Surrounded by Saints and God the Father*, c. 1495, oil on panel, central panel from *St. Thomas Altar*, Wallraf-Richartz-Museum, Cologne.

do something, seeks his own interest in the things around himself, is filled with self-love and the like."[53] According to medieval medical theory, *superbia*, or the desire for autarky vis-à-vis God, transformed man into *homo rebellis*, disfiguring his perfect nature and throwing him into the imbalance of humors that causes sickness and death. And of the four humors, it is melancholy that is associated with the originary vice of *superbia*[54]— melancholy, which in the Bremen *Self-Portrait*, and also in the engraving of 1514, may be Dürer's characteristic, character-determining ailment.

Theology functions here, as throughout my account of Dürer's self-portraits, not as a coherent set of beliefs that the artist adheres to or illustrates. Statements by Cusanus, the author of the *Pilgrim Tract*, or for that matter Dürer himself are but temporary and partial responses to contradictions within belief and experience, contradictions that are often more openly and eloquently stated *as* the works of art themselves. As Blumenberg has shown, Cusanus's restriction of self to the "*quasi* alius deus" does not survive the next century, and the death of Giordano Bruno signals the failure of this restriction.[55] We may read the 1500 *Self-Portrait* as a version of this late medieval piety, yet this hardly explains

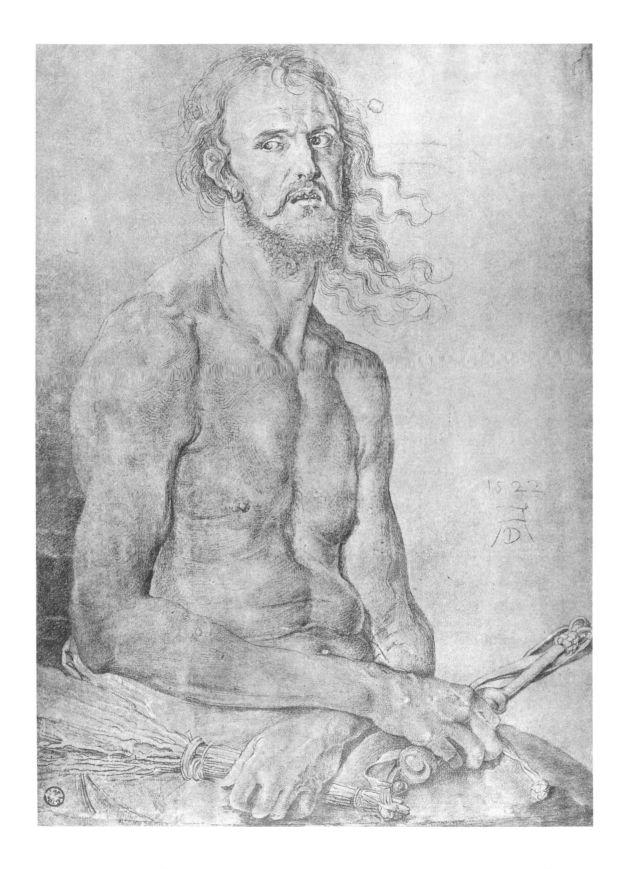

96. Albrecht Dürer, *Self-Portrait as Man of Sorrows*, 1522, lead point heightened with white on bluish green prepared paper, formerly Kunsthalle, Bremen.

the painting's motivation. At best it recovers the artist's self-validating account of his own art—his attempt, as it were, to mask slippages in his project as a whole. Nor will the moment of self-portraiture, augured within Dürer's play as a thirteen-year-old boy, enacted in his graphic exercises as a journeyman, and exploited in the self-promoting portrait of himself as *gentilhuomo* (fig. 20), be fully explained by the Munich panel, even if that was one purpose for which the work, in 1500, was originally made.

Self-assertion is but one tendency within the emergence of a modern identity during the Renaissance, as is Dürer's short-lived dream of a narcissism reconciled to piety. A more troubled stance is evident in Dürer's writings when he answers the charge, raised by his society, that art fosters pride: "It is not bad that a person learns a lot, as indeed some people bluntly say, who charge that art makes people vain [*hoffertig*]. Were that so, then no one would be more vainglorious than God, who created all art."[56] The argument is unconvincing. Contemporaries leveled their charge of vanity precisely at those people who, implicitly or explicitly, compared themselves to God—something that Dürer, more than any German artist of the Renaissance, was wont to do. To say, as Dürer does, "If God has done it, I can do it" cancels the self-restriction imposed by Cusanus, which forbids the human-divine *analogon* to be conducted as if between equals.

Such instabilities in Dürer's project will not be revealed primarily in his writings, however. They emerge rather as gaps within his pictures themselves, disparities between the "theory" that an image proposes about itself—the theology, moral, or metaphysics it deploys as its own commentary—and the image's physical appearance, which always is more mingled, always elicits a more heterogeneous response that any theory can support. And they shape the image's afterlife, when this heterogeneity of response becomes the history of reception. They are evident in Dürer's late self-portraits, fashioned as he ages, suffers illness and pain, and bears his humanity as precisely *not* equivalent to God; and they determine the art of Dürer's epigones, who represent themselves in the shadow of Dürer's greater self.

Interpretations that fail to discern this disparity between the image and its self-proposed theory, that domesticate the 1500 *Self-Portrait* as an artful illustration of Christian orthodoxies, obscure what is intentionally new about the work. They overlook those commanding indications of *time* that are inscribed at both sides of Dürer's likeness: at the left, the date "1500" above the monogram; and at the right, in elegant Roman lettering, the artist's age: "Thus I, Albrecht Dürer of Nuremberg, painted myself with indelible colors at the age of twenty-eight years" ("Albertus Durerus Noricus / ipsum me proprijs sic effin / gebam coloribus aetatis / anno XXVIII").[57] Of course, that the *Self-Portrait* was produced in the year of the half-millennium is not in itself proof that Dürer regarded his project as in any way epochal. More than just a sensitivity to important-sounding dates, epochal thinking presupposes the view that history is a succession of discrete periods, each with its own specific character. As Walter Haug has written, "The Middle Ages has no consciousness of 'epoch' in the modern sense of the word,"[58] for the one break that it

does admit—the birth of Christ—is so radical that it allows no other genuine historical divisions to follow. The church, it is true, declared 1300 a Jubilee Year and repeated this every half-century.[59] And Dante timed the story of his *Divine Comedy* so that it coincided with a journey undertaken in 1300, at the precise middle of the poet's life (at age thirty-five, rather than Dürer's representative twenty-eight).[60] Yet these commemorate the singular event of *Heilsgeschichte* that inaugurated their calendar. They do not style their own moment as the beginning of something new for history as a whole, since after Christ the only meaningful temporal division will be one that eradicates history itself: the constantly anticipated and continually deferred end of the world. Although this view of history survives into the Reformation, another begins to emerge in the thought of German humanists of Dürer's generation. Like their earlier Italian counterparts—for example, Petrarch—they regarded the recent past as a dark age or middle period between an antiquity that was their chosen paternity and a golden age that they were now founding.[61] As Franco Simone writes, "The men of the Renaissance saw a rupture where earlier there had been a belief in a smooth development, and from this rupture they took the origins of their enthusiasm and the certitude of their originality."[62] Unlike the Last Judgment's eradication of history (visualized for the age by Dürer's Apocalypse woodcuts), artistic originality, Dürer's "new creature," proposes a caesura in time that still remains history.

In a recent study of the relationship between Dürer and Conrad Celtis, Dieter Wuttke has demonstrated that the German humanists in the circle associated with Celtis were eager to link their work to the epochal date of 1500.[63] They fashioned the turn of the half-millennium into a symbol of their momentous leap forward from the past, investing their art and learning with the status of an epochal turning point. Their vision of progress was a secularized eschatology: under the rule of the Holy Roman Emperor Maximilian I, and through the humanizing labor of German poets, painters, and scholars, the world would be at peace, and harmony would be restored between God and man.[64] The center of this celebration of 1500 was the publication of the complete works of Celtis in a lavish edition embodying the aesthetic ideals of the age. This meant not only reprinting what Celtis had written up to 1500, but also issuing an avalanche of new works so that the edition could assume properly epochal proportions. Celtis, called the *Erzhumanist* ("archhumanist") and crowned the first German poet laureate (1487), wrote literally hundreds of epigrams in the year 1499–1500 so that, when all were printed in five large volumes, they would number a significant five hundred.[65] Like so many projects of German artists and poets of this period, this one was more ambitious than successful. In addition to his own writings, Celtis edited and translated several older texts, all by Germans or having to do with Germany: for example, Hrosvitha of Gandersheim's plays, works by Cusanus, and Tacitus's *Germania*. By the end of 1501, Celtis and his friends were still issuing volumes backdated to 1500. All in all, the date was less an occasion for celebrating the new voice of an age than a motivation for inventing a voice not yet fully present.

It is not surprising, given the self-mythicizing relation between Celtis and the turn of the half-millennium, that a later biography of the archhumanist should have rearranged some facts so that Celtis could be said to have died at the age of forty-two in the year 1500

(he actually died in 1508 at forty-nine). Such fictionalized biography, which recasts history in order to affirm a magical coincidence between the life of an epoch maker and the epochal scheme of world time, repeats the equation between self and history proposed by Celtis's great publishing project.[66] Celtis's celebration of the half-millennium takes the form of a monumental act of self-promotion. It is not enough to say, however, that he is merely appropriating for his person the epochal date of 1500. The year 1500 becomes epochal *because* of such "self"-promoting projects as Celtis's, such monumental forms of self-presentation that celebrate their break from the past. Self-presentation, abetted by a mythicizing vision of history, fashions the very concept of the epoch in which the self can be said to emerge.

The connections between Dürer's 1500 *Self-Portrait* and Celtis's publishing project are clear enough. Through his friend Pirckheimer, Dürer was in close contact with Celtis, and the place of publication for the archhumanist's complete works was Nuremberg.[67] Moreover, Wuttke has shown that the form of the inscription at the right of Dürer's Munich panel—its Roman lettering and symmetrical arrangement that, though common in Italy, represented a novelty in Germany at the time—was modeled after title-page designs for Celtis's collected works.[68] That Dürer's *Self-Portrait* should serve as a frontispiece for surveys of Renaissance art is thus perfectly appropriate, given that the painting belonged to a project itself devoted to celebrating the dawn of a new age.

It is possible to read Dürer's inscriptions as a comment on the nature of dates and on the relation between self and epoch. The date of the new half-millennium appears at the upper left, above Dürer's monogram. At the right, the Latin inscription begins with Dürer's name, amplified as the Latin "Albertus Durerus Noricus" (imitating elaborate triple names of antique poets), under which is written Dürer's age: *aetatis anno XXVIII.* Reading the inscriptions from left to right, we pass from the epochal moment of world history (1500), through the artist's initials and name, to the biographical historicity of Dürer himself—age twenty-eight years old. It is probable that the AD monogram also doubles, by way of mythicized coincidence, as the true point of reference for the date's very monumentality: that is, *anno domini,* the "year of our Lord," which is the cataclysmic turning point of *Heilsgeschichte* itself.[69] Between "1500 AD" and the artist's age ("anno" 28) rises Dürer's likeness, the Christomorphic dimension of which would find appropriate resonance in the analogy between "Durerus" and "Dominus." This kind of thinking may already have been present in Jan van Eyck's *Holy Face* (fig. 33), in which the historical date of the panel's production ("anno 1440 30 January"), replacing the myth of divine production *in illa tempore,* established the authenticity of the work of art upon the new basis of the individual artistic self. The date of Dürer's panel, linked to the person of the artist, situates self not merely as the origin of *this* work of art, but as agent and emblem of the new saeculum.

Like Dürer's 1493 Louvre likeness (fig. 18), which was a marriage portrait, the Munich *Self-Portrait* is an occasional work. It functions in the manner of Celtis's publishing project, celebrating the historical moment of its making. What is this moment emblematized by Dürer's self-portrait? Though it was fashioned for the new epoch, Dürer consciously

embedded his likeness in older image traditions as well as in already established paradigms of private devotion. Yet once these precedents are acknowledged and their meaning for Dürer's panel is established, we are faced with a much larger question: What possible *function* could the 1500 *Self-Portrait*'s mixture of piety and narcissicm, submission to an exemplar and fetishistic self-possession serve within Dürer's larger aims as an artist and within the culture of pre-Reformation Germany? I have suggested that the Munich panel and, even earlier, the Erlangen drawing make complex statements about the nature and authenticity of human representation. By fashioning his *Self-Portrait* after the *vera icon*, Dürer inscribes his likeness, and by extension his art, into a myth of perfect representation, as well as into a sacred hierarchy of images that reaches from man as *imago Dei* to Christ as the living icon of God. Furthermore, in the personal references surrounding the tuft of fur, Dürer weaves together the attribute of his bodily being with the token of his painterly craft, thus erasing the distinction between the artist and his likeness. Such a monumental statement about the equivalency between image and prototype served a powerful *legitimizing* function for Dürer's art as a whole.[70] Dürer was conscious of his role as inventor of a new notion of art in Germany, one founded upon the authentic and irreducible presence of the artist in his works. In works like the *Melencolia* (fig. 14) or the 1500 *Self-Portrait*, Dürer not only creates a highly personal iconography to express his own spiritual nature, he also places unprecedented demands on the individual *viewer* to decipher his private code. As a response to the self's expanding role in both the production and the reception of works of art, the Munich panel offers the viewer a powerful model of the integrity, as well as the ultimate piety, of the individual human self and its works.

In the next chapters I shall suggest some larger spiritual, aesthetic, and economic problems for which the 1500 *Self-Portrait* might have been proposed as "answer." In certain works by Dürer from after 1500, we will observe alternative technologies of self in the visual image. Self-portraiture proper comes to serve a different function here, as Dürer compares his own body, now aging, with the ideality of his art, and as he utilizes and redefines the new image technology of the mechanically produced print.

9

Representative Man

In his essay "Of Beauty," Sir Francis Bacon mocked Dürer's aesthetic experiments as an example of past follies: "A man cannot tell whether Apelles or Albert Durer were the more trifler; whereof the one would make a personage of geometric proportions, the other, by taking the best parts out of diverse faces to make one excellent. Such personages, I think, would please nobody but the painter that made them."[1] There is no universal rule for beauty, and those who believe they have devised one fashion objects beautiful to themselves alone. A century after Dürer, Bacon draws the consequences of the subjective determination of art. No matter how much a painter may try, through geometry or eclecticism, to elevate his art above his own particular tastes, his products will remain reflections of himself and, as such, cannot be universally binding.

Dürer himself acknowledged as much when he wrote, in 1513, "For every mother is well pleased with her own child, and thus also it arises that many painters paint figures resembling themselves," and when he declared, "What beauty is, I do not know."[2] This skepticism, the outcome of Dürer's struggle with the problem of beauty waged between the completion of his 1500 *Self-Portrait* and the beginning of his theoretical writings (1511–1513), was not without its qualification.[3] "And yet," he continues, "I wish here to understand beauty for myself: that which the majority of people of all times consider beautiful, that we should diligently fashion."[4] The artist passes from a confession of ignorance, through an assertion of personal conviction ("beauty for myself"), to a middle position of beauty mediated by the *commune arbitrium*. What has become uncertain in Dürer's thinking is the exemplarity of the individual artist in his products and judgments.

Whereas his self-portraits celebrate the artist as the irreducible subject of his works, Dürer's art theory confronts the dilemma, deeply modern in nature, of demonstrating the universality of the artistic self. If art is about the self, what interest does it have for *other* selves? The link between artist and audience is already negotiated by the 1500 *Self-Portrait*. There Dürer proposes his own body, in all its particularity, as an exemplum

(fig. 21). His physical features may be altered to conform to a canon of ideal proportions, yet because the image is recognizably *of* Albrecht Dürer, because it can function for posterity as portrait likeness, it also retains the singularity of artist as physical being. Indeed the spectacle of *Feinmalerei* in the sitter's hair, beard, and *wild kappen* hyperbolizes singularity as such. Why, though, would anyone outside Dürer's immediate family or circle desire to see the artist thus portrayed? In its unusual format and its allusion to pictorial types unrelated to secular portraiture, the Munich panel was not intended, say, as simply one among many portraits of illustrious citizens of Nuremberg. Our understanding of function and audience must follow from an exegesis of the picture's meaning. When Dürer associates himself, both as maker and as model, with the figure of Christ, he asserts for his person a special kind of exemplarity, one that will legitimate the new functions—and implied audiences—that he himself is inventing for his art.

Throughout the Christian tradition, Christ was called the "universal man."[5] His exemplarity was multiply founded. Morally, in his sinless life and his acceptance of the Passion, he models Christian behavior, giving "himself as a most singular example of every kind of virtue."[6] Anagologically, through his perfect sacrifice, fulfilling once and for all the letter of the law, he took upon himself the sins of all mankind. And theologically, as the true *imago Dei*, beside whom other humans are but *ad imaginem Dei*, he represents man's perfect spiritual and physical state; hence his typological aspect as New Adam. For Dürer to thus endow his body with the proportions of Christ is more than merely an inflation of the *imitatio*. It affirms that Dürer stands as a model not only in the beautiful things he creates, but also in the person he is: as paragon of artistry and indeed of humanity per se.

Dürer's ambitions were ultimately fulfilled. For German artists of the sixteenth century, Dürer became *the* great original, to which all subsequent artistic endeavors were fashioned as mere responses in the form of imitation, emulation, or parody. This is obvious in artists immediately associated with Dürer's shop or working under his influence in Nuremberg: Baldung, Hans Leonhard Schäufelein, Hans Süss von Kulmbach, Barthel and Hans Sebald Beham, Hans Springinklee, Wolf Traut, Georg Pencz, and Erhard Schön. But it is also true for major masters elsewhere in the Germanies. Artists like Altdorfer and the elder Cranach derive their early graphic style, their repertoire of subjects, their commitment to the print medium, their penchant for self-inscription, and indeed their whole conception of what it means to be an artist from Dürer. What Bernhard Decker aptly terms the phenomenon of "Dürer as model"[7] is more than just the burden of influence on a mediocre following. It is the product of an idea of art, of its meaning, function, and source, invented for a culture by one person, Albrecht Dürer.

What Dürer proposed about himself in the 1500 *Self-Portrait* also survived his century. In the Dürer renaissance of about 1600, his person was sanctified and his works were treated like relics. In nineteenth-century Germany, his example focused a new cult of art. From 1815 until the end of the century, an annual Nuremberg Albrecht Dürer Day was celebrated and consciously styled like a saint's feast day; the massive 1828 tricentennial of his death was, among many other things, the occasion for establishing the first public

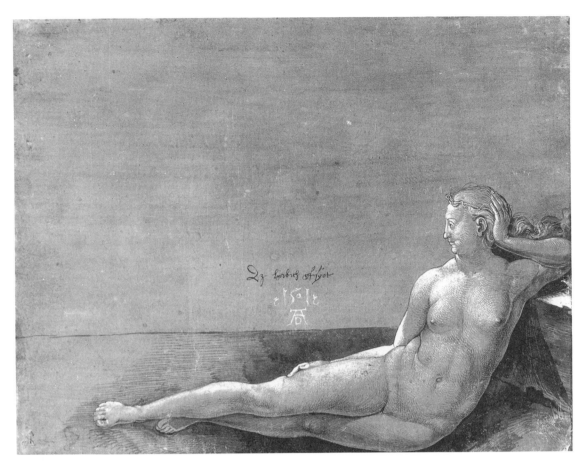

97. Albrecht Dürer, *Reclining Female Nude*, 1501, pen and brush in black ink and gray wash heightened with white on green grounded paper, Graphische Sammlung Albertina, Vienna.

museum of contemporary art in Europe; a bronze statue of Dürer, erected in Nuremberg's milk market in 1840, was the Western world's first public monument to an artist. And in this century, Dürer as model served various aesthetic and political ends. From nationalistic proclamations, first heard in 1904, of *Dürer als Führer* to the two Germanies' separate celebrations of the "Dürer year" of 1971, his work and his person have been pivotal to constructions of German self-identity.[8]

Having fashioned his Munich panel at the representative age of twenty-eight years, when he would have appeared most like himself, Dürer produced no more autonomous painted self-portraits.[9] The project of the idealized human figure as exemplum of beauty, first instantiated in the Munich panel, now found quite different pictorial vehicles. In particular, the artist turned to the constructed nude (what Dürer called the *nackete Bilder* by Italian painters he had seen) as the privileged domain of the beautiful (fig. 97).[10] One could say that instead of fashioning his own specific body as universal exemplar, Dürer took it upon himself to construct a representative image of man *in general*, elevated and

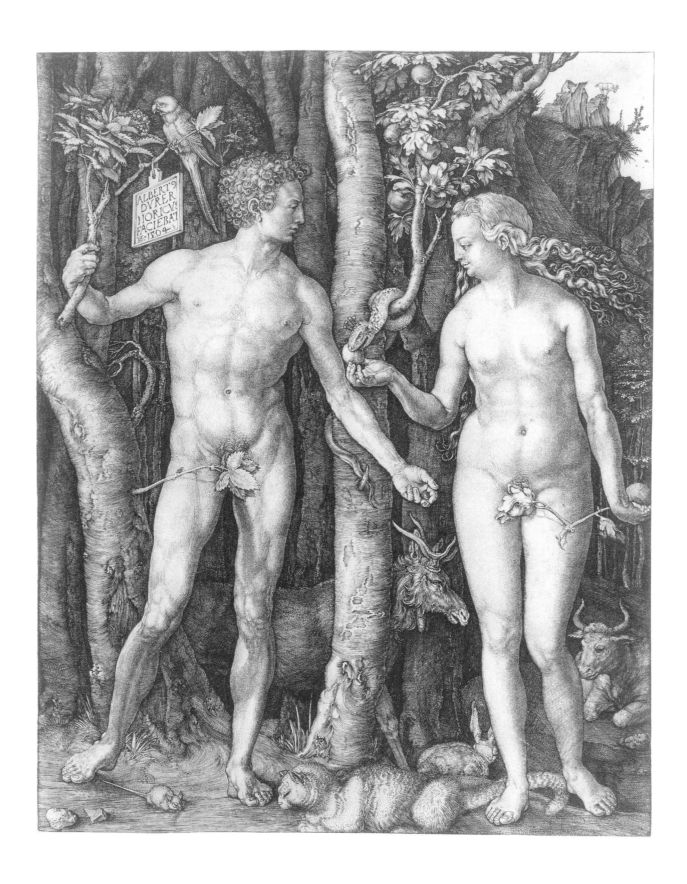

98. Albrecht Dürer, *Fall of Man*, 1504, engraving.

abstracted from the fallen particularities of individual character and identity. Interestingly, self-portraiture lingered on at the margins of his art, in *assistenza* figures bearing the artist's marks of authorship (monogram, signature, and date) and usually stationed at the border of the image, and in small sketched self-portraits, all nude or partially nude, representing the artist as sick or suffering: the Bremen *Self-Portrait of the Sick Dürer*, the lost *Self-Portrait as Man of Sorrows*, and the Weimar *Nude Self-Portrait*, probably executed after Dürer's illness in 1503 (figs. 91, 96, and 120).[11]

The first important product of this new orientation is Dürer's famous and enormously influential engraving *Fall of Man*, dated 1504 (fig. 98; Kn. 43). The figures of Eve and Adam demonstrate aesthetic principles the artist developed during the four years following the Munich *Self-Portrait*. As in the oft-repeated anecdote of the painter Zeuxis modeling his portrait of Helen of Troy from the five most beautiful living women,[12] Dürer combined in his figures the most perfect elements from various classical and natural models, submitting them to strict canons of proportion and geometry and perfecting the result through a painstaking process of construction, simplification, and reconstruction. Dürer writes in two early drafts of the *Proportionslehre*: "Item. Gathered together from many pieces, from many beautiful people, something good can be made." And again, "If you wish to make a beautiful human figure, it is necessary that you probe the nature and proportions of many people: a head from one; a breast, arm, leg from another; and so on through all the parts of the body, front and back, omitting none."[13] The sources and pedigree of the various "parts" assembled in the engraved *Fall* are too numerous to recite here. Already during his first trip to Italy (1494–1495), Dürer sketched a nude akin to the 1504 Adam. At the base of a study sheet now in Florence, the figure of a man in contrapposto with a shield and club (perhaps originally a pagan idol)[14] probably copies a classicizing nude by a fifteenth-century Italian master (fig. 99; W. 86). Dürer's nudes involved more than an imitation of antique or pseudoantique models, however. They entailed a dialectical process in which Dürer measured the proportions in his original sketches, fleshed out from these a new figure, and integrated this figure into a finished work of art by adding natural details and a framing narrative.

This story begins essentially in 1500, when the Venetian painter Jacopo de' Barbari, working for various German patrons, met Dürer and introduced him to a classical approach to the nude by showing him some proportion studies and referring to the ideas, if not the name, of Vitruvius. As Dürer himself tells it, "A man named Jacobus of Venice, born a sound painter. He showed me the figures of a man and woman that he made according to a canon of proportions. I would now rather see what his method [*mainung*] was than behold a new kingdom. If I had this method I would put it into print in his honor, for the use of all men."[15] Jacopo, it seems, guarded his canon of proportions as a shop secret. Dürer, glimpsing a new kingdom of beauty, would have to search for it alone, and after twenty-eight years of labor he incorporated his discoveries in the treatise *Four Books of Human Proportion*, released posthumously in 1528.

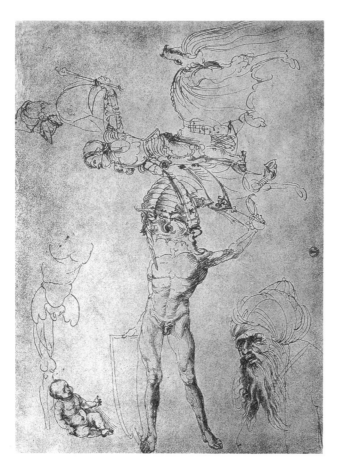

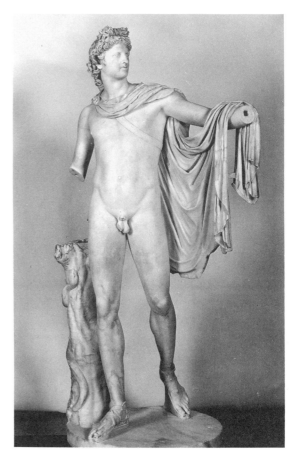

99. Albrecht Dürer, *Study Sheet with Apollo*, c. 1495, pen and gray ink, Uffizi, Florence.

100. *The Apollo Belvedere*, Roman copy, c. 130–140 C.E., after Greek original, c. 330 B.C.E., Parian marble, Museo Pio-Clementino, Cortile Ottagono.

We can observe Dürer's early "method" in the genesis of his 1504 Adam. Dürer derived the posture and general arrangement of his nude from that totemic statue of High Renaissance art in Italy, the *Apollo Belvedere* (fig. 100). Discovered in Rome about 1496, this Roman copy after a Greek bronze original would have been known to the German artist only through Italian intermediaries.[16] Dürer seems to have been either unsure of or uninterested in its precise iconography. His earliest extant works related to the *Apollo* fitted the god with a variety of different attributes. Thus in a drawing from about 1501–1502, now in the British Museum, Apollo bears a solar disk and scepter, denoting his aspect as sun-god (fig. 101; W. 261). And in a sketch in Berlin he appears as god of health, identified by the goblet and snake (fig. 102; W. 263).[17] In both sheets, the lines and points of construction are still visible under the finished drawing. This suggests that Dürer has not merely copied an Italian model but has also submitted his copy to a Vitruvian canon of proportions.[18] Both drawings, as well as the 1504 engraved *Fall*, adhere to the same

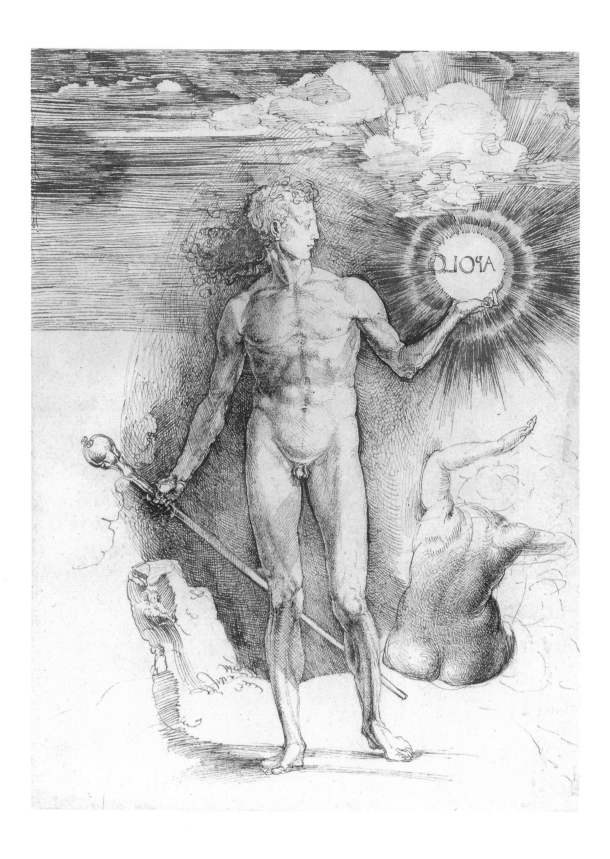

101. Albrecht Dürer, *Apollo as Sol*, c. 1502, pen and brown ink, British Museum, London.

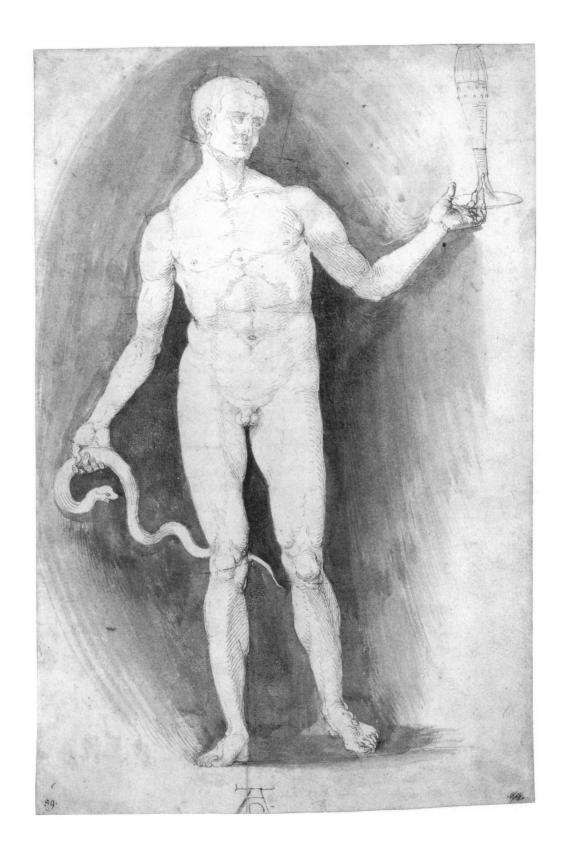

102. Albrecht Dürer, *Apollo Medicus* (or *Aesculapius*), 1501–1502,
pen and ink with light green wash, Kupferstichkabinett, Staatliche
Museen Preußischer Kulturbesitz, Berlin.

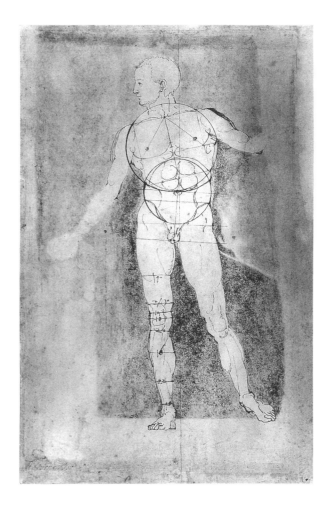

103. Albrecht Dürer, *Study for Adam* (recto), c. 1503–1504, pen and brown ink, Graphische Sammlung Albertina, Vienna.

104. Albrecht Dürer, *Study for Adam* (verso), c. 1503–1504, pen and brown ink with brown wash, Graphische Sammlung Albertina, Vienna.

scheme: head one-eighth of body length; face one-tenth; square of chest one-sixth, with its base at one-third from the crown of the head.[19]

By about 1503, Dürer abandoned the denotation of his nude as a classical Apollo, fashioning it instead as the Old Testament exemplum of perfect man, Adam. Dürer defended such transpositions when he wrote: "Just as they [the pagans] apportioned the most beautiful form of man to their idol Apollo, so too we want to use the same proportions for Christ the Lord, who is the most beautiful of all men in the whole world."[20] Like Christ, Adam was physically perfect before the Fall. As we read in Dürer's "Aesthetic Excursus," "The Creator once made people as they ought to be,"[21] suggesting not only that Adam was beautiful, but also that he is exemplary for the form of all men. On the recto of a sheet now in the Albertina, Dürer has outlined the figure of Adam following

measurements of the Apollo sketches and utilizing ruler and compass (fig. 103; W. 420). He has reduced the figure to almost pure silhouette, presenting the face in perfect profile and radically simplifying the posture; and he has eliminated the *Apollo Belvedere*'s striding, forward motion, restricting the figure to lateral motion across the picture plane. Once having set this down on the recto, Dürer then traces the figure through on the verso and works up a more naturalistic "Adam" (fig. 104; W. 421). The nude is modeled in relief, silhouetted against a dark ground, and fitted with attributes: in his left hand the forbidden fruit, and in his right a branch of the tree of life. Before transferring this sketch to his engraving, Dürer collects other details by observing real bodies posed as the *Apollo Belvedere*. This reparticularization of the nude is the function of a meticulous study of an arm (Adam's left), now in the British Museum, with its careful attention to the pattern of veins and wrinkles around the wrist (fig. 105; W. 336).

The Albertina sketches, along with a large number of other study sheets for the 1504 *Fall*,[22] embody a peculiar kind of pictorial *work*. Dürer not only invents here a new classicizing form for the northern nude, inscribing it into the doctrine of the *imago Dei*; he also transforms the working procedures of a painter, shifting emphasis from the imitation of past models and the observation of nature to a new process of analysis, abstraction, and completion, all taking place on, and even through the surface of, the individual study sheet. Overwritten with unit marks, measurements, retraced contours, and clarifying background, and riddled with pinpricks to transfer the sketch on the recto to the verso, the original sheet in the Albertina testifies that Dürer's project of fashioning representative man involved a reinvention of the idea of artistic labor. We could not be further from the procedure celebrated by Camerarius, in which the artist sets down his image *alla prima*, without preparation. Dürer seems to willfully protract the process of making far beyond what would be required for the task at hand, as if registering work were itself a message of the image, or as if Adam's exemplarity rested on his total reconfiguration as embodied labor. Even the completed engraved *Fall* in 1504 did not put the Albertina sheet to rest. As Ludwig Justi demonstrated, the unit marks and numbers jotted on Adam's right leg on the sheet's recto were not added until about 1513, when Dürer, by then deeply involved in his theoretical writings, began to test a new canon of proportions against his earlier efforts. If nothing else, the human toil visible in the Albertina sheet emblematizes how prelapsarian beauty is indeed achieved only by the sweat of the brow.

By the time he appears in the 1504 engraving, Adam's nude form has been traced and retraced scores of times, which explains not only its aesthetic finish, but also its uncanny appearance as pure boundary, as the outline of a body closed off from the world. Although engineered to convey potential movement in all directions, Adam interacts little with his surroundings. He is entirely self-complete: man cleansed of all vulgar traffic with the world, purged of any extremity of humor, or body, or surface that might threaten his sublime integrity. This impression of the human body as boundary is nicely conveyed by two trial impressions of the print, in which Dürer reserves a blank for Adam's form, completing the densely detailed background tapestry before incarnating his figure as three-dimensional, fleshly object (fig. 106). And when he renders that flesh, Dürer takes

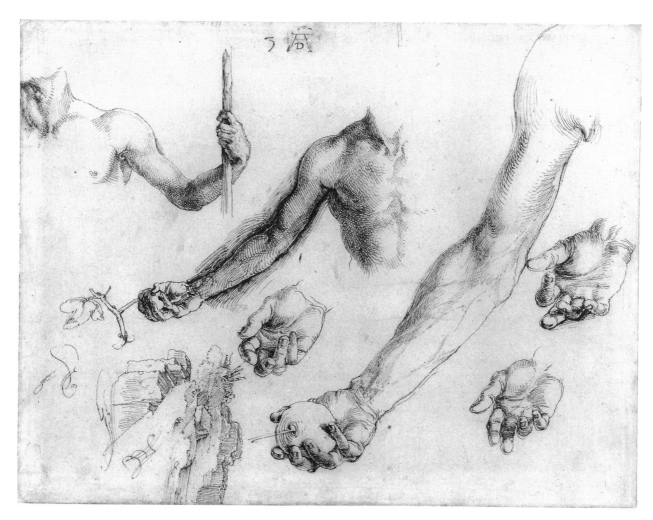

105. Albrecht Dürer, *Study Sheet of Arms and Hands*, c. 1504,
 pen and ink, British Museum, London.

care to differentiate between contours particular to it and any stray shadow that might
fall on its surface. For as Wölfflin first noted, the artist distinguishes between, on one
hand, the way he models Adam's flesh itself from dark to light by curved hatchings that
adhere to the body's surfaces (*Eigenschatten*) and, on the other hand, the way he depicts
shadows cast upon that surface by parallel hatchings (*Schlagschatten*).[23] Even at the level
of technique, Dürer separates the body from the world.

In an early draft of the "Aesthetic Excursus," Dürer notes that whereas human beauty
was once embodied in a single man, Adam, it is now imperfectly "distributed among the
multitudes of all people."[24] Dürer celebrates this diversity in the sheer number of possible
human proportions cataloged in his *Four Books*. Despite the fall into manifold nature,
however, there is a radical difference between man and the rest of creation: "For in the

end, the human form must remain separated [*ab geschiden*] from other creatures." [25] The fundamental *anomaly* of man complements what Dürer elsewhere terms "the comparative thing" (*die vergleichlichen Ding*). Sameness and difference, analogy and anomaly, determine man's ontological status, as a being ambivalently placed between God and the rest of creation. And they are the operative principles of the 1500 *Self-Portrait*, where Dürer is at once identical to himself and akin to God.

Since Mikhail Bakhtin's aesthetics of the grotesque, it has become easier to theorize the carnivalesque body, open to time, nature, and the lower strata, than to recover the closed body, which Bakhtin regards as the dominant post-Renaissance paradigm. The "classic" body, associated with "the bourgeois concept of the completed atomized being," was

> isolated, alone, fenced off from all other bodies. All signs of its unfinished character, of its growth and proliferation were eliminated; its protuberances and offshoots were removed, its convexities . . . smoothed out, its apertures closed. The ever unfinished nature of the body was hidden, kept secret; conception, pregnancy, childbirth, death throes, were almost never shown. The age represented was as far removed from the mother's womb as from the grave, the age most distant from either threshold of individual life. The accent was placed on the completed, self-sufficient individuality of the given body. [26]

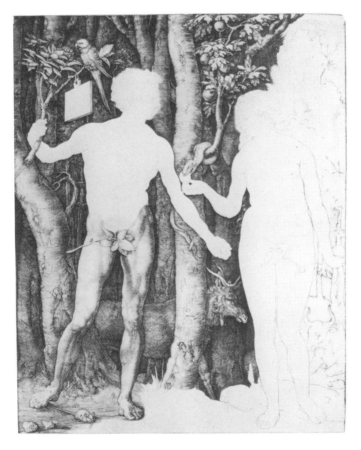

106. Albrecht Dürer, *Fall*, 1504, engraving, trial impression, Graphische Sammlung Albertina, Vienna.

This describes well both Adam of the engraved *Fall* and Dürer of the 1500 *Self-Portrait*. In the Munich panel, the artist, pictured at the precise middle of his life (twenty-eight years), labors to capture his person in an image that, through the magic of *Feinmalerei* and the myth of *non manufactum,* appears always already complete and purged of temporal making. Yet such desired closure cannot mask the fissures in Dürer's project: the conspicuously elided working right hand, the mixture of pride and shame conveyed by hair and fur, the strange indirection of self-reference. What Bakhtin terms the "atomized being" of the Renaissance and treats as a monolithic, finished, and closed fiction is in Dürer still a project in the making.

For in northern art at 1500, the dominant paradigm of corporeality was still that of a partialized body, split between a new fantasy of closure and an old awareness of abject openness and of decay. Vischer's nymph-monster *Scylla* (fig. 87) and the partialized subject of the painter Marcia's art reflect this paradigm, as do the many statues representing "World" that were placed at the entrances of German cathedrals in the Middle Ages. In a sandstone figure from about 1325, originally beside the bridal portal of Nuremberg's Church of St. Sebald, the Prince of the World appears from the front as a young and beautiful man, while from the rear his clothes and skin open up to reveal a macabre

107. *The Prince of the World*, Nuremberg, 1320–1330, sandstone, Sebalduskirche, Nuremberg.

spectacle of worms, frogs, bones, and festering flesh (fig. 107).[27] The split body models the disparity between outer beauty and inner depravity, and between the pleasures of this world and the torments of the next. The viewer who, upon entering the church, passes the statue and experiences the contradiction of its form will be instructed on the delusion of appearances per se. The overthrow of an "aesthetics of the beautiful"[28] by the grotesque body is not a subversion of official culture by the life-affirming voice of the people, as Bakhtin idealizes it. Rather, it reflects the orthodoxy of the medieval church terrorizing the people into the space of its cathedrals.

The self-consuming antiaesthetic of images like *Prince of the World* will reappear in the macabre art of Baldung, suggesting the persistence of this paradigm well into the Reformation. By this time, however, Dürer's art will have become the dominant pictorial mode, and truer to Bakhtin's vision, the reoccupation of the grotesque body functions to travesty the now-normative aesthetics of the beautiful. What remains unclear, however, are the conditions that govern this normative aesthetic, as well as the pictorial techniques by which it is established. In Dürer we encounter the veritable embodiment of a normative Renaissance. It is he who, in Germany, first theorizes and codifies an ideal of the beautiful as the aim of art and who affirms, in his images, those by now familiar and discredited discourses of the dignity of man, the freedom of the artist, and the autonomy of art. Even our historical assumption that such fictions could have been founded single-handed by one person seems to have been partly Dürer's own doing, the outcome of his celebration of life time as world time. Yet precisely because it thus asserts its own authority and closure, Dürer's "bourgeois conception of atomized being" is difficult to open to its origins and history. In Dürer's self-portraits and idealized nudes, the classic body, although fashioned to hide its "conception, pregnancy, [and] childbirth," appears indeed newborn and therefore still visibly contingent, bearing the scoriae of its creation and the evidence of its necessary demise.

In his nudes of 1500–1504, Dürer does not present his proportioned figures as pure and abstracted constructions, beautiful in themselves and unencumbered by qualifying narratives. Rather, he embeds them in a framework of myth, even if he is unsure exactly which myth to invoke. Thus the various early Apollos give way to Adam but retain one common feature: the equation of beauty with bodily health, expressed most obviously in the *Apollo Medicus* (fig. 102), sometimes called the *Aesculapius*, but recurring also as an undersong of the 1504 engraved *Fall*.

In Dürer, the Zeuxian method of combining the best from many things in one better thing acquires a quasi-theological significance. Dürer's conception of the beautiful reiterates the traditional Neoplatonic belief that nature or the material world is evil and that what we see around us are only particular, imperfect, and fallen manifestations of a single, unified, and transcendental Idea. To give this Idea concrete expression, an artist

must mitigate particularity, creating out of nature's fallen diversity the most perfect and representative synthesis.[29] In Dürer's 1504 engraving, this process is interpreted by a Christian understanding of the Fall. Dürer's Adam is representative man because he has been resurrected from the manifold postlapsarian human forms into which he was thrown. Man was created with a perfectly balanced constitution; only after the Fall was this equilibrium destroyed, subjecting mankind to sickness and death. In Dürer's engraving, Adam and Eve stand surrounded by animals emblematic of the four humors and their moral connotations: the rabbit denoting sanguine sensuality; the elk, melancholic gloom; the cat, choleric cruelty; and the ox, phlegmatic sluggishness.[30] The 1504 engraving thus juxtaposes the state before the Fall, when "man was in a place of honour, but did not realize it," to a future moment when man "has been brought to the level of the animals without understanding and been made like them."[31] Dürer asserts, implicitly, that as *alter deus* he can recollect our prelapsarian nature by fashioning a new Adam as the embodiment of beauty and aesthetic perfection.

Dürer's contemporaries recognized the print's extraordinary aesthetic claims. In a Latin epigram written sometime before 1522, the Silesian poet Caspar Ursius Velius celebrated Dürer's art by praising his representation of the Fall: "When the Angel saw them [Adam and Eve], he said with amazement: 'You were not yet this beautiful when I drove you out of Paradise.'"[32] The implied viewer here is the angel of the Expulsion, who beholds a beauty surpassing even the perfection of prelapsarian man. The angel, that is, asserts that Dürer's engraved *Fall* has not only resurrected but improved God's loftiest creation: man as *imago Dei*. Velius was familiar with Italian humanist art criticism and biography through his personal acquaintance with Vasari's friend and inspiration, the bishop Paolo Giovio. He places Dürer in an agon with God just as other humanists pit the German artist against Bellini or Apelles or Zeuxis. The 1500 *Self-Portrait*, of course, assembled the terms of the competition, although the painting asserts at most an analogy to, not victory over, divine creation.

In the 1504 *Fall*, too, Dürer displays massive confidence, again within a novel mode of self-denomination. At the upper right of the engraving, on a branch grasped by Adam, Dürer hangs a tablet inscribed with his name, date, and monogram. The branch itself is of the mountain ash, identified in the North with the tree of life, and it stands juxtaposed to the fig branch held by Eve to the left, associated with the tree of knowledge from whence came death. Dürer thus places the sign of his authorship squarely in the domain of immortality, a gesture reinforced by the text of the inscription, which reads: *Albert Durer Noricus faciebat*. This is the first print Dürer signed with his full name in Latin—a device that might invite the viewer to compare the engraving with earlier Italian models thus signed.[33] Moreover, Dürer's text itself is based on a literary conceit. In a dedicatory letter from 1509 by Christoph Scheurl, Dürer's use of the imperfect form *faciebat* ("was making"), instead of the usual perfect *fecit* ("made"), is interpreted to mean something about the nature of his art.[34] Following an ancient practice recorded in Pliny and rediscovered by Pirckheimer, Scheurl writes, Dürer signed his work with *faciebat* to suggest

that the making of the work is never fully complete and past but remains always active and ongoing. Representing the moment just before the lapse into sin and death, Dürer's engraved *Fall* aspires to recapture or outdo the immortal forms of Adam and Eve at their origin. The text of Dürer's signature, as well as its natural support in the tree of life, asserts that, though man's moment of perfection has passed, art can reoccupy a space prior to fallen history.

But what is this thing, an artist's monogram, that can thus intrude on the garden of perfect forms as the one overt object of artifice in an otherwise perfectly natural world? And what are its rules, functions, and history within the medium of the printed image?

10

The Law of Authorship

The artist's use of a personal symbol or monogrammed initials to identify a work he has made emerges in the North out of various spheres of economic and juridical life at the end of the Middle Ages.[1] In Germany since at least the thirteenth century, commercial, diplomatic, and legal transactions (for example, contract law) were increasingly dependent on written documents,[2] and yet, except for an educated few, the vast majority of craftsmen, small merchants, and farmers were illiterate. The coat of arms, trademark, and *Haus-* and *Hofmarken* when used to identify property owned by a person, family, or institution; the personal device or seal employed to "sign" or notarize contracts and other legal documents; the marks of stonemasons, which indicated the identity of the producer so that he could be paid for the pieces he fashioned; and the goldsmith's plate mark, which identified the maker and guaranteed the quality of the gold used—all these were ways of registering the *person* in law and commerce within the culture out of which Dürer emerged.

Between 1420 and 1440, graphic artists appropriated this practice from other crafts, placing within their engravings some personal sign. This was partly a response to the new economic demands of their trade. Prints were not financed by commission or sold only locally; their production by a heavy press required an outlay of capital far beyond the costs of plate, paper, and ink; and their distribution often depended on the new, erratic, and intensely competitive industry of the printed book. The printed image, therefore, needed to advertise its origins and assert its value differently than painting did, through a recognizable sign of authorship. It is not coincidental, for example, that though none of the panel paintings of the late fifteenth-century Alsatian master Martin Schongauer are signed, all of his engravings are. At the base of a very early print by Schongauer, the *Peasant Family Going to Market* produced shortly after 1470, we see a typical form of the engraver's mark: the artist's initials in antiqua capitals separated by a shop trademark—the cross-shaped device (fig. 108). In the case of this artist, historical links to the goldsmith's trade are evident. Schongauer, whose father was an Augsburg-born gold-

108. Martin Schongauer, *Peasant Family Going to Market*, c. 1470–1475, engraving.

smith, engraved a design for a crosier in which his MS sign appears integrated into the represented object, as a plate mark on the crosier's shaft. The elements and format of such signs varied from artist to artist. Sometimes a symbol or an object might be represented, perhaps punning on the artist's name, as later in Hans Schäufelein's shovel device (*Schäufelein* means "little shovel") and the early Hans Baldung Grien's vine-leaf motif, suggesting the word "green" of his nickname. Sometimes, as in Schongauer, it will combine initials with symbol, which is also the case for Veit Stoss, the Master bg, and the Cranachs. Most commonly, the artist will be identified simply by his monogrammed initials, which can be written in a characteristic lettering (as in the monograms of the Master E. S., the Master L Cz, I A von Zwolle, and Israel von Meckenem) or linked in a clever pattern, which is the chosen mode of the mature Dürer.[3] What is important is that the sign be recognizable and consistent throughout an oeuvre, linking the individual print to its producer, be it an artist, a shop, or a publisher. For in the medium of engraving, the artist is potentially absent both from the community of viewers who initially purchase and use the image, and from the actual process of production, which demands manual labor from the artist only in fashioning the original plate. The monogram emerges within this absence, as part of a strategy for making mechanical reproduction pay.

When Dürer takes over this native German practice, he expands its scope and fundamentally changes its message. As early as 1493 Dürer places his initials on panel paintings and drawings, something that is unknown to Dürer's teacher Michael Wolgemut;[4] by 1494–1495 he begins to monogram not only his engravings (the first thus monogrammed

is the *Virgin with the Dragonfly* [Kn. 4]), but also his single-leaf woodcuts, a practice that presupposes fundamental changes in the conditions of trade for this medium.[5] Dürer could have derived his strategy both from his father, who as a successful and cosmopolitan goldsmith would have understood the form and function of plate marks, and from the artists with whom he trained in Nuremberg. Wolgemut had already begun to free the art of woodcut designing from the domination of publishers, changing what had been the specialty of professionally employed "illustrators" into a lucrative industry for painters.[6] In illustrated books like the *Schatzbehalter* of 1491 and Hartmann Schedel's *Nuremberg Chronicle* of 1493,[7] Wolgemut organized the financing and publication of his shop's productions, employing the services of the local printer, Anton Koberger. Dürer, who was Koberger's godson, took this process one step further. In his famous *Apocalypse* woodcuts, published in Latin and German editions in 1498, he was at once designer and publisher, having purchased his own printing press about 1497.[8] The artist followed this practice in all his printed works, even naming himself as publisher of his own theoretical tracts (the *Unterweysung der Messung* of 1525 and the *Befestigungslehre* of 1527 are *gedruckt von Albrecht Dürer*). After his death his widow Agnes continued this practice, printing the 1528 *Proportionslehre* under her own name and defending her copyright in the courts of Nuremberg. The artist's monogram, appearing in all his major woodcuts from 1496 on, thus functioned to indicate the image's designer *and* publisher.

In producing his woodcuts, Dürer monopolized all stages of an image's making, from invention and execution to publication and sale.[9] He thus freed himself from any dependency on the large book publishers, with their complex division of labor (Coberger, for example, employed more than 150 journeymen and had branch offices in Paris, Lyons, Budapest, Leipzig, Regensburg, Wrocław, and Frankfurt). This autonomy affected his whole conception of himself and his art. More than anyone else, Dürer transformed the conditions of the trade for artists working in Germany. What had been a craft financed by commissioned works, and organized in large and hierarchically organized shops, became through him a more diversified industry, producing a range of commodities—from portraits and panel paintings to engravings, woodcuts, book illustrations, and drawings—to be sold on the open market and featuring, as its essential product, a work particular to the singular master. It is significant that although, from about 1500 on, Dürer was by far the most famous and sought-after painter in Germany, he never produced a work in that dominant pictorial genre of pre-Reformation Germany, the large winged retable altarpiece.[10] The retable consisted of a number of elaborate components. At the center, the shrine or *corpus* was a shallow box containing carved depictions of the narrative, personage, or mystery to which the altar was dedicated; crowning the shrine, the *Auszug* or *Gesprenge* consisted of carved vaultings, foliage, and finials; below, a *Sarg* or predella raised the shrine above the altar table; and wings, either painted or sculpted in low relief, served to protect and conceal the more precious shrine on workdays. These structures, sometimes huge, were often financed publicly and used in the collective rituals of the Christian cult. They required a complex division of labor between a number of different craftsmen (painters, sculptors, joiners, and locksmiths, along with their various appren-

tices and assistants). The painter was generally relegated to a subordinate role of poly-chroming the statues and relief sculpture or decorating the external panels, frames, and rear of the altarpiece. Dürer would have been familiar with this mode of production from his training under Michael Wolgemut, who continued to operate the largest workshop in Nuremberg (and one of the largest in Germany) until his death in 1519. In his family chronicle, he recalls that he "had to endure much from [Wolgemut's] apprentices,"[11] suggesting, perhaps, the frictions of class divisions within such huge workshops.

Although successful painters of the early sixteenth century were still enjoying lucrative commissions for retable altarpieces,[12] the mature Dürer never participated in such a project. Perhaps he rejected the subordination of painting to sculpture inherent in the genre. Perhaps he recognized the financial disadvantage of being employed by another master or of belonging to such large-scale operations. The few altarpieces he did produce are all relatively small works, privately commissioned and financed, and they generally consist of a single painted panel in the mode of the Italian *pala* or *ancora*.[13] His most ambitious work of this kind, the 1511 *Landauer Altarpiece*, represents the first real break in Germany from the tradition of the retable, taking the form of a wingless image framed in an Italian-ate *aedicula* (fig. 59). Sculpture appears in an ancillary role, in the massive, classicizing frame designed by Dürer and executed by a local sculptor (perhaps Ludwig Krug).[14] Again Dürer has monopolized the various stages and components of his commission, making the altarpiece, as much as possible, a one-man product.

Dürer's rejection of the retable as the economic mainstay of his trade transcends the question of painting's status relative to sculpture, however. It reflects Dürer's general ambivalence toward commissioned works as a source of income. His letters to Jacob Heller document the financial burdens and physical difficulties Dürer experienced in completing the *Ascension of the Virgin*. It was in one of these letters, recall, that the artist hyperbolized his labor, claiming that the *Ascension*, were it to be made with what his patron termed the "greatest possible diligence," would take more than a lifetime to finish. In an afterthought, Dürer raises a question about the viewer of traditional religious art. "Besides, who ever heard of making such a thing for an altarpiece? Who would see it?"[15] Invested in a single object in some local church or private chapel, *Feinmalerei* is a wasted effort, a dimly lit and distant spectacle visible only to a privileged few. Against this viewing situation, in which a painting is used as Christian cult object and not experienced as art object, we may set the printed image. Here an artist's pictorial invention, multiplied by mechanical reproduction, can be seen—and owned—by thousands of people, and his genius and diligence appreciated within such new and private spaces as the humanist's *Kunstkammer* and *studiolo*.[16]

His *Apocalypse* woodcuts of 1498 would already have demonstrated to Dürer how his labor, invested in the medium of the print, could spread rapidly through Europe and beyond, earning lucrative returns along the way. As the artist writes to Heller on August 29, 1509: "In one year, I can make a pile of common pictures [*gmaine gmäll*], so that no one would believe it possible that one man could do them all. One can earn something on these. But assiduous, hair-splitting labor gives little in return. That's why I am going to

devote myself to my engraving. And had I done so earlier, I would be today one thousand florins richer."[17] Dürer describes three kinds of images and their profit margins. First, common pictures or *gmaine gmäll,* produced swiftly and in large numbers, can be lucrative either because the buyer does not discern this haste (owing to the painter's skill) and will pay as though they were carefully produced or because the speed with which an artist makes such pictures is itself a source of wonder to his public. This is what Camerarius refers to when he writes of Dürer's *alla prima* method; and it is the idea behind Dürer's own "strange saying" that the hasty sketch of a master is more valuable than the labored product of a lesser talent. The problem with fast painting, presumably, is that its products are less permanent, less materially stable than the carefully crafted masterpiece, of which Dürer can boast (as he does to Heller) that it will last "five hundred years clean and fresh."[18] Second, "assiduous, hair-splitting labor" (*fleissig kleiblen*) takes too much time and does not fetch a proportionately high price—as evidenced by Heller's quibble with the price of the *Ascension.* Finally, engraving is the artist's medium of choice, and his only regret is that he did not realize this earlier. For rather than being paid according to the labor he expends, the maker of prints profits from the number of copies sold, which are *non manufactum,* as it were, made not by human hands. But what, then, *does* define the value of the print for Dürer's culture?

Dürer was no less innovative in his marketing practices than in his acquisition and use of a printing press. Already by 1497 the artist experimented with colportage as a means of selling his prints in towns and cities throughout Europe. A contract between Dürer and a certain book hawker named Georg Koler testifies to this scheme.[19] Paid a weekly wage of half a florin, Koler agreed to peddle Dürer's engravings and woodcuts "in the cities and towns he deems good and profitable; and he should hawk and sell them for the highest possible price, and carry them from one city and region to another, and offer them for sale, letting nothing, neither play nor other frivolous activities, hinder their sale, and the money he earns he will send to the said Dürer forthwith."[20] A similar contract exists between Dürer and Jakob Arnolt, the brother of the Nuremberg painter Hans Arnolt.[21] This contract was witnessed by the printer Anton Koberger, suggesting the close link between Dürer's system of distribution and the burgeoning Nuremberg book industry. The artist profited from the new commercial network growing up around the printed book, with its special fairs, its system of local agents, and its advertising strategies,[22] as well as from traditional sites of trade—local fairs, shooting contests, religious festivals, markets at the doors of cathedrals and pilgrimage shrines, and so on.

Ultimately, however, Dürer's use of colporteurs brought him near financial disaster. In a passage from his *Gedenkbuch* written about 1506, Dürer complains that although he worked hard "with his hand" he never profited much, for he sustained great losses in bad loans and speculations. He adds: "The same is true of servants [i.e., colporteurs] who did not turn a profit. One died in Rome with great loss of my wares. For this reason, when I was in the thirteenth year of my marriage, I paid great debts with the money I

earned in Venice."[23] After 1506 Dürer never employed professional agents again, preferring to sell his prints by less risky methods, peddling them himself on his travels, arranging their transport to foreign markets through merchants like the Tuchers and Imhoffs,[24] or entrusting them to his wife, mother, and maid, who sold them from stands at the fairs of Augsburg, Frankfurt, and Ingolstadt as well as at the annual Imperial Relics Fair (*Heilstumsmesse*) in Nuremberg.[25] What the artist's short-lived experiment with colportage demonstrates, though, is the extent to which Dürer treated commercial relations in new and creative ways. His inventive, if flawed, schemes of production, advertising, and distribution reflect how, within the middle-class urban milieu of Nuremberg at 1500, individuals could regard themselves as makers of their own destiny, thwarted only by the deception of other people or by the hazards of fortune. The 1498 *Self-Portrait* of Dürer as *gentilhuomo* emblematizes this drive to transcend the *ordo* into which he, practicing "painter handwork" (*maler handtwerk*), was born. Thanks to regular commissions, sales of his prints, an annual pension from the emperor, profits earned on his properties, and a tax-exempt status granted him by the Nuremberg city council, Dürer died a wealthy man, leaving his wife a fortune of 6,848 silver gulden, a sum so great that Pirckheimer later remarked in a famous letter to the Viennese master builder Johann Tscherte that Agnes must have driven her husband into an early grave through her greed.[26]

The legal status of the professional painter in Dürer's Nuremberg was particularly well-suited for creative commercial arrangements.[27] Contrary to what is frequently asserted in the Dürer literature,[28] painters of fifteenth- and sixteenth-century Nuremberg were not bound together in a guild, as they were in virtually every other German city, since as a result of the 1348 artisans' revolt, craftsmen's guilds were generally forbidden by Nuremberg's patriciate-controlled council.[29] And though painting, like the city's other trades, was carefully regulated by the council, it was categorized as a "liberal art" (*freie Kunst*), a status enjoyed by sculptors, book printers, and engravers as well.[30] Although monopolistic guilds offered ordinary painters more protection, Nuremberg's commercial structure put ambitious painters at an advantage by favoring talent and entrepreneurship. Dürer's self-assertion thus does not represent the elevation of artisan or *Handwerker* to the new status of "artist," such as was being invented in Italy; rather, it is an attitude made possible by, on the one hand, a modern style of finance and commerce developed in Nuremberg by 1500[31] and, on the other, the very lack of a predetermined legal definition of what the trade of the painter should or should not be. Indeed, most local Nuremberg painters between 1500 and 1596[32] were fighting precisely *for* the ordinary status of *Handwerk* so that, through guild monopoly, they could protect their products from more talented foreign competitors. Dürer's historical role in the development of art as a commodity salable on the "open" market presupposes a particular freedom of movement between crafts (painting, engraving, woodcutting, and printing) that was uniquely possible in his native city.

The print industry, with its novel structures of production, sale, and consumption and its attendant redefinition of the value of art, introduced new liabilities for the individual artist. Dürer discovered early that while prints could generate more profits than panel

paintings, they were also more vulnerable to unfair modes of competition in the form of unauthorized copies—what is called in the sources criminal plagiarism (*crimen plagii*). From Vasari's *Vite* we learn that Dürer was involved in a lawsuit in Venice against the young Italian engraver Marcantonio Raimondi, who, it seems, produced a pirated edition of the monumental woodcut series the *Life of the Virgin* and the *Great Passion*, complete with Dürer's monogram (fig. 109; Kn. 228 and fig. 110).[33] In a letter to Pirckheimer of February 7, 1506, Dürer complains of artists in Italy copying his work: "Many of them are my enemies and copy my things in churches and wherever they can find it."[34] The case against Raimondi was heard by the Signoria in Venice, which decided that Dürer (so Vasari) "could receive no other satisfaction but this, that Marc'Antonio should no longer use the name or the above mentioned signature [*segno*] of Albrecht in his works." Dürer's compositions themselves, in other words, were not protected, only his personal monogram, the main function of which would have been precisely to claim authorship for the composition.

An identical decision was reached by the Nuremberg council against a foreign copyist of Dürer's prints. In a decree of 1512, filed in the city records under the heading "Albrecht Dürer's art stolen," we read: "The foreigner, who sold prints before the town hall, some with Albrecht Dürer's monogram [*hanndzaichen*] that were fraudulently copied from him, shall be bound by oath to remove all the said monograms and sell none of them here; and if he refuses, all his said prints shall be confiscated as counterfeit [*ain falsch*] and taken into the hands of the council."[35] The forger's crime did not lie in producing a copy, for indeed woodcuts and engravings were often purchased precisely to be copied as models by painters, illuminators, sculptors, jewelers, and the like. The young Dürer, for example, made two engraved copies of a sketch of a carnival horseman by the Nuremberg artist Wolfgang Peurer.[36] And since at least 1494, Dürer's early prints were being copied by known German contemporaries like Wenzel von Olmütz, the Monogramist A, the Monogramist HS, Israel von Meckenem, and Hieronymus Graff.[37] What the city did decree in 1512, however, was that to copy Dürer's prints with his *hanndzaichen*, which means literally the "sign of his hand," constituted a criminal act of deception or fraud. A pirated copy of a Dürer, complete with the artist's monogram, was termed *ain falsch*—a nebulous but important category of medieval law that encompassed counterfeit coins, falsified signatures, forged or altered documents,[38] untrue weights and measures, and false or adulterated commodities (e.g., fake wine, saffron, furs, and precious minerals, as well as rotten or altered ingredients that had been disguised).[39] Emerging partly out of the legal class of the *crimen falsi* of Roman law,[40] *der falsch* denoted certain deliberate misrepresentations of material objects, either in the form of making something appear different from what it actually was, or of purposely changing the nature of a thing so that its original appearance was preserved but its alteration concealed. Punishment for such crimes varied greatly, ranging from death and maiming to mere confiscation of falsified goods, as was the case in Nuremberg's decision for Dürer. Note that the counterfeiting of goods—what in German law is still termed *Warenfälschung*—was regarded as above all a crime against the public trust, or *publica fides*, and not against the individual producers of proper goods.

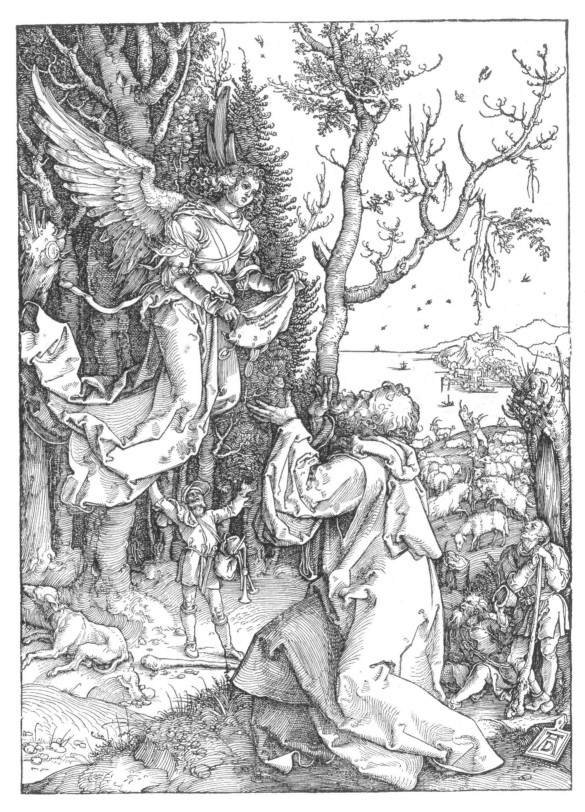

109. Albrecht Dürer, *Joachim and the Angel*, 1503–1504, woodcut from the series *Life of the Virgin*.

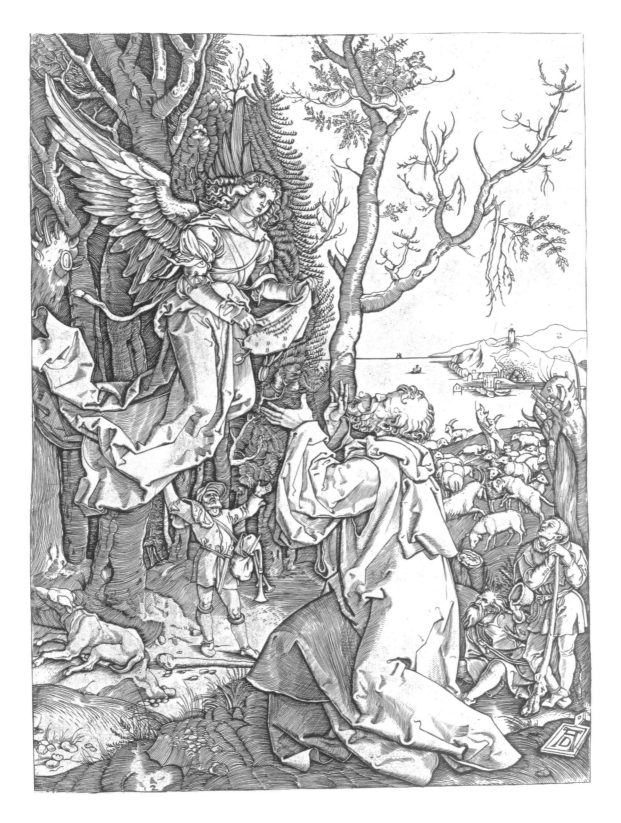

110. Marcantonio Raimondi, *Joachim and the Angel*, c. 1506, engraved copy of Dürer's woodcut from *Life of the Virgin*, showing false monogram.

Producers were generally protected from unfair competition not through criminal law, but through the monopolistic rules of the craftsmen's guilds. By seeking protection from copyists in the courts of law in Nuremberg and Venice, Dürer operated within a new relation between the individual producer and the state.

What does it mean, though, that the Nuremberg Rat protected Dürer's *hanndzaichen* from copyists, but not his pictorial inventions? What makes a replica of a Dürer that omits the artist's monogram any less *ain falsch* than one that includes it? If we follow a medieval definition of counterfeiting as "making something appear as other than it is,"[41] then the only thing that is truly Dürer's, and that can be protected as such, is his name; or better, what is criminal about replicating the monogram is the false appearance the copy conveys that it is the immediate product of Dürer's hand, hence its term *"hannd"-zaichen*. And yet the point about the printed image is precisely that it sidesteps manual labor, and therefore that its relation to the artist is not as product of his body, but as invention of his mind. Legal discourse concerning unauthorized Dürer copies constitutes an early and pivotal episode in the larger history of copyright. The expansion of notions of property to encompass products of intellectual and artistic labor involved fundamental changes in the notion of authorship, origination, and authenticity, notions that were challenged by the new technology of mechanical reproduction. It is useful, therefore, to turn very briefly to the status of copyright at 1500.[42]

Before the advent of the printed book, the only indications that a text might be regarded as the property of a particular author are the notion of plagiarism (known since antiquity) and the commonplace that writers should be able to decide whether their texts will be made public.[43] Emblematic of the status of the author during the High Middle Ages is a case of literary plagiarism from 1269. Two Dominican friars, both going by the name John of Colonia, claimed authorship for a certain well-received work of theology. Their dispute was brought before a committee of eminent scholars and theologians, including Thomas Aquinas and Siger of Brabant. The commission finally decided that the work in question should be dissociated from any named author, bearing instead a neutral title.[44] In Aquinas's account of this case in his *De secreto*, there is no evidence of any special legal—or moral—concept of a text as the special property of its author. Even in the period of the incunabula, the issue of copyright seems not to arise, perhaps because well over half of the books published before 1501 were either new editions of much earlier texts or reprints of other incunabula.[45] The only notion analogous to copyright expressed in this period is an author's desire that further publication of his work in other editions be faithful to the original text.[46] Toward the end of the fifteenth century, and then only in Italy, there appears a form of protection against unauthorized copies: the privilege.[47] What justifies this protection, according to the texts of such early privileged books, are the attentiveness and labor expended on making a work (*multis vigiliis et laboribus*) and the public good that will be derived from it (*ad universalem commoditatem et utilitatem*).[48] In Germany the first imperial privilege was granted to none other than Conrad Celtis for his 1501 edition of Hroswitha von Gandersheim, followed by privileges for editions of old texts prepared by Konrad Peutinger and Johannes Stabius.[49] For Emperor Maximilian, the

imperial privilege functioned partly as a way of achieving a closer supervision of the production of German presses.⁵⁰ For the publishers, it offered a modicum of protection for their product, asserting that an edition had been prepared at the cost of human labor and material expense, that it was intended for the general good of man, and that to copy such a thing was to gain something for free—hence the Nuremberg council's categorization of the crime of unauthorized copying as "theft" (*Albrecht Dürers kunst abgestollen*).⁵¹

Note, however, that what is safeguarded in these early versions of copyright is never the *author's* original text—that is, his or her verbal and intellectual invention, independent of particular editions and impressions. Rather, the imperial privilege protects the individual publication alone, as financed and therefore owned by the *printer*. In this period authors, if they are remunerated at all, are paid by piece or by time expended, not by profits made on a particular edition.⁵² It is only much later that the notion of a text as the spiritual property of an individual author becomes enunciated within a legal category of the imperial privilege or copyright. The wording of the Nuremberg city council's 1512 decree suggests, too, that it was not Dürer as artist they were defending against copyists, but Dürer as printer and commercial entrepreneur, whose monogram functioned as the trademark of his press, not the sign of his person.⁵³

Dürer himself had a very different notion of spiritual property, however, one that is without precedent in the whole history of copyright. In a Latin colophon printed on the final leaf of the 1511 complete edition of his *Life of the Virgin, Large Passion,* and *Small Passion,* Dürer defines *what is his* in the form of a warning to all copyists of his art: "Beware, you envious thieves of the work and invention [*laboris et ingenii*] of others, keep your thoughtless hands from these works of ours. We have received a privilege from the famous emperor of Rome, Maximilian, that no one shall dare to print these works in spurious forms, nor sell such prints within the boundaries of the empire. . . . Printed in Nuremberg by Albrecht Dürer, painter."⁵⁴ Copyists steal more than an artist's manual labor. Dürer's phrase *laboris et ingenii* asserts that they also steal his unique pictorial invention, which is the product of his personal talent or *ingenium*. According to classical rhetoric since Quintilian, *ingenium* signifies innate ability that cannot be learned. It is usually defined in opposition to the term *ars,* meaning a skill, competence, or art learned through rule and imitation.⁵⁵ In Dürer, *ingenium* is equivalent to the notion of *Gewalt,* which refers to something like a quasi-divine "power" placed within the artist by God and manifested in everything the artist produces, from large panel paintings down to the roughest sketch or woodcut illustration.⁵⁶ Above all, *Gewalt* is manifested most immediately in the strength, accuracy, agility, and freedom of the artist's own characteristic and calligraphic line.

This notion of *Gewalt* or personal force finds its most important theoretical articulation in a famous passage from Dürer's "Aesthetic Excursus," to which I alluded earlier:

> It is to be noted, however, that an understanding and practiced artist can display more of his great power and art [*gwalt vnd kunst*] in little things of rough and rustic form [*in grober bewrischer gestalt*], than many others can in their large works. Only powerful artists will understand that I speak truth in this strange saying. For this reason, something one man sketches in a day, with a pen on

a half-sheet of paper, or engraves with his graver in a little block of wood, will be more artful and excellent than another man's large work, which he makes with great diligence in a whole year. And this gift is wonderful. For God often allows one man to learn and understand how to do something well, for which no equal can be found in his time, and perhaps no one will come before him and after him none shall soon come. We see examples of this among the Romans, when they were in their time of splendor. What was made by them, which we still see in ruins, has in its artistry few equals in our works.[57]

The aesthetic Dürer works against here is one that regards the value of an art object as dependent solely on the amount of time it takes to produce it. By "large works" Dürer means commissioned works like retable altarpieces, which were the economic mainstay of German painting. As I suggested earlier, Dürer sought to replace such commissions with less time-consuming commodities such as drawings, engravings, and woodcuts. These "little things," produced swiftly on paper, could, by virtue of the artist's talent (*ingenium*) and practice, manifest what is most valuable in art: the *gwalt vnd kunst* most individual to an artist. The traditional value of a great work has been transferred to the idea of a great painter, the "powerful artist" who towers over his contemporaries and has neither precursors nor followers. And the model for this greatness is the unique and heirless genius of antiquity.

Dürer, of course, is bound to make such claims. In the printed image—his new source of income—it is not the manual labor that gives each impression its value. Rather, value is invested in an image's unique pictorial conceit, executed with calligraphic skill on the plate or transferred to the woodblock from an original sketch. It resides in the traces of a free and original mind, not in products of a servile hand. Having taken control of the means of production for his prints, Dürer seeks in his 1511 colophon to expand what of this product should be regarded as his own, thereby extending the boundaries around the individual self, its assertions and possessions. Invention and genius are properties of the self. And as properties they must be commodified, and therefore bounded and protected by the laws regulating commerce and ownership. Even after the artist's death, his widow Agnes spent a busy old age in the law courts of Nuremberg and southern Germany, waging legal battles against her husband's students and followers who sought to copy his images or writings. Dürer's former apprentice Hans Sebald Beham, for example, was forbidden to publish his own treatise on perspective, the *Kunst und Lehrbüchlein*, on the grounds that it had plagiarized Dürer's 1528 *Proportionslehre*; and in 1532 the Nuremberg courts heard a suit Agnes brought against Hans Güldenmund, a Nuremberg woodcutter and printer who produced a pirated edition of Dürer's 1522 *Great Triumphal Chariot of Emperor Maximilian I* (Kn. 346–351).[58] Dürer is the first artist to claim and receive such explicit rights, and he does so, not coincidentally, in Venice and in Nuremberg, two cities associated with the most advanced juridical thinking in Europe at 1500.[59] A full account of the artist's struggle for copyright would have to place Dürer's efforts within the context of the reception of Roman law in pre-Reformation Germany[60] as well as within larger transformations in the notion of private property that occurred during the early modern period.

The legal definition of what was or was not copyrightable remained unstable even after Dürer's death. This is demonstrated by a curious case heard by the Imperial Cameral Tribunal (Reichskammergericht) in Speyer on October 17, 1533.[61] The plaintiff Johann Schott, an important Strasbourg book publisher active 1500–1544, claimed that an herbal he had financed and printed, which was protected under an imperial privilege granted by Charles V, had been unlawfully pirated by a Frankfurt publisher, Christian Egenolf. Schott maintained that his illustrator had invested time, money, and labor in making the images for the text and had created a totally new work, the likes of which had never been seen before. The illustrator "Hans Weiditz, painter at Strasbourg," depicted the individual plants "in a praiseworthy manner, through artful observation of their age, herbage, leaves, seeds, stem, and roots, following them through the seasons, until their fifth year, and all this with great trouble, expense, and labor in a new work, never seen before in print, and added to this many represented figures drawn and cut, which are renewed from impression to impression."[62] Schott did not exaggerate the novelty of his publication. The work whose copyright he defended is the great *Herbarium vivae icones*, or *Contrafeyt kreuterbuch*, illustrated by Weiditz (before 1500–1536) and compiled and annotated by the Strasbourg humanist, physician, and reformer Otto Brunfels (c. 1488–1534).[63] Published in German and Latin in multiple volumes between 1530 and 1536, the *Herbarium* revolutionized the format and conventions of scientific publications. In his masterly woodcuts, Weiditz depicts plants in their entirety and shows the successive stages of their development through different seasons of the year. An illustration of the plaintain or *Breyter Wegrich* evolving from seed cap to maturity demonstrates Weiditz's method (fig. 111); neither abstracted nor idealized, the herb appears as a singular example of its species, displaying wilted areas and random losses unique to this *particular* plantain. Brunfels, too, in his concise and orderly exposition, which introduces each plant by genus, species, and subspecies, and in his knowledge of both contemporary and classical botany, sets standards for the presentation of scientific material. And Schott's book design is also revolutionary, employing a readable roman type and an alphabetical index. The *Herbarium* was to become a model for illustrated texts of this kind published in Germany after 1530.

Christian Egenolf's response to the charges of plagiarism is threefold.[64] First he contests the jurisdiction of the Reichskammergericht over a case involving neither a violent crime nor warfare between cities. He asks instead that the dispute be settled by a local judge, presumably in the municipal court of Strasbourg. This underscores the fact that even if an author or artist was granted full privilege for his work by the emperor, it was next to impossible to defend such a right, let alone punish offenders, beyond suing the pirating publisher within his own city. Second, Egenolf asserts that, even were he to acknowledge the Reichkammergericht's authority (which he does not), his herbal is altogether different from Schott's, having been modeled after a much earlier book composed and illustrated by a certain Dr. Cuba of Frankfurt. Against Schott's assertion that his *Herbarium* had been plagiarized "word for word," Egenolf lists over a hundred species encompassed by his herbal that are omitted by Schott and remarks that, anyway, the use of previous herbals is justified by the public good brought by such books in times of

epidemic. Third, Egenolf discusses illustrations shared by his herbal and Schott's, contending that what was copied were not Weiditz's illustrations but the plants themselves, which both herbals sought to reproduce:

> And even if the herbs resemble one another somewhat, Your Honor should consider that one can never paint or represent rosemary, asphodel, or another herb in another form or shape than what it itself is. . . . It would be an absurdity if the imperial privilege were to be understood to demand that, because Hans Schott printed the herbal, an herb with small, narrow leaves must henceforth be represented with long, broad leaves and printed as a monster contrary to the type, shape, form, and nature of the herb. This is not as trivial as it seems, for although Albrecht Dürer, Jacob Meller of Wittenberg, and others received privileges declaring that no one is allowed to copy their paintings, this does not therefore mean that, if these artists paint an Adam, Eve, Acteon, or Achilles, because of their privilege no other painter is permitted to paint the same fables.[65]

Plantago Maior.

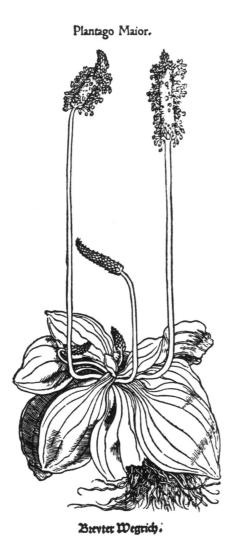

Breyter Wegrich.

111. Hans Weiditz, *Breyter Wegrich (Plantain)*, woodcut illustration for Otto Brunfels, *Herbarum vivae icones* (Strasbourg: Johann Schott, 1530), vol. 1, fol. 23.

At the far side of the notion of artistic property stands a claim to copyrighting nature itself.

The case of Schott versus Egenolf negotiates the changing relations between artist, image, and model in the visual culture of the German Renaissance. Weiditz's woodcuts, rather like Dürer's signed and dated nature studies, proclaim themselves at once to be *by* someone and to *be* the object as "it itself is."[66] Because of their naturalism, these illustrations will not be copied or imitated for their style, composition, or graphic signature, for such traces of artifice will be concealed in an image rendered transparent to its prototype. The stylistic ascesis of naturalism, however, arises simultaneously with the self's all-powerful desire to appropriate art *and* nature to itself, as if the enlightened movement toward the empirically true were indeed dialectical with the self's total absorption of the world as property. Weiditz, Brunfels, and Schott, because of their originality—because, that is, of their ingenious decision to take as their model not previous herbals (e.g., Dr. Cuba's), but nature itself—can regard any future naturalistic herbal as always derivative from their 1530 creation. Scientific depiction, gathering, defining, and possessing each individual plant in its totality, from root to flower and from germination to death, becomes itself a copyrightable human invention, and its idea and its products can be protected as the personal property of its inventor.

Egenolf's *exceptiones contra citationem*, in turn, articulate the predicament of all followers of an original and appropriative artist. The defendant's strategy is to sever reality from image. He says, in effect, that even if it is the plaintiff's invention to affirm the identity of the two, nature remains untouched and wholly communal as a model. What Egenolf's herbal has in common with Schott's, then, are not the *images* of individual plants, but the plants themselves, whose healing powers should benefit everyone. Otherwise, Egenolf argues, to avoid the charge of plagiarism an artist coming after Weiditz would have to deviate from the natural object itself, producing pictorial monsters and misleading the public for whose health the herbal is fashioned.

Precisely this necessary disfiguration of the "natural" will characterize Albrecht Dürer's strongest artistic followers, who are left with the option of either imitating their master and risking charges of criminal plagiarism or exaggerating their distance from Dürer so that they produce willfully artificial images. Mannerism, as the dissociation of form from content, would thus be the mirror image of Egenolf's claim to share with Weiditz things "as they themselves are." What is also crucial for us is that at this historical moment, when a battle is waged in the imperial tribunal over the artistic ownership of plants *an sich*, the name of Dürer should be invoked. Clearly, by 1533 Dürer represents the primary legal precedent in cases of copyright and unauthorized reprinting; yet Egenolf tries to sidestep this precedent. He argues that Schott claims for his *Herbarium* not the privilege of a maker's original composition, such as Dürer received from, and upheld in, German and Italian courts, but rather the ownership of the very subject matter of the work of art, as if after Dürer monogrammed the engraved *Fall* of 1504, no future artist could ever again reproduce this motif. It is a pleasing irony, however, that what Egenolf terms an "absurdity"—Dürer's total appropriation of the fable of the Fall—becomes a reality in

German painting of the sixteenth century. For as we shall see in the willfully disfiguring representation of Adam and Eve by Baldung, Dürer's claims to originality were so immense and so unavoidable for his artistic progeny that to represent the Fall in any manner after the 1504 engraving will amount to a travesty, an image "contrary to the type, shape, form, and nature" of the Dürerian model.

Dürer expressed a proprietary relation to his art quite early in his career. In a chiaroscuro drawing of a nude woman dating from 1501, now in the Albertina, Dürer placed his monogram and an inscription of the sketch's date in white body color at the center of the scene's horizon, adding above these the boastful words: "This I have designed" (*Dz hab ich gfisÿrt*) (fig. 97; W. 260). The artist can indeed be proud of his sketch. Probably the first nude produced in the North to be wholly constructed according to a classical canon of proportions,[67] it marks a beginning of that formalistic phase of Dürer's career that carries through the 1502–1503 Apollo sketches to the engraved *Fall. Gfisÿrt*, from the verb *visieren* meaning "to design,"[68] denotes the artist's working method, which is not one of sketching directly from nature, but rather of constructing an ideal plan or elevation, a blueprint of the female body as it should be. Dürer avoids any conspicuous foreshortening of his object, arranging the woman's reclining body flat against the picture plane, her head turned in perfect profile. That such a posture appears unnatural is not the issue here, for the drawing's "model" is not an observed real body, but an ideal body deduced by principles of geometry and constructed by rule and compass, whose marks are still visible under the drawing's finished form.[69] Elevating his nude above the contingencies of both the viewer/artist's individual perspective and the particularity of actual bodies, Dürer fashions a "new creature," perfecting his own earlier efforts, such as the nude woman of the *Sea Monster* engraving of 1498 (fig. 112; Kn. 23). When Dürer writes, *Dz hab ich gfisÿrt*, allowing the *I* to fall exactly at the midpoint of the sentence and of the sheet's width, he is at once claiming originality within the pictorial tradition and placing the sketch within the development of his oeuvre. Dürer's idealized nude, isolated from any landscape or narrative and rendered as pure, self-enclosed contour, is linked through inscription, date, and monogram to another monologic presence: the artist himself as economic man, defining his intellectual property and protecting it from usurpation or disfiguration by lesser talents.

Already in the mid-nineteenth century, the art historian Anton Springer discerned a relation between the idea of Dürer's "greatness" and the activities of his copyists: "If it is true that the greatest artist is he who is most often imitated and most diligently counterfeited, then indeed no other master can contest Dürer's laurels. The history of his works is simultaneously the history of the most spectacular forgeries of all time."[70] By far the most copied artist of the German Renaissance, Dürer himself established his originality partly through the exclusion of, or defense against, later copyists. The reception history of his early prints bears out this curious dialectic. At first Dürer designs and publishes woodcuts bearing his personal initials as advertisements of their authorship. These

112. Albrecht Dürer, *The Sea Monster,*
c. 1498, engraving.

prints, valued precisely as products of Dürer's unique hand, are then copied by other artists, who insist on including the AD monogram in an effort, presumably, to sell them at the price of an ''original'' Dürer.[71] Dürer, in turn, is forced to defend his right of ownership over his product, achieving for his personal monogram—but not for the art it undersigns—the status of private property. What emerges here is the protection not of the artist's works, but of his name, or better, of his asserted authorship per se.

In her exhaustive studies of spurious Dürer monograms, Lisa Oehler has shown that the initials AD, as they appear frequently in works by other German artists of the period, can signify a range of dependencies. When it is not simply an optimistic or deceptive addition by later collectors or dealers, the spurious monogram can identify a work as the product of Dürer's shop rather than his own hand, as seems to be the case in certain images bearing the ''tossed monogram.''[72] Or it can appear in works copied directly from an original Dürer, as a means either of signaling the copy's source or of passing the copy off as an original. Finally, and most obscurely, it can appear in works having no thematic or stylistic link to Dürer, as in Hans Burgkmair the Elder's *Self-Portrait* in Hamburg, which

bears a large Dürer monogram inscribed in Burgkmair's own hand.[73] In such instances the spurious initials signal something more than a minor master's attempt to sell his work as Dürer's, alluding or paying homage to an idea of art exemplified in the person Dürer. In Burgkmair's Hamburg likeness, Dürer's project of self-portraiture finds a curious vicissitude. Burgkmair feels it necessary to link his likeness to German painting's representative self-portraitist, thus emptying his own panel of that equivalence between image and maker asserted by Dürer's art in the first place. Similar combinations of self-ascesis and Dürer celebration occur in the renaissance of Dürer's art in northern European courts at 1600 (e.g., the London copy of the 1484 silverpoint *Self-Portrait* in the Albertina [fig. 23]). They are unsettling, for they expose the double bind of Dürerian self-denomination, which at once defines great art as what is unique and original to the individual artist and also proclaims one artist, Dürer, as *the* example to be imitated by future talents.[74]

I have traced Dürer's idea of the inseparability of the self from its works within the Erlangen and Munich self-portraits, as well as within Dürer's idea of a personal graphic style. These ideas function as a kind of counterfiction to the artist's growing investment in the medium of the print, where the presence of the maker's body as labor is obviated. When Dürer places a massive version of his monogram below the head of the dead or dying Christ in a charcoal drawing from 1503, he is not merely reminding the viewer of the image's maker (fig. 113; W. 272). Rather, he affirms an irreducible relation between the artist and the substance of his art. The inscription flanking the monogram reads: "These two faces I made in awe [?] during my illness" (*Dis 2 angsicht hab ich uch erl[furcht?] gemacht in meiner kranckheit*).[75] It links the subject of the drawing, Christ of the Passion, to the artist's own bodily condition at the moment of the drawing's production. This intrusion of self and biography into the work transforms Christ's face into a personal emblem for Dürer's suffering and expands that will to self-portraiture present in the oversized monogram.

Such a transumption of the religious by the personal was already monumentally expressed in the 1500 *Self-Portrait*, where the Holy Face served as model for the artist's face. There again, Dürer combines signature and self-portrait not merely to declare the image to be *by* himself, but also to found exemplarily and upon quasi-theological principles the Renaissance fiction of the presence and value of the individual self in the work of art. In the 1503 drawing, Dürer appears in his work in a new way. The heavy charcoal lines rendering the sharply lit contours of Christ's face have been invested, through inscription and monogram, with pain and sickness consubstantial with the body that draws them. It is as if, infected with Dürer's disease, the charcoal adheres as much to the picture's author, present in his marks, as to the picture's model, present in his image.

By contaminating the image with his name, biography, and body, Dürer responds to another possibility. The head of Christ and the large monogram were fashioned in the crisis of an illness whose outcome, at the moment of the drawing's production, was not yet clear to its maker. The drawing would have functioned as a potential last testament, which gives it its awesome sense of finality. The inscription was written sometime later, when the crisis has passed, but its tenor remains bound up with death. Affirmation of

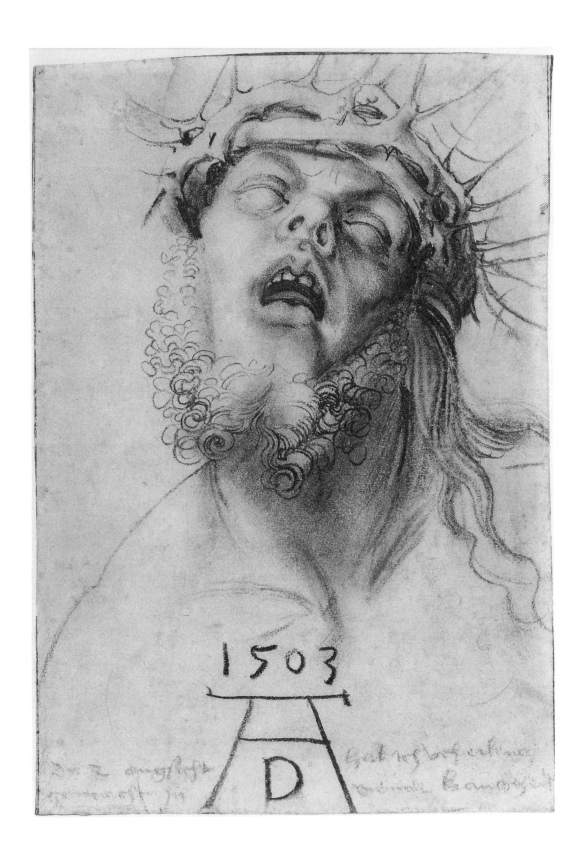

113. Albrecht Dürer, *Head of the Dead Christ*, 1503, charcoal, British Museum, London.

self-presence functions here as a lie against the annihilation of self, either as projected bodily death or, more hauntingly, as an absence felt in representation itself. Dürer's experience with the thieves of his *ingenium* would have taught him that the image, and in particular the printed image he champions for the North, can introduce a separation between the self and its works. It is the function of the monogram to negotiate this separation, to conceal this threat to the private, egotistic, economic man—what Bakhtin nicely terms the "monologic."[76]

In his engraved *Sudarium* of 1513, Dürer returns to the image of the thorn-crowned head of Christ, now in the medium of print (fig. 43). The Holy Face, peering out at us from the relic, again stands juxtaposed to Dürer's monogram and date. These are inscribed on a tablet whose square shape evokes both the sweat cloth and the original engraved copper plate, which bit its impression into the paper rather as the monogrammed tablet stands out from it in raised relief. Yet where in the charcoal drawing the artist inhabits his work through its specificity as object, as surviving material testament to one critical "moment" in biographical time, in the engraving the image is mechanically multiplied and therefore cannot act as contact relic of Dürer's bodily being. In place of this, Dürer fashions for the medium of print a myth of the maker's *praesentia* in his works. The sudarium, impressed with the self-portrait of Christ, is the visual account par excellence of an image at once made without hands and fully its maker's *own*. Dürer's mark of ownership and originality, together with Christ's image of images, pushes toward us from the surface of the page.

More specifically, the 1513 *Sudarium* dramatizes a miraculous *concretion* of objects and bodies on the two-dimensional surface of the paper. The angels' crumpled, fluttering drapery; the sharp-edged tablet in the *bas-de-page*; Christ's likeness, more like a head mounted as a trophy than like an image printed on a cloth; and the print's sheer wealth of detail (the angels' hair and feathers, Christ's curly beard, the crown of thorns): all demonstrate the uncanny bodily presence, the precision of form, and the faithful mimesis of material surfaces that are medium-specific strengths of engraving as Dürer practices it. That Dürer thinks about his printed sudaria as comments on their medium is clearer still in the 1516 etched *Sudarium*, in which the uncertain presence of Christ's face in the sky interprets the visual characteristics of etching (fig. 49). Where in the 1513 engraving Christ's likeness stood forth from the page like relief sculpture, here his face almost dissolves into the sky; where his beard was a tight concatenation of volumetric coils, here it is a loose play of calligraphic lines drawn freehand on the plate; and where light modeled evenly the stable, rounded surface of things, here light catches the edges of moving tissues (the hem of the large angel's garment as it mingles with the cloud's margin; one corner of the sudarium; one corner of the *cartellino* upon which appear Dürer's monogram and date). Dürer has experimented with etching's capacity to evoke atmosphere. Behind the four angels with the arms of Christ, he has indicated other angels with lines that could just as well be underdrawings or mistakes, so that the instability of the image mirrors the uncertainty of creation. In an impression of the etched *Sudarium* in the Fogg Museum at Harvard University, Dürer seems to have experimented with the printing process itself. The verso retains the mark of a small piece of paper that Dürer must have

placed against the sheet during printing, probably to intensify that part of the image on the recto (the area of the angel's billowing skirt).[77] Each impression of the etching, like the inverted sudarium, the monogrammed *cartellino*, and indeed the calligraphic line itself, becomes a malleable tissue, a unique, uncertain surface bearing the maker's marks. This interprets one valence of the print's motif. Just as the angel appears to pull the Holy Face down from the dark surface of the sky, so too Dürer pulled his image up off the inked and etched plate. Or alternatively, the angel appears as a printmaker hanging his prints out to dry. Dürer thus fashions the Christian *non manufactum* to mythicize the process and the product of printing.

11

Bas-de-Page

Dürer's self-portraits model a relation between artist and artwork.[1] Their historical moment is multiply determined: an aesthetic consequence of changing paradigms of religious experience; an episode foreseeable within the larger course of northern art since 1400; one particular inflection of Renaissance self-assertion, or of an emergent modern identity. Most immediately, though, self-portraiture responds to the changing material and technical conditions of art production at 1500. Dürer explicates this connection between self-display and the medium of printing in his most semantically complex depiction of the sudarium: the face of Christ decorating the *bas-de-page* of the penultimate page of Dürer's contribution to the *Prayer Book* of Maximilian (figs. 45 and 114).[2] This small sketched *vera icon* serves to link two distinct projects at work in the *Prayer Book:* on the one hand, the artist's desire, as Dürer puts it in his "Aesthetic Excursus," "to make himself seen in his works"; on the other hand, the desire of the patron and partial designer of the *Prayer Book*, Emperor Maximilian I, to use the work as a mode of imperial self-glorification. Read as an interchange between producer, patron, and public, the *Prayer Book* is a study in what Ernst Kantorowicz termed the "sovereignty of the artist," that is, the analogy, articulated in Renaissance humanist theology, between artistic and political authority.[3] But first a word about the general nature of Maximilian's *Prayer Book* and its relation to the medium of print.

Dürer executed his illuminations on one of ten copies of a book printed in movable type in 1513. The text itself consists of a Book of Hours and a collection of psalms, biblical passages, and hymns selected or composed by the emperor himself with the help of his literary adviser, Conrad Peutinger.[4] Even in its undecorated state, the *Prayer Book* is a unique object, employing a new, readable type (the so-called Fraktur script) designed especially for the commission and adorned with movable flourishes invented by the Antwerp woodcutter Jost de Negker.[5] Overlaying the text is a printed pink grid intended to simulate the rulings required by medieval scribes to keep their script even, thus giving the *Prayer Book,* which is printed on parchment, not paper, an overall impression of a

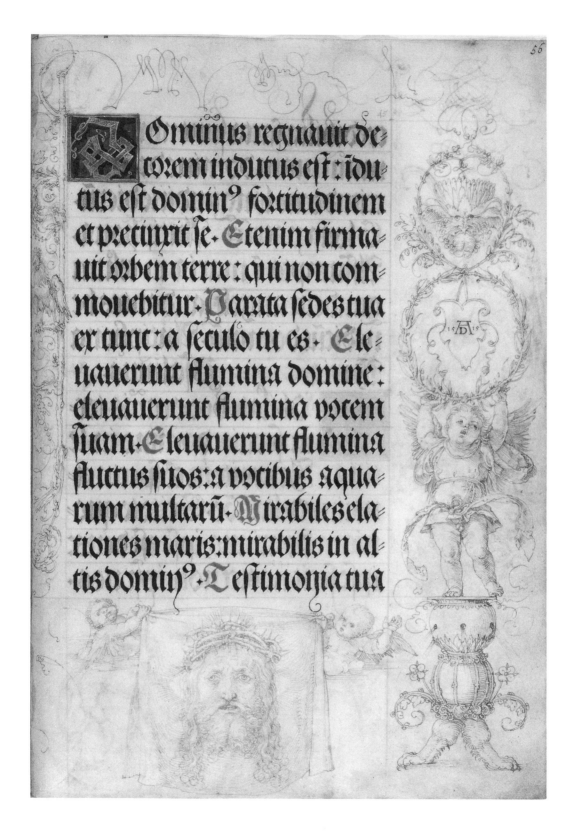

114. Albrecht Dürer, decorated page of the *Prayer Book of Maximilian*, 1515,
 pen and olive green ink on parchment, Staatsbibliothek, Munich,
 L. impr. membr. 64, fol. 56.

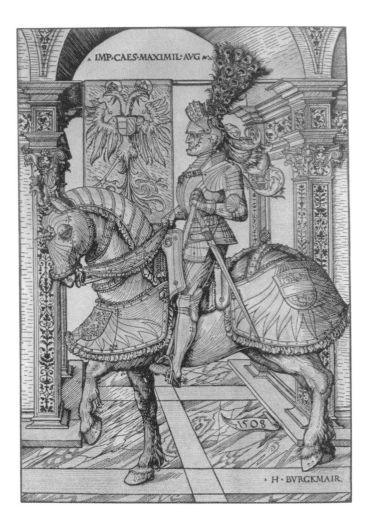

115. Hans Burgkmair the Elder,
Emperor Maximilian on Horseback,
1508, chiaroscuro woodcut.

precious, hand-produced manuscript. Already in 1508 Jost de Negker, after a design by Hans Burgkmair the Elder, had printed woodcuts of *St. George* and of *Maximilian I on Horseback* in gold and silver on colored paper, imitating the visual effect of illumination (fig. 115).[6] In the *Prayer Book,* it seems, this conceit was to be carried out on a grand scale, creating a printed book that could vie with the legendary manuscripts of Burgundy (the duchy Maximilian acquired through his 1477 marriage to Mary of Burgundy).[7] Portions of one of the ten printed texts were sent out to the leading German artists of the time, to be outfitted with decorations as each master saw fit: first to Dürer, who established the basic stylistic idiom and technique—monochrome pen drawings in olive green, red, or violet ink[8]—then to Hans Burgkmair, Lucas Cranach the Elder, Hans Baldung Grien, Jörg Breu, and Albrecht Altdorfer and his shop. As Karl Giehlow, Erwin Panofsky, and others have suggested, these illuminations were not finished products, however, but *modelli* to be translated into woodcuts and imprinted around the text of the unadorned books, which would then be distributed as gifts to the members of Maximilian's newly founded

Order of St. George.[9] The idea of a printed, illustrated prayer book could have been inspired by the various Books of Hours published in Paris between 1489 and 1498, which were decorated in woodcut or relief metal cut. The most famous of these, the lavishly illustrated *Heures à l'usage de Rome* of September 16, 1498, produced by Philippe Pigouchet for Simon Vostre, was probably known to Dürer and contains compositions reminiscent of those found in Dürer's *Prayer Book* drawings.[10]

The *Prayer Book* stands at a pivotal moment in the history of the *production* of art. It at once proudly demonstrates the new possibilities of the specifically German technology of printing,[11] which can produce precious objects in unlimited numbers and at the same time still desires to capture the magic of the unique, hand-produced manuscript.[12] The movable flourishes that appear as if spontaneously from the ends of certain letters; the paraphs or *Schreibmeisterschnorkeln* that fill many margins of Dürer's pages (e.g., at the base of folio 19; fig. 116); and the calligraphic style of the images themselves, which are as much about the free movement of the artist's hand on the page as about the subject they depict—all these appear to resurrect the very manual labor that the printing press will have obviated. To discern the meaning of innovative modes of art production in the *Prayer Book,* however, we must first examine its relation to the new patterns of patronage and public in Maximilian culture.

Since the 1982 publication of Jan-Dirk Müller's magisterial study of the literary and artistic projects of Maximilian, we are in an excellent position to understand the specific intentions behind the *Prayer Book* and its illustrations.[13] The nineteenth century nurtured a conception of Maximilian as the "last knight," born on the eve of a new era marked by religious division, political chaos, and the rise of the modern bourgeois, absolutist state, yet himself yearning nostalgically for the values and symbols of the Christian Middle Ages, whose aristocratic ethos he sought to stage through historicizing reenactments of a chivalric past.[14] In place of this account, Müller regards Maximilian as a threshold figure of a different kind. Inheriting what had become, by the end of the fifteenth century, a chronically weak position of rule, Maximilian sought to transform his power base by allying himself with the prosperous German cities and the wealthy merchant class, while distancing himself from his traditional allies, the aristocracy and princely electors. His rule, which lasted from 1493 to 1519, thus anticipates the movement from feudal aristocracy to absolutist state characteristic of the early modern period, with many of the attendant changes: for example, the expansion of a money economy; the centralization of a legal system (e.g., Maximilian's founding of the Reichskammergericht in 1495); the organization of a well-trained, infantry-based, paid, professional army; the establishment of a bureaucratic hierarchy based on merit and dependent on the Crown, which could take over functions traditionally fulfilled by a court aristocracy based on birth; and the compensatory process Norbert Elias calls the "courtization of the warrior."[15] The marked medievalism of the Habsburg court at 1500 must be understood in this context. The lavish jousts and tournaments, the retrospective literary and artistic tastes, the exaggerated cultivation of courtly manners and values, and the new, pseudochivalric confraternities like the Order of St. George (the *Prayer Book*'s intended public) were devised by the emperor

to rechannel the real power of its principal players (the German aristocracy) into a new and purely symbolic power.[16]

Maximilian's literary and artistic projects were fashioned to respond to and navigate precisely these changes. His preferred medium of self-representation—the printed book and image—was perfectly suited to these special conditions. As an itinerant monarch or *Wanderkönig*, Maximilian had no fixed court like Versailles or even Fontainebleau and was forced to divide his time between the various cities and local courts throughout his realm. The print, which does not distinguish between original and copy, enabled the emperor to disseminate the emblems of his personal power to all the sites of his rule without having to establish an absolute center where things in their "original" or authentic form would be located. As Larry Silver has argued, unlike the symbols of political power of earlier *Wanderkönige*, who carried their insignia, treasury, and tapestries around with them as a kind of "portable court,"[17] Maximilian's printed monuments—for example, the *Triumphal Arch* (published 1517–1518) and *Great Triumphal Chariot*, both designed by Dürer in collaboration with Pirckheimer, Peutinger, and Johann Stabius[18]—existed in many copies and could therefore transform any location into a version of his court.

"Even in the most perfect reproductions," writes Walter Benjamin, "one thing is missing: the here and now of the art work, its singular existence in that place where it is to be found."[19] Benjamin's 1936 essay "The Work of Art in the Age of Mechanical Reproduction," perhaps this century's grandest deployment of the secularization thesis, chronicles our modern notion of "art" and "beauty" as they emerge from the experience of the cult object. Put simply, mechanical reproduction, from woodcuts and lithographs[20] to photography and film, calls into question the singularity of the art object, a singularity whose cultural meaning was founded within the domain of ritual, where the object had been given its "original and first use-value."[21] Out of this loss emerged, dialectically, a new kind of value: the estimation of a work of art according to whether it is *authentic*. Replacing the cultic value of the image, the new notion of authenticity fetishized the simple fact of the image's singularity, canonizing the productions of certain great artists and defining their worth according to the measure of price.

We have already seen such a transition in Dürer's art, in which the value of a print of his *Life of the Virgin* becomes contingent upon Dürer's immediate authorship. The issue of authenticity is intensified by the fact of mechanical reproduction, but it is already felt in the pictorial tradition out of which Dürer's works emerged. For what was Jan van Eyck's signed and dated *Holy Face* but the ceremonious transferral of the singularity and therefore authority of the cultic relic (the *vera icon*) to the new category of the individual artist authentically present in his works? Dürer's 1500 *Self-Portrait*, which endows the very body of the artist with what Benjamin calls the aura of the cultic, carries this logic to one conclusion and articulates the transition from the cultic to the aesthetic within the modern interpretative category of history—1500 as moment of the new. The material pressures acting upon the artist are clear by now: at once the promoter of the mechanically reproduced image and the victim of its very ability to be copied, Dürer must establish, single-handed, the economic and juridical category of the "authentic Dürer." What

116. Albrecht Dürer, decorated page of the *Prayer Book of Maximilian*, 1515, pen and violet ink on parchment, Staatsbibliothek, Munich, L. impr. membr. 64, fol. 19.

will be gained for him is precisely his art's transcendence over its "singular existence in that place where it is to be found," for it was precisely the singularity and cultic embeddedness of panel painting that Dürer lamented in his letter to Heller.

But what of Maximilian's *patronal* use of such a mode of production? Capable, as Benjamin said, of transcending the singularity of time and place, the printed symbols of imperial power could be a useful tool of statecraft for a ruler who wished to unify disparate territories around the mere *idea* of a center (and who, always pressed for cash, could hardly afford anything more lavish than prints). In the *Prayer Book,* printed text and image, potentially ubiquitous, are endowed with the aura of a unique original, as conveyed within the work's simulation of manual labor. In its general form, the work invokes the tradition of the Flemish luxury manuscript, which had demonstrated the prestige of its patron through the sheer effort and expense involved in its making.[22] Yet in its mode of production, the *Prayer Book* transforms the very nature of exclusivity. Possession of a copy is no longer contingent on an owner's wealth, power, and prestige but depends on his relation to the sovereign. This fits the emperor's overall political designs. For against his traditional position as figurehead of a constellation of relatively autonomous aristocratic powers bound together by common political aims and by the shared class value of *Ritterlichkeit,* Maximilian constructs a more centralized court, in which hierarchy is determined by personal favor bestowed by the emperor alone. The printed object (*Triumphal Arch, Prayer Book, Triumphal Procession,* etc.) enables the surrounding culture, itself highly heterogeneous, to share in the sphere of princely self-representation. Yet it also limits the audience for such imperial display. For just as they may be potentially everywhere, Maximilian's various published triumphs are very difficult to view as a whole. The *Triumphal Arch,* made up of 192 separate woodcuts, is much easier to appreciate, its difficult symbolism and decorative splendor more accessible, when it is disassembled and mounted, say, in albums. The festive *display* of royal symbols is thus replaced by limited *ownership* of the simulacra of such symbols.

Maximilian's creation of a particular public for his productions is clear from the nature of the *Prayer Book*'s intended audience: the favored members of the Order of St. George. While deriving its outward form and insignia from the medieval chivalric orders based on birth, the Order of St. George was open to all groups of society, from noblemen and patricians to wealthy Jews. Such an audience is delimited by the emperor alone, who prints his books and triumphs singularly for specific individuals, rather than for an open market.[23] Maximilian's impulse to manufacture the exclusivity of a public centered on the sovereign determines the character of most of his cultural productions. The overtly autobiographical nature of the emperor's literary works, from *Freydal* and *Theuerdank* to the *Weiß kunig,* links the person of Maximilian indissolubly with the founding myths and symbols of his empire. Similarly, in the *Prayer Book* the emperor proliferates his personal *livre d'heure,* traditionally an object of private devotion and determined in this case by a heraldry and symbolism specific to Maximilian, into the hands of his trusted servants and allies. He provides his constructed court with inexpensive signs of himself, thus conveying his authority in a condition of rule marked by political fragmentation, shortage of capital, decentralization, and lack of the monologic presence of a ruler.

Albrecht Dürer's desire for self-presence within the visual image has an analogous historical motivation. His self-portraits, artist's monograms, and willfully individual graphic style all simulate the link, rendered tenuous through printing, between image and maker. Before Dürer, mechanically reproduced images were not intended as replicas of unique objects made by the characteristic "hand" of an individual master. They were not, that is, ersatz master drawings (for drawings were not yet a salable commodity) but were cheap likenesses of some object of general interest: the physical appearance of a saint, ruler, or notable criminal; the look of a misshapen birth foretelling the future; the how and what of a biblical event; and so on. In the North, the master drawing is more a response to prints. It is a commodity whose value as unique and handmade product is established retrospectively, after technology has obviated singular manufacture. The collectible virtuoso sketches of Dürer and his followers—works like Dürer's *Green Passion* in the Albertina (fig. 123); Baldung's various chiaroscuro drawings of witches from about 1515 (figs. 159, 160, 162); the Maximilian *Prayer Book* itself; and the color-ground drawings of Altdorfer, Wolf Huber, Urs Graf, and Niklaus Manuel Deutsch (figs. 198 and 200)—are products for a public grown accustomed to the graphic line through the medium of print, but demanding (and affording) something more exclusive. Thus, just as Maximilian manufactured self-presence in his printed works within the reality of a rule by absence, so too Dürerian self-display occurs as a consequence of mechanical reproduction's elision of the artist. It is within this context that Dürer's fascination with the *vera icon* becomes understandable. For in this image "not made by human hands," the artist discovers a mythical analogue to a printed image fully consubstantial to its maker.

The *vera icon* decorates the base of the penultimate page of Dürer's contribution to the *Prayer Book* (Signatures 2 to 10). Executed in pen and olive green ink, this illumination occurs below the opening lines of Psalm 93. As Theodor Hetzer has argued, Dürer probably executed his sketches in the order they appear in the manuscript, beginning with fairly modest bands of foliage or isolated figures in the outer margins of the early pages (6ᵛ–7ᵛ), then developing a tentative, narrow strip of ornament on the inner margin (8–12) and experimenting with various connecting devices in the *bas-de-page* (15–16ᵛ), until in the later pages he evolves a complex interplay between zones of a totally filled page or double page (e.g., 35ᵛ–36).[24] Since the last page of Dürer's segment of the manuscript (56ᵛ) echoes the design and iconography of the first, acting as a kind of visual coda to his image cycle, the page with the *vera icon* represents the proper pictorial finale or signature to the work, in which Dürer emblematizes the controlling aesthetic of his project within an image rich in personal associations.

As with most of the border illuminations of the *Prayer Book*, the iconographic meaning of the *vera icon* on folio 56 is still open to debate.[25] The sudarium, uplifted by two winged putti, might illustrate "lifting" or *elevatio* of the waters as described in Ps. 93:3 printed on the same page. Or alternatively, it might visualize the word *testimonia* printed directly above it, in the phrase *Testimonia tua credibilia facta sunt nimis* ("Thy testimonies are very sure"; Ps. 93:5). For the face of Christ certainly embodies a notion of the "true" evidence

of God's incarnation as man.[26] The association forged here between Dürer's image and the text of Scripture accords well with everything we have learned about the *acheiropoetos* and its theology, as well as its transformation, within the 1500 *Self-Portrait*, into the emblem of Dürer's own pictorial veracity per se.

There is a problem, however, with the nature of God's *testimonia* as they are specifically described in Psalm 93: "The Lord reigneth, he is clothed with majesty; the Lord is clothed with strength, wherewith he hath girded himself: the world also is stablished, that it cannot be removed." Yet the God who appears in the Dürer sketch is Christ of the Passion, wearing a crown of thorns rather than the girdle of strength, and reflecting in his vacant stare and half-open mouth the vulnerability of his human flesh. But then, the whole page is full of paradoxes and antithetical juxtapositions. Beside the opening of the Psalm, in the outer border, Dürer constructs a playful vertical grotesque[27] consisting of a monstrous face and a shield hanging within two wreaths of foliage, a supporting putto, and a round object with jets spraying out of it in the manner of a table fountain,[28] all atop a pair of lion's legs. The uplifted wreaths probably refer to the glory of God as described in the Psalm.[29] Their message of victory thus stands juxtaposed to the Man of Sorrows in the *bas-de-page*, according to a traditional allegory that says the Christian's triumph is crowned not with the laurels of earthly conquest, but with the crown of thorns of Christ's victory in death.[30] Previous scholars have wrongly identified the monster of the grotesque simply as "unvanquished evil,"[31] for Dürer's image does not simply juxtapose victor with vanquished. Rather, it thematizes the very notion of triumph as it can be represented within the visual image.

Regarded as one of the instruments of the Passion in the late Middle Ages, the sudarium was integrated into the visual formula of the *arma Christi*—that curious coat of arms of the Man of Sorrows that, though fashioned during the European craze for heraldry, overturns the symbols of strength and earthly wealth assembled in a secular armorial.[32] The figurative basis for such an inversion is foundational to the message of Christianity. In his Passion, Christ dies a humiliating and human death, yet in his Resurrection this apparent order of things is turned on its head. The weak become strong, the low are raised high, the disfigured *Schmerzensmann* of Isa. 53:2 becomes the majestic Christ of Matt. 24:30.[33] The crown of thorns emblematizes the plot of this inversion, for though fashioned to mock Christ as king of the Jews in the moment of his *humilitas passiones*, the crown instead mocks Christ's detractors, who fail to see that he, in reality, *is* king and that the insignia of his divine victory are precisely the marks of his human defeat. It is this logic of inversion that informs Dürer's illustration in the *Prayer Book*. Against the pomp of antique pagan triumph or apotheosis on the left, there are the *arma* of the degraded Christ, uplifted but also displaced to the *bas-de-page*;[34] and against the bearded, vegetable monster surrounded by "laurels" there is the similarly en face Holy Face. Remember also that, during the period of his work on the *Prayer Book*, Dürer was preoccupied with the question of triumphal representation. In 1512 Maximilian commissioned the artist to design the colossal woodcuts *Triumphal Arch* and *Triumphal Chariot;* in the latter image, no fewer than twenty-four wreaths are assembled to crown the emperor

seated in his allegorical wagon (fig. 117). Dürer also experimented with mock triumphs, for example, in sketches of fantastic columns from 1515–1517, now in the British Museum (W. 715) and later in the famous and much-debated *Monument to Commemorate a Victory over the Rebellious Peasants*, published as an illustration to Dürer's 1525 *Unterweysung der Messung* (fig. 118; Kn. 369).[35] In the *Prayer Book*, the artist weaves together the pictorial logic of the mock heroic with that central Christian emblem of grotesque inversion, the crowned Man of Sorrows, expressing thereby the paradoxes of the Christian faith as it fulfills and revaluates the heroic Old Testament prophecies of the Psalm.

For nearly two centuries now, the essential interpretative problem raised by the whole of the *Prayer Book* has been that of gauging the relation between text and image.[36] Against recent assertions that every element of Dürer's sketches has some definite reference to the written passage it decorates,[37] it seems more likely that the principle of play clearly at work in the drawing's style also operates at the level of iconography. What we have analyzed as Dürer's intermingling of high and low, elevation and degradation, sacred and profane, serious and playful does not simply illustrate the principle of inversion inherent

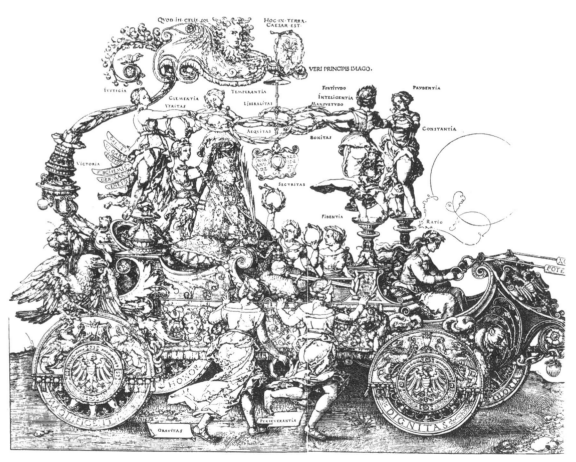

117. Albrecht Dürer, detail of *The Great Triumphal Chariot of Emperor Maximilian I*, 1520, woodcut.

in a particularly Christian reading of divine testimony. The artist's method here and throughout his *Prayer Book* drawings is informed by a general aesthetic of the grotesque characteristic of the marginalia of illuminated manuscripts in the North since at least the thirteenth century.[38] In the image of the *vera icon* of folio 56, this visual tradition of sacred parody, in which the tone and intention of the written text are ignored or travestied by the carnivalesque images that enframe it, merely finds its exemplary expression. For in a tradition that runs from St. Paul to Erasmus, Christ as *Schmerzensmann* stands as a model and legitimation of Christian folly itself.[39]

The sudarium's status as *signature* of Dürer's contribution to the *Prayer Book* runs even deeper than this, however. For in the very way it represents divine *testimonium*, it thematizes the link between the work of art and its maker. Far more than any of Dürer's

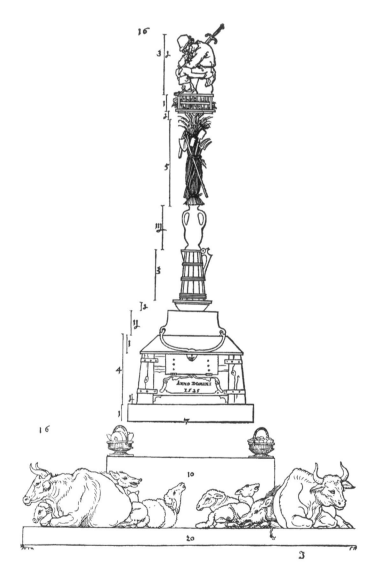

118. Albrecht Dürer, *Monument to Commemorate a Victory over the Rebellious Peasants*, woodcut illustration for *Unterweysung der Messung* (Nuremberg: Hieronymus Andreae, 1525).

engraved, etched, or woodcut sudaria, the *vera icon* at the base of folio 56 celebrates the artist's free and endlessly flexible pen line. Here are assembled in one object the basic graphic idioms of the *Prayer Book*. In the crown of thorns, Dürer discovers a real object analogous to the controlling decorative motif in all his illuminations: those looping and knotted branches, tendrils, and foliation, in German called *Ranken,* that flourish around the margins, harboring fantastic animals, fruits, and other objects in their curving forms. In Christ's hair and beard, the artist displays, in miniature, the purely calligraphic lines and paraphs that extend from the ends of objects and branches. And in the delicate rendering of his features, as well as the overall modeling of Veronica's cloth in parallel hatching, Dürer demonstrates the illusionistic potential of his pen, its ability to simulate on the surface of parchment another surface, far more precious, upon which appears the imprinted afterimage of God. What is extraordinary about Dürer's illustrations in the *Prayer Book* is how fluid the boundaries between these graphic modes have become. In the upper border of the page, for example, Dürer concatenates an ornamental flourish that responds subtly to the profile of the Fraktur script below it. At its origin, this line is the outer edge of a curving branch at the far left. Almost imperceptibly, however, the line begins to metamorphose, growing smoother as it forsakes the knobby surface of the plant, twisting around itself at first rather like a tendril, later like the symmetrical loops of a purely ornamental pen flourish. The transition from the representational to the abstract, from the natural to the artificial, can also be reversed. In the upper and lower borders of folio 19 (fig. 116), Dürer shapes his flourishes as animals, suggesting to the viewer that what is seen as pure line may potentially configure faces and beasts, like the folds of the Metropolitan *Pillow* (fig. 2).[40] Conversely, volumetric objects (here the fantastic column lifted above its rounded base by an explosion) become transparent, revealing themselves *as line*, no matter what the struggling posture of the putti may suggest about the weight and forces of their world.

The translation of visible nature into the graphic line is a process we have discerned in a number of areas of Dürer's oeuvre: in the Erlangen *Self-Portrait*, where the nervous lines of the sketch were themselves as much a record of the artist's body as was his sketched likeness (fig. 1); in the nature studies like the *Great Turf* (fig. 85), in which the indivisible atoms of the visible were discovered to be consubstantial with the artist's brush and pen lines; and in the 1500 *Self-Portrait* (fig. 21), where Dürer's own hair represented at once the product and the very essence of his bodily being. The *Prayer Book* is a culmination of this aesthetic, linking the artist to his works through the medium of the graphic mark. Dürer's ineluctable presence within these sketches is guaranteed by a single fact: his virtuosic movement of pen on parchment can be neither imitated nor copied by other masters of his time. The sheer technical difficulty of his designs is demonstrated by failed attempts even within Dürer's own oeuvre. At the lower left of the preparatory *Study Sheets of Arms and Hands* for the 1504 engraved *Fall* (fig. 105), the artist falters in his construction of balanced flourishes with parallel loops. More striking, however, is the abyss separating Dürer's sketches in the *Prayer Book* from those of his collaborators, such as the stiff, hesitant, and rather dull *rinceaux* by Jörg Breu ornamenting the outer margin

of folio 87ᵛ (fig. 119). Here the clumsy spiral in the *bas-de-page,* far too large in proportion to the thickness of the line itself, demonstrates that the success of Dürer's calligraphy depends on more than merely geometric perfection, which could be laboriously constructed. The flourish must be produced swiftly, its proportion and order the immediate result of the manual dexterity particular to Dürer—what Camerarius termed his "divine hand." One recent commentator wrote that reproductions of the *Prayer Book* ought to be life-size, because only then can the viewer fully experience the indissoluble connection between the sketches and the body of the artist.[41] As in the Dresden *Hand* (fig. 76), Dürer's physical being has become the measure of his art. That is why there is no need for signature or monogram: the whole ensemble of images, from flourish and tendril through to the sacred relic of Christ itself, constitutes a sustained paraph, a *testimonium* to the hand of the author.

Taken as a whole, the *Prayer Book* commemorates Germany's leading painters, men of exceptional talent whose display of skill would appeal to members of Maximilian's newly fashioned meritocracy. Within the emperor's scripted project, each master is canonized according to his personal and inimitable *style.* The conceit, planned but never carried out, that all these signatures be cut in wood and printed in multiple copies would only intensify the miracle of self-presence in the work of art. For like the *acheiropoetos* that undersigns Albrecht Dürer's exemplary labor, mechanical reproduction will ensure that, though made without human hands, the artist's individual testimonies, imprinted, will remain "very sure."

This dream, needless to say, did not keep a future owner or keeper of the manuscript from outfitting each of Dürer's forty-four decorated pages with a monogram and date fashioned in dark ink. Karl Giehlow suggested that these devices were added when the *Prayer Book* was divided sometime at the end of the sixteenth century, at the height of the Dürer renaissance. In folio 56ʳ, the spurious mark of authorship adorns the formerly blank shield encircled by a laurel wreath in the outer margin. It is one of the strange ironies of Dürer's reception that the artist's monogram, which had functioned in his prints as the legal mark of spiritual property, should be thus installed as self-apotheosis within a mock triumph. For within the logic of Dürer's border illumination, the monogram is linked now to the bearded monster whose face echoes the shape of the shield, and it thus stands juxtaposed to the face of Christ, triumphant in its very self-ascesis. Submitted to the eager market for original Dürers around 1600, the penultimate page of the artist's contribution to the *Prayer Book* enacts one final, unforeseen inversion. Whereas at 1515 Dürer identified himself, through his Munich *Self-Portrait,* with the Holy Face in the *bas-de-page,* by 1600 his monogram has linked him to a baser presence: the *haarig bartet* idol framed in the laurel wreath of the calligraphic line.

How, exactly, does the monogram claim to guarantee Dürer's presence of self within his images? For one thing, even though Dürer's 1513 engraved *Sudarium* (fig. 43) exists in many copies, the monogram will always refer the work back to its unique creator, and

119. Jörg Breu, decorated page of the *Prayer Book of Maximilian,* 1515, pen and olive green ink on parchment, Bibliothèque Municipale, Besançon, fol. 78ᵛ.

thus to the singular event of its creation. Like the image on the sweat cloth, which claims not only to look exactly like Christ but also to have come into being uniquely through the physical contact of image with model, the monogram as *hanndzaichen* asks to be read as the authentic relic of an originary act. Like the signature on a contract, monograms imply almost by definition the empirical nonpresence of the signer. Yet as Jacques Derrida has written, the signature also "marks and retains his [the signer's] having-been present in a past now, which will remain a future now, and therefore in a now in general, in the transcendent form of nowness [*maintenance*]."[42]

This explains the imperfect verb *faciebat* inscribed on the tablet in Dürer's prelapsarian garden in the 1504 engraved *Fall* (fig. 98). The monogram itself, asserting the activity of the maker in the moment of production, affixes the work of art to a continuous present that will always remain *in the making.* Indeed, by virtue of being a print, whatever image of Dürer's *Fall* we see never really was finished, in the sense of being produced manually, once and for all in fallen time, by the sweat of Dürer's brow. Dürer, needless to say,

profited handsomely by this fact. For just as, in theory, the image always *was being made* (*faciebat*), it also always *was being printed* on the press and *sold* on the market. Thus Adam returns to paradise not simply because Dürer's art is sufficient to recuperate the coherency and sovereignty of unfallen selfhood through the representation of a beautiful body. Adam inhabits a new scene of origins, one that will remain timeless and present, because Dürer himself has entered that garden with him. It is the artist's monogram, not its natural support, the mountain ash, that represents the true source of eternal life in the picture. Linking his name to the tree of life, and through that tree to his perfect creation in Adam, Dürer installs himself as an origin that will be reproduced with each impression of the plate on the paper and with each impression of the work of art on the viewer.

Interpreting the 1504 engraved *Fall* as the coincidence of the biblical myth of Adam and the Renaissance myth of the artist, I am struck by the achieved coherency of Dürer's projects: how they are engineered for all-encompassing interpretations that can link pictorial style, iconographic meaning, and the heterogeneity of an oeuvre, all under the unifying terminus of the originary artistic self. Rhetorical closure comes easily in studies of "Dürer and his art." Dürer validates the interpreter's own faith in self-coherence, perhaps because our aesthetic assumption about the constitution of the human subject discovers part of its prehistory in Dürer. It is not coincidental, I think, that the two founders of the modern discipline of art history—Heinrich Wölfflin and Erwin Panofsky—produced their only artists' monographs in their books on Dürer, as if the transsubjective validity of formalism and of iconology needed to be tested against this singular, representative, and German master. Dürer's monologism, his complete assimilation of all traditions, contradictions, predecessors, and even disciples to *his* singular voice, is such that even when we think we have discerned an alien element in his products—some fissure or anxiety that appears in the undersurface of his totalizing project—we find that this too will have been circumscribed and claimed by Dürer as *his own*. Thus, for example, I have been tempted to juxtapose Dürer's "bourgeois conception of the completely atomized being" (Bakhtin) to an alternative pictorial mode of the grotesque or the macabre that should be repressed in such a conception. Yet as any student of the German Renaissance knows, it is Dürer who first appropriates the repertoire of popular grotesque images—witches, animated corpses, wild men, prodigies, etc.—and translates them into high art for an educated audience.

It is tempting to explain Dürer's artistic scope through his personal temperament. Unlike Baldung, for example, who allows the grotesque and erotic to overtake his productions, even the ostensibly most pious and conventional ones, Dürer does not dwell on any one particular tradition, manner, or voice. He can found any number of different "projects," no matter how contradictory, subsuming them all under the monologizing force of an oeuvre. That is why, as he puts it in his "strange saying," a woodcut in a rustic style, or of a rustic peasant, is as aesthetically significant as a retable altarpiece, since the measure of value is simply that the image be *by* someone great. Dürer's scope is very different from the flexibility of the elder Cranach, who can produce humanistic, polemical, courtly, erotic, or pious works depending on his patron or audience. Submitting

Dürer's productions to their social context, which is to say to the circumstances of their production and reception, never undermines our sense of the coherency of his oeuvre. He will always appear to us as the *initiator* of the exchange between work and world.

To bridge the gap from Dürer to his reception by Hans Baldung Grien, I find it useful first to introduce into Dürer's 1504 garden the figure of the artist himself, not as he is named in the monogram hung from the tree of life, but quite the opposite: as a creature of flesh and blood already betraying marks of fallenness and mortality. I shall therefore place beside the engraved figure of Adam as representative man what may be his truest companion: the *Nude Self-Portrait* from 1503, now in Weimar (fig. 120).

Dürer's chiaroscuro drawing, executed in ink and body color on green prepared ground, displays the artist's body with a frankness that is without antecedent or successor within the Western tradition until this century.[43] Representing himself in three-quarter length, with his locks pulled back in a hairnet, Dürer shifts attention from the usual focus of self-portraiture—the artist's face and hands—to his naked and exposed private body. A full reading of the Weimar drawing would address issues that I leave aside here: for example, the work's intended audience, its relation to earlier self-portraits and to Dürer's developing conception of the nude, and its curious mixture of narcissism and self-denigration. I shall focus on two aspects of the work that establish an exemplary opposition.

First, the Weimar *Self-Portrait* belongs to Dürer's formulation of the idealized nude, an effort that occupied him between the 1500 Munich likeness and the 1504 engraved *Fall* (figs. 21 and 98).[44] The overall format of the sheet, its silhouetting of a human figure carefully modeled in pen against a neutral dark ground applied with brush in black ink, links it to those several studies of Adam and Eve that were produced in preparation for the engraved *Fall,* such as the Albertina *Adam* discussed earlier (figs. 103 and 104). In the Weimar sheet, Dürer assumes a pose akin to that of his Adams and Apollos and observes the displacements and asymmetries of skin and muscle on his own torso. There are specific similarities between the self-portrait and *Adam.* For example, the backlit folds of Dürer's own left flank and haunch as they play against the underside of his arm are akin to this area of Adam's body, and the shadow of the artist's genitals against his left leg recalls the *Schlagschatten* of the leaf covering Adam's groin in the engraving. The Weimar drawing might have helped Dürer construct representative man, providing certain particularizing details for an otherwise abstracted body—rather in the way the *Study Sheet of Arms and Hands* in the British Museum, executed "from life," observed the minutiae of veins and wrinkles used to animate the surface of Adam's flesh. In his *Self-Portrait,* then, Dürer reenacts the pose of his idealized nudes, perhaps so that he can compare his own body, with all its peculiarities and flaws, against his more abstract constructions. The gap between the *Nude Self-Portrait* and the Adam/Apollo figures measures the distance Dürer has traveled from his 1500 *Self-Portrait,* in which his own body was itself elevated to the status of universal exemplar.

120. Albrecht Dürer, *Nude Self-Portrait*, c. 1503,
 pen and brush, heightened with white on green grounded paper,
 Staatliche Kunstsammlung, Weimar.

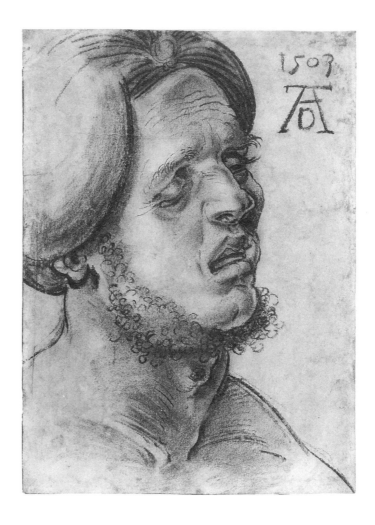

121. Albrecht Dürer, *Head of a Suffering Man*, 1503, charcoal, perhaps with gray wash, British Museum, London.

Second, although the Weimar sketch may be linked to Dürer's ideal nudes, with their connotations of health and immortality, it also seems to have been produced during or immediately after Dürer's illness of 1503. We know of this malady from the inscription on the charcoal *Dead Christ* from this year, sketched "in my sickness" (fig. 113). And we can guess from its companion piece, the *Head of a Suffering Man* (fig. 121; W. 271), that the artist may have been struck by some epidemic disease that flared up in Germany between 1503 and the summer of 1505. As Panofsky remarked of the Weimar *Self-Portrait:* "The convalescent painter looks at his emaciated body and still haggard face with the same mixture of fatigue, apprehension, and dispassionate curiosity with which a farmer might take stock of his crops after a bad storm."[45] The drawing thus presages Dürer's two later self-portrait sketches, both representing the artist nude from the waist up: the *Sick Dürer,* now in Bremen (fig. 91), in which the artist points out his malady; and the *Self-Portrait as Man of Sorrows,* dated 1522 (fig. 96), showing the artist carrying the instruments of the Passion as if they were emblems of the mortality evinced by his anxious face and aging

body. Moreover, if Werner Schmidt is correct in identifying the tentative and anatomically inexplicable crease or shadow just above the fold of Dürer's midriff in the Weimar sketch as an allusion to Christ's side wound,[46] then the *Nude Self-Portrait* might also possess a Christomorphic dimension common to both these later self-portraits. Unlike Dürer's 1500 likeness, however, the *analogon* here would be not to Christ as embodiment of divine *pulchritudo*, but rather to his aspect as Man of Sorrows suffering a human death. Dürer had already forged such an association between his own disease and the *deformitas Christi* in the charcoal sketch *Dead Christ* from 1503, with its biographical inscription. Whether or not one accepts Schmidt's argument (as I do), the *Nude Self-Portrait*, with its unflattering, indeed self-critical, rendition of the artist's skull-like head and knobby genitalia, does intimate a mortality that contrasts to the perfection of both the 1500 *Self-Portrait* and Adam of the engraved *Fall*.

The moment of self-portraiture becomes the coincidence of the beautiful and the macabre, and of self-love and self-loathing. Freud speculated that melancholia results from a crisis in narcissism: bereft of a love object that has become identified with himself, the narcissist avenges his loss sadistically upon his own person, through the sickness, insomnia, and loss of appetite that afflict him, in Freud's words, "like an open wound."[47] In the Weimar sheet, the melancholic Dürer's unprecedented spectacle of narcissistic self-display is coupled with a fantasy of self-punishment, and not *only* because of the unflattering treatment of face and genitals. For it is possible to discern an initial and specific function for the drawing. Like the artist's gesture in the Erlangen *Self-Portrait*, used for figures of Joseph, Christ, and Melencolia, Dürer's twisted posture in the *Nude Self-Portrait* may have modeled a more public image: *Christ at the Column*, such as in a slightly earlier sheet by Dürer, now in Berlin (fig. 122; W. 179), or in a sheet from the 1504 *Green Passion*, now in the Albertina (fig. 123; W. 307). True, the medium of black and white line on green prepared ground suggests that the Weimar drawing was intended as a finished work, rather like the *Green Passion* itself. Indeed, the literature often assumes that color-ground drawings in the period were generally autonomous, collectible works. Yet the *Nude Self-Portrait* also looks somehow willfully incomplete, and it reads easily as a model for images of Christ's torture. Marking his side tentatively, almost imperceptibly, with the *coup-de-lance* (which the Bremen *Sick Dürer* associates with the artist's affliction), Dürer constructs himself at once as flagellant and tormentor: a bound body designated with the "open wound" of melancholy that is his temperament. Whether the Weimar sheet's purpose was functional or autonomous should be subsumed under a broader consideration: the artist represents his own body as simultaneously open and closed, idealized and degraded, finished and incomplete.

In the note "To the Reader" that opens his *Essays*, Michel de Montaigne writes of his intention to portray himself: "My defects will here be read to the life, and also my natural form, as far as respect for the public has allowed. Had I been placed among those nations which are said to live still in the sweet freedom of nature's first laws, I assure you I should very gladly have portrayed myself here entire and wholly naked."[48] Montaigne's potential immodesty in writing about himself, hyperbolized in the figure of a nude self-por-

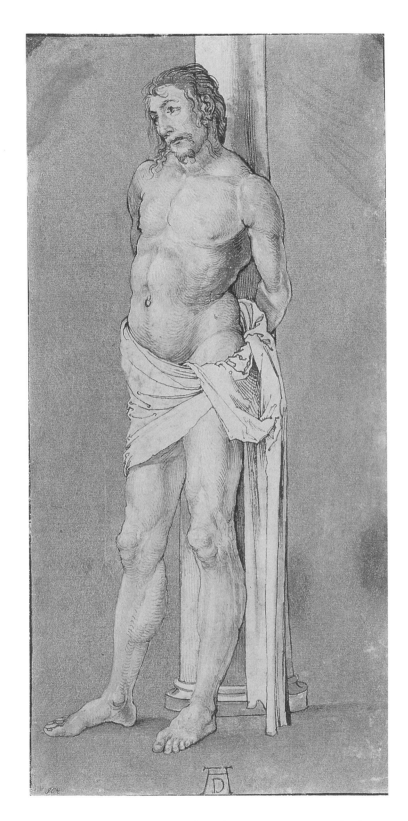

122. Albrecht Dürer, *Christ at the Column*, c. 1505, pen and ink
modeled in watercolor, with gold ground added by later
collector, Kupferstichkabinett, Staatliche Museen Preußischer
Kulturbesitz, Berlin.

trait, is deflected by the assurance that what will be revealed to readers is not an idealized self, but the author's true person, down to the defects and scars of his body. Montaigne will speak with prelapsarian candor, "tuck[ing] up this stupid rag that covers our conduct"[49] and displaying to us his total being. In the Weimar *Nude Self-Portrait* Dürer does just this, representing his whole body unclothed and treating his nudity with an unselfconscious directness avoided even in the prelapsarian garden of the engraved *Fall*, for there a leaf meticulously conceals Adam's genitalia. Dürer's self-portrait thus represents a pivotal moment in the Renaissance recuperation of the whole body. It rejects the medieval partialization of the human figure into morally charged zones of high and low, reason and instinct, soul and body, such as we observed in Butzbach's anecdote of Marcia painting her subjects only from the waist up.[50] How complete, though, is the nude Dürer in the Weimar sheet?

As in Dürer's 1500 likeness, the impulse toward a total image is thwarted by the work-

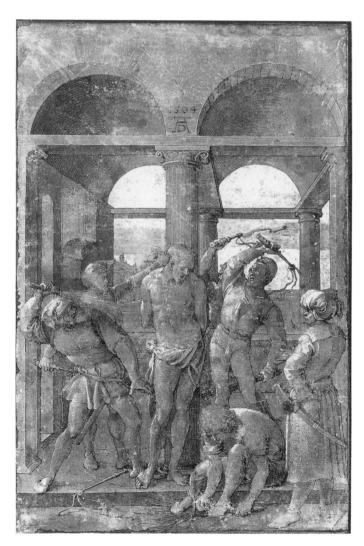

123. Albrecht Dürer, *Flagellation of Christ*, 1504, from the *Green Passion*, pen and brush with white body color on green grounded paper, Graphische Sammlung Albertina, Vienna.

124. Jean de Limbourg, *The Fall of Man*, 1415–1416, from the *Très Riches Heures of Jean de Berry*, Chantilly, Musée Condé, MS. 65, fol. 25ᵛ.

ing conditions of self-portraiture. The artist's active right arm, indicated only by a single line that passes over the green ground, vanishes at the side of his torso. This is combined with a depiction of his left arm that stops short at the elbow, making the likeness appear helpless and exposed to a punishing gaze. Dürer crops his arms just above waist level, as if also to prevent them from hiding his sexuality in the traditional posture of fallen shame (fig. 124, far right).[51] This, combined with the figure's shadowed face and incompleteness at its base, estranges Dürer's body from its coherency as person, causing it to appear curiously phallic as it leans toward the picture plane, highlighted from the right. In his engraved Adam, Dürer cleanses the male nude of protrusions and extremities, creating a perfect contour closed off from the world. In his Weimar sketch he repeats this operation on his own body, with the result, however, that his self-portrait becomes at once incomplete and heterogeneous.

The *Nude Self-Portrait* divides into a number of different pictorial manners depending on whether the artist depicts his body's extremities or the contours and surface of his torso. The torso itself receives the most controlled and idealizing treatment, being modeled from dark to light in full relief through a meticulous and systematic use of hatching in black ink and white body color. Indeed, in this regard the Weimar sheet represents one of Dürer's most masterly renditions of surface, surpassing even the engraved Adam

in its suggestion of volume and mass. The artist works best on the region around his chest, inventing the marvelous conceit of depicting his left breast in dark hatching and his right in almost solid white, defined only by a few reserved patches of green ground and by a single stroke of ink indicating the nipple. His attention seems to slacken in the depiction of his legs, until, at the base of the sheet, he simply stops work on the figure. More marked, however, is the disjunction between the delicate modeling of Dürer's beautiful, nude torso and the hasty depiction of his head and face in loose, thick pen strokes. It is as if the features that identify the drawing as a self-portrait were part of a wholly different project, or as if the artist's face, which in the Erlangen sketch had been discovered through observation of his body, is pushed into the background of his art. To fully appreciate Dürer's new attention in this sketch, we need only compare his depiction of his face with the careful rendering of that sixth extremity, the artist's sharply lit genitals, standing out from his groin with an almost unnatural presence. The artist does not quite exaggerate his penis and testicles. Rather, highlighting the area of his right inner thigh in a manner inconsistent with the logic of the prevailing light sources, he foregrounds his genitals before his body, treating them like the separate object of a nature study. They constitute the area of greatest contrast in the sketch, harboring and casting the darkest shadows, touched by the most sudden and irrational highlights, so that each surface stands out in stark relief from neighboring shapes. In other studies of the male nude by Dürer, genitals are reduced in size and abbreviated to a decorous, unspecific, and conventionalized sign (e.g., the *Apollo Medicus;* fig. 102). In the Weimar sheet, the sexual organs are perhaps the most particularized area of the sketch, displaying an irregularity and profile distinctly their own.

Interestingly, the only analogous genitals in all of Dürer's nudes are those that appear in the Albertina *Adam* sketch, where they are encircled by the leaf that, in the finished engraving, will conceal them (fig. 104). It is tempting to read this resemblance between Dürer's penis and Adam's according to the classical myth of Zeuxis and the statue of Helen of Troy. If the Albertina *Adam* is a figure gathered from many "parts," then what the artist contributes from his own body are the genitals, seat of his male creative powers—as suggested by the etymological link between genitals, genius, and *ingenium.*[52] The genitals, of course, are also precipitators of the Fall. They are the seat of carnal desire that overthrows the rule of reason and brings into the world illness and death. Medieval *summas* for confession call the genitals *turpia*, shameful things, which combine in their unpleasant appearance the mortal, the ugly, and the morally corrupt. Heinrich Cornelius Agrippa, in his "De originali peccato," allegorized the penis as the serpent.[53] Dürer not only displays these *turpia* but, by eliding his hand, prevents self-concealment. My line of reasoning, introducing the artist's "self-portrait" at precisely that bodily zone where the recuperation of ideal, representative beauty fails, may seem far-fetched. Yet it comes close to Hans Baldung Grien's exemplary response to Dürer. Therefore, in place of a conclusion to Dürer's project of self-portraiture I shall turn directly to the sexualized, fallen, and macabre "self"-portraits of his greatest epigone. For it is Baldung who supplies the blows that Dürer, melancholy narcissist, awaits on the whipping post of self-portraiture.

The Mortification of the Image

HANS BALDUNG GRIEN

ЮB

*Was der Vater schwieg, das kommt im Sohne zum
Reden; und oft fand ich den Sohn als des Vaters
entblößtes Geheimnis.*

—Nietzsche, *Also sprach Zarathustra*

12

Dürer Disfigured

When Dürer died on April 6, 1528, his friend Willibald Pirckheimer composed a moving epitaph that still adorns the artist's tombstone in Nuremberg: "Whatever was mortal of Albrecht Dürer is covered by this tomb."[1] Invoking the classical theme of immortality through fame, Pirckheimer asserts that though the artist's body is dead, his memory will live forever in his art. Yet as in his life, so too after his death Dürer's body, his mortal and physical being, was itself treated with a veneration bordering on hagiolatry. On the day following his burial in the churchyard of St. John, a group of artists opened Dürer's grave, exhumed his cadaver, and fashioned a plaster cast of his face and hand.[2] Dürer's followers produced for posterity one final and authentic effigy of a body that had, again and again, reduplicated itself in its self-portraits. This episode is highly unusual, and not only because of the violation of the grave.[3] Casts made from corpses are exceedingly rare in the North before 1528, and indeed the next German known to have received such posthumous treatment was Luther, whose face and hands were cast in wax in 1546.[4] Dürer's deathmask, unfortunately, is lost, destroyed in the 1729 fire that consumed Elector Maximilian I of Bavaria's *Kunstkammer,* along with Dürer's great *Heller Altarpiece.*[5]

Something else of Dürer's cadaver, however, remains with us still: a lock of hair cut from the artist's body two days after his death, and now preserved like a sacred relic in a silver and glass box in Vienna's Academy of Art (fig. 125).[6] This object, which its eighteenth-century owner labeled "the only bodily remains of an old and distinguished German,"[7] has an impressive provenance known to us through various documents that have accumulated around it. In the nineteenth century it was in the possession of the late Nazarene painter Edward Steinle (1810–1886), whose art was one of the last flowerings of the romantics' Dürer imitations. Before that, at 1800, it was owned by the famous art collector and Dürer connoisseur Heinrich Sebastian Hüsgen (1745–1807), author of the book *Raisonierendes Verzeichnis aller Kupfer- und Eisenstiche,* which for years was the authoritative catalog of the artist's intaglio prints. In the seventeenth century Balthasar Ludwig Künast (1598–1667) displayed the lock of hair in his huge *Kunstkammer* in Strasbourg.

At the end of the sixteenth century it was in the hands of Sebald Bühler (1529–1595), the Strasbourg painter, historian, and art collector, who seems to have been responsible for a great number of spurious Dürer monograms. Bühler recounted the actual origin of the relic: "Herein is, or lies, the hair that was cut, as a memorial, from the talented and renowned painter, namely Mr. Albrecht Dürer of Nuremberg, after his death in 1528, on the eighth day of April. This hair was afterward Hans Baldung's, the talented painter and citizen of Strasbourg."[8] The lock of hair, that is, went first to Dürer's student, Hans Baldung Grien, who had been apprenticed to the Nuremberg master between about 1503 and 1507.[9]

Although we possess no letters or contracts detailing the relationship between the two artists, evidence suggests that Baldung, together with Agnes Dürer, managed Albrecht's shop while the master was on his second trip to Italy in 1506.[10] This trust may have had more to do with Baldung's social position than with his talent or his personal intimacy with Dürer. Whereas all other major German artists of the period came at best from middle-class, artisanal families, Baldung was born into the professional class of university-trained lawyers, doctors, and court bureaucrats. His father, Johann Baldung, studied law, probably at the University of Heidelberg, and became an episcopal official at Strasbourg (1492–1505).[11] And his uncle, Hieronymus Baldung, was a doctor of medicine and honorary personal physician to Emperor Maximilian I. Although Hans Baldung had no university training, he would amass a modest fortune through annuities, real estate, and usury and could move within an aristocratic milieu in Strasbourg.[12] Dürer, who was always concerned to elevate his own social status, would have appreciated his apprentice's superior background and connections. Even after Baldung left Nuremberg to establish a successful trade in Strasbourg (1509–1512 and 1518–1543) and in Freiburg im Breisgau (c. 1512–1518), the two artists remained in contact. Dürer twice records selling prints by "hans grun" during his Netherlands journey of 1523.[13] With the death, in 1522, of his one possible artistic equal, Hans Süss von Kulmbach, Baldung was indisputably Dürer's most famous and successful student, having even been canonized as one of the artists invited

to decorate Maximilian's *Prayer Book* (figs. 218 and 219). The lock of hair might well have been more than an apprentice's sentimental memento of his teacher (Bühler called it a *gedechtnus,* or "memorial"). It could also have symbolized the transmission of an artistic inheritance from a spiritual father to his chosen son. What kind of symbol of *tradition,* however, is this tress cut from Dürer's corpse?

In our discussion of the 1500 *Self-Portrait* (fig. 21), we read Dürer's own locks and beard as synecdoches for his whole bodily being, and we noted further that, in depicting hair, the artist could prove his personal skill in a graphic line consubstantial with its object. Like the project of self-portraiture generally, Dürer's hair was that place where the artist as beautiful body coincided exactly with the aesthetic perfection of his art—where the artist, that is, could be at once subject and object of beauty. Dürer's hair also had other, less positive valences, however. In the literary feud with Spengler, in the fur of the *Krel* portrait (fig. 86), and in the potential reference to melancholy in the 1500 *Self-Portrait*'s tuft of fur, hair discovered a dark underside of Dürer's art, one in which self-assertion shifted to vanity and to bestiality, and in which the pious imitation of Christ became the radical *velle se esse deum* of sinfulness itself. Dürer's locks marked a split within the historical moment of self-portraiture between the new Renaissance empowering of artistic self and an abiding anxiety about what that power might finally mean.

It is tempting to regard Dürer's posthumous gift to Baldung as an overdetermined object, rife with knotted iconographies and an aesthetics particular to Dürer. The very idea of transmitting a piece of the master's cadaver to an epigone literalizes that ineluctable bond, expressed throughout Dürer's art and writings, between the painter's body and his works, and between the individual creative subject and the pictorial tradition he founds. The fetishizing of Dürer's person in the reception of his art at 1600, and again in the nineteenth century, represents stations along this same trajectory. For just as Dürer's images will be valued precisely as the material products of his singular bodily gesture, so too his body, reproduced in countless later paintings, prints, and statues[14] and treated as a sacred relic in the hair now in the Vienna Academy, will be framed, displayed, and cataloged along with his works. Yet more than an apt symbol of Dürer's general legacy, the lock of hair stands as an uncannily fitting emblem of Hans Baldung Grien's particular inheritance. For Baldung brings to light all those ambivalences half-concealed in Dürer's hair and beard, establishing them as the primary focus of his art. Self-assertion descends into vanity, the divine artist is refigured as sinful beast, and the idealized body, as either Adam or the artist, is transformed into its opposite: the macabre corpse.

The sins of the father are visited early upon the son. Baldung's disclosure of the instabilities underlying his master's art commences while he is still apprenticed to Dürer. In a chiaroscuro drawing from about 1506, now in Basel, Baldung formulates a radical response to Dürer. It is the younger artist's most characteristic image: the animated and still putrefying human cadaver, here bearing the inverted victory banner of universal defeat (fig. 126; K. 15).[15]

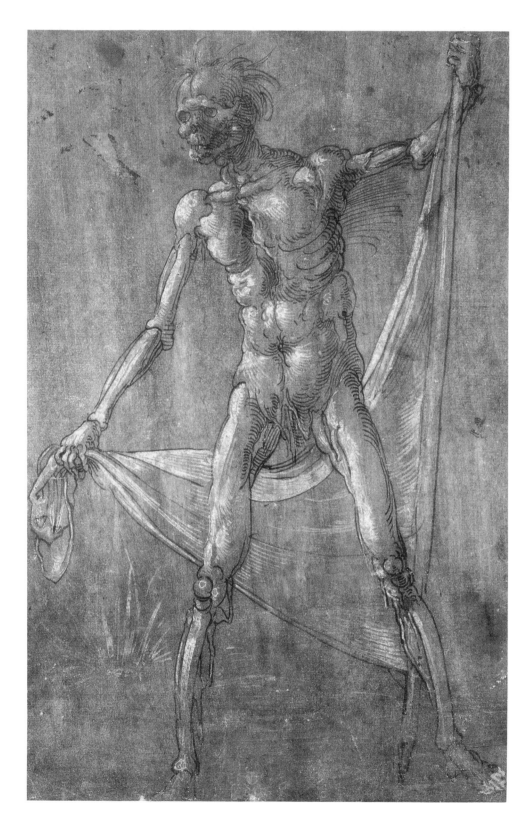

126. Hans Baldung, *Death with an Inverted Banner*, c. 1506,
 pen and ink, heightened in brush with white, on light brown tinted paper,
 Kupferstichkabinett, Kunstmuseum, Basel.

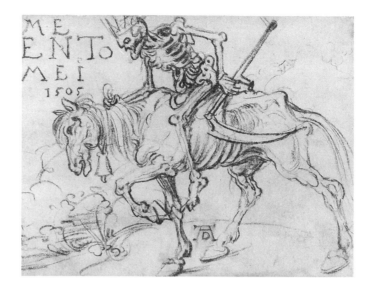

127. Albrecht Dürer, *King Death on a Nag*, 1505, charcoal, British Museum, London.

Let us recall the situation in Dürer's shop during the period when *Death with an Inverted Banner* was executed. When Baldung arrived in Nuremberg about 1503, he would have found Dürer engaged in constructing the idealized nude as embodiment of human beauty. This project was prepared for by the 1500 *Self-Portrait* and influenced by Jacopo de' Barbari's nudes, and it yielded its first fruit in the engraved *Fall* of 1504 (fig. 98). Baldung would thus have observed the painstaking process whereby classical prototypes, known through Italian intermediaries, were copied, abstracted, and perfected according to fixed canons of proportions. He would have witnessed, too, Dürer's struggle to explain and legitimate the nude by inscribing it into various framing myths (Aesculapius, Apollo Medicus, Sol, and Adam), all linked by a notion of beauty as the recuperative antithesis of disease, fallenness, and death. The years 1503–1505 were also plague years, during which Dürer expressed a fear of death and an anxiety over the body's frailty in works like the macabre *Head of the Dead Christ* (fig. 113), the Weimar *Nude Self-Portrait* (fig. 120), and the great charcoal sketch *King Death on a Nag*, inscribed with the *vanitas* motto [me]mento mei and dated 1505—the worst year of the epidemic (fig. 127; W. 377). Clearly Baldung's *Death with an Inverted Banner* owes much to this darker dimension of Dürer's art. Yet in his drawing Baldung also expands the scope of his teacher's macabre mode, turning its grim message onto precisely that place where Dürer had aspired to transcend death through art—the idealized nude. Probably made during the months of Dürer's sojourn in Venice, when Baldung was entrusted with managing the Nuremberg shop, *Death with an Inverted Banner* witnesses the emergence of Baldung's original artistic vision, a vision always in dialogue with the art of Dürer.

In the Basel drawing, Baldung invents a striking visual formula for the human corpse, one that will reappear in many of the artist's later macabre prints, sketches, and paintings. Death is personified as an animated and nude *transi*, its banner held like a shroud

and its motley form articulating the passage from life to death (hence *transi*, from the Latin *transire*, "to go across").[16] Although its head is a fleshless, eyeless skull, enlivened only by stray wisps of disheveled hair, its body still retains large patches of skin and muscle displayed in an advanced state of putrefaction. Part of the drawing's visual interest lies in this unpredictable play of bone and flesh, in which the viewer is allowed to peer, here and there, under the skin of the animated figure and to discover the nothingness of which we are made. In place of Death's left biceps there is only a gaping hole; and in place of genitals, flesh hangs from the groin like a ragged loincloth. Such material heterogeneity stands in subtle contrast to Dürer's depiction of corpses, which tend to be either all bone, as in the charcoal sketch of *King Death* (fig. 127), or all flesh, albeit emaciated, as in the famous grim rider of the *Four Horsemen of the Apocalypse* woodcut of 1497–1498 (fig. 128; Kn. 155), or in the engraved *Young Woman Attacked by Death* (called *Der Gewalttätige*; Kn. 3) from about 1494. The most striking feature of Baldung's corpse, however, is its uncanny sense of energy, its obscenely alive stance. In its complex posture, the corpse outdoes all other figures, dead or alive, that the young Baldung had depicted up to this point in his career.

Death is muscular and strong, even if its muscles are everywhere falling away from the bone. It should not be surprising that the corpse of *Death with an Inverted Banner* is, as it were, well built and that it appears exceptionally mobile in its stance, for Baldung has modeled his figure after *the* canonical representation of the perfect male figure in German Renaissance art—the figure of Adam in Dürer's engraved *Fall* (fig. 98).[17] In the contrapposto position of the corpse's body, in the distribution of weight between the load-bearing leg and the extended leg, in the position of the arms and hands, and in the subtle vertical alignment on the sheet between the striding right foot and the lagging left, we can make out the transfigured but unmistakable shape of Dürer's ideal man. Of course Baldung's drawing reverses the orientation of the engraved Adam and turns the figure's head from profile to three-quarters, yet such variations are amply visible in the scores of preparatory sketches and tracings for the engraving that must have littered Dürer's shop at the time.

Baldung's early interest in the 1504 *Fall* and in Dürer's project of the idealized nude can be documented elsewhere in his work. He seems to have fashioned several loose copies of his teacher's constructed figures, each time subtly altering the aesthetic character of his model. Thus in a chiaroscuro drawing, *Reclining Female Nude*, attributed to Baldung (fig. 129),[18] Dürer's 1501 Albertina *Nude*, with its proprietary inscription *Dz hab ich gfisyrt* (fig. 97), is sketched in reverse and submitted to certain alterations and distortions (e.g., the figure's intertwined feet and energized hair) that prefigure Baldung's later "manneristic" treatment of the human body.[19] And in *Study of a Head in Profile* from about 1505, now in Berlin, Baldung copies the face of Dürer's Adam, probably from some lost preparatory sketch for the *Fall* engraving (fig. 130; K. 22).[20] More important, however, the younger artist discovered in Dürer's engraving an interpretation of the biblical story of the Fall that would inform his own later depictions of Adam and Eve as well as his developed iconography of death. Already in 1510, in a sheet now in Hamburg, Baldung fashioned his Eve in conscious imitation of Dürer's engraving. Yet by turning her gaze

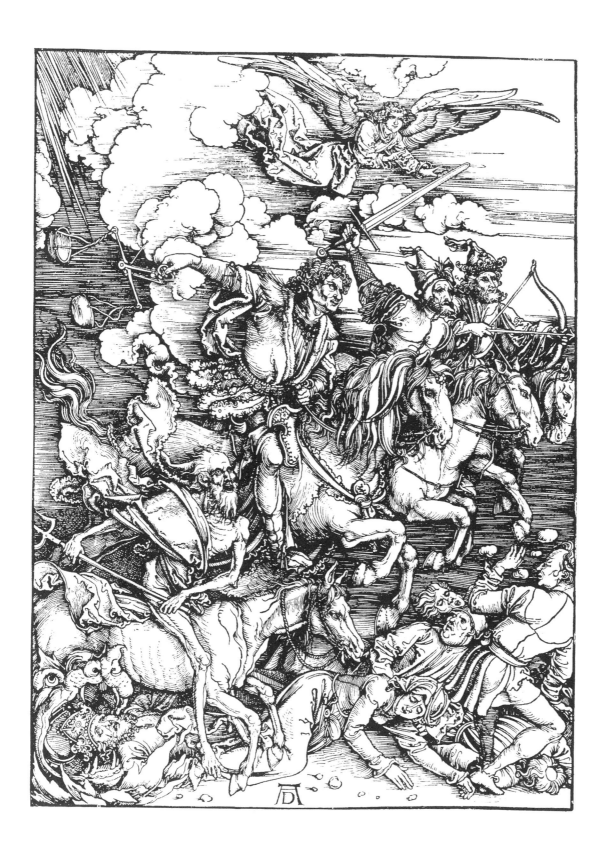

128. Albrecht Dürer, *Four Horsemen of the Apocalypse*, 1497–1498,
 woodcut from the *Apocalypse* series.

toward the viewer, he endowed her with a seductive quality absent in the more "innocent" Dürerian model (fig. 131; K. 25). And in two panels from about 1507–1508 (fig. 132; O. 5),[21] Baldung copied Dürer's Prado *Adam* and *Eve* (fig. 133) and added the symbolic animals from the 1504 engraving. This demonstrates his familiarity with Dürer's understanding of the Fall's relation to the humors.[22] Thus when Baldung invokes the figure of Adam in his drawing of *Death with an Inverted Banner,* he does so with a full knowledge of both the iconography and the implicit aesthetic of his pictorial mode.

The macabre drawing's allusion to Dürer's perfectly proportioned figure has an obvious theological message. The decaying corpse is linked to Adam because it was through Adam's sin that death came into the world. Thus all that is living in Dürer is given over to death in Baldung's sketch. The mountain ash held by Adam, associated with the tree of life, is replaced by the staff of an inverted banner—the standard of Death, whose victory is our defeat. And the whole naturalistic setting has vanished, except for a bunch of grass at the lower left that, echoing the torn flesh of the cadaver, perhaps recalls the words of Isa. 40:6, "All flesh is grass." In a deep sense, Baldung's drawing expresses the *consequences* of Dürer's engraving. The rotting corpse, modeled *after* Dürer's First Man (and therefore belatedly), actualizes the effects of the Fall. We shall see this again and

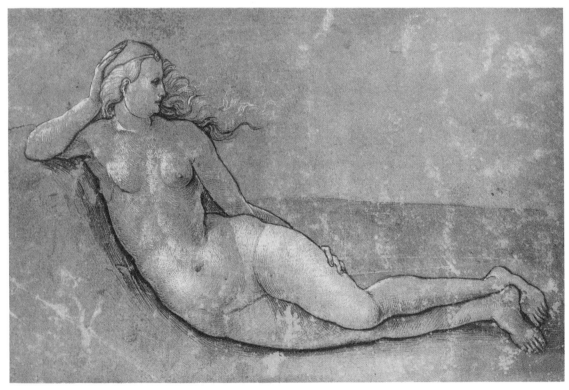

129. Hans Baldung, *Reclining Female Nude,* c. 1504–1505, pen and ink, heightened in brush with white, on grayish green prepared paper, Lichtenstein Collection, Vienna.

130. Hans Baldung, *Study of a Head in Profile*, c. 1505, pen and ink, Kupferstichkabinett, Staatliche Museen Preußischer Kulturbesitz, Berlin.

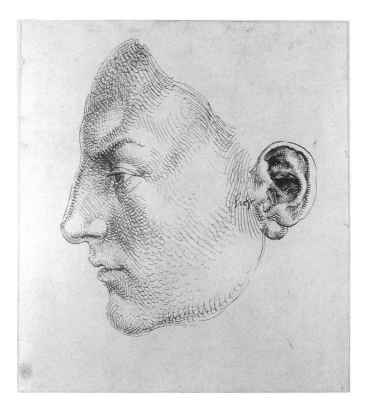

again in Baldung's figuration of death: Adam, the cause of our mortality, becomes the emblem of his own influence, thus overturning the natural sequence of time. Note that Baldung here invokes *history* as the true dimension of such a grotesque reversal of cause and effect, for he links the conventional personification of death (the animated corpse) to its specific origin in the event of the Fall. He thereby recalls, perhaps intuitively, that it was only with the Fall that human history qua history came into being.

Let us recall the aesthetic and interpretative assumptions of Baldung's model. In his Adam, Dürer produces an example of physical beauty constructed according to the classical, Zeuxian procedure of taking the best parts from many existing models to fashion a yet more perfect synthesis. This method, really as much the figure of a method as a necessary working routine, gets linked in the 1504 *Fall* to a Christian ontology. Dürer's beautiful man is Adam before the Fall, renovated to a state of perfection wherein we human viewers discern our own original but now faded status as *imago Dei*. With this Dürer invests the whole system of his art, its self-constructed regiment of image, artist, and viewer, with a set of controlling metaphors. Adam's abstracted and generalized visual form, elevating him above the heterogeneity of fallen and, because fallen, ugly and corrupt and mortal particulars, becomes the source of his exemplarity, his status as representative man for all particular viewers. One intended effect of such abstraction is that Adam and Eve's nudity, which might otherwise have seemed indecent to northern cul-

ture at 1500 (and which will be rendered again obscene by Baldung's revisionary art), becomes purged of a purely erotic appeal that would arouse the corrupt desires of its fallen viewers.[23] Dürer offers viewers, in their own individuality, sexuality, and mortal corruption, an idealized, abstracted image, in order to recuperate for them the experience of prelapsarian self-control.

Ultimately, though, Dürer's engraved *Fall* is less about Eve and Adam, the four humors, or original sin than it is about the renovative powers of art. By instantiating in his image a beauty that, as contemporaries like Caspar Ursius Velius saw it, equals or surpasses the splendor of our first parents, the artist achieves an immortality for himself through the perfection of his works. The engraved *Fall* thus retells the founding myth of the Renaissance. The creative artist, recuperating the lost magnificence of the art of antiquity (present here in both Adam's source in Apollo and his construction according to a recovered classical canon), enables the rebirth of *widererwaxsung* of prelapsarian representative man. And this historical self-understanding, grounded in an analogy to Christ as the New Adam of salvation history, sustains Dürer's more audacious *analogon*, monumentalized in the 1500 *Self-Portrait*, between the artist and God. Note that Dürer's self-conception and his figure of Adam share a common anthropology. Just as Adam is rendered perfectly complete and finished, a figure of pure outline, so too the artist, through the juridical category of intellectual property, and through the equation of aesthetic value with creative originality, is a bounded, closed entity, in control of his labor and in possession of his products. It is against this monologic closure, enacted at the levels of image, viewer, and artist, that Baldung fashions his drawing *Death with an Inverted Banner*.

There is a sense in which Baldung's Death is the same as Dürer's Adam. Like the Adam, Baldung's cadaver aspires to portray representative man in a manner valid and binding for all its various viewers. Except for some refinements in technique and posture, the cadaver of *Death with an Inverted Banner* looks quite similar to Baldung's earlier sketch of *Death and a Landsknecht* from 1503, now in Modena (fig. 134; K. 2). And it resembles the corpses of Baldung's much later painted panels of *Death and the Woman* (e.g., fig. 135; O. 48). The point is, cadavers generally have no particularizing features to distinguish them from each other. Thus Baldung transforms Dürer's generalized, abstracted, exemplary nude into an anonymous cadaver through the natural process of putrefaction. The message of the medieval dance of death, "death makes everything equal" (*mors omnia aequat*), expresses itself immediately in the featureless corpse. Depictions of the *Totentanz* always play on this conceit. Individuals representing the various classes and professions of society, framed in separate scenes or as distinct elements in a procession, are paired with an animated skeleton, who is at once the individual's future state as corpse and the personification of Death itself. The skeleton's anonymity, that is, allows it to function both as parody of its victim and as ubiquitous guide, bringing all differentiated members of a worldly *ordo* into a community of equals (fig. 136).[24] Death abolishes physical and social distinctions even as it erases the biological historicity of the individual. Thus, where in Dürer's engraved Adam beautiful parts create a perfect and therefore represen-

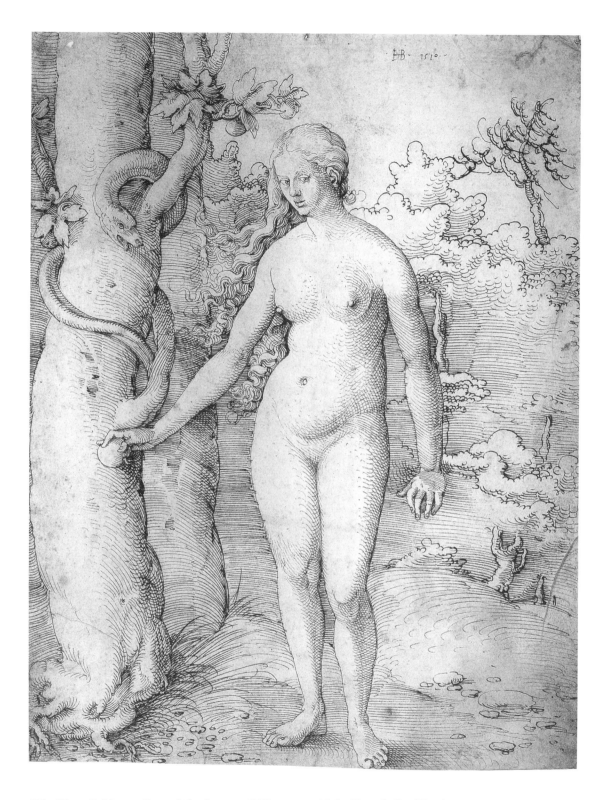

131. Hans Baldung, *Eve and the Serpent*, 1510, pen and ink, Kunsthalle, Hamburg.

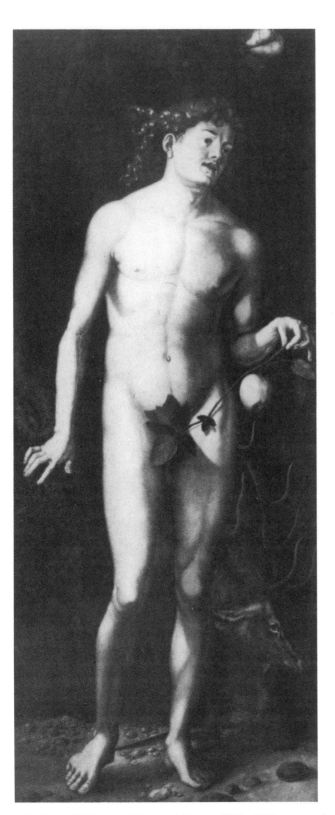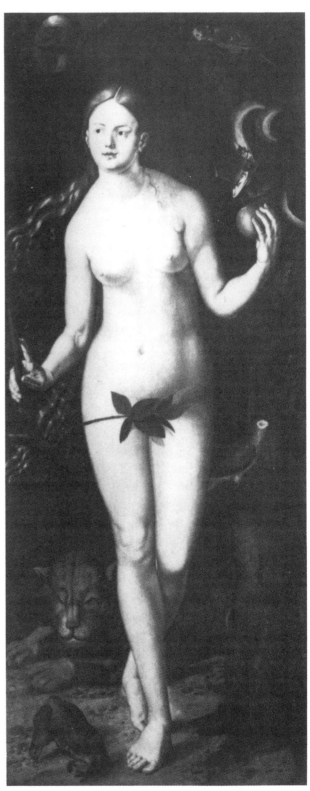

132. Hans Baldung, *Adam* and *Eve*, c. 1507–1508, copy after Dürer, oil on twin panels, Uffizi, Florence.

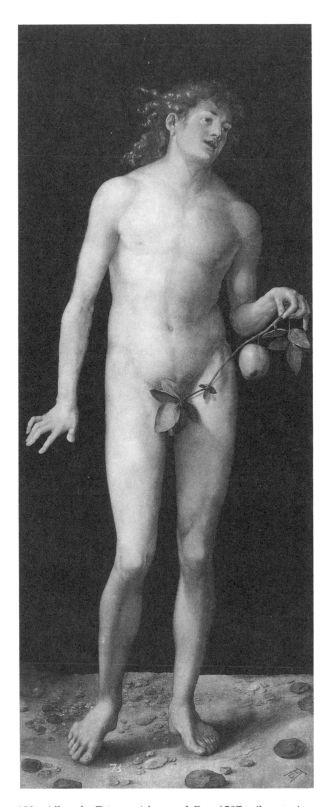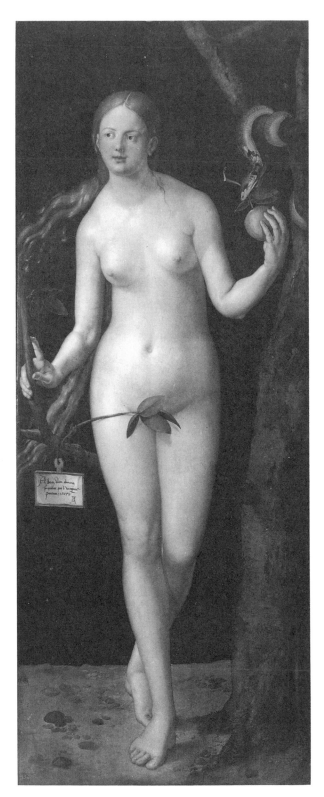

133. Albrecht Dürer, *Adam* and *Eve*, 1507, oil on twin panels, Prado, Madrid.

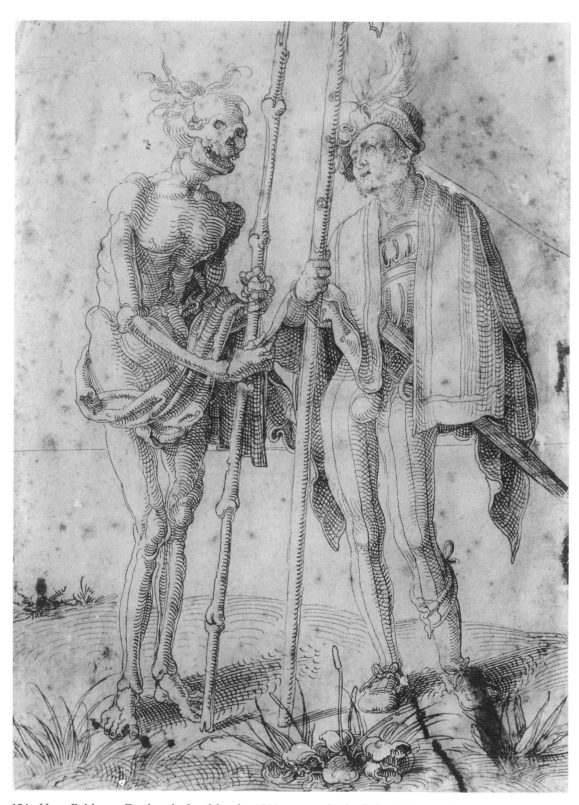

134. Hans Baldung, *Death and a Landsknecht*, 1503, pen and ink, Galleria Estense, Modena.

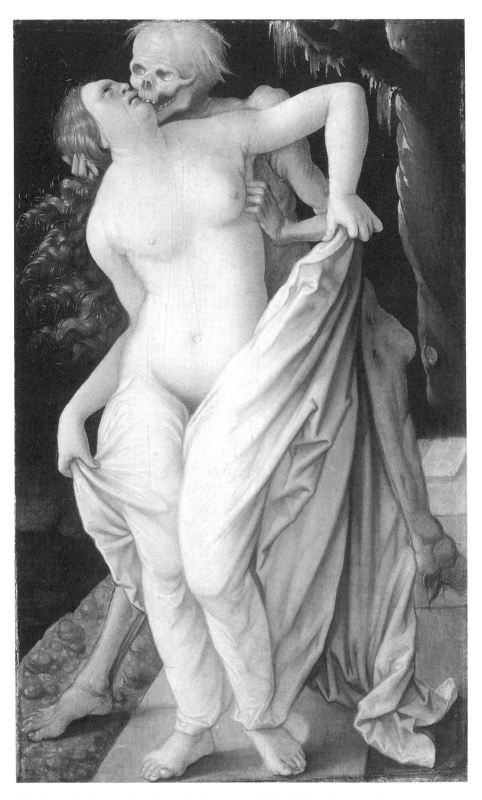

135. Hans Baldung, *Death and the Woman*, c. 1518–1519, oil on panel,
Kunstmuseum, Basel.

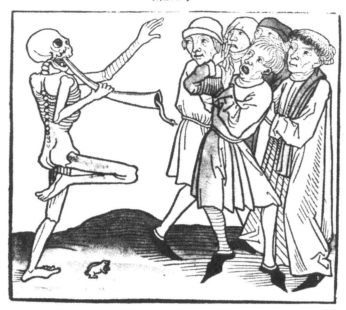

Der doit xxxviij von allem staidt

136. *Death and All Estates*, woodcut illustration for *Der doten dantz mit figuren* (Heidelberg: Heinrich Knoblochtzer, c. 1485–1490).

tative synthesis, in Baldung's Death these parts are rotting away, leaving what is common to all people in their form and as their destiny. Where Dürer recuperates our shared origins, Baldung reveals our common ends.

Comparing Baldung's corpse with its model in Dürer's Adam recalls the baleful words of the fallen Satan in Milton's *Paradise Lost*. Observing the disfigured form of his friend and lover Beelzebub lying fallen on the floor of hell, the once most beautiful angel exclaims:

> If thou beest hee; But O how fall'n! how chang'd
> From him, who in the happy Realms of Light
> Cloth'd with transcendent brightness didst outshine
> Myriads though bright.
>
> (1.84–7)

Satan's lament, "breaking the horrid silence" after the Fall, is that of a narcissist who, having contested the strength of the father, confronts his vanquished double and wonders, "If that is how bad he looks, how terrible must I appear?"[25] The shock of postlapsarian recognition staged in Baldung's *Death with an Inverted Banner* is essentially double. First, the image confronts the viewer with a grotesque emblem of what he or she will become. Where the engraved Fall aspires to elevate us above the level of carnal desire to a new domain of self-control (a domain that will, some three centuries later, be termed "aesthetic experience"), Baldung's sketch responds by making us aware of our continuing corruption and our richly deserved end. And second, this revision of Dürer's image by Baldung, this willful mutilation of a master's beautiful art by an ambitious apprentice,

264 The Mortification of the Image: Hans Baldung Grien

also plots a kind of fall. The human cadaver, ugliest of all things, inverts the aesthetic values embodied in Adam. The smooth and coherent surface of Adam's body, which had closed him off from the world, has been torn away randomly in Baldung to reveal only bones and spaces. The grotesque body opens up to the world as it decays into the dust or humus that it is. Adam's disfiguration, which is also a defacement of Dürer's art, sets in motion very different assumptions about the visual image and about its meaning, its viewer, and its maker.

In his engraved *Fall,* Dürer forges a classical equivalence between pictorial form and symbolic content. The perfectly constructed male nude, defined through attributes and context as "Adam," is the immediate and seamless visual expression of who he is: the unfallen *imago Dei.* The life animating Adam's limbs, the way they are engraved to appear in dynamic, contrapuntal motion, is an image of the life-giving power of God and, by analogy, of Dürer himself. Baldung too seeks an equivalence between form and content, image and meaning, yet the result is a travesty of his model. Adam, through whom death came into the world, *is* what he *means:* his meaning has become our mortality. Yet nothing could be more unclassical in form and in spirit than the animated corpse. The *symmetria* or harmony of the parts in Dürer's Adam—and indeed in the whole classical tradition recuperated in him—gives way to a body whose very flesh falls from it in unpredictable, asymmetrical pieces. The liveliness of Dürer's form, what Ficino called the "vivacity and grace which radiate in the body from the infusion of its Idea [i.e., the perfect synthesis of form and content],"[26] gives way to the oxymoronic animation of the dead body. By reading Adam as the true embodiment of his message *for us,* Baldung makes of him a monster, a travesty of decorum, whose only life is meaning and whose meaning kills.

Baldung's *Death with an Inverted Banner* is a parody, a "song sung beside" Dürer's figure of Adam. Its method is akin to the farcical death dances, in which an animated cadaver takes its form and its attributes from its victim. In Baldung's slightly earlier drawing *Death and a Landsknecht* (fig. 134), for example, the cadaver wields a staff of bone that, running parallel to the foot soldier's instrument of death (the halberd), mocks the heroism of war by exposing its outcome. *Death with an Inverted Banner,* though, mocks neither an individual nor an estate, but rather the idealizing art of Baldung's teacher. And what is staged in this farce is not merely a reinterpretation of Dürer's Adam, but a very different model of the way images mean. The Fall, according to Christian epistemology since Augustine, not only brought death into the world, but also effected a fundamental change in the way human beings have, or do not have, access to knowledge in the world. According to St. Bonaventura, God created the whole of nature as a sign sufficiently readable to lead man to the proper end of meditation—his creator. After the Fall man lost this source of meaning. He could no longer "read" nature as he had done in paradise. The true names and signs Adam himself had given things were no longer understandable. It was for this reason that God created the Second Book (nature itself being the First Book), the Bible, so that man could still have access to the meaning of things—*ut acciperet metaphoras rerum.*[27] The world was not readable by itself, and between it and man there rose the signs of Scripture.

The Fall involves a corruption of the way man originally *saw* the world. The serpent tempted Eve by promising that her eyes would be opened by eating of the fruit of the tree, and the tree was indeed pleasurable to behold (Luther's Bible renders this phrase as *eine Lust für die Augen* [Gen. 3:6]). After "Adam ate," their eyes indeed opened, but instead of greater beauty they saw a nakedness that was shameful. Baldung's transformation of Adam into Death not only implies a *vision of the Fall* very different from Dürer's garden (pleasurable to behold); in giving over to death the lively forms of the Renaissance, and in changing the relation between objects and their meanings, Baldung's art expresses *fallen vision. Death with an Inverted Banner* is a corruption of sight. The paradisal form of Baldung's model is barely recognizable beneath the burden of its scriptural significance. For, to reiterate once again, Adam is what he means in Baldung, and yet, in constituting this message, he dies. Between "Adam" and his significance there thus exists the caesura of death that makes the very identification—that Adam *is* or *lives as* what he means—impossible. Thus Adam and the whole postlapsarian world cannot be tied directly to their meaning without become macabre. We begin to see how distant Baldung's self-thematizing image is from conventional spectacles of the macabre. The animated corpse in *Death with an Inverted Banner* does not simply mortify our spirit by admonishing us on the vanity of all things. It also emblematizes our loss of meaning, and it enacts that loss within the way, as image, the corpse conveys its content to us. Baldung could easily have chronicled the Fall through an assemblage of historical components: Eve, Adam, the serpent, and the tree. Instead he chronicles the *meaning* of the Fall through the absence of these conventional components. The cadaver mortifies the visual image itself. It becomes, in Baldung's hands, the vehicle through which we, as interpreters, learn that there is always more there than can meet the eye, that whatever image we see is only a travestied echo of some absent and more meaningful image that has been withheld from us. We almost forget that the identity of the corpse in the Basel drawing is, strictly speaking, absent, existing only as a ghostly allusion pointing beyond the image to another very different work of art. Through the corpse, Baldung makes the very shape of interpretation a consequence of the Fall.

Death with an Inverted Banner foreshadows one essential feature of Baldung's mature art. In its uncanny and radically oblique allusiveness, it throws its viewers into a troubled relation to their own *response* to what they see. And this uncertainty serves also to undermine the certainty and sovereignty of the interpretive self. Baldung, that is, installs the viewer as the true subject of his pictures, only then to sabotage, through the experience and message of the macabre, the self-coherency of the viewer.[28] The cadaver subverts the autonomy, or monologism, of the self at a number of different levels. First, as body image, it overturns the Renaissance fiction of the closed and finished person, replacing it with an admonishing vision of the physical dissolution of all boundaries. In the haphazard process of putrefaction, in which the *transi*'s flesh seems to rot from within and from without (hence the macabre penchant for snakes, frogs, and worms emerging from the

orifices and wounds of the cadaver), the "confines between bodies and between the body and the world are overcome: there is an interchange and an interorientation."[29] Second, because the corpse is the tabooed realm of bodily pollution par excellence,[30] it will not affect viewers as a simple, definable "object" placed before us in represented space. Eliciting in us a primal nausea or abjection, it marks a realm of the not-me, not-that, from which we recoil, and infects us with a quasi-physical horror. Julia Kristeva writes that, before the corpse, "it is no longer I who expel; 'I' is expelled. . . . It is something rejected from which one does not part, from which one does not protect oneself as from an object. Imaginary uncanniness and real threat, it beckons to us and ends up engulfing us."[31] In his later images of eroticism mixed with death, and in his images of witches, Baldung does all he can to heighten this dialectic between engulfment in the object through desire and annihilation of self through abjection. Third, fundamentally ambivalent as an object, the corpse also effects an instability of meaning. Baldung allows this essential property of the macabre to augment the peculiar allusiveness of his art, its virtually bottomless play of references to other pictures, other figures, and other meanings. Earlier I suggested that, for Dürer, self-portraiture functioned as prosopopoeia for the operation of representation per se. In Baldung this function is assumed by the corpse, and as a result the self, now annihilated or radically destabilized, can no longer be the simple object of a representation.

The end of Dürer's project of self-portraiture is already envisioned by *Death with an Inverted Banner* and its immediate precedents. Baldung does not register his identity as author directly within the drawing through signature or monogram. Indeed, at this early stage of his career, he tends at most to inscribe a date in his works.[32] Baldung's first clearly identifiable marks of authorship—first a vine leaf, then the HB monogram—appear in a few drawings from 1505 to 1506, but the artist remains largely anonymous during the period of his apprenticeship to Dürer. *Death with an Inverted Banner* does contain one detail that may have been meant as a personal device, however: the spray of grass, executed in white body color, that decorates the sheet's lower left corner.[33] Appearing on a number of Baldung's drawings from this period, this grass might pun on Baldung's shop nickname, "Grien" (meaning "green"), in the manner of his vine-leaf insignia, such as we find at the base of a chiaroscuro drawing, *Thief on a Cross*, from about 1506 (fig. 137; K. 14). If this is so, then *Death with an Inverted Banner* might represent the first example of what will become, in Baldung as well as in other artists of the period, a characteristic conceit: the macabre or travestied monogram or personal device, in which the message of physical and moral corruption is turned upon the name of the image's author. For if the calligraphic *Grasbüschel* registers Hans Baldung Grien, it also submits him to the picture's admonishing message—that all flesh is grass. This reading, albeit speculative, is consistent both with the "self"-annihilating logic of the image as a whole and with Baldung's later representations of himself, which will close our study.

Macabre portraiture was a well-established genre at the end of the fifteenth century. The juxtaposition of the portrait likeness of a living individual with his or her cadaver, often depicted either in a mirror or on a pendant panel, allowed the picture to function both as a proleptic epitaph designed to show posterity the sitter's appearances both *then*

and *now* and as an advertisement of the sitter's piety—of his or her proper recognition, despite the potential *vanitas* of a portrait likeness, of the ultimate end of life. Thus the Master of the Aachen *Life of the Virgin* (active in Cologne about 1480) depicts a marriage couple on the recto of a panel now in Bonn-Bad Godesberg, placing them before a round mirror in the manner of Jan van Eyck's *Arnolfini Wedding Portrait*, while on the verso he fashions a pair of animated cadavers who harvest the living (fig. 138).[34] This play between the living bodies of the sitters and their future state as corpses is clearer still in Lucas Furtenagel's *Portrait of the Artist Hans Burgkmair the Elder and His Wife Anna* from 1529, now in Vienna (fig. 139).[35] While the portrait depicts the living as they *appear*, the convex mirror reveals them as they truly *are*. For as we read in an inscription at the panel's upper right, "In the mirror the form of us both was nothing but this." Baldung's travestied mirroring of Adam, as well perhaps as his own macabre "signature," owes something to this kind of image, in which the identity of the sitter, registered in the particularity of his likeness, finds its annihilation in the anonymous death's-head.

Baldung's mortification of the engraved Adam was, in a way, prefigured in Dürer's own *Nude Self-Portrait* in Weimar (fig. 120). In this sketch, Dürer's new interest in the male nude was extended to his own private body, producing a nature study that could perhaps aid in the completion and particularization of his mathematically constructed figures. Executed during an epidemic in 1503, however, and displaying the artist in a convalescent state and in a posture related to iconographies of torment (Christ on the column), the *Nude Self-Portrait* revealed an imperfect, vulnerable, mortal body that contrasted with the healthy and health-giving Apollos and Adams of the same period. Dürer evinced here a kind of narcissistic crisis,[36] in which the celebration of his own physical beauty in the 1500 *Self-Portrait* gives way to an awareness of the frailty of the flesh or, more radically, in which all that had to be expelled in order to sustain the narcissistic ideal—ugliness, particularity, sexuality, and death—comes back to haunt the self as it compares its own real body against its constructed ideal.

In *Death with an Inverted Banner*, Baldung audaciously carries the passage from narcissism to abjection to its conclusion. His parody of Dürer's nude might well have been informed by Dürer's own revision of the Adam/Apollo figures in the Weimar *Nude Self-Portrait*, which was produced in the first year of Baldung's apprenticeship in Nuremberg (as if the melancholy, nude, and wounded "Dürer on the column" received from Baldung his awaited chastising blows). If so, then *Death with an Inverted Banner* truly is Dürer disfigured—that is, defaced both in his works and in his body. One also might speculate about the meaning of the absent or ripped away genitals in Baldung's cadaver, as a macabre retribution against the self-display of Dürer's *Nude Self-Portrait*, against their potential reappearance in the Albertina *Adam* (fig. 104), and against their concealment in the 1504 engraved *Fall*.

This much, at least, is clear. Just as Baldung demonstrates our fallen perspective as viewers through the interpretations elicited by his image, so too his own misprision of Dürer recapitulates the Fall. God gave Adam the whole garden to "dress and to keep" (Gen. 2:15), but Adam betrayed this gift for the one thing denied him, the fruit of the

137. Hans Baldung, *Thief on the Cross*,
c. 1506, pen and ink, heightened in brush
with white, on reddish prepared ground,
Universitätsbibliothek, Erlangen.

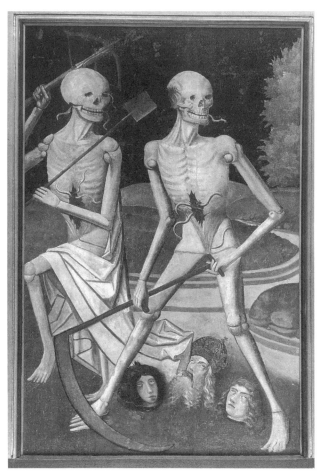

138. Master of the Aachen Life of the Virgin, *Macabre Wedding Portrait* (front and back), c. 1480–1485, oil on panel, College of Aloisius, Bad Godesberg.

tree of knowledge, and for that reason he and his offspring were doomed to die. Baldung was given the whole world of Renaissance beauty and proportion to dress and to keep. Instead, though, he betrayed his inheritance, misreading Dürer the artistic father for the sake of knowledge—here the scriptural meaning of the Fall. And for this reason his images are doomed to die. In this allegory of the epigone, what emerges as artistic self in Baldung's art is not a representation of the painter's body within the work, but rather a refiguration of the *artist as viewer:* Hans Baldung Grien as paradigmatic voyeur of the beautiful forms and founding self-representations of his massively original teacher.

Our viewing of *Death with an Inverted Banner* depends on our recognition of parody and therefore occurs within a constant dialogue between Baldung's present image and its more famous model. Baldung's art perpetually invades and is invaded by the art of Albrecht

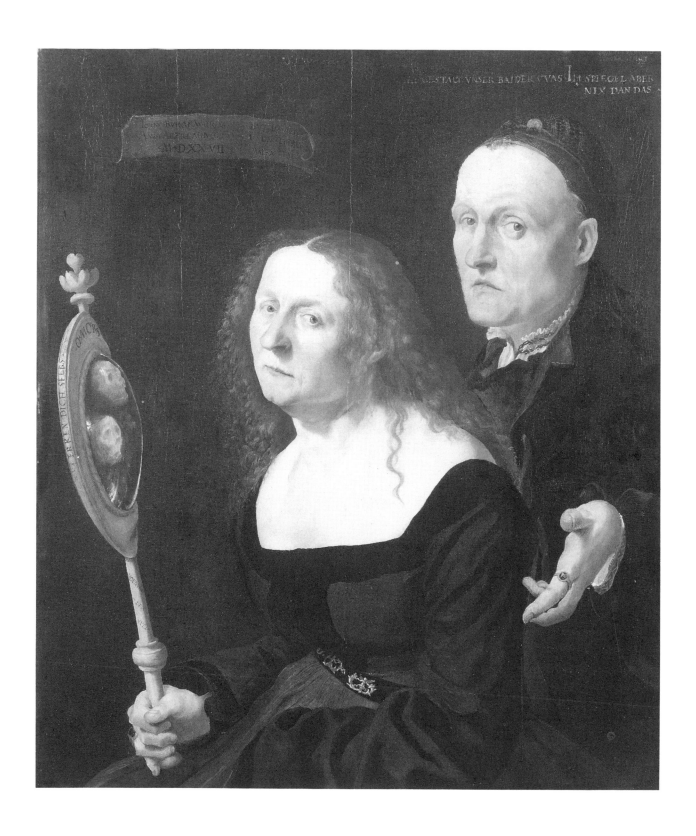

139. Lucas Furtenagel, *Portrait of the Artist Hans Burgkmair the Elder and His Wife Anna*, 1529, oil on panel, Kunsthistorisches Museum, Vienna.

Dürer. Yet parody, which places earlier works of art in quotation marks, overturns the closed relation between the self and its works continually affirmed by Dürer, replacing it with a macaronic hybrid of different voices and different selves. The dependency of *Death with an Inverted Banner* on the engraved *Fall*, the fact that the drawing conveys its message through its stance toward a prior visual source that it almost exactly copies (for the difference between Baldung's corpse and Dürer's Adam amounts to surface detail and to the quality of the covering, enclosing flesh), means that Baldung cannot be present in his image in the same way Dürer is. Baldung never stands at the center of his work as the singular, self-sufficient origin of what we see. That is because that center is occupied by another self, most often a disfigured version of a Dürerian subject. Baldung remains still present in our experience of his images, but more as a willfully idiosyncratic or potentially blasphemous *attitude toward* his subject. As vision is superimposed on vision, Baldung himself remains the invisible, but nonetheless actualizing background for his art's often aggressive originality.[37] I can think of no better way of summing up this dialogism than to say that Baldung's images read like works by Dürer as they would appear to the gaze of a fallen viewer.

Baldung's hand has been forced. As we have seen, Dürer founds Adam's original prelapsarian splendor not only upon the beauty of his form, but also upon the fiction of artistic originality inscribed in the work of art through the agency of the artist's personal mark. And just as Adam is constructed as a being complete and self-enclosed, so too Dürer works to close off his own domain of originality, defending it against imitators and latecomers through the legal categories of property, plagiarism, and fraud. After all, other apprentices and imitators of Dürer who followed his art too closely found themselves on the losing end of costly copyright suits. Thus Baldung's later successor in Dürer's shop, Hans Sebald Beham, was exiled from Nuremberg in 1528 for having attempted to publish his teacher's writings on proportion under his own name. Emerging as an artist in this competitive climate, Baldung will always stand as interloper to originality, as Satan in the garden of Dürerian forms, which is in part how he will represent himself in later works.[38] In *Death with an Inverted Banner*, Baldung literally sees Adam from the fallen perspective of filial disobedience.

Disfiguration here describes both the literal effect of Baldung's parody on the beauty of Dürer's art and the profound figurative change this parody introduces.[39] Baldung radically alters the essential *figurative* alignment of self and image as it is modeled in Dürer. In Dürer, the representative expression of self in art was the self-portrait. There the individual artist was installed at once as maker and model, representer and represented, subject and object of beauty. In Baldung, portraits of self will be a more complicated business. They will involve a process enacted within the self of every viewer as it is implicated in the plot of the picture. If Dürer's art aspired to be the artist's self-portrait, Baldung, a paradigmatic viewer of Dürer's art, aspires to portray the beholder's self, which has become the true subject of his art. The portrait thus projected *before* the work of art, however, is never one of finished, contained, and autonomous man, such as appeared

exemplarily *within* Dürer's self-portraits. Rather, Baldung portrays a heterogeneous and fallen self, always subject to the disfiguring effects evident in the picture itself.

To discern this new alignment of self and image, I start where Baldung began his disfiguring of Dürer, and where his art is most original: in images of death and the Fall. Corpses as moralizing portraits of self, or as admonishments precisely against the self's valorization as adequate subject of portrayal, are the legacies of a macabre strain in late medieval northern art. Baldung expands the reference of death images, allowing them to comment on the whole nature of interpretation and on the constitution of the viewing subject. In chapters 13 and 14 I analyze this expanded reference of death; in chapter 15 I explore Baldung's real and implied audience as it is interpellated by his images of nude female witches; and in chapter 16 I locate this audience within period notions of exegesis, image, and self, as visualized by Cranach the Elder in collaboration with Luther. Thus only circuitously, by way of images that at first sight appear radically divergent from Dürer's moment of self-portraiture, do we arrive, in chapter 17, at Baldung's own images of himself. There the artist's monogram or signature, together with a disguised or oblique self-portrait, places the artist's self in a radically new context.

13

Death and Experience

In *Experience and Poetry* Wilhelm Dilthey writes, "The relation that most deeply and universally determines the consciousness of our existence is that of life to death; for the limitation of our existence through death is always decisive for our understanding and our estimation of life."[1] This is one of the extravagances of Western thought: to regard death as the necessary companion of knowledge, as if without death to mark off the boundaries of what we are, there can be no interpretation, no "meaning" of life. The myth of the Fall chronicles this companionship. The promise of the forbidden fruit was fulfilled in both its aspects; the trespass of Eve and Adam may have brought death into the world, but it also brought knowledge, "for the eyes of them both were opened" (Gen. 3:7). Mortality makes us *see* the world differently. Accordingly, Christian theology, from the writings of St. Paul to those of Luther and Calvin, always insists that its own understanding, its own interpretation of life, is determined by the fact of human mortality.[2] Death is not simply the event of the end of each person's history. As a punishment leveled against humanity for Adam's sin, death defines and interprets earthly existence. It is part of the fabric of experience after the Fall, life as *morir viviendo*, as death-in-life.

St. John Chrysostom, in his "Homily on the Transferral of Martyrs' Relics," wrote that God wanted to make sure that men would not go blindly to their deaths but would, within their lives, understand what terrible end awaits them. For this reason, observes Chrysostom: "God allowed Abel to die first, so that Adam, the transgressor, could learn what death really is from its appearance. . . . Had Adam died first he never would have seen any dead bodies. Adam, though, remained alive and saw in another body—that of his son—the triumph of death. Thus he could recognize more clearly and exactly just how huge his punishment was."[3] It is not enough that Adam should die for his sin. God demands that he also understand death's meaning while still alive.[4] To inflict this double penalty of death and of the knowledge of death, God shows Adam his future in the fate of his son: the body that cannot be brought back to life realizes death's finality. Adam also learns of the perpetuity of a punishment that includes not only himself but all his heirs.

274

Abel's death brings home to Adam the total suffering that is his guilt. And in this death Adam sees the true nature of all earthly life after the Fall; henceforth even what is most beautiful and most "virtuous" must die.[5] Adam cannot experience all these "truths" directly, as the event of his own death. Death is precisely the horizon of what a mortal person can experience as his or her life. The living have access to their own end only through the death of others. Only through the physical encounter with the corpse do the living have a sense of the "meaning" of death.

In Chrysostom, the vision of Abel's cadaver makes death into a spectacle that occupies all the senses. Everything about the corpse becomes an emblem of mortality: "God showed what death is, how heavy, bitter, and hostile. Adam learned this not only through the first sight of death, but also through all that happened after: through the foul smell of the corpse, through the pus that oozed from it, through the ashes into which it was transformed, and through all the circumstances that followed the burial."[6] Putrefaction is not simply the natural decay of a body after death. It is a vehicle of God's ugly message to the living, a repugnant display denoting moral corruption and designed to elicit terror. As the fifteenth-century French poet Jean Molinet wrote of the human cadaver:

> Horrible spectacle, detestable mirage,
> Proud vision, most fearful object,
> Mortal signal, O most lively example,
> You are a monster impossible and contrary.[7]

The corpse mirrors the living and conveys a point applicable to all: today me, tomorrow you (*hodie mihi cras tibi*).

In the *St. Trudpeter Hohenlied*, a German poem of the twelfth century, the fear Adam felt at the sight of Abel's corpse is related to the seventh and final gift of the Holy Spirit, the spirit of "knowledge and of fear of the holy ghost" (Isa. 11:2–3). The cadaver and the terror it inspires are gifts, for they foster piety that can lead the living back to God.[8] It is interesting that Chrysostom never discusses Abel's death as it relates to the victim himself. Abel's death has significance only insofar as it is interpreted by those who survive him and who can behold his remains. Death transforms the body into a *sign* directed toward the gaze of the living. And this sign torments the senses, mediating fundamental truths about our postlapsarian existence that would be unknowable without the corpse. It is the total spectacle of the stinking, disfigured cadaver that enables us to regard our life in its proper relation to death.

The image of the corpse plays a special role in the art of the late Middle Ages and Renaissance, particularly in the North. As Johan Huizinga writes in *The Waning of the Middle Ages:* "No other epoch has laid so much stress as the expiring Middle Ages on the thought of death. An everlasting call of *memento mori* resounds through life. . . . The medieval soul demands the concrete embodiment of the perishable: that of the putrefying corpse."[9] The dead body comes to haunt the living not only as an inert object of contemplation, as in Chrysostom, but also as an animated being who haunts earthly society and

mingles in the affairs of the living. In German art at the eve of the Reformation, the cadaver ambushes, rapes, murders, dupes, and dances with the living.[10] It is simultaneously executioner and confidant, victor and victim, wise man and fool. The animated corpse reaches its richest and most complex visual expression in the art of Baldung. In his paintings, drawings, and prints, Baldung invokes virtually all the various traditions of the macabre that he inherits from the Middle Age, partly by way of Dürer's art. And he infuses these traditions with a heightened awareness of the theology of evil and the Fall. Many other German artists of the period, of course, evinced a marked and, to modern tastes, disturbing fascination with death, violence, and the macabre. The ugly, brutalized Christs of Wolgemut, the Master of the Karlsruhe Passion, or Grünewald in the *Isenheimer Altarpiece;* Hans Holbein the Younger's woodcuts for the 1538 *Dance of Death,* his anamorphic death's-head in the London *Ambassadors* portrait of 1533, and his 1521 *Dead Christ* predella, now in Basel; Dürer's depictions of the animated corpse within secular scenes of pleasure or love; brutal images of war, executions, torture, and physical mutilation by the Swiss masters Urs Graf and Niklaus Manuel Deutsch; the violent and willfully repulsive art of Jörg Ratgeb—all these represent a morbid strain within the northern tradition whose meanings for Renaissance culture remain largely unexplored.[11] Baldung, however, makes the corpse into a central—I would urge *the* central—element of his intensely personal and novel mode of representation. For it is through the corpse that Baldung thematizes how visual images convey meaning in a fallen world. More than any other artist of his time, he studies that companionship between death and knowledge that has been present from the start.

It is possible, of course, to interpret the culmination of the macabre in Baldung by analyzing external historical factors that motivated late medieval death symbolism generally. The thirteenth through the sixteenth century, we are often told, was a calamitous epoch in which death was especially omnipresent, and this occasioned a rich and varied imagery. The bubonic plague or Black Death, which killed about two-fifths of Europe's population in the mid-fourteenth century, and which recurred in some places as often as once every four years between 1348 and 1500, was only the most massive spectacle of death.[12] There were other spectacles of carnage: lesser epidemics, including the new disease syphilis; frequent bad harvests and famines;[13] numerous urban and rural revolts, including the bloody Peasants' War of 1524–1525 in Germany; over a hundred wars in Europe in the century before Baldung, with rising casualties owing to the new heavy artillery; and the increasing threat of the Turks to the east. And all the while the Great Schism, patched up in 1417 but reopened during the Reformation, made people feel their spiritual lives were uncertain even as their physical being was in jeopardy.[14] The explosion of death imagery in the period may indeed be a reaction to these circumstances, yet it remains unclear just what *kind* of reaction the macabre constitutes. A number of historians, from Emile Mâle and Johan Huizinga to Alberto Tenenti and Jean Wirth, regard the emphasis on death as essentially non-Christian in character and origin.[15] Although contemplation of the corpse may subdue pride and encourage piety and good works, in its extreme form it can also shift attention away from redemption and toward earthly life

and its pleasures. In the bleak art of Baldung, it is argued, the memento mori shifts uneasily into a *memento vivere*. Other historians, most notably Jean Delumeau, have pursued a strictly Christian reading of the macabre. Knowledge of death heightens the attitude of contempt for the world that was cultivated first by ascetic monks of the High Middle Ages and that spread to the laity through preaching and iconography. The impulse behind this "evangelism of fear" was, according to Delumeau, "the growing desire for earthly goods in a civilization that, at least at its highest social levels, moved from poverty toward ever-increasing comforts."[16] Yet, as we shall see, Baldung's cadavers do far more than remind us that we are doomed to die. In their curious mix of eroticism, farce, and the theology of the Fall, and in their entrapment of the viewer in their terrible plot, they link up with Baldung's other obsessive subjects—for example, witches, nude women, and wild horses—that are neither immediately related to death nor obviously encouraging of the *contemptus mundi*.

My focus is less on what Baldung's images of death mean, or on their historical cause, than on *how* they mean, and on how self is constructed within the encounter with the corpse. Therefore much of what I am seeking—that is, the way pictures elicit interpretation and portray self—will be contained in, or will itself be constituted by, the process of my own search. The heuristic nature of my argument will be served, in part, by an emphasis on extended descriptions of specific works of art. I believe that description still offers the best access to an immediate experience of the visual image. Description, of course, can never be objective. It can, however, register the way a work of art functions for one particular observer. Rather than saying *what* a visual image means, description tells us *how* an image has opened itself up to an interpretation. It is central to Baldung's genius that his images of death can comment on the status of experience and of self. In their explicit manipulation of the beholder, they thematize the very activities of seeing and interpreting that make the production of meaning possible. If we are to be sensitive to this problematizing of the limits and powers of the experiencing, experienceable self, then the shape of our own interpretative experience will provide some of the best "evidence" for Baldung's artistic intentions.

The claim that description reproduces the immediate viewing of the object described, free from all interpretation and from the pressures of argument, is of course a fiction. One of the abiding paradoxes of literary ecphrasis is that, in its digressive structure, it represents as much a story as the story from which it seems to digress. In our case, what claims to mediate how Baldung's art means turns ineluctably into yet another interpretation, a discourse about what his art means. There is still no adequate theory of the relation between aesthetic experience and its mediation in art historical texts.[17] Perhaps the study of images of the corpse is the best starting point for such a project. The gap between interpretation and experience, between the stasis of writing and the activity of seeing, finds resonance in the question of death. For death is known only as something outside me, yet its message must penetrate to the heart of everything I am.

My starting point is an image by Baldung that was recently discovered in the print room of the Uffizi in Florence (fig. 140).[18] The print, a single-leaf woodcut, is oblong in

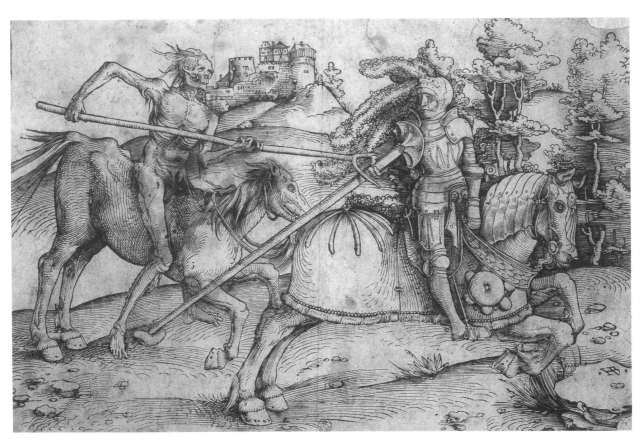

140. Hans Baldung, *Death Overtaking a Knight*, 1510–1511, woodcut, Uffizi, Florence.

format and slightly smaller than Dürer's illustrations for the *Apocalypse*;[19] it is not included in Matthias Mende's otherwise exhaustive catalog of Baldung's graphic works. Depicted is an animated corpse overtaking a knight on horseback. Although *Death Overtaking a Knight* is undated, we can be reasonably certain that it was made in 1510–1511,[20] that is, during Baldung's first period of independent activity after leaving Dürer's shop. The discovery of this important single-leaf woodcut, which is in fact the only extant print by Baldung representing an animated corpse, puts us in a position to take a new look at the imagery of death in the artist's oeuvre. *Death Overtaking a Knight* is about horizons. On one level, it attempts to place death within the earthly horizon of human experience and human history. On another level, Baldung's print is engaged in a complex dialogue with an image by Dürer. Baldung's response to his teacher's art will explain how his images of death achieve their significance against such an earthly horizon.

Before a castle and near a group of trees, an animated corpse mounted overlarge upon a mangy nag has come out to joust with the living. Death attacks its victim from behind,

brandishing a long pitchfork. Baldung puts this instrument to use elsewhere in scenes of witchcraft and the supernatural. One pitchfork serves as a potholder and three form a magic triangle on the ground in the 1510 *Witches' Sabbath* woodcut (fig. 158; M. 16);[21] and the supine man, probably a self-portrait of Baldung, in the late *Bewitched Stable Groom* print (fig. 213; M. 76) lies atop a pitchfork.[22] Baldung's corpse thus wields no ordinary weapon for jousting, no lance or sword, nor does it carry the traditional attribute of Death—the scythe. Its tool is not for killing, but for collecting or gathering. It is harvest-time, and Death has come to gather the living into its fold.

The knight, mounted on a powerful horse, pivots his upper body away from the direction he rides and toward the picture plane. His face is shown three-quarters, as if he were turning to face his opponent approaching from the rear, yet Death remains out of sight, attacking from the knight's blind spot. Instead of keeping his eyes on his macabre enemy, the knight seems to look out at us from within the picture's space. Including us in the picture's plot, the knight's eyes interpellate us as a fatal distraction. This sad glance directed toward the beholder plays through Baldung's oeuvre. In the early *St. Sebastian Altarpiece* (fig. 141; O. 6), for example, the martyr beholds us from a very similar angle, his gaze amplified by the disconcerting stare of the man behind him, a figure often identified as a self-portrait of Baldung.[23] Such a gaze, which opens up the space of the image to include the viewer in the picture's plot, acts here like a memento mori, like the inscription written over one of Baldung's panels of *Death and a Woman*: "Here must you go" (*Hie must du yn*).[24]

And yet the knight's eyes in our print do not quite fix us in their gaze. They seem to be focused elsewhere, the lid of the left eye closing over the pupil, the right eye cast in a different direction. The knight's look is positioned somewhere between glancing at us and looking nowhere, between an active gaze and the dead eyes of a corpse. The knight seems strangely lifeless for someone under attack. He barely raises his lance above the ground, and his left arm hangs limply toward the horse's bridle. The knight appears dead before Death actually touches him with its tool. The corpse's weapon casts a shadow on the knight, just below where the pitchfork's lower prong crosses the knight's lance. This darkness, indicated by four hatchings that run perpendicular to the direction of the lance, actualizes a moment just before Death makes contact with its victim. In this little shadow of death, Baldung insists that we experience a specific instant in *time* within the scene of an individual's death. We behold a particularized moment at death's threshold, a threshold mediated also by the knight's peculiarly liminal glance (in German, his *Augenblick*). The glance becomes at once an active force interpellating us before the picture and a blank stare suggesting that the body before us has died and we are too late. We stand perhaps already alone with Death in the full temporality of this harvesttime scene.

As in *Death with an Inverted Banner*, the mounted cadaver in Baldung's woodcut is very much alive. While the knight sits stiff and lifeless on his galloping steed, barely able to raise his lance, the corpse wields its weapon with vigor, its sinuous, almost muscular body leaning forward to make the catch. Its powerful right arm, silhouetted against an empty sky, forms the outer edge of an energetic play of curved forms that give this wood-

cut movement. The shape adumbrated by Death's arm carries a curve formed by the upper feathers of the knight's helmet through to the contour of the rear haunches of Death's horse. This movement then spills into the horizontal lines on the ground, which collect in a sort of whirlpool beneath the tree at the print's far right. Death's form thus participates in the whole dynamic of lines that, circulating through the woodcut, stand in opposition to the stiff, vertical form of the knight. The knight, although expressive in his sad gaze, is dying or has died. Death has the upper hand and is allied to the active rhythm of the world.

The oxymoronic aliveness of Death is just one of the ironies Baldung forges in his woodcut. The corpse parodies its victim in its method of attack, jousting with one whose trade is jousting. The irony that Death will kill the killer, that what the victim does as his livelihood will finally haunt him as his death, is why knights and soldiers were such

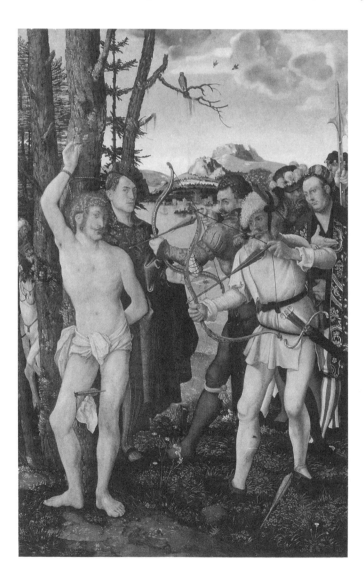

141. Hans Baldung, *St. Sebastian Altarpiece*, c. 1506–1507, central panel, oil on panel, Germanisches Nationalmuseum, Nuremberg.

The Mortification of the Image: Hans Baldung Grien

favored elements in the medieval dance of death. Since the circular logic of their ends exemplified life's vicious circle, knights and soldiers could stand as Everyman, and scenes of their encounter with Death were synecdochal for a whole *Totentanz*.[25] In Baldung's woodcut, Death acts like a mirror that mocks its victim. The knight's strong, well-armored horse, shown in perfect profile, stands in contrast to Death's bony nag, which moves awkwardly and obliquely toward the knight. The nakedness of Death itself parodies the obviously useless armor covering the knight's body. The ostentatious feathers that adorn the knight's helmet and that, in the exuberance of Baldung's own ostentatious calligraphy, lose themselves in the background trees, contrast with the wispy hair that streams back from Death's skull. The feathers, that is, displaying worldly *vanitas*,[26] are mocked by the corpse's hair, which, according to superstition, continues to grow even after death, like a *memento vitae* intrinsic to the body itself. There are other contrasts. The corpse's pitchfork parodies the chivalric lance. This instrument, totally unsuitable for a joust, is also socially unsuitable, a peasant's tool wielded in the manner of a nobleman. As Rudolf Chadraba writes in connection with Dürer's *Apocalypse* woodcuts, "The pitchfork crossed over a sickle and halberd became, during the era of the Peasant Wars of 1525, the seal of the rebellious peasants."[27] The German word for Death's weapon, *Mistgabel*, suggests another dimension of the picture. Wielding a "fork" (*Gabel*) particularly suited for pitching "dung" (*Mist*), the corpse reduces his victim's body to a pile of shit. Death plays at chivalry with the bathetic tool of a peasant, and his behavior is anything but chivalrous, attacking his opponent from behind.[28] Baldung's parody is not bitter satire, however. In his sad glance, in his stiff and helpless posture, and even in the worldliness of his dress and the futile pride such ostentation suggests, the knight conveys a humanness and thus a pathos that makes this scene of death not at all comic, or even distanced, but deeply disturbing.

Parody is never divorced from a strong sense of human pathos in Baldung's art of the macabre. We have seen this even where the target of mockery is not the form of the living individual but the liveliness of certain past works of art: in Baldung's travesty of Dürer's Adam in *Death with an Inverted Banner*. To convey pathos, Baldung must place death within the range of human experience. Death becomes experienceable for the doomed individual, or else the experience must be mediated by an expressive cadaver. In the late Middle Ages, meditating on death not only was a way of being vigilant about one's soul and of repenting one's sins and despising the pleasures of this world, it was also a mode of self-knowledge and of self-contemplation per se. In the so-called *vado mori* poems, the representatives of different estates, professions, and phases of life take the stage to announce, with the refrain "I go to die," who they are, what they have to lose, how they have fooled themselves into believing that earthly life has value, and whither they are now bound.[29] Although the specificity of their persons is articulated at the moment of their passage into an anonymous and common end (for, as Walter von der Vogelweide asks, "Who can tell the master from the slave when he finds only the bones?"),[30] within late medieval literature these poems are nonetheless privileged sites of a revealed interiority. This tendency is evinced, as well, in a drypoint *Death and a Youth* attributed to the Housebook Master and dating from about 1485 (fig. 142). Here the confrontation of the

living and the cadaver takes on a distinctly meditative coloring. Death, naked except for a loose shroud, grasps the shoulder of a young man dressed in fine clothing. The corpse, whose flesh is still intact, gazes at the youth with a look that is at once sad and insistent; the young man, in turn, returns its gaze with a defiant eye and an almost sly smile.[31] Death touches the youth as if to claim him, and the young man crosses his arms over his chest in a position traditionally assumed by the dying or the dead. Like Baldung's knight, the victim does not resist Death, nor does he register fear. The Housebook Master, however, invests the corpse, and not its victim, with that sad, meditative expression we saw in Baldung's knight. Death confronts the boy as a stern companion; a knowledge of death, an acquaintance with its grim necessity, is written in the face of the cadaver, who stands as one well versed in the effects of human mortality.

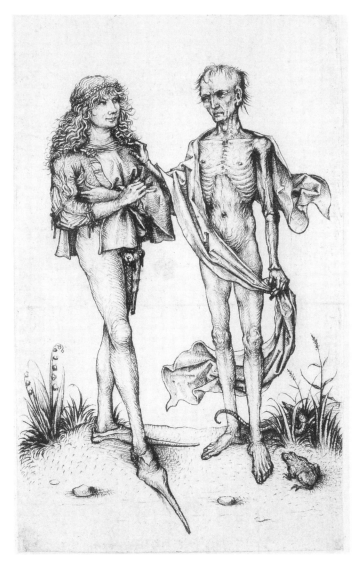

142. Housebook Master, *Death and a Youth*, c. 1485–1490, drypoint, Rijksprentenkabinet, Amsterdam.

The Mortification of the Image: Hans Baldung Grien

In his early *Death and a Landsknecht* (fig. 134), Baldung echoes the structure of the Housebook Master's drypoint. Here, however, it is the living man who looks at Death with a meditative gaze, while the corpse looks off to the right, its rotting features assuming a grin. The foot soldier's sad face prefigures the gaze of the knight in our woodcut. The parodic correspondences between the living and the dead appear here as well: the soldier's halberd stands parallel to Death's bony lance, and the wisp of hair on the corpse's skull is repeated in the shape of the soldier's feathers. It is interesting that the melancholy expression on the soldier's face—the open mouth, furrowed brow, and backward tilt of the head—bears a relation to Baldung's late illustration for Walter Hermann Ryff's 1541 *Anatomi* (fig. 143; M. 526), in which a seated man is shown with his inner organs exposed.[32] Baldung's diagram is not an image of inert matter displayed for the dispassionate

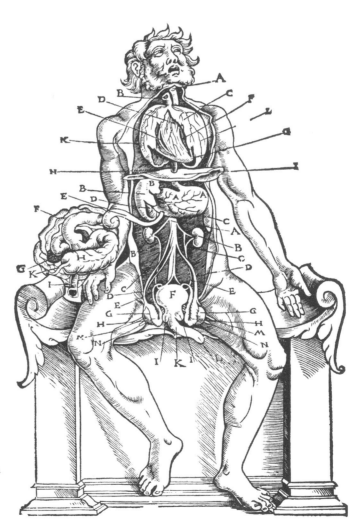

143. Hans Baldung, *Intestinal Tract of a Seated Man*, woodcut illustration for Walter Ryff's *Anatomi* (Strasbourg: Balthazar Beck, 1541), fol. A.

eye of a scientist. The dissected corpse, set like a statue upon an ornamental seat, appears to endure its own deadness as a kind of labor. In this suffering expression, we encounter a synthesis of the traditional encounters of the living with the dead. Whereas in the Housebook Master Death looked sadly at youth, Baldung's late anatomy illustrations merge the figure of Death with its victim, creating corpses that seem to be saddened by their own death.

In *Death Overtaking a Knight*, the paradox of making death available to human experience involves a curious reversal of history. Baldung, I have suggested, insists on the particularity of the moment through the small, temporalizing shadow of Death's pitchfork. And yet the temporality of *Death Overtaking a Knight*, its character as an event, remains deeply ambiguous. Not only does the knight seem dead before Death actually touches him, Baldung also imagines death as an overturning of time. Death's effect, the corpse, returns to become the cause of death; the knight is killed by the very thing he will become. This metonymic substitution of effect for cause[33] is not, of course, peculiar to Baldung. In the popular tradition of representations of the Three Living and Three Dead, for example, the corpses that ambush the noble youths wear crowns that correspond to the headgear of their victims.[34] Each of the youths struggles with a parody of the thing he will become. The function of such a reversal of temporal contiguities (present, past, and future) is to make death representable and therefore accessible to the experience of the living beholder. As a *state* that is by definition outside lived experience, death is the instance par excellence of the irreversibility of history. It must therefore be dramatized as an *event*—an event, moreover, that seems to parody real time just as the cadaver's physical form parodies that of its victim. The cadaver, the condition of the body after death, participates in the event that is its cause. In his later works Baldung will demonstrate his awareness that the controlling dimension of all such fictions, such reversals of the natural sequence of cause and effect, is *history*. As we began to see in *Death with an Inverted Banner*, Baldung invokes the elements of earthly history as the true components of his macabre imagery. Death becomes a figure in the drama of its historical cause, the Fall, as well as in that of its abolition in the Last Judgment.

Before entering the difficult territory of history as a controlling dimension in Baldung's figuration of death, I will consider one key visual source for *Death Overtaking a Knight*. For just as the corpse is a mirror interpreting the living, so too this print itself reflects and revises an earlier image within the history of the macabre. Baldung's animated corpse and its mount are modeled after the figure of Death in Dürer's 1498 woodcut *Four Horsemen of the Apocalypse* (fig. 128; Kn. 155). This, the fourth of Dürer's fifteen woodcuts illustrating the Revelation of St. John, depicts the four riders who will appear at the end of time to "destroy them which destroy the earth" (Rev. 11:18). At the right the first two horsemen, wielding a sword and a bow, bring war and destruction. The central figure, holding a set of balances, plagues the world with famine; his scales suggest the attribute of St. Michael (the Christian Psychopompos), who in the final hour shall weigh and judge all souls.[35] Below, and wielding a pitchfork, Death rides an emaciated horse, followed by a hellmouth that devours the damned. In Revelation we read: "And when he had opened the

fourth seal, I heard the voice of the beast say, Come and see. And I looked and behold a pale horse [*equus pallidus*]: and his name that sat on him was Death, and Hell followed with him. And power was given unto them [i.e., the Four Horsemen] over the fourth part of the earth, to kill with sword and with hunger, and with death, and with the beasts of the earth" (Rev. 6:8). Dürer's grisly figure of Death, who rides over the carnage of a fourth of mankind, is the source for Baldung's mounted corpse in *Death Overtaking a Knight*. Although the faces of the two cadavers are very different,[36] and though Dürer's rides draped in a shroud, the similarities are still striking. Both horses are emaciated jades equipped with only rudimentary reins. Both keep step with the powerful horses in front of them, galloping from the left and at a slight angle to the picture plane. And both animated corpses sit large upon their animals, their faces in three-quarters, their naked legs almost touching the ground, and their right arms extended behind them to wield their weapons. There are areas where the figures are nearly identical: the position and shape of the corpse's right hand and right leg, the corpse's neck and the angle of its head, the hair that streams from its skull, and the position of the horse's front legs. Most striking is that both riders wield pitchforks (though of different shapes); this tool, as far as I know, is never used as an attribute of Death before these two prints.[37] The presence of this unusual instrument in Baldung's print would be enough to suggest Dürer's influence from the *Apocalypse*.

That Baldung knew Dürer's woodcut is beyond question. Indeed, when Baldung entered Dürer's shop the master's fame was founded largely upon these fifteen woodcuts. Panofsky writes of the place of the *Apocalypse* in sixteenth-century art: "Like Leonardo's *Last Supper*, Dürer's Apocalypse belongs among what may be called the inescapable works of art. Summarizing, yet surpassing an age-old tradition, these works command an authority which no later artist could or can ignore, except perhaps by way of deliberate opposition which in itself is another form of dependence."[38] If Baldung is quoting the inescapable in Dürer, then he wanted this quotation to be recognized. For, importantly, in order for Death to appear in the same pose and orientation direction as it does in Dürer's print, Baldung had to copy his model in reverse (for printing always reverses the image as it is drawn). What stance does Baldung assume in what seems to be a deliberate allusion to his master's most monumental vision of death? As I argued for his reference to Dürer's Adam in *Death with an Inverted Banner*, it is doubtful that Baldung's interest in his teacher's art is ever purely formal. For one thing, the figure of the *equus pallidus* of Rev. 6:8 appears again and again in Baldung's work, from the white horse in his early *St. Sebastian* panel (fig. 141) to the Crucifixion scenes in Berlin, Freiburg, and Aschaffenburg (O. 10, 20h, 78).[39] Usually placed behind the cross, the pale horse is Baldung's sign of redemption, of Christ's Second Coming at the end of time.

To understand Baldung's reference to Dürer's Fourth Rider in the secular image of *Death Overtaking a Knight*, it is necessary to recall the notion of death as it is revealed in the Apocalypse of St. John. The Book of Revelation, like most early Christian texts, distinguishes between two radically different kinds of death: on the one hand, the death of the body, an event that befalls every human being at one time or another in profane

history as a result of Adam's sin; on the other hand, the "second death" (*mors secunda*) with which the damned shall be punished finally and for all time at the Last Judgment. Between the inevitable first death and the terrible possibility of the second, the soul rests like the seven sleepers of Ephesus, only to awaken at the day of Christ's return. On that day all distinctions of earthly life, between rich and poor, emperor and beggar, shall disappear into the distinction between chosen and damned, living and dead. The figure of Death on the *equus pallidus* is the harbinger of this moment at the end of time. With his three terrible companions, he avenges the blood of martyrs (Rev. 6:10) and hurries the damned to their eternal death. As part of the Last Judgment and as executor of the *mors secunda*, his appearance marks the end of human history that began with the Fall. Dürer's interest in the Apocalypse of St. John might have been influenced by the millenarian belief, widespread in his time, that the end of the world was coming in 1500.[40] Dürer represents the end of history and fallen time through a dissolution of earthly space. The Four Horsemen ride across a world with no fixed horizon, no necessary ground. Beneath them the old world crumbles so that the new world, the thousand-year reign (Rev. 20:6), can come into being. As a work of art, the woodcut merges the visionary and the earthly in a new and unique synthesis. As Max Dvořak wrote, Dürer's *Apocalypse* "stands between two worlds. One it brings to a close and another it ushers in; it links what was before the Renaissance with all that will follow."[41] In what world does Baldung set his image?

To return from Dürer's *Apocalypse* to Baldung's *Death Overtaking a Knight* is to return to earth. This is not just because of the far simpler composition and more modest scope of Baldung's print. The rear hooves of the jousting horses are planted firmly on the ground. Indeed, the rounded shadows that darken the ground beneath their hooves convey a sense of impact against the earth, as if the soil were giving way under the weight of their bodies.[42] Contrast this to the sense of weightlessness in Dürer's print. Baldung's woodcut disturbs us all the more because of its everyday setting. Death jousts in a mundane world in which castle and forest, culture and nature,[43] as it were, are neither threatening nor obscure. Elsewhere in his woodcuts and drawings, Baldung creates appropriately uncanny settings for supernatural events. The roughly contemporary woodcut *Witches' Sabbath* demonstrates just how demonic Baldung's landscapes can be (fig. 158); the nocturnal setting is as strange and obscure as are the witches and their rites. The background of *Death Overtaking a Knight*, however, stands closer to those conventionalized earthly settings that Baldung uses in his woodcuts of the Holy Family.[44] The oblong format of *Death Overtaking a Knight* enhances this earthliness. There are very few woodcuts of comparable size and importance produced in the North before 1521 (when Dürer began the *Oblong Passion*) that are organized in the horizontal form. Whereas Dürer's *Four Horsemen* has no horizon to speak of, *Death Overtaking a Knight* is organized around the horizon, that limit of our earthly experience of the world. Our eyes are kept gazing across the oblong shape, controlled by the dimension of horizontality, of being-in-the-world.

With this one might compare the effect of a vertical format in Dürer's famous engraving of 1513, *Knight, Death, and the Devil* (fig. 144; Kn. 72). Dürer's vision of difficult passage

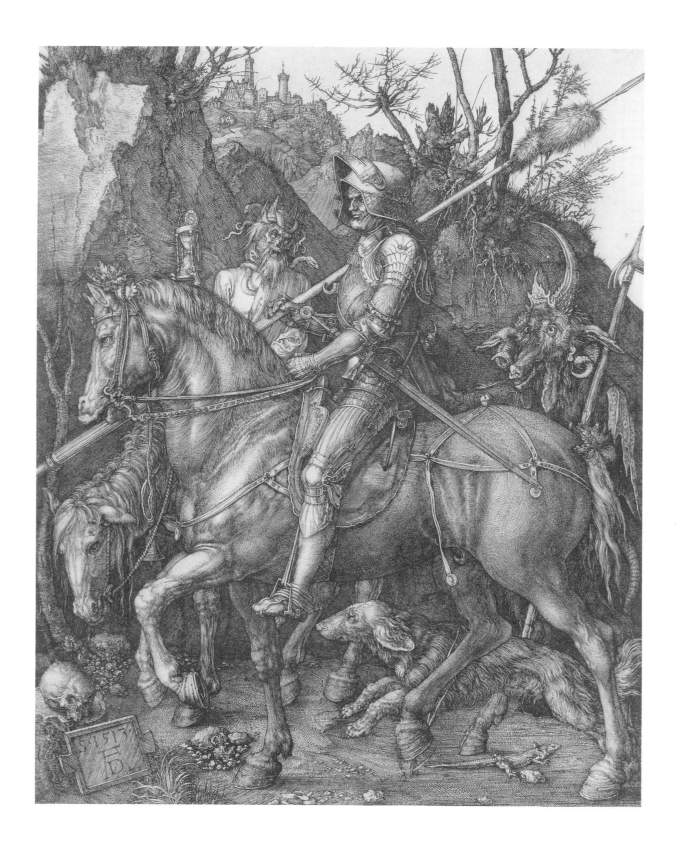

144. Albrecht Dürer, *Knight, Death, and the Devil*, 1513, engraving.

takes place deep beneath the horizon, in a narrow pass made narrower by the knight's companions, Death and the devil. At the left, the sky is barely visible above the ground, and at the right, the height of the knight's head does not quite reach the base of the trees. Dürer buries this encounter between life and death in a deep grave. In the lower left corner, a skull keeps watch over Dürer's monogram. The painting's vertical format recalls the structure of the hourglass that Death holds up before the knight. In the sand that runs from top to bottom through a minute hole designating the "present," we see how the passage from life to death is as close as is the knight's call with Death and the devil. Dürer's print itself repeats this passage. To move our eyes heavenward, toward the trees and distant town, is to pass toward life, while to peer downward to the skull and into the "grave" is to encounter death. Dürer places the scene deep in the earth, below the horizon, in order to suggest a movement beyond, along the vertical axis. For positioned at the top of Dürer's engraving, the lofty town suggests not an earthly place, but a heavenly city—Jerusalem or the *civitas Dei* that exists beyond time and history.[45] Resisting the devil and Death, and resolved to ascend to the timeless city, the knight as *eques christianus* defies the emptying, earthward motion of the hourglass's sand that relentlessly marks time. Baldung's print, on the other hand, offers no such resistance, no such consolation or possible escape from the earth through the vertical. Baldung's castle is not a promise, however remote, beyond the scene, but seems to be party to the carnage. And the arm of Death, silhouetted above the horizon, closes off the sky as a possible dimension of escape or salvation.[46]

Baldung thus removes Dürer's grim Fourth Rider of the Apocalypse from the visionary scene of the Second Coming to a wholly earthly setting, in which horizontality as *Weltlichkeit* is the controlling dimension. This shift has profound theological consequences. Dürer's Fourth Rider, we recall, was harbinger of the "second death" at the end of time, when human history is annihilated and the damned are punished. By placing Dürer's figure back into the world, Baldung implicitly erases the distinction between physical death and judgment. He transforms the end of time into the end of an individual's life, an event rooted in history and caused by Adam's fall. Just as profane space is inescapable in Baldung's print, so too is profane time. This is perhaps why Baldung insists on the particularity of the moment in *Death Overtaking a Knight*. The shadow cast by Death's pitchfork and the strange liminal expression on the knight's face historicize death. Baldung has lowered the horizon of his precursor's vision so that death, admitted into time and into human experience, can have its full significance in the here and now of the beholder.

The transformation of the "second death" into an event in human history, implied in Baldung's reference to Dürer's *Apocalypse*, is not unique to this artist. Historians have argued that one of the most decisive features of the West's changing attitudes toward death at the end of the Middle Ages is precisely this displacement of judgment to the end of each individual life. By the fourteenth century, Scholastic thought embraced the idea of individual judgment; and Pope Benedict XII's 1336 edict, the *Benedictus Deus*, made it official, declaring that the just behold the beatific vision immediately after death, without

a general judgment.[47] This new conception, linked to the invention of purgatory as an interim stage in the soul's passage from earthly to heavenly existence, also supported an increasingly individualized and subjective piety, in which each person became more responsible than ever before for fashioning the soul's unique and imminent destiny.[48] The iconography of the macabre, with its emphasis on the corruption of the individual body, represents an important outgrowth of this new particularizing attitude toward persons, their biography and their vicissitudes.[49] As Philippe Ariès wrote in his monumental survey of this subject: "The traditional interval between judgment, the definitive conclusion of life, and physical death disappeared, and this was a great event. . . . [F]rom now on, the fate of the immortal soul was decided from the very moment of physical death. . . . The drama no longer took place in the vast reaches of the beyond. It had come down to earth and was now enacted right in the bedroom of the sick person, around his bed."[50] Ariès is referring to the illustrations of the *ars moriendi*, those manuals on the technique of dying that enjoyed enormous popularity during the fifteenth century.[51] The dying person appears on the deathbed surrounded by angels and demons who vie with one another for possession of the soul. What finally decides a person's fate—that is, whether one will die a second death or die only to be born again into eternal life—is the attitude one assumes at the last moment of life, when one's personal biography reaches its conclusion and thus reveals its meaning. Recently scholars have disputed Ariès's claim that the individualization of judgment is specifically a late medieval phenomenon, contending that his evidence, culled mainly from personal wills and visual sources (prints, book illustrations, tomb iconography, etc.), reflects older, superseded opinion. The crucial period in the history of Christian attitudes toward death, they argue, is instead the end of the twelfth century and the beginning of the thirteenth and is revealed in such texts as hagiographies, the exempla literature of monastic culture, and popular tracts describing visions of the beyond.[52] Whether it originated in the fifteenth century or the thirteenth, however, the desire to locate judgment at the end of a person's life reflects the changing estimation of the importance of the individual human subject within the machinery of redemption. The macabre, linked to changing conceptions of eschatology, thus illuminates the prehistory of early modern conceptions of self.

The conflation of death and judgment, implicit in the *Apocalypse* reference in *Death Overtaking a Knight*, also suggests a changing notion of the way meaning is—or is not—revealed in the world. Christianity had always regarded death as a bearer of meaning, an event that reveals the true nature of things. In his "Sermon concerning the Earthquake," St. John Chrysostom invokes the classical metaphor (also popular during the Renaissance) of the deceptiveness of human experience: the trope of life as a play and the world as a theater. In drama the king is not really a king, nor can the doctor really heal. They are only actors, and their identity is their disguise: "One actor is dressed as a slave, even though he is free; another plays a teacher, even though he does not know the alphabet. They all are not that which they seem to be; and what they really are, that they appear not to be."[53] The difficult distinction between illusion and reality troubles man's relationship to meaning after the Fall. The play, the pageant of disguises, represents

human history, in which reality is hidden under a mask of illusion. Chrysostom goes on to say that the "evening comes, though, and the masks are laid aside, . . . the play is over and truth appears. So it is too at the end of this life of ours."[54] Chrysostom's "night," which brings the play to a close, which makes what things *are* commensurate with what they *appear to be*, is death. Only after death do we know the true meaning of things; only then can we tell "who is rich and who is poor . . . who is king and who is impoverished." This passage should warn against interpreting death too narrowly in an account of macabre images, as if it were something to which we can simply assign a meaning, or as if we could discover the "meaning of death according" to Baldung, or Dürer, or Cranach, or Luther. Death is less a vehicle for signifying something else in particular than a condition that guarantees the possibility of proper signification generally. It is that horizon of experience through which all things of this world finally and properly come to signify. Death, appropriately equipped with a pitchfork in Baldung, harvests meaning.

The "night" Chrysostom speaks of is not our first, physical death, however. "Soon the day will come to an end and there will come the terrible night, or rather, the day: night for the damned and day for the righteous." Truth comes "to light" in the Last Judgment at the end of time. For the distinction between illusion and reality to be erased, human history, with its beginning in the Fall, must end so that all works and all souls can be judged as a self-enclosed and therefore readable whole,[55] free of the shifting disguises of the temporal world. But if meaning comes at this end of time, why does Baldung displace this event back into time and history? *Death Overtaking a Knight* may bring us to the point where death becomes the object of individual human experience, and where the apocalypse occurs within the horizons of this world. Yet it remains unclear how death means in Baldung's works, as well as why this meaning is inextricably bound up in human history. Such questions cannot, of course, be answered by a single woodcut. It will be necessary for us to understand Baldung's radical conception of the image, its fallen viewer, and its equally fallen artist.

One final word, though, on *Death Overtaking a Knight*. Death jousts with the living in a lonely world. This loneliness is only increased by the presence of the castle, which, while suggesting society, offers no comfort but stands as a mute witness to the event. The victim is surrounded by neither friends nor relatives nor even the groups of angels and demons that populate the deathbed scenes of the *Ars moriendi*. Nor has the animated corpse come to gather the knight's body along with the multitude of humanity, as in Dürer's *Apocalypse*. There is a kind of comfort in crowds, even if the crowds are damned. Baldung's knight dies alone, prefiguring a solitude envisioned some years later by Luther:

> We are all summoned to death, and no one can die on behalf of another; rather, each individual must be personally armed and armored in order to fight with the devil and death. We can cry in the ear of our neighbor; we can comfort and admonish him . . . but we cannot fight or struggle with him. Each individual must take his own risks and pit himself against the enemies, the devil and death, and fight with them alone. I will not be with you, nor you with me.[56]

Nothing is got for nothing. The rise of the "individual," associated since Jacob Burckhardt with the epoch of the Renaissance and exemplified for German culture by the self-

portraits and aesthetic ideals of Dürer, was not without its darker consequences. A new anthropology that stressed the instrumentality of the human will and intellect both in the conduct of earthly affairs and in the achievement of personal salvation placed upon the pious laymen unprecedented spiritual and moral demands.[57] The heightened fear of sin and damnation that fuels the macabre was born, in part, from the disparity between these new obligations placed upon the self and an increasing sense of moral impotence. It was precisely at death that an individual would have been most aware of the self's responsibility for its spiritual destiny, which would be fulfilled immediately upon the extinction of the body. Yet there was little guidance along the way. The late medieval Catholic church, with its fantastically legalistic conception of individual redemption, its quasi-inquisitive procedures of confession, and its increasing insistence on works of righteousness, could offer at best an institutional fideism that, by Baldung's time, became unsatisfactory for the spiritual needs of much of the laity in the North.[58] If Dürer's art celebrated the Renaissance self's empowerment, Baldung's art will betray the darker aspect of this new individualism. His images of death make sense of a world in which all die their own deaths alone and, more important, in which all must make sense of their own lives alone.[59]

14

Death as Hermeneutic

The absence of any sign of redemption in *Death Overtaking a Knight*; the woodcut's suppression of all elevation, all movement beyond the futile race across the landscape and the imminent fall of the knight from his mount; the sheer mundanity of the spectacle, with its somehow expected intervention of the cadaver (the knight's lifeless posture is the tired acceptance of less-than-divine *ananke*): all these are the devices of an art uniquely focused on *this* world in its most fallen, and therefore most inescapable, aspect. Other artists before Baldung envisioned more terrible scenes. Michel Wolgemut's sadistic tormentors of Christ in the Berlin *Sketchbook*,[1] Stefan Lochner's damned souls in the Cologne *Last Judgment*, and Hieronymus Bosch's demons are perhaps more hideous than Baldung's animated cadavers. Yet in these artists the power of horror belongs to a spiritual hierarchy that stretches from the depths of hell to the prospect of a possible divinity. Baldung's refusal of any transcendence beyond the mere passage into death, or beyond the banal prurience of witchcraft, stems from his vision of human experience as quintessentially abject. The Fall of Eve and Adam lurks behind all of Baldung's macabre images, and indeed behind his art as a whole.

The notion that death has a specific historical origin in Adam's trespass runs through the whole tradition of the macabre, from the *Plowman of Bohemia* and the *Totentänze* of the late Middle Ages to the sermons of Johann Geiler von Kayserberg and Martin Luther.[2] Interpreting 1 Cor. 15:22 ("For as in Adam all die, even so in Christ shall all be made alive"), Luther exposes the error of believing that death is simply "our natural lot." For Scripture tells us "that our death and dying . . . is the fruit and punishment of the sin of our father Adam, who wrongly aspired toward a high majesty, so that everything that comes from him and is born on earth must be forever death's, and no one on earth can escape or defend against this misfortune."[3] Similarly, in his sermon on the dead youths of Nain (Luke 7), Luther notes: "Most people think it just happens that we die like a beast. . . . Here Scripture teaches us, though, that death came, first of all, from paradise, from the bite of the forbidden fruit."[4] The Reformer's emphasis on the catastrophic origin

of death, its historical and human cause, belongs to his conviction that sin and its consequences are our individual burden. As we observed already in the early sketch *Death with an Inverted Banner*, Baldung also weaves his macabre images into a theology of the Fall, stressing the historicity of death's origins. Baldung's central vehicle for such reflections are his paintings in which Death confronts or rapes a naked woman.

In Baldung's *Death and the Woman* from about 1518–1519, now in Basel, everything seems to open to our gaze (fig. 135; O. 48).[5] The woman's garments separate to reveal her naked body. Her white flesh stands out against the dark background and brownish cadaver, drawing our eye toward her. We cannot tell whether she actively reveals herself (she holds the ends of the white cloth at either side of her body) or whether, in trying to resist the corpse, she accidentally lets her garments fall. Perhaps she tries to hold them up, to keep herself covered despite the assault. The gesture of her arms, however, exposes her body even more, making her more vulnerable to both the groping hands of Death and the open eyes of the beholder. Baldung captures a particular instant in this cruel drama of exposure: the falling garments form a V whose apex is also the apex of the V of her groin. These diagonals organize the picture. The upper edge of the cloth at the right carries down into the orthogonal on the ground plane at the lower left, while from the left a diagonal passes from the woman's right upper arm, through the edge of her falling garment, and along Death's exposed left shin. These organizing lines are paralleled and strengthened by others, such as the line formed by the bough of the tree or the diagonal formed by the woman's right forearm. Baldung thus focuses his painting matrix of shapes around the pubic triangle, where the cloth is just about to part and reveal the woman's "full" sexuality.[6]

The painting arrests us at the instant just before this revelation, at a visualized "point" of anticipation. Such a particularized temporality, which suspends the scene's event at its threshold, is already known to us from *Death Overtaking a Knight*. The knight's eyes suggested a liminal state between life and death, and Death's pitchfork just cast its shadow on its victim's lance. In *Death and the Woman*, the instant of nakedness coincides with another event that we also see arrested before completion. Death's teeth are poised to bite its victim but have not yet grazed her flesh. The sense is that the moment Death closes its teeth, the woman's garments will fall open. The painting thus situates us at the moment when Eros and Thanatos merge: sex, expressed in the woman's concealed/revealed flesh and in the corpse's act (for its bite is also a lipless kiss), becomes identical to death, expressed in the garments as funeral shroud and in the bite as putrefaction. And all around, opening up with the woman's clothes, the beholder's eyes, and the jaws of Death, are yawning graves, cemetery versions of the bridal bed.

The woman's striptease, imagined as both willing and unwilling and arrested at the point where "more" will be revealed, engages and sustains the viewer's open eyes. She becomes an object of a specifically male desire, a bait deployed to trap the phallic gaze; her function is to elicit this gaze and to interpellate it as reprehensible.[7] Her tears, cleverly rendered by the artist as highlights upon white flesh, might register her own status as experiencing subject, yet the overall plot of the picture, the way it addresses the viewer

and fashions its controlling allusions, overlooks her plight. Her efforts, as they are staged by Baldung, collapse two moments. At the same time as she turns toward her attacker as if desiring him despite herself, her tears express a suffering consequent on that desire, a suffering born from the contradiction between willing and knowing.[8] Her very overdeterminedness—she at once is an object of desire and herself dramatizes desire's essential ambivalence—also informs the curiously irrational shape of the funeral shroud. The white cloth (or rather cloths, for the shroud seems to be made of two separate pieces) could never have dressed the woman but function only to suggest that she is undressed. Thus drawn to the woman's body, the eye can travel along its curved shape to her face, where warmth of life has collected in the pink blush that colors her otherwise cadaverously white body. At this point at which the desiring phallic gaze apprehends a touch of life, Death's teeth meet the woman's flesh.

Nothing in this painting is quite as sensual, in the sense of strongly felt, as this meeting of opposites, where the soft, warm, and living flesh of the woman meets the hard, cold teeth of Death. Surely the corpse's gesture is linked to the position of the picture's implied male beholder: where he can only look, the cadaver can touch and taste. This grotesque tableau of almost fulfilled desire links sexuality to repulsion within the *experience* of the painting. Death is the viewer's doppelgänger within the painted world. Nibbling at the bait, it expresses male erotic desire at the very instant it annihilates that desire and therefore mortifies the flesh through the power of horror inherent in its macabre form. Unlike the woman's accented pubic triangle, Death's sex (those rags of flesh that, in Baldung's corpses, take the place of genitals) is carefully concealed by the woman's cloth. Put simply, *Death and the Woman* assaults the sovereignty of the viewer's "self." Simultaneously aroused by his sight of the nude woman and repelled by his vision of the rotting cadaver, the male viewer, despite him*self*, becomes the true subject of the picture's plot. Or better, he is installed as subject in the very moment of his erasure *as subject*, that is, as closed, distanced, commanding "I" set off against an object. "Self"-portraiture here marks not the entrance of the individual human subject into representation, but rather the point of its annihilation.

"Cadaver" comes from the Latin *cadere*, "to fall." Baldung's Basel panel, mingling erotic desire and the memento mori within the experience of the image, recapitulates the trespass in the garden. For as we read in an important passage on Adam's sin in St. Augustine's *City of God*, sexual desire was, from the start, linked to death as a sign of fallenness:

> For after their disobedience to God's instructions, the first human beings were deprived of God's favour; and immediately they were embarrassed by the nakedness of their bodies. They even used fig leaves, which were perhaps the first things they could lay hands on in their confusion, to cover their *pudenda*, the "organs of shame." These organs were the same as they were before, but previously there was no shame attaching to them. Thus they felt a novel disturbance in their disobedient flesh, as a punishment which answered to their own disobedience. . . . This then was the time when the flesh began to "lust in opposition to the spirit," which is the conflict that attends us from birth. We bring with us, at our birth, the beginning of our death, and with the vitiation

of our nature our body is the scene of death's assault, or rather of his victory, as the result of that first disobedience.[9]

Erasmus, in his *Enchiridion militis Christiani* of 1503, echoes the tenor of Augustine's position when he metaphorizes the self as a king and the sexual organs as rebellious subjects: "Just how beastly and intractable this lowest part of our nature is, the pudenda of the body can demonstrate, in which area it [the tyranny of desire] exercises the most absolute tyranny. With its foul incitements it, alone of all the members, continually promotes rebellion in spite of the king's fruitless protests."[10] Baldung does not mediate our fallenness as some distant event, or as some doctrine to be understood intellectually. Rather, he addresses the body as well as the head, the rebellious members as well as their troubled sovereign, by fashioning an erotic art that itself arouses the desires that reflect a viewer's kinship with Adam. And Baldung punishes those desires through the viewer's experience of revulsion in encountering himself in the habit of the corpse.

In *Death and the Woman*, the corpse rapes the woman from behind, recalling those surprise attacks in such macabre scenes as the Three Living and Three Dead,[11] or Baldung's own *Death Overtaking a Knight*. More important, however, Baldung positions the corpse in *Death and the Woman* so that its form echoes the figure of Adam as he appears in certain of the artist's depictions of the fall of man. In Baldung's 1519 woodcut *Fall*, a work exactly contemporary with the Basel panel, Adam approaches Eve from behind, trapping her in a subtle and erotically charged embrace (fig. 145; M. 73).[12] Grasping her shoulder with one hand while covering—or tickling—her groin with a leaf held in the other, his right foot planted before hers, Adam does not so much restrain Eve as resist or impede her progress. Eve, in turn, appears to draw away from Adam; reacting to his touch, she assumes a posture quite similar to that of the woman in the Basel panel.[13] Even more suggestive are the parallels between *Death and the Woman* and Baldung's later *Adam and Eve* from 1531–1533, now in the Thyssen-Bornemisza Collection in Lugano (fig. 146; O. 75). Again Adam approaches Eve from behind, this time assuming a stance in many details almost identical to that of the corpse in the Basel painting. *Death with an Inverted Banner* associated Adam with Death through a visual allusion to the work of Baldung's master, Dürer. Here the allusion is to other images within Baldung's own oeuvre, which testifies to this artist's extraordinary self-consciousness about the significance and unity of all his productions. Baldung's model of the relation between artist and image may differ radically from Dürer's, yet his art itself depends for its messages upon the notion of an oeuvre, and of the uniqueness of personal invention, first founded by the Nuremberg master.

In the Lugano *Adam and Eve*, a naked woman again stands exposed to our gaze. This appeal to the eye is deliberate: Adam seems to hold or offer Eve up to our sight. He rests his left hand gently on her hip, as if simultaneously to touch and to frame the contours of her body. His right hand, too, is careful not to cover any curve of the breast it cups. Within this painting, touching is secondary to seeing. The transparent veil covering Eve's genitals, held in place by Adam's hand (which covers Adam's genitals just as the cloth

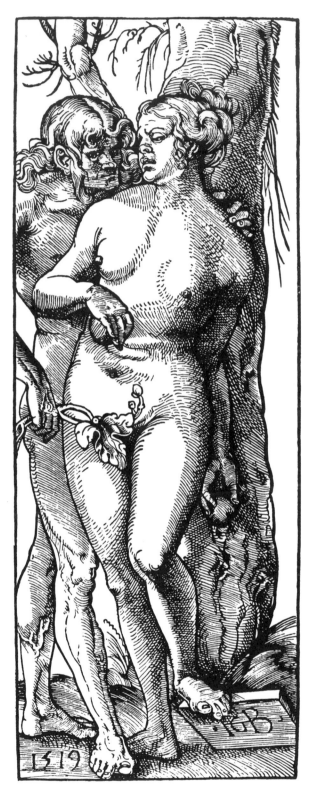

145. Hans Baldung, *The Fall*, 1519, woodcut.

146. Hans Baldung, *Adam and Eve,* c. 1531–1533, oil on panel, Thyssen-Bornemisza Collection, Lugano.

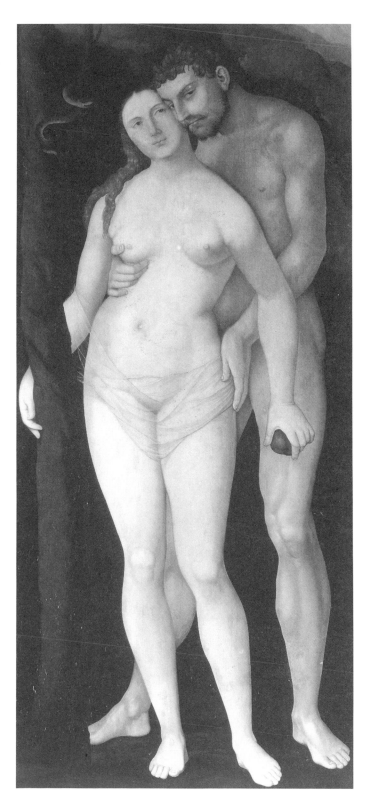

covers the corpse's groin in the Basel panel) conceals nothing. Rather, like the shroud in *Death and the Woman*, the gossamer wrapped about Eve's hips only draws attention to her sexuality. We find ourselves looking through the veil, and like it or not, our gaze becomes a trespass.[14] There is, of course, something willfully artificial about Baldung's placement of this transparent shroud within Eden's natural paradise, as if the Fall occasioned not merely the fig leaf, but also the already fetishized paraphernalia of sexual concealment. Made of costly imported fabric, such a weave would, at the very least, have suggested an attitude of *vanitas*. Baldung's contemporary viewers, moreover, would have recognized in the veil an attribute of prostitutes, who in this period were often forced to wear such a garment as a badge of their profession.[15]

By thus outfitting his Eve with the marks of a fallen sexuality, Baldung invites, or even forces, his male viewers to experience their own voyeuristic desire, mirroring the worst in them in the lascivious gaze of Adam. The word "mirror" is, I believe, appropriate, for in this painting one has the sense that Adam not only gazes out of the painted space toward us but also appears to be regarding himself in a mirror, fascinated by the sight of his own flesh making contact with Eve's body. Thinking about the painting in this way illuminates Adam's sidelong glance. He wants both to touch Eve and to observe himself touching her. Thus he leans his face toward her, resting cheek against cheek, while at the same time glancing off to the right to watch his gesture mirrored. That is why he takes care to handle her body so that everything erotic remains exposed even as it appears to be touched by him. We, of course, stand where this notional mirror would be. Adam's leering eye interpellates the viewer in its gaze, making him an accomplice to fallen sexuality. Such an arrangement is already present in Baldung's earliest depiction of the *Fall of Man*, the chiaroscuro woodcut dated 1511, in which Adam, gazing with Eve out at the viewer, plucks a fruit from the forbidden tree with his right hand, while with his left he cups Eve's breast from below (fig. 147; M. 19).[16] And it is made even more explicit in a lost work by Baldung, known from a contour drawing now in Coburg, in which Eve gazes out at the viewer while Adam reaches down to finger her genitals between her crossed legs (fig. 148; K. A27).[17] James Marrow, following E. M. Vetter, has remarked that Baldung is the first artist ever to represent the Fall as an overtly erotic act.[18] In the Eve of the Lugano *Adam and Eve*, with her see-through veil, Baldung carries his intentions a step further. The Fall is now explicitly associated with voyeurism, with fallen sexuality as perverted vision or scopophilia. As such, any distance between original sin and the beholder's fallenness is annihilated. Party to Adam's desires (if not to his actions), the male viewer recognizes his true kinship with Adam. Thus are the sins of the fathers visited upon the sons.[19]

Our loss of innocence as beholders finds an interesting expression in the twin panels of *Adam* and *Eve* from 1525, now in Budapest (fig. 149; O. 57). A swaggering Adam stands hand on hip, his face in profile. His goatee and upturned mustache, together with his hair, which curls to form two hornlike points, give him the appearance of a satyr, which is appropriate to his lustful character.[20] The association of Adam with Bacchus's woodland attendants is made explicit in Baldung's woodcut illustration of the Fall of the *Leien Bibel*

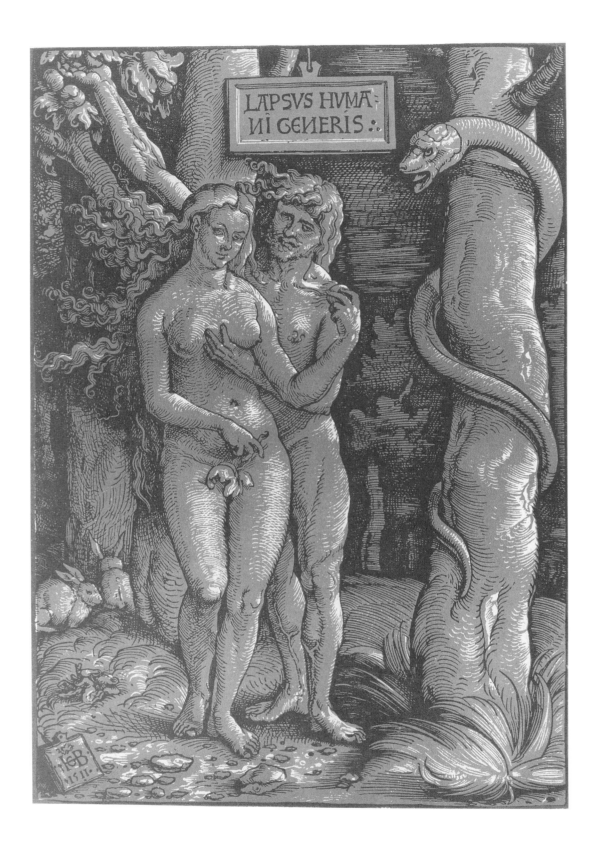

147. Hans Baldung, *The Fall of Man*, 1511, chiaroscuro woodcut.

of 1540, in which Adam's face is juxtaposed to the head of a goat shown in profile (fig. 150; M. 473).[21] In the Budapest panel, Adam's left hand grasps a branch whose leaves covers his genitals. The branch itself, jutting out from his groin, accentuates or stands in for the very thing it is meant to conceal—a "coincidence" of shape made all the more suggestive by the way his hand curls lewdly inward toward his genitals, grasping the twig between the index and middle fingers. Baldung, exploring territories that Freud will map about four centuries later under the rubric "sexual aberration," represents the Fall as a passage into fetishism, in which the "natural" sexual object is replaced "by another

148. *Adam and Eve*, after 1530,
 contour copy after original by Baldung,
 Kunstsammlungen der Veste, Coburg.

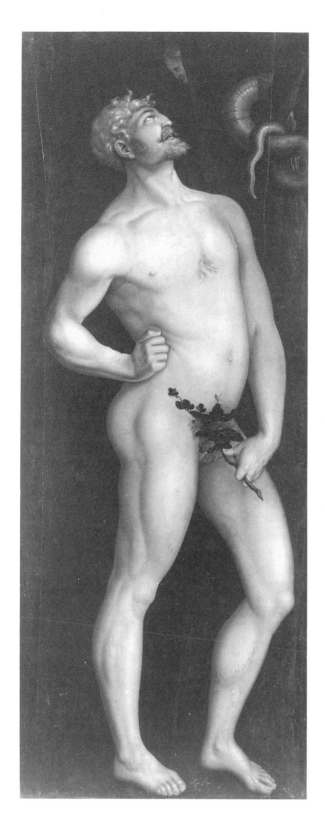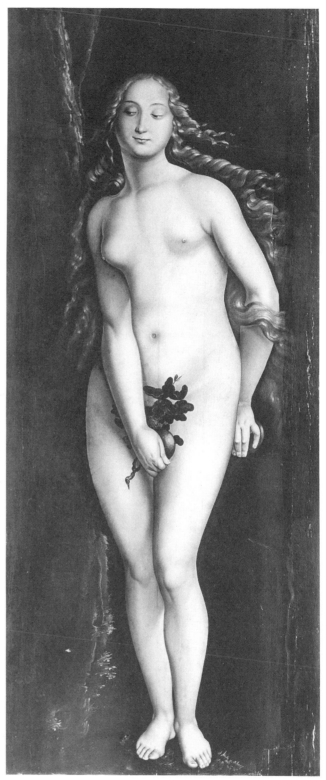

149. Hans Baldung, *Adam* and *Eve*, 1525, oil on twin panels,
Szépmüvešzeti Muzeum, Budapest.

150. Hans Baldung, *The Fall*, woodcut illustration for the *Leien Bibel* (Strasbourg: Wendelin Rihel, 1540), fol. A3ᵛ.

which bears some relation to it, but is entirely unsuited to serve the normal sexual aim."[22] Thus any attempt to hide the body will appear to us as exhibitionism, and the very implements of concealment will refigure, through resemblance or contiguity, the things they conceal: Eve's covering veil becomes a means of visual access, Adam's concealing branch and leaves become his penis and pubic hair, and postures of modesty become exhibitionist or autoerotic. This principle of substitution and inversion reaches a superb expression in the Budapest *Eve*. Looking coyly off to the left, Eve seems to pretend not to notice the viewer's eye. And in that feigned attitude, she indulges the phallic gaze. In her right hand she holds an apple on a branch and, like Adam, covers her groin. The way her arm wraps closely around her body, however, and the way her hand is clenched around the bright red fruit, focuses attention on her sex. She has learned the logic of concealment, how the gaze is attracted more by a fetishized promise of exposure than by any full or "natural" presence of the flesh and how, by concealing in her coy look her awareness of the male viewer's gaze, she can tempt him with the alluring fiction of unnoticed visual trespass.

To appreciate the distance Baldung has traveled from his teacher's representations of the prelapsarian Adam and Eve, we need only compare the Budapest panels with Dürer's Prado *Adam* and *Eve* of 1507 (fig. 133). As we recall, Baldung not only knew these twin panels from the period of his Nuremberg apprenticeship, but also produced a faithful copy of them, elaborated by animals taken from Dürer's engraved *Fall* (figs. 132 and 98). Dürer's *Adam* and *Eve* panels also provide the essential formal model for a number of

secular works by Baldung, including the Basel *Death and the Woman*, the Otterlo *Venus* (O. 55), the *Judith* in Nuremberg (O. 56), the late *Eve, the Serpent, and Death* in Ottawa (fig. 151; O. 54), and the Kassel *Hercules and Antaeus* (fig. 220; O. 72). In all these works, nude bodies, often large in scale and filling a narrow vertical panel, are modeled softly in pale tones and silhouetted against a very dark ground, which rises above an unnaturally low horizon. Yet Baldung overturns the whole tone and message of his teacher's art. Dürer, in his Prado panels, labored to create delicate, youthful, and indeed innocent figures, improving on his construction of ideal beauty in the engraved *Fall* by naturalizing his figures' poses, freeing up their movements, and softening their contours. Baldung, in the Budapest *Adam* and *Eve*, contorts his nudes into deliberately artificial poses[23] and thematizes that very "artifice" through the conceit of the now patently corrupt pair.

Dürer's Prado Eve stands naked and unaware of our gaze, while a leafy branch "happens" to cover her genitals, meanwhile supporting a tablet with the artist's name and monogram. The link between this branch and the Dürer's self-denomination is perfectly fitting, for according to some medieval sources, the aprons that Adam and Eve sewed together from leaves after the Fall were the world's first art objects.[24] In Dürer, Eve's innocence (or what remains of it before she eats the fruit offered to her by the serpent) is expressed in the candor with which she is exposed and concealed. For as contemporary theologians had it, "Blameless nudity . . . is that which Adam and Eve had before sin . . . nor were they confounded by that nudity. There was in them no motion of body deserving shame, nought to be hidden, since nothing in what they felt needed restraining."[25] Baldung, on the other hand, reveals and dismantles the false artifice involved in the venerable artistic convention of concealed prelapsarian nakedness—that is, the illusion, engineered by Dürer[26] and subsumed under a notion of "decorum," that the covering leaves are there just by chance. Baldung demonstrates that human representation cannot pretend to be the purveyor of an unspoiled, prelapsarian innocence of vision. This "message" is instantiated in the way we, as beholders, interpret his images. To say, for example, that Eve's gesture in the Budapest panel is a deliberate, seductive, and erotic concealment of sexuality, or to interpret her as possessing a "knowing"[27] look, is to betray our knowledge of sexuality and deception and therefore to admit our own fallenness. Whereas Dürer places his marks of authorship at precisely the place of recuperated, innocent modesty (the tablet hanging as if "naturally" from the covering branch), Baldung locates self within the domain of fallen self-consciousness, evident both within and before the painted image. Later we shall examine how Baldung also degrades his *own* person through perverse placements of the Dürerian monogram.

That Adam caused death to come into the world and that men and women became conscious of their nakedness only after the Fall are theological commonplaces. What is interesting about Baldung's interpretations of the Fall, though, is not so much their content but the way they communicate this content. On one level, the "meaning" of the Fall is expressed by images that invite the viewer to reenact, or at least to reflect, his own postlapsarian condition in the shape of his interpretation.[28] Thus in the Lugano *Adam and Eve*, Adam stands behind Eve, and his look, mirroring our own, serves to expose us and

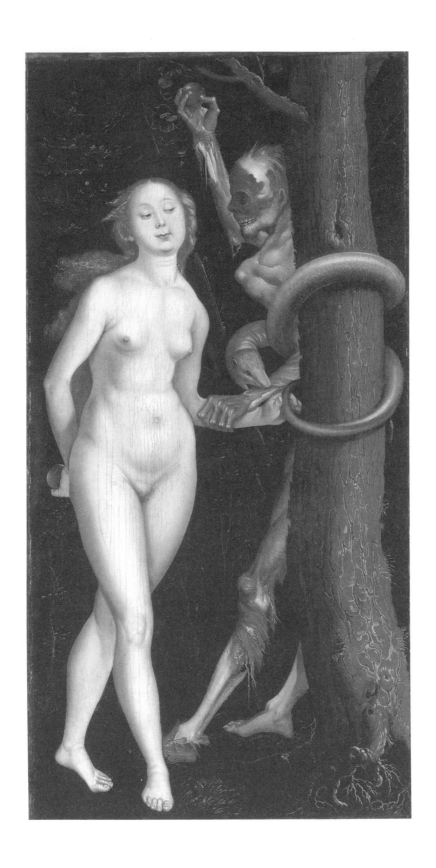

151. Hans Baldung, *Eve, the Serpent, and Death,* c. 1530,
 oil on panel, National Gallery of Canada, Ottawa.

reveal the fallenness of our gaze. But the mirror has other reflections on its surface. The figure of Adam has itself been parodied by the animated corpse in another of Baldung's paintings. Although Baldung executed the Lugano panel over ten years after the Basel *Death and the Woman*, the two compositions realize consecutive moments in a single event. It is as if Adam, after fondling Eve from behind (the Lugano *Adam and Eve*), turns to kiss her and, in that instant, becomes the emblem of his fall (the Basel panel). Gazing through Baldung's painting *Adam and Eve* to the macabre image of *Death and the Woman*, we see at once our kinship with Adam and, dimly, the effect of that kinship. In a sense, we are close here to that macabre tradition of portraiture in which the face of the sitter is reflected as a skull in a mirror. In Baldung, however, a ghostly allusion called forth from the viewer's memory of other images replaces the more direct illusion of a reflected likeness. The corpse haunts the viewer from within, from his recollection of previous visual forms, so that, as St. Jerome writes: "If you see a woman to lust after her, death shall enter in through the window."[29] The felicity of Baldung's conceit is that this very indirection, this absence of a natural access to the message even of the memento mori, is itself an appropriate sign of the nature of the visual image after the Fall. The allusiveness and semantic complexity of Baldung's images of the macabre are as much symptoms of the Fall as vehicles for rendering the Fall accessible to fallen vision.

An important instance of the willful multivalency of Baldung's images, as well as of the ontological implications of this multivalency, occurs in the symbolism of the "bite" in the Basel *Death and the Woman*. The cadaver's bite has resonance with the metaphor of time as *edax rerum*. In Ovid's *Metamorphoses* we read of time, old age, and death as devourers: "O Time, thou great destroyer, and thou, envious Age, together you destroy all things, and slowly gnawing with your teeth, you finally consume all things in death."[30] Luther, too, speaks of the "bite" of death. In his Ascension sermon of 1527, he writes that "Death fastens his grip on Christ, wanting to eat for once a dainty morsel; Death opens his jaws wide and eats him up like all other people."[31] Elsewhere Luther prays for death not to "bite" him.[32] And surely Luther and Baldung could not have been unaware of the close proximity in Latin between "death" (*mors*) and "bite" (*morsus*). The corpse that sinks its teeth into the woman's flesh in Baldung's painting can be read as enacting this old prandial metaphor. Furthermore, corpses are often called food for worms—"wormes mete" as the fifteenth-century poem "Disputacioun betwyx the Body and Worms" puts it.[33] Rather than biting the living, the cadaver is what is bitten. Death's traditional attributes include the snake and worm, which, after devouring the corpse's flesh, appear crawling from its ears or mouth. According to medieval science, such decomposition is itself a sign of the Fall: the worms devouring cadavers do not come from the earth but are generated spontaneously, from the inherent corruption of the body's natural "liquors."[34] In Baldung's painting, where the worm-bitten corpse bites its victim, and where the Fall is the hidden narrative behind the painting, we find again that metonymic substitution of effect for cause that characterized Baldung's *Death Overtaking a Knight*.

We have already observed how death and sexuality are linked in the corpse's bite: the moment Death's teeth sink themselves into the woman's flesh, her garments will open

and uncover her body to our gaze. That this association is imagined in temporal terms, as a simultaneous *event*, is fitting, for the Fall, which brought death and erotic sexuality into the world, is also the origin of human history—that dimension that controls Baldung's temporalization as well as his complex reversals of cause and effect. But the play of signification does not stop here. For within the allegory of the Fall, Death biting the woman becomes a version of Adam eating the fruit of the tree of knowledge. In Scripture, God warns Adam: "In the day that thou eatest thereof thou shalt surely die" (Gen. 2:17). Representing the corpse as poised to bite into the woman, and echoing in this posture the figure of Adam from elsewhere in his oeuvre, Baldung can assert in his image that it is precisely because of the original trespass (the eating of the apple and all its consequences) that Adam can appear as Death. Again, Death enacts both the cause and the effect of its own state. Moreover, because the corpse bites specifically into a woman, Eve also becomes the apple that Adam tastes—an association that resonates throughout Baldung's work. As we recall, Eve covers her genitals with an apple in the Budapest *Eve*; and in the chiaroscuro woodcut *Fall* from 1511 (fig. 147), Adam reaches at once to the apple and to Eve's breast, just as he did in the Lugano *Adam and Eve*. These apples circulate through Baldung's oeuvre. Eve holds them in both hands in the 1519 woodcut *Fall* (fig. 145); she smuggles them out of paradise in the *Expulsion* woodcut of 1514 (M. 34); and they appear in nearly every scene of the Virgin and child, being passed to or held by Christ. Christ as apple born to redeem man's sin in the garden was a familiar allegory in the Middle Ages. As Ernst Guldan describes it: "Since the first sin, the wild apple trees of the human race were damned to barrenness, but the divine gardener took pity on one of these (Anne, the Virgin's mother) and grafted that slip (Mary) under its dry bark, which would bring forth a new apple (Christ)."[35] In Baldung's painting *Virgin and Child with St. Anne* from about 1513, now in Basel, Christ holds up one of these redemptive fruits to Anne, while another lies in the foreground (fig. 152; O. 19). Higher up, above the canopy that shelters the Holy Family, a group of putti play with apples that grow in the decorative garlands. And above these, lining the rafters and completely filling the narrow space just below the picture's frame, are yet more apples. In this scene, which some scholars interpret as Heavenly Jerusalem,[36] Baldung gathers the fruits that have played through his oeuvre and stores them in what appears as an almost comic hyperbole of the very importance he has given his symbol. Thus, through the apple, the bite of death and its implications seem to extend through and reinterpret much of Baldung's work.

What does it mean, though, that the bite can be so many things at once, and that so many things can appear affected by the bite? The taste of the forbidden fruit was not just punishable by death. It also promised knowledge. In our analysis of the bite, the visual image seems to generate meaning, to refer beyond itself in so many different ways and to images so far removed from their point of reference that we threaten to lose sight of the image itself. We cannot penetrate to one meaning that controls all others; nor can we even regard one image on its own without its being implicated in and transfigured by

152. Hans Baldung, *Virgin and Child with Saint Anne*, c. 1513,
 oil on panel, Kunstmuseum, Basel.

some other image. Does not the whole character of our interpretation represent the kind of knowledge precipitated by the bite into the apple: fallen knowledge as the advent of a plethora of meanings without the authority of *a* meaning, and as the loss of an unequivocal and "natural" access to things and to the meaning of things? In the *Origins of German Tragic Drama*, Walter Benjamin argued that allegory, as it was employed and understood in German art since Dürer, always signaled a particular awareness of the fallen state of knowledge. Writing about the deliberately obscure and far-fetched connections that Renaissance and baroque allegory drew, Benjamin proposed that such obscurity was itself intended as the sign of the Fall: "Any person, any object, any relationship can mean absolutely anything else. With this possibility a destructive, but just verdict is passed on the profane world: it is characterized as a world in which the detail is of no importance"[37] and in which, I would add, meaning never resides in the particulars themselves. In Baldung, the play of interpretation still remains confined to a finite set of images and meanings related to the story and exegesis of the Fall. Yet within this set, everything we see will be connected, in form and in meaning, to something else—usually to something as radically different as Dürer's Adam is from Baldung's cadaver.

Meaning is situated "elsewhere" in Baldung's images of the macabre and of the Fall, produced within formal echoes of other works and within the characteristic play of signifiers: the bite, the apple, the corpse, and so on. The pivotal example of this is the interchangeability of Adam and Death. Dürer's Adam, and through him Dürer's *Nude Self-Portrait*, is present in Baldung's *Death with an Inverted Banner* even if the images themselves and the way they convey meaning have been completely altered or reversed. But is this not fundamental to the corpse as it is experienced by the living? Is it not exactly this impossible transfiguration that Adam confronted in the corpse of Abel? St. John Chrysostom, we recall, observed that the cadaver does not fall into the usual categories of things: what lay before Adam was not his son, nor was it another person or even another object. In his treatise *On Patience*, Chrysostom writes:

> He who yesterday I found beautiful now brings horror when he is recumbent. He who yesterday was like a part of myself, henceforth I see as a stranger. He who only recently I held in my arms, now I can no longer touch. I would bathe him with tears as if he were my own, yet like a stranger I flee from his rotting matter. My affection for him urges me toward his festering cadaver, but I am stopped by the putrefaction and the worms. Where is his lovely face? I see it now faded. Where are his beautiful eyes once so mobile? They rot here.[38]

The corpse of a friend, at once deeply familiar and deeply foreign, combines in a single object the known and the unknown, love object and repellent abject, I and not-I, calling into question the self's experience of other persons and, by extension, the self's own coherence as a body familiar with itself. In their mixture of eroticism and horror, Baldung's images of death effect a similar to-and-fro movement between affection and abjection expressed in Chrysostom's macabre text. What shall be consumed in this dialectic is, on the one hand, our experience of the *image*, which through its combination of dizzying allusiveness and grotesque visual spectacle has lost its closure and immanence as signi-

fier, and on the other hand, the *self*, which tastes both its present incoherence in its lack of self-mastery and its future extinction in the vision of the cadaver.[39]

Such inherent paradoxes in the way the corpse signifies become an appropriate context for Baldung's reflection on the Fall. For to reiterate, with Eve and Adam's bite we lost both our immortality and our natural access to meaning. Expelled from the garden, we need new ways of communicating. In his work on allegory, Benjamin demonstrates better than anyone else how death becomes the controlling figurative device for conveying meaning in German art and literature during and just after the Reformation. The cadaver becomes, for this culture, the master trope of allegory and of all that allegory implies:

> Everything about history that, from the very beginning, has been untimely, sorrowful, unsuccessful, is expressed . . . in a death's head. . . . This is the heart of the allegorical way of seeing. . . . The greater the significance, the greater the subjection to death, for death digs most deeply the jagged line of demarcation between physical nature and significance. . . . Significance and death both come to fruition in historical development, just as they are closely linked as seeds in the creature's graceless state of sin.[40]

It is perhaps within this larger tradition that Baldung's images of death will find their truest context.

Baldung's early *Death and the Maiden* emblematizes nicely this *signifying* function of death (fig. 153; O. 10). Scholars have argued over the functions of the various figures. They have read the corpse as an embodiment of a variety of special notions of death. But almost unanimously they see the cadaver as there to claim, or at least to try to claim, its victim.[41] Yet Death gestures here not to "kill" the girl, but to reveal her mortality. The corpse has arrived in its capacity as hermeneutic. Its sinuous right arm engages in signification. Holding the hourglass, symbol of time, Death stares at the girl with fanatical blue eyes, as one whose only task is to give a sign. The old woman here does not prevent Death from seizing the girl, as some interpreters would have it, but stops its symbolizing her death. Simultaneously supporting a mirror and deflecting the vision of the hourglass, the hag enables the girl to behold herself undisturbed by a completed symbolism of *vanitas* (mirror *and* hourglass). Death, with its left hand, supports a see-through veil, as if to uphold the decorum of earthly life or to elicit from us a transgressive gaze and a pleasure experienced as our *own* lust for life. With one hand, that is, Death denotes that time is passing and that we will die; with the other, it sustains our illusions of bodily continuance. Death's own wispy, veil-like flesh suggests that the corpse may not be a particular *kind* of image but, quintessentially concealing and revealing, is the image itself. As Maurice Blanchot wrote over thirty years ago, "At first sight, the image does not resemble a cadaver, but it could be that the strangeness of the cadaver is the strangeness of the image."[42]

One painting from late in the artist's career recapitulates all aspects of Baldung's symbolism of death. *Eve, the Serpent, and Adam as Death*, now in Ottawa (fig. 151), makes explicit the link between the macabre corpse and the story of the Fall.[43] Baldung's earlier

depictions of Adam and Eve, which had invoked death through formal allusion (e.g., the Lugano *Adam and Eve*'s reference to the *Death and the Woman*), here give way to an Adam whose flesh is already rotting away before he has picked the apple or done more than touch Eve. Eve, for her part, recalls the "knowing," seductive Eve of the Budapest panel, only this time her oblique glance seems drawn toward (though not quite fixed upon) the suggestive form of the serpent. Fingering the snake, her hand and arm participate in the complex "knot"[44] of forms at the center of the composition, which concatenates all elements of the drama of the Fall. Beholding this tangle, tracing its physical interconnections in the hands of Eve and Adam and in the body and jaws of the snake, we discover an entire narrative of the Fall and its consequences.

Eve fingers the snake, a gesture suggesting her seduction by, or pact with, Satan in the garden. And the snake's tail, curving up from where the corpse's penis might be, codes this trespass as sexual. The aftermath of sin is already implied by the cadaver. Its pas de deux with Eve, circling around the picture's center and twisting off the apple held as pivot above, is a well-turned dance of death. Picking the apple, Death clearly is Adam already mortified, whose mortal clutch enacts male heterosexual desire.[45] Sexual arousal and putrefaction, the erect penis and the dead body, lust and its consequences, sin and punishment, are loops that make the painting's knot inextricable. This is how St. Augustine described sexual sensation: a *discordiosum malum* whose onset and climax, occurring from within, are as random and uncontrollable as death.[46] The one new element for Baldung in the Ottawa panel is the active participation of the serpent, which, having lured Eve to the tree of knowledge, now wraps itself around the tree as if to tie the first parents to the scene of their crime. The serpent's bite both explains Adam's state of putrefaction (as if a poison has done its work) and echoes the biting of the apple that caused the Fall. The apples held by Eve and Adam mark the proper origins (in the sense of the ends of a rope) of this complex knot. A full account of the symbolic overtones in Baldung's painting would read like a hermeneutic "House That Jack Built," in which everything is dependent on and implicated in everything else. The metamorphosis of Adam into Death, already taking place before our eyes, is thus replayed at the level of interpretation. The moment we think we "have" the meaning of one particular element of the picture, it transforms itself and all it touches into something else. Discursive language proves inadequate, for only in the visual can the interconnection between the Fall and its meaning, between sin and its consequences, be properly experienced as the single inextricable whole it is.

In *Eve, the Serpent, and Adam as Death*, Baldung expresses the history of the Fall, and thus the fall into history, in an image whose stasis or lack of temporality appears as the outcome of the self-entrapping forms that make up that history. Baldung has successfully transformed the contiguities of time—past, present, and future, and cause and effect—into contiguities of space—the physical contact between elements of the painting. The "unchanging duration" that, according to Lessing, is the medium of visual, as opposed to verbal, representation gives way in this Christian *Laocoön* to a duration that represents history and the origins of history. The snake, coiling its body around both Adam and the tree, bites into Adam's arm as if into its own tail. Indeed, in an outline drawing of Adam

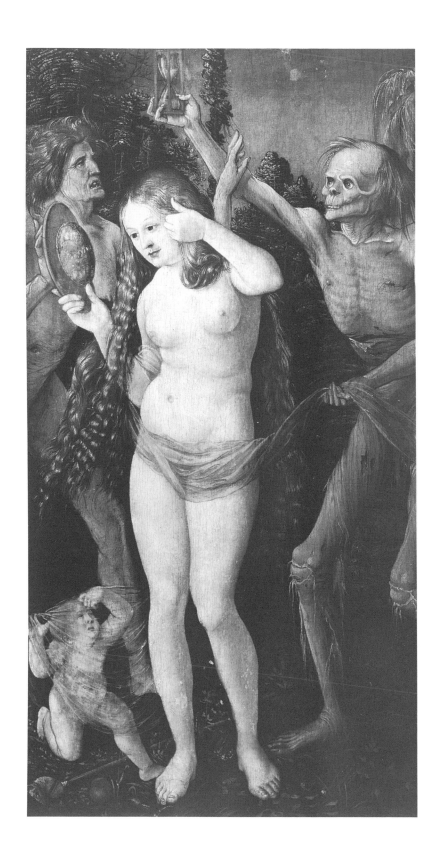

153. Hans Baldung, *Death and the Maiden*, 1509–1510, oil on panel,
Kunsthistorisches Museum, Vienna.

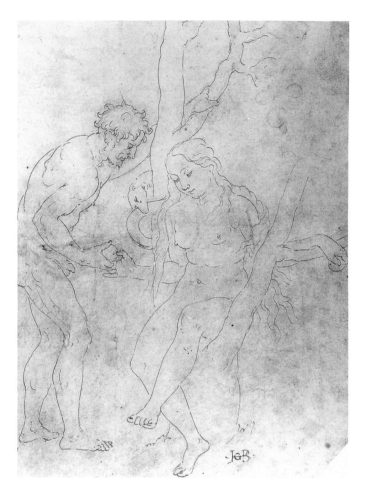

154. Copy of Baldung, *Adam Takes the Apple from Eve's Hand*, after 1530, contour drawing after original from 1530, Kunstsammlungen der Veste, Coburg.

and Eve, believed to copy a lost work by Baldung dating from the period of the Ottawa panel, the serpent actually bites its own body (fig. 154; K. A26). The history that Baldung records began with the tempting voice from the serpent's mouth and ends with the coming of death into the world. As an embodiment of this "conclusion," Adam's cadaverous arm is the end of the tale.

The snake that loops to bite its own tail recalls the *ouroboros*, traditional attribute of Chronos, god of time and of history. Echoes of Chronos play throughout Baldung's oeuvre. While, for example, the two-pronged pitchfork wielded by the corpse in *Death Overtaking a Knight* is rare if not unique in the iconography of Death, such an instrument sometimes appears as a crutch for the time-god, or as a farming implement suggesting Chronos's other aspect as patron of agriculture.[47] Baldung himself links his images of Death with time, as in his painting *Three Ages of Women*, in which the corpse presides over the passage of life (fig. 155; O. 87b). Even the overdetermined "bite" in *Death and the Woman* belongs in Chronos's orbit. For the Greek god of time, Kronos, oldest and most

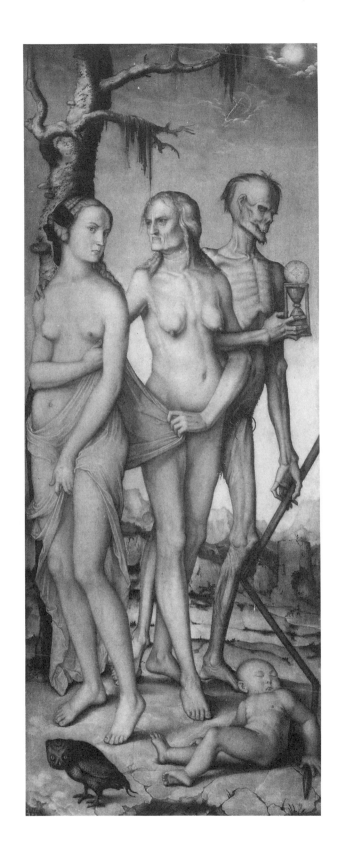

155. Hans Baldung, *Three Ages of Woman*, 1540–1543, oil on panel, Prado, Madrid.

formidable of gods, devoured his own children. Roman allegorists, linking this god (their Saturn) to the Greek word for time (*chronos*), rationalized this myth as an expression of how time, and history, devours its own creations. In Hans Burgkmair's classicizing 1510 woodcut *Saturn*, the antique god, equipped with an *ouroboros* and scythe, appears poised to bite into a child (fig. 156).[48] Whether explicitly or not, the god of time is the presiding deity of Baldung's art. In the persistent reversals of cause and effect that characterized his scenes of the macabre, Baldung grounds his imagery in the dimension of history. In his insistence on rendering specific the "moment" of an event in his images (the temporalizing shadow of Death's weapon in *Death Overtaking a Knight*, the simultaneity of the falling garments and the bite of Death in *Death and the Woman*, Eve's poised fingers in the Ottawa panel, the impending drop of the apple in the 1519 *Fall* woodcut, etc.), he insists upon the irreducibly *temporal* nature of his scenes. In his macabre treatment of the narrative of the Fall, he links the symbolism of death to the fall into history. And in his

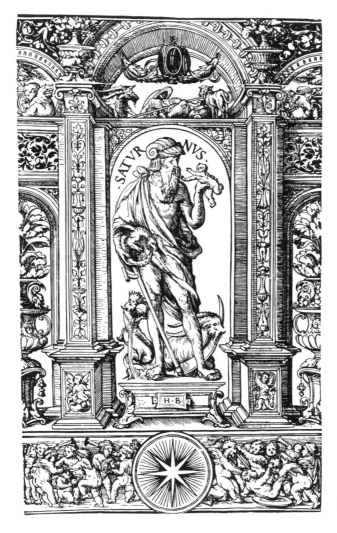

156. Hans Burgkmair the Elder, *Saturn*, 1510, woodcut.

transformation of Dürer's Fourth Rider of the Apocalypse into an apparition of earthly death, he suggests that judgment and therefore meaning must unfold within the realm of fallen, human history.

In sum, death cannot properly be said to "mean" any one thing in Baldung. We will not discover some single message, however arcane, for which the corpse is the vehicle. Most scholarship on Baldung has been devoted to just such a reduction. Confronted by his strange images, historians seek to explain them by discovering a commensurately strange and esoteric philosophy, current at the time, that supplies the "content" of Baldung's art. Jean Wirth's book *La jeune fille et la mort* is a notable example. After acknowledging the error of always seeking a text to explain a Renaissance artist's visual vocabulary, Wirth nevertheless proposes that Baldung's early representations of women being attacked by corpses are really illustrations of a single, now-forgotten superstition that Wirth unearths for us: namely, the belief, inherited from antiquity and rejuvenated in certain unorthodox texts by Agrippa and Paracelsus, in the *mort prématurée* caused by angry and violent ghosts.[49] Wirth argues, furthermore, that Baldung's later images of death, mixing the erotic and the macabre, have as their message not the traditional memento mori, with its contempt of worldly pleasures, but rather a hedonistic, libertine *memento vivere*, in which the individual, confronted everywhere by the inevitability of death but grown skeptical of the Christian promise of redemption, is encouraged to take pleasure in the little life that's left.[50] And because such an attitude would have been deemed heretical in Baldung's time, the artist (so Wirth) employs the artistic equivalent of Nicodemism—the practice, developed by Protestants living in Catholic territories and condemned by Calvin, of dissembling one's opinions in the face of a hostile authority.[51] The obscurity of Baldung's images becomes the consequence of a conscious strategy of dissembling.

Three things seem wrong to me about this argument. First, although certain individuals (most famously Dürer's Nuremberg followers Georg Pencz, Hans Sebald Beham, and Barthel Beham)[52] were accused of being "godless," this term signified very different things to a sixteenth-century person than it did, say, to Friedrich Nietzsche, who is Wirth's chief expositor of Baldung's faith.[53] For as Lucien Febvre observed long ago, only with the greatest caution can we impute radical atheism to people of the early modern period.[54] Second, Wirth's method, which privileges esoteric texts over the immediate experience of the image, overlooks what is obvious to the most casual observer of Baldung's macabre panels: every pang of erotic pleasure felt before these images is more than matched by feelings of intense abjection. What Jean Delumeau nicely terms "the ambiguity of the macabre"[55] is an ambivalence felt not at the level of Baldung's moralizing message, but at the level of contradictions discovered within the self of the beholder. Third, and most important, Wirth's analysis errs because it is informed by conceptions of meaning, as well as of self, that are brought into question precisely by the art of Baldung. The modern iconographer's confidence, on the one hand, that the *image* conveys a single, textually based meaning, however heretical in nature—and, on the other hand, that this meaning will be available to a coherent experiencing *self*, unified in its beliefs and in

control of its actions and expressions—finds in the macabre pictures of Baldung one of its most radical deconstructions.

Nothing could be more wrong than Wirth's erudite reading of Baldung, for it discovers secrecy precisely where it is not.[56] The theological "content" of Baldung's images of death is neither heretical nor arcane, but is drawn from the rich and well-known tradition of Christian interpretations of the Fall. In associating Adam with Death, Baldung can also follow pictorial precedent. The appearance of Adam's skull at the base of the cross is a venerable convention, and Baldung exploits it with particular zeal in a number of his own Passion panels.[57] What is novel in Baldung is not *what* his images of the macabre mean, but *how* they mean, that is, how they structure experience and interpretation. His art is a lesson in what might be called the historicity of meaning: the sense that not only do the specific meanings of images vary throughout history (the insight of the method of traditional iconology), but also that the very concept of meaning can itself undergo change. Death in Baldung is a hermeneutic, that is to say, a mode of figuration that occasions or even demands that images be regarded as signs pointing beyond themselves to truer and usually absent images beyond the painting. Itself as empty of specific content as it is of life, the corpse signals the presence of meaning elsewhere.

In a sense, Wirth's account is itself proof of the efficacy of Baldung's hermeneutic. The strangeness of Death hurries its viewers to find meanings elsewhere, in hidden histories and obscure texts that might make the uncanny familiar. Neither esoteric beliefs nor learned authority will finally solve the puzzle of this art, however. By referring to death as a hermeneutic, I mean to stress the immense self-consciousness with which Baldung both problematizes and prioritizes the act of interpretation through the visual image. Like his famous contemporary Erasmus, Baldung embraces the lonelier faith of relative, but humanly experienceable truth. In *Death Overtaking a Knight*, the apocalyptic vision of Dürer is replaced by a mundane vision in which meaning unfolds against the banal, temporal horizon of personal death and against the spatial horizon of this, our postlapsarian world. In such a landscape, Death has the upper hand. The human body, experience's instrument, is emptied of life and of self only to be admitted to the realm of manifold signification.

15

The Crisis of Interpretation

The macabre art of Baldung has taken us far from Dürer's moment of self-portraiture. Picturing himself as the quintessential subject of painting, Dürer proposed a new model of the image, of its value, function, and relation to the viewer. An image was, above all, the spectacle of the labor and inborn genius of the person who created it. And interpretation, the viewer's implied response to an image, disclosed the artist in his works. Self-portraiture proper simply made the relation of image to maker explicit. The motives for Dürer's new model of what a picture is and does were various. The 1500 *Self-Portrait* functioned partly to negotiate the image's epochal transformation from cult object to art object (fig. 21). Linked allusively to the signed and dated *Holy Face* of Jan van Eyck (fig. 33), it legitimized its new cult of authorship by discovering that cult already in the founding master of the northern pictorial tradition. Our investigation of the Nuremberg trade conditions at 1500 revealed, further, that Dürer asserted self-presence dialectically with his attempts to absent himself from the labor of production through the new technology of printing. The self encountered in this endeavor was that of economic man, in command of his expressions, products, and desires and circumscribed by what is his. In works of this bounded, monologic self, we as viewers witnessed an achieved coincidence of person and product. Beholding the 1500 *Self-Portrait*, we reoccupied the place of the artist, who in painting his own likeness became at once maker and model, subject and object of representation. Self-portraiture and its reception constituted a closed, finished, and timeless circuit, rather like the artist's own idealized body and ordered products.

Baldung explodes the hyperbolic closure of Dürerian self-portrayal. His images of eroticism and the macabre, of bodies sinfully open to other bodies and tragically open to the world, are engineered to appear radically incomplete without the viewer. And interpellating that viewer through their baleful plots, they accuse him of being himself open, incomplete, and mortal. Adam's leering glance in the Lugano *Adam and Eve* (fig. 146) seems light-years removed from Dürer's gaze in the 1500 *Self-Portrait*.[1] Yet both are fixed upon the viewer, and both announce that these pictures are, in their own special ways,

portraits of self. In the 1500 *Self-Portrait,* the viewer sees the artist as the artist sees himself. Perfectly proportioned, neatly confined within the picture frame, and consubstantial with its works, Dürer's body appears objectified and whole, and the viewer is voyeur to this narcissistic apparition of self. In Baldung, the male, heterosexual viewer sees in Adam a reflection of himself. Yet along with Adam, and through his kinship with Adam, he is always drawn to Eve, object of a carnal desire that subverts the male subject's coherence with his own body. It is not simply that where Dürer portrays the artist, Baldung portrays the viewer. Baldung's portraits of self occur as images of the male subject's radical Other: the festering cadaver, the nude female body, and as we will study in this chapter, the witch.

Tradition is destiny. Baldung received his vision in an encounter with the prior vision of Dürer. Born later, but striving to be original, Baldung magnifies the fate of any successor to Dürer's project of self-portraiture. Unable ever to be the originary self demanded by Dürer's aesthetic,[2] yet forbidden to imitate Dürer because of the new laws against plagiarism, Baldung expresses his artistic self-consciousness as the parodic response to an earlier—usually Dürerian—subject. Against the exemplarity of the artist *within* the work of art, Baldung therefore proposes the self of the viewer *before* the work of art. In the closing chapter of this book, I will explore the bizarre consequences of this voyeuristic stance for actual self-portraits by Baldung. The present chapter is about the status of the viewer in Baldung's pictures, and about broader historical conditions that might also have motivated this interest in spectatorship. Baldung's special relation to Dürer may have uniquely shaped his vision, yet his art also found an enthusiastic public and therefore has a place within a context wider than the enclosed genealogy of father to son.

First, let us return to *Death and the Woman* and observe more closely the viewer in Baldung's images of the macabre (fig. 135). Earlier I interpreted this panel as a condensed and eroticized dance of death linked allusively to the catastrophe of the Fall. For a period viewer, however, this picture of a nude woman behind whom lurks Death would also have appeared as an emblem of "Voluptas" or, in German, *Wollust.*[3] In a woodcut illustration from Jacob Locher's 1497 Latin translation of Brant's *Ship of Fools,* for example, Voluptas stands at one end of a forking path that leads to the sleeping figure of Hercules (fig. 157).[4] Half hidden behind her seductive form, an animated corpse reveals that the final end of the path of vice is not "pleasure and joy" as promised by Voluptas, but "death with woe."[5] The ugly cadaver thus may seem to be Voluptas's aesthetic opposite, yet it is in fact the price of her charms, for the wages of sin is death. At the end of the scene's alternative path stands Virtue, depicted as an old woman garbed and shod in rags and holding a distaff, attribute of Eve, feminine industry, and the shrewish wife. This woodcut *Hercules at the Crossroads* illustrates Locher's learned, classicizing elaboration of Brant's chapter "On the Rewards of Wisdom." It shows virtue and vice as the contrast between ugliness and sensual beauty, thistles and roses, starry sky and hellfire, rocky path and smooth. And the cadaver labels which choice is incorrect.

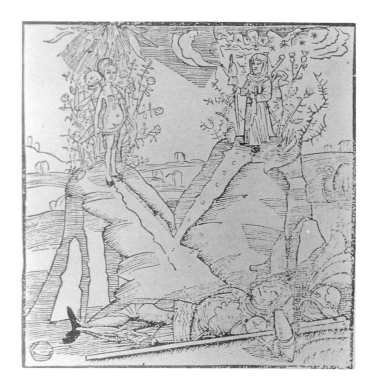

157. *Hercules at the Crossroads between Voluptas and Virtue,* woodcut illustration to Jacob Locher's Latin version of Sebastian Brant's *Narrenschiff* (Basel, 1497), fol. 131.

At the eve of the Reformation, people north of the Alps hardly needed such clues to read a moral landscape aright, for they were well trained in the paradoxes of visual experience. That "fair is foul and foul is fair" was drummed into them variously by sermons in the streets and from the pulpits, by images in their churches, and by printed books and broadsheets in their homes. At the very foundation of their faith lay a contradiction of appearances: Christ as Man of Sorrows; the perfect image of God become, in his torments, the ugliest of men. The *Ship of Fools* woodcut, like the monumental sandstone *Prince of the World* discussed earlier (fig. 107), shows the equally familiar obverse, where fair appearances mask a corrupt reality. In his important 1930 study *Herkules am Scheidewege,* Panofsky demonstrated the complex influence that this woodcut exerted on the art of Renaissance Italy and Germany.[6] I would add that when Baldung was resident in Strasbourg, the city's popular preacher Johann Geiler von Kaysersberg, in his 1498–1499 sermons on the *Ship of Fools,* laid particular stress on Brant's chapter "On the Rewards of Wisdom," devoting three separate sermons to it.[7] Twenty years later, in his *Death and the Woman,* Baldung invokes the iconography of Voluptas and rethinks its vision of choice and of human agency.

What the macabre panel does is collapse the temporal dimension of choice, allowing temptation, trespass, and punishment to be fulfilled within a single unavoidable event. Not merely standing behind Voluptas as a warning that the reward of sin is death, Baldung's animated cadaver bites into the woman's flesh, thus already fulfilling his punitive mission. And vice's consequence visits not only the male subject who chooses wrongly,

but also the youthful figure of Vice herself. This reflexive turning of the image upon itself is predicated on a deeper reversal, in which the image's internal plot is projected outward to the beholder. For as noted earlier, Baldung presents the nude woman to arouse lust in the male viewer. The corpse mirrors the viewer's own concupiscence at the very instant it annihilates his sexual desire through the horror of its macabre form.

Baldung's unholy marriage of desire with abjection has particular significance when read against an implied iconography of choice. Combining volition and punishment, Baldung's Voluptas negates the very possibility of decision by erasing any *time* when choice could take place. The viewer will have been damned from the moment he sets eyes on the image. It is therefore appropriate that Baldung provides no pendant to *Death and the Woman,* no companion picture of Virtue who, however unalluring she may be, would offer hope to the pious. Instead of standing at a crossroads, the viewer suffers for a choice already taken in favor of vice, a choice whose inescapability is expressed as the image's experienced effect. For the "message" of Baldung's painting does not reveal itself as something behind or outside the image, as is the case in the *Narrenschiff* illustration, where an impish Death waves at us as a label of vice's consequences. Instead, *Death and the Woman's* meaning *is* its effect—that fatal union of desire and entrapment that, while structured by the image, is fulfilled only within the viewer's response. Interpretation thus becomes fatally interwoven with moral choice. The viewer, called upon to complete the image's meaning, arrives at the scene already implicated in its terrible event. And Baldung has designed that event so as to eradicate the interval between desire and retribution, between vision and action, during which any choice, moral or interpretative, can be made.

Death and the Woman not only mirrors the paradoxes of human choice, it also embeds these paradoxes in the problem of theodicy. Baldung's macabre image can be read as a perfect expression of the theology of evil as it was worked out in Christian apologetics from St. Augustine to the Augustinianism of certain strains of pre-Reformation piety. The patristic doctrine of evil emerged from a battle against heresy waged on the double front of Gnosticism and Pelagianism. On the one front, Gnosticism believed evil to be a "thing," a physical reality that infects people from without. Evil not only is external to individuals, it is, in Gnosticism's extreme formulation, exteriority itself. To which the Greek and Latin Fathers responded that evil has no nature by itself. Not any *thing* that can be the object of knowledge (*gnosis*), evil instead describes an existential direction. Evil proceeds from human activity—activity, moreover, in the direction of nothingness. As Paul Ricoeur writes, "Evil is not *being* but *doing.*"[8] Perhaps nowhere in the history of art is the assumption of the externality of evil as vividly undermined as in Baldung. For however terrifying the event he depicts may appear to be, he always locates the source of the trouble in the self of the viewer. Because meaning has become effect, evil is no longer the "object" of our attention but is revealed subjectively, within the shape of our own interpretative "doing."

Locating the origin of evil in the personal choices of individuals has heretical consequences. It was this position that Pelagius assumed when he carried the anti-Gnostic

argument to the extreme, declaring that man retains the power not to sin.[9] Against this second front, with its creed of *posse non peccare*, Augustine formulated his doctrine of original sin. By discovering evil's source in the sin of Adam, Augustine demonstrates evil to be the inescapable inheritance of all people. Insofar as we initiate evil individually, we do so only to discover that evil is already there. As Ricoeur writes, paraphrasing Augustine's position: "I do not begin evil; I continue it. I am implicated in evil. Evil has a past; it is its own past; it is its own tradition."[10] Baldung's images correct any voluntaristic conception of evil, any faith that there is escape from original sin. That is why *Death and the Woman* is more than merely a macabre image of the viewer. Through the allusion discussed earlier, Baldung links the cadaver to the figure of Adam as he appears in several of the artist's images of the Fall (figs. 145–147). In the way evil is experienced as the image's effect, and in the way that effect is referred back to Adam, evil appears as what it really is: a direction of human desire that repeats its historical origin in the choice of our common ancestor.

Baldung's *Death and the Woman* thus implicates the self in a paradox. On the one hand, by arousing and punishing specular desire in a single gesture, it insists that the viewer can do nothing but choose in favor of sin. The servitude of the will thus effected in our experience of the image is shown, through visual allusion, to proceed from the inescapable dimension of fallen history. So great is our bondage that even our inescapable choice of sin is emptied of all present volition, being the consequence of Adam's trespass. This is why Baldung's Voluptas appears isolated from any imaginable symmetry between virtue and vice, any false sense that there are other choices open to the viewer besides the discovery of his fallenness. On the other hand, along with this severe reduction of the self's moral scope, Baldung has expanded the role assigned to the self in constituting the image's message. By locating meaning in the painting's effect, by structuring the image in such a way that it is completed only within the viewer's response, Baldung gives the viewer a centrality virtually unprecedented in the history of Christian art. If Baldung offers an asymmetric image of moral choice, he also engenders through his image an asymmetry between image and beholder in which the interpreter, however fallen he may be, has taken his place as the real source of meaning, rather than as meaning's passive recipient.

What kind of viewer is this, whose presence seems always indicated by Baldung's pictures, whose desires, revulsions, and interpretations are my conjectures, and whose gender and erotic orientation appear to be specified as those of a heterosexual man? Baldung constructs him as possessing both a body and a mind. He is subject to an unruly flesh as aroused by the sight of a nude woman; but he is capable also of perceiving, in spite of this arousal, the image's fabric of allusion and parody, which shows him to himself in his fallenness and at his origins. Yet he is not the same as Baldung's *real* viewers, those empirical beings, past and present, who privately and unpredictably experience the work of art. We possess no sixteenth-century text documenting someone's actual experience of

Baldung's art. And even if Baldung, within his works, documents at least *his* experience of images by Albrecht Dürer, this period reception only stages another equally inscrutable viewing experience. The viewer I speak of is something more internal to the picture, even if he seems to be standing in our place. He is a "figure of the viewer" implied by the picture's plot: difficult to theorize, but as much present as a fire is where there is smoke.

For Wolfgang Iser, writing about literature, the implied reader "embodies all those predispositions necessary for a literary work to exercise its effect—predispositions laid down, not by an empirical outside reality, but by the text itself. Consequently, the implied reader as a concept has his roots firmly planted in the structure of the text; he is a construct and in no way to be identified with any real reader."[11] The concept of the implied reader or viewer is at once useful, evasive, and tautological: useful, in that it models interpretation as the dialogue between audience and work; evasive, in that it is also the prosopopoeia of any present viewer's local reception even as it claims to recover, in the absence of solid evidence, historical experience;[12] and tautological, in that every image, insofar as it is viewed, will be felt to imply a viewer, even if it was intended to please God.[13] What Baldung's pictures imply, however, is something much more specific. We feel it immediately in the difference between his 1511 woodcut *Fall* and Dürer's engraved *Fall* of 1504 (figs. 147 and 98). It is not simply that Baldung's Eve and Adam look out at us and turn all they do and are in our direction or that, by reducing Dürer's inventory of animal species to one (the rabbit, symbolic of sexual appetite), Baldung gives his image an intimacy and interconnectedness that pairs it with us. Dürer's whole print, like his perfectly silhouetted First Parents, appears distanced and self-enclosed beside Baldung's: a balanced assemblage of nature's unfallen multiplicity that we see panoptically, as it were, but that in no way appears to see us. Even Dürer's witches and temptresses—those beings who, in Baldung, always turn their power outward on us—maintain their emblematic distance (e.g., figs. 164 and 198). Only in his self-portraits does Dürer permit his creation to gaze fully outward, and then what it is meant to see is not ourselves but its own reflection in a mirror. It is therefore tempting to hypostatize the figure of viewer not as an interpretative category equally useful for all art of the period, but as a visual device specifically present in the art of Baldung.

Art historians are peculiarly fond of discovering the epochal rise of the viewer in the periods they study. Thus, for example, Wilhelm Pinder attributed to late medieval German sculpture a new "acknowledgment of the beholder"; Ernst Michalski proposed the history of art as a sequence of shifts from "autonomous" images enclosed in themselves to "heteronymous" images open to the viewer; Michael Fried chronicled eighteenth-century French painting through the changing relation between painting and beholder; and Hans Belting, writing about the reception of the icon in the fifteenth-century West, found the old dialogue between cult image and viewer internalized as the subject of the new private devotional image.[14] In such accounts, the work of art's representation of its own reception becomes hard to disentangle from the reception itself. And any *history* of the figure of the viewer, even any faith that such a figure can have a history, becomes

increasingly dubious. One sometimes wonders whether what art historians discover as the implied viewer is not really a reflection of themselves, transposed into the historical material. For is there any century or epoch or tradition where the viewer is *not* somewhere "rising"? Indeed, might not this rise, which is always experienced by readers of such histories as déjà vu, itself constitute our sense of history, of the semblance of a temporal sequence? The relation between art object and beholding subject, modeled as a movement from what an artist shows to what a viewer sees, becomes inflated until it describes two stages in the historical development of art. It develops, that is, into a framework for narrating art history as always a movement from naive to sentimental, that is, from the artwork as mere object, innocent of its being seen, to an artwork cognizant of its viewer and self-conscious of its effects.

The figure of the viewer in Baldung is not at all a stable category. Yet, himself a paradigmatic viewer of Dürer's art, Baldung presages the art historian's own tendency to interpolate a viewer in the material he or she beholds. Dürer and Baldung, regarded as emblems of production and reception, are less successive moments in a history than complementary elements in one visual system divided between master and pupil. This system, and its division, will be clearest in the final chapter of this book, when I analyze Baldung's self-portraits and monograms. The purpose of the present chapter is to make Baldung's viewer more concrete. It asks, among other things: How exactly do Baldung's images portray their implied beholder? Can this portrait tell us anything at all about Baldung's real, historical viewers, about their gender and their social and intellectual milieu? And what in German culture at about 1500 might have motivated this intense interest in viewing and interpretation? Baldung does not make this task of concretion easy. Even as his pictures mirror the beholder's self, they show things always radically other than that self. Nude temptresses and putrefying cadavers are, to the male viewer, quintessentially the not-I, the not-me. Yet they work together to invade and dissolve the boundaries around the self, so that the figure of the viewer appears always in a morbid state of dissolution.

The corpse represents but one of Baldung's signature motifs designed to overthrow the male beholder's self-sovereignty. The witch, depicted nude and engaged in some evil and usually sexually charged activity—what contemporary enemies of witchcraft called *maleficium*—represents another. Before these scenes of malevolence and ravishment, of women's ritual loss of self as fantasized by a male artist for his male audience, the figure of the viewer appears at his most concrete and paradoxical.

At the very start of his career as an independent master in Strasbourg, and as his first published print after leaving Dürer's shop, Baldung executed the monumental *Witches' Sabbath* woodcut of 1510 (fig. 158).[15] The picture's date appears on a tree trunk at the right, just beneath the vine-leaf motif that had been the artist's personal mark during his Nuremberg apprenticeship. And for the first time in his woodcut oeuvre, Baldung also includes his HBG monogram, placing it on a hanging tablet in imitation of Dürer's

prints.[16] The artist publicizes his authorship in an ambitious print, novel in both subject matter and medium. It is perhaps the earliest single-leaf woodcut ever to treat the theme of witchcraft.[17] And it is executed in the new technique of chiaroscuro woodcut, which had been developed only two years earlier by Hans Burgkmair and Jost de Negker in their great equestrian *Maximilian* (fig. 115).[18] Combining the black lines of the key block with the white lines reserved on the tone block, Baldung heightens the bodily presence of his subjects while achieving an uncertain, flickering brilliance suggestive of a moonlit night.

Baldung's night witches are simultaneously mundane and fantastical. Mundane, because their bodies, imperfect, awkwardly posed, and thoroughly real, sit heavy on the ground, and because the ruined landscape they inhabit is recognizably an earthly setting; and fantastical, not just because one witch rides backward on an airborne goat while another sends vermin skyward in plumes of smoke, but also because, in this woodcut, contours and highlights, black lines and white, are everywhere interchangeable, so that what we see becomes unstable and wholly dependent on *our* making the distinction between surfaces and lights. The chiaroscuro technique, which Baldung uses for similar effects in his 1511 woodcut *Fall* (fig. 147) and, in the medium of drawing, in *Death with an Inverted Banner* (fig. 126), resists the viewer's easy comprehension of the whole. It demands that we ourselves first conjure up the objects we perceive even as it then convinces us, far more than simple black-line images do, that what we have summoned is real.

The reality of witches and the nature, source, and extent of their powers were subjects of an enormous debate in Baldung's culture. In Strasbourg, Geiler von Kaysersberg devoted twenty-six of his forty-one Lenten sermons of 1508 to the subject. In answer to the question whether women really "can fly at night and meet together," Geiler responds that indeed "they fly here and there, and yet they stay in one place. But they believe that they fly, for the devil can produce an illusion in their heads, that is, a fantasy [*ein fantasey*], so that they think they fly everywhere, and think they come together and meet with other women and dance and jump and eat."[19] To illustrate the illusory nature of witches' flight, the preacher cites a case from Johann Nider's 1435–1437 *Formicarius*, in which a village woman who claims to fly turns out merely to fall asleep astride a kneading trough and dream she is in flight. Later in the same sermons, however, Geiler admits that though witches themselves do not have the power to fly, they can be carried from place to place by the devil.[20] Learned discourse of the period usually wavers between highbrow skepticism and blind credulity. From the early fifteenth through the seventeenth century, scholars, lawyers, judges, and magistrates fabricated their image of witches out of sundry tales of peasant *maleficia* that they half believed: stories of men made impotent, women barren, cows milkless, and crops fruitless by a malevolent neighbor; of storms raised by weather witches and of infants cannibalized by midwives and Jews; of houses, barns, and villages destroyed by witches' arson. Interpreting these tales through classical and biblical parallels and through stories of heretics like the Waldensians, they submitted them to a single, all-encompassing explanation. Witches, they maintained, were members of an organized sect of Satan worshipers. They were the most extreme apostates and constituted Satan's

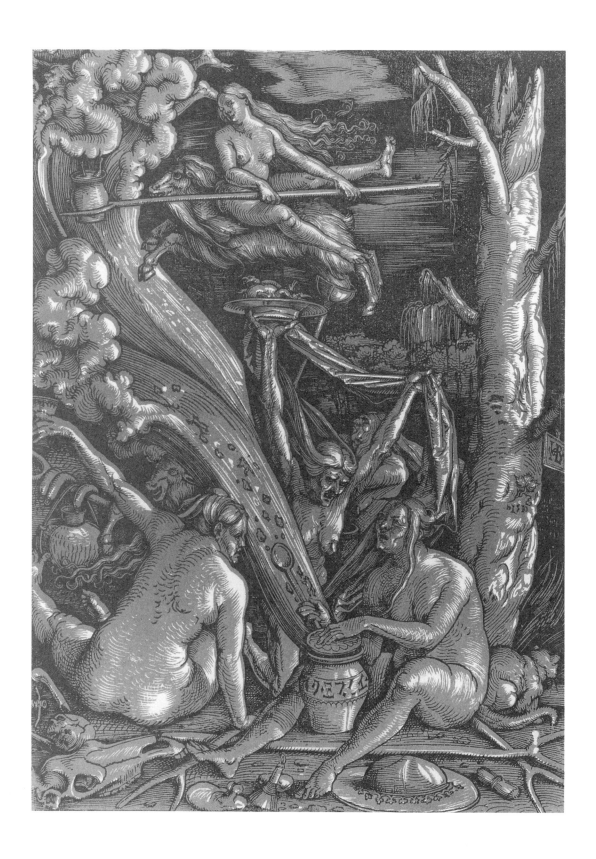

158. Hans Baldung, *Witches' Sabbath*, 1510, chiaroscuro woodcut.

fifth column on earth. Bent on the destruction of Christianity, they flew through the air at night to join in sabbaths or "synagogues," where they worshiped the devil, copulated with him and with each other, and feasted variously on children, corpses, bats, sliced turnips (parodies of the Host), and other nameless brews.[21] Predominantly but not exclusively women, witches came from all classes of society and could be found everywhere. Always growing in number, they threatened Christian society and thus had to be discovered, tortured, sentenced, and executed.

Today we understand the witch cult to be a fantasy far less of villagers worried about local charms and spells than of learned men like Geiler worried about a general, diabolical, and organized evil.[22] And though the main evidence about witches was derived from the witches' own confessions recorded in the courts of law, those confessions, often obtained by torture, reiterated what the learned inquisitor set out to hear. The fantasy of the sabbath, flight, and feast, recounted with "gruesome monotony"[23] in all the period documents and pictured by Baldung in his 1510 woodcut, was largely the product of identical questions combined with intolerable pain.[24] Yet precisely because this fantasy is so vivid and so consistent throughout the extant sources, scholars even in our own century have argued for the existence of an actual witch cult. Some have contended that witchcraft was a real anti-Christian heresy with the sabbath as its central rite.[25] Others, following Margaret Murray, have interpreted witches in early modern Europe as the remaining members of a pre-Christian fertility cult whose benign ritual was misrepresented by alarmed trial judges as a diabolical sabbath.[26] Still others have argued that witches' assemblies were organized protests against a dominant social order or against patriarchy; and those historians who deny the reality of this organized protest are suspected of continuing the suppression of disfranchised voices begun during the great witch-hunt.[27] Yet the problem with such interpretations is, first, that we have no evidence that witches ever gathered in large numbers for any purpose, satanic or otherwise; and second, that confessions of devil worship almost never arose in witchcraft trials until the moment when torture was applied.[28] For our purposes, what the continuing historiographical debate about the reality of witches' sabbaths reveals is the curious persistence of the question that vexed Geiler. Modern scholars, like the ecclesiastic and lay judges of early modern Europe, still seek to establish whether people accused of witchcraft *really*—that is, *physically*—participated in diabolical gatherings.[29] What, in this regard, distinguishes today's queries from yesterday's inquisitions lies chiefly with *whose* "fantasy" is under suspicion: the witch or the witch-hunter.

Baldung's chiaroscuro woodcut, with its willfully unsettling mix of realism and fantasy, stages precisely this question of whose vision it is we see. It translates into a single image the whole crude and learned myth of the witches' sabbath, and it disseminates that myth to a broader public through the print medium. Witches, it shows us, are women who fly on devil goats and gather naked in the forest at night to brew potions, cast spells, and meet with animal familiars. Their equipment—mirrors, bones, brushes, pots, pitchforks, pots inscribed with "Hebrew" lettering—is for causing evil. The woodcut suggests, but does not name, this repertoire of *maleficia*. The sausage-shaped objects draped over the

handle of a pitchfork at the left could be food for the feast or instruments of imitative magic. Or they could be the effect of a witch's spell: the fantasy of castration that witches were believed to induce in their male victims' minds. Depicted within a printed image, such lore becomes available to a wide audience, both literate and illiterate. And since seeing is believing, this image is more immediately convincing than any learned text. Unlike a text, however, and with no accompanying inscription, the image cannot exactly label the evils it depicts; and Baldung himself designs his print to confound any easy visual reading through its fabulous play of black and white lines. The *Witches' Sabbath* does not represent the final verdict of the witch-hunter, when fact has been separated from fantasy, and when apostasy has been determined and verified and its tortured adherents burned. Rather, it portrays the inner substance of the witch-hunter's gaze, when a sausage still may be a severed penis, a castration fantasy, or just a sausage; when the aim, nature, and perpetrators of the *maleficia* are still unknown; when, in short, the work of the inquisitor has just begun.

Where did Baldung get this anxious, arrogant, hate-filled vision? In Strasbourg, he would have had direct contact with recognized authorities on witchcraft. Geiler von Kaysersberg, for example, who preached in the city during Baldung's youth, died in Strasbourg in 1510, and his disciples continued editing, translating, and publishing his sermons there until 1522.[30] And the great satirist and Franciscan friar Thomas Murner (1475–1537), who was probably born in Strasbourg in 1475 and was active in the city during the first decades of the sixteenth century, published a copious account of how he had been crippled as a child by an old witch.[31] Indeed, most of the important Strasbourg humanists, from Sebastian Brant to Johann Pauli and Otto Brunfels, expressed their belief in the cult of witches.[32] In addition, Baldung would have had available to him a profusion of texts, both Latin and vernacular, that dealt systematically with witches. The most important of these, the intensely misogynist *Malleus maleficarum* (*The Witches' Hammer*) by the Dominican inquisitors Heinrich Kramer and Jacob Sprenger, was published first in Strasbourg in 1487 at the press of Johann Prüss and was reprinted fourteen times before 1520.[33] The *Malleus* was simultaneously an inquisitor's handbook, an encyclopedia of witchcraft, and an attempt to situate witches within the systems of theology and law. Johann Prüss also published Ulrich Molitor's enormously influential *De laniis et phitonicis mulieribus* (1489), which took the form of a conversation between Archduke Sigismund of Austria, Konrad Schatz, and Molitor on the question of the reality of witches. The second edition, as well as the 1490 German translation, *Tractatus von den bosen weibern, die man nennet die hexen* ("Tract on the evil women, who are called witches"), contains numerous simple woodcut illustrations.[34] Of course, Baldung would already have seen more elaborate depictions of witches during his Nuremberg apprenticeship. His 1510 woodcut relies not only on Dürer's *Witch* engraving (fig. 164), but, perhaps, also on a chiaroscuro drawing by Albrecht Altdorfer.[35] In short, there is no problem of finding sources for Baldung's witches.

Explaining his special emphasis on witches in his artistic oeuvre, as well as his unique formal and narrative approach to the subject, is another matter. Baldung may have ac-

quired his peculiar intimacy with the inquisitor's gaze through his own family. We recall that his father, Johann Baldung, was a university-educated jurist employed by the bishop of Strasbourg between 1492 and 1505. Through him Hans Baldung could have had early firsthand experience with inquisitorial procedure. There were lawyers in the artist's own generation as well. His cousin Pius Hieronymus (son of Dr. Hieronymus Baldung, personal physician to Maximilian I) taught law in Freiburg im Breisgau, where Hans Baldung lived between 1512 and 1517; Pius became chancellor of the Tyrol in 1527.[36] And the artist's brother Caspar Baldung, a doctor of law, succeeded Sebastian Brant as city advocate in Strasbourg (1521–1532) and later became a judge in the Imperial Chamber Court.[37] Hans Baldung, in other words, had many links to the milieu of university-trained lay magistrates that constituted the core of the great witch-hunt.[38]

It is true that, relative to the years 1435–1500 and 1560–1630, the period of Baldung's activity saw a decline in witch trials and prosecutions throughout Germany, Switzerland, and France.[39] And fifteenth- and sixteenth-century Strasbourg, in particular, was known to be more tolerant of religious differences than most other cities. Indeed, except for a few cases,[40] there are no recorded witch-hunts within the city until the seventeenth century.[41] Yet Strasbourg was also the seat of a diocese that stretched along the Rhine from the Black Forest to the crest of the Vosges. Since 1262, the city had been governed independently of the bishop, who resided in Saverne; but the church's administrative and judicial affairs were carried out by the bishop's officials—men like Johann Baldung—who continued to live in the city.[42] The Strasbourg episcopal archives record that five thousand witches were burned in the years 1515–1535; the archivist himself claims to have participated in two thousand *interrogatoria*. The tiny town of Sasbach, for example, about forty kilometers south of Strasbourg, saw 122 burnings in a single year.[43] This is the period of Caspar Baldung's activities as lawyer and city advocate. And even though such witch trials took place in the outlying villages, they would have been prosecuted by, or at the very least known to, members of Strasbourg's legal community. The witches of Baldung's woodcut thus not only celebrate their sabbath in a wilderness; they would also be tried and burned in the hinterlands, though by means of questions and methods formulated in the city, by an educated elite.

Baldung intensifies the radical otherness of his subject through a crucial detail that distinguishes all his represented sabbaths from those imagined by Molitor, the authors of the *Malleus,* and Geiler von Kaysersberg. Central to the fantasy of witchcraft as organized apostasy, and therefore to the theological and legal foundations of the great witch-hunt, was the belief that all the powers attributed to witches were really the devil's work and that what witches themselves did in their rites was merely to signal for his aid. Thus Geiler writes: "The action the witches or monsters do is not really an instigating cause of the things [the *maleficia*] that occur. That action is nothing more than a sign. When the devil sees the sign and hears the word, he knows what the witches want; he, the devil, does it and not they."[44] Baldung's witches make and manipulate signs. They arrange magic triangles of pitchforks, brew potions in pots lettered in pseudo-Hebrew, chant spells, and so on. Yet as Sigrid Schade has argued, unlike other witch images of the

period, Baldung's never show the devil outright. At most they imply his presence through various animal familiars: cats, dragons, and goats.[45] The witches of the woodcut *Sabbath* are ordinary Alsatian women who seem to derive their power from nature itself. Their spells invoke chthonic forces, hence their seated posture on the naked earth as themselves nude, heavy, and material.

Now the belief that women are more material and carnal than men, and therefore more prone to witchcraft, is hardly unique to Baldung. The *Malleus* spends a whole chapter on "Why It Is That Women Are Chiefly Addicted to Evil Superstitions."[46] And Geiler, in his 1508 Lenten sermons, recalls the truism that "if one burns one man, one probably burns ten women."[47] These numbers are borne out in fact. It has been estimated that about 80 percent of the some 100,000 witches executed in Europe between 1400 and 1700 were women.[48] This proportion was probably higher in the period before 1560; for as Norman Cohn puts it, "Until the great European witch-hunt literally bedevilled everything and everyone, the witch was almost by definition a woman."[49] Baldung visualizes this terrible, seamless equation. He confirms the misogynist double fantasy that all witches are women and all women are potentially witches. And he does this through the spectacle of nude female *bodies:* bodies rendered in the figural style and linear idiom of Dürer's *Apocalypse,* but capable of gestures and postures far more energized, unruly, and potentially seductive than anything seen before in northern art. For us whose mental picture of witches is so determined by Baldung's formulation and its heirs, it is hard to imagine the impact the 1510 woodcut must have had on its original viewers. They must have felt their fantasies suddenly made real, and vindicated in their hate, they would have learned exactly what it was they sought to expose and destroy. Yet those familiar with the complex lore of the *maleficium* would also have noticed the devil missing from the scene. Searching for him, they would have found him too close by. Indeed he is, I shall argue, present as the image's implied beholder.

Depending on its audience, Baldung's chiaroscuro woodcut can establish, confirm, and anatomize the male fantasy of the night witch. Although produced in a period and a city not especially prone to witch-hunting, its concrete vision of evil certainly derived from, and could lend support to, the work of the inquisitors and thus can be linked to the great massacres of later decades. My concern is more narrow than Baldung's place within the larger history of the witch-hunt, however. I seek to analyze what his images of witches say about their *viewers* and about the general character of Baldung's art.

The theme of witchcraft occupied the artist until his death in 1545. Indeed, about 1544, in his last extant work, Baldung portrayed himself overthrown, or slain, by the witch that was his lifelong obsession (fig. 213). It has even been suggested that Baldung's nickname, "Hans Grun" or "Grünhans,"[50] has a playfully diabolical aspect. For according to popular lore, the devil sometimes approaches women in the form of a horseman, hunter, or Junker named Grienhans.[51] In my final chapter I shall say more about how, in his late works, the artist implicates himself in the scenes he depicts. At present I shall focus on a group of images produced in Freiburg in 1512–1516, while Baldung was at work on the high altar of the city's great cathedral. Made in the immediate wake of the woodcut

Witches' Sabbath, perhaps as Baldung's way of personalizing his popular product for special friends and patrons, these depictions of sabbaths are not prints but drawings, each uniquely and meticulously executed by the artist's hand. Before these more exclusive representations of possession and ravishment, of ritual loss of self as imagined, perhaps, by a threatened patriarchy, the figure of the male viewer rises at once concrete and impossible.

In a chiaroscuro drawing dated 1514, known from what may well be a workshop copy in the Albertina, Baldung concatenates three nude female bodies to form a triangular shape on the plane surface of the sheet (fig. 159; K. 62).[52] The women strike wild, energized poses, stretching and twisting their fleshy limbs and torsos in movements akin to an orgiastic dance—or, rather, akin to what polite society *imagines* an orgiastic dance to be. The exact purpose of their actions is left open, though most of their efforts focus on the somersaulting foreground woman who, assisted by her companions, peers out at us from between her legs. The nudes thus form the machinery or frame for this inverted gaze. Like the look of Cusanus's omnivoyant icon of God, the topsy-turvy woman's eyes follow us wherever we go, interpellating us constantly as the picture's center.

In a chapter entitled "Of the Continuing of the Torture," the *Malleus* warns inquisitors of the hypnotic power of a witch's gaze: "We know from experience that some witches, when detained in prison, have importunately begged their gaolers to grant them this one thing, that they should be allowed to look at the Judge before he looks at them." For by "getting the first sight" of the inquisitor, they can rob him of his judgment. Witches, therefore, "should be led backward into the presence" of the inquisitor. And because they sometimes conceal charms and potions in their clothing, they should also have been "stripped by honest women of good reputation" beforehand.[53] In Baldung we see the foreground woman naked and from behind. Yet peering backward between her legs, she sees us first and, our sovereignty of judgment potentially destroyed, we cannot know whether what we observe before us are ordinary women or witches at a sabbath.

Accompanying this evil eye within the picture are symptoms of a nameless, polymorphous power that seems at once to rage across and to emanate from Baldung's three nudes. It blasts the women's hair into surrounding spaces. It fuels the flame that, rhyming visually with the witches' hair, bursts from the pot at the upper framing edge and explodes the picture's closure as it seems to pass out of the sheet. And it haunts the image's sharp lighting, conveyed as hatched lines of white set off against a reddish brown ground, which seems to rush over the witches' bodies in the direction of their streaming locks and to be consubstantial with the brilliant fire that intermingles light, wind, and hair. Baldung leaves open the question of the source of this disturbance: whether it is something the witches endure, or invoke, or themselves *are*. As in the 1510 woodcut *Sabbath*, Baldung's chiaroscuro technique contributes to this uncertainty. Modeling volumes of things in space, it establishes a corporeal reality for everything it depicts. Yet monochrome, it distinguishes neither among different substances nor among bodies,

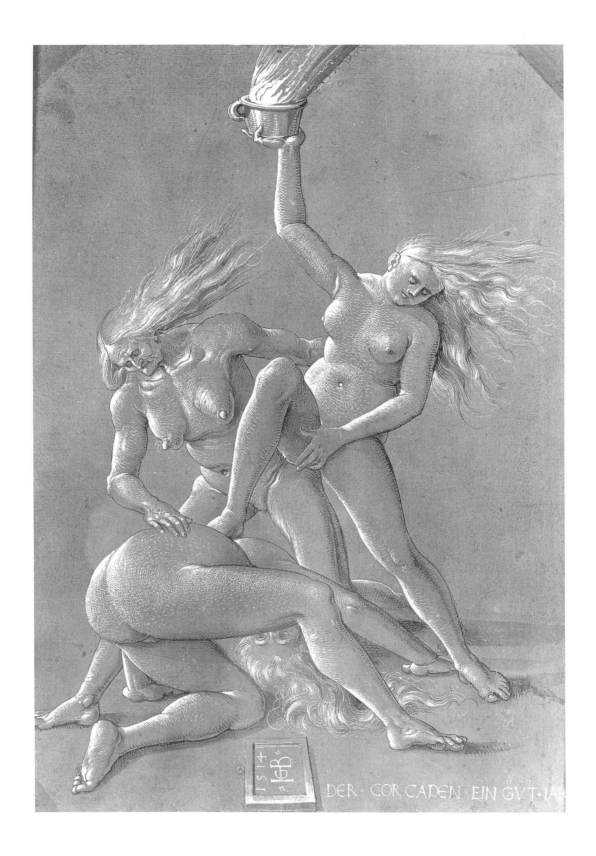

159. Hans Baldung (shop), *New Year's Sheet*, 1514, pen and ink, heightened with white on reddish brown prepared ground, Graphische Sammlung Albertina, Vienna.

forces, and spirits. It blurs the threshold separating matter from energy, human from natural, inner from outer.

The elemental medium for this procedure is the artist's graphic line. Baldung's line is mobile and polymorphous, an energy felt in the swirls of hatching that model the nudes, in the flourishes that render the bursting flame, and most ostentatiously, in the flowing hair that reads like paraphs hypostatized as flesh.[54] Here we discern the debased inheritance of Dürer. The graphic mark, unified with its natural prototype, hair, celebrates the power of the painter's skillful hand in the singularity of its gesture. Dürer, we recall, termed this power *Gewalt*, suggesting both strength and violence; and he attributed it particularly to the artists of Germany. The Swiss soldier-painters Urs Graf and Niklaus Manuel Deutsch (e.g., figs. 72, 197, and 199), working under the combined influence of Dürer and Baldung, seem to have understood this link between violence and the *Gewalt* of drawing.[55] Their pen sketches of their life as mercenary soldiers simultaneously depict and inflict violence. Wielding their pens like swords, they draw the carnage of war in a self-confident, even jubilant, calligraphic style that celebrates the swaggering attitude expected of mercenaries in battle. Baldung's witch drawings evince an analogous complicity between a diabolical subject matter and the medium of drawing. In them Baldung associates the unrestrained graphic line with the darker forces of nature, and he thereby demonizes the sign of painterly craft and physical beauty that had been his teacher's—the hairy, bearded painter's—personal emblem of artistic power.

Hair has a disorienting effect on our experience of Baldung's chiaroscuro drawing. True, the witches' locks, along with the flame, flow generally from left to right, in the direction of the light and consistent with the swift movements of the artist's pen as it glides on the sheet's burnished, color-ground surface. Yet this hair also seems to explode from the women's heads independent of gravity, sending the nudes whirling about the center of the sheet. Baldung encourages this dizzying sense of rotation by varying the angles of the witches' streaming hair and by omitting altogether any horizon line that might securely ground the scene. And by folding over the foreground witch's body into a somersault, he invites us, quite literally, to spin the sheet upside down. At the hub of this maelstrom of bodies, and near the geometric center of the sheet, Baldung places the groin of the young, flame-bearing witch. This groin is also the point of intersection between the scene's two principal diagonals: the one carried by the flame-bearing witch's left leg, the other indicated by the old witch's right leg and by the leaning torso of her younger companion.[56] It is hard, in a drawing as erotically charged as this, to discern a principle of decorum at work. Yet Baldung has chosen to cover with a hand the witch's sex, which otherwise would be gaping between her widespread legs.[57] How are we to interpret this hand? One might propose that without it the drawing would simply have been beyond the limits of period propriety and that Baldung was therefore compelled to emplot his own or his audience's pudency by letting the witch appear to cover herself. Yet given the foreground witch's lewder posture, and observing the way two fingers of the concealing hand turn inward toward the hidden groin, one is tempted to suggest that, rather than covering herself, the standing witch is actually masturbating.[58] I say

"tempted," for there is no way to be certain whether this gesture is modest or wanton. Like the play of concealment in Baldung's images of the Fall, the chiaroscuro drawing demands that its viewer guess what is "really" going on. Eliciting this interpretation of its plot, the image reveals the viewer to be himself innocent or wanton and exposes him to the embarrassment of having thought or said what lies beyond decorum.

Everything focuses on the female genitals but eddies back to the implied male viewer. Below and to the left of the concealed central groin, the old witch's sex marks the approximate vanishing point of the picture's nominal construction of space. The long edges of the tablet in the foreground and, more clearly, the sheet's date and the artist's monogram inscribed upon it, converge as orthogonals about this groin. More strikingly, the third witch exposes her buttocks and pubes to the viewer as she bends over and looks between her legs. With her upside-down eyes aligned with her groin, she invites us to rotate the sheet so that her head appears at the top of the page and the flaming pot at the base. Thus reoriented, the flame can be read as a self-enflamed and enflaming vagina; the witches' nude bodies and flowing hair become the pubic triangle; and the sheet's reddish brown ground doubles as flesh.

Baldung frequently invokes the flaming or fuming pot to visualize the female body as an unclean chamber out of which pour all evils of the flesh. In the 1510 woodcut *Sabbath*, the corpulent foreground witch straddles a bulging vessel and lifts its lid to release a stream of smoke, frogs, and debris (fig. 158). If the outlines of this stream are extrapolated backward through the open pot, they converge at the witch's groin. The female sexual orifice as the source of an evil vapor finds far more direct expressions in Baldung's drawings of witches. Intended for a more limited audience, these sheets show openly what the more widely disseminated woodcut cloaks in visual metaphor. In a chiaroscuro drawing in the Louvre, dating from the same year as the Albertina sheet, a seated witch reaches between her legs to light a wand on flaming vapors that explode from between her legs. Above and to the right, the hair of her companions bursts forth with an equal and opposite force (fig. 160; K. 63); and at the lower right, a cat exhales or vomits similar fumes. Such a drawing exhibits a misogyny and a sexual terror that, while difficult for us to fathom today, are common throughout medieval art and literature. Like the popular images of *Frau Welt*, it visualizes woman as corrupt and corrupting flesh. In *The Plowman of Bohemia*, composed about 1400, Death reminds its victim that he was "conceived in sin [and] nourished in the maternal body by an unclean, unnamed monstrosity" and that he in turn is himself "a wholly ugly thing, a shitbag, an unclean food, a stinkhouse, a repulsive washbasin, a rotting carcass, a mildewed box, a bottomless bag . . . a foul-smelling piss-pot, a foul-tasting pail."[59] The body is born a macabre corpse from a tomb-like womb. From this perspective, Baldung's witches are indeed variations of his images of death. They conflate the sensual lure of the nude female body with the polluted, uncanny interior of the festering cadaver.

Sigrid Schade has linked Baldung's Louvre *Witches' Sabbath* more specifically to two pseudoclassical tales of the power of women that were current in the artist's culture. The woman as dangerous pot recalls the story of Pandora as it was told in the Renaissance.

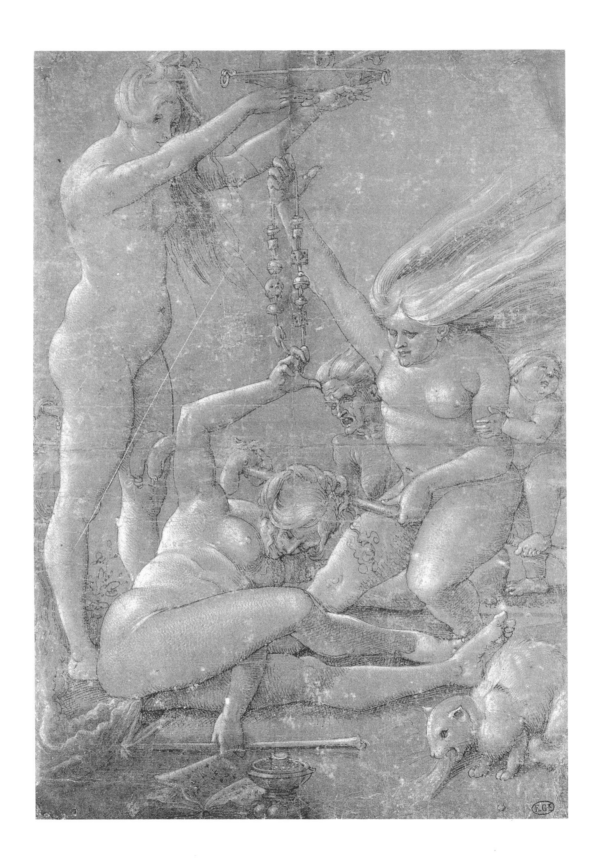

160. Hans Baldung, *Witches' Sabbath*, c. 1514, pen and ink, heightened with white on green prepared ground, Louvre, Paris.

In an intensely misogynist play of 1544, for example, the Nuremberg preacher Leonhard Culman identifies the "beautiful Pandora" with the box (*Büchse*) that had become her attribute. Both are containers of "lust and pleasure" and instruments of the devil.[60] And long before that, the church fathers, attempting to corroborate their doctrine of original sin by classical parallel, likened Pandora to Eve and her vessel to the forbidden fruit.[61] The notion of *Eva prima Pandora*, monumentalized in Jean Cousin's picture of that title in the Louvre, would have appealed to Baldung as a bridge between his witches and his images of the Fall. Still closer to Baldung's witch igniting a wand at her genitals is the story of Virgil and the king's daughter.[62] Held in highest esteem throughout the Middle Ages owing to his alleged prophecy of Christ, Virgil was believed to have been a sorcerer as well as a poet and prophet, and starting in the twelfth century there arose a body of legends about his magic. In one of these Virgil, having been humiliated in love by a princess, punished the girl by extinguishing all the fires in Rome and causing her vagina to be the city's only source of flame. Urs Graf, who executed and signed a virtually exact copy of Baldung's 1514 Louvre *Witches' Sabbath*, illustrated this legend in his title-page woodcut to a 1519 *Dictionarium Graecum* (fig. 161).[63] The princess, assuming a posture reminiscent of Baldung's Louvre and Albertina witches, is transformed into a prostitute who gazes out at the viewer, enflaming him just as she ignites the torches of the citizens of Rome. What links the stories of Pandora and of Virgil and the princess to Baldung's witches is their shared symbolizing of women as a dangerous vagina or an uncanny interior that simultaneously arouses and repels male desire.

Yet in Baldung's Louvre sheet, the women are more than merely "like" unclean boxes, and the wand, pitchfork, and sausages they place between their legs are more than merely "symbols" of the phallus. Baldung pretends to expose the hidden reality behind the legends of women's power. Witches, he wants his viewer to believe, *themselves* use their bodies as diabolical vessels and create, manipulate, and enchant phallic objects for their *own* carnal pleasures and malevolent plots. Sausage and wand are therefore not the *artist's* symbols of the penis, but the *witch's*. With them she can variously stimulate herself, cause erection and impotence in men, and induce fantasies of castration. Indeed as the *Malleus* argues, in a chapter entitled "How, as It Were, They Deprive Man of His Virile Member," male victims of witchcraft can never be sure whether their castration is actual or illusory—whether the sausages they might see at a sabbath are, or only look like, their own missing penises. For though witches unman through mere illusion and only seem to "collect male organs in great numbers . . . and put them in a bird's nest or shut them in a box," the devil can actually castrate a man.[64] Baldung, accordingly, renders the difference between reality and fantasy anxiously uncertain. In Urs Graf's copy of the Louvre sheet, which is better preserved than the Baldung original, one "sausage" is highlighted so that a vein appears to bulge from its surface. Such details force the viewer to separate fact from fantasy, to scrutinize the evidence as an inquisitor would a victim's testimony or, better, as the victim would his own experience. What makes Baldung's witch drawings finally so nightmarishly literal is that their own powers are analogous to those of the witches they depict. Along with the wands, sausages, and flaming pots,

161. Urs Graf, *Virgil and the King's Daughter,* detail of title-page woodcut for the *Dictionarium Graecum* (Paris, 1521).

Baldung's pictures are themselves like the witches' fetish. At once grotesque and erotic, they cause in their male viewer alternately disgust and excitement, impotence and erection, abjection and onanism.

Baldung's most audacious hybrid of the ugly and the obscene is his chiaroscuro drawing of a witch, a dragon, and two putti, dated 1515 and now in Karlsruhe (fig. 162; K. 65). This bizarre scene, exquisitely rendered in pen and ink and white body color on a burnished brown ground, defies any summary even of its plot. A young witch appears to aim some sort of emission from between her legs into the dragon's mouth. From an ear-shaped opening at the dragon's other end, another more gaseous efflux jets skyward, echoed by the witch's streaming hair and counterbalanced by the reedlike object that the woman seems to plunge into the dragon's rear orifice. One might conjecture that the witch's genital emission passes through the dragon's tubular body to emerge from its anus as flaming vapor; or alternatively, that what we have called the witch's emission is actually the dragon's tongue of fire licking or entering the witch's vagina from behind and that the reedlike object is another column of flames emerging from the dragon into the witch's hand. Again, Baldung's chiaroscuro technique, which conjures bodies without specifying substances, makes it impossible to decipher the scene according to the laws of stable things in space. Liquid and gas, influx and efflux, reception and penetration, inside and outside, womb and penis, female and male, human and animal all interchange. The phallic dragon becomes a two-holed chamber entered at both "ends" by a phallic witch; dragon and woman, avatars of the ugly and the beautiful, are simultaneously opposites

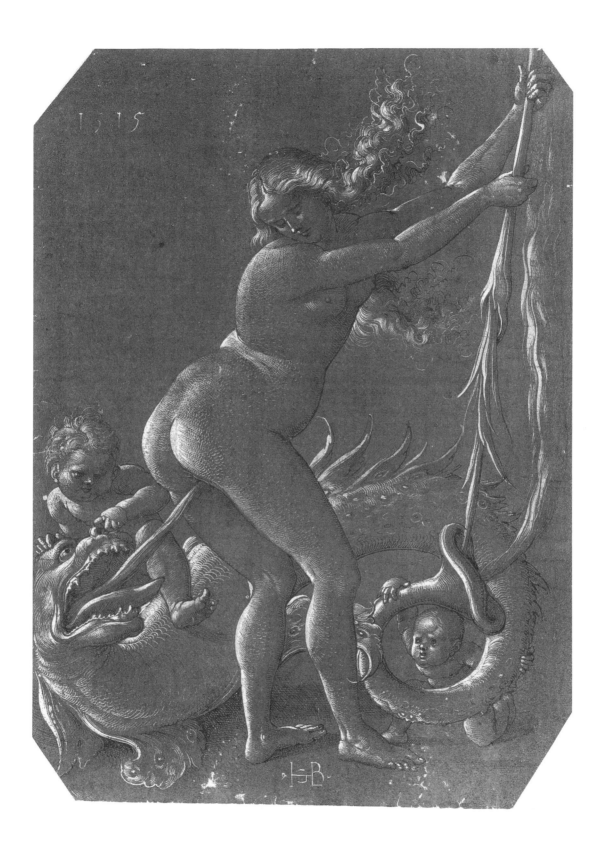

162. Hans Baldung, *Witch and Dragon,* 1515, pen and ink, heightened with white on reddish brown prepared ground, Staatliche Kunsthalle, Karlsruhe.

and, like the putti who assist them, twins; the substance linking dragon's mouth and witch's sex could equally well be the monster's fire or tongue or the woman's flatus, urine, or menses.

Ignorant of what these things precisely *are,* we as interpreters are forced to rely on similarities, to speculate about what things are *like.* And even if, by sifting through late medieval witch lore, we were to positively identify the witch's emission as, say, menses, the play of analogy and anomaly would not stop here. For when witches use their menstrual blood in their rites (as they were indeed believed to do), it is because of its resemblance to, and resonance with, other substances and bodies. This is also how sausages and pitchforks can trope for penises, and how witches' flight can equal female orgasm. According to both learned and popular accounts, witches' magic is chiefly imitative, effecting metamorphosis through metaphor. It is, as Geiler put it, "nothing more than a sign" whose efficacy requires the participation of the devil. A jealous woman prevents a couple from having intercourse by closing a lock and casting lock and key into two different wells;[65] a witch splashes water between her legs and afterward a heavy rain falls.[66] In a deposition of 1502 from the Willisau region in Switzerland, a certain Dichtlin and her daughter Anna, both accused of witchcraft, are observed in acts of unknown content but of suspected effects: "A beggar [said] . . . he had seen the two women sitting in the stream; and as he passed by they called him back, saying: 'Be a good fellow, give us our shifts' (they were hanging on a bush). He did so, and saw clearly that they were holding something or other between their legs; though he did not know what it was. That same night there was a great hailstorm."[67] This "something or other between their legs" describes well how we ought to regard the young witch's emission in the Karlsruhe sheet. Baldung makes the viewer into a bewildered voyeur of a rite, the requisites and purpose of which are known only to the witch herself.

Yet offered this spectacle, the viewer will himself be introduced into the witch's art of analogy and anomaly. He will be initiated into an open, fluid body of fantasy that overturns the categories of inside and outside, of I and not-I, upon which the otherness of spectacle itself is founded. In fashioning his emblems of abject carnality, Baldung returns to a more archaic conception of the body, in which the body's parts, fluids, and functions are not separately defined, as bounded entities or discrete processes, but are linked each to each through internal correspondences and analogies. Marie-Christine Pouchelle has studied the history and logic of this phantasmagorical body, as well as its tentative replacement by new, more empirical, "modern" models that emerged in the universities starting in the fourteenth century. Analyzing the 1305–1312 *Chirugie* by Henri de Mondeville, surgeon to Philip the Fair, she discovers an "anatomy of desire" that, for us, can answer to the female body image pictured in Baldung's witch drawings. In Mondeville's text, men are models for the visible, external body and for the morphology of the body in general, while women model the internal body, the invisible, hidden, "secret places" that dissection alone can bring to light—the womb, stomach, vulva, cecum, brain, and heart.[68] The female body was, quintessentially, an orifice and cavity, an inversion of the normative externality of the male phallic body. As such, it was profoundly equivocal: in

Pouchelle's words, "the domain of trickery, of seeming, of lies . . . a secret garden in longing dreams."[69]

In Baldung's Karlsruhe sheet, the cultural fantasy of the deceptive female body is enacted in an obscene, demonic, and dissembling plot. Baldung transforms the encounter of opposites—ugly and beautiful, male and female, animal and human—into a nightmare of unnatural coupling and unstable analogy. The drawing, most scholars assert, depicts a witch and the devil in an amorous embrace.[70] Yet like the nameless substances that pass in and out of the monster, and like the to-and-fro motion of copulation itself, the positions, directions, and genders assumed to interpolate this basic plot can be reversed—*should*, in fact, be reversed if the male viewer is to experience fully the scandalously polymorphous nature of woman. Thus the witch's hidden vagina is mirrored as the dragon's gaping mouth and anus; the dragon's bumpy, phallic body, receiving rather than ejaculating fluids, is a womb; and the witch, wielding her efflux and "reed" like penises, assumes the active, male role in the embrace. Such dreamlike reversals must also be applied to the drawing's particulars. Take, for example, the substance exchanged between the witch's sex and the dragon's mouth. Clearly related to the flaming vapors that jet from the groins, jars, and chamber pots of Baldung's other witches, this corporeal flux sums up everything that is threatening to men about women's bodies. Its material indeterminacy reflects and maintains men's ambivalence toward women as life-bearing and menstruating Other.

Fear of women's menses dates back, in the West, at least to antiquity. Pliny the Elder writes of menstrual blood: "Contact with it turns new wine sour, crops touched by it become barren, grafts die, seeds in gardens are dried up, the fruit of trees falls off, the bright surface of mirrors in which it is merely reflected is dimmed, the edge of steel and the gleam of ivory are dulled, hives and bees die, even bronze and iron are at once seized by rust, and a horrible smell fills the air; to taste it drives dogs mad and infects their bites with an incurable poison."[71] Christina Larner has discovered that Pliny's sixteenth-century translators transferred the evil powers of menstrual blood to the menstruating woman herself, whose gaze alone could dim mirrors, blunt knives, and drive dogs mad. This shift, according to Larner, "reflects an intensified misogyny in this period."[72] Yet what are the menses within the whole phantasmagorical body of woman? In Galen and Avicenna, they are concocted of blood and akin to sperm: "Male and female semen, more and less refined fluids, thus stand in the same relationship to blood that penis and vagina stand to genital anatomy, extruded and still-inside organs."[73] In the *Chirugie*, too, they are a condensation of superfluous humors, yet Mondeville embellishes their fungibility. Men expel such waste as body hair, but women, whose bodies are more cold and moist, emit their broader efflux as blood from the womb, which is why their bodies are largely hairless.[74] The analogy of menses with hair again depends upon the model antithesis of male as outside and woman as inside, yet Baldung's visions demonstrate that, through deviltry, this natural order can be reversed. His witches expel their evil vapors both as phallic discharge and as hair. Their locks resemble—and jet in counterpoint to—their flaming efflux because they are of the same foul substance. The *Malleus,* incidentally,

warns that witches' head and body hair is magical and can hide malicious charms. Therefore inquisitors are advised to shave witches before their trial.[75] Hair itself becomes a threatening, secret, interior space that, like the body of woman itself, must be exposed to the externalizing gaze of man.

It would be interesting to study the competing medical models that inform Baldung's fantasy body. Already in the early fourteenth-century *Chirugie,* the endlessly mutable system of analogy and anomaly that had mapped the body was giving way to more stable and empirical models of the flesh. Baldung, I suspect, drew his image of the phantasmagorical body partly from a medical culture that, by his period, had long been marginalized: the culture of midwives, wise women, and unlicensed healers who, lacking university training and existing outside the emergent professional associations, figure so heavily among the accused at witch trials.[76] Indeed, the *Malleus* categorizes the three types of witches according to their capacity to heal: "those who injure but cannot cure; those who cure, but, through some strange pact with the devil, cannot injure; and those who both injure and cure."[77] Baldung's family connections with the "official" medical profession were nearly as strong as his links to legal culture. His uncle Hieronymus, we recall, was a doctor of medicine and personal physician to Emperor Maximilian I; and late in his career Baldung himself designed some eighteen woodcuts for the widely circulated and translated 1541 *Anatomi* of Walter Hermann Ryff (figs. 143 and 163). Set side by side, Baldung's anatomy of the female reproductive organs and his Karlsruhe sketch of a witch seem to inhabit two separate worlds, the one official and learned, the other unofficial and "popular." By consciously invoking body images whose source lies in the unsanctioned, persecuted, and predominantly female culture of healing, Baldung can claim to transport his male viewers beyond the boundaries of their class, learning, and gender and plunge them into a sabbath as seen fully from within.

Needless to say, this transport is itself as fantastic and self-deluded as the witches' flight it pretends to expose. Not only are the boundaries between the magical and the scientific body still quite permeable in this period,[78] but the magical body as invoked by Baldung is itself largely a figment of learned imagination, a product of an elite gaze as it beholds and marginalizes popular superstitions that it itself still believes. This body is mythicized in such Renaissance fables as Pandora and Virgil's princess; and it underwrites the misogynist ideology of the great witch-hunt. The inquisitors never ceased to fabricate physiological explanations for witchcraft and, in particular, for why women were especially apt to become witches. These explanations were generally grounded in both the Judeo-Christian conception of woman as source of sin and cause of the Fall and the Aristotelian view of women as imperfectly human through a failure in the process of conception. The *Malleus,* quoting copiously from Scripture, lists numerous reasons for devilry among women. Women are more credulous, vengeful, idolatrous, and slanderous than men; their memories are weak; their bodies, feeble; their minds, childlike; and their faith, wavering. All these various defects, however, are reducible to one: "The natural reason is that she is more carnal than a man, as is clear from her many carnal abominations."[79] Men's bodies may be the norm against which women's are understood, mea-

sured, and found lacking. Yet women are synonymous with body, and their insatiable lust is the outward sign of their heightened carnality. In his witch images, Baldung emplots the naked, lustful, lust-inducing female body within the learned fantasy of the sabbath, just as in his death images, woman appears paired with that other emblem of alterity, the ruined flesh. "And I have found a woman more bitter than death," write Kramer and Sprenger, "who is the hunter's snare, and her heart is a net, and her hands are bands. . . . More bitter than death, again, because bodily death is an open and terrible enemy, but women is a wheedling and secret enemy."[80] Both of Baldung's signature images, the diabolical and the macabre, conjure up for their male viewer the same enemy. Both set before him, as an image before the self, the same Other: to his mind a body, to his life a death, to his closure a cavity, to his reality a fantasy, to his manhood a woman,

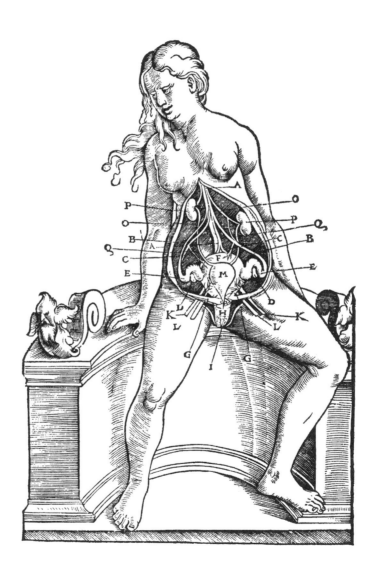

163. Hans Baldung, *Organs of Generation of a Seated Woman*, woodcut illustration for Walter Hermann Ryff's *Anatomi* (Strasbourg: Balthazar Beck, 1541), fol. Aᵛ.

The Crisis of Interpretation *341*

to his learning a superstition, and if the Strasbourg witch-hunting records are an indication, to his city a hinterland. And if the spectacle destabilizes such dyads, exposing their conceptual fragility, its effect is also to invent and police the boundaries of the beholder, to portray the male viewer negatively, as if in phobic flight from everything he is not. Whereas Dürer's self-portraits are, from a psychological point of view, narcissistic, Baldung's are misogynist: hatred of women becomes, as it were, the psychic model of art's reception.

Yet what of masculine presences *within* Baldung's chiaroscuro drawings of witchcraft? The monster in the Karlsruhe sheet, while doubling as a womb, is principally male, an incubus devil who has assumed the phallus-shaped body of a dragon. Much learned speculation was expended on the ontological status of such embodied incubi, on the substance of their apparition, on the semen they steal from men to inject into witches, and on the intensity of pleasure enjoyed by witches in their embrace. According to the *Malleus,* a beast like Baldung's possessed no material body and was visible only to the witch: "But with regard to bystanders, the witches themselves have often been seen lying on their backs in the fields and woods, naked up to the very navel, and it has been apparent from the disposition of those limbs and members which pertain to the venereal act and orgasm, as also from the agitation of their legs and thighs, that, all invisibly to the bystanders, they have been copulating with Incubus devils."[81] To the untrained eye, a solitary half-nude woman who has orgasms alone in a field or forest might appear to be simply a woman masturbating. But to the inquisitor she is a witch copulating with an invisible demon. Framing his images similarly as encounters between an "agitat[ed]" female nude and "any bystander," Baldung explores the liminal zone surrounding female sexuality, where illusions permeate reality and where men's fear of women's onanism and autonomy is refigured as their belief in the devil.

Each of the three chiaroscuro drawings under discussion shows one witch slightly spreading her thighs as she offers her backside in the direction of the viewer. The Karlsruhe sheet reveals what lies hidden to an ordinary bystander and corporealizes the diabolical coupling in the stream of materially and semantically fungible fluids exchanged between the witch's sex and the dragon's mouth. The Louvre sheet depicts the witches by themselves, equipped with surrogate penises which they ignite with vaginal fumes (fig. 160). And the Albertina sheet positions the foreground witch to receive, or invite, a still invisible demon; the fumes of her sex are displaced to the chamber pot above (fig. 159). This last drawing seems the soberest of the group and comes closest to what "any bystander" might be able to see of a witch's copulation. Yet precisely for that reason it invites us to look more closely for evidence of demonic male presences, to scrutinize the image for incubi who would properly constitute the scene as a "sabbath."

They appear, I believe, as texts below the somersaulting witch. At the center of the drawing's lower edge, the tablet with the date and monogram thrusts sideways into the scene, its orthogonals aimed through the witch's inverted eyes toward the old woman's groin. And to the right appears a curious greeting written in majuscule: "To the cleric, a good year" (DER COR CAPEN EIN GUT JAR). Artist and viewer, Hans Baldung Grien and the

sheet's specific recipient, are paired in the *bas-de-page* as the signs, or remnants, of the masculine. What exactly do they signal?

The monogrammed tablet is certainly a figure of entrance. Baldung aligns it with the chamber pot and places its near edge flush with the picture plane. Name and flame, respectively entering and exiting the scene, explore the passage between world and work. But because Baldung's drawing, like others of its kind, fantasizes interior spaces as women's bodies, indeed, because this drawing's plot involves a woman awaiting carnal entrance from behind, such passages acquire a sexual coloring. The tablet, one is tempted to propose, inserts itself into the picture's space like a penis into a vagina. Baldung, we recall, lays the ground for this proposition, assembling in his other sabbaths objects that are clearly phallic and that, furthermore, owe their symbolic charge not to the artist or the viewer but to the witches themselves. The sausages in the Louvre sheet are signs that the *witches* manipulate at their sabbath and may even *be* penises depending on the level of devilry at work. To propose, as I do, that the monogrammed tablet acts like a penis, or that its entrance into the picture simultaneously maps our gaze and genders it as phallic and male, is not really to expose the artist's intentions, conscious or unconscious, but rather to read the witches' signs as devils—or inquisitors—might. It is to regard the artist's monogram as a potential requisite of the *maleficium.*

Earlier we noted that Baldung's drawings, like the witchcraft they depict, imply a double effect on their viewer, at once arousing carnal desire through the spectacle of the nude and destroying that desire through the mixture of sexual threat and grotesque detail. Witchcraft, it was believed, worked directly on men's genitals, causing either erection or else impotence or imagined castration. Consequently, Baldung's monogrammed tablet, if indeed phallic, is at once virile, in its forward thrust into the picture's center; flaccid, in its debased position on the ground plane; and castrated, in the way its near edge, marking the split between world and work, cuts between the space of our body and the body-filled space into which our gaze, desirous and fearful, extends. Baldung exploits the same ambiguity in his last and most famous print, the *Bewitched Stable Groom,* where monogram and oblique self-portrait, placed with their "feet" against the ground plane, together enter the picture as vanquished phalluses (fig. 213).

I shall have more to say about Baldung's debased monograms, how they cast the artist simultaneously as hapless victim of the power of women and as hidden serpent of the Fall. In the Albertina sheet, the tablet's far edge is touched by one lock of the foreground witch's curling hair. The artist's personal mark thus fills in for the efflux-gulping dragon and sex-ignited wand of the other chiaroscuro drawings. Baldung leaves open his allegiance: whether his monogram is the women's fetish used to curse him or whether it is a token of the artist's deviltry, of his status as the invisible demon before the scene. Baldung, after all, engendered this sabbath with all its mixed thrills, and the monogram announces that paternity. It signals, too, that the original value of the sketch—what it was for and why it was preserved—lies less in its corrupt, corrupting plot than in its pleasing and personal execution by an artist of distinction. Baldung had published his original vision of witches only four years earlier in the 1510 woodcut *Sabbath.* The chiaroscuro drawings,

as well as the several copies after Baldung's sheets by artists like Graf, were produced in the wake of that print's success. As unique luxury versions of Baldung's signature theme, they were intended as personalized tokens for the artist's special friends and discerning patrons.[82] This "taste for drawings" that is the Albertina sheet's enabling circumstance is, like the monogrammed tablet, a legacy of Albrecht Dürer. Scarcely two decades separate Baldung's witches from the youthful Dürer's self-inventing sketches. In their meticulously prepared color ground, in the grace and authority of their line, and in their perfect finish, the chiaroscuro sheets of 1514–1515 yield, and presuppose a public for, other pleasures besides the erotic. The violent play between desire and abjection staged within the implied viewer thus seems to find resolution in the new, neutral realm of the *aesthetic* reception. Henceforth kept, as the German knight Franz von Sickingen advises in 1522, "in beautiful rooms and as ornament,"[83] the visual image as work of art is appreciated solely for its beauty and for the artist's inborn talent that it displays. Surely it is the Karlsruhe sheet's most unsettling feature that woman and monster, hair and menses, ugliness and beauty are *all* beautiful in their depiction. Such formal beauty invites us to overlook the evil we see (in Baldung's time the wickedness of apostasy, in ours the evil of misogyny) and with disinterested satisfaction to appreciate art and artist. Working within aesthetic perimeters invented by his teacher, and indeed dependent on Dürer for his subject, style, and self-inscription, Baldung signs these precious gifts,[84] these handmade variations of his famous print, as if to advertise himself to a more elite public and to forge for his art a place within its beautiful rooms.

When the doors of those rooms are shut, however, and the connoisseur or humanist or cleric is alone with Baldung's gift, the innocent pastime of aesthetic pleasure will be once and for all defiled. The lover of art will stand before the image as before a sabbath. His sovereign, discriminating gaze will be exposed as alternately lecherous and impotent. And he will observe himself portrayed at best as the vanquished target of the picture's magic, at worst as the sabbath's missing man.

Fortunately, the *bas-de-page* inscription on the Albertina sheet tells us something specific about this original viewer, as well as about the occasion for which Baldung fashioned his image. For *Der Cor Capen ein gut Jar*, written between the monogrammed tablet and the sheet's right edge, reveals the image to be an off-color New Year's greeting from Baldung to a particular cleric, probably in the artist's Freiburg or Strasbourg circle.[85] *Chor Kappe*, meaning one who wears a *cappa choralis* or choir cope, could name, for example, a monk, friar, or canon. At first glance it might seem highly inappropriate that this bizarre and erotic work was thus intended. Yet the Albertina *New Year's Sheet* has deep roots in antique and medieval calendar celebrations. Clerical observance of the New Year took a variety of forms in the late Middle Ages and was not always "clothed in Christian seriousness."[86] The Feast of Fools (*festa stultorum*), observed on New Year's Day or on December 28, and often organized by members of the lower or junior clergy, was celebrated by parodic inversions of the rituals of official culture. People danced in the churches,

played cards in sacred places, sang bawdy songs, and elected a boy bishop or an abbot of fools who performed a mock liturgy and granted obscene "indulgences."[87] Celebrants of these travesties donned masks and women's clothing or wore ecclesiastic garb back to front. Reading from missals held upside down, they parodied the catechism, the Ten Commandments, the creed, the litany, the Psalms, and the Lord's Prayer. This ritual enactment of the reversed world or world upside down (what the Greeks called *adynata*),[88] while temporarily overturning the order and decorum of the church, was largely a sanctioned affair. It was justified theologically by the inversion implicit in the Christ child, for as the Magnificat proclaims, "He hath put down the mighty from their seat and hath exalted the humble" (*Deposuit potentes de sedes et exaltavit humilis*). In the sixteenth century, the Feast of Fools was sometimes replaced by Childermas, at which, on the anniversary of Herod's massacre of the innocents, children were allowed to occupy the places and roles of the mighty. The vast majority of printed New Year's greetings produced in Germany before Baldung depict the Christ child seated on a pillow and accompanied by some variant of the phrase *Ein gut selig jar*.[89]

In its mockery of the viewer and its indecorous eroticism, Baldung's Albertina sheet belongs to the traditions of license and inversion associated with celebrations of the New Year. The *Chor Kappe* who received the drawing would have been familiar with its topsy-turvy message and method, for he was conversant with the comic, festive genres of the pre-Reformation clergy: the monkish pranks (*jaco monacorum*), paschal laughter (*risus paschalis*), and other forms of sacred parody (the *coena Cypriani*, the mock liturgy, the *sermon joyeux*, etc.).[90] He would also have been familiar with the popular tradition of obscene New Year's poems that flourished in Germany around 1500. And while most of the extant woodcut and engraved New Year's greetings depict Christian subjects, there are some fifteenth-century examples with mildly erotic themes.[91] Baldung's *New Year's Sheet* illustrates carnival inversion at the foreground of his image. The witch's somersaulting body visualizes the turning of the calendar year. Her impudent, inverted gaze, passing under her body to light upon the viewer, is appropriate to that turning. For when the new year replaces the old, the low will become high; the serious, comic; the chaste, lustful; the accuser, the accused. And the official order's confidence in its power and mastery is mocked and exposed as folly.

Now, the posture of Baldung's witch echoes that of a winged putto at the base of Dürer's famous *Witch* engraving of 1501 (fig. 164; Kn. 35).[92] Somersaulting below the old witch mounted backward on an airborne goat, the putto represents the world turned upside down. Yet where Dürer *symbolizes* inversion through an assemblage of erudite emblems (somersault, backward ride,[93] spinning globe, woman on top,[94] and reversed artist's monogram), Baldung *effects* a carnivalesque overthrow within the very self of the picture's beholder. We have seen how the witch's somersault invites us to set the whole drawing on its head and discover it to be an occulted vagina. This inversion does not, however, merely expose what the *witch* is; it also extends, with her gaze, outward to the viewer in the here and now of his experience. For according to a superstition alive during Baldung's time, to thus glance behind oneself between one's legs was a way of seeing the

devil.[95] This was particularly useful for witches, who, as Baldung's Karlsruhe *Witch and Dragon* makes clear, were believed to have sought sexual commerce with the devil, allowing him to take them from behind. In the *New Year's Sheet*, the viewer thus stands in the place of the incubus devil. Such mockery would be especially appropriate for the image's initial audience, the *Chor Kappe*. For while the new year, to him particularly, meant renewing his vows of celibacy, Baldung's gift itself would have surely aroused in him a carnal desire undermining those vows.

Criticism of clerical celibacy was a well-established theme in late medieval literature and art.[96] The laity enjoyed bawdy tales of the sexual exploits of monks, canons, and nuns, observing therein a heightened case of the hypocrisy and concupiscence of all people. Clerical prurience, moreover, jeopardized the economy of the sacred. If, as the church maintained, it was the role of priests, monks, and nuns to pray for everyone, and if the efficacy of their prayer depended on their celibacy, then any breach of their vows compromised the spiritual health of the whole.[97] In Germany on the eve of the Reformation, such criticism entered a new, more intense phase. Partly reflecting a general anticlericalism of the period, partly responding to a number of very public scandals concerning sexual promiscuity, alleged infanticide, and concubinage in the monasteries and convents,[98] a number of preachers and theologians called for a general reform of the church's stance toward celibacy. In Strasbourg, Geiler von Kaysersberg led the way, on one hand urging the church to punish clergy more severely for sexual misconduct, while on the other hand extolling marriage as people's natural and favorable state, praised and sanctified by God.[99] Baldung's *New Year's Sheet* was produced in the midst of this controversy, contemporary with a heightened awareness that man's fallenness precludes universal celibacy even for the Christian priesthood, but a decade before the radical solution of the Reformers—Luther's institution of clerical marriage.[100] As is so often the case in Baldung's art, the Albertina sheet discovers and intensifies a spiritual dilemma that would have troubled its original viewer yet does not offer any solution or consolation. Confronted by the nude witches in their provocative behavior, the *Chor Kappe* will find himself transformed into the true subject of the picture, recognizing thereby that the evil he believed was outside himself is really within. The bleakness of this message is lessened only by the drawing's occasionality—its status as a New Year's inversion that will vanish into the church's quotidian world of a commanded (if unfulfilled) rule of celibacy—and by its comic tone, which it shares with all the other chiaroscuro witch drawings.

Few interpretative tasks are as necessary and as neglected as determining the tone of an image. By tone I mean something akin to a social exchange: the attitude the work of art takes to its audience.[101] Northern satirists of the sixteenth century, from Brant, Thomas Murner, and Hans Sachs to Erasmus, Pirckheimer, Niklaus Manuel Deutsch, Friedrich Dedekind, Caspar Scheidt, and the authors of the *Letters of Obscure Men*, display an astonishing tonal range, and I believe it is likewise with the period's painters. Dürer and Baldung, as well as Cranach, Altdorfer, Holbein, Peter Flötner, Urs Graf, and the Nuremberg Kleinmeister, differ from one another as much in the tone of their satires as in their pictorial style. Baldung's chiaroscuro drawings, in the rude way they address their

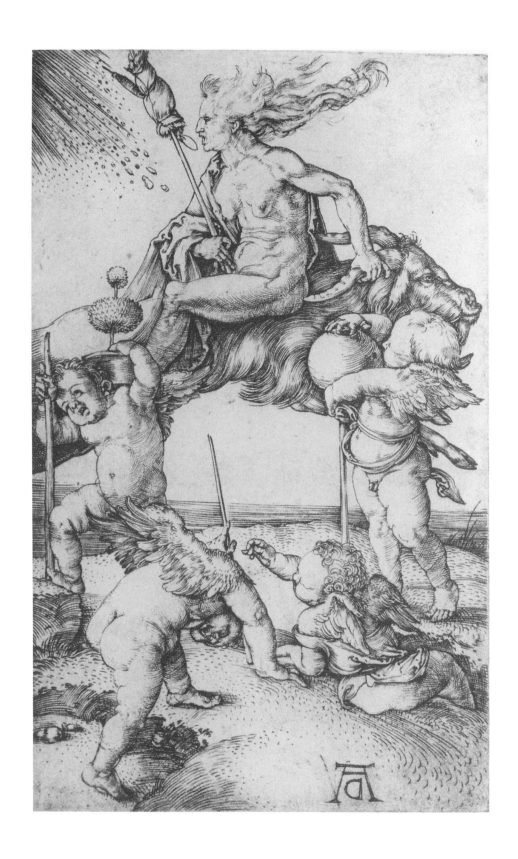

164. Albrecht Dürer, *The Witch*, 1501, engraving.

viewer, are worlds apart from the distanced and learned assemblage of emblems in Dürer's engraved *Witch*. Yet they have tonal precedents in an earlier German tradition of comic prints. The secular engravings of the anonymous master E. S., for example, bridge Baldung's grotesque eroticism to the drollery of medieval art. In a sheet from the *Figure Alphabet* of 1466–1467, animals, a woman, and five monks dressed as fools concatenate to form the letter *n* (fig. 195).[102] One monk empties a urinal in the smiling face of his trouserless companion; on his shoulders stands another monk, whose genitals hang visibly before his bearer's tonsured head. At the lower right, a bare-bottomed monk kneels to be caned (seemingly with pleasure) by a "woman on top." Behind her stands a fifth monk who watches the revelry through spectacles. Not only are the figures' lewd, twisted, and intertwined postures and abstracting silhouettes similar to Baldung's Albertina witches, the two works also share themes: the power of women; lustful clerics who give and receive sexually pleasurable pain; and the beholder as collusive voyeur—in Baldung, the interpellated *Chor Kappe* before the image; in the Master E. S., the bespectacled monk behind the fun.

Perhaps closer in plot to Baldung's sheet is the so-called *Feast in the Garden of Love* from about 1465 (fig. 165).[103] Here the Master E. S. satirizes the courtly pastimes of tournaments, feasting, and love, which had been stock subjects of secular art and poetry in Germany since the late twelfth century. At the base of the sheet, a court fool stands (or sits) peering out at us while an elegantly dressed woman lifts his garments to display his genitals. His discarded instruments of entertainment—pipe and drum—embellish this rude exposure. Courtly love, embodied in the upper scenes, is revealed to be "at bottom" sexual: ordinary carnal lust clothed as elegant leisure. The fool's outward glance mediates between the viewer and the enclosed love garden, framing and qualifying the depicted pleasures as sin. By placing the fool's genitals specifically in the *bas-de-page*, and by letting a woman reveal them to us, the artist conveys not only a message but an interpretative attitude as well. The message is that the lower body motivates all pursuits of pleasure, even those of the higher social order, and that women bring this downward fall of man to light. In order for viewers to grasp this message, however, they must descend to lower details and discern the tiny, half-hidden form of the fool's penis. This detail forces us to pass from the elegant outer garments of everything we see to a naked truth within a visual penetration that literalizes the figural shift from surface to meaning. Keith Moxey has defined the likely historical audience of this print as members of an educated, urban middle class, whose ascetic values would have been expressed in the print's moral directives and whose positive class definition would have been well served by mocking aristocratic ideals and courtly subjects—here love gardens.[104] An engraving like this is the pictorial equivalent of the Shrovetide farces (*Fastnachtspiele*) that flourished in Germany, and especially in Nuremberg, between about 1420 and the end of the sixteenth century. As Werner Lenk has demonstrated, these plays often took their subjects and diction from courtly literature, but they overturned the courtly ideal through lewd gestures and verbal asides directed at their middle-class viewers.[105]

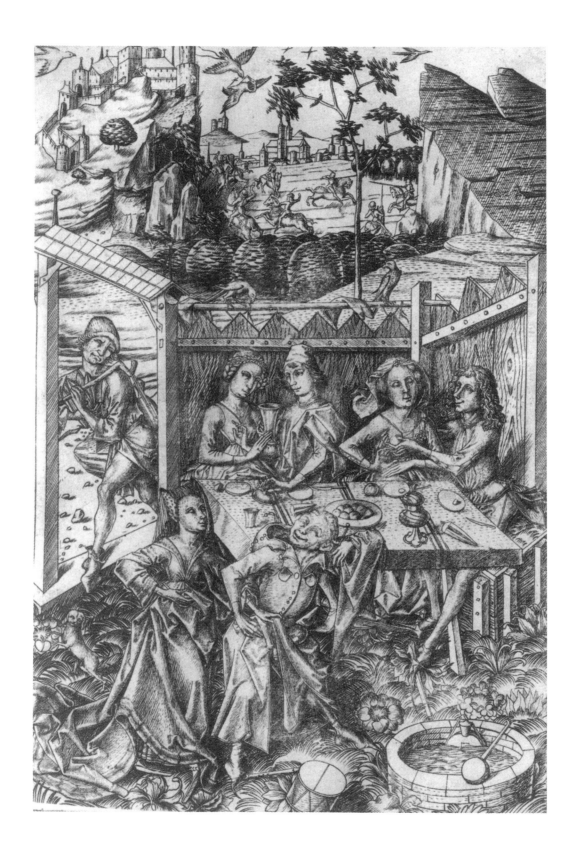

165. Master E. S., *Feast in the Garden of Love*, c. 1465, engraving.

In their link to popular festive entertainment, their moralizing message against lust, their subtle inversion of meanings and hierarchies, their grotesque display of the body, and their direct address and mocking attitude to the viewer, the engravings of the Master E. S. presage much that seems unique to Baldung. These affinities to a print culture two generations past suggest that Baldung fashions his artistic response to the Renaissance individualism of Dürer by returning to an earlier point within the genealogy of the modern self, to images of self produced just before Dürer's moment of self-portraiture. To determine an image's tone, its attitude toward its viewer, we must follow Moxey and gauge the social milieus of artist and of viewer involved in the exchange. Baldung's *New*

166. *Vanity and the Devil,* woodcut illustration from *Der Ritter vom Turn* (Basel: Michael Furter, 1493).

167. *Followers of the Devil Kissing His Ass,* woodcut illustration from Francesco Maria Guazzo, *Compendium maleficarum* (Milan, 1608).

Year's Sheet, as opposed to works like the *Feast in the Garden of Love* and *The Letter "N,"* simultaneously exposes the sexual reality that lies behind any sublimated ideal (courtly love, clerical celibacy, elegant pastimes, etc.) *and* effects the failure of that ideal within the individual viewer himself. What the Master E. S.'s courtesans do to fools, Baldung's witches do to the image's audience. They hold up to their implied male viewer a grotesque but fitting portrait not of other men, or of "man" in general, but of himself in his own aroused and abject body.

The "self" portraiture enacted here is far older than the Dürerian project it overthrows. It is at work, in a general way, in the Master E. S., when the artist shows what people "really" are. And it is the subject of an anonymous woodcut illustration for *Der Ritter vom Turn,* published in Basel in 1493 (fig. 166).[106] A vain "noblewoman," as the text calls her, gazes into a convex mirror as she combs her hair. Behind stands the devil with the head of a horned donkey, who sticks out his tongue and spreads his buttocks to display his anus, which is round like an open eye. The devil's ass appears again in the mirror as the woman's reflection. Although contrary to the logic of space, this grotesque specular image makes apparent the picture's (and the text's) moral lesson. Like the dancing corpse behind Voluptas in the 1497 *Narrenschiff* woodcut (fig. 157), the devil's ass admonishes that women, in essence, are easily corruptible, and that their external beauty is a vain illusion concealing the ugliest of the ugly. Moreover, learned authorities on witchcraft held that women make their pact with the devil by kissing his anus. In a woodcut from Francesco Maria Guazzo's influential *Compendium maleficarum* of 1608, for example, the "members of the devil . . . kiss him upon the buttocks in sign of hommage" (fig. 167).[107] In the *Ritter vom Turn* illustration, self-love or "Vanity" is a devil's pact, and the convex mirror, sized and shaped like the devil's ass, becomes a witch's instrument, as it indeed is in Baldung's 1510 *Sabbath* (fig. 158). The mirror's magic, which transforms face into ass,

eye into anus, same into other, beauty into ugliness, and outer into inner, extends beyond the boundaries of the image. For if we follow the scene's principal orthogonals to their area of convergence, we discover the eye of the devil, which peers at Vanity and, beyond her, at its grotesque reflection in the mirror. As the image's constructed vanishing point, this evil eye or *fascinum* becomes simultaneously the picture's organizing center and the double of *our* eye, around which all lines of single-point perspective are ordered. Not only does Vanity see her true image in the demon's ass, then; the male viewer who might lust after her and the female viewer who might *be* like her find themselves, too, portrayed as the devil's anal eye.[108]

This rough-hewn woodcut offers a model of vision and representation radically different from that other mirrored, self-reflexive interior scene: the Arnolfini wedding portrait (fig. 25). Against Jan van Eyck's ennobling and, for northern art, normative *mise en abyme*, which labels everything we see as the work of the artist, the woodcut's rude conflation of eye, anus, mirror, and picture turns all we see *and are* into the devil's work. Analogizing illusion and *maleficium*, beholder and devil, it offers a powerful antimodel of what images do that is applicable also to Baldung. For in the *New Year's Sheet*, too, the viewer confronts the witch's exposed buttocks as a mirror of his own corruption. And as focus of the somersaulting witch's gaze, he too stands as the picture's point of convergence, indeed, both as participant in a witch's pact and as the devil to whom the witches dedicate their rites. Here the picture's vanishing point is neither an eye nor an anus, but the sterile sex of the old witch, that final station in converging lines of sight extending through the topsy-turvy eyes of the witch and along the tablet's edges, between which the artist is present in his monogram. Like Jan van Eyck's calligraphic inscription, this tablet says "I was here," although in a place, and as a self, no viewer would admit himself to be.

There may well exist a historical link between Baldung and the "Vanity" image. In their relatively sophisticated handling of light, space, and perspective, and in their legible and compelling narratives, the woodcuts for the 1493 Basel edition of *Ritter vom Turn* transcend all illustrations published previously in that city. The young journeyman Albrecht Dürer probably worked in Basel in 1492–1493, and it has often been claimed that he is the artist behind these precocious woodcuts.[109] If so, then Baldung is again dependent on Dürer even where he seems furthest from him; or better, Dürer always already encompasses Baldung's disfiguring reception. Yet whether or not the 1493 "Vanity" is as concretely related to Baldung as this, its self-reflexive plot, which extends the represented scene's moral message to the act of beholding and to the order of representation itself, does provide a clear and popular precedent for Baldung's seemingly eccentric pictorial strategies. In the *New Year's Sheet*, of course, the artist's personal and virtuoso graphic style adds the beauty of art to the seductive lure of the nude witches. Yet through the debased monogram, even this new post-Dürerian orientation has a place within the antimodel proposed by "Vanity."

Such similarities in tone and in plot between Baldung's art and numerous late fifteenth-century prints should caution against constructing too narrow a historical context for a work like the *New Year's Sheet*. It would be a mistake, on the evidence of its inscription,

say, to limit the drawing's message to a statement about clerical celibacy aimed at a particular clergyman on New Year's Day 1514. What greeted the *Chor Kappe* is, in essence, the same story of arousal and abjection that greets viewers of nearly all of Baldung's secular images, whether of witches, corpses, Adams, Eves, or horses. And this plot is prefigured by popular prints and by the festive world of carnival from which they draw their images and techniques of inversion. Yet Baldung's images resist context in even more fundamental ways than this. Just as the Arnolfini portrait, through the convex mirror, purports to include within the painting the reality that lies before it, so too the *New Year's Sheet* and the earlier woodcut of "Vanity" claim to absorb the viewer as the true focus of their distorting reflection. There is no "outside" to this reflection, no vantage point, spatial or temporal, that the picture's omnivoyant eye will not already have claimed to see. If *we* are therefore to posit such an outside—to motivate, that is, a context that can surround this inescapable interior—we must aim wide and investigate the historicity of Baldung's perennial focus: the interpretive self.

Baldung's witches dedicate their sabbath to the male onlooker, disclosing within his heart the corruption they themselves parade. As I suggested of *Death and the Woman* (fig. 135), this conversion of evil from outer to inner, from external image to interior action, is essential to the Christian conception of sin as subjectified abjection. As Christ said, and as the German reformers ceaselessly reiterated, "There is nothing from without a man, that entering into him can defile him: but the things which come out of him, those are they that defile the man" (Mark 7:15). Christianity is at once a salvation religion and a confessional religion.[110] Its promise depends not only on God's intervention, but on a reciprocal preparedness of each person; it thus imposes on believers strict obligations of truth, not only in what they *believe* (Scripture and the authorities and institutions that interpret Scripture), but also in what they themselves *are*. In one of his last seminars, Michel Foucault remarked that in the Christian faith, each "person has the duty to know who he is, that is, to try to know what is happening inside him, to acknowledge faults, to recognize temptations, to locate desires, and everyone is obliged to disclose these things either to God or to others in the community and hence to bear public or private witness against oneself."[111] Christian hermeneutics of self begins as the inquiry into a fallenness that lies hidden within. This secret and largely sexual defilement, more of thought than of deed, must be externalized by the "technologies" of personal self-reflection and penitential confession before a priest.

When Baldung produced the *New Year's Sheet* for his priestly acquaintance, the Christian sacrament of confession had reached a turning point in its history. Deathbed instructions, catechismal writings, and manuals for confessors attest that the late medieval church had not grown lax in its vigilance against sin, as Max Weber and others have maintained.[112] Rather, it increasingly urged its priests to be watchful of their own sins and to demand of their flock a full and sincere penitence at every turn of life.[113] It was the church's onerous psychological, social, and economic demands that the first Protes-

tants—and, before them, humanists like Erasmus—criticized. And one of the chief targets of their assault was the sacrament of confession and penance. On the one hand, they argued that father confessors had grown overly scrupulous, that their quasi-inquisitorial methods frightened the laity from the churches, and that their demand for a complete confession, without which no single sin could be forgiven by God, was anyway impossible given the inherent and continuing sinfulness of all people. As the reformer, church historian, and Old Testament scholar Johannes Oecolampadius put it in 1521, priests were "psychotyrants" (*psychotyranni*).[114] Installed as judges, and never satisfied, they drove their flock into apathy or despair or into a spiritual hypochondria that imagines sins even where there are none.

On the other hand, humanists and Protestants accused confessors of having incited, by suggestion, the very sins they sought to expose. Thus the Eisenach preacher Jacob Strauss wrote in his influential *New Book of Confession* of 1532:

> In the confessional simple folk learn things about sin and evil which have never occurred to them before, and which need not ever have occurred to them! The confessional is a schooling in sin. It is known and many thousand can attest how often mischievous and perverse monks out of their shameless hearts have so thoroughly and persistently questioned young girls and boys, innocent children, and simple wives about the sins of the flesh in their cursed confessional corners that more harm was there done to Christian chasteness and purity than in any whorehouse in the world. He is considered a good father confessor who can probe into every secret recess of the heart and instill into the innocent penitent every sin his flesh has not yet experienced. They want to know from virtuous wives all the circumstances of the marital duty—how their husbands do it, how often, how much pleasure it brings, when it is done, and the like. In this way new desires and lusts are stimulated within the weak.[115]

The criticism that confession can cause what it purports to cure was already heard in the twelfth century. The important thirteenth-century *Summas* for confession routinely cautioned priests against detailing in their questions what a penitent might *not* have done.[116] However, scrupulousness also demanded that priests not take no for an answer but seek behind every denial a hidden affirmation. One important instance of this hermeneutics of suspicion is Jean Gerson's *De confessione mollitiei*, dating from about 1410.[117] The tract explains how best to interrogate penitents about onanism. Since many people masturbate without knowing what masturbation is, or that it is a sin, a confessor must learn the art of circuitous and leading questions. He must try to trap the penitent into a confession by detailing a number of private and seemingly innocent actions and asking whether she or he ever did *that*. No one leaves this inquisition innocent. The penitent either will be found to masturbate or will have learned new skills required for the sin. And priests and monks, according to their Reformation critics, derive carnal pleasure from the encounter, hearing lurid tales from sinners and seducing innocents into vice. The forced confessions of wives and children become the "celibate" clergy's pornography.

Baldung's eroticized images of witchcraft and of death evoke the psychotyranny of the pre-Reformation confessor. Like confession, they are a technology of self, exposing the inner person as a secret, sexual defilement, an original and continually reenacted lapse

from the *imago Dei*. Their tools are entrapment and fear: the macabre corpse elicits repentance, for death and judgment are at hand.[118] And because, like the scrupulous confessor, their method is to discover sin by representing it, they risk pleasing the corrupt viewer and corrupting the innocent. What, after all, was the interpretive effect of the nameless stream exchanged between the witch's sex and the dragon's mouth in the Karlsruhe sheet but to expand our carnal knowledge, causing us to see and think upon things we might never have known before (fig. 162)? And what was shown by the central concealing/masturbating hand in the *New Year's Sheet* (fig. 159), or by Eve's gestures in the Budapest panel (fig. 149), but the prurience of the interpreter? Baldung's pictures portray the viewer by posing embarrassing questions for which there is no "no." They involve him in a double bind in which to behold innocently is to dissemble and to behold knowingly is to admit a fall. Baldung expresses this inescapable logic pictorially, through the ubiquitous gaze out of the picture. The eyes of the somersaulting witch, of Adam of the Fall (figs. 146 and 147), and of the seductress Eve (fig. 131) see us wherever we go and accuse us whatever we think. They are indeed demonized versions of Cusanus's divine omnivoyant, in whose likeness Albrecht Dürer resurrected himself as *imago Dei*.

It is hard to judge whether Baldung's art satirizes or merely reflects late medieval technologies of self. The unusually lewd things his pictures show might be intended simply to heighten an admonition against lust; that these pictures themselves become lewd or pornographic would then be an unintended by-product of their didactic purpose. Or alternatively, Baldung might *want* his pictures to exceed their moral brief so that they can expose as futile any human attempt at righteousness, whether of the viewer or of the artist. The line between complicity and critique, or between unintended and intended effects, is notoriously difficult to draw. Other German artists of the period, it is true, propose markedly different alignments. Lucas Cranach the Elder's mythological paintings always convey some moralizing message, yet their main effect is to please us with their decorative design and to titillate us with their mild eroticism (figs. 179–180, 183). The contradiction between what an image means and what it does evinces little pathos: Cranach can simultaneously and unabashedly warn against vice and exploit vice's sensual charms.[119] Measured against such sweet medicine, Baldung's images are certainly more critical of their own more lewd eroticism. The *New Year's Sheet*, I have argued, focuses this critique. By naming the work's recipient as the sabbath's missing devil, and by including Baldung's monogram within the depicted malevolence, the drawing accuses both its viewer and its maker of being drawn to evil even as they pretend to reject it. The *Chor Kappe* may judge the nude women to be witches; as potential confessor and inquisitor, and vowed to celibacy, he may even be specifically ordained to make this judgment; yet he will nonetheless desire carnally what he condemns. And neither the neutralizing powers of art nor the moral force of abstinence can prevent this fall.

Baldung's critique becomes even more radical when placed within the context of pre-Reformation debates concerning the tyranny and lustfulness of confessors. Like Jacob Strauss's "mischievous and perverse monks" who use the confessional for their own erotic ends, Baldung's *Chor Kappe* is assumed to take pleasure in the drawing's represen-

tation of vice. This may picture the cleric's personal confession, his acknowledgment that he too is defiled within. Yet as figure of the viewer, the *Chor Kappe* also signals a crisis in the Christian technology of self. Confession, according to the medieval church, assumes the capacity of its clergy to see and to judge sin as it is; even if the individual confessor sins, the sacrament he performs remains pure. Therein lies the priest's authority as audience of the laity's necessary self-revelation. Denied his capacity to judge evil, his rituals of inquisition and confession exposed as a witches' sabbath, Baldung's *Chor Kappe* suggests the demise of this authority. In the next chapter, I will examine Luther's epochal solution to this demise as it is embodied in images of salvation through faith alone. In Baldung, nothing replaces the confessor's now-defiled gaze; the viewer is left uncertain wherein his hope now lies.

It would be highly misleading, however, to confine the psychotyranny of Baldung's witches to their effect upon the viewer. These prints and drawings mockingly expose the hidden lust of the cleric, and of a male audience generally, yet they derive their substance from far crueler interrogations and forced confessions. As mentioned earlier, Baldung's repertoire of what witches are and do is largely the concoction of minds "learned" in the evidence of witchcraft trials. Assuming always the guilt of the accused, establishing apostasy through entrapping questions and, when necessary, breaking the accused through imprisonment, threat, and torture, these trials are the violent cousins of penitential confession. The *Malleus*, for example, advises how inquisitors should construe the tears of women tortured for witchcraft. She who does not cry in pain is a witch whose magic numbs the hurt; she who sheds tears dissembles, for what are witches but mistresses of deception?[120] I am reminded here of the cadaver's victim in *Death and the Woman*, whose tears are not her own but are a misogynist fantasy of women's "deserved" punishment (fig. 135). Baldung constructs his rigorously gendered technology of self upon a sadistic, circular logic that cannot countenance its real victims' experiences, even as it will not take no for an answer. Thus, while the sabbath's real victims are the women and men who died as witches at the hands of magistrates and inquisitors, Baldung—for his whole male, learned culture—poses himself and his viewers as dupes of women's carnal power. He may qualify his accusations by playing requisite to the sabbath, or by satirizing the *Chor Kappe* as the hidden devil. He may even locate the source of the trouble within the male self, that is, within its faulty cognitions and fallen desires. This was also Dürer's position when he wrote why absolute beauty was unavailable to him: "The lie is in our understanding [*erkantnus*]."[121] Today, however, these paradoxes of visual experience seem rather the ironies of an unequal society. They are the consequences of real contradictions between, for example, patriarchy's dream of self-sovereignty and the realities of desire, here projected misogynistically onto the bodies of women. In hindsight, the psychotyranny of Baldung's witches includes the inquisitor's fires. The lies and deception that the male viewer sees before him are, far more than he or the artist would confess, his own.

Baldung thus introduces us to the dark side of the rise of modern identity. The technology of confessors and inquisitors, appropriated by the artist, aims at discovering the true self within. What it finds could not be further from the pious, complete, and resur-

rected *imago* of Dürer as representative man. Baldung's images of witches and of death return the viewer to a radical uncertainty about what a person is. They return him to where both his perceptions of outer fact and his inner fantasy might be the devil's work, where tears always mean something worse than suffering, and where pictures of the enemy are portraits of self. Yet no matter how encompassing these self-flagellating portraits claim to be, they still portray a kind of self to the exclusion of—indeed *as* the exclusion of—other selves. Baldung's witches remind us that Renaissance Man was male.

The inscription on the *New Year's Sheet*, addressing one specific cleric as the work's intended viewer, encourages us to imagine the milieu of Baldung's original audience. It asks how, at this particular time and place, and beyond the artist's personal formation as epigone of Dürer, an art as eccentric in its imagery and as wildly self-reflexive in its effects as Baldung's could find a public. For whom, beyond himself, did Baldung mortify the image and demonstrate interpretation's vagary?

Relative to other important German-speaking cities like Nuremberg, Basel, Augsburg, Vienna, and Cologne, Baldung's native Strasbourg emerged as an intellectual center rather late.[122] Through its size (about twenty thousand inhabitants), its dual status as free imperial city and bishop's seat, its strategic location along key land routes between Italy and the North, and its possession of the Rhine's northernmost bridge, the city had long been an economic and political power in the Upper Rhineland. But only in Baldung's lifetime, during a rare interval of peace between 1480 and 1520, did Strasbourg begin to attract a significant number of prominent scholars, poets, and theologians. Though trained elsewhere, they established the Alsatian city as the hub of a new and distinctive brand of humanism. One vital focus of their community was a *sodalitas literaria*. Founded about 1510 by Jacob Wimpfeling and Sebastian Brant and modeled after Celtis's circles of the same name in Vienna and Nuremberg, the *sodalitas* was an informal association of the city's principal humanists: clerics, lawyers, scholars, and publishers like Hieronymus Gebwiler, Nicolaus Gerbel, Otmar Luscinius (Nachtigall), Johann Rudolphinger, Peter Heldung, Thomas Vogler, Jacob Sturm, Johann Ruser, Johann Guida, Thomas Rupp, Stephan Teiler, and Matthias Schürer.[123] Although we know nothing about actual meetings of the Strasbourg *sodalitas* other than a banquet it held in 1514 in honor of Erasmus,[124] one can surmise from other such groups that the members gathered regularly to read from classical works, present their own poetry and historical writings, plan new editions of classical authors to be published by one of the many Strasbourg presses, and devise educational programs for the elite.[125] It was for this kind of a learned, like-minded, and rather closed[126] group that Baldung might have intended his most difficult creations. For works like the *New Year's Sheet*, the Basel *Death and the Woman*, and later the Ottawa *Eve, the Serpent, and Adam as Death* (fig. 151) demand not only that the viewer grasp the image's complex theological implications, but also that he recognize the dense fabric of allusions to other works by Baldung and by Dürer—a situation best imagined for an intimate circle

of educated, self-consciously sophisticated, and visually literate men in contact with patrician and aristocratic collectors and personally acquainted with the artist himself.

Unlike Dürer, whose access to the humanist circles of Pirckheimer and Celtis was achieved through talent and fame, Baldung was born into the ranks of Strasbourg's intellectual elite. As noted earlier, his father, brother, uncle, and cousin all held high bureaucratic posts and were doctors of either law or jurisprudence.[127] Baldung also maintained his status through marriage, money, and professional achievement. His bride, Margarethe Herlin, whom he married in 1510 soon after his return to Strasbourg, came from a family of merchants, artisans, and professionals; her uncle Martin Herlin the Elder (d. 1547) was a minor merchant who became a major political figure in Strasbourg, serving five terms as *Ammeister,* the commune's highest office.[128] In the course of their thirty-four-year marriage, Hans and Margarethe Baldung accumulated a modest fortune by investing money that Hans had received in 1517 for painting the great retable for the high altar of the Freiburg Minster. It was at least as much through income on secure annuities, speculation in land and real estate, and investment in peasant debt as through Baldung's art that the couple increased their wealth.[129] If many of his images seem, in their theme, style, and mode of address, inaccessible to a broad public, this is perhaps because, after about 1517, Baldung did not need to live from his art alone, as Dürer and Cranach had to. Of course Baldung also remained active and highly esteemed as an artist throughout his life, despite the decline of art patronage during the Reformation. Whereas some Strasbourg artists were thrown into poverty in the 1520s,[130] Baldung enjoyed a healthy market for his portraits, secular panels, and designs for coats of arms. In 1533 he became a permanent member of the ruling council of the guild Zur Steltz (a corporation dominated by wealthy goldsmiths but including printers, painters, and glaziers); and in 1545, the year of his death, Baldung held the prestigious office of senator for the guild in Strasbourg's civic senate, which was the highest political position ever held by a painter during Baldung's career in the Alsatian capital. Socially, financially, and politically well connected, Baldung would thus have had full access to the city's humanist elite.

Early Strasbourg humanists tended to be intellectually conservative. Dominated by the fierce moralism of Geiler and of Brant, they regarded their present age as growing ever more corrupt, and they distrusted innovation as potentially a sin. They placed their new methods of advanced philology at the service of traditional theology and moral doctrine, emphasizing above all the sinfulness of man, his consequent mortality, and the vanity of his earthly endeavors. The radical pessimism of the *Narrenschiff,* rejecting all forms of individualism as merely versions of the controlling sin of vanity, set the tone for the culture and defined its aesthetic sensibility. Brant's poem introduces individual selves as colorful exempla of general categories of folly, each of which can be summed up in a chapter and pictured in a woodcut (figs. 157 and 204). Yet the overall message of the *Narrenschiff* is that the very existence of such individuals, such heterogeneous deviations from the group or the *ordo,* is itself the sign of the Fall. Brant's anti-individualism, far removed from the Burckhardtian Renaissance as discovery of self and world, also determines his literary style.[131] Paratactic in its structure, impersonal in its narrative voice, and

purged of any formal or moral surprises, the *Narrenschiff* practices what it preaches; as a work of art it refuses, even within its own poetry, to valorize the power, autonomy, and freedom of human making. In the manner of medieval artisans, who register their authorship at most within formulas of modesty, Brant portrays himself as a fool twice within his poem. Hans Baldung Grien's disfiguration of Dürer, his portrayal of self as always a fallen category of experience, is perhaps a continuation of this native Alsatian pessimism.

Yet where Brant keeps the chaos of folly at bay, preserving the omniscience and authority of his own gaze throughout and styling only his poem's end as the onset of carnival proper (the *Narrenschiff*'s colophon dates the publication to "Fastnacht . . . 1494"), Baldung embeds his art more deeply in the sins and follies it depicts. The self-conscious originality and eccentricity of his images link Baldung to a younger group of Strasbourg humanists who, succeeding the generation of Brant, Geiler, and Wimpfeling, embraced Erasmus as their spiritual and aesthetic model and accepted the Dutch humanist's scriptural interpretation as a means toward a truer, though perhaps less self-evident, faith.[132] While his obsession with death, witchcraft, and the Fall links him to Geiler and Brant, Baldung's method lies far closer to that of Erasmus in the *Praise of Folly*. Erasmus reveals us to be hermeneutic animals, beings for whom the right reading of the world and of Scripture is at once impossible and necessary, for thus are we judged. Baldung's images, similarly, are about interpretation. They are, as I have shown, portraits of the interpretative self as sole, but wholly fallen, arbiter of a picture's plot. Read against the humanist culture that received them, they articulate, in visual terms, a "crisis of interpretation" that characterized intellectual life on the eve of the Reformation.

Discussion about the rules, nature, and role of interpretation arose from two distinct areas of thought in the period. First, Renaissance humanists developed the skills of an advanced philology in their encounter with classical texts.[133] The efficacy of philological hermeneutics supported the humanists' claim to have instituted a genuine revival of antiquity; the world of classical letters and learning could be embraced only when the old texts had been properly reconstructed and their original meaning recovered. Second, religious reformers from Erasmus to Luther and Philipp Melanchthon were developing new methods of scriptural exegesis as part of their effort to establish a more accurate text of the Bible and to provide a more faithful interpretation of Christ's message there. As Wilhelm Dilthey argued in his *Entstehung der Hermeneutik*, hermeneutics as a discipline can be said to have arisen out of the reformers' defense against Catholic theologians, who, questioning the evangelical understanding of the Bible, appealed to tradition as the indispensable arbiter of truth.[134] Against the authority of tradition, Luther proposed that truth was not something preserved within the unbroken genealogy of orthodox exegesis but was a message discovered in any believer's immediate and pious encounter with the Bible. As Hans-Georg Gadamer writes, for Luther "Holy Scripture is *sui ipsius interpes*. Neither tradition nor an exegetical art in the manner of the antique doctrine of fourfold allegory is required to gain its correct understanding. Rather, the letter of Scripture has an unequivocal meaning ascertainable from itself: the *sensus literalis*."[135] The doctrine

of the immanent legibility of the Bible involved a number of troubling paradoxes, how-ever. Given Luther's Augustinian insistence on the fallenness of man and the absolute servitude of the will, how was it possible that the self, incapable of independent moral judgment, could turn to the Bible with its interpretative faculties unimpaired? Having repudiated the *consensus omnium* as a guarantee for the right reading of the Bible, how could Luther, or any other single Christian, maintain that his interpretation of God's word was any more valid than a heretic's?[136] The violent schisms within the evangeli-cal movement itself were ample proof that Scripture's *sensus literalis* varied according to the doctrinal outlook of the interpreter. The Bible is one book, but read alone, without any authoritative guidance, it can transform Christendom into a many-headed Hydra (fig. 31). The possibility of multiple interpretations was only enhanced by the dissemi-nation and multiplication of Scripture through vernacular translations and the printing press. As we read in the opening couplets of the *Narrenschiff:*

> All lands are now full of holy writ,
> And of that which touches on the soul's salvation:
> Bibles, the writings of the holy fathers,
> And many other similar kinds of books.[137]

Yet the world is as full of fools as it is of Bibles: "All streets and alleys are full of fools / Who go about with nothing but folly."[138] Indeed, folly multiplies precisely because of this proliferation of books. Erasmus's comic antiscripture *Praise of Folly,* the *Narrenschiff*'s im-mediate heir, embeds this message within the reader's very experience of the text. Self-love, folly's first principle, turns everything we read into a mirror of ourselves; yet Christ is the supreme fool, and salvation depends upon our right reading of his testament.[139]

A contradictory message of the authority and abjection of self runs through the whole theology of the Reformation. By locating piety in a personal relation to God, in the au-tonomous act of belief outside any clerical hierarchy or saintly intercession, the Refor-mation raised the level of the self's responsibility to an apocalyptic pitch. It established what Dilthey was to call "the self-glorification of the believing person"[140] that consti-tutes a crisis in the history of subjectivity. Luther, looking back on his own early spiri-tual development, understood the epochal turning point in his thought as a reorientation of his reading of Scripture, a reformation of the *hermeneutical* encounter between self and text. In an autobiographical passage of 1545, the Reformer recalls how, about 1514, he struggled with the words of Rom. 1:17: "Therein is the righteousness of God re-vealed." At first Luther took "righteousness" to be an objective attribute of God, and he despaired that he, sinner that he knew he was, could ever be justified in these terms. By an act of divine mercy, however, it became clear to him that the "righteousness" St. Paul wrote of was something we ourselves achieve through our faith as constituted within our exegetical response to the gospel. This grammatical turn, through which Scripture refers wholly to individual readers in the here and now of their faith, transformed the very message of the Bible: "At once the whole Scripture showed me a different face."[141] Every-thing suddenly *meant* differently: "God's work, that means what God works in us; God's

power, through which he makes us powerful; God's wisdom, through which he makes us wise; God's strength; God's salvation; God's glory."[142] At 1514, the year of Baldung's *New Year's Sheet*, and through one individual's revolutionary exegesis, the human self in the pious act of reading the gospel stood as the gospel's true and ongoing subject.

The reformers, however, also undermined this very sense of selfhood whose historical emergence they had helped bring to pass. They admonished the self with the knowledge that its power to believe or not to believe, and to interpret correctly or not correctly, was not its own power but was the gift of a merciful God, a gift comparable to the coming of Christ into the world. After all, it was the personal recognition of his inner defilement and weakness, of his inability ever to justify himself, that led Luther to his hermeneutical breakthrough of 1514. Even as they invested the self with an unprecedented authority, raising it to be sole arbiter of Scripture's significance, the reformers burdened it with a deeper awareness of how clouded, how fallen, its vision really was.

It is within such contradictions of an emergent selfhood that we begin to discern a crisis of interpretation in sixteenth-century northern culture. By "crisis" I mean that interpretation had reached a critical moment or turning point in its history and, further, that this historical process also deprived individual selves of some part of their own sovereignty as knowing subjects.[143] No longer merely a submerged component of human understanding, interpretation became the object of intense scrutiny by theologians, scholars, lawyers, writers, and artists alike. Baldung may have established spectatorship as the obsessive theme of his secular images because he himself was quintessentially a viewer of Dürer's originary art; yet this thematization of response, akin to Erasmus's *Praise of Folly* and to the *initia Lutheri*, would have resonated deeply in his surrounding culture. For in its spiritual life and its learning, this culture too was rethinking interpretation's very nature. Baldung's contemporary viewers in Strasbourg and beyond would have been familiar with the *message* of his art: how original sin ensnares us simultaneously in sexual desire and in death; how any admonishment against evil can become, in the words of a corrupt confessor or the pictures of a lustful painter, an invitation to sin; how witchcraft merely manifests, in the extreme forms of devil's pact, *maleficium*, and autoeroticism, the turn from love of God to love of self that is our perennial inheritance; and how Renaissance individualism may itself be a form of apostasy. What would have been new to these viewers, however, and what would have addressed their most urgent concerns, was the *method* of Baldung's art. The bottomless play of visual allusions upon which his images are built; the engineered uncertainty as to the objects, substances, and actions he depicts; the projection of his picture's plot onto the very body of the viewer as involuntary desire for, or revulsion against, what is seen: these are all strategies for internalizing the image's message in subjective experience, that is, for locating that message in the work's hermeneutical effect. It may have seemed that my own account of Baldung, which regards meaning as both the image's constative message and the way that message is experienced, projects a modern interpretive paradigm on the objects of the past. Yet as Dilthey has already argued, this modern hermeneutics began in Germany about 1500 in exegetical struggles like Luther's, was newly inflected by Friedrich Schleiermacher about

1800, and formed the epistemological foundation of the human sciences as they developed in the wake of romanticism. In curious and yet unexplored ways, Baldung's pictures are also *historical* portraits of ourselves.

It lies beyond the scope of the present book to write this self-inclusive history or even to sketch the shape and motivating conditions of the crisis with which it may have begun. Instead, I have investigated one group of German works from about 1530 in which a new mode of scriptural exegesis—Luther's hermeneutical breakthrough regarding "righteousness"—explicitly determines both the content and the form of the visual image. Although they complicate our trajectory from Dürer to Baldung, the works analyzed in the next chapter place our controlling terms of "self" and "image" in the broader historical context of the Reformation.

16

Homo Interpes in Bivio
CRANACH AND LUTHER

You should not show me any honor,
I am an image and nothing more,
And cannot give you the slightest help,
Therefore don't you fall in love with me.[1]

These homely lines, inscribed on a 1617 crucifix in the German village of Geislingen, Württemberg, sum up a Lutheran attitude toward pictures. The representation of the holiest of holies, Christ the redeemer on the cross, speaks directly to the viewer in the here and now only to say: Do not worship me, I will give you nothing, I am nothing. The help (*Hülff*) that the picture will not give are the indulgences, miracle cures, and spiritual advancements promised by the church's cult of images. The honor (*Ehr*) that the viewer should not pay, equated here with erotic infatuation (*vergaffen*), is what icono-phobes in the Latin West since the late eighth-century *Libri Carolini* term *adoratio:* prayer to the icon itself, rather than to what or whom it represents. In simple language for simple people, the text negates the image it inscribes. Neither labeling the crucifix nor citing Scripture nor publishing a prayer, it warns against the power of images, against their capacity not merely to depict God, but also to be mistaken for him. In the Reformed faith, the second commandment against graven images merges with the first: *Du solt nit ander Götter haben,* reads a wholly imageless retable altarpiece from 1537 in the Lutheran Spital-skirche in Dinkelsbühl.[2] In Geislingen, the text's task is to maintain the boundary between icon and idol, to ensure that the love of God does not become a love of things.

Baldung's disfiguration of Dürer is neither the only nor even the most central critique of the Renaissance aesthetics of the beautiful. I have limited my study of the moment of self-portraiture to these two artists because Dürer founded what art and artist meant to most successful German masters working in his wake, and because Baldung decon-structed these foundations, but always from within. The viewer of the *New Year's Sheet* may learn that he is fallen, that is, that he knows too much. He may even learn that the

love of beauty is *also* a carnal infatuation or *vergaffen* and that, rather than offering a neutral space outside the church, the art lover's "beautiful rooms" (Franz von Sickingen) are still chambers of desire. Yet in experiencing his taint, the viewer will also savor the prestige of his learning, taste, and ownership. Dürer evokes a nascent humanism eager to see everything anew; Baldung's viewers seem already to have seen it all; but neither recommends that worldly seeing be given up. The much-debated decline of German painting after about 1530 was hardly a necessary consequence of the tradition's inner logic. It came rather from without, either as iconoclasm, as a decline of patronage for religious art, or as a reinvention of the visual image's cultural function.

The Geislingen crucifix speaks for itself, like the magically real statues of Daedalus, but only to deny there is any magic in it. For the source of power lies not in the image but in a beholder who wrongly does it honor. Attention to the role played by the viewer in constituting a picture's message is not limited to the art of Baldung. It forms the core of Luther's theology of images as it emerged in the 1520s, as a middle path between the church's flourishing cult of images and the violent iconoclasm of Wittenberg's radical theologian, Andreas Bodenstein von Karlstadt (1477–1541).[3] Luther did not accept or reject images because of any immanent power, good or evil, they might possess. Rather, he judged them by their effect on the viewer and on the uses to which they were put: *Non est disputatio de substantia, sed usu et abusu rerum.*[4] To believe otherwise, to invest the image with intrinsic virtue *or* vice, was idolatry. Hence Karlstadt and the iconoclasts were as bad as their Catholic enemies, for instead of correcting the human practices and beliefs that empower the image, they vented their anger on the image itself.

A Nuremberg broadsheet from 1530 clarifies this point.[5] In the woodcut by Erhard Schoen that heads the sheet, iconoclasts burn, hammer, and steal the images of a church, while at the upper right their richly clad leader stands surrounded by wine, women, and wealth (fig. 168). The curious object that extends like a diagram of his gaze is the "beam that is in thine own eye" of Matt. 7:3. The iconoclast, we are meant to infer, accuses others of idolatry but does not see his own much greater sins. In the long poem printed below, entitled *Complaint of the Poor, Persecuted Idols and Temple Images,* the pictures rally to their own defense. They admit they deliver "such a good illusion" that people take them to be "God himself"; yet this is not the fault of the images: "You yourself made us into idols, who now laugh at us." Like the Geislingen crucifix inscription, the *Complaint,* written as if actually voiced by the poor idols, itself ironizes the projection of person onto inanimate things. Against the iconoclast blinded by the beam of his own vision, the Nuremberg broadsheet urges self-knowledge. It argues that idolatry and iconoclasm are both projections of self, and that this self remains sinful whether it creates, worships, or destroys these projections. The moment of self-portraiture, which in Dürer transformed the icon into the artist's apotheosis, is in the Reformation art's disenchantment.

No artist is as closely linked to Luther and the Reformation as Lucas Cranach the Elder (1472–1553), court painter to the electors of Saxony in Wittenberg.[6] Throughout his career, which stretched over half a century, Cranach produced panel paintings, book illustrations, title pages, and broadsheets that articulated and furthered the Reformation's

168. Erhard Schoen, illustration to *Complaint of the Poor, Persecuted Idols and Temple Images* broadsheet, 1530, woodcut.

cause. Already his panel *Ten Commandments* (FR 69), completed for the Wittenberg town hall in 1516, is clearly influenced by Luther.[7] In 1521 he illustrated Luther's *Passional Christi und Antichristi*, the book that launched the Reformer's attack on the papacy through the medium of the printed image (J. 557–583; fig. 187).[8] In his numerous altarpieces and epitaphs, he restructured older visual forms to fit the rituals and beliefs of the new faith.[9] And in his many painted, engraved, and woodcut portraits of Luther, he created a rich iconography that shaped and preserved the popular conception of the Reformer. Some impressions of Cranach's 1520 engraving *Luther as Augustinian Monk* contain a small likeness of a bearded man (fig. 169). Etched faintly on the blank ground in the upper left, this profile bears a distinct resemblance to the known self-portraits of Cranach; rays of inspiration extending from its forehead toward Luther's brow suggest a deep spiritual bond between the two men.[10] Cranach's relations with Luther were personal as well as professional. Luther corresponded with him during the Wartburg captivity (1521–1522); he was the only layman at Luther's wedding in 1525; in the same year he made Luther godfather to his daughter Anna; and in 1526 he became godfather of Luther's son Johannes.[11] But of all the connections between these two citizens of Wittenberg, the most important was their probable collaboration on the iconography and composition of a group of images variously called "Allegory of Law and Grace," "Justification of the Sinner through Faith," and "The Law and the Gospel."[12]

Devised in 1529–1530, Cranach's formula juxtaposes the law and the gospel, *lex et evangelium,* as two antithetical scenes around a central axis. In some versions of the formula, Cranach stages the antithesis as a single scene of choice or decision, in which the deciding self, represented as a nude man and labeled *Mensch,* occupies the center between the two alternative covenants. The crisis thus depicted within the picture is meant to extend to the picture's beholder: *we* are placed before a decision, and in the specific status afforded us as willing subjects, we are instructed on our own capacity to know and

to choose. The human subject within the scene, and by extension the image's implied viewer, is afforded a particular role to play in confronting choices, a role that can easily pass from the manifest realm of ethical and spiritual impasse to a more latent crisis regarding the interpretation of the work of art itself. Observing the interplay between choices open to the viewer, and checking our own responses against Luther's account of the proper form and function of visual representation, we can discern not only the status afforded the self in making sense of a Reformation image, but also what the image imagines "understanding" and "meaning" to be.

Cranach's formula appears in a large number of images not only by Cranach and his school, but also by other northern artists who copied Cranach's invention, among them Hans Holbein the Younger, Peter Gottlandt, Franz Timmermann, Erhard Altdorfer, Georg Lemberger, and Geofroy Tory.[13] The formula was also executed in an extraordinary range of media, from retable altarpieces, epitaphs, wall paintings, and monumental panel paintings to popular broadsheets, illuminated miniatures, title-page woodcuts, stained-glass windows, marriage chests, pulpit decorations, iron stove tops, and tooled book bindings.[14] The sheer diversity and scope of its visual embodiments already denote something about the nature of our object. The law and the gospel is a visual formula, a pastiche of traditional Christian motifs arranged in a new way. Framed by biblical quotations, cluttered with identifying labels, possessing the two-part structure of an open book, and heedless of the rules governing a unified representation of space and action, it aspires to the condition not of painting, but of writing.[15] It does not depend upon subtle execution for its effects, nor does it, therefore, demand that we interpret it in its earliest, most authentic, or aesthetically most pleasing concretions. We stand far removed from Dürer, whose self-portraits emblematized art as the irreducible link between image and maker, and from Baldung, whose images, however self-mortifying, are valuable through their eccentric originality and understandable through their cross-referencing within a personal oeuvre. That the artist Cranach the Elder—his personality, artistic styles, shop practices, and so on—plays far less of a role in our interpretation of the law and the gospel than does the theologian Luther is not a methodological strategy but a consequence of these images themselves. In both its content and its form, Cranach's the law and the gospel dismantles the notion of self and image upon which most Renaissance, and post-Renaissance, myths of the artist are founded.

The law and the gospel does seem to have played an important role in Cranach's own conception of himself as a person, however. In the central panel of the retable of the high altar of the City Church of Saints Peter and Paul in Weimar, the artist appears together with Luther within the allegorical landscape of *lex et evangelium* (fig. 170; FR 352).[16] The work was probably begun by Cranach the Elder about 1552, but because he died the following year, it was completed by his son Lucas the Younger and installed about 1555; the artist's likeness is therefore a kind of posthumous self-portrait made possible by his son's exceptional ability to continue where his father left off.[17] The presence of Luther in the *Weimar Altarpiece* is also appropriate, not only because the Reformer was probably involved in formulating the original iconography of Cranach's image, but also because the image articulates *the* doctrinal center of Luther's theology.

169. Lucas Cranach the Elder,
Luther as Augustinian Monk,
1520, engraving,
Kupferstichkabinett,
Kunsthalle, Hamburg.

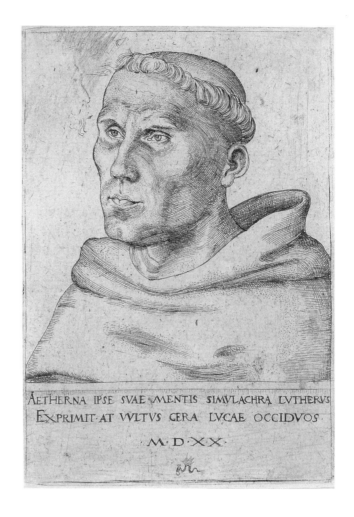

AETHERNA IPSE SVAE MENTIS SIMVLACHRA LVTHERVS
EXPRIMIT·AT VVLTVS CERA LVCAE OCCIDVOS·

M·D·XX·

In the course of his career, Luther renewed the urgency of St. Paul's contrast between the law and the gospel, expanding it from an exegetical scheme distinguishing two stages of salvation history to a difficult figure of thought, the understanding of which forms the basis of all theological knowledge.[18] In his *Enarrationes epistolarum et euangelium* of 1521, Luther recommends the contrast between the law and the gospel as a pedagogy for understanding Scripture: "Nearly all of Scripture and the comprehension of the whole of theology depends upon the proper understanding of the law and the gospel."[19] And again in 1537, in his first *Disputation gegen die Antinomer:* "You have often heard that there is no better way of preserving and transmitting the pure teaching of Christ than to follow this method: that we divide Christian teaching in two parts, namely, the law and the gospel."[20] Understanding, here, is not the property of an ecclesiastical elite, the coveted knowledge of priests, doctors, and officers of the church. Since Luther maintains that all people's salvation depends on their personal response to Scripture, then each believer's understanding of the law and the gospel, indispensable to reading Scripture, carries a universal soteriological burden. Luther presents the law and the gospel as an interpretative task characterized by its difficulty; to distinguish between the two, he writes, is

"the highest art in Christendom."[21] Difficulty functions here more as invitation than as obstacle to thought: a quasi-calculated obscurity that deepens a reader's interpretative response.[22] The law and the gospel is Scripture's immanent hermeneutic; it is a georgic of the mind, in which the central labor of a Christian is taught: the pious reading of and response to the Word of God embodied in the Bible.

All this is not new to Luther. In the Gospel of John, Christ himself relates Old Testament to New Testament, type to antitype, when he interprets the brazen serpent of Numbers 21 as a prefiguration of his own crucifixion (John 3:14).[23] In the *Weimar Altarpiece*, Cranach depicts this very typology in the landscape just above his own likeness, and he shows Luther pointing to the brazen serpent passage in the Bible he holds open to us as if to validate the painting's controlling interpretation of Scripture and of history through the scriptural norm. What is new to the thought of the Reformation, however, is the way the law and the gospel is projected into the present moment. The transformation of the formula *lex et evangelium* from a description of history to an elusive figure of thought not only reflects the existential thrust of Lutheran theology; it also represents faith not as a gift given to those who happen to be born after the era of the law, but rather as something achieved through a right *interpretation* of precisely that historical transition. For every believer must understand the *meaning* of the gospel's succession of the law if he or she is to receive that gift of grace that is the gospel's promise. The passage from law to gospel takes place as exegesis, not as history. That is one reason why, in the *Weimar Altarpiece*, a contemporary figure can appear as specific antitype of an Old Testament type, perhaps for the first time in Christian art.[24] Luther points to the text of the gospel as the postfiguration of Moses pointing to the tablets of the law. Cranach, in turn, appears in the scene as Everyman who, alone and in his own way, must come to terms with the dialectic of the law and the gospel. Self-portraiture thus appears as a moment of salvation history transformed, through Luther's epochally new understanding of self, into the here and now of faith.

At once a privileged object of interpretation and a preferred hermeneutic for understanding Scripture, Luther's law and the gospel can serve as a perfect example of the crisis of interpretation in sixteenth-century German culture. The Reformer taught that Paul "deals with the law with respect to the inner man and the will and not with respect to the outer man and his actions."[25] This difficult distinction between inner and outer occurs in Luther's intellectual development, as it will for all those who follow him, as an exegetical awareness, a quasi-heroic return to a right reading of the Bible. What this reading urges is not the power of self, however, but its opposite: "The purpose of every word of Scripture and of God's every action is to effect the change by which every man becomes spiritually a sinner, and this change must take place in our self-awareness and self-esteem."[26] The law and the gospel is the Reformer's central pedagogy against self-assertion.

Examining pictorial representations of the Lutheran doctrine, I shall consider both how Cranach structures his image to instruct viewers on the distinction between the law and the gospel and what this instruction implies about the viewer's self. One of

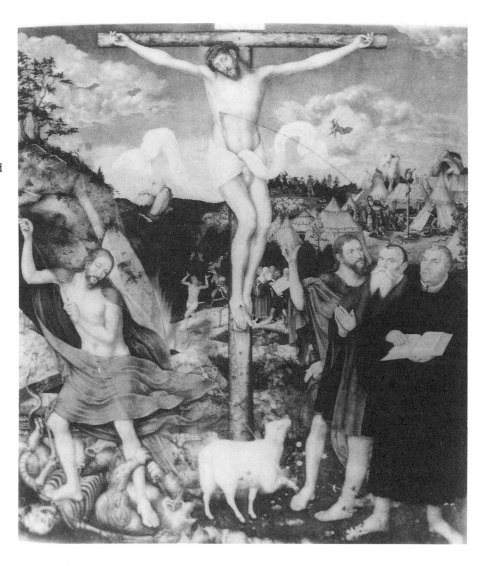

170. Lucas Cranach the Elder and Lucas Cranach the Younger, *Crucifixion with the Law and the Gospel*, central panel of the high altar in memory of Johann Friedrich of Saxony, 1555, oil on panel, City Church of SS. Peter and Paul, Weimar.

Cranach's strategies is to represent the distinction not as a succession of historical eras, but as two choices open to the viewer in the present. While he restores to the image of choice a traditional symmetry—one denied, for example, by Baldung's *Death and the Woman* (fig. 135)—Cranach renders the actual nature of choice profoundly problematic. Choice, or the implied lack thereof, addresses different period concerns here, including Luther's doctrine of free will and the Reformation's growing awareness of itself as a movement that requires of its followers a decision. My concern lies primarily with the history of art, however. I will suggest that Cranach's images of the law and the gospel intentionally curtail interpretative choice and, further, that the schematic character of these images, their abstracting symmetry, negotiates a deepening asymmetry between image and viewer. More explicitly even than Baldung, Cranach depicts man, the interpreter, at the crossroads.

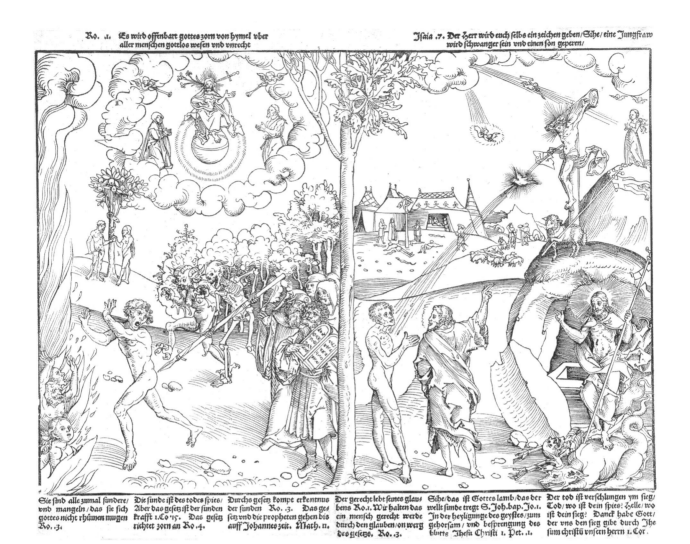

Ro. 1. Es wird offenbart gottes zorn von hymel vber aller menschen gottlos wesen vnd vnrecht

Isaia .7. Der Herr wird euch selbs ein zeichen geben/Sihe/ eine Jungfraw wird schwanger sein vnd einen son geperen/

Sie sind alle zumal sündere/ vnd mangeln/das sie sich gottes nicht rhümen mugen Ro. 3.

Die sünde ist des todes spies/ Aber das gesetz ist der sünden krafft 1.Co.15. Das gesetz richtet zorn an Ro. 4.

Durchs gesetz kompt erkentnus der sünden. Ro. 3. Das gesetz vnd die propheten gehen bis auff Johannes zeit. Math. 11.

Der gerecht lebt seines glaubens Ro.1. Wir halten das ein mensch gerecht werde durch den glauben/on werg des gesetzs. Ro. 3.

Sihe/das ist Gottes lamb/das der wellt sünde tregt S. Joh.bap. Jo.1. In der heyligunge des geystes/zum gehorsam / vnd besprengung des bluts Jhesu Christi 1. Pet. 1.

Der tod ist verschlungen ym sieg/ Tod/wo ist dein spies: Helle/wo ist dein sieg: Danck habe Gott/ der vns den sieg gibt durch Jhe sum christu vnsern herrn 1. Cor.

171. Lucas Cranach the Elder, *The Law and the Gospel*, c. 1530, woodcut, British Museum, London.

The best known of Cranach's images of the law and the gospel is a single-leaf woodcut dating from 1529–1530 (fig. 171; J. 311). Extant in only two impressions, it is probably preceded by a panel painting by Cranach from 1529, now in Gotha (fig. 172; FR 183).[27] The woodcut is a better starting point for my discussion, however, because it endows the system of correspondences between the various scenes and figures with the greatest legibility. Cranach visualizes the law and the gospel best in the abstracting medium of the line. "Graphic" comes from the Greek *graphe*, "writing"—the condition toward which Cranach's formula aspires. In one impression of the woodcut, the lower edge of the sheet supplies the text or *verbum Dei*, ubiquitous in Reformation art, which places the image against its proper horizon in the word.

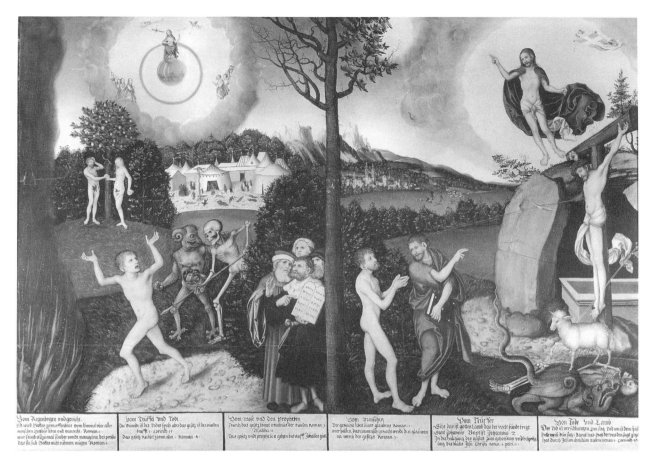

172. Lucas Cranach the Elder, *The Law and the Gospel*, 1529, panel, Staatliches Museum, Gotha.

The left or sinister half of the woodcut represents the gloomy message of the law. At the center of the scene, and emerging from a forest of sin,[28] Death and the devil—stock characters of the macabre—drive a naked sinner into the flames of hell. The impish glee with which the cadaver and its partner pursue their chase, as well as the rude placement of Death's spear behind the sinner's buttocks, underscores the bathos of sin. The spear puns on the biblical quotation printed below: *Die Sünde ist des Todes Spies* ("The sting of death is sin" [1 Cor. 15:56]). Cranach invokes the comic in order to deflate damnation's pathos and turn tragedy to farce. The sinner, thus pursued, glances back over his shoulder at Moses. Surrounded by Old Testament prophets and bearing the two tablets of the Decalogue, Moses appears as lawgiver, urging man to follow God's commandments. Yet the effect of the law is not obedience, but the story of deviltry, death, and damnation enacted before us. Cranach shows the cause of this failure. Farther back in the landscape, squeezed into a narrow space directly above the sinner's outstretched left hand, Adam takes the apple from Eve. The sinner's gesture has at least two valences, expressing his futile flight from sin and death and repeating Adam's left-handed acceptance of the fruit.

The Fall, where "by one man sin entered the world, and death by sin" (Rom. 5:2), is at once the historical origin of our disobedience to the law and an inheritance repeated in our every gesture and volition. Hence Cranach's visual echo of the Expulsion in his depiction of the sinner driven to hell,[29] and hence his conflation of flight from sin and reiterated trespass in the sinner's outstretched left hand.

Cranach thus assembles the core of Luther's Pauline reading of the law: because we are fallen and cannot obey God's commandments, the law exists only to damn us. "The law brings sin and the wrath of God," writes the Reformer in 1515 in his *Lectures on Romans*.[30] The argument, Luther admits, is hard to grasp. It runs contrary to "human self-understanding" and "contrary to the metaphysical or moral method of reasoning," which suppose that the law is addressed "to the outer man and his actions" and is therefore meant to be obeyed. Cranach tries to visualize Luther's "spiritual" reasoning, where the law has meaning to "the inner man and the will."[31] Man's actions may seem to ascend toward God, just as the naked sinner gazes toward the tablets of the law, yet unable to fulfill the law, man directs himself ineluctably downward, following the diagonal slope of death's spear. The woodcut's composition nicely expresses the inverting effect of the law by reversing pictorial direction. In the way Moses' pointing finger runs contrapuntal to Death's pointed spear, and in the way the sinner is posed, looking back but running forward, we behold the disparity between what the law asks and what it receives. We have seen such things before, although far more subtly visualized. The sinner in Cranach's the law and the gospel, always trapped in corrupt volition and attended by Adam, Satan, and a corpse, is Baldung's viewer diagramed.

Yet unlike Baldung, and contrary to the late medieval culture of pessimism out of which his art emerges, Cranach imagines "good news." In the right half of the woodcut, the scene of the gospel shifts the *direction* of man's relationship to God, expressed in the image's own reading structure. The scene is again dominated by a diagonal movement carried by the blood of Christ, which streams from his wound onto the figure of man. Unlike Death's sloping spear, however, this blood is of a redemptive death, and it sustains an opposite movement up toward the right, following the gesture of John the Baptist and the forward gaze of the naked man. The gospel, we are meant to infer, changes all lines of force in the human world. Under the law, man fled in the direction opposite from his gaze. Here his posture is resolved, his mind and body unified in his prayer for grace from Christ. The gospel also reorients man vis-à-vis the whole of Scripture. Unlike the futile gesture of Moses the lawgiver, the pointing finger of John the Baptist is a directive man can follow. As prophet of transition between the old and new dispensations, the Baptist embodies the new referentiality of Scripture attendant upon Christ's coming. The New Testament unveils the meaning of the Old and institutes a straightforwardness of meaning that was missing from the law.[32]

If the law tells the ever-repeated history of man's disobedience, what does the gospel say? At the upper right of the woodcut, a homunculus-Christ descends to the Virgin; before her, Christ hangs crucified on the cross. That this outcome issues forth from Mary is conveyed by the image's organizing lines: the paschal lamb's standard, the slope of the

hill, and the rays of the Incarnation simultaneously frame Christ crucified and converge on the Virgin's womb. Below, the resurrected Christ crushes Death and the devil underfoot, fulfilling the plan of salvation history as foreshadowed by the law. The gospel's story thus says that one man, Christ, fulfilled the law's letter and redeemed us from sin, death, and damnation by the law. In Cranach, the naked believer does not participate in this story but rather beholds, believes, and benefits from it. Belief is indeed part of the story. For the images Cranach assembles as the gospel are the irreducible elements of faith: Christ's virgin birth, death on the cross, and resurrection from the grave constitute the second article of the Creed,[33] an inventory that Luther reaffirms for the Reformation in his *Little Catechism* in 1529—the moment of Cranach's composition. The gospel's story is at once historical past and effective present.

The woodcut makes visible this double message of the gospel. The lines indicating Christ's saving blood, linking the foreground compositionally and physically to the midground, literalize the link between the past of Christ's life and the here and now of the believer. A contemporary viewer would have recognized in these lines overdetermined signs of the sacraments. The dove or Holy Spirit through which they pass makes Christ's blood into the saving waters of baptism;[34] the presence of the Baptist beside the naked sinner underscores this reference. Christ's death not only redeems us but also washes us of that inner stain originating in the Fall and reiterated as the effect of the law. The blood refers furthermore to the ubiquity of Christ, the real presence of his flesh and blood in the sacrament of Holy Communion, a doctrine upheld by Luther in his Marburg Colloquy with Ulrich Zwingli in the year 1529.[35] Cranach's graphic link between the believer and Christ thus affirms dogma, for in the sacraments of baptism and communion that this link signifies, the redemptive power of Christ is witnessed by the reformers to break through the alienating dimension of history.

Cranach thus structures the law and gospel scenes differently to suit their divergent modes of address. Read by itself, without the gospel's intervening gloss, the law speaks to the outer self—what Luther, following Paul, refers to as "carnal man."[36] It demands obedience from people in their actions and desires, but receiving none, it elicits the history of sin and death repeated since the Fall. In Cranach, therefore, man remains under the law as the protagonist and victim of a history; we behold carnal man damned for his actions. Luther understood the law less as written text (the Decalogue or Old Testament) or past epoch (the *tempus legis* of the Jews before Christ) than as "event" (*Geschehen*) in which the Christian still unwillingly participates today.[37] Christians must see that they continue to be carnal—cannot obey the law—before they turn to Christ for redemption. Having made that turn, however, their whole being is transformed. Cranach expresses this transformation structurally, by shifting man from the center of the law to the margin of the gospel, posing him there as witness to Christ's life. Christ is known through his saving action; man, we are meant to reflect, is known only as the object of that saving action.[38] In removing man from the center of the scene, in transforming him from active agent to passive object, Cranach visualizes the surrender of self necessary for justification, that is, "the change [that] must take place in our self-awareness and self-esteem."

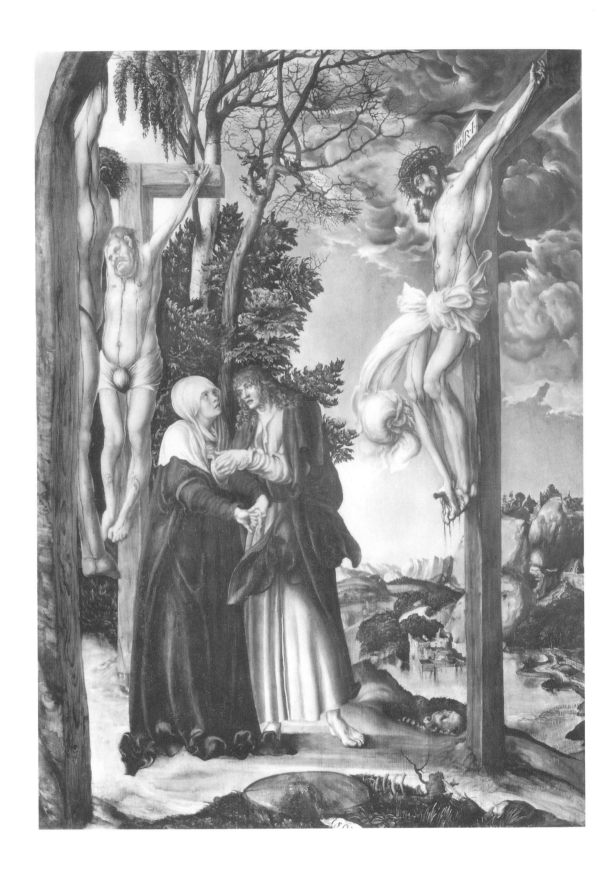

173. Lucas Cranach the Elder, *Crucifixion*, 1503, Alte Pinakothek, Munich.

What are the aesthetic effects of this relinquishment of self? The graphic lines that render Christ's blood not only signify the immediate, sacramental relation between the present believer and the gospel's history, they are also the consequence of the way Cranach constructs the law and the gospel *as image*. That the image coheres as a "scene" only if its disparate figures and events are linked to one another through such unnatural, diagrammatic lines as these results from the paratactic character of Cranach's woodcut.[39] The artist assembles his image with little regard for the customary connectives of visual representation: unity of time and action and the illusion of a continuous space in which events occur. These are pictorial values that Cranach himself helped introduce into German painting about 1503.[40] In his Munich *Crucifixion*, for example, as indeed in all his earliest works, Cranach does all he can to make viewers feel that they are physically present at Christ's death (fig. 173). The integration of figures into setting through light and atmosphere; the expressive, quasi-animate landscape that seems responsive to the human drama it frames; the oblique angle of the crucifix that, positioning us off to the side, emphasizes our specific, subjective viewpoint; the violent gestures of the players, combined with a turbulent painterly execution, that makes everything we see before us appear colored by a subjective state within us: these are all devices for unifying image and viewer into one seamless whole. In his woodcut *The Law and the Gospel*, Cranach returns to the motif of the cross observed from the side, yet by placing it in a mosaic of heterogeneous events and figures, he purges it of any of its original experiential immediacy. Crucifixion, Virgin, paschal lamb, shepherds, brazen serpent, and tents of the Israelites share the same horizon; homunculus, annunciating angel, and dove clutter one sky, so that it is hard to tell exactly where each is bound. Most jarring, perhaps, is the caesura between the scenes of the law and the gospel. The ground above which the brazen serpent hangs appears opposite the treetops of the forest of sin; the Fall is vertically aligned with the annunciation to the shepherds, yet therefore vastly out of scale. Cranach observes the unity of space and scale only within individual scenes, which he arranges according to their semantic importance and shuffles into what can only loosely be termed a landscape. Parataxis does not imply, however, that the elements of the image are not finally interrelated. The discontinuous nature of Cranach's image challenges the viewer to discover an alternative connectedness. Baffling our visual expectations, it elicits our interpretative attention and suggests that coherence must be sought not in the scene's *appearance*, but in its *meaning*—what biblical exegetes call the *hyponoia*.[41]

Start with the tree. Rising from the lower edge of the composition and passing beyond the upper edge, it divides the woodcut neatly in half. Notionally part of the landscape, yet diagrammatic in its function, it helps to naturalize the antithetical arrangement of law and gospel. An extant project drawing allows us to see what Cranach's contrast would look like without the separating tree (fig. 174; J. 28): the picture centers on a troubling gap. Even when Cranach introduces the tree in another, probably later, preparatory sketch, the division between the two landscapes is scarcely better resolved (fig. 175; J. 29). The dividing tree, of course, has as much a semantic as a compositional function. The transition from the *aera sub lege* to *aera sub gratia* brought about by Christ's sacrifice is a

174. Lucas Cranach the Elder, *The Law and the Gospel*, c. 1529, pen and ink,
Kupferstichkabinett, Dresden.

175. Lucas Cranach the Elder, *The Law and the Gospel*, c. 1529, pen and ink,
Städelsches Kunstinstitut, Frankfurt.

cataclysmic event that changes the whole fabric of the world; hence the theological aptness of a jarring formal caesura. Yet the reformers, and Luther in particular, were especially wary of ontological dualisms, whether between Old and New Testaments, or body and soul, or literal and figurative meaning.[42] The law, according to Luther, is not erased by the gospel; rather, it continues as one term in the dialectic of belief. The tree appropriately separates the two dispensations while simultaneously suggesting that together they make up the fabric of one reality. It is, moreover, itself a caesura—barren above the law, leafy above the gospel—as if by just spreading its boughs into the contrasting scenes, it is infected by their different messages. For as Luther writes in his commentary on Genesis: "Arbor mortis est Lex, arbor vitae est Euangelium seu Christus."[43]

The idea is very old, and based partly on an early Christian legend that Christ's cross was made from the tree of knowledge.[44] As in so many formulas of typology (for example, the brazen serpent),[45] redemption comes about through the very things that once damned. A title-page miniature from about 1480 by the Regensburg illuminator Berthold Furtmeyr (c. 1440–1506) makes this point clearly (fig. 176).[46] From a single, central tree,

176. Berthold Furtmeyr, *Tree of Death and Life*, illuminated page from *Missal of the Archbishop of Salzburg, Bernhard von Rohr*, c. 1480, Staatsbibliothek, Munich, Clm. 15710, fol. 60[v].

under which sits the bewildered and nude figure of Everyman, Eve gives an apple to the Jews and the Virgin administers the Host to the Christians. Cranach's *The Law and the Gospel* looks back to this kind of symbolic image, in which the visible world appears less as it is seen than as it means. Against the grain of northern naturalism that, since Jan van Eyck, sought to subsume spiritual references under the all-embracing illusion of reality, and against the expressiveness of the early Cranach, which maintained that reality but bent it to suit an all-embracing emotion, Reformation art, with its disregard for pictorial unities and its preference for labels, quotations, and diagrammatic marks, returns the image to its earlier medieval character as willfully "signlike" in its appearance.[47] Later we will see how this fits perfectly Luther's theology of the image. I would point out here that this retrospective tendency might have its own meaning. Itself a conscious transition from old to new, the Reformation wanted always to euphemize its rupture by styling it as a return to a true tradition: the Bible, the early Fathers, and perhaps also the earlier images of faith.

The bifurcated tree is an emblem of the symbolic order of Cranach's image. Its bare branches extend into the scene of the old dispensation whose meaning is death; its leafy branches point toward the new dispensation with its kerygma of eternal life; and in the symmetry of its form, it suggests that the two scenes will be related to each other by means of a symmetry, a pairing of visually similar but semantically antithetical forms. Where parataxis engages our interpretative attention, symmetry assures us that there is sense in everything.[48] It functions by engaging our belief that things that look alike must somehow be related. Cranach's composition is a visual equivalent of imitative magic:[49] the gospel heals or redeems the man under the law by arranging its events into a series of antitheses. Thus the outstretched arms of the naked sinner are repeated by a bearded man in hell and, again, by the skeleton under the resurrected Christ. This means that Death receives its just deserts under the gospel, assuming the posture of its former victims. Similarly, Christ vanquishing the screw-tailed devil at the woodcut's lower right mirrors the shape of the billow of hell's smoke at the upper left; and these rising vapors contrast with the descent of God from heaven at the right. Such reversals are again semantically charged: man *sub lege*, we are meant to infer, rises only as smoke from hell, whereas God's descending incarnation is the true path of ascent. There are numerous other couplings, each with its own theological charge: Moses and the Baptist, the interceding Virgin of the Last Judgment and the kneeling Virgin annunciate, the tree of knowledge and the crucifix, and so on. The most dominant parallel, however, is between the spear wielded by Death and the blood that streams from Christ's wound. This visual rhyme says that Christ's death, itself a fulfillment of the law, defeats death. It also reminds us that Christ's sacrifice took place at an unrepeatable moment in history and at the hands of particular human tormentors. For Christ's blood flows from a wound inflicted by just such a weapon as is held by Cranach's animated corpse—the lance of the centurion Longinus, which was believed to be the final instrument of the Passion and which became, during the Middle Ages, the attribute of Synagogue. And by including the dove and St. John in this scene, Cranach refers the blood to the waters of baptism,

saying in effect that the believer is washed of original sin, indeed of that trespass for which Adam was expelled from Eden—an event echoed visually in the woodcut by the scene of Death and the devil chasing the sinner to hell. Unpacking the intentions that underlie the symmetry of Cranach's composition, we are thus led step by step through the Protestant theology of justification.

There is something unsatisfying about this exegetical labor, however. Christ's blood reveals itself to be so thorough an answer to Death's weapon that we experience it as a kind of semantic overkill, in which the easy production of meaning eclipses the image itself, emptying it of any intrinsic aesthetic value. It is as if, once Christ's sacrifice has done its work, the image can offer no surprises, as if, once interpreted, the image becomes as interesting as a solved crossword puzzle. Cranach creates a picture transparent to its referent and purged of elements that either resist interpretation or sustain the picture's appeal once it has been deciphered for its content. Anything that might particularize figures, so that they could become objects of continuing visual interest in themselves, must be avoided if they are to fulfill their functions as recognizable components of an antithetical pair; and once recognized within their antithesis, these figures abstract themselves from their original spatial context, losing whatever interest they may have had as integral parts of an overall scene. Cranach assembles not figures in a landscape, but elements of a diagram. The spear of Death, the stream of blood, the rays of grace, the banner of Christ are all akin to abstract lines, like the schematic marks that order the woodcut *Christ as Cornerstone* by the anonymous Monogramist H (active c. 1525–1550; fig. 177).[50]

The highly schematic quality of Cranach's images of the law and the gospel, their emphasis on legibility above all else, has prompted scholars to belittle this important area of the artist's output. In 1908, for example, Wilhelm Worringer wrote of these works: "The succession of allegorical scenes, mocking any kind of pictorial closure, achieves clarity only through rationalistic interpretation. Instead of works of art we have mere theological tracts. . . . Instead of devotional images we stand before sad conglomerations of tasteless, external symbolism."[51] Writing less as a historian than as a critic, Worringer betrays the aesthetic preferences of his day: the idealist celebration of the autonomy of art; the romantic denigration of allegory; and the irrationalistic glorification of emotion over reason. Yet there is a descriptive truth in Worringer's invectives. Even if we do not call Cranach's cipherlike images "tasteless, external symbolism," they do seem to exhaust themselves through "rationalistic interpretation," that is, through a puzzling out of doctrinal messages that are never far from the image's surface and that are usually already given in the marginal biblical quotations. In experiencing aesthetic disappointment, however, we must inquire whether this itself has a discernible *semantic* content—whether, indeed, part of the image's meaning resides in the felt limitation of the viewer's role in constituting that meaning. The theology of Luther can interpret the form, as it has done the content, of Cranach's woodcut. Formulated as a middle way between the church's cult of images and the violent iconoclasm of reformers like Karlstadt and Zwingli, Luth-

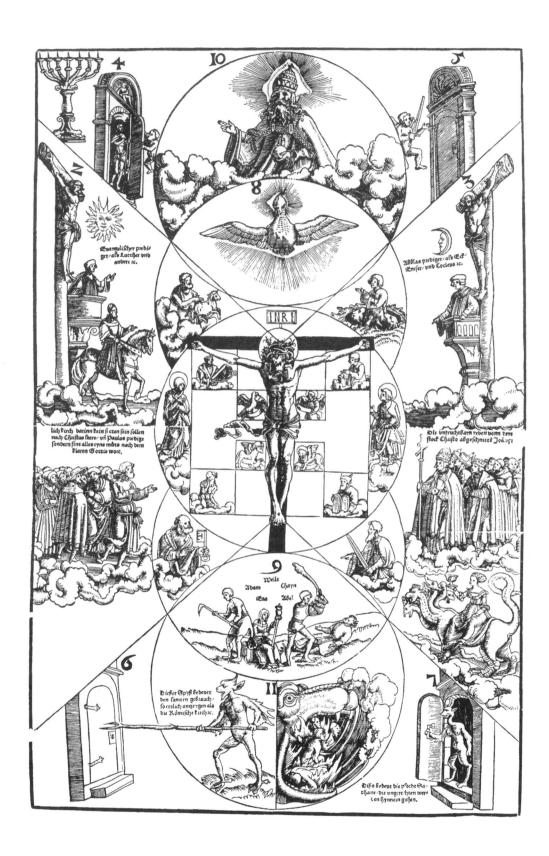

177. Monogramist H, *Christ as Cornerstone*, 1524, woodcut.

er's position on images favors precisely that restriction of aesthetic and interpretative response experienced in images of the law and the gospel, disparaged by Worringer as "external symbolism."

In his seventh sermon on Deuteronomy, delivered on October 21, 1529, Luther condemns as "idolatrous"[52] all images that are worshiped as if they themselves had redemptive power. Yet he accepts another kind of picture: "One does not pray to penny images, nor does one trust them. They are *Merckbilder*, and we do not reject them."[53] By penny images Luther means inexpensive, mass-produced prints or broadsheets, such as Cranach's own woodcut of the law and the gospel, designed in the same year as the Deuteronomy sermon. These images are acceptable because people do not "trust" them, that is, believe them to be agents of intercession or indulgence. They are valuable instead as *Merckbilder*, which in Luther's German suggests an image that draws notice to an element of faith or visualizes a theological point. *Mercken* comes from the Gothic *markjan*, meaning "sign" and "to interpret"; it is the source of the English word "mark." Lying somewhere between the mimetic representation and the written mark, the *Merckbild* works by simultaneously eliciting interpretative response (*merken*, in German, means both "to notice" and "to understand") and limiting that response through its overtly signlike appearance. Unlike the church's cult images that pretend to do too much, the *Merckbild* is acceptable because it claims so little, merely reminding believers of what they should already know. In the introduction to his 1522 *Passional*, written under the pressure of Karlstadt's iconoclasm, Luther accepts images as mnemonic aids, advising Christians to decorate their private spaces, their "sitting rooms and bedrooms" (*Stuben und kamern*), with biblical scenes accompanied by quotations (*Sprüche*) from Scripture, "so that God's work and word everywhere is held before the eyes, exercising fear of God and belief."[54] Cranach's law and the gospel, in its signlike character, its contrast of terror and belief, and its link of "work" to "word" provided by the Bible passages printed below it, is indeed a *Merckbild*. Its practical use is clear. Since for Luther the relation between the law and the gospel forms the basis of all theological understanding, and since this understanding must be made present to every Christian, Cranach's broadsheet functions as a visual lesson for the illiterate and quasi-literate: *ad instructionem rudium*, as the Scholastics would say.

But Luther's preferences are more precise than this. Certain mysteries of faith demand the use of pictures. As Luther notes in his "Easter Sermon" of 1533: "All those things we do not know or understand we must grasp through images, even if they do not exactly hold quite true, or are in reality not as they are painted."[55] By "images" (*bilde*), he means both actual pictures and the figurative language of Scripture—a conflation of image and word that runs through all of the Reformer's writings, motivating his own imagistic literary style and informing his predilection for paintings and prints that include written texts. It will always be necessary, Luther writes, to convey "the teachings of divine things through crude, external images . . . just as Christ himself, everywhere in the gospel, illuminates the secret of heaven through clear image and likeness."[56] Luther's phrase "crude, external images" (*grobe, eusserliche bilde*) refers more to visual images than to figurative language; earlier in the same text he writes of "crude paintings" (*groben gemelden*).

It is uncanny how close this comes to Worringer's pejorative terms for Cranach's Reformation art as "tasteless, external symbolism." For Luther, however, crudity and superficiality are precisely appropriate for images whose only proper brief is to speak simply and directly to simple people, without any intervening aesthetic pleasures or interpretative detours. But why this rush from the signifier to the signified?

In the "Easter Sermon," Luther cites particular images that are indispensable to understanding Christ: John the Baptist pointing at Jesus on the cross; the risen Christ crushing Death and the devil underfoot; the paschal lamb with the banner of victory; and the Crucifixion.[57] The list includes all the principal elements of the gospel scene in Cranach's woodcut. Luther prefers these images because, first, they picture mysteries that are not otherwise imaginable and second, they are so overtly merely signs for something else, referring beyond their jarring appearances to the substance of faith: the letter of the Creed. Such images, Luther writes, "fix and bind . . . our hearts and thoughts on the word of faith . . . which says: I believe in the lord Christ, God's son . . . of the Virgin born . . . died, was buried, and traveled to hell."[58] Christian images must be linked clearly to a text of Scripture. More than that, they should, by their awkward appearance alone, their aesthetic character as "crude" and "external" (e.g., a symbolic lamb bearing a banner instead of an expressive, flesh-and-blood Christ), be obviously absurd if taken at face value. That way they will point beyond their visible form to what they mean.[59] Thus what modern scholars regard as aesthetic poverty in Cranach's woodcut is, from a Lutheran perspective, a pious form of imagistic *ascesis*. Luther writes that "one has to represent things to the common folk [*groben volck*] as childishly and unequivocally as one can. Otherwise one of the following occurs: either they will understand nothing, or they will want to become smart and reason themselves into high thoughts, so that they abandon faith. I say this because I see that the world now wants to be smart in the devil's name [*die wellt itzt wil klug sein jnns Teufels namen*]."[60] Complex images excite interpretation, causing the viewer to speculate and contradict faith. Images must therefore be crude or rough-hewn (*grob*) so as to be understood by simple people (*groben volck*). And they must also *appear* crude and rough-hewn so that simple people recognize them for what they are: not the representation of a reality, but the mere sign for the otherwise unimaginable.[61]

Luther's worry over a viewer's interpretative excess emerges from his dark verdict on the expanding role of the self in his epoch: "The world now wants to be smart in the devil's name." By himself deciding how far his flock should pursue the exegesis of visual images, Luther betrays his anxiety about exegetical authority, and about the status he himself has given the interpretative self in constituting faith. Scripture may be *sui ipsius interpres*, but pictures somehow are not; and idolatry, iconoclasm, and perhaps even the secular thrills of a love of art are proof of the image's dangerous excess, its power to say more than its intended message. Dürer, in the epochal "now" of 1500, fashioned emblems of this new epoch of self. If he yet intimated the deviltry that Luther would deplore, he couched it in elegant, erudite terms of melancholy. Baldung exposed Dürer's desires with an almost Lutheran frankness but maintained for his own art the image's

excess. His erotic images of witches and of death were fashioned—self-mockingly, to be sure—in the "devil's name," causing in their viewers not only carnal lust but, more subtly, the will to be "smart" before works as subtle as these. The crisis of interpretation, however, has more sober expressions in art, which brings us back to Lucas Cranach.

I have argued that *The Law and the Gospel* woodcut is a Lutheran *Merckbild*. Cipherlike, eschewing formal coherency and excess visual interest, it presents itself as nothing but an inadequate sign for something far greater. And in its unequivocal illustration of the Christian creed, and in its dependence on texts, both as they exhaust the individual elements of the scene and as they surround the image as written inscriptions, it "fix[es] and bind[s] our hearts and thoughts on the word of faith." How, though, does Cranach position the individual believer in his composition, that representative of the "simple folk" forever in danger of being tempted to interpret more than he should? And if Worringer is right that the image coheres only through "rationalistic interpretation," where does Cranach place us as interpreters in his paratactic image?

In Cranach's woodcut the naked believer is linked to the scenes of salvation history through the stream of blood that issues from Christ's wounds. This device is telling both in what it purports to mean and in how it conveys that meaning. *What* it means is that Christ's redemptive death overturns the law by fulfilling it, affecting fallen man in the here and now through the mystery of the sacraments and through Christ's presence in the word of Scripture. The dove reminds us of that word whose embodiment as gospel is Cranach's theme. *How* Cranach's image means entails that this relation between the believer and the substance of belief can be expressed visually only through the self-consciously inadequate medium of the graphic mark. Where Worringer writes scornfully that Cranach draws these lines of blood "with an unmisunderstandable clarity calculated for the interpretative capabilities of catechism pupils,"[62] Luther would have understood Cranach's literalized bond between viewer and viewed as part of the image's message. Meaning, here, is imagined as a tangible object that reaches out of the thing seen to touch or wound the seeing subject. The blood that sprays on the believer's breast visualizes the Reformer's notion of the right reading of the Scripture, in which "our heart" is indeed "fixed and bound to the word of faith."

Our role as beholders is prefigured in this demonstration of the image's overly efficacious reference. Cranach implies that there can be no distance, no critical interim between image and beholder, for in the moment when we grasp the message of the law or the gospel, we will experience its effect as damnation or justification. Moreover, by splitting the subject within the landscape into two figures, the unredeemed and the redeemed sinner, or the carnal and the spiritual man, he posits no place of convergence, no imagined vantage point from which the image can be viewed and interpreted as a whole. The law and the gospel each have their own particular interpreter with his own particular fate. Our own experience thus becomes one of caesura, not merely because of the image's split form, or because we as interpreters are offered no place within the landscape where these messages meet. Cranach simply denies us the dignity of a monologic presence within or before the work of art.

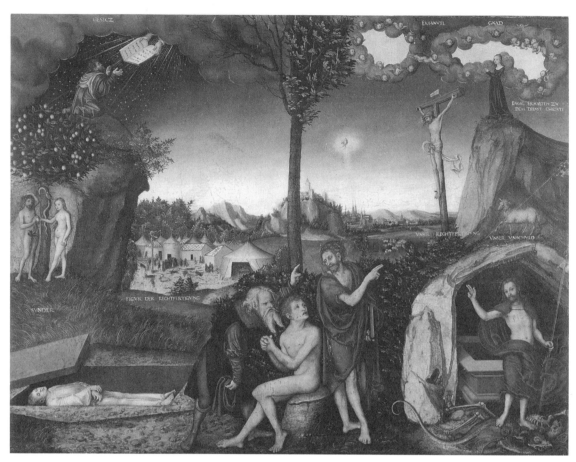

178. Lucas Cranach the Elder, *The Law and the Gospel*, c. 1529, oil on panel, National Gallery, Prague.

Cranach designed another version of the law and the gospels in which the self is afforded a very different place within the symbolic landscape. In a panel dating from about 1529, now in the Prague National Gallery, a nude figure labeled "Man without Grace" appears at the center of the composition, seated on a stump at the base of the bare and leafy tree (fig. 178; FR 116). To his right is the prophet Isaiah, herald of the virgin birth,[63] who points to the crucifix; to his left John the Baptist, labeled "Announcer of Christ," points to the paschal lamb. "Man without Grace," however, does not turn fully toward the gospel announced by these prophets. He raises his hands in prayer and looks up at the crucifix and the lamb of God, but his body twists back to the landscape of the law. His posture describes his predicament: no matter how resolved his mind is to embrace Christ, his body remains subject to the desires and the destiny represented by the law.

Cranach makes it clear that this pessimistic anthropology agrees with Scripture and with the new evangelical faith.[64] He fills the panel's lower margins with passages from St. Paul that are also crucial to Luther's early theological breakthrough. The essential force

of these texts is to locate the contrast between the law and the gospel neither in the divisions of history (before Christ and after Christ) nor in the divided peoples (Jews and Christians), but in a divided self. Paul writes in his letters to the Romans: "For I am delighted with the law of God according to the inward man. But I see another law in my members, fighting against the law of my mind, and holding me captive in the law of sin that is in my members. Unhappy man that I am, who shall deliver me from the body of this death? The grace of God, by Jesus Christ, our Lord. Therefore, I myself with the mind serve the law of God but with the flesh the law of sin" (Rom. 7:22–25).[65] In his 1515–1516 *Lectures on Romans,* Luther calls this "the most telling passage of all," for in it is explained how we can be at the same time sinful and righteous. Paul, argues Luther, "does not say: 'My mind serves the law of God,' nor 'My flesh serves the law of sin,' but he says, 'I, this whole man, this person here, stand in this double servitude.'"[66] By combining the two figures of man from his *Law and the Gospel* woodcut into a single hybrid form, Cranach visualizes this difficult point about the self's "double servitude." In the Prague panel, man remains *between* the two covenants. His label, "Man without Grace," does not say he is necessarily damned, but only that he is not yet saved. Being Christian, according to Luther, is a constant struggle between the law's announcement that man is trapped in sin and death and the gospel's promise that he can be saved through Christ. Faith is not a steady state but a process, an existential *transitus* of self from law to gospel. Luther calls the self of this process "a fighter who stands in between two opposite laws."[67]

The Prague *Law and the Gospel* depicts man, specifically, as a fighter and his struggle as a *decision*. For in the seated nude man at the base of the bare and leafy tree, flanked by two standing figures and between divergent moral worlds, we recognize the Renaissance motif of agonistic choice par excellence, Hercules at the Crossroads.[68] Cranach was familiar with the motif and produced several paintings of it. At the center of a small panel executed by Cranach's shop about 1537 and now in Munich, Hercules sits on a stump at the base of a tree, flanked by female figures representing Virtue and Vice (fig. 179; FR 328). Taking the hand of a thinly clad Virtue, Hercules demonstrates the valor of his moral choice even if his large club, rising suggestively from between his legs and grasped by the nude Vice as Voluptas, assures us that his carnal desires remain intact. In a similar panel now in Braunschweig, Voluptas merely points, John the Baptist–like, to the hero's weapon; the panel as a whole depicts less a decision rendered (Hercules has not quite taken Virtue's hand) than the conditions under which human choices are made (fig. 180). Like the Prague "Man without Grace," who prays for salvation but whose body turns to the law, Hercules expresses in his posture a conflicted relation to both sides of the moral landscape.

Other elements in Cranach's Prague panel link it to Hercules at the Crossroads and related secular motifs. The bare and leafy tree, while indeed present in medieval Christian typology, also appears importantly in Dürer's *Hercules* engraving of 1498 (fig. 181; Kn. 24). The structure of Cranach's landscape, with its two cliffs rising up to frame a threesome at its center, recalls such crossroads images as the woodcut illustration for

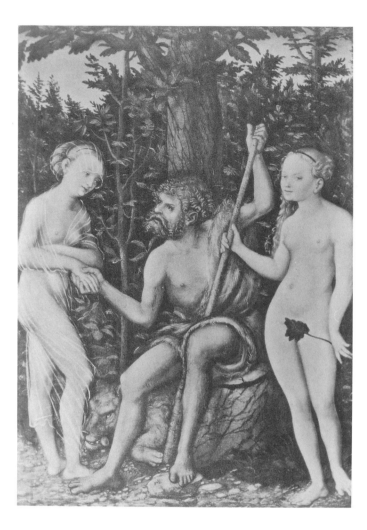

179. Lucas Cranach the Elder
(shop), *Hercules at the Crossroads,*
c. 1537, oil on panel, Julius
Böhler Gallery, Munich.

Locher's *Narrenschiff* translation discussed earlier (fig. 157). Cranach was certainly famil-
iar with the iconography of the Hills of Virtue and Vice. In a 1548 panel by Cranach
the Younger, Hercules and ''Virtus'' point to a summit labeled ''To God and Virtue''
(fig. 182).[69] Their gestures recall those of Isaiah and the Baptist in the Prague panel, and
Virtue practically copies the Prague Virgin annunciate. This is fitting, for the path ''To
God and Virtue'' should lead through the Virgin, just as by implication the path to sin
and death, occupied in Hercules scenes by Voluptas, leads in *The Law and the Gospel*
through Moses. The whole posture and general arrangement of ''Man without Grace'' at
the foot of a tree, as well as the bearded, bent-over figure of Isaiah, recalls, moreover,
Cranach's 1530 treatment of that other classical scene of decision, the Judgment of Paris
(fig. 183; FR 210). German humanists read this story of Paris as exemplary of a flawed
human decision, of choice sabotaged by carnal lust and the power of women. For in
choosing the sensuous Aphrodite, Paris caused the war that led to the fall of Troy.[70] His
decision emblematized the *vita voluptaria,* and was frequently contrasted to Hercules'

virtuous choice at the crossroads. The formal kinship between the Isaiah of Cranach's Prague panel and the Hermes of his *Judgment of Paris* is semantically appropriate, I would note, for both figures are go-betweens for their gods. The Hebrew prophet and Zeus's messenger appear before a figure of man as "fighter" and elicit from him a choice upon which destiny rests.

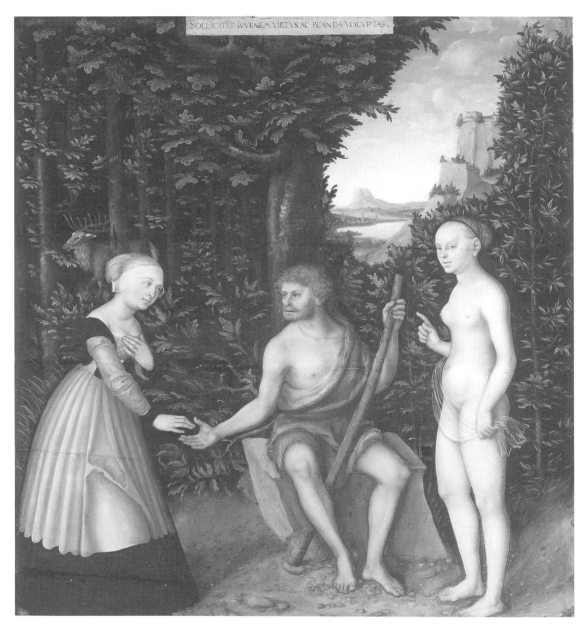

180. Lucas Cranach the Elder (shop), *Hercules at the Crossroads*, 1537, oil on panel, from series *Labors of Hercules*, Herzog Anton Ulrich-Museum, Braunschweig.

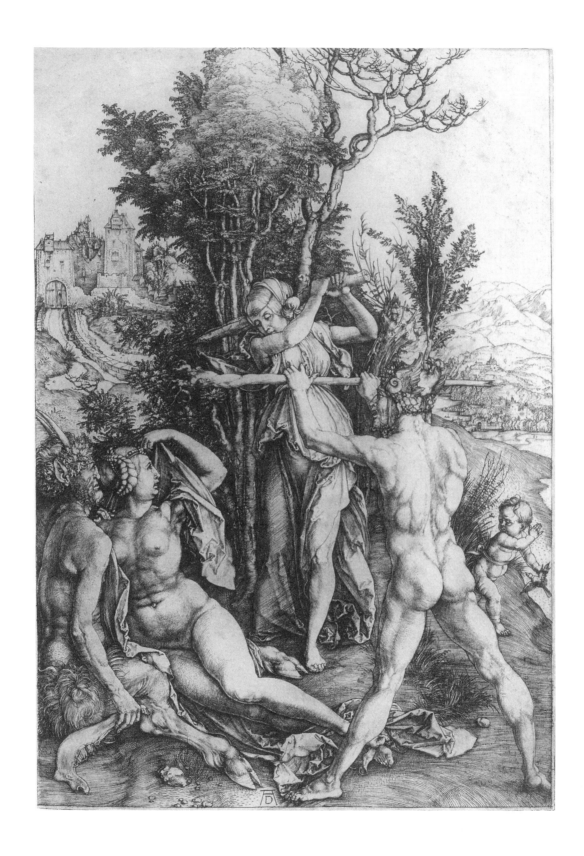

181. Albrecht Dürer, *Hercules*, 1498–1499, engraving.

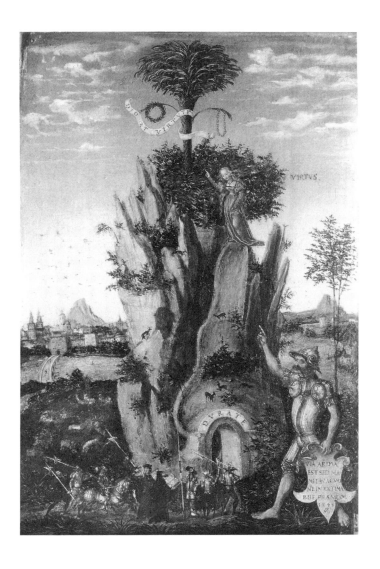

182. Lucas Cranach the Younger, *Allegory of Virtue,* 1548, oil on panel, Kunsthistorisches Museum, Vienna.

The condition symbolized by all these images is that of *homo viator in bivio:* man the traveler halted at a crisis where he must choose between alternative paths.[71] The metaphor of travel can have several meanings here. In the Hercules tale, the crisis occurs when the hero passes from youth to manhood.[72] This moment in an individual life can also stand for a historical progression from one epoch to another. Thus the paths of vice and virtue can spatialize the eras of barbarism and civilization, or of old and new dispensations. In Cranach, the passage from law to gospel is at once the historical progress from Moses to Christ and an existential conversion of self from sin to salvation that is continually taking place and that maintains the self precisely as a traveler not yet arrived in its ultimate future. The crossroads motif, furthermore, says that *homo viator* cannot proceed along one trustworthy path but must choose between alternative roads, each with its own hardships and rewards. It says that individuals decide on, and therefore are responsible

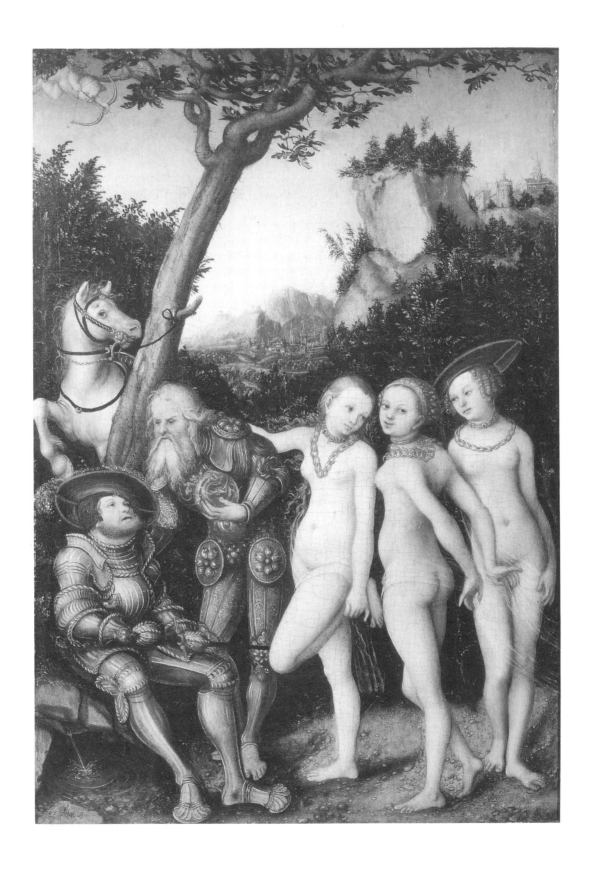

183. Lucas Cranach the Elder, *The Judgment of Paris*, 1530,
oil on panel, Kunsthalle, Karlsruhe.

for, their own destiny. The Hercules tale is as much a valorization of human agency per se as it is of the hero's particular decision in favor of virtue. Endowed with the authority of its antique origins, Hercules at the Crossroads provided Renaissance artists with the perfect image of self-assertion: man as the measure of all things and as arbiter of destiny.

In *The Individual and the Cosmos in Renaissance Philosophy,* Ernst Cassirer argued that the most original and characteristic feature of Renaissance humanists' approach to traditional philosophical questions such as free will was their conviction that *images* convey answers more eloquently and accurately than does syllogistic logic or discursive argument. Analyzing Lorenzo Valla's *De voluptate* (a text, incidentally, that probably influenced a number of images of Hercules at the Crossroads, including Dürer's 1498 engraving),[73] Cassirer writes: "Instead of discussing the concepts of divine foreknowledge and divine omnipotence, and opposing both to the concept of human freedom of the Will, Valla begins with a concrete embodiment of the concepts. Ancient myth now receives a new role; it becomes the vehicle for logical thought."[74] At stake here is something more than Valla's literary form, for in their use of classical myth and in their valorization of images over logical argument, humanists regarded content as inseparable from form and meaning as inextricable from rhetorical presentation. Indeed, as Giordano Bruno later argued, the image should become the preferred vehicle for knowledge precisely because it cannot be reduced to any simple, abstract statement of its meaning.[75] Whether as painted picture or as rhetorical trope, the image constitutes an epistemological freedom that is new to the Renaissance. From this perspective, Hercules at the Crossroads not only expresses the idea of individual autonomy in *moral* choice; insofar as this idea is expressed as image, as pictorial or mythical figure, it affirms individual autonomy in *interpretative* choice as well. As Cassirer writes of the relationship between willing and knowing in humanist thought: "The problem of freedom is closely allied to the problem of knowledge; the concept of freedom determines that of knowledge, just as, conversely, the latter determines the former. The spontaneity and productivity of knowledge finally become the seal of the conviction of human freedom and human creativity."[76] This link between ethical and epistemological freedom is critical in visual images that have, as their explicit theme, moral or confessional decisions. It suggests that to unpack a picture's particular message about the will, or to discern the figure of self implied both within and before the picture, we must first of all attend to the *visual* character of the picture itself. We must ask, again, not only what the image means but how it means, since this "how" will determine the degree of freedom afforded viewers in their attempt to "know" what the image means.

It is significant that Erwin Panofsky, himself deeply influenced by Cassirer's arguments both about the Renaissance and about the apriority of symbolic forms, took as the test case for his new method of iconology Raphael's early panel sometimes titled *Hercules at the Crossroads,* now in London (fig. 184).[77] Arguing that formalist scholars like Heinrich Wölfflin always read meanings into the objects they analyze, Panofsky set out to demonstrate that even the much-vaunted "beauty" of a Raphael had a specific semantic content for its culture and that deciphering this content today involves recuperating the genealogy of obscure philosophies, forgotten texts, and rough-hewn images against

which the London panel was originally measured. *Herkules am Scheidewege* of 1930 is at once Panofsky's most elaborate iconological argument and, I believe, his most radical attempt to relativize the formalist position by subsuming it under his new historical semiotics.

In Raphael's panel, Virtue and Pleasure flank a sleeping knight like the content of his dream. The landscape takes its features from Hercules images: to the left, the narrow road ascending to a church on a rock is Virtue's difficult path; to the right, the prospect of a broad river valley is the easy way of pleasure; and at the center, a slender tree divides the scene in two. Crucial to Raphael's evocation of these motifs is his transformation of the two women from personifications of good and evil into something far subtler. Virtue, perhaps more angular in shape and somber in color than Pleasure, but hardly the hag of the *Narrenschiff* woodcut, offers the knight a sword and a book, symbolic of the arms and letters of the active life.[78] Pleasure, dressed in graceful but modest garb and concealing neither corpses nor demons, offers a simple sprig of flowers. Together they divide not a moral but an aesthetic universe, and what they offer is not life versus death, salvation versus damnation, but simply different kinds of life. Panofsky explains this reconciliation by recovering various period theories of pleasure that would have been known to Raphael. In *De voluptate,* for example, Valla argues that sensual delight is not necessarily antithetical to the Christian faith; indeed, pleasure is the "conserving principle of life, and therefore the basic principle of value"[79] in all things, including Christ's promise of eternal bliss. Yet even as Panofsky proves the legitimacy of pleasure for Renaissance humanists, his iconographical method, which deciphers images more for what they mean than for how they look, erases that very pleasure of appearances.

In Raphael, our conviction that the knight is free to choose between virtue and delight is not experienced as an argument about, say, Christianity's dependence on the pleasure principle, nor is it changed by our learning that Raphael was, from a period perspective, right. Freedom is rather an instance of the painting's aesthetic appeal, a consequence of the beauty that embraces all figures and joins as one world the church and the pleasant valley.[80] Raphael's picture does not take sides in the psychomachia between virtue and pleasure *because* it refuses to delimit the range of interpretative responses it elicits. The reciprocity between dreamer and dream that makes the knight as present to us as are the women of his vision reflects a semantic plenitude in which hero and beholder together occupy a middle ground balanced by the panel's exquisite compositional equilibrium. Against this we might set the *Narrenschiff* woodcut's polarization of pleasure and virtue within an image reduced to the condition of the ascetic written cipher—the Pythagorean Y of *homo viator in bivio* that structures the scene's divergent worlds. Before such ciphers, the self occupies a place not of reconciliation and balance, but of rupture, where inner desires war with one another. This is the situation that Baldung, too, projects on his implied viewers in works like *Death and the Woman* (fig. 135). I shall not claim that images conveying ethical freedom necessarily take a form experienced by the beholder as interpretative autonomy or that, conversely, images expressing the servitude of the will always do so in a manner that limits the beholder's responses. Rather, images of decision

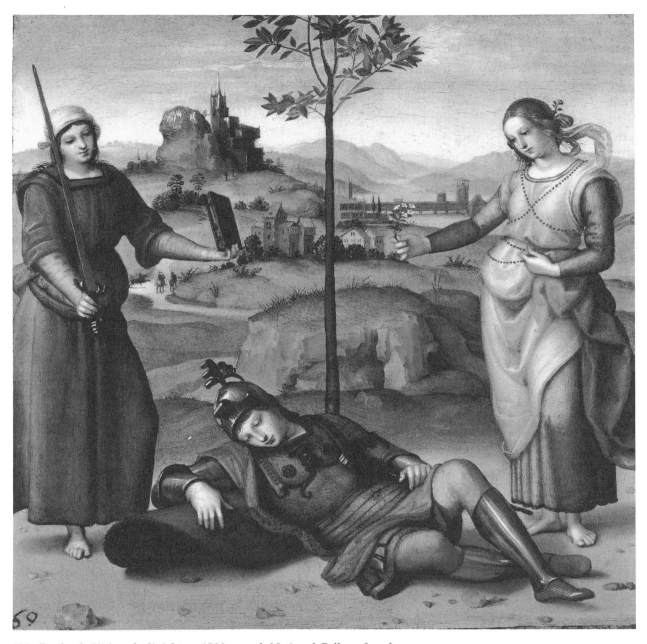

184. Raphael, *Vision of a Knight*, c. 1500, panel, National Gallery, London.

can make apparent the dialectic between form and content, between what the image says and how it says it.

Although Panofsky discovers, by assembling textual and pictorial precedents, the legitimation of aesthetic pleasure in the Renaissance philosophy and, by implication, the historical source of formalism's cult of beauty, his antiformalism compels him to elide precisely the aesthetic experience. The effect is, granted, pleasantly sobering, as when he

places the London panel side by side with the crude *Narrenschiff* woodcut and accounts for differences in terms of meaning and figuration rather than of quality or beauty. Yet Raphael's panel argues, and its humanist audience would have agreed, that form is itself semantically charged—indeed, that freedom, creativity, and beauty are not messages extracted from, but values embodied by, the image itself. The reconciliation of pleasure and virtue is, from a period perspective, predicated on beautiful art. This holds true for Dürer's *Hercules* engraving as well (fig. 181). The hero intervenes to stop the fight between the clothed Virtue and the nude Voluptas, yet a reconciliation between the two has already taken place *as* Dürer's image itself. The perfectly constructed figure of the hero makes the ideal of chaste beauty concrete. His nudity may link him to Voluptas, but his identity as Hercules, and the labor that went into giving him form, allies him to Virtue. It is this message of the moral force of art, of its ability to atone for the Fall by making something new and better, that was monumentalized in Dürer's engraved *Fall* and, more audaciously, in that quintessential emblem of artistic free will, the 1500 *Self-Portrait* (figs. 98 and 21).

The Prague *Law and the Gospel* lies much closer to the *Narrenschiff* woodcut than to Dürer's *Hercules* or Raphael's *Knight*. Our experience of the image, I have argued, is one of a willful curtailment of aesthetic pleasure. Dogmatic in its message and unequivocal in its expression of that message, the Prague picture exhausts itself in conveying a significance that it itself does not pretend fully to constitute. Anything more would exceed Luther's brief of "crude, external images" and invite idolatry. For unlike the humanists Cassirer studied, who embraced the image for its refusal to settle on a constative message and who regarded this multivalence as a token of their new freedom of knowledge and choice, Luther suspected all such excess of meaning and interpretation as things done *jnns Teufels namen*.

The Prague panel explicates the scriptural foundation for Luther's view. Self-assertion, or the belief that the individual can decide between virtue and vice, is precisely what the law mortifies. The Ten Commandments, Cranach shows us, do not offer man a choice of paths but lead him irrevocably down one road to damnation. The picture's explicit message about choice thus matches the visual form that message takes, as an image curtailing interpretative freedom. Why, then, does Cranach cast the center of his composition as an allusion to Hercules at the Crossroads, with its connotations of self-assertion and of the semantic plenitude of myth? To picture the way to God as a path leading up the Hill of Virtue is to regard salvation as contingent on good works—a doctrine precisely contradicted by Luther's reading of the law and the gospel. And the identification of Everyman with Hercules is a heroizing of the human will absolutely alien to Luther's antivoluntarism.

Commentators have found no adequate explanation for the Hercules motif in Cranach's painting. Jean Wirth, noting that the motif represented "a pagan anthropology that Luther detested," has suggested that the Prague panel, unlike Cranach's woodcut *Law and the Gospel* and Gotha picture (figs. 171 and 172), was designed in collaboration with Philipp Melanchthon, who wavered in his belief in the servitude of the will.[81] Yet

185. Erhard Altdorfer, *The Law and the Gospel*, title border for Luther's *New Testament* translated into Low German (Lübeck: Ludowich Dietz, 1533).

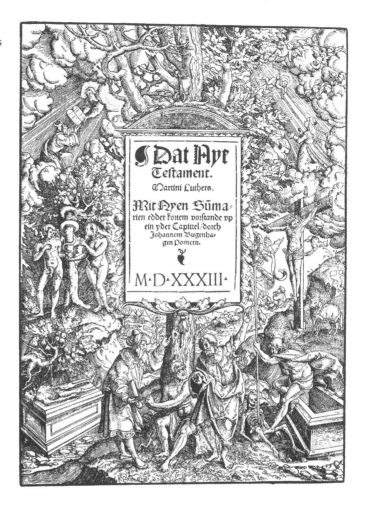

Wirth ignores the many Prague-type images of the law and the gospel that were made for Lutheran projects. The Hercules motif appears in no less Lutheran a work than Erhard Altdorfer's title-page woodcut for Luther's first complete translation of the Bible into Low German, published by Ludowich Dietz in Lübeck in 1533 (fig. 185).[82]

At the outset of the last chapter we discussed how, in Baldung's *Death and the Woman*, the figure of Voluptas undermined the notions of choice implied by the motif of Hercules at the Crossroads. I propose that Cranach's Prague panel is similarly a conscious revision of the pagan motif it invokes. We know from the work of Aby Warburg that Luther transformed the pagan ideas he detested into propaganda for his cause.[83] In the Prague panel, Cranach creates an image fully expressive of the Reformer's complex stance on the role of human decision in Christian life. The question of man's ethical and epistemological freedom is deeply vexed in the Reformation.[84] On the one hand, Luther's notion of the priesthood of all believers emancipated the individual from the hierarchy of the medieval church. For that reason Hegel called the Reformation "the moment of freedom, the autonomy of the spirit, and the self's coming to itself."[85] On the other hand, Luther's explicit

theology of the will embraced just the opposite view: the German title of the Reformer's central text on the subject, *De servo arbitrio*, reads unequivocally: "That the Free Will Is Nothing." [86] It is at such a crossroads, between an emergent selfhood and the anxiety over what that emergence might mean for Christian life, that Cranach's image is staged.

Luther's great *De servo arbitrio*, first published in 1525 and often described by the Reformer as the single best expression of his thought,[87] dissects the image of the crossroads. Luther refers to a passage in Erasmus's 1524 *De libero arbitrio diatribe sive collatio*, which uses the figure of man the traveler at the crossroads to repudiate Luther's doctrine of the servitude of the will. Erasmus, citing Old Testament stories about human decision, notes that already in paradise God asked Adam to choose between life and death by forbidding him to eat the apple. The Fall, concludes Erasmus, demonstrates that God rewards and punishes according to man's actions.[88] God offers Moses and the Israelites a similar choice. Paraphrasing Deuteronomy, Erasmus writes that God said to Moses: "I have set before you the path of life and the path of death [*viam vitae et viam mortis*]. Choose the way of good, and follow it to me." [89] Erasmus has recast Scripture here, for the text of Deut. 30:19 reads simply: "I have set before you life and death, blessing and cursing: therefore choose life, that both thou and thy seed may live." Into this radical antithesis between life and death, Erasmus thus introduces the mundane, perspectivizing metaphor of the two paths and equates the path of life with the decision to follow the law. Erasmus continues: "It would be ridiculous to say to someone, 'Choose,' if he did not himself possess the power to turn this way or that; it is like saying to a man stopped before a crossroads, 'You see before you two paths: choose which of the two you want to pursue,' when in fact only one is passable." [90] To demonstrate that the Bible supports the doctrine of free will, Erasmus thus projects into its text the metaphor of *homo viator in bivio*. To his humanist audience, this metaphor would have resonated not only with New Testament images of life's "two paths" (Matt. 7:13 and Luke 13:24), but also with the pagan myth of Hercules. Erasmus's rhetorical ploy, I would note, supports Cassirer's thesis that Renaissance humanist philosophy will let images stand in the place of logical argument.

Responding to this passage in Erasmus's text, Luther highlights the figurative ground of his opponent's argument. He asks us "to hear the simile" of Diatribe:

> It would be ridiculous, you say, to say to a man standing at a crossroads, "You see these two roads; take which you like," when only one was open to him. This is just what I said before about the arguments of human Reason, that she thinks man is mocked by an impossible precept, whereas we say that he is warned and aroused by it to see his own impotence. Truly, therefore, we are at a crossroads, but only one way is open; or rather, no way is open, but by means of the law it is shown how impossible one of them is, namely, the way of good, unless God gives the Spirit, and how broad and easy the other is if God allows us to take it. It would not be ridiculous, therefore, but a matter of due seriousness, to say to a man standing at a crossroads, "Take which way you like," if he was either inclined to imagine himself strong when he was weak, or was contending that neither road was closed.[91]

The argument here is rather labyrinthine. Luther starts by taking the position that Erasmus dismissed as absurd: "we are at a crossroads, but only one way is open." Then he rejects the crossroads metaphor ("or rather, no way is open") and replaces it with a vision of man as already on a path either of life or of death. "By means of the law," Luther observes, we learn how impossible the path of life is; man alone cannot stand *in bivio*, but travels sin's unicursal path to death, unconnected to the "way of good." By means of God's grace, however, man can arrive already on a "broad and easy" path without ever having made a decision himself. This path, with no crossroads to complicate it, implies a geography different from that of *homo viator in bivio*, which traditionally associates breadth and ease with vice and narrowness and difficulty with virtue. Here Luther's revision resembles Cranach's woodcut *Law and the Gospel* (fig. 172). This image, we recall, presents the viewer with two antithetical landscapes with no point of intersection. Under the law man already travels—or rather runs—toward hell, no matter what he does, while under the gospel he does not properly choose salvation, or travel toward it, but stands passively and easily linked to it through the blood of Christ.

However, the Reformer does not leave his argument at this point where "no path is open" and where man inhabits one landscape when he is saved and another when he is damned. It is "a matter of due seriousness," Luther writes, to ask a man at the crossroads to choose between two paths, not because he has the power to decide, but precisely because his lack of power, demonstrated through the very inappropriateness of the crossroads image, can take on a *pedagogical* function. Read not through reason but through faith,[92] Erasmus's simile itself admonishes the man who "imagines himself strong when he was weak, or was contending that neither road was closed." Luther here confounds the humanists' doctrine of the dignity of man, which represents man at the moment of decision as the mythical embodiment of heroic strength: the figure of Hercules. Luther overturns the pagan motif, and with it the optimism of a Renaissance humanist anthropology, by imagining man as an infirm antihero. He grounds this revision in the Pauline understanding of the law and the gospel: demonstrating human frailty is the law's only proper function. Citing Rom. 3:20 ("Through the law comes knowledge of sin"), Luther writes: "The whole meaning and purpose of the law is simply to furnish knowledge, and that of nothing but sin. . . . [T]his knowledge is not power, nor does it confer power, but it instructs and shows that there is no power there, and how great a weakness there is."[93] By submitting Erasmus's crossroads image to the law's paradox, Luther reverses the humanist's exegesis, which had projected *homo viator* onto Scripture. Man, Luther shows, "is warned and aroused" by such an "impossible precept" and thereby comes "to see his own impotence." *Homo viator in bivio* becomes a source of truth when truth becomes only the recognition of the limits of human knowledge, that is, when the crossroads motif means the opposite of what it had traditionally meant: instead of strength, it signals weakness; instead of celebrating the eloquence of symbols, it shows their inadequacy, becoming significant only when it is transformed into something crude and external, a *praecepto impossibilis*.

Cranach's Prague panel *The Law and the Gospel*, painted just four years after the Latin

edition of *De servo arbitrio* and three years after the German edition, should be viewed in light of the Reformation theology of the will. Just as Luther dismantles Erasmus's voluntaristic reading of *homo viator in bivio* by subordinating it to the Pauline doctrine of the law and the gospel, Cranach evokes the Renaissance image of Hercules only to overturn its humanist message and form. The success of this conceit is evident in its reception. From the mid-1530s on, images of the law and the gospel by other German artists, including Holbein, Timmermann, the younger Cranach, and Erhard Altdorfer, are nearly all modeled after Cranach's Prague, rather than Gotha (fig. 172), type,[94] suggesting that the centralized figure of man at a moment of decision was felt to be deeply appropriate to the concerns of the new evangelical church.

A monumental French woodcut of the law and the gospel, printed about 1534 after a drawing by the Parisian artist Geofroy Tory (d. 1533), represents an early and striking elaboration on Cranach's formula (fig. 186).[95] Tory's print affirms the pictorial values of Renaissance humanism: the evocation of classical myth in the Hercules motif; the learning implied by the two antique sarcophagi and by the antiqua lettering of the labels; the prestigious pedigree of Tory's figure style, which includes such Italian masters as Raphael and Andrea del Sarto; the virtuoso treatment of landscape and perspective, which renaturalizes Cranach's schematic settings; the sheer ambition of design and quality of execution reminiscent not of Cranach's *Merckbild* but of the best prints by Dürer and Raimondi; and the idealizing proportions of the central nude labeled LHOME. Yet just where one would expect to find an affirmation of man as the measure of all things, Tory fashions *homo viator* to echo the figure of Adam as he appears at the left of the print, receiving the apple from Eve; the bare and leafy tree rising up behind man is more clearly than ever a hybrid of the deadly tree of knowledge behind Adam and the living cross of God at the right. Thrown back on himself, Tory seems to say, man will repeat his trespass in the garden until one greater man, Christ, restores him to grace. Scrupulously Renaissance in form but thoroughly Reformation in content, Tory's image disputes the doctrine of free will *and* revises the humanist enterprise of letting antique myth, image, and style interpret the Christian faith.

Cranach's Prague panel and Tory's woodcut offer the viewer a vision of choice only to reveal in the surrounding scenes that "only one way is open, or rather no way." It would be misleading, however, to regard the crossroads as simply an admonishment in these works. Luther, we have seen, interpreted the law and the gospel not as two separate codices, nor as unrepeatable stages of salvation history (as the Scholastics believed),[96] but rather as terms of a dialectic through which we are always passing. Man is stationed *between* the law and the gospel, engaged in an existence that, as Luther writes already in 1516, is "an imperfect act, always in part acquired and in part to be acquired, always in the midst of opposites, and standing at the same time at the starting point and at the goal. . . . [T]he present life is a kind of motion and phase, that is, a transition and a Galilee, that is, a moving from this world to the coming one, which is eternal rest. . . . And so we are moved constantly between the evils of sins and the good things of merits."[97] The Prague panel expresses this state of perpetual transition aptly in the figure of

186. Geofroy Tory, *The Law and the Gospel*, 1533–1535, woodcut.

homo viator. Representative man at the moment of faith encounters the law's message of death and turns in despair to the gospel's promise of life. Thus, even if the Reformation doubts the strength of self celebrated by humanists in the story of Hercules at the Crossroads, it still affords the individual a privileged place in its theology. The anthropocentric perspective of Luther's thought at first grants the self that importance and valor afforded it by the Renaissance but then interprets it as our lack: man not only is but will remain *homo viator in bivio.*

The present moment as "a transition and a Galilee" describes something more specific, however, than the existential state of Everyman. It expresses the historical situation in Germany in the sixteenth century. As the traditional church hierarchies and patterns of worship dissolved, and as the ruling political institutions encouraged or resisted this dissolution, people were more and more called upon to regard faith as a path they must fashion for themselves consciously and individually, either as agreement with the new evangelical church or as opposition to it. Thus, for example, the Strasbourg humanist Wolfgang Capito (1478–1541), describing his 1523 conversion to the new evangelical faith, writes of a "decision" upon which rests an individual's salvation: "I felt I must be sure

then, before God and my own conscience, of my decision and my partisanship. It was a time which required decision. Now who acknowledges Christ before other men will be acknowledged by Him before His Heavenly Father, who denies Him and does not accept Him will not be received in Heaven."[98] Analyzing the interplay between theological doctrine and personal conviction, the modern Protestant philosopher Karl Barth has summarized the meaning and form of the Reformation in terms of a "decision" rendered:

> The Christian thinking and speaking of the Reformers, as it was expressed in their doctrine, was like that of the Prophets and Apostles, a thinking and speaking that issued from a decision reached at that moment. A decision has been reached where one has come to a judgment, to a choice, to a definite preference or rejection, to a placing things higher or lower. To reach a decision means to surrender one's freedom to freedom. Whoever has reached a decision has bound himself. . . . The Reformers were such men bound by decision. They had chosen. They had now abandoned the position where they still had many possibilities. Therefore their teaching had only one dimension, one concern, one purpose. It was in part a call to all to reach a decision together with them, in part a vindication of the content of this decision over against those who did not want to reach a decision with them, in part an understanding with them. . . . Reformation is decision, and the church of the Reformation is there and only there where there is decision.[99]

Viewed from this perspective, Cranach's allusion to Hercules at the Crossroads fits perfectly the Reformation as a crisis of faith. Luther's renewed gospel demands that each person sit, like Hercules, at the deciding juncture and choose the faith and the fate that are right. And even if the Reformation is a self-disempowering decision, a conversion away from the law's false message that one can be saved by one's own will and works, the historical audacity of this decision itself, the radical break with the authority of tradition and of the *consensus omnium*, is predicated on Renaissance self-assertion. While seemingly the antithesis of Dürer's multivalent, narcissistic, iconic 1500 likeness, with its pairing of Christ and artist, *anno domini* of salvation history and moment of self-portraiture, Cranach's compositions of the law and the gospel are also its legitimate heir, fashioning the response of each single beholder as the turning point of Christian history.

What choices does Cranach give his viewers? At the opening of a 1532 sermon with the emphatic title "How the Law and the Gospel Are Quite Fundamentally to Be Distinguished," Luther sets his faith in opposition to the church in Rome: "Under the papacy, the pope and all his scholars, cardinals, bishops, and high schools have not yet realized . . . how the gospel differs from the law. For that reason their faith is nothing but the Turk's faith in the law, which alone believes that, to ascend on high: Thou shalt not steal, not murder, so forth. But nothing is said about how to become a Christian."[100] Through his doctrine of good works and his system of indulgences, the pope interprets the gospel as just another law, just another table of rules that, if followed, will lead to salvation. His faith is therefore like that of the infidels, who think (or so Luther believes) that salvation is a deserved reward. This equation of the papacy with the law and the new evangelical faith with the gospel was a common formula of self-validation for the reformers.[101] At the opening of Niklaus Manuel Deutsch's Shrovetide farce *Of the Pope and His Priesthood* (1522), for example, the pope as "Enchriselo" (Antichrist) advises his officers to "lie that

you are preordained / And preach always the papal law! / That way we'll be lords and the laity servants." If, however, the gospel is known and righteousness is measured by it, "everything will be ruined."[102] The force of this equation of the church and the law was at least twofold. First, it cast the Reformation as the authentic guardian of Christ's teachings: if the church is another lawgiver and the law is false, then the evangelical faith is the gospel and its message is true. Second, the law and the gospel also describes a transition from old to new. By appealing to the Bible's own paradigm of cataclysmic change, which regards the moment of Christ's sacrifice as a turn from falsehood to truth, the Reformation could vindicate the radical historical change that it had itself brought to pass. The reformers' assertion that they saw the truth when all others were deceived found a scriptural precedent in Christ's overturning the Jewish law. This strategy of modeling present-day religious change upon the authoritative shift from old to new covenant was not new to the Reformation. The Hussites too equated themselves with Christ's followers and the church with the Jews.[103] And before that there exists a long tradition, lively in the twelfth century, of endowing any self-proclaimed renascence, be it in religion, poetry, philosophy, or rhetoric, with the dignity and legitimacy of the New Testament's advance over the Old.[104] Luther is heir to this language of change and rebirth: the gospel's succession of the law became a way for him to describe the changes he himself was instituting.[105]

Viewed in this light, Cranach's compositions not only express Everyman's state of permanent transition between the old and new dispensations, they also picture the decision facing every Christian in Germany at one specific moment in history. The years 1529–1530, when Cranach developed these compositions, were of special consequence to the history of the Reformation. In the Marburg Colloquy of 1529, Luther finally broke with Zwingli over the interpretation of the Mass; in the 1529 Speyer Protestation, which gave Protestantism its name, the German princes supportive of Luther demanded that the emperor decide religious issues once and for all "on the basis of Scripture";[106] and in the Augsburg Confession of June 1530, which Joseph Lortz calls "the first Protestant denominational tract of world-historical importance,"[107] Melanchthon defines the Lutheran faith both against the church's false doctrines and against Swiss and sectarian Protestantism. Cranach's images of decision thus appeared at a historical moment when, perhaps more than ever before, Western Christendom itself stood *in bivio*. As *Merckbilder* their function was to guide common people in their passage from the false teachings of the church to Luther's evangelical faith.

The compositional symmetry of Cranach's law and the gospel, its antithetical pairing of bad versus good, death versus life, has its immediate source in the polemical broadsheets and pamphlet illustrations that flourished in the early years of the sixteenth century. As Konrad Hoffmann, R. W. Scribner, and others have shown, antithesis was a controlling compositional strategy in the war of images waged between the reformers and the church.[108] Juxtapositions of Antichrist and Christ, false and true preachers, bad and good shepherds, and houses in ruin and repair visualized contemporary religious conflicts in terms of moral antithesis,[109] subsuming, through texts and local details, all

Passional Christi und
Sanfftmütig der Herr kam geritten —

Sich an, dein König kompt dir demüthig, uf einem jungen Esel, Matthäi 21. (V. 5.). Also ist Christus kommen reitend uf in frembden Esel, arm und sanftmüthig, und reit, nicht zu regieren, sondern uns allen zu einem seligen Tode. Johannis 12. (V. 41.)

Antichristi.
Der Papst in Hoffart und stolzen Sytten.

Die Geistlichen seind alle Könige, und das bezeugt[1] die Platten usim Kopfe, duo. 12. q. 1. Der Papst mag gleich-wie der Kaiser reiten, und der Kaiser ist sein Trabant, uf daß bischofflicher Würden Gehalt nicht gemindert werde. c. Constantinus 10. c. 6. Dis.
Der Papst ist allen Volkern und Reichen vorgesetzt. Exvag. sup. gentes, Johannis 22.

1 bezeugen.

187. Lucas Cranach the Elder, *Sanfftmütig der Herr kam geritten—Der Papst in Hoffart und stolzen Sytten*, woodcut illustrations for the *Passional Christi und Antichristi* of Martin Luther (Wittenberg: Johann Grünenberg, 1521).

specific differences of doctrine and practice under an absolute polarity. Importantly, the two works that introduced this visual strategy into Reformation propaganda were both by Lucas Cranach the Elder: the so-called *Chariot of Heaven and Hell*, produced collaboratively with Karlstadt in 1519 (J. 362), and the illustrations for Luther's enormously influential *Passional Christi und Antichristi* of 1521. In one image pair from the *Passional*, Christ's humble entrance into Jerusalem is juxtaposed to the pope's pompous departure from Rome (fig. 187; J. 574–575). Obvious symmetries between these scenes encourage the viewer to compare them point by point and arrive at a verdict on the meaning of the whole. Read like a book, from left to right, Christ's simple robe becomes the pope's lavish garments; friendly donkeys become haughty, well-bred steeds; impoverished apostles on foot become dandyish mounted clergy; Christ's benediction becomes the pope's gesture

toward hell; the heavenly city becomes the city of the damned. The papacy, we are meant to infer, may pretend to be Christ's custodian on earth, aping his gestures and the externals of his example, but it has turned into his antithesis, and its followers shall be damned. The use of symmetry and antithesis to visualize the church as a travesty of Christ's teachings was indeed so ubiquitous in Reformation broadsheets that Cranach, in his law and gospel images, did not need to make explicit the equation of law with papacy, and of gospel with reformers, for this polemic to be understood. The critical tenor of his works would have been fully apparent to a contemporary viewer through their antithetical pictorial design alone. In his title-page illustration for Luther's two-volume 1535 translation of the complete Old and New Testaments, however, Cranach the Younger discloses the contemporary parallel by dressing the devil in a cardinal's hat and placing a monk and the pope in the flames of hell (fig. 188; J. 698).

188. Lucas Cranach the Younger, *The Law and the Gospel*, title-page woodcut for Luther's *Biblia: Das ist: Die gantze heilige Schrifft: Deutsch* (Wittenberg: Hans Lufft, 1541).

Homo Interpres in Bivio: Cranach and Luther 403

There are other, more subtle indications that Cranach intends the law to be read as an emblem of the church's false teachings. In the woodcut version of *The Law and the Gospel* (fig. 171), Christ in judgment flanked by the interceding Virgin and Baptist appears, curiously, in the sky on the side of the law. Luther formulated his central doctrine of justification by "faith alone" (solifidianism) in opposition to what he regarded as the church's legalistic approach to salvation. The church, Luther argued, encouraged Christians to believe that God's wrath could be appeased through the elaborate system of papal indulgences, good works, and saintly intercession. The Pauline distinction between the law and the gospel, though, argued that Christ redeems us by overturning the economy of rewards and punishments proclaimed by the covenant of Moses—indeed, that precisely man's despair at his inability to fulfill any law and therefore to personally effect his own salvation leads him, dialectically, to faith in the gospel. By placing the image of judgment and intercession characteristic of the church's theology above the scene of sin, death, and damnation, Cranach not only identifies the doctrine of works with the false message of the law, he also invokes and condemns an important pictorial convention of late medieval art. The motif of the Last Judgment that fills the sky at the left of Cranach's woodcut *Law and the Gospel* is one that Luther, in his writings, frequently rejects as incompatible with the teachings of Christ. In a sermon from 1538, for example, Luther advises painters: "Therefore do not make Christ into the severe, angry judge before whom one is afraid, as before someone who wants to throw us into hell; this is how people paint him, seated in judgment on a rainbow, with his mother Mary and John the Baptist at both sides as intercessors against his terrible wrath."[110] We can see the sort of image Luther rejects in a panel of *The Last Judgment* executed by the Flemish painter Jan Provost sometime after 1525 (fig. 189). Christ, flanked by Mary, John, and angels, sits in judgment above a pay table on which are placed the orb of the world, the book of life, and a variety of coins and valuables signifying indulgences and good works. Resurrected souls pop up from the sludge, bearing their works to the grand accounting desk, like plucky job applicants with offprints and résumés in hand. Viewed in the light of Luther's rejection of such pictures, Cranach's scene of the law, which includes not only Old Testament imagery but also motifs from traditional Catholic artworks like Provost's panel, becomes an image about images. The Deesis scene, common in church art, is now a vision of punishment alone. The church's system of rewards and punishments condemns itself, like man under the law, and with it are condemned its visual instruments: the cult image worshiped for salvation or indulgence and the work of art donated to the church as a "good work." For an image of salvation, the viewer must turn to Christ alone, who redeems us as we are: sinful, naked, and bearing no works or treasures.

Cranach's *Law and the Gospel*, juxtaposing two alternative visions of redemption, called upon its original viewers to make the central decision of their age. The choice between the old faith of the papacy and the new faith of the evangelical church was indeed a Herculean one, since it had to be made alone, without the guidance of tradition and authority, through the self's interpretative encounter with Scripture. But while the decision had to be rendered in freedom, the content of that decision, the choice of the gospel

189. Jan Provost, *The Last Judgment*, after 1525, oil on panel, Kunsthalle, Hamburg.

over the law, meant denying that there was any real freedom. By rejecting, that is, a doctrine of justification by works and accepting salvation as possible only when God offers it to us, the individual freely gave away his freedom to a faith in the absolute freedom of God.[111] This is the paradox of decision for the Reformation: the individual begins as a Hercules at the Crossroads, halted at a crisis in history and asked to choose the path of a personal faith. And yet the only true path open is a faith without choice, where "only one way is open, or rather no way."

Here and there we have discerned the interpretative self at the crossroads: on the one hand, the center of a new theology, imaged as a hero called upon to render belief as decision; on the other hand, a site of rupture and "double servitude," the condition of being powerless to effect salvation. In the uneasy presence of the Hercules motif in the Prague panel and in the split figures of man in the Gotha and woodcut *Law and the Gospel,* the self appears at once as the image's focus and as the source of an anxiety that seeks to empty that self of power, to deny it any valor within the image or before it. For the viewer's own felt lack of interpretative freedom is but an extension of the image's theology. Against the peril of the overfilled Renaissance self,[112] which threatens to color everything it sees with its own idealized or distorted image, Cranach restores a stricter, though more artificial symmetry. In his analysis of the aesthetics of social forms, Georg Simmel notes that symmetry relieves the pressure of the unfamiliar by controlling it within a closed and balanced system:

The lower levels of the aesthetic drive express themselves in a system that grasps objects in a symmetrical image. . . . The mind can understand objects quickest, and with the least resistance, when they are bent under the yoke of this system. The system's form disintegrates at the moment when one oneself has become inwardly equal to the object in its particular meaningfulness, and the object no longer needs to define itself against other objects. . . . Symmetry means not only the individual element's aesthetic dependence on its interrelation with other elements, but also the closure of the whole circle thus characterized, while asymmetrical formations give more space to the individuating rights of every element and allow much more far-reaching relations.[113]

In my chapter on Baldung and the crisis of interpretation, I argued that, in certain strands of German Renaissance art, the interpreter had become at least the equal of the object. Cranach's Reformation art represents a countercurrent to this. The highly symmetrical compositions of the law and the gospel, in which each individual element has significance only with reference to others, may be an attempt to restore through pictorial means an epistemological balance that was being eroded in all spheres of culture. Against the possibility of a lost symmetry between viewer and viewed, Cranach proposes a perfect reciprocity within the image itself—an image *sui ipsius interpres*—that offers no real point of entrance for the interpreter himself. Against the anxiety that the new theology his image embodies is itself a version of interpretative extravagance and a product of the self's belief in its own powers to enact change in the world, Cranach employs no less orthodox a pictorial device than typology. Typology's original function of sanctioning the New Testament by balancing its figurations with images from the Old finds here a curious destiny of legitimizing the Reformation's break from the church itself. Perhaps Cranach's insistence on semantic closure represents the cause of that which it purports to cure. The historical schism of the Reformation may appear to be represented and therefore controlled here by the balance between old and new that forms the image's symmetrical architecture. Yet it is precisely this schism that creates the crisis Cranach tries in his image to repress.

We can gauge our distance here from Dürer and Baldung by returning to a work in which Cranach himself stands in the place usually occupied by the nude figure of man in images of the law and the gospel. The artist's likeness, we recall, appears receiving Christ's saving blood in the central panel of the *Weimar Altarpiece*, begun by Cranach the Elder and completed by his son in 1555 (fig. 170). This large winged retable, 3.6 by 6.21 meters when open, was executed just after the five-year captivity of the elector Johann Friedrich of Saxony, who had been deposed by Emperor Charles V after Wittenberg fell to Catholic forces. In 1553, when the emperor's power began to wane, Johann Friedrich was released to his new residence in Weimar, and Cranach followed him there. Fashioned mainly as a memorial to Johann Friedrich and his family, but doubling also as an epitaph to his court painter Cranach, who died in 1553, the *Weimar Altarpiece* represents the single most important visual monument of the German Reformation. In it we can discern one vicissitude of self-portraiture at the end of the German Renaissance.

In certain ways the placement of Cranach's likeness as the focus of a retable altarpiece's plot of redemption is even more audaciously self-aggrandizing than Dürer's Christomorphic *Self-Portrait*. Situated on a high altar, at the sacramental core of Christian devotion, the artist stands for Everyman receiving divine justification through his faith alone. The Lutheran community in Weimar would confront not simply Christ's historical death on the cross or its link, through the mystery of the Eucharist, to the here and now of belief. They would also behold, in the person of Lucas Cranach the Elder, an exemplar of themselves as they hoped to be, touched by Christ's saving death. The artist looks out at us from the moment of his justification, accompanied by his friend and spiritual guide Luther, who appears as Moses' Christian antitype. The painter and the theologian, personages known to the Weimar community, together draw the painting's biblical and allegorical ensemble into the historical present, as if to say that, even if the message of the gospel is "faith alone," faith occurs as difficult decisions by real people in the here and now. Before this altarpiece, believers will not "have" the object of their devotion, either as icon embodying the miraculous *praesentia* of a sacred figure or event or even as the product of a more magical kind of painting—the veristic ideal of Jan van Eyck and Dürer that is compromised by the visual *ascesis* of Cranach's willfully "crude, external symbolism." In place of a representation of the sacred, the *Weimar Altarpiece* represents the *experience* of the sacred by installing between the beholder and the crucifix a figure whose very historicity shows redemption not yet fulfilled *for us*. The portrait of the artist casts the faith of the viewer as "a motion and a phase" of the self, "a transition and a Galilee."[114]

The younger and the elder Cranach express their new attitude toward faith through a reformation of Christian iconography. As Friedrich Ohly has argued for the *Weimar Altarpiece,* and for Cranach's Gotha and woodcut *Law and the Gospels* (figs. 171 and 172), the absence of the traditional chalice catching the blood of Christ, such as we see in Dürer's woodcut *Christ on the Cross* of about 1516 (fig. 190; Kn. 335), expresses the Lutheran rejection of the church as necessary intermediary in the sacraments.[115] The blood falls directly on the deceased artist's head, thus obviating that very institution out of which the winged retable altarpiece, as instrument of visual and sacramental mediation, emerged in the North at the end of the Middle Ages.[116] Cranach's conceit has some precedents. In the first sheet of Dürer's *Engraved Passion,* the Virgin and John the Evangelist, representing both intercessors and exemplary Christians, are touched by an unmediated stream of Christ's blood (fig. 94). At 1509, when the print was produced, this arrangement might already have reflected the desire for a new, more personal piety, a piety prepared by the *devotio moderna* and fulfilled a decade later by the Reformation. Before Dürer, however, Christ's blood ran freely only to the base of the cross, where it sometimes touched Adam resurrected from his grave (fig. 191).[117] The deceased Cranach, replacing Adam in the *Weimar Altarpiece*, similarly promises a return to prelapsarian immortality through Christ. As posthumous self-portrait, his likeness at once reaffirms Dürer's optimism about the artist as renovated *imago* and answers Baldung's pessimistic vision of our continued entrapment in the Fall. That the blood should fall on an individual

190. Albrecht Dürer, *Christ on the Cross with Three Angels*, c. 1516, woodcut.

of Weimar's recent historical past, coupled with the totally unprecedented inclusion of a contemporary individual as antitype of an Old Testament type (Luther as Moses), demonstrates even more powerfully than the 1500 *Self-Portrait* how the critical moment of faith has erupted into history.

What role does Cranach *as artist* play within this plot? Earlier I characterized the diagrammatic device of the stream of blood as a negation of naturalism. Literalizing the link between believer and Christ, and by extension between viewer and image, the blood fulfills Luther's brief of visual representation as mere sign. Emerging out of the doctrine of the servitude of the will, and informed by Reformation iconophobia, Cranach's formula is finally antithetical to the claims of an artist like Dürer. While linked to a tradition of northern *in assistenza* self-portraits reaching at least to Dürer's *Feast of the Rose Garlands* and *Landauer Altarpiece* (fig. 59) and to Baldung's overbearingly self-conscious *St. Sebastian Altarpiece* (fig. 141), Cranach's likeness in the *Weimar Altarpiece* marks not only the historical end of German Renaissance art (for with Cranach's death we reach the conclusion of that pictorial tradition prefaced by Dürer), but also the end of an aesthetics that celebrates the power of images as the product of an individual personal talent. Cranach appears not as unique genius but as Everyman; his picture is less an advertisement of the artist than of the theologian Luther, who, more than anyone else, is the picture's hero and designer as well as, ultimately, its curtailment.

There is something conclusive, for a history of German Renaissance art, about the way Christ's blood strikes the head of the deceased Cranach (fig. 192). At the point where the diagrammatic blood splashes off to the right, the lines of red paint are picked up by the curving shape of a poison snake in the background scene of Moses and the brazen ser-

191. *Trinity, the Crucifixion, and the Risen Adam*, detail from top of *Mauritius Portable Altar*, Cologne, c. 1160, gold, enamel, lead, and copper on wood, Siegburg, St. Servatius.

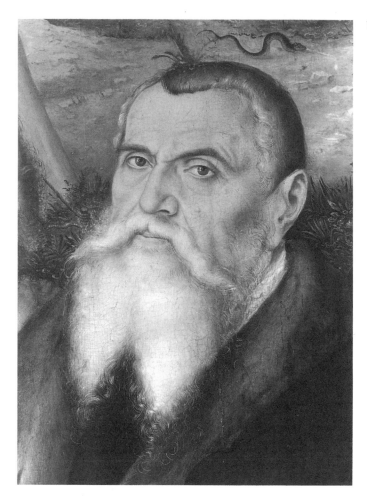

pent. As a symbol of evil overcome by Christ's sacrifice, as well as of the law's fulfillment by the gospel, the serpent above Cranach's head signals the artist's redemption. It says that he is released now from the serpent's curse, from his kinship with Adam, and from his death as commemorated in the altarpiece itself. Yet a serpent appears elsewhere in the image, in almost the same scale, and equally touched by Christ's blood: the winged and crowned dragon inscribed on the cross just below Christ's feet, in the place traditionally marked by the macabre skull of Adam. The dragon, of course, is Cranach's personal device, akin to the vine leaf of the young Baldung and, most important, to Albrecht Dürer's AD monogram. With this association of the serpent of sin and death with the mark of the artist, where fallenness is overturned through an abjection of authorship, we reach one end of self-portraiture. It will take an artist more self-conscious than Cranach, however, to bring this moment to its close.

17

The Death of the Artist

The romantic allegorization of the Fall is powerful and seductive. Eve and Adam, originally one with the natural world, taste in the forbidden fruit a knowledge that sets them apart from nature. Recognizing their own nakedness, they enter into a severed existence. They are now split between a nostalgia for a prior belonging in the world and an entrapping consciousness of self that keeps them perpetually repeating their tragic exile. Fueling the romantic dialectic of nature and consciousness, however, is a promise of return. As Heinrich von Kleist wrote in his famous 1810 essay *On the Marionette Theater:* "The gates of paradise are shut, and the cherub is behind us. . . . We must eat once more of the tree of knowledge to fall back into the state of innocence."[1] This is Kleist's version of the last chapter of the history of the world, where innocence is recovered at the far side and by means of experience.[2] As in most romantic fables of fall and salvation, Kleist stages this drama in the privileged domain of art: it is through the artist that the tragic consequences of self-consciousness are at once perfectly exemplified and apocalyptically overcome.

The pairing of self-consciousness and the Fall is not in itself new to the romantics. Already in the fourteenth century the anonymous author of the *Theologia Deutsch* translates the historical events in Eden into an inner struggle of the self with itself: "Some say, because Adam ate the apple, he was lost or fallen. I say, it was because of his presumption, and because of his I, my, mine, me [*syn ich, meyn, myr, mich*], and the like."[3] For the fourteenth-century anonymous, as for Luther two hundred years later, self, or "selfhood" and "I-hood"[4] is at once cause and symptom of original sin as well as agency of redemption. For what Luther calls the "German theology" is a faith of radical interiority, in which justification occurs only when a believer discovers, by the grace of God, his true self or God's I within. German romanticism revises this Christian theology of the self in two fundamental ways. First, no clear distinction is maintained between, on one hand, the "I" of disobedience and guilty self-consciousness and, on the other, the "I" of redemption. And second, the struggle of self-consciousness is staged in the secular but culturally binding space of art.

In *On the Marionette Theater*, Kleist's examples of fallenness are not moral but aesthetic: the actor who overdoes his gesture, so that "his soul seems to dwell (it is frightening to see) in his elbow";[5] the fencer whose deft feints keep him from ever hitting his mark; the beautiful but vain young man who tries consciously to imitate the pose of an antique statue and loses in that moment all his inborn bodily grace. Against such "affectations" (*Ziererei*), Kleist sets a curious vision of aesthetic perfection: "Grace shall appear at its purest in a body that is entirely devoid of consciousness or that possesses it in an infinite degree; that is, in the marionette or in the god."[6] In the ideal of a body without consciousness, ironized in the image of a puppet, Kleist prophesies the apocalypse of self in the work of art. The puppet's dance occurs within the interplay between the actions of the human puppeteer, linked to the puppet only by invisible threads, and the kinetic forces of nature, which the machinery of the puppet's jointed body is engineered to utilize and express. Man thus recovers innocence in his representation as machine. Technology and artifice, formerly symptoms of the Fall, have purged the human body of self and of inwardness, freeing it to dance again in a wild state of grace. At the end of the history of the world, Kleist's marionette as New Adam redeems us by entering paradise in place of, and indeed as antidote to, our *selves*.

I open my analysis of the late self-portraits of Hans Baldung Grien with Kleist's romantic fable of fall and redemption in order to ward off, through interpretative homeopathy, the charge of historical projection. The modern myth of a fall into self-consciousness through art, as well as postmodernism's antidote of the "death of the artist," will seem, as in déjà vu, already visible in this area of German Renaissance art. Baldung's farces on the biblical Fall, produced in dialogue with visions of prelapsarian perfection by his teacher Dürer, constitute a singularly bizarre episode in the prehistory of romantic self-consciousness. By disfiguring Dürer's art and self-portraiture, Baldung exposes for us the underbelly of the fiction that art is an expression of self. If this vision is too modern for its date, if the art of Baldung actually represents something older, stranger, or more local, at least he will have mocked my projections as a fallen faith that I can measure what I see. Dürer's signed drawing of a proportioned nude from 1526, with its hardly visible jointed neck identifying it as an atelier mannequin, may prove to be an ancestor, through Baldung, of Kleist's uncanny marionettes (fig. 193; W. 930).[7]

Baldung's 1519 woodcut *Fall* centers on the nude Eve and assembles around her a repertoire of possible selves (fig. 145). Behind her stands Adam, who in the *Theologia Deutsch* "*is* disobedience and selfhood and I-hood and the like."[8] Before her stands the viewer, whose presence, as in all Baldung's images of the Fall, is implicated in the picture's plot. And under her, in the form of a shadowed, rectangular tablet with monogram, appears the artist, Hans Baldung Grien. Eve's complicated posture, which seems to take her everywhere and nowhere at once, enables her to address all comers, fashioning them into one community of desire. Adam approaches Eve from behind, catching her with his foot, his left hand, and the tip of a fig leaf as she appears either to draw away or to turn toward him. Eve's contrapuntal movements and irritated expression register Adam's

touch as excitation, as something between pain and pleasure. The fig leaf, which far from covering her groin titillates her sex, reveals Eve's irritation to be nothing less than carnal arousal itself. In the leaf's shape and position, in the upturned bud that curves inward toward Eve's navel, we read the form of Adam's excited genitals as they would appear directly behind Eve. It is possible that while tickling her from the front, the fig leaf actually anatomizes Adam's hidden entry of Eve from the rear—a coital position that medieval summas for confession termed *bestialiter* and branded as a deadly sin and an offense against nature.[9] Man's trespass, as Peter of Lombard and before him Augustine had argued, is sexual in nature, and that is why, after the Fall, Adam and Eve felt it necessary

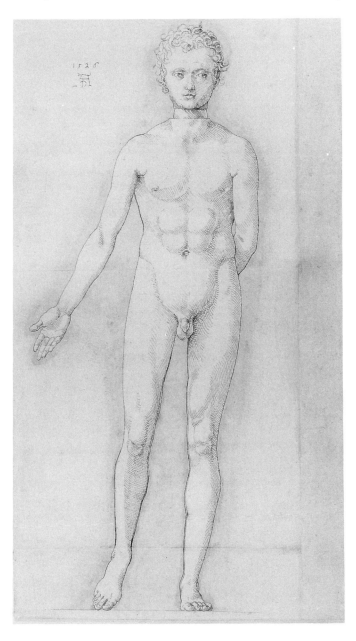

193. Albrecht Dürer, *Proportioned Nude as Atelier Mannequin*, 1526, pen and ink with yellow wash, British Museum, London.

to cover their guilty members.[10] As is usual for Baldung, the fig leaf does double duty in this woodcut, appearing to cover shame while in fact exacerbating it. The artist extends this perversion through every convoluted, unfulfilled, and doubly meant gesture of the fallen pair, in whom coitus appears as simultaneously a pleasure they cannot enjoy and a pain they cannot avoid.

What is most unusual about the 1519 *Fall*, however, is that Baldung has woven into this fabric of contradiction another self. At the base of the tree of knowledge, and under Eve's left foot, the artist has included his own mark, thereby claiming authorship of the work. Yet unlike most artists' monograms and signatures of the time, the tablet here does not occupy a neutral space outside or at the border of the image's subject, but always a part in the scene's narrative. Eve holds an apple directly over the artist's name almost like a temptation. She seems about to let it drop in an instant just after what we see, and for which the whole picture is but an expectation. Stepping toward us, Eve will trip on Adam's trapping foot, the apple will drop from her hand, and the tablet will fall face down on the ground, effacing Baldung's name. The "Fall" of Eve and Adam, itself a metaphorization of their sin or transgression as a sudden downward drop in space, occurs here as a general collapse that includes a little death of the artist. Commentators have read the conceit biographically, as evidence of the artist's real lust for women.[11] I prefer to subsume any such confessional function of the print under the more general theme of the artist's role in the drama of sexuality and self he constructs.

It has been suggested that Eve's stance, with one foot on Baldung's monogram, alludes to the text in Genesis where God curses the serpent after the Fall and admonishes him that woman, Eve, "shall crush thy head."[12] In the *Enchiridion,* Erasmus reads this passage as an emblem of the conquest of lust: "Woman undauntingly grinds under her foot the venomous head . . . and the tyranny of the flesh has been diminished."[13] A version of this gesture appears in a later allegorical panel by Baldung dated 1529, now in Munich, in which a nude woman personifying Prudence or Virtue, bearing a mirror with the reflection of a skull, crushes a serpent underfoot (fig. 194; O. 66b). In the 1519 woodcut Baldung installs his own mark in the place of the serpent, thus associating himself at once with the devil as original instigator of the Fall and with the continuing symptom of fallenness: carnal lust. The artist appears here as a punished originator of evil, or at least as the kind of enabling agent of sin represented by the serpent in the mythic story of the Fall. As I argued in an earlier chapter, Baldung constructs his images to tempt viewers into carnal desire, and in that sense he "causes" a lapse within every act of viewing. But by transforming the artist's monogram, proof of authorship and emblem of artistic originality, into the malevolent instigator of evil, Baldung also constructs an audacious analogy between fallenness and the originary power of the individual artistic self.[14]

Again, the point of reference is Albrecht Dürer, whose Prado *Adam* and *Eve* panels (fig. 133) provided the elongated vertical format for Baldung's woodcut, and whose 1504 engraving of the *Fall* (fig. 98) established the form, as well as the conceptual ambitions, of the artist's monogram itself. Like Baldung's woodcut, Dürer's engraving represents the moment just before the fall into sin and death; but rather than finding Adam and Eve

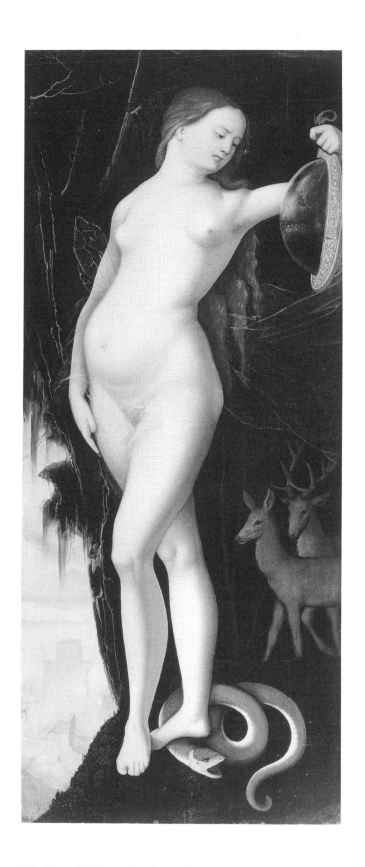

194. Hans Baldung, *Prudence* (?), 1529, oil on panel,
Alte Pinakothek, Munich.

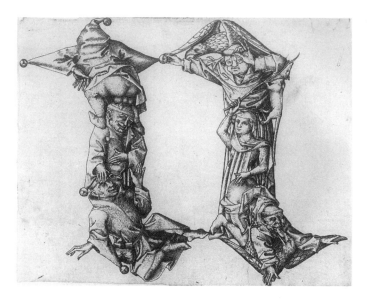

195. Master E. S., *The Letter "N,"*
c. 1465, engraving,
Kupferstichkabinett, Staatliche
Museen Preußischer
Kulturbesitz, Berlin.

already fallen, Dürer recovers, or outdoes, their prelapsarian forms. Although Eve is about to take the apple, the cat is about to catch the mouse, and the goat on the cliff is poised to jump, Dürer's figures possess the beautiful bodies, innocent poses, and free movements indicative of their status as *imago Dei.* The 1504 engraving, however, is less a statement about our original appearances, or about the circumstances of our lapse, than a demonstration of the powers of the artist who, despite his kinship with Adam, can create anew our erstwhile divinity. Dürer's signature and monogram, we recall, as well as its support by the tree of life, asserts that, though man's perfection is lost, art can reoccupy a space prior to the Fall and death. It is in part against this self-glorification of the artist that Baldung fashions his 1519 woodcut. The Fall, here enacted by our already fallen parents, occasions imperfect bodies, lewd postures, and convoluted movements (what Kleist described as *Ziererei*); and this tableau of a debased, erotic parental embrace should provoke similarly ugly and uncontrolled passions in the fallen flesh of their heirs, Baldung's viewers. Note that Baldung marks the perimeters of his picture's story as co-extensive with fallen history. In the gesture of Eve crushing the serpent-as-artist under-foot, the moment of original sin is linked anagogically to the end of time, when Satan's head will be finally crushed. Baldung's monogram, about to disappear, literally topples Dürer's idealizing emblem of the place and powers of the artistic self. Where Dürer in-vents self-portraiture as the prosopopoeia of quasi-divine making, Baldung responds in an apocalyptic fall and mortification of the artist's personal work.

Although Baldung's method seems very modern, his message is resolutely medieval. Against the Renaissance belief that unfallen perfection can be attained through creativity and self-assertion, and against the claims of originality and ownership embedded in the monogram's legal status, Baldung sets his version of self-portraiture, in which the con-struction of beauty does not ascend to self-mastery and regained innocence but descends

to the artificial, the bawdy, the pornographic, and in which the creative "I" is precisely that which is sinful, belated, dispossessed, and mortal. Baldung's attitude of self-ascesis has much in common with German piety of the Middle Ages and with the pessimistic Alsatian humanism of men like Geiler and Brant. There the perfect or *volkommen* is always that which is *not* self, *not* I; and there sinful man is admonished to renounce all claims of individual "originality" and to attribute unique talents, inventions, and possessions to God. For as the anonymous author of the *Theologia Deutsch* writes: "When perfection comes, that means—and when it is known, then it is announced that—creaturehood, createdness, I-hood, selfhood, and my-hood are all disdained and valued as nothing."[15] Baldung, who certainly had a keen sense of his own artistic "createdness" simply by being Dürer's epigone, rebels against his master by revealing the vanity, if not to say the fallenness, of the project of self-portraiture.

Baldung is not the only artist of the period to produce self-mocking or macabre monograms. Indeed, as is the case for so many seemingly anti-Dürerian aspects of Baldung's art, this conceit originates with Dürer himself. At the base of the 1501 *Witch* engraving, a work that inspired most of Baldung's later images of witches, Dürer's initials appear deliberately in reverse, as if perverted by the "world upside down" that they undersign (fig. 164).[16] The backward D, moreover, is reiterated and amplified in the overall shape of the demonic figural group behind, which recalls the grotesque alphabets formed of juggled men and animals that were produced by German engravers of the fifteenth century (e.g., fig. 195). The witch, riding backward on the goat-as-devil but forward on the D, is the cause of this distortion, just as she has invoked the hailstorm at the upper left. Read in this manner, the engraving as a whole represents Dürer, through his personal mark, conjured and bewitched by what he creates.

Closer still to Baldung's tricks, and probably influenced by them,[17] are the monograms of Niklaus Manuel Deutsch, painter of the great *Totentanz* in Bern and later literary satirist for his city's Reformation. We have already discussed the interplay that Manuel devised between image and artist's signature in his monogrammed sketch *Lucretia*, in which Manuel's personal emblem, the *Schweizerdolch*, doubled as the heroine's dagger and perhaps as her rape by Tarquinius Sextus (fig. 72).[18] This conceit of situating signs of authorship in places or subjects associated with sex and death appears often in this Swiss master's works. In the *Dance of Death*, for example, Manuel signs his work by including a self-portrait at the end of the dying procession (fig. 196). While he appears to prop his mahlstick against the surface upon which he paints a group of Jews and heathens, thereby establishing himself as different from his evil subject, an animated cadaver tugs at the mahlstick from behind, threatening to make Manuel's hand slip. This is a way of saying that his art too will fail and that death will have the last laugh, joining the artist and the wicked figures he portrays in one dance. And, more personally, in a chiaroscuro drawing from about 1513, Manuel depicts himself as a skull held by an airborne witch (fig. 197).[19] The identity of this macabre "portrait" is signaled by the artist's characteristic feathered cap and by a small tag bearing the artist's monogram, which dangles from the skull's teeth. And as with so many of Baldung's concatenations of the macabre and the

erotic, Manuel's drawing responds to, and demonizes, a well-known work by Dürer: the *Large Fortune* or *Nemesis* engraving from 1501–1502 (fig. 198; Kn. 36).

Manuel even involves his initials, NMD, in a self-reflexive conceit. His personal motto, *Niemann kann als wüssen* ("Nobody can know everything"), often abbreviated as the letters NKAW, appears on dozens of Manuel's drawings (e.g., fig. 199). On a literal level, the phrase admits the limits of human knowledge or, more precisely, of a knowledge of Dame Fortune, who is Manuel's principal deity and whose Dürerian embodiment the 1513 chiaroscuro *Witch* recalls. The motto also belongs, however, to the language games of the so-called *Nemo* sermons. Originating in a parodic text called the *Historia de Nemine* (1290) by the French monk Radulfus Glaber, these mock sermons enjoyed great popularity in the monastic culture of the Middle Ages and in the carnival life and popular literature of the early modern period.[20] By the sixteenth century in Germany and Switzerland, the figure of *Niemann* or *Niemand* had become a character in printed broadsides and Shrovetide plays, along with figures like Pfaff von Kalenberg and Eulenspiegel.[21] These

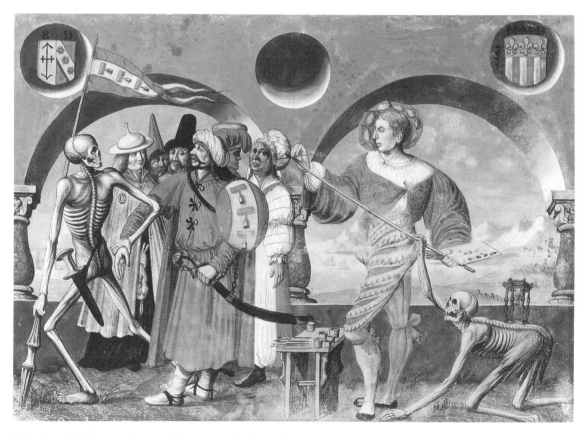

196. Brandolf Egger, *Dance of Death,* detail of *Heathens, Jews, and Niklaus Manuel,* 1646, gouache, copy after Niklaus Manuel Deutsch, *Totentanz* (1516–1518), in the Predigerkloister in Bern (destroyed in 1660), Historisches Museum, Bern.

197. Niklaus Manuel Deutsch, *Airborne Witch Carrying Skull of the Artist*, c. 1513, pen and ink, heightened in white, on brownish orange prepared ground, Kupferstichkabinett, Kunstmuseum, Basel.

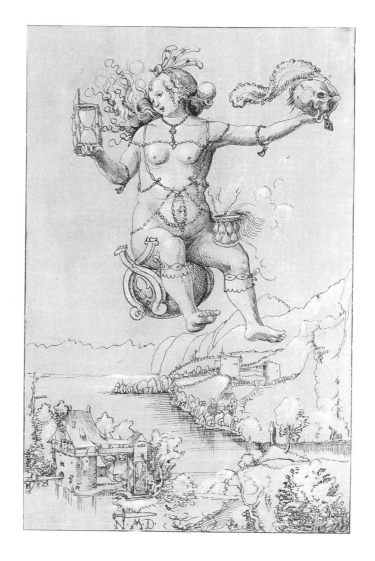

carnivalesque games of negation focus on a hero, "Nobody," who is at once everything and nothing, a worthless fool and Christ's equal. As Mikhail Bakhtin writes:

> The word *nemo*, (nobody), which in Latin is used as a negation, was interpreted by Radulfus as a proper noun. For instance, in the Scriptures *nemo deum vidit* (Nobody has seen God) in his interpretation became "Nemo saw God." Thus, everything impossible, inadmissible, inaccessible, is, on the contrary, permitted for *Nemo*. Thanks to this transposition, *Nemo* acquires the majestic aspect of a being almost equal to God, endowed with unique, exceptional powers, knowledge (he knows that which no one else knows), and extraordinary freedom (he is allowed that which nobody is permitted).[22]

Pieter Bruegel's engraving *Everyman*, published in Antwerp in 1558 by Hieronymus Cock, is a late example of this theme (fig. 200). The figure Nobody appears in a picture at the back of the scene, bearing the inscription, "No one knows himself." Manuel, who in

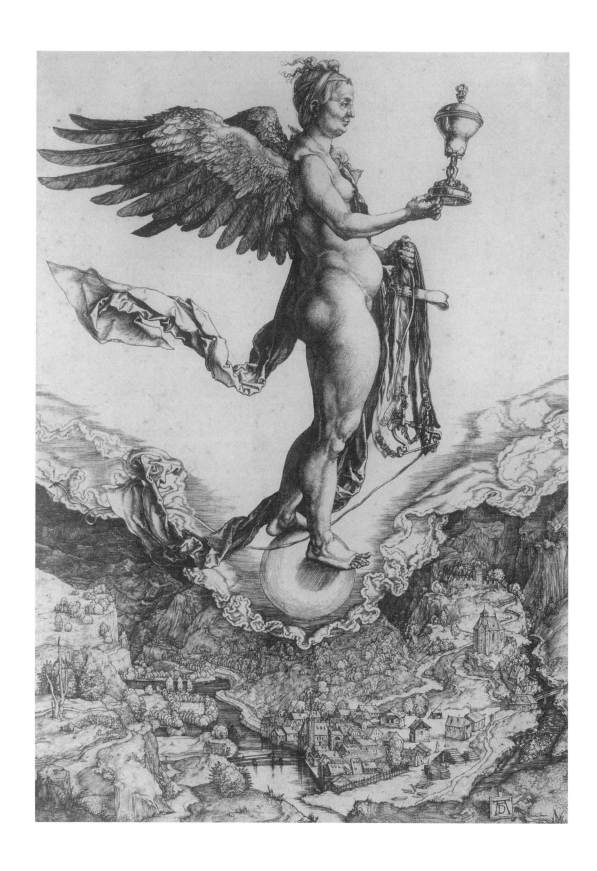

198. Albrecht Dürer, *Large Fortune* or *Nemesis*, 1501–1502, engraving.

199. Niklaus Manuel Deutsch, *The Flute Player*, c. 1514–1515, pen and ink, heightened with white chalk and white pencil, with yellow wash on reddish brown prepared ground, Kupferstichkabinett, Kunstmuseum, Basel.

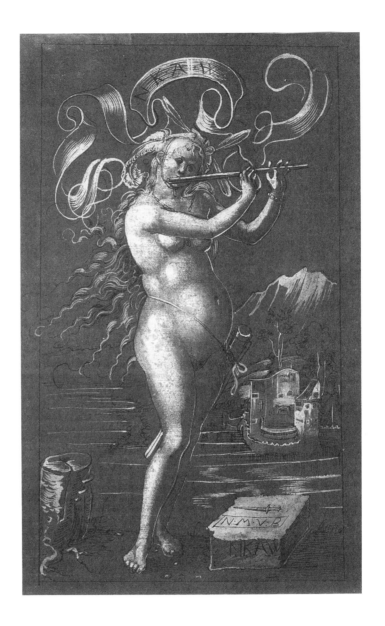

the 1520s became an influential and prolific author of satirical Shrovetide plays, would certainly have been familiar with this tradition when he produced his drawings and prints combining carnal knowledge and human impotence.[23] I submit that the *Niemann* or *Niemand* of his motto is a version of Manuel himself, whose initials would, if pronounced together, sound this self-negating name.[24] In this way the artist could claim to know nothing and everything at once, thus reconciling the contradictory modes of self-representation for German Renaissance artists: as demigod and as death's-head.

It lies outside the scope of this study to consider the specific historical and aesthetic circumstances behind this Swiss painter's macabre self-portraits. Probably devised under

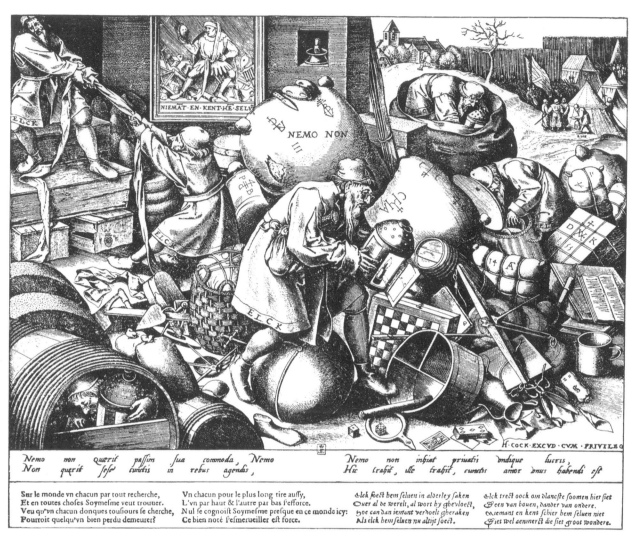

NIEMĀT·EN·KENT·HE·SELV

NEMO NON

H·COCK·EXCVD·CVM·PRIVILEG

Nemo non querit passim sua commoda, Nemo
Non querit sese cunctis in rebus agendis,

Nemo non inhiat priuatis vndique lucris,
Hic trahit, ille trahit, cunctis amor vnus habendi est

Sur le monde vn chacun par tout recherche,
Et en toutes choses Soymesme veut trouuer.
Veu qu'vn chacun donques tousiours se cherche,
Pourroit quelqu'vn bien perdu demeurer?

Vn chacun pour le plus long tire aussy,
L'vn par haut & l'autre par bas s'efforce.
Nul se cognoist Soymesme presque en ce monde icy:
Ce bien noté sesmerueiller est force.

Elck soeckt hem seluen in alderley saken
Ouer al de werelt, al wort hy gheuloeckt,
hoe can dan iemant verdoelt gheraken
Als elck hem seluen nu altijt soeckt.

Elck treckt oock om blanckste soomen hier siet
Seen van bouen, dander van ondere.
Niemant en kent schier hem seluen niet
Siet wel aenmerckt die siet groot wondere.

200. Pieter Bruegel the Elder, *Everyman*, 1558, engraving
 (published in Antwerp by Hieronymus Cock).

Baldung's influence (the two like-minded artists could have met in or around Strasbourg about 1510) and often involving overt allusions to the art of Dürer, Manuel's images of death and sexuality remind us that Baldung's seemingly idiosyncratic pictorial strategies are not without parallels in the art of his immediate contemporaries, and that carnivalesque distortions of marks of authorship perhaps belong to the larger phenomenon of early Dürer reception in the first half of the sixteenth century.[25] However ingenious Manuel's pictures may be, though, they are different from Baldung's most complex creations, relying mostly on stock iconographic conceits and verbal games to convey their message. Baldung's images deconstruct artistic self-assertion through their very structure of address. I therefore end my study of German Renaissance self-portraiture by examin-

ing a group of his works in which the artist's monogram, together with an oblique or disguised self-portrait, makes statements not only about the status of the artistic self, but about the whole regiment of visual representation. With the artist writing his name under erasure and posing as the mortal victim of his own art, Baldung's late, secular woodcuts offer a fitting conclusion to Dürer's project of self-portraiture.

Up to now I have largely ignored the question of Baldung's presence *within* his works, that is, the ways he registers, thematizes, and scandalizes authorship. I have focused instead on what I regard as the more fundamental mode of self-inscription in his art: the interpellation and overthrow of the individual beholder *before* the work. However, Baldung's viewer-oriented images also depend, and comment, on a particular notion of the artist and of his relation to what we see. While rejecting the confident individualism of Dürer, these images are profoundly self-involved. Although it is Dürer who produces the German Renaissance's only true, epochal self-portraits, he seems far less burdened by an immense, crippling, and characteristically modern self-consciousness than is his greatest follower.

The critical rehabilitation of Baldung that took place in the early decades of the twentieth century hinged upon the estimation of precisely this self-consciousness. In an essay from 1933, Walter Hugelshofer challenged the view, dominant in the previous century, that Baldung was at best a quirky but rather tasteless imitator of Dürer, and at worst the veritable embodiment of *altdeutsche Kunst* in decline.[26] Baldung's art, Hugelshofer argued, differed radically from the northern pictorial tradition from the Middle Ages through Dürer, because what was central to Baldung was not the person, object or narrative depicted, but rather the subjective personality of the artist himself, which was forever being superimposed upon his products in uncanny and often disruptive ways. Hugelshofer concludes the essay thus:

> In the case of Dürer, Holbein, and "Grünewald," the psychological constitution and private sphere of the artist can be inferred from his works only in the most general and peripheral sense. In Baldung, this subjective sphere is dominant. And with that the deep foundation of late Gothic art in Germany is assaulted at its most critical point. A fine fissure now runs through the whole structure. The invasion and final domination by further subjective elements had to change the very fabric of this art and, in the end, destroy it from within.[27]

Baldung's self-consciousness, his insistence that his art is primarily about himself, represents here the total and irreversible break with medieval art. We may take issue with Hugelshofer's assessment of Dürer, Holbein, and Grünewald, and of medieval art generally, yet we can see what he means already in Baldung's earliest commission, the *St. Sebastian Altarpiece*, produced about 1507 at the time of Baldung's departure from Dürer's shop (fig. 141).[28] St. Sebastian, a popular subject of late medieval art and piety, stands gazing out at us as if unaffected by his martyrdom. This in itself is traditional, for as we see in a panel from Cologne by the anonymous Master of the Holy Kinship, dating from

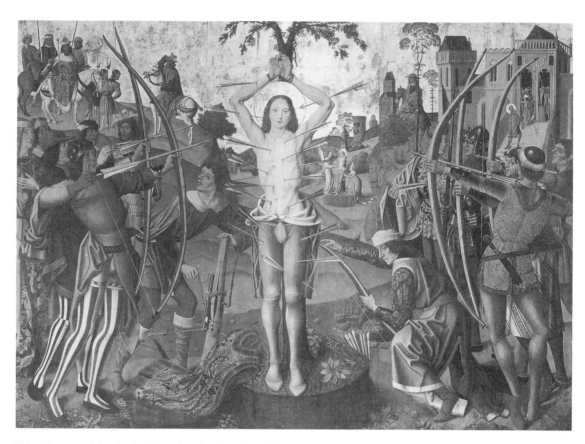

201. Master of the Holy Kinship, *St. Sebastian Altarpiece,* c. 1493, central panel, oil on panel, Wallraf-Richartz-Museum, Cologne.

the previous decade, the plague saint and *Nothelfer* Sebastian should be at once player in a historical narrative of suffering and object of cultic piety in the here and now of the beholder (fig. 201). In Baldung, however, the saint's gaze is doubled by that of a clothed figure behind, who is thought to represent the artist himself in his personal color, green (hence his nickname "Grien").

Baldung places himself so close to the saint, and endows both likenesses with such similar facial expressions, that it is easy to read Sebastian's nude body as the artist's own. This may have a pious function. The artist gestures with his left hand toward the Mauretanian archers as if to point out the evildoers in the scene; the gesture of his open hand is picked up by a well-dressed man at the far right who, pointing to himself, seems to accept this responsibility. Thus distinguished from the villains, Baldung identifies with Sebastian, and the possibility that the saint's body can be mistaken for the artist's, and that the sap green of the latter's costume and name can blend into the background foliage, underscores this empathy. Baldung, one might imagine, sought to merge the *imitatio* theme of Dürer's 1500 Munich panel (fig. 21) with the *in assistenza* self-portrait of Dürer's recently completed *Feast of the Rose Garlands* to produce a likeness that was simultane-

ously a confession and a signature. The matter-of-fact tone of the picture, however, deflates any such intentions. Baldung gestures more like a stage director than an accuser, and the nude body with which he doubles appears more like a young artist's advertisement of his talent and training than an emblem of suffering or sanctity. In constructing Sebastian, Baldung draws everything he has learned about nudes in Dürer's shop. The vigorous contrapposto, the slanting shoulders, the subtly modeled torso, and the outward glance recall, among other Dürers, the Weimer *Nude Self-Portrait* (fig. 120). In its style, execution, and ambition, the *St. Sebastian Altarpiece* is the work of a remarkable, but also still derivative painter whose empathy with the beautiful, arrow-pierced saint doubles as an identification with, and perhaps also an unconscious vanquishing of, his artistic master.

The study of German Renaissance art does not yet possess the critical tools for interpreting the dominant presence of the self-portrait in this sacred panel from 1507 (fig. 202). However much we may want to see him *in assistenza*, or as mere witness to the event, we remain disturbed by the artist's centrality, which both undermines the narrative

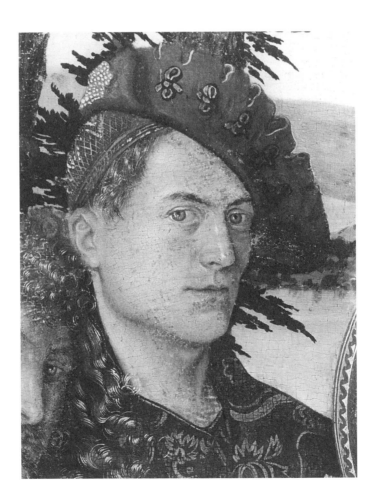

202. Hans Baldung, Self-portrait, detail of *St. Sebastian Altarpiece* (fig. 141 above).

coherence of the event depicted and overwhelms the supernatural immediacy of the saint's presence in the cultic image. Whereas in the anonymous Cologne panel the picture clears a direct path of vision from the beholder in his attitude of devotion to the centralized, cultic presence of the saint, in Baldung the religious elements seem pushed toward the margins, framing a relation, uncannily modern in tone, between the viewer and the picture's maker. Baldung's late, oblique self-portraits will put us a little on the way toward understanding that relation invented in a work like the *St. Sebastian Altarpiece*.

In none of Baldung's works is the artist's name as strangely and complexly placed as in the great woodcut series *Wild Horses*, dating from 1534. In what is probably the first of these images, *Johannes Baldung Fecit* appears inscribed on a tablet stationed below a sexually aroused stallion (fig. 203; M. 78). A monkey sits at the tablet's upper edge, his tiny genitals echoing the large, erect phallus above. The monkey is a traditional emblem of lust: fallen concupiscence, which degrades men to the level of beasts, is aptly represented by this animal that resembles man and that was noted for its voracious sexual appetite. Thus in a woodcut illustration for the first edition of Brant's *Narrenschiff* (fig. 204), sometimes attributed to the young Dürer, a monkey appears among figures attending Voluptas in the scene "On Amour."[29] And in his border decorations in the *Prayer Book of Maximilian*, Dürer twice includes the monkey as *immundia simia* to express the triumph of evil in a fallen world.[30] Scholars have also argued that the ape relates to the tablet and its inscription. Artistic making, registered in the verb *fecit*, is a process of imitation or mimesis, and Renaissance writers, stressing art's dependence on nature, metaphorized it as an "aping" of appearances.[31] The monkey, framing Baldung's name with its little hand and foot, functions as comic simulacrum of the artist himself. These two readings are perfectly compatible, for mimesis produces images in a manner analogous to sexual reproduction; hence the cluster of related terms like generate, genius, genital, and, closest to Dürer's heart, *ingenium*.

In addition to the tablet and ape, Baldung has also included a reference to himself in the figure at the upper left of the print. From the hat and bearded face, we recognize a self-portrait of the artist, such as he appears in an exactly contemporary woodcut illustration (fig. 205; M. 466).[32] Peering from behind a tree, Baldung appears here not as maker, but as viewer. Together with the tablet, he provides an island of humanness in an image otherwise threateningly wild. The way he peeks from behind a tree suggests he does not want to be seen and therefore marks him as voyeur, which is comforting to us as viewers. For by labeling the wilderness as *something to be viewed*, he helps to bracket and domesticate it. The sense of lingering caution, of still-intact control, is underscored, by the presence of the elk, symbol of prudence, in the forest's inner depths. In the course of the woodcut series, however, the self-portrait will vanish, together with the elk, and the tablet will wander about the landscape, functioning in ways we shall explore.

The sequence of images has been worked out most convincingly by Sigrid Schade, who links the prints in the following narrative.[33] In the first print the stallion, aroused by the

sight or smell of a mare's hindquarters, neighs in excitement as he prepares to mount her (fig. 203). In the next image, the mare has kicked off the stallion (fig. 206; M. 79). Unable to copulate, the horse ejaculates his semen on the ground. In the last print, the wild horses have descended into chaos (fig. 207; M. 77). The thwarted sexual desire of the stallion has led to anarchy and death. Note that the inscribed tablet appears tossed behind a fallen horse's hindquarters. Its edges stand oblique to the picture plane but parallel to the limbs of the toppled animal, suggesting that not only the natural world, but also the artist himself, has been overthrown in the series' final apocalyptic scene.

But let us return to the first print, *Aroused Stallion Approaching Mare*, and work out the placement and itinerary of the self in Baldung. As in the perilously balanced and soon to be toppled monogram in the 1519 woodcut *Fall* (fig. 145), Baldung's name does not appear in a border around the image, as a frame that brackets the visual field as something made by the artist. Rather, it lies embedded at the heart of the action, in an erotically charged zone framed by the underbelly of the stallion. The horse's body, its swelling volume as articulated in the woodcut's sharp modeling of light and shadow, engenders and determines the scene's pictorial space. In the print *Ejaculating Stallion*, the stallion's back hoof at the left and the head of the kicking mare at the right occur at the precise limits of the scene. The boundary of the visual field is thus experienced as contingent upon the anarchic movements of the animals, whose energy appears even to bend the physical world: note, for example, how the contour of the tree at the right in this print adheres to the outline of the mare's head. Baldung's woodcut series is "about" the body: through the horse, it chronicles the rule of the flesh in sexuality.[34] Antique and medieval zoological literature stressed that horses possessed exceptional sexual appetites. According to Lucius Junius Moderatus Columella, for example, mares were capable of self-impregnation, conceiving their young simply "by imagining in their own minds the pleasures of love."[35] And Varro advises breeders to tie up the mare before mating, so that "the stallions do not, in their eagerness, eject the seed to no purpose."[36] Baldung's vision of premature ejaculation is an emblem of the fruitlessness of wild lust.

Baldung frames his name with the symbols of carnality—the monkey, the phallus, the horse. But the pictorial source for the tablet's placement has a quite different trajectory. In Albrecht Dürer's so-called *Small Horse* engraving of 1505, the artist's monogram appears similarly under the animal on a square surface positioned at an oblique angle (fig. 208; Kn. 44). Yet whereas Baldung's tablet looks as if it had been abandoned in the landscape, there to be degraded by the beasts of the forest, Dürer's monogram fits snugly into the ordered geometry of the image. Panofsky identified the print's iconography as "Animal Sensuality Restrained by the Higher Powers of the Intellect."[37] The horse, emblem of violent, irrational passion, stands surmounted by a bursting flame, signifying reason.[38] I disagree with this reading of the fire, for in its numerous reincarnations in Baldung's witch images, the flaming pot refers not to reason but to all-consuming, never-fulfilled desire and to the "mouth of the womb" that is "never satisfied" (Prov. 30:16). But Panofsky is right that the print is all about restraint. Roughly contemporary to the 1504 *Fall* and, like that engraving, conscious of its antique pedigree (i.e., its evocation of

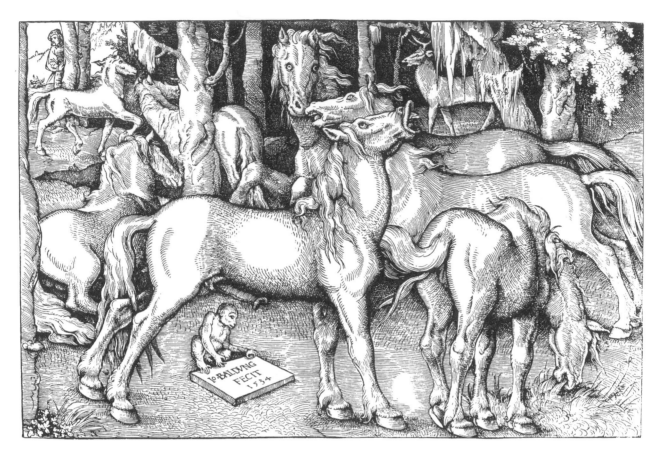

203. Hans Baldung, *Aroused Stallion Approaching Mare*,
 1534, woodcut.

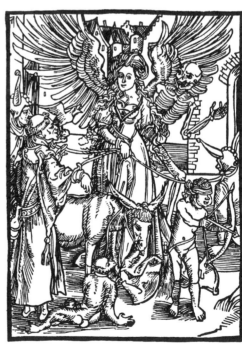

204. *Von Buolschafft*, woodcut illustration for Sebastian
 Brant's *Narrenschiff* (Basel: Johann Bergmann von
 Olpe, 1494), chap. 13.

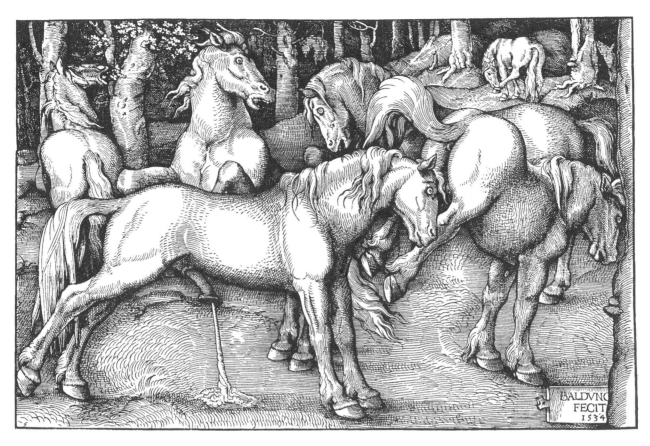

206. Hans Baldung, *Ejaculating Stallion*, 1534, woodcut.

205. Hans Baldung, *Self-Portrait*, woodcut illustration
for Sixtus Dittrich's *Epicedion Thomae Sporeri musicorum
principis modulis* (Strasbourg: Peter Schöffer and
Matthias Apiarius, 1534).

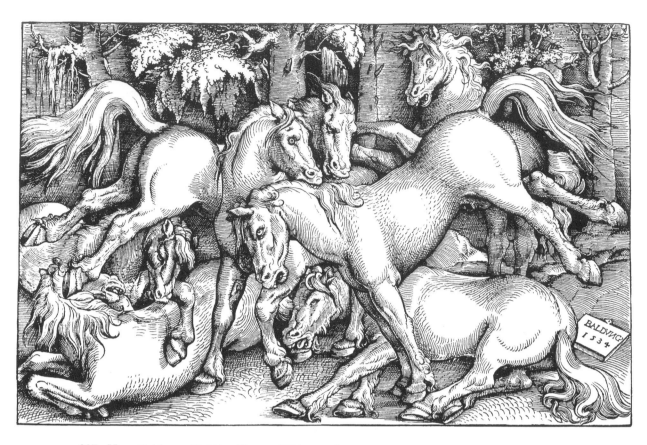

207. Hans Baldung, *Fighting Horses*, 1534, woodcut.

classical equestrian monuments like the Marcus Aurelius statue), the *Small Horse* is a well-bred cousin to Dürer's Adam. In it, art and knowledge claim to control the body and restore to man his status as the measure of all things. Thus in a letter from about 1510 addressed to Dürer, Lazarus Spengler likens the "inner desires" to an "untamed horse."[39] Reason (*vernunfft*), he argues, can "tame" desire and bring it "to the right path," as one does a wild horse. Reason's rules are best deduced from classical examples and should be collected and published for the common good.[40] And before that Erasmus, in his *Enchiridion*, writes that "some have a rebellious body, an unbroken and refractory horse, so to speak; and the result is that even with the harshest bit, spurs, and club, the seating driver has trouble taming its wildness."[41] The Erasmian ideal of self-mastery, in which the I asserts its sovereignty over temptations from within and without, finds its most monumental pictorial expression in Dürer's own mounted Christian, the 1513 engraving *Knight, Death, and the Devil* (fig. 144). Here the monologic self, bounded off from the world, is metaphorized as a knight in armor controlling his powerful mount of classical pedigree as he passes through the world on the difficult, pathless journey toward salvation.[42]

Dürer expresses the idea of control, however, less through emblem than through the

very fabric of the pictorial image. In the *Small Horse* engraving Dürer's proportioned animal, displayed in strict profile to reveal its perfect contour, stands nervous yet obedient at the center of the image. The horse's muzzle and tail maintain precisely equal distances from the edges of the sheet, affirming thereby that the power to frame, which is to say the force of aesthetic construction through rule, can contain the body and desire. The artist's monogram belongs to this domain of restraint. Carved on a cube of stone and aligned along the central axis with the prominent date above, Dürer's initials link the agency of framing to the self of the artist. This is true, as well, in Dürer's *Large Horse* engraving from the same year (fig. 209). Although the foreshortened body of the animal exerts pressure on the picture's borders, Dürer meticulously reserves a margin of space

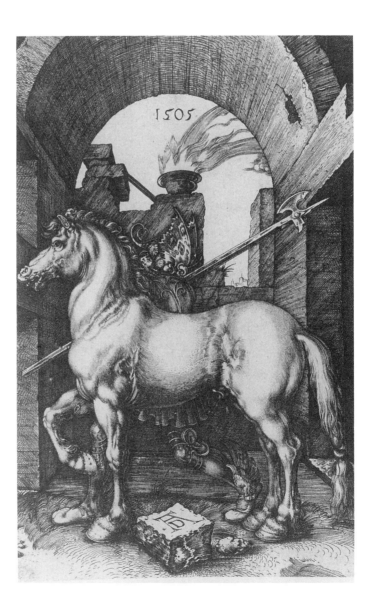

208. Albrecht Dürer, *Small Horse*, 1505, engraving.

in which to place the date and monogram. How different is framing here from the coincidence of body and border in Baldung!

Early in his career, Baldung mocked Dürer's horses on precisely this point. His 1510–1511 engraving *Groom Bridling a Horse* shows a stallion in profile, held in place at the center of the image in the manner of Dürer's *Small Horse,* yet only through a comic and obviously futile expenditure of energy on the part of the groom (fig. 210; M. 548). Baldung draws his picture's setting from his teacher's art as well: the crenellated stone wall and the twisted tree at the left evoke the wall and column of Dürer's *Large Horse* engraving but strip them of their antique aura. This is Dürer's horse behind the scenes, always threatening to trot out of the picture, leaving the artist to stare blankly into space. Baldung returns the horse from Dürer's ideal and classicizing world of moral restraint and aesthetic closure back into the real world, where the artist's framed construction of space cannot control its objects, and where carnal desire, symbolized by the horse, clearly overpowers any human will to restraint.

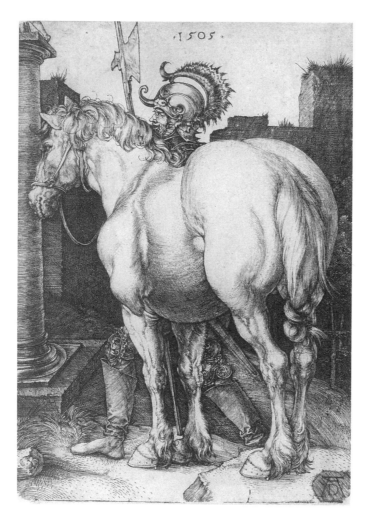

209. Albrecht Dürer, *Large Horse,*
1505, engraving.

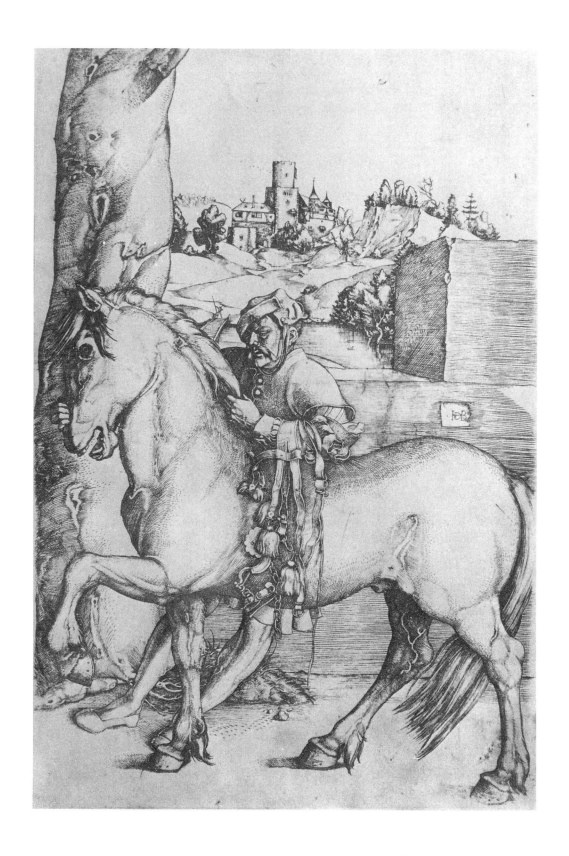

210. Hans Baldung, *Groom Bridling a Horse,* c. 1510–1511, engraving.

In the *Aroused Stallion,* Baldung contrives an even more debased pastiche of Dürer. He twice invokes the *Small Horse* engraving: once in the enflamed stallion in profile in the foreground, and with it the oblique, monogrammed tablet, and again in the horse at the upper left, which, trotting in strict profile between the sordid scene before us and Baldung's self-portrait as voyeur, appears like the artist's own *memory* of Dürer, through whom Baldung beholds everything he makes.[43] And Baldung invokes also Dürer's *Large Horse* engraving, as the model for the foreshortened mare in the foreground, whose genitals, visible to us under her swishing tail, have enflamed the stallion's carnal desire. Baldung thus stages, as in a farce, the impending, carnal, but in the end misfired mating of Dürer's two ideal horses. Artistic tradition, or the generation of new works through a conscious imitation and recombination of old, has seldom failed as miserably, and as comically, as here.

When, in the woodcut series *Wild Horses,* Baldung frames his own name with the sexualized body of the horse, he implicitly undercuts Dürer's aesthetic moral, and even economic and legal fictions of the sovereignty of self. This becomes clearest in the scene of the *Ejaculating Stallion* (fig. 206). The horse ejects his semen on the ground where the tablet with Baldung's name had been placed. The tablet, in turn, has ducked for cover, avoiding this bizarre degradation but registering shame by partially hiding itself behind the framing tree on the right. We are familiar with the conceit of self-debasement from the oddly placed monogram of Baldung's 1519 *Fall.* In the *Wild Horses* series, the forest clearly represents fallen nature, in which sexual instinct has run amok, and again Baldung has implicated himself in the shameful events he depicts. In the first scene, his likeness may be comfortably positioned as mere observer to the action, yet his name and authorship have been dragged into the center of the scene. When the stallion's ejaculated semen, which is the scandalously literal outcome of sexual arousal in Baldung's allegory, threatens this inscription of self, the coy gesture of shame embodied in the half-hidden tablet has at least three valences. First, it mirrors or mocks the beholder's own violated modesty in having to witness the event. Its partial concealment behind a tree links up with the posture of voyeurism assumed both by Baldung's self-portrait in the first print and by ourselves, for we too behold a visual field framed on one side by a tree trunk. Second, the inscription, *Baldung fecit,* reminds us that the artist is more than mere observer, indeed, that he produced these obscenities whose central event is precisely about *failed making.* In that sense Baldung produces a sexualized, travestied, fallen version of Dürer's boastful tablet in the engraved *Fall,* which also had affirmed an analogy between artistic origination and the mythic source of human life.

"Self-consciousness" generally has two meanings. In common speech it denotes embarrassment, when the self, knowing itself to be seen by others, feels too visible and behaves in an awkward manner. In philosophy, self-consciousness means more generally the self's awareness of itself. The term "artistic self-consciousness" builds on the latter sense, describing those phenomena when an artist recognizes and, within his works, explicitly registers the fact of his artistry. Rarely do we mean by an artist's self-consciousness his embarrassment over what he has done or shown. Yet it is to this do-

main of shame that the half-hidden tablet of authorship in the *Wild Horses* woodcut belongs. As a comment on the relation between self and image, Baldung's tablet has perhaps a third valence: in its oblong format and in the way its edge passes behind the framing tree, the tablet seems to echo the shape and visual field of the woodcut as a whole. What could Baldung have meant by this subtle *mise-en-abyme*?

As we have noted, the tree cropping our view of the tablet functions similarly to frame our visual field as a whole. In the previous print, our position next to a tree is mirrored in the self-portrait at the upper left, which defines our posture as that of a voyeur. Baldung may well have borrowed the conceit from Dürer, who, in the early *Bath House* woodcut of about 1496, places what seems to be a self-portrait in a similarly half-hidden position just outside the revels (fig. 211). The motif of a clothed man peering into an enclosed space reserved for nudity has its own history. I show as one example a miniature from a fifteenth-century illuminated *Roman de la violette* depicting a count violating the private space of a woman's bath (fig. 212).[44] Now, one of Baldung's most characteristic features as an artist is that he insists on thrusting before us, in an aggressive and often

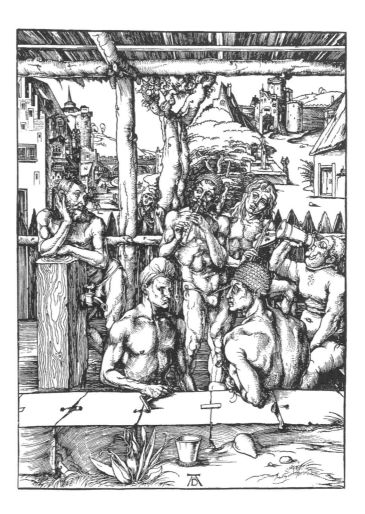

211. Albrecht Dürer, *The Bath House*, c. 1496, woodcut.

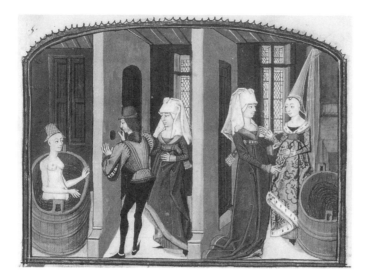

212. *Count Observing Woman at Bath*, mid-fifteenth century, illumination from the *Roman de la violette*, Bibliothèque Nationale, Paris.

rude manner, scenes that were meant to exclude us. This is clearest in his many images of witches and their sabbaths, in which he composes scenes of naked women, possessed children, and demonized animals all involved in an evil conspiracy against the world of masculinity and civilization. Baldung's *New Year's Sheet* demonstrated well this strategy of lewd exposure aimed at undermining the beholder's sovereignty of self (fig. 159). In the *Wild Horses* woodcuts Baldung represents an analogous scene, only the object of desire, as well as the picture's masculine presence, has descended into the animal realm. The grazing mare exposes her genitals to the aroused stallion in much the same manner as the female witch had done to the viewer in the earlier *New Year's Sheet:* note, for example, the similarities between the mare's hindquarters and the woman's buttocks, as well as the obscene placement of Baldung's monogram in both works.

Philippus Aureolus Paracelsus (1493?–1541) wrote that sexual desire begins with a self-excitation through fantasy and sight: man, endowed by God with a will to procreate, gazes and fantasizes until he achieves desire, which in turn creates semen as *liquor vitae*.[45] Although this process was originally at the service of the will, after the Fall the body gained the upper hand. Baldung's wild horses enact a stark version of the fallen process of excitation through sight and fantasy. As such, they chronicle the trajectory of vision and sexuality operative within every viewer of Baldung's erotic art. The ejaculation depicted in the primeval forest animalizes, and therefore literalizes, what might occur in front of the image—or, more radically even, onto the surface of the sheet—though behind the closed doors of the humanist's *studiolo*.[46] By engaging our interest at the primary level of sexual desire, in a manner directly analogous to the cleric's experience in his New Year's greeting, they truly degrade us. As in the 1519 *Fall* and the *New Year's Sheet,* the approach of the stallion, or Adam, or the viewer from behind expresses, through the traditional notion of the sexual position *a tergo* as "against nature," a descent from man to beast enacted in any act of sexual desire.

Baldung expresses this blurring visually throughout the woodcut series, when he mingles the horses' bodies with their environment, rendering inanimate nature alive. The horse that champs its hoof at the upper right of the *Ejaculating Stallion* scene, for example, is surrounded by trees whose trunks and roots rhyme visually with its shape. Similarly, the hanging moss, echoing the form of the horses' tails and manes, makes the forest alive and uncertain. Strangest is the passage between Baldung's self-portrait and the aroused stallion, in which a horse's turned body actually merges with the tree in front of it. The disappearance here of a horizon line between animal and landscape threatens the more important boundary just behind. The tree that is placed before Baldung's self-portrait, framing his visual field, stands for the entire possibility of drawing boundaries around the individual human self. Self-portraiture thus functions to subvert its very founding fictions in the humanist concept of man: that is, the fantasy of the bounded, complete, and sovereign self, in possession of its representations and in command of a world rendered homologous to itself. Baldung portrays the self in dissolution. Like the oblong tablet bearing the artist's name and authorship, his woodcut itself marks that place where the self, desiring, expends itself.

The distance from Dürer's 1500 *Self-Portrait* could not be greater. Whereas the master fashions his emblem of authorship after the icon of God, the epigone poses his signs as surfaces where wild horses, figuring defiled viewers, spill randomly their semen.

Ten years after the *Wild Horses* series, Baldung created his final and most monumental expression of the vanquished artistic self. Produced in 1544, the year before the artist's death, and subverting all those scenes of origin with which Albrecht Dürer prefaced his oeuvre, Baldung's *Bewitched Stable Groom* woodcut stands as a fitting end page to the brief moment of self-portraiture in German Renaissance art (fig. 213; M. 74).[47] The print's subject has been much debated by scholars. Indeed, there exists little consensus even on what could possibly constitute a "subject" for the work at all. Some historians have interpreted the woodcut as the illustration of some specific popular legend: for example, the Alsatian fable of a witch who, transforming herself nightly into a horse, causes havoc in the local stables, or the various stories of a robber baron who meets his death in the form of a horse from hell.[48] Other historians have viewed the woodcut as Baldung's last and most personal document, in which, as in a swan song, he confesses to being overthrown by the power of women.[49] The self-referential tenor of the print can be documented. The unicorn on the wall just under the witch's flame belongs to the coat of arms of the Baldung family, such as he depicted in two remarkable woodcuts dating from 1530 (fig. 214; M. 81, see also M. 80) and in a chiaroscuro drawing dated 1544, now in the British Museum (K. 142). In one of these woodcuts the unicorn appears both on a shield and in the background, where it rears up against a darkened sky and beside a ruined tree, like one of Baldung's wild horses. Less certain is the identification of the fallen stable groom with the artist himself.[50] The beard and mustache of the radically foreshortened figure, as well as the crenellated bands on his sleeves, accord with Baldung's self-portrait drawing exe-

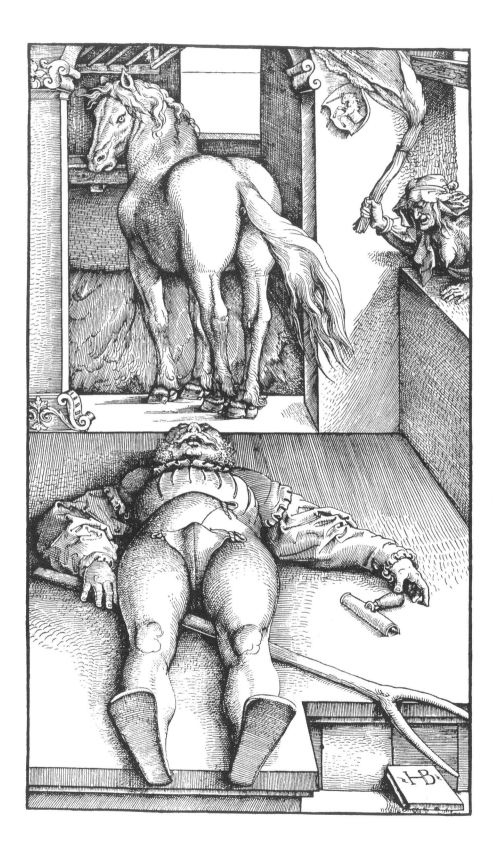

213. Hans Baldung, *Bewitched Stable Groom*, c. 1544, woodcut.

 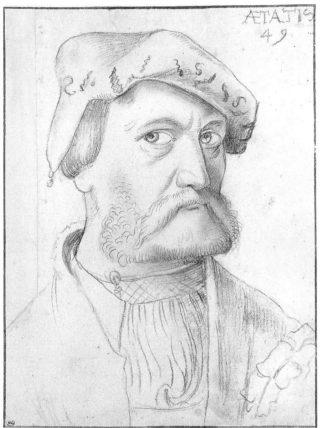

214. Hans Baldung, *Coat of Arms of Baldung Family,*
c. 1530, woodcut.

215. Hans Baldung, *Self-Portrait at Forty-nine
Years,* 1534, black chalk, Louvre, Paris.

cuted in black chalk about 1534 (fig. 215; K. 138). The woodcut, moreover, establishes a visual analogy between the groom, whose supine body extends into space as in ortho- gonal projection, and the artist's HB monogram, which, inscribed on a tablet placed flat at the lower left, also leads the eye into the scene. The tablet's top edge and the groom's head, moreover, both abut an impenetrable vertical plane: the step's high riser and the dangerous entrance to the horse's stall. I believe the woodcut does represent Baldung himself, placed within an assemblage of demonic motifs loosely culled from popular folk- lore, as well as from other images by Dürer and by Baldung himself. It is even possible that the artist had long associated himself with this local folklore through his nickname Hans ''Grien,'' which evoked tales of the womanizing devil disguised as a horseman named Grienhans.[51] Were these motifs to be convincingly identified as all belonging to a single identifiable narrative known to Baldung's culture, however, this narrative would be subsumed under the overarching plot, which concerns the relation between the visual image and the self. That the artist's appears only obliquely in this print, in the form of a monogram, coat of arms, and distorted likeness, expresses Baldung's skepticism regard-

ing the claims, and indeed the very possibility, of self-portraiture. Baldung carries out his final disfiguration of self at the fundamental levels of artistic tradition and of pictorial form.

Like the *Wild Horses* series, Baldung's *Bewitched Stable Groom* woodcut is partly a travestying response to Dürer. The well-built horse seen from behind recalls Dürer's masterpiece of foreshortening and compression, the *Large Horse* engraving of 1505 (fig. 209). In Baldung, however, the animal does not stand harnessed and docile beside its rider, with its tail in a tight knot, but turns toward the viewer with an evil eye and, swishing its flamelike tail, reveals its anus. It is a gesture we have seen before in the woodcut illustration to *Ritter vom Turn:* the devil spreads his buttocks, and wags his piggish tail, to reveal an ass that, within the plot of the picture, is analogized to the viewer's eye (fig. 166). Also from Dürer's *Large Horse* are the classical column to the left and, in the lower right, the curious indentation where appears the artist's monogram. The interior architecture of Baldung's woodcut, however, depends more on Dürer's *Small Horse* engraving, in which the animal appears centered between stone walls rendered in veering perspective and framed above by an arch (fig. 208). Here too appears the motif of the flame exploding beyond the picture's limits, as well as the geometricizing openings in the rear wall. Baldung, it is true, everywhere partializes Dürer's construction. His sheet's upper edge conceals the extension of the arch; its abrupt left edge disrupts the recession into space; and its maddening evasion of frontality, with its zigzag (or parallax) view of the scene's principal players, stands at odds with Dürer's central alignment of arch, date, flaming pot, rider, horse, and monogram. Baldung evokes the virtuoso devices of Renaissance perspective—human figure *in scurto,* foreshortened horse seen from behind, difficult classical interior, and so on—but erases the customary connective tissue of unified space as observed from one unchanging viewpoint.

Perhaps the most striking invention in this print is the contradiction between a rational, geometric construction of the visual field and the nightmarish nature of the scene's principal players. Unlike the *Wild Horses* woodcuts, which were set outdoors, and which rendered space as contingent on the chaotic movement of intermingled bodies, here thick, straight lines, as if drawn with a ruler, close off a boxlike interior. Plane surfaces exert an uncanny tyranny on objects, as if the rule of geometry had itself turned demonic. Note, for example, how the groom's flat shoe soles rise up stubbornly in the foreground, simultaneously exceeding the space of the ground plane and asserting the surface of the picture plane. If observed for too long, they can disorient us, forcing us to feel ourselves *under* the supine body rather than before it. This potential for inversion, reminiscent of the effects of the somersaulting witch in Baldung's *New Year's Sheet* (fig. 159), is encouraged by the perpendicular conjunctions of neutral plane surfaces and, most strikingly, by the decorative column at the left, which has a classicizing capital for its base. This architecture, Baldung seems to say, is equally coherent, or incoherent, whether the print is held upside down or right side up. Note, too, how the foreshortened face of the stable groom loses coherence as it intersects with the far edge of the room and how this horizon, cutting through the groom precisely at eye level, pins him down to the ground plane. In certain passages the woodcut loses all illusion of space, becoming pure surface, as, for

example, along the whole left edge of the sheet, where the floor and the columned doorway appear as merely the upper and lower registers of a flat facade.

Throughout the *Bewitched Stable Groom,* the surfaces that should construct space do not really enclose the scene's figures. Rather, each player adheres stubbornly to its own quite separate plane. The witch in the window haunts the wall to the right. The groom haunts the ground plane, his currycomb appearing like a half-submerged cylinder. And the horse holds the far wall, although his outward glance pierces the picture plane to haunt the viewer. Exiled to these surfaces, the figures cannot overlap, although part of each extends into adjacent space: the witch's torch, the horse's fiery tail, and the groom's feet and eyes. Baldung arranges these players not so much in space as in a magic diagram: their left eyes occur as the apices of a perfect equilateral triangle. These are the three prime coordinates of Baldung's art throughout his career: the witch, embodiment of woman as Other; the horse, emblem of fallen desire; and the stable groom, the self who cannot bridle desire and is overthrown—the artist as corpse.

Baldung was fond of the pictorial conceit of the radically foreshortened, supine figure. Consciously dependent on the famous Italian experiments of this type, such as Andrea Mantegna's *Cristo in scurto,* but more intimately linked to Dürer's theories of perspective and, perhaps, to their subsequent domesticating reception by the Dürer epigone and *Kleinmeister* Erhard Schoen, these foreshortened figures perfectly complement Baldung's more general desire to make individual viewers aware of their specific place before the represented scene.[52] He used this device successfully in several images of the dead Christ, as in the woodcut of the *Lamentation* from about 1516, where it expresses the divine humility of God made flesh (fig. 216; M. 40).[53] This Christ figure appears also in a *bas-de-page* illumination by Baldung for the *Prayer Book of Maximilian* (fig. 217; K. 52), where it is compared, through a visual echo, to its grotesque antitype: the image of the drunken Bacchus, emblem of a radical submission to instinct and parody of the eucharistic blood as intoxicating wine (fig. 218; K. 53).[54] The supine body belongs to the realm of what Bakhtin calls the carnivalesque, in which all that is high, ideal, and abstract, indeed all that Dürer attributed to the artistic self, descends to the material level, there to have commerce with the earth. Peter Flötner's scatological broadsheet *Human Sundial* represents a cheerfully frank version of the principle of degradation implied by the supine figure in the *Bewitched Stable Groom* (fig. 219).[55]

Baldung allegorized the earth, which is to say the ground plane, in a powerful work from 1531, in which Hercules crushes the giant Antaeus (fig. 220; O. 72). The hero, I believe, has the facial features of the artist himself; observe the resemblance between the grimacing Hercules of a project drawing for the Kassel panel (fig. 221; K. 137) and Baldung's *Self-Portrait* in the Louvre (fig. 215). Antaeus represents libido,[56] and Hercules triumphs over him by simultaneously lifting him off the earth and squeezing the wind out of him, for according to the myth Antaeus, born of the mother earth, had limitless strength as long as his feet touched the ground. In Baldung's panel, Hercules vanquishes the giant also by gripping him under his groin (the curving lion's paw is a euphemizing overpainting). This gesture, along with the hero's stance and stooped posture, echoes almost exactly the form of Adam as he appears in Baldung's erotic panel *Adam and Eve,*

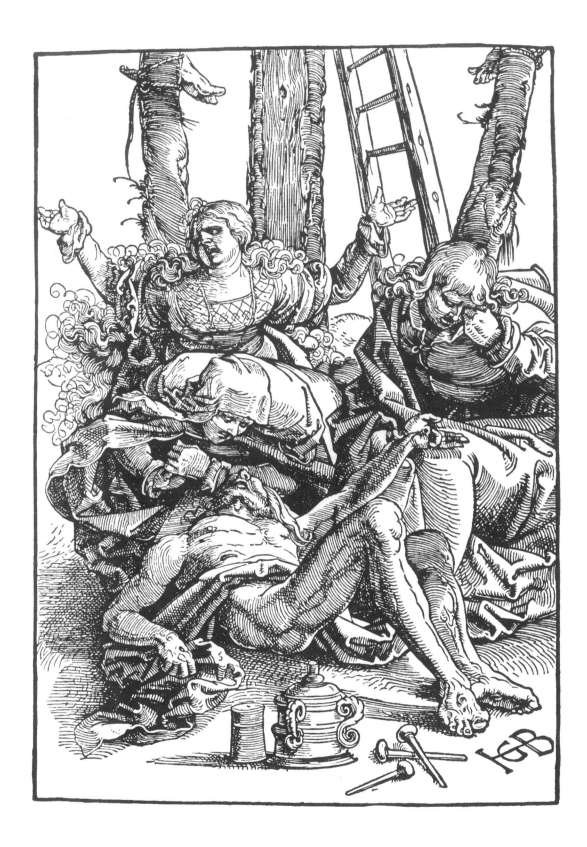

216. Hans Baldung, *Lamentation*, c. 1515–1517, woodcut.

217. Hans Baldung, *Crucifixion and Lamentation*, decorated page of the *Prayer Book of Maximilian*, 1515, pen and olive green ink on parchment, Bibliothèque Municipale, Besançon, fol. 71ʳ.

218. Hans Baldung, *Bacchus*, decorated page of the *Prayer Book of Maximilian*, 1515, pen and olive green ink on parchment, Bibliothèque Municipale, Besançon, fol. 73ᵛ.

known to us only through a contemporary contour drawing in Coburg (fig. 148).[57] Thus entering into the complex web of allusions that links the artist's images of the Fall to his images of the macabre, and beyond these to his inheritance from Dürer, Baldung's Kassel panel seems to settle old scores. Here Hercules, replacing the lustful Adam, and perhaps devised as an *in figura* self-portrait of Baldung himself, destroys the source of the trouble: the unruly genitals, instrument of fallen desire, that entered Albrecht Dürer's own garden through the troubling Weimar *Nude Self-Portrait* (fig. 120), that were associated with the serpent in the Ottawa *Eve* (fig. 151), and that were rendered most graphically in the scene of barren ejaculation onto the forest ground (erstwhile resting place of Baldung's mono-gram) in the *Wild Horses* woodcuts. In the *Bewitched Stable Groom*, it seems, Baldung again submits himself to this very ground, as if overcome by that flesh that he had symbolically vanquished in the earlier *Hercules* panel. His body, horizontal except for his nose, shoe

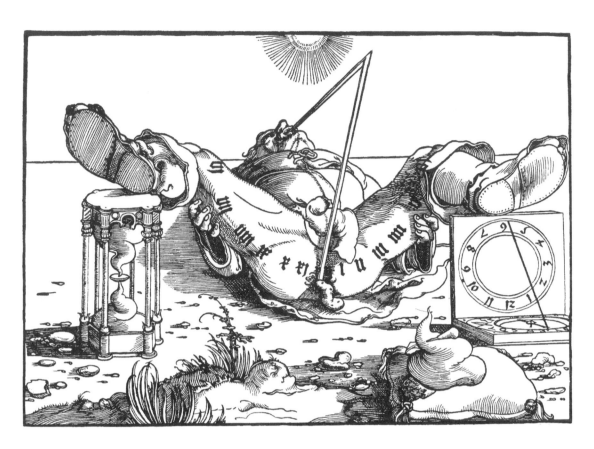

219. Peter Flötner, *Human Sundial*, c. 1535–1540, woodcut.

soles, and upward-turned codpiece, enters space from below, like the male viewer's flaccid penis. We know this conceit from the monogrammed tablet of the *New Year's Sheet*, which aimed its orthogonals at the witch's sex. In the *Bewitched Stable Groom*, one suspects, the target has become more abject: the unruly horse's anus or the devil's ass as *anus mundi*.

Yet the message of Baldung's prints runs deeper than any confession of lust, no matter how bizarre. The *Bewitched Stable Groom* subverts the humanist regimen of visual representation with its clear and bounded categories of artist, model, image, and viewer. In the German Renaissance this regimen finds an exemplary expression in the writings of Dürer, and in his pedagogical woodcut illustration for his treatise on perspective, titled the *Instruction of Measurement,* published posthumously in the edition of 1538 (fig. 222; Kn. 373). With his eye held in place by a pointer, the artist observes a nude model through a framed grid of threads, transferring what he sees onto a sheet ruled off in squares. As in the *Bewitched Stable Groom*, Dürer's squared-off interior marshals a vertiginous intersection of haunted surfaces: the table as ground plane, inhabited to the left by the supine nude and to the right by her foreshortened image as it will be sketched on the page; the vertical plane of the upright artist; the picture plane of the woodcut; and the

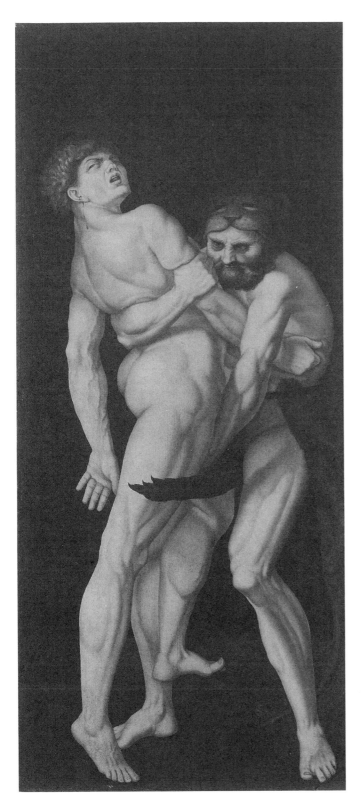

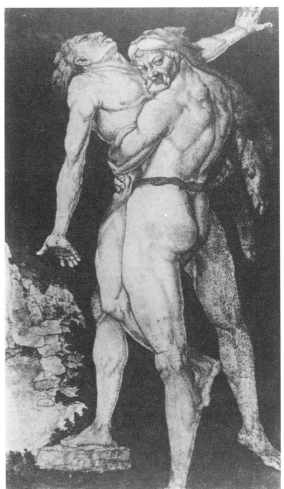

221. Hans Baldung, *Hercules and Antaeus*,
c. 1530–1531, pen and watercolor,
private collection.

220. Hans Baldung, *Hercules and Antaeus*, 1531, oil on panel,
Staatliche Gemäldegalerie, Kassel.

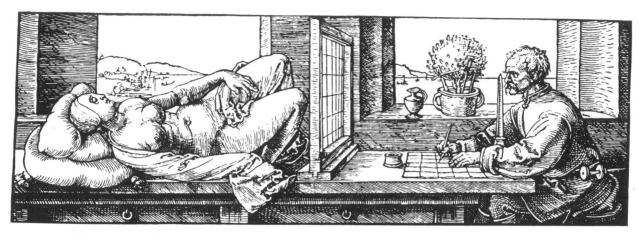

222. Albrecht Dürer, *Artist Sketching a Reclining Nude Woman*, c. 1525, woodcut illustration for *Underweysung der Messung mit dem Zirkel und Richtscheyt*, 2d ed. (Nuremberg: Hieronymus Andreae, 1538).

plane marked by the grid of thread, which intersects the artist's line of vision and bisects perfectly the rectangle of the woodcut itself. Dürer has articulated the various zones of representation—artist, model, image, and viewer—classifying them through a system of antitheses: female and male, supine and upright, naked and clothed, rounded and square. The strictness of this regimen renders the whole scene unintentionally comic. The artist looks uncomfortably stiff as he aims his vision from the rather phallic pointer toward the woman, whose body thrusts itself at him legs first. Indeed, were all the paraphernalia cleared away—pointers, grids, draperies, and all—the artist would appear staring directly into the woman's sex. Eros, however, is controlled by the machine of representation that institutes the self of the artist as distinct, closed off, and therefore protected from the lure of the object. In his poem "On the Evil World," Dürer himself expresses an ideal of self-mastery over against the spectacle of the female nude:

> He who lies naked with naked women,
> And, through struggle, conquers himself,
> So that his heart commits no movement . . .
> He has the courage of a pious man.[58]

The woodcut for the *Instruction of Measurement* shows the artist protected from the lure of the object by his sketching contraption. In another illustration for the same text, Dürer does away with the eye altogether, replacing it with a string that, like the strings of Kleist's marionette, will produce an art perfect but "devoid of consciousness" (fig. 223; Kn. 371). In the woodcut of the reclining nude, the eye is retained, yet it is controlled and stabilized, able to reenter the paradise of beauty only through the renunciation of desire. That explains, perhaps, the topiary in the window as a symbol of paradise as enclosed garden.

I am reminded, however, of a remark by Max Horkheimer and Theodor Adorno on

The Mortification of the Image: Hans Baldung Grien

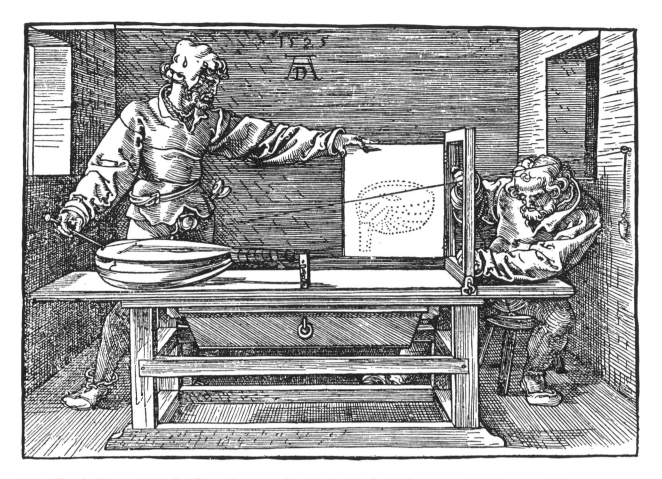

223. Albrecht Dürer, *Artist Sketching a Lute*, woodcut illustration for *Underweysung der Messung mit dem Zirkel und Richtscheyt* (Nuremberg: Hieronymus Andreae, 1525).

masculine dominance: "Behind male admiration of beauty lurks always the ribald laughter, the withering scorn, the barbaric obscenity with which strength greets weakness in an attempt to deaden the fear that it has itself fallen prey to impotence, death, and nature."[59] It is only 1544, just half a century after the Erlangen *Self-Portrait*, and German Renaissance art's dialectic of enlightenment has already run its course. Revisiting Dürer's scene of instruction, the epigone uncovers its secret desires and, in the *Bewitched Stable Groom*, represents them as his own demise. In place of the cleverly foreshortened lute or decorously aestheticized nude—in place, that is, of the object stripped of its power and submissive, as art, to the gaze—there lies the artist himself, unthroned from his upright and godlike place as measurer and measurement of the world. Above him rises a different model: the wild, devilish horse that, reversing my field of vision through its backward gaze, is not object but abject. Staring into Baldung's abandoned, vandalized machine of representation, my eye caught by the horse's anus, I am pulled into this marionette theater not as person but as puppet on the invisible threads of history and desire.

Notes

The following works are frequently cited by author and short title or by a letter abbreviation. For other works cited by author and short title, the chapter and note number of the full reference are given with the first citation of the work in each chapter.

Dürer, *Schriftlicher Nachlaß*
Albrecht Dürer, *Schriftlicher Nachlaß*, ed. Hans Rupprich (Berlin, 1956–1969).
Friedländer, *Early Netherlandish Painting*
Max J. Friedländer, *Early Netherlandish Painting*, 14 vols. in 16, comments and notes by Nicole Veronée-Verhagen, trans. Heinz Norden (Leiden, 1967–1976).

FR Friedländer and Rosenberg, *Paintings of Lucas Cranach*
Max J. Friedländer and Jacob Rosenberg, *The Paintings of Lucas Cranach*, rev. ed. (Ithaca, 1978).

J. Jahn, *Lucas Cranach*
Johannes Jahn, ed. *1472–1553 Lucas Cranach der Ältere: Das gesamte graphische Werk* (Herrsching, 1972).

Kn. Knappe, *Dürer*
Karl-Adolf Knappe, *Dürer: The Complete Engravings, Etchings, and Woodcuts* (London, 1965).

K. Koch, *Die Zeichnungen*
Carl Koch, *Die Zeichnungen Hans Baldung Griens* (Berlin, 1941).
Luther, *Werke*
Martin Luther, *Werke. Kritische Gesamtausgabe*, 94 vols. in 109 (Weimar, 1883–1980).

M. Mende, *Baldung*
Matthias Mende, *Hans Baldung Grien: Das graphische Werk* (Unterschneidheim, 1978).

O. Osten, *Baldung*
Gert von der Osten, *Hans Baldung Grien: Gemälde und Dokumente* (Berlin, 1983).
Panofsky, *Dürer*
Erwin Panofsky, *Albrecht Dürer* (Princeton, 1943).

W. Winkler, *Die Zeichnungen Albrecht Dürers*
Friedrich Winkler, *Die Zeichnungen Albrecht Dürers*, 4 vols. (Berlin, 1936–1939).

Preface

1. Jean Hyppolite, paraphrasing Hegel, wrote: "A preface is for people who want to speak *about* rather than for those who want to speak from *within*" ("The Structure of Philosophic Language according to the 'Preface' to Hegel's *Phenomenology of the Mind*," in *The Structuralist Controversy: The Languages of Criticism and the Sciences of Man*, ed. Richard Macksey and Eugenio Donato [Baltimore, 1970], p. 160).

2. See the discussion in chapter 8 below.

3. The term "Great Original" is Harold Bloom's, first formulated in *The Anxiety of Influence: A Theory of Poetry* (London, 1973), p. 31 and passim.

4. My work in this area has been influenced by Hans-Georg Gadamer's notion of "reception history" (*Wirkungsgeschichte*), as proposed in *Wahrheit und Methode. Grundzüge einer philosophischen Hermeneutik*, 3d rev. ed. (Tübingen, 1972), pp. 284–289 and 324–360. I have also found useful Hans Robert Jauss, "Literary History as Challenge to Literary Theory" (1970), in *Toward an Aesthetics of Reception*, trans. Timothy Bahti, Theory and History of Literature, 2 (Minneapolis, 1982), pp. 3–45; Wolfgang Iser, *The Act of Reading: A Theory of Aesthetic Response* (Baltimore, 1978);

and David Couzens Hoy, *The Critical Circle: Literature, History, and Philosophical Hermeneutics* (Berkeley, 1978).

5. This argument appears as my chapter 16 ("*Homo Interpres in Bivio:* Cranach and Luther").

6. Mikhail Bakhtin, "The Problem of the Text," in *Speech Genres and Other Late Essays,* trans. Vern W. McGee, ed. Caryl Emerson and Michael Holquist, University of Texas Press Slavic Series, 8 (Austin, 1986), p. 109; see also similar formulations in "Towards a Methodology for the Human Sciences," in *Speech Genres,* p. 160.

7. Katerina Clark and Michael Holquist, *Mikhail Bakhtin* (Cambridge, 1984), pp. 87–94; see the c. 1920–1923 text, "Author and Hero in Aesthetic Activity," in Bakhtin, *Art and Answerability: Early Philosophical Essays,* trans. Vadim Liapunov, ed. Michael Holquist and Vadim Liapunov, University of Texas Press Slavic Series, 9 (Austin, 1990), pp. 4–256.

8. I take this term from Philippe Lejeune, *Le pacte autobiographique* (Paris, 1975).

9. Joseph Leo Koerner, "The Mortification of the Image: Death as a Hermeneutic in Hans Baldung Grien," *Representations* 10 (1985): 52–101.

10. See Boris M. Ejxenbaum, "The Theory of the Formal Method" (1927), in *Readings in Russian Poetics: Formalist and Structuralist Views,* ed. Ladislav Matejka and Krystyna Pomorska, Michigan Slavic Contributions, 8 (Ann Arbor, 1978), pp. 29–32.

11. My account of Dürer's self-portraits as motivating Baldung's viewer-oriented art is indebted to Paul de Man's critique of reception theory. As de Man wrote in an essay on Georg Lukàcs: "The problematic relationship between subject and object that prevails in the sphere of aesthetics is better understood when one considers it from the point of view of the author rather than from the point of view of the reader (or beholder). For the author is directly engaged in the ambiguities of aesthetic invention" ("Ludwig Binswanger and the Sublimation of the Self," in *Blindness and Insight: Essays in the Rhetoric of Contemporary Criticism,* 2d ed. rev., Theory and History of Literature, 7 [Minneapolis, 1983], p. 43). For a penetrating account of the history of viewer-oriented art history, see Wolfgang Kemp, *Der Anteil des Betrachters. Rezeptionsästhetische Studien des 19. Jahrhunderts* (Munich, 1983), pp. 10–40.

12. The lecture was published in *Daphnis. Zeitschrift für Mittlere Deutsche Literatur* 15 (1986): 409–439.

13. Published as Joseph Leo Koerner, "Albrecht Dürer's *Pleasures of the World* and the Limits of Festival," in *Poetik und Hermeneutik,* vol. 14, *Das Fest,* ed. Rainer Warning and Walter Haug (Munich, 1989), pp. 180–216. A shorter version appeared in German as "Der letzte Gast des Festes. Eine Interpretation von Albrecht Dürers Federzeichnung 'Die Freuden der Welt.'" *Frankfurter Allgemeine Zeitung,* October 14, 1987, 35.

14. Published as Joseph Leo Koerner, "The Disfigured Self-Portraits of Hans Baldung Grien," in *Traditionsbewußtsein und Traditionsverhalten,* ed. Walter Haug and Burghart Wachinger, Fortuna Vitrea, 5 (Tübingen, 1991).

15. Published in 1990 by University Microfilms International, Ann Arbor.

16. Quoted in Paul Valéry, *Autobiography: Essays Theoretical and Critical,* ed. James Olney (Princeton, 1980), p. xi.

Chapter One

1. Friedrich Winkler, *Die Zeichnungen Albrecht Dürers,* 4 vols. (Berlin, 1936–1939); henceforth Winkler numbers will be referred to in the text and notes as "W." Note that the inscription and date on this drawing are spurious. For a general guide to the vast literature on Albrecht Dürer, see Matthias Mende, *Dürer-Bibliographie. Zur fünfhundertsten Wiederkehr des Geburtstag von Albrecht Dürer* (Wiesbaden, 1971), with its more than ten thousand entries. For work published after 1971, see H. J. Berbig, "Sammelbericht über die Literatur zum Dürer-Jahr 1971," *Archiv für Kulturgeschichte* 55 (1973): 35–53; Wolfgang Stechow, "State of Research: Recent Dürer Studies," *Art Bulletin* 56 (1974): 259–270. Jan Białostocki's *Dürer and His Critics, 1500–1971: Chapters in the History of Ideas Including a Collection of Texts,* Saecula Spiritalia, 7 (Baden-Baden, 1986), gives an overview of the history of Dürer interpretation from the Renaissance to the present.

2. Mirrors larger than pocket size were rare before the later Middle Ages. Made from blown glass, they magnified whatever was near their surface. Dürer's inability in the Erlangen *Self-Portrait* to sketch his whole body or its spatial context resulted in part from the fact that only a small area of the visual field could be seen clearly on the mirror's surface. The artist could glimpse his whole body only if he stepped back from the mirror, in which case his reflection on the convex mirror would be tiny (as in the mirror in Jan van

Eyck's *Arnolfini Wedding* [fig. 25]; on the use of
convex mirrors in artists' studios, see especially
D. Gioseffi, "Complimenti di prospettiva, 2," *Critica d'Arte* 5 [1958]: 102–105). There exists substantial scholarship on mirrors in the literature
and art of the Middle Ages and Renaissance; for
example, Gustav Hartlaub, *Die Zauber des Spiegels*
(Munich, 1951); Heinrich Schwarz, "The Mirror in
Art," *Art Quarterly* 15 (1952): 97–118; idem, "The
Mirror of the Artist and the Mirror of the Devout," *Studies in the History of Art Dedicated to William E. Suida* (London, 1959), pp. 90–105; Jan
Białostocki, "Man and Mirror in Painting: Reality
and Transcendence," in *Studies in Late Medieval
and Renaissance Painting in Honor of Millard Meiss*,
ed. Irving Lavin and John Plummer (New York,
1977), pp. 61–72; Herbert Grabes, *The Mutable
Glass: Mirror-Imagery in Titles and Texts of the
Middle Ages and the English Renaissance* (Cambridge, 1982); Edward Peter Nolan, *Now through a
Glass Darkly: Specular Images of Being and Knowing
from Virgil to Chaucer* (Ann Arbor, 1990).

3. Here, as in all of his extant self-portraits,
Dürer's body has been reversed through the
agency of the mirror. Thus his right eye appears
in the drawing at *our* right.

4. The phrase is *Unruh im Gemäl*, as quoted in
Otto Pächt, "Zur deutschen Bildauffassung der
Spätgotik und Renaissance" (1952), reprinted in
*Methodisches zur kunstwissenschaftlichen Praxis.
Ausgewählte Schriften*, ed. Jörg Oberhaidacher, Artur Rosenhauer, and Gertraut Schikola, 2d ed.
rev. (Munich, 1986), pp. 107–108.

5. When Dürer received a gift of drawings
from Raphael, he interpreted the gesture as the
Italian artist's attempt to "show him his hand"
(*im sein hand zw weisen*) (Albrecht Dürer, *Schriftlicher Nachlaß*, ed. Hans Rupprich [Berlin, 1956–
1969], 1:209; the most extensive selection of
Dürer's writings in English is still *The Writings
of Albrecht Dürer*, trans. and ed. William Martin
Conway [1898; New York, 1958]). As we shall see,
Dürer's stated aesthetic underlies the great *Prayer
Book* of Emperor Maximilian, in which the hand
of each participating artist is intended to be legible within the characteristic shape of his calligraphic lines. And it motivates the graphic style
of several artists working under Dürer's influence, such as Lucas Cranach the Elder, Albrecht
Altdorfer, Wolf Huber, and Urs Graf.

6. The loose style of the Erlangen *Self-Portrait*
does have a general, though modest, precedent
in the expressive line of Dürer's teacher, Michael
Wolgemut, and his school. See the discussion of
Dürer's early drawings in Hanspeter Landolt,
"Zur Geschichte von Dürers zeichnerischer
Form," *Anzeiger des Germanischen Nationalmuseums*, 1971–1972, pp. 143–156.

7. Elfriede Bock and Max Friedländer, *Die
Zeichnungen alter Meister im Kupferstichkabinett.
Die deutschen Meister*, 2 vols. (Berlin, 1921), no. 2551.
Seventy-two sheets from Holbein's original sketchbook are now in Berlin; on their character and provenance see, in addition to Bock and Friedländer,
Alfred Woltmann, *Hans Holbein's des Aelteren
Silberstift-Zeichnungen im Königlichen Museum zu
Berlin* (Nürnberg, n.d.). After Holbein's death,
the sketchbook probably belonged to the great
collection of Basilius Amerbach (1534–1591),
where we read in an inventory of 1584: "H. Holbein senior. 56. sambt zwei büchlin mehrteil mit
stefzen" ("H. Holbein the Elder. 56 [drawings].
With two little books mostly of silverpoints,"
Woltmann, iii). Although some later collector
went over many of the sheets with pen and brush,
Kungspergs Niclas seems to me mainly autograph.

8. Hugo Kehrer, *Dürers Selbstbildnisse und die
Dürer Bildnisse* (Berlin, 1934), p. 31.

9. Heinrich Wölfflin writes: "This is how one
must imagine the young painter who has gone
forth into the world and pondered about himself,
'What do I want?'" (*Die Kunst Albrecht Dürers*, 9th
ed. rev. [Munich, 1984], p. 46). So too Wilhelm
Waetzoldt: "The drawing was made during the
time of alienation and continual self-testing and
hypercritical self-reflection. It is as personal and
immediate as a lyrical poem by the young Goethe" (*Dürer und seine Zeit*, 4th ed. [London, 1938],
p. 33). Erwin Panofsky uses the self-portrait as an
occasion for discussing Dürer's character as a person (*Albrecht Dürer* [Princeton, 1943], 1:24).

10. Some relevant passages are G. W. F. Hegel, *Vorlesung über die Geschichte der Philosophie*,
ed. Eva Moldenhauer and Karl Markus Michel
(Frankfurt, 1971), 2:600, and Jacob Burckhardt,
Die Kultur der Renaissance in Italien. Ein Versuch,
10th ed., ed. Walter Goetz (Stuttgart, 1976),
p. 123.

11. *Seltzame red* (Dürer, *Schriftlicher Nachlaß*,
3:293); the idea might derive from Pliny the Elder, *Natural History*, 35.36.67 and 35.40.145.

12. Pomponius Gauricus, *De sculptura*, ed.
André Chastel and Robert Klein (Geneva, 1969),
p. 131.

13. Gottfried Boehm has recently analyzed
Pomponius's notion of portrayal *ex se* as follows:

"It means the renunciation of all dominant references that turn the depicted person into the representative of a world of meaning extrinsic to him. . . . The portrait can be called autonomous only when the depicted person has broken off those bridges to the external world that were not only his reference (e.g., as *representative* of a profession, class, or ideal), but also his determination" (*Bildnis und Individuum. Über den Ursprung der Porträtmalerei in der italienischen Renaissance* [Munich, 1985], p. 22). See also the review of Boehm by Hans Robert Jauss, "Die Entdeckung des Individuums in der Porträtmalerei der Renaissance," *Merkur* 41 (1984): 331–338.

14. They are the Erlangen sheet; a sketch formerly in the Dornington priory (W. 24); and the drawing of the *Holy Family* in a landscape, now in Berlin (fig. 6; W. 30).

15. Ernst Heidrich noted that Dürer's graphic style does not generally emphasize the plasticity of objects but conceives space and volume "as a displacement of the net of coordinates, as a breaking and bending of the picture surface, which suffices as a suggestion of the possibility of movement" (*Geschichte des Dürerschen Marienbildes*, Kunstgeschichtliche Monographien, 3 [Leipzig, 1906], p. 130).

16. Josef Meder, "Zur ersten Reise nach Venedig (1494–95)," *Jahrbuch der kunsthistorischen Sammlung des Allerhöchsten Kaiserhauses* 30 (1912): 189; Eduard Flechsig, *Albrecht Dürer. Sein Leben und seiner künstlerische Entwicklung* (Berlin, 1928–1931), 2:351.

17. For discussions of the late medieval model book and sketchbook, see Ulrike Jenni, "Vom Musterbuch zum Skizzenbuch," in *Die Parler und der Schöne Stil*, ed. Anton Legner, exh. cat. (Cologne, 1978), 3:139–141; also Otto Pächt, "Der Weg von der zeichnerischen Buchillustration zur eigenständigen Zeichnung," *Wiener Jahrbuch für Kunstgeschichte* 24 (1971): 178–184.

18. "Solichs erstlich anzuzeygen dient wol, ee man in das werck greyfet, das man solichs als, wie mans haben wil, for mit linien auff reyß, auff das man for die gestalt sech, ob etwas darynn zu bessern wer" (Dürer, *Schriftlicher Nachlaß*, 3:294).

19. "Darumb ist eim yedlichen künstner not, das er wol reyssen lern. Dann es dient vber die maß zu vil künsten vnnd leyt vil daran" (Dürer, 3:294).

20. "Freie geübte hand" (Dürer, 2:133).

21. See the discussion of this ideal in Joachim Camerarius's preface to the Latin translation of Dürer's *Vier Bücher von menschlichen Proportion* published in 1532 (given in Dürer, *Schriftlicher Nachlaß*, 1:308–309); a partial German translation appears in Heinz Lüdecke and Susanne Heiland, *Dürer und die Nachwelt. Urkunden, Briefe, Dichtungen und wissenschaftliche Betrachtungen aus vier Jahrhunderten* (Berlin, 1955), pp. 50–51.

22. This has long been recognized. See, for example, Winkler, *Die Zeichnungen Albrecht Dürers*, 1:25. Winkler dates the drawing to the end of Dürer's time as a journeyman (1494–1495), while more recently Fedja Anzelewsky (*Dürer: His Art and Life*, trans. Heide Grieve [New York, 1980], p. 28) dates it to 1492–1494. The depiction of Joseph in this evocative posture is not new to Dürer; see, for example, the carved figure of Joseph produced in the region of Lake Constance about 1330 (Rosgarten Museum, Constance).

23. The thumb of this hand, with its narrow stem, enlarged joints, and broad tip, accords with the shape of Dürer's own thumb such as we find in the *Study of Three Hands* from the same period, now in the Albertina (W. 47), and the Louvre *Self-Portrait* (fig. 18). On the shape of Dürer's hand, see Kurt Gerstenberg, "Dürers Hand," *Monatshefte für Kunstwissenschaft* 5 (1912): 524–526.

24. "Diß puech ist nun allein ain materi und ain unvolkumenlich werckh und nichts annders, dann ain gestalt die Ime der allerdurchleuchtigist . . . kayser Maximilian . . . furbereit hat, daraus mit lieblicher wolsprechung der teutschen sprach mit rechter ordnung der menschenvernunft und mit aller seiner notturfftign zugehörungen der kunigclichen warhait, ein volkumenlich werk zu machen" (Emperor Maximilian I, *Der Weisskönig. Nach den Diktaten und eigenhändigen Aufzeichnungen Kaiser Maximilians I.*, ed. Alwin Schultz, *Jahrbuch der Kunstsammlung der allerhöchsten Kaiserhauses* 6 [1888]: 195; Schultz's edition is based on Treitzsaurwein's 1514 manuscript now in Vienna [Cod. man. 3032, Österreichischen Nationalbibliothek, Vienna]). On this passage, see Jan-Dirk Müller, *Gedechtnus. Literatur und Hofgesellschaft um Maximilian I.*, Forschungen zur Geschichte der älteren deutschen Literatur, 2 (Munich, 1982), pp. 65–72.

25. The illumination belongs to the typological cycle in the manuscript *Dialogus de laudibus sanctae crucis*, produced in Regensburg about 1170–1175 for the Benedictine cloister of Prüfening and kept now in the Bayerische Staatsbibliothek in Munich (Clm. 14159, fol. 4).

26. See also the figure of Christ in Dürer's

woodcut frontispiece to the *Small Passion* from 1511 (Karl-Adolf Knappe, *Dürer: The Complete Engravings, Etchings, and Woodcuts* [London, 1965], no. 254; henceforth referred to as "Kn."), and Hans Leinberger's monumental limewood sculpture *Christ in Distress*, c. 1525, now in Berlin-Dahlem (Wilhelm Pinder, *Die deutsche Plastik der Hochrenaissance*, Handbuch der Kunstwissenschaft [Wildpark-Potsdam, 1929], p. 464). For the relation between the type of the seated Christ and the figure of Job, see Gert von der Osten, "Job and Christ," *Journal of the Warburg and Courtauld Institutes* 16 (1953): 153.

27. The device of the gaze out of the picture is common in late medieval devotional images; see, as a complex precedent for Dürer's Karlsruhe panel, Geertgen tot sint Jans's *Man of Sorrows* in the Archepiscopal Museum in Utrecht (reproduced and discussed, with bibliography, in Albert Châtelet, *Early Dutch Painting*, trans. Christopher Brown and Anthony Turner [Secaucus, N.J., 1980], pp. 116–117 and cat. no. 76; also Erwin Panofsky, "'Imago pietatis.' Ein Beitrag zur Typengeschichte des 'Schmerzensmann' und der 'Maria Mediatrix,'" in *Festschrift für Max J. Friedländer zum 60. Geburtstag* [Leipzig, 1927], pp. 289–290).

28. See Johann Eckhart von Borries's interpretation of this work as an expression of the young Dürer's own troubled nature in *Albrecht Dürer: Christus als Schmerzensmann*, Bildhefte der Staatlichen Kunsthalle Karlsruhe, 9 (Karlsruhe, 1972), pp. 25ff.

29. See chapter 4 below.

30. Folio 45 of the original manuscript (Staatsbibliothek, Munich, L. impr. membr. 64). Reproduced in Walter L. Strauss, ed. *The Book of Hours of the Emperor Maximilian the First* (New York, 1974), p. 89; see the discussion of this figure in Panofsky, *Dürer*, 1:188.

31. See Ewald M. Vetter and Christoph Brockhaus, "Das Verhältnis von Text und Bild in Dürers Randzeichnungen zum Gebetbuch Kaiser Maximilians," *Anzeiger des Germanischen Nationalmuseums*, 1971–1972, pp. 100 and 120n142.

32. Jan Białostocki, "La 'melancholie paysanne' d'Albrecht Dürer," *Gazette des Beaux-Arts* 6 (1957): 195ff.

33. The Lisbon panel is based partly on Dürer's 1521 color-ground drawing of an old man (W. 788; now in the Albertina). The sheet bears the autograph inscription, "The man was ninety-three years old and healthy and of good spirits, at Antwerp [*der man was alt 93 jor und gesunt und ver-*

muglich zw antorff]." Interestingly, the sitter's birth year (1427 or 1428) was close to that of Dürer's father, Albrecht the Elder (1427–1502), which suggests that the artist may have regarded the old man in Antwerp as a vision of what his own father might have looked like were he still alive. The sitter's contemplative posture thus takes on a personal meaning for the artist, as *memoria* of origins and reminder of ends. (I am indebted to Eric White for this suggestion.)

34. On Friedrich's self-portraits, see Joseph Leo Koerner, *Caspar David Friedrich and the Subject of Landscape* (New Haven, 1990), pp. 69–76 and 188–189.

35. Waetzoldt, *Dürer*, p. 33; H. T. Musper, *Albrecht Dürer. Die gegenwärtige Stand der Forschung* (Stuttgart, 1952), p. 15; Nuremberg, Germanisches Nationalmuseum, *Albrecht Dürer, 1471–1971*, exh. cat. (Munich, 1971), p. 47.

36. Friedrich Winkler, *Albrecht Dürer. Leben und Werk* (Berlin, 1957), p. 37.

37. For an exhaustive reception history of Dürer's *Melencolia*, see Peter-Klaus Schuster, *Melencolia I: Dürers Denkbild*, 2 vols. (Berlin, 1991); I was able to consult only the earlier shorter version, "Das Bild der Bilder. Zur Wirkungsgeschichte von Dürers Melancholiekupferstich," *Idea. Jahrbuch der Hamburger Kunsthalle* 1 (1982): 73–134. The reception of the print is usefully summarized in Thomas DeCosta Kaufmann, "Hermeneutics in the History of Art: Remarks on the Reception of Dürer in the Sixteenth and Early Seventeenth Centuries," in *New Perspectives on the Art of Renaissance Nuremberg: Five Essays,* ed. Jeffrey Chipps Smith (Austin, 1985), pp. 23–24.

38. This is the tenor of the earliest known account of the print, Joachim Camerarius's ecphrasis in the *Elementa rhetoricae* (Basel, 1545). The print, Camerarius says at the start, represents "the emotions of a deep and thoughtful mind" (published, with translation and commentary, by William S. Heckscher, "Camerarius on Dürer's 'Melencolia I,'" in *Joachim Camerarius (1500–1574). Beiträge zur Geschichte des Humanismus im Zeitalter der Reformation*, ed. Frank Baron, Humanistische Bibliothek, ser. 1: Abhandlungen, 24 [Munich, 1978], p. 33).

39. See Walter Benjamin, *Ursprung des deutschen Trauerspiels* (1925), in *Gesammelte Schriften,* ed. Rolf Tiedemann and Hermann Schweppenhäuser (Frankfurt, 1974), 1:316–335; a more recent interpretation along similar lines is Hartmut Böhme, *Albrecht Dürer—Melencolia I. Im Labyrinth*

der Deutung, Kunststück (Frankfurt, 1989).

40. There is ample evidence that Dürer and his patrons regarded the *Melencolia* and *St. Jerome* as a pair; see Dürer, *Schriftlicher Nachlaß,* 1:156 and 295; Philip L. Sohm, "Dürer's *Melencolia I:* The Limits of Knowledge," *Studies in the History of Art* 9 (1980): 13.

41. See, for example, Erasmus's chapter "The First Point of Wisdom Is to Know Yourself," in *The Enchiridion,* trans. and ed. Raymond Himelick (Gloucester, Mass., 1970), pp. 59–63.

42. Charles Taylor, *Sources of Self: The Making of Modern Identity* (Cambridge, Mass., 1989), pp. 189–191.

43. Hildegard von Bingen's *Liber subtiliatatum diversarum naturarum creaturarum,* written between 1150 and 1160, describes the effects of the Fall thus: "Man's eyes, which before had glimpsed the heavenly majesty, were extinguished; his gall was transformed into bitterness, black gall into the darkness of godlessness. And so man was transformed, through and through, into another mode of existence. There fell on him a great sadness [*melancholy*]" (quoted in Heinrich Schipperges, *Der Garten der Gesundheit. Medizin im Mittelalter* [Munich, 1985], p. 22).

44. Erwin Panofsky and Fritz Saxl, *Dürers "Melencolia I." Eine quellen- und typengeschichtliche Untersuchung,* Studien der Bibliothek Warburg, 2 (Leipzig and Berlin, 1923). See also Raymond Kilbansky, Erwin Panofsky, and Fritz Saxl, *Saturn and Melancholy: Studies in the History of Natural Philosophy, Religion, and Art* (London, 1964): 275–373. Panofsky and Saxl's argument is indebted to Karl Giehlow, "Dürers Stich *Melencolia I* und der maximilianische Humanistenkreis," *Mitteilungen der Gesellschaft für vervielfältigende Kunst* 26 (1903): 29–41; 27 (1904): 6–18 and 57–78; and Aby Warburg, *Heidnisch-antike Weissagung in Wort und Bild zu Luthers Zeiten,* Sitzungsberichte der Heidelberger Akademie der Wissenschaften, Philosophisch-historische Klasse 26 (Heidelberg, 1920).

45. Thus Panofsky summarizes his position in his 1943 monograph on Dürer (*Dürer,* 1:171).

46. Frances A. Yates, *The Occult Philosophy in the Elizabethan Age* (London, 1979), p. 54. A number of recent interpreters regard Dürer's print not at all as a "self-portrait," but as a universalizing compendium of contemporary knowledge and belief (for example, Konrad Hofmann, "Dürers 'Melencolia,'" in *Kunst als Bedeutungsträger. Gedenkschrift für Günter Bandmann,* ed. Werner Busch, Reiner Haussherr, and Eduard Trier (Berlin, 1978), pp. 251–277.

47. Carl Gustav Carus, *Briefe über Goethes Faust* (Leipzig, 1835), pp. 39ff.; and idem, *Lebenserinnerungen und Denkwürdigkeiten* (Leipzig, 1856), 1:286 and 2:391; discussed in Schuster, "Bild der Bilder," p. 73; Gautier's poem "Melancholia" is cited in Böhme, *Albrecht Dürer—Melencolia I,* p. 79n65.

48. On the Bremen self-portrait as melancholy, see Robert W. Horst, "Dürers 'Melencolia I,'" in *Wandlungen christlicher Kunst im Mittelalter* (Baden-Baden, 1953), p. 416; and chap. 8 below. Melanchthon's epithet appears in *De anima,* fol. 82ʳ, quoted and discussed in Warburg, *Heidnisch-antike Weissagung,* pp. 61–62. For Dürer's statement on the melancholy of young apprentices see Dürer, *Schriftlicher Nachlaß,* 2:91 and 93n7.

49. For an assessment of the significance of Panofsky's *Melencolia* study to his whole project of art history, see Michael Ann Holly, *Panofsky and the Foundations of Art History* (Ithaca, 1984), p. 111.

50. Heinz Ladendorf, "*Mouseion.* Zur Frage der künstlerische Phantasie," in *Mouseion. Studien aus Kunst und Geschichte für Otto H. Förster,* ed. Heinz Ladendorf and Horst Vey (Cologne, 1960), pp. 21–22; Patrik Reuterswärd, "Sinn und Nebensinn bei Dürer," in *Gestalt und Wirklichkeit. Festgabe für Ferdinand Weinhandl,* ed. Robert Mühlher and Johann Fischl (Berlin, 1967), pp. 412–414; New York, Metropolitan Museum, *Gothic and Renaissance Art in Nuremberg, 1300–1550,* ed. Ellen Shultz, exh. cat. (New York, 1986), p. 265. My reading of the Metropolitan *Pillows* has been strengthened by conversations with Christopher Wood and by Hermann Leber's discussion of hidden faces in Dürer's c. 1495 watercolor *The View of Arco* (W. 94) (*Albrecht Dürers Landschaftsaquarelle. Topographie und Genese,* Studien zur Kunstgeschichte, 50 (Hildesheim, 1988).

51. The term "seeing as" is Ludwig Wittgenstein's (*Philosophical Investigations,* 3d ed., trans. G. E. M. Anscombe [New York, 1958], pp. 193–208). See also Richard Wollheim, *Art and Its Objects,* 2d ed. (Cambridge, 1980), pp. 205–226; and Kendall L. Walton, *Mimesis as Make-Believe: On the Foundations of the Representational Arts* (Cambridge, Mass., 1990), pp. 300–304.

52. On the distorting effects of the mirror in this drawing, see John Pope-Hennessy, *The Portrait in the Renaissance* (Princeton, 1966), p. 126.

53. Dürer, *Schriftlicher Nachlaß,* 3:287, 288n44, 298n45, and 366.

54. The marriage was arranged by their fa-

thers. As Dürer himself writes in his *Family Chronicle:* "And when I had again returned home, Hans Frey negotiated with my father and gave me his daughter named Maid Agnes [Und alß ich wider anheimbe kommen was, handelt Hanns Frey mit meinen vater und gab mir seine tochter mit nahmen jungfraw Agnes]" (Dürer, *Schriftlicher Nachlaß,* 1:31).

55. Panofsky, *Dürer,* 1:6 and 25; for the tradition of engagement portraits, see Ernst Buchner, *Das deutsche Bildnis der Spätgotik und der frühen Dürerzeit* (Berlin, 1953), pp. 56–60, 123–124, and passim.

56. George Szabo, "Content and Form: Notes on Drawings by Albrecht Dürer and Hans Baldung Grien," *Drawing* 1 (1979): 3. In her catalog entry on the Metropolitan drawing, Barbara Drake Boehm agrees with Szabo's account (New York, *Gothic and Renaissance Art in Nuremburg,* p. 265).

57. "My sach die gat / Als es oben schtat" (Dürer, *Schriftlicher Nachlaß,* 1:205, 211n6).

58. In the *Hortus sanitus* published in Mainz in 1485, *Eryngium,* referred to as *Yrungus kruß,* is recommended for its strengthening effects on male sexual potency: it "brings a man great pleasure and increases his semen and excites him to unchastity" (Lottlisa Behling, *Die Pflanze in der mittelalterlichen Tafelmalerei* [Weimar, 1957], p. 117). For the general subject of the young Dürer and love magic, see Ludwig Grote, "Dürer Studien," *Zeitschrift für Kunstwissenschaft* 19 (1965): 156–162.

59. See the passage in a letter of March 7, 1507, from Lorenz Beheim to Willibald Pirckheimer that refers to Dürer's "boy" (Lüdecke and Heiland, *Dürer und die Nachwelt,* p. 18). The possibility that Dürer was homosexual has been entertained by several writers, most recently Fritz Neugass, review of Walter L. Strauss, *The Complete Drawings of Albrecht Dürer,* in *Frankfurter Allgemeine Zeitung,* July 29, 1975, p. 15; and Peter-Klaus Schuster, "Zu Dürers Zeichnung *Der Tod des Orpheus* und verwandten Darstellungen," *Jahrbuch der Hamburger Kunstsammlungen* 23 (1978): 7–25. See also Panofsky's overview of evidence about Dürer's marriage, in *Dürer,* 1:6–10; also, more recently, Jane Hutchinson, *Albrecht Dürer: A Biography* (Princeton, 1990), pp. 40–42, 92, and passim.

60. I follow here Paul de Man's discussion of prosopopoeia as the essential "trope of autobiography" in his essay "Autobiography as De-facement," in *The Rhetoric of Romanticism* (New York,

1984), p. 75. See also his "Anthropomorphism and Trope in Lyric" in the same collection, as well as Cynthia Chase's useful interpretation of de Man's concept in *Decomposing Figures: Rhetorical Figures in the Romantic Tradition* (Baltimore, 1986), pp. 82–112.

Chapter Two

1. For a brief overview of the literature on print and drawing collections in Renaissance Germany, see Peter W. Parshall, "The Print Collection of Ferdinand, Archduke of Tyrol," *Jahrbuch der kunsthistorischen Sammlung in Wien* 78 (1982): 139–144.

2. In a manuscript draft for his *Lehrbuch der Malerei,* Dürer himself speaks of the young artist's need to be trained through "love and inclination [*lib vnd lust*]" rather than "coercion [*czwang*] . . . until he achieves a free hand [*pis daz er ein freie hand erlangt*]" (Dürer, *Schriftlicher Nachlaß,* 2:99). See also in this regard Dürer's comments on the "freedom of painting [*freÿikeitt molens*]" (2:91).

3. See Hans-Georg Gadamer's account of the concept of "horizon," in *Wahrheit und Methode,* pp. 284–290 (see preface, n. 4 for full reference).

4. On this problem in the study of medieval literature, see Hans Robert Jauss, "The Alterity and Modernity of Medieval Literature," trans. Timothy Bahti, *New Literary History* 10 (1979): 181–227.

5. Tzvetan Todorov, *The Conquest of America: The Question of the Other,* trans. Richard Howard (New York, 1984), p. 5. Todorov's reading of the discovery of the New World is a provocative reanimation of the concept of the epoch.

6. For example, that Galileo died in the year of Newton's birth, or that Michelangelo died in the year of Shakespeare's birth.

7. See Hans Blumenberg's magisterial history of the concept of the "epoch" in *The Legitimacy of the Modern Age,* trans. Robert Wallace (Cambridge, 1983), pp. 457–480.

8. See, for example, Hans Wuhr, "Albrecht Dürer: Selbstbildnis," *Die Kunst im dritten Reich* 8 (1939): 257.

9. For example, Josef Kunstman, *Christi Machtbild, Bildmacht Christi* (Ettal, 1971), p. 34.

10. See Wolfgang Schöne et al., *Das Gottesbild im Abendland,* Glaube und Forschung, 15 (Witten and Berlin, 1959), p. 41.

11. For example, Gert von der Osten and Horst Vey, *Painting and Sculpture in Germany and*

the Netherlands, 1500–1600, Pelican History of Art (Harmondsworth, 1969).

12. In Germany, as in Italy and the Netherlands, artists sometimes represent themselves within larger religious compositions, as beholders or participants in the sacred action. Self-portraits of this kind have been identified for Friedrich Herlin in Nördlingen; Jan Pollack in Bavaria; Thoman Burgkmair, Hans Holbein the Elder, and Jörg Breu in Augsburg; and the Master of the St. Bartholomew Altarpiece and the Master of the Holy Kinship in Cologne, to mention just a few (see Buchner, *Deutsche Bildnis,* pp. 15–16; full ref. chap 1, n. 55). An interesting case of an isolated self-portrait roughly contemporary with Dürer's Albertina sheet appears on the rear of the shrine of the *Herrberg Altarpiece* (now in the Staatsgalerie in Stuttgart) by the Ulmish master Bartholomäus Zeitblom, in which the bust of the artist, identified by banderoles, appears in the midst of decorative *Rankenwerk* (see Buchner, p. 197 and pl. 7).

13. Waetzoldt, *Dürer,* p. 31 (full ref. chap. 1, n. 9).

14. See H. Jantzen, "Dürers Selbstbildnis von 1493," *Velhagen-Klasings Monatshefte* 2 (1927): 223; George Dehio, *Geschichte der deutschen Kunst* (Berlin, 1926), 3:29; Kehrer, *Dürers Selbstbildnisse,* p. 33 (full ref. chap. 1, n. 8).

15. Max Friedländer, *Albrecht Dürer* (Leipzig, 1921), p. 34; Nuremberg, *Albrecht Dürer,* p. 47 (full ref. chap. 1, n. 35); Kehrer, *Dürer Selbstbildnisse,* p. 33. This point is debatable. About 1450 the French painter Jean Fouquet produced a tiny enamel-and-gold likeness of himself, which is now in the Louvre; and before that Jan Van Eyck's *Man with a Red Turban,* dated 1433 and now in London, is probably a self-portrait, though unlike Dürer's Louvre portrait, the identification remains uncertain.

16. Panofsky, *Dürer,* 1:42.

17. Here, for the first time in his oeuvre, Dürer includes his characteristic monogram in a panel painting, having developed the device for his work in engravings and woodcuts. See Gustav Pauli, "Dürers Monogramm," in *Festschrift für Max J. Friedländer zum 60. Geburtstag* (Leipzig, 1927), pp. 34–40.

18. "Das malt jch nach meiner gestalt, / Ich was sex vnd zwenczig jor alt" (Dürer, *Schriftlicher Nachlaß,* 1:205).

19. On the importance of labels in self-portraiture, see Philippe Lejeune, "Looking at a Self-Portrait" (1986), in *On Autobiography,* ed. Paul

John Eakin and trans. Katherine Leary, Theory and History of Literature, 52 (Minneapolis, 1989), p. 110; also, in the same volume, p. 29.

20. Gottfried Boehm writes of this distinction: "The Other, whom painter and viewer alike see before themselves, served for a long time as the prototype of self-portraiture. Painters interpret themselves according to the same model they apply to others. In the developmental history of portraiture, it was necessary first for the artist to be included among persons worthy of being portrayed, before he could want to distinguish himself from these and develop the appropriate means of artistic expression" (*Bildnis und Individuum,* p. 231 [full ref. chap. 1, n. 13]).

21. See Ludwig Grote, *"Hier bin ich ein Herr" Dürer in Venedig,* Bibliothek des Germanischen National-Museums Nürnberg zur deutschen Kunst- und Kulturgeschichte, 2–3 (Munich, 1956), p. 48.

22. As the son of a successful goldsmith, Dürer belonged to the upper ranks of the middle class of Nuremberg society, though his 1494 marriage to Agnes Frey, daughter of a wealthy merchant of patrician descent, supported his friendship and commerce with the city's elite. Although he became Nuremberg's most famous citizen during his lifetime and amassed a considerable personal fortune, Dürer was never admitted into the enfranchised ranks of the patrician (called *ratsfähige* or "council-worthy") families. On Dürer's social status, see Ludwig Grote, "Vom Handwerker zum Künstler. Das gesellschaftliche Ansehen Albrecht Dürers," in *Festschrift für Hans Liermann zum 70. Geburtstag,* ed. Klaus Obermayer and Hans-Rudolf Hagemann, Erlanger Forschungen, ser. A, Geisteswissenschaften, 16 (Erlangen, 1964), pp. 26–47. On Nuremberg social structure, see Werner Schultheiss, "Die Mittelschicht Nürnbergs im Spätmittelalter," in *Städische Mittelschichten,* ed. Erich Maschke and Jürgen Sydow, Veröffentlichungen der Kommission für Geschichtliche Landeskunde in Baden-Württemberg, ser. B, Forschungen, 69 (Stuttgart, 1972), pp. 135–139; and Rudolf Endres, "Zur Lage der Nürnberger Handwerkerschaft zur Zeit von Hans Sachs," *Jahrbuch für fränkische Landesforschung* 37 (1977): 107–123.

23. "Hÿ pin jch ein her, doheim ein schmarotzer etc" (Dürer, *Schriftlicher Nachlaß,* 1:59).

24. See Panofsky, *Dürer,* 1:42.

25. Michel Foucault, "What Is an Author?" in *Language, Counter-memory, Practice: Selected Essays*

and Interviews, ed. and trans. Donald F. Bouchard and Sherry Simon (Ithaca, 1977), p. 135; also Foucault, *The Order of Things: An Archaeology of the Human Sciences* (New York, 1970), pp. 328–335.

26. On the history of the concept of the epoch, see Blumenberg, *Legitimacy,* p. 462 and passim.

27. See, for example, the well-known reading of the panel by the Reformation historian Roland Bainton, "Dürer and Luther as Man of Sorrows," *Art Bulletin* 29 (1947): 269–272.

28. Friedrich Nietzsche, *Briefwechsel,* ed. Giorgio Colli and Mazzino Montinari (Berlin, 1984), 3, pt. 5:482; discussed in Blumenberg, *Legitimacy,* p. 471.

29. Dürer, *Schriftlicher Nachlaß,* 1:211n1.

30. There is a record of an earlier work: a sheet of studies of three heads dating from 1480 that, along with the Albertina *Self-Portrait,* belonged to the *Kunstkammer* of the Imhoff family during the sixteenth century. This lost sketch was reportedly sold in the seventeenth century to Maximilian, the elector of Bavaria (see the *Geheimbüchlein* of Hans Hieronymus Imhoff, published by Erwin Rosenthal in "Dürers Buchmalereien für Pirckheimers Bibliothek," *Jahrbuch der preussischen Kunstsammlung* 49 [1928], fasc. 1:47).

31. Dürer, *Schriftlicher Nachlaß,* 1:31.

32. Panofsky, *Dürer,* 1:15.

33. "Und sonderlich hate mein vater an mir ein gefallen, da er sahe, daß ich fleißig in der übung zu lernen was" (Dürer, *Schriftlicher Nachlaß,* 1:30).

34. The identification of the sitter is based on his resemblance to the young Dürer's portrait panel *Albrecht Dürer the Elder* from about 1490, now in the Uffizi (Max Friedländer, "Dürers Bildnisse seines Vaters," *Repertorium für Kunstwissenschaft* 19 [1896]: 15–19).

35. The literature is divided on the issue. Winkler follows Max Friedländer's attribution to the younger Dürer (*Die Zeichnungen Albrecht Dürers,* 1:9); similarly also Anton Springer, "Dürers Zeichnungen in neuen Publikationen," *Repertorium für Kunstwissenschaft* 29 (1906): 555; Woldemar von Seidlitz, "Dürers frühe Zeichnungen," *Jahrbuch der preussischen Kunstsammlungen* 28 (1907): 3; and, tentatively, Walter L. Strauss (*The Complete Drawings of Albrecht Dürer* [New York, 1974], cat. no. 1484/4). However, Henrik Ochenchowsky ("Das Bildnis eines Goldschmiedes. Metallstiftzeichnung aus dem 15. Jahrhundert," *Repertorium für Kunstwissenschaft* 34 [1911]: 1), Kurt Bauch ("Dürers Lehrjahre," *Städel*

Jahrbuch 7–8 [1932]: 80), Hans Tietze (*Dürer als Zeichner und Aquarellist* [Vienna, 1951], p. 7), Panofsky (*Dürer,* 1:16), the editors of the 1971 Nuremberg exhibition catalog (Nuremberg, *Albrecht Dürer,* p. 53), and Peter Strieder (*Albrecht Dürer: Paintings, Prints, Drawings,* trans. Nancy M. Gordon and Walter Strauss [New York, 1982], pp. 10–11) believe that the drawing's similarities to the younger Dürer's Albertina sheet, its strange depiction of the sitter's eyes and right arm, indicate that both are self-portraits produced at roughly the same time. I am in full agreement with the attribution of the drawing to Dürer the Elder.

36. "Dz hab jch aws eim spigell nach mir selbs kunterfet jm 1484 jar do ich noch ein kint was. Albrecht Dürer" (Dürer, *Schriftlicher Nachlaß,* 1:205). The provenance of the sheet is given in Winkler, *Die Zeichnungen Albrecht Dürers,* p. 8.

37. "Wer ime im leben kain gedächtnus macht, der hat nach seinem tod kain gedächtnus und desselben menschen wird mit dem glockendon vergessen" (Maximilian, *Weisskönig,* p. 226 [full ref. chap. 1, n. 24]).

38. Dürer's collecting and labeling of the Albertina sketch belong to the artist's general efforts to preserve his memory for posterity. Many of the dates and autobiographical inscriptions that appear on Dürer's works, or on works of other artists that he possessed, he added in the last decade of his life. Similarly, his so-called *Gedenkbuch* (1502–1514) and family chronicle (1524), the earliest such documents to survive for any artist, imply that Dürer assumed that his genealogy and personal experiences were worthy of preserving for posterity. In this he follows the example not of other Nuremberg artists, but of their higher-born patrons, the Hallers, Tuchers, Scheurls, Holzschuhers, and so on, many of whose family chronicles survive. That three handwritten copies of Dürer's chronicle are known to have been made by the end of the seventeenth century proves Dürer was correct in his assumption (Dürer, *Schriftlicher Nachlaß,* 1:27–28 and 35; Hutchison, *Albrecht Dürer,* pp. 3–4 [full ref. chap. 1, n. 59]).

39. Dürer, *Schriftlicher Nachlaß,* 3:293.

40. "Zw der kunst recht zw molen ist schwer zw kumen. Dorum wer sich dortzw nit geschickt fint, der vnderste sich der nicht. Dan es will kumen van den öberen ein gissungen" (Dürer, 2:113).

41. See Rupprich's gloss of the phrase in Dürer, 2:114.

42. "Sy achtetten solche sinreichikeit ein gleich formig geschopff noch got" (Dürer, 2:113).

43. "So het er aws den jnneren jdeen, do van Plato schreibt, albeg ettwas news durch dy werck aws zw gissen" (Dürer, 2:113). Dürer will later intensify this notion of a "new" embodied in art. In the "Aesthetic Excursus" concluding the third book of his posthumously published *Vier bücher von menschlicher Proportion* (1528), Dürer speaks of "the new creation a person fashions in his heart in the form of a thing [die newe creatur, die einer in seinem hertzen schöpfft inn der gestalt eins dings]" (3:296).

44. See Jan Białostocki, "Vernunft und Ingenium in Dürers kunsttheoretischem Denken," *Zeitschrift des deutschen Vereins für Kunstwissenschaft* 25 (1971): 107–114; also, on *ingenium* in Italian humanist writing, Michael Baxandall, *Giotto and the Orators: Humanist Observers of Painting in Italy and the Discovery of Pictorial Composition, 1350–1450*, Oxford-Warburg Studies (Oxford, 1971), pp. 15–17 and passim. The topos of the child prodigy in biographies of artists is discussed in Ernst Kris and Otto Kurz, *Legend, Myth, and Magic in the Image of the Artist: A Historical Experiment*, trans. Alastair Laing and Lottie M. Newman (New Haven, 1979), pp. 13–38.

45. See Jean Baudrillard's discussion of the concept of the oeuvre in *For a Critique of the Political Economy of the Sign*, trans. Charles Levin (St. Louis, 1981), pp. 102–106.

46. Parshall, "Print Collection," pp. 140–142; Elisabeth Scheicher, "Zur Entstehung des Museums im 16. Jahrhundert. Ordungsprinzipien und Erschließung der Ambraser Sammlung Erzherzog Ferdinands," in *Der Zugang zum Kunstwerk: Schatzkammer, Salon, Ausstellung, "Museum,"* Acts of the Twenty-fifth International Congress of the History of Art, Vienna 1983, 4 (Vienna, 1986), pp. 43–52; and generally, Julius von Schlosser, *Kunst und Wunderkammern der Spätrenaissance* (Leipzig, 1908). In Italy, the collection and evaluation of a work according to its maker occurred much earlier. Petrarch, for example, valued an icon he owned because it was by Giotto. The Antwerp painter Frans Francken II fashioned a fascinating emblem of Dürer's art as the keystone of early modern art collecting. In the foreground of his famous *Picture Gallery* of 1636, now in Berlin, the artist's signature ("d o f franck") appears beside an album of Dürer's prints. (Mounted on one page are Dürer's engravings *Frederick the Wise* [1524] and the *Marvelous Sow of Landser* [1496];

a trompe l'oeil fly appears on the facing blank page.) In this great picture of pictures, artistic self-demonition, paired with the example of Dürer, marks the threshold to *Kunstkammer*.

47. The Albertina sketch is described there as "Des Albrecht Dürers Contrafait, da Er noch ein Kind gewesen, mit einem silbern Griffel" (Joseph Heller, *Das Leben und die Werke Albrecht Dürers*, 2 vols. [Bamberg, 1827], 2:82); also Anton Springer, "Inventare der Imhoff'schen Kunstkammer zu Nürnberg," *Mitteilungen der kaiserlichen königlichen Zentral Kommission zur Erforschung und Erhaltung der Baudenkmale* 5 [1860]: 352–357).

48. Dürer's thinking about works of art in terms of a master's oeuvre is not confined to his own production. On a sketch by Martin Schongauer of the *Blessing Christ* (now in the British Museum; W. 13), which the young Dürer must have acquired during his years as a journeyman, we read the following inscription fashioned by the Dürer of 1520: "Das hat hubsch martin gemacht. Im 1469" (Dürer, *Schriftlicher Nachlaß*, 1:209; Flechsig, *Albrecht Dürer*, 2:495; Musper, *Albrecht Dürer*, 13ff.).

49. British Museum, Print Collection, obj. no. 5218.1.

50. "Anno 1576 Adi. 4 februarÿ machet ich diß Conterfect von dem ab welches der Weitberümbt Albrecht Dürer mit aigner hanndt gemacht darzü er selbsten geschrieben Also · Das hab ich auß ainen spiegel nach mir selbs Conterfect im · 1484 Jar do ich noch ein kind war. Albrecht Dürer."

51. On the total transformation of German graphic style through Dürer, see Landolt, "Zur Geschichte," pp. 152–155 (full ref. chap. 1, n. 6).

52. A painting in oil on paper, formerly in the Pommersches Landesmuseum in Stettin, provides an example of this. Depicting Dürer as a boy, and inscribed at its base with a text to that effect (*in 13 jar was ich . . .*), it represents either a painting after the Albertina *Self-Portrait* or a copy of a lost self-portrait painted about 1484. Whatever its source, however, the Stettin panel is completely different in style and format from anything Dürer himself produced, suggesting rather the manner of Augsburg portraiture about 1500, particularly in the circle of Hans Burgkmair the Elder. See Buchner, *Deutsche Bildnis*, pp. 143–144, 212, and pl. 163; and Fedja Anzelewsky, *Albrecht Dürer. Das malerische Werk* (Berlin, 1971), p. 113.

53. For a short introduction to the Dürer renaissance, see Fritz Koreny, *Albrecht Dürer und*

die *Tier- und Pflanzenstudien der Renaissance*, exh. cat. (Munich, 1985), pp. 11–26. On art collecting in the court of Rudolf, see Thomas DeCosta Kaufmann, "Remarks on the Collection of Rudolf II: The Kunstkammer as a Form of Representation," *Art Journal* 38 (1978): 22–28; Eliška Fučiková, "Die Kunstkammer und Galerie Kaiser Rudolfs II. als eine Studiensammlung," in *Der Zugang zum Kunstwerk*, pp. 53–58 (see n. 46 above); and Essen, Kulturstiftung Ruhr, *Prag um 1600. Kunst und Kultur am Hofe Rudolf II.*, exh. cat. (Freren, 1988), pp. 39–44. Another fascinating use of Dürer's Albertina *Self-Portrait* in a work of the Dürer renaissance is a small painting on vellum by Daniel Fröschl (1573–1613), dating from the first decade of the seventeenth century and now in the Kunsthistorisches Museum in Vienna. Fröschl was employed as conservator at the court of Emperor Rudolf II between 1607 and 1612. His Vienna painting copies exactly the composition of a 1512 charcoal sketch of a Virgin and child by Dürer (W. 512), adding color, a background, and a painted ornamental frame. At the lower left of the image, in place of a signature or monogram, Fröschl has included a painted version of the Albertina *Self-Portrait*. Dürer's portrait here does not falsely claim that Fröschl's vellum painting is itself by Dürer, but rather states that it imitates, embellishes, and combines Dürer's works, perhaps as a way of commemorating his person (see Thomas Kaufmann's comments on this work in "Hermeneutics in the History of Art," p. 25 [full ref. chap. 1, n. 37]).

54. See Koreny, *Albrecht Dürer*, pp. 17–18 and passim; Hans Kaufmann, "Dürer in der Kunst und im Kunsturteil um 1600," *Anzeiger des Germanischen Nationalmuseum*, 1954, p. 30; Bernhard Decker, "Gelingen oder Mißlingen des Fortschritts," in *Dürers Verwandlung in der Skulptur zwischen Renaissance und Barock*, ed. Herbert Beck and Bernhard Decker, exh. cat. (Frankfurt, 1981), p. 449.

55. Gustav Glück, "Fälschungen auf Dürers Namen aus der Sammlung Erzherzog Leopold Wilhelms," *Jahrbuch der Kunsthistorischen Sammlungen des allerhöchsten Kaiserhauses* 28 (1909–1920): 1–25; Winkler, *Die Zeichungen Albrecht Dürers*, 1:8.

56. For example, copies by Hoffmann exist of Dürer's *Wing of a Blue Roller* (1512; W. 614), *Dead Blue Roller* (1512; W. 615), and *Rabbit* (1502; W. 248), all originally owned by Imhoff and now in the Albertina in Vienna. For the account, un-

documented, of Hoffmann's friendship with Imhoff see Heller, *Das Leben und die Werke Albrecht Dürers*, 1:72.

57. The work's central panel was then acquired by Maximilian I of Bavaria, who wanted only those parts of the altarpiece that were executed by Dürer's hand. This panel was destroyed by fire in 1729 but exists in a copy by Jobst Harrich, now in the Historisches Museum in Frankfurt.

58. Carel van Mander, *Dutch and Flemish Painters: Translation from the Schilderboeck*, trans. Constant van de Wall (New York, 1969), p. 40.

59. From Joachim Sandrart, *Teutsche Akademie*, as quoted in Białostocki, *Dürer and His Critics*, p. 68 (full ref. chap. 1, n. 1).

60. "Seine manuscripta und andere schlecht hin entworffene papierlin und pergamentlein werden von den Kunstnern und anderen admiratoribus für Heilig thum verwaret: Seine Tafeln und Schildereien für die högste und edelste Klein- oder auffgesetzt unnd gehalten, das man von etlichen auch gelt geben muß sie nur besehen und abspiculiren wil" (P. Kutter, "Des Matthias Quad von Kinckelbach Nachrichten von Künsterlern—der älteste deutsche Versuch einer Kunstgeschichte," *Wallraf-Richartz Jahrbuch* 3–4 [1926–1927]: 429; also Lüdecke and Heiland, *Dürer und die Nachwelt*, p. 65 [full ref. chap. 1, n. 21]).

61. This term, a variation of Friedrich Nietzsche's notion of "untimeliness" (*Unzeitgemäßheit*), is elaborated by Siegfried Kracauer in "Time and History," in *Zeugnisse. Theodor W. Adorno zum 60. Geburtstag* (Frankfurt, 1963), pp. 50–64; see also idem, "Ahasverus, or the Riddle of Time," in *History: The Last Things before the Last* (New York, 1969), pp. 139–163, and Hans Blumenberg, *The Genesis of the Copernican World*, trans. Robert M. Wallace (Cambridge, Mass., 1989), pp. 52–64.

Chapter Three

1. Walter Benjamin, "Literaturgeschichte und Literaturwissenschaft" (1931), in *Gesammelte Schriften*, 3:290 (full ref. chap. 1, n. 39).

2. I am thinking of efforts in what is sometimes called the "new historicism." Useful anthologies are H. Aram Veeser, ed., *The New Historicism* (New York, 1989); Arthur F. Kinney and Dan S. Collins, *Renaissance Historicism* (Amherst, 1987).

3. Michel Foucault, "Technologies of the Self," in *Technologies of the Self: A Seminar with Michel Fou-*

cault, ed. Luther H. Martin, Huck Gutman, and Patrick H. Hutton (Amherst, 1988), pp. 16–19.

4. Quoted from Nietzsche, *Also sprach Zarathustra*, in Ernst Bertram, *Nietzsche. Versuch einer Mythologie*, 8th ed. (Bonn, 1965), p. 24.

5. Ejxenbaum, "The Theory of the Formal Method," pp. 29–32 (full ref. preface, n. 10); also Yury Tynyanov, "On Literary Evolution" (1927), in *Readings in Russian Poetics*, ed. Matejka and Pomorska, pp. 66–78 (full ref. preface, n. 10).

6. Jauss, "Literary History as Challenge to Literary Theory," p. 18 (full ref. preface, n. 4). See also Jurij Striedter, *Literary Structure, Evolution, and Value: Russian Formalism and Czech Structuralism Reconsidered* (Cambridge, Mass., 1989), pp. 69–82.

7. Taylor, *Sources of Self*, p. 203 (full ref. chap. 1, n. 42). Taylor's chapter "Digression on Historical Explanation" informs my distinction between explaining and interpreting self-portraiture.

8. On the history of the panel, see Martin Davies, "Corpus de la peinture des anciens pays-bas méridionaux au quinzième siècle," in *Les Primitifs Flamands: The National Gallery London* (Antwerp, 1954), pp. 117–118. The literature on the panel is summarized in Linda Seidel, "'Jan van Eyck's Arnolfini Portrait': Business as Usual?" *Critical Inquiry* 16 (1989): 54–86.

9. The huge and various literature on the *Arnolfini Portrait* depends, for its ambitions, on the assumption that this painting is in a special way exemplary of a whole approach to the image. And this imagined exemplarity is to a great extent the product of Jan van Eyck's artistic self-denomination and of its character as *mise en abyme*.

10. I quote here the definition of Lucien Dällenbach (*The Mirror in the Text* [1977], trans. Jeremy Whiteley with Emma Hughes [Chicago, 1989], p. 8); Gide's discussion of the *mise en abyme* dates from 1893 (*Journals, 1889–1949*, trans. J. O'Brien [London, 1984], pp. 30–31).

11. Dällenbach, p. 8.

12. See Hans Blumenberg, "'Nachahmung der Natur'. Zur Vorgeschichte der Idee des schöpferischen Menschen" (1957), in *Wirklichkeiten in denen wir leben* (Stuttgart, 1981), pp. 58–61.

13. "Auch hab jch gesehen die dieng, die man dem könig auß dem neuen gulden land hat gebracht . . . und hab mich verwundert der subtilen jngenia der menschen jn frembden landen" (Dürer, *Schriftlicher Nachlaß*, 1:155).

14. Dürer figures as a pivotal figure in one ac-

count of this transition: Alfred Sohn-Rethel's *Intellectual and Manual Labour: A Critique of Epistemology*, trans. Martin Sohn-Rethel, Critical Social Studies (London, 1978), pp. 111–116.

15. Louis Althusser, *Lenin and Philosophy and Other Essays*, trans. Ben Brewster (New York, 1972), p. 162.

16. In Dürer's case, as we shall see, the split occurs within his labor through his investment in the technology of printing.

Chapter Four

1. X rays of the 1500 *Self-Portrait* reveal that the present dark ground is painted over an equally neutral ground. The inscription at the right originally appeared in a butterfly-shaped cartouche still faintly visible beneath the overpainting (Anzelewsky, *Dürer*, p. 164 [full ref. chap. 1, n. 22]).

2. The panel, formerly in the collection of Edmund Attems, is now in private hands in Germany. Buchner suggests the possible influence of Byzantine images of Christ on Elsner's portrait or its earlier prototype—something that would bring it closer to Dürer's 1500 *Self-Portrait*; see *Deutsche Bildnis*, pp. 138 and 211 and pl. 154 (full ref. chap. 1, n. 55).

3. For example, the triptych *Virgin with Sleeping Child* from 1496, now in Dresden, and the *Altarpiece with the Seven Sorrows of the Virgin*, also 1496, split between Dresden and Munich.

4. Isidore of Seville, *Etymologiae*, 11.2; and *De differentiis rerum*, 19. See Dieter Wuttke, "Dürer und Celtis. Von der Bedeutung des Jahres 1500 für den deutschen Humanismus: 'Jahrhundertsfeier als symbolische Form,'" *Journal of Medieval and Renaissance Studies* 10 (1980): 85–86; and Schipperges, *Garten*, p. 39 (full ref. chap. 1, n. 43).

5. Stephen Greenblatt, *Renaissance Self-Fashioning: From More to Shakespeare* (Chicago, 1980), p. 2.

6. On this tendency, see Hajo Holborn, *A History of Modern Germany: The Reformation* (Princeton, 1982), pp. 255–256. Thiem's panel is described in Eva Schmidt, *Die Stadtkirche St. Peter und Paul zu Weimar*, 3d ed., Das christliche Denkmal, 86 (Berlin, 1991), p. 21. I have profited from Sergiusz Michalski's discussion of the panel in "'Widzialne słowa' sztuki protestanckiej," in *Słowo i Obraz*, ed. Agnieszka Morawinska (Warsaw, 1982), pp. 171–208; I am indebted to Peter

Parshall for this reference, and to Woyzeck Kotas for translating the article for me.

7. Klaus Lankheit, *Das Triptychon als Pathosformel* (Heidelberg, 1959), pp. 34–35. Thiem's format also derives from Lucas Cranach the Elder's *The Three Electors of Saxony: Frederic the Wise, John the Steadfast and John Frederic the Magnanimous* from about 1535, now in Hamburg, with woodshop versions in Nuremberg and elsewhere (Max J. Friedländer and Jacob Rosenberg, *The Paintings of Lucas Cranach*, rev. ed. [Ithaca, 1978], no. 338; henceforth referred to as "FR").

8. Johannes Jahn, ed., *1472–1553 Lucas Cranach der Ältere. Das gesamte graphische Werk* (Herrsching, 1972); henceforth referred to as "J."

9. Martin Warnke, *Cranachs Luther. Entwürfe für ein Image* (Frankfurt, 1984), pp. 24–39 and passim.

10. See also the 1521 portrait panel *Luther as "Junker Jörg"* by Cranach now in Weimar (FR 126).

11. For example, the *Dual Portrait of Luther and Melanchthon* from 1532 in Dresden, with versions in Frankfurt, Augsburg, and Wrocław; and *Luther as Reformer*, with versions in Copenhagen, Rhöndorf, Braunschweig, Nuremberg, and New York (FR 314–315); also the Luther portrait of 1539, now in the collection of Emile Isambert in Paris, with versions from the 1540s and 1550s in Weimar, Pillnitz, Wörlitz, Veste Coburg, Cambridge (Mass.), Philadelphia, and Schwerin (FR 423).

12. Werner Hofmann, ed., *Köpfe der Lutherzeit*, exh. cat. (Munich, 1983), cat. no. 29; see also the Reformation responses to this image: *Das sibenhabtig Papstier*, with text by Hans Sachs, from 1530; the round, movable volvette woodcut *The Changing Faces of the Catholic Church* from 1556, in which a pinwheel of interchangeable grotesque heads revolves under another woodcut of the body of the pope in a landscape; and the trick woodcut from 1535 by Hans Rudolf Manuel Deutsch and others, consisting of variable upper and lower bodies of clerical figures (all illustrated and discussed by Christiane Andersson, "Polemical Prints in Reformation Nuremberg," in *New Perspectives on the Art of Renaissance Nuremberg: Five Essays*, ed. Jeffrey Chipps Smith [Austin, 1985], pp. 48–59).

13. Dieter Wuttke, "Unbekannte Celtis-Epigramme zum Lobe Dürers," *Zeitschrift für Kunstgeschichte* 30 (1967): 321–325.

14. See Ludwig Grote, "Die 'Vorder-Stube' des Sebald Schreyer. Ein Beitrag zur Rezeption der Renaissance in Nüremberg," *Anzeiger des Germanischen Nationalmuseum Nürnberg*, 1954–1959, pp. 43–67; Elizabeth Caesar, "Sebald Schreyer," *Mitteilungen des Vereins für die Geschichte der Stadt Nürnberg* 56 (1969): 1–213; Anzelewsky, *Dürer*, 61–62.

15. The panel was split about 1800 by the painter A. W. Kufner, who copied the *Self-Portrait* on the separated board and tried to keep the original for himself.

16. This important viewing context for Renaissance portraits has been admirably explored in Angelica Dülberg, *Privatporträts. Geschichte und Ikonographie einer Gattung im 15. und 16. Jahrhundert* (Berlin, 1990).

17. The passage reads: "Servatura tuos tamen est in imagine vultus, / Grata tuis meritis officiosa manus. / Hos olim spectans aliquis, tua gloria, dicet, / Vivit, et aeternos est habitura dies," which I translate as: "The official hand, thankful of your services, will preserve your face in its image. When it is once seen by someone, they shall say: Your fame lives and has eternal duration." The text and its interpretation are given in Dürer, *Schriftlicher Nachlaß*, 1:300–301. Rupprich's reading has been disputed by Peter Strieder, who translates *officiosa manus* simply as *une main zélée* ("a zealous hand") referring to Dürer's own hand employed in making his image. See "La signification du portrait chez Albert Dürer," in *La gloire de Dürer*, ed. Jean Richter, Faculté des lettres et des sciences humaine de l'Université de Nice, Actes et colloques, 13 (Paris, 1974), pp. 51–52.

18. Van Mander, *Dutch and Flemish Painters*, p. 40.

19. The passage appears in book 5, folio 361, of the so-called *Starkische Chronik* preserved in the Stadtbibliothek in Nuremberg (for which see Ernst Mummenhoff, *Das Rathaus in Nürnberg* [Nuremberg, 1891]). In addition, in 1606 Hans Georg Erstinger writes of seeing *Dürers contrafet* in a room in which hung "old and new things made quite artfully by himself" (Otto Glauning, "Neveu und der Raub Nürnberger Kunst- und Bücherschätze im Jahre 1801," *Mitteilung des Vereins für Geschichte der Stadt Nürnberg* 22 [1918]: 212). For a discussion of the placement of the Prado *Adam* and *Eve* in the Rathaus see Peter Strieder, "Albrecht Dürers *Vier Apostel* im Nürnberger Rathaus," in *Festschrift Klaus Lankheit zum 20. Mai 1973* (Cologne, 1973), p. 154.

20. Joachim Sandart, *Teutsche Akademie der edlen Bau-, Bild- und Mahlerey-Künste* (Nuremberg, 1675). The relevant passage is given in Lüdecke

and Heiland, *Dürer und die Nachwelt,* p. 106 (full ref. chap. 1, n. 21).

21. Glauning, "Neveu," pp. 212–213. The panel was sold to Munich by the city of Nuremberg in 1805.

22. Bayerische Staatsgemäldesammlungen, inv. no. 1411.

23. In the collection of Albert Graf von Rechberg. See Gisela Goldberg, "Zur Ausprägung der Dürer-Renaissance in München," *Münchener Jahrbuch der bildenden Kunst,* 3d ser., 31 (1980): 143 and fig. 4.

24. Goldberg, p. 143 and fig. 5.

25. This allusion was first noted by Moriz Thausing (*Dürer. Geschichte seines Lebens und seiner Kunst* [Leipzig, 1876], p. 364). Vischer's whole arrangement might derive from Dürer's panel of *Christ among the Doctors* from 1506, now in the Thyssen-Bornemisza Collection in Lugano.

26. *The Feast of the Rose Garlands,* 1506 (Prague), *The Martyrdom of the Ten Thousand,* 1508 (Vienna; fig. 67); and the *Landauer Altarpiece,* 1511 (Vienna; fig. 59).

27. See my discussion of the Lentulus letter in chapter 5.

28. Thausing, *Dürer,* pp. 355–365. The only earlier instance is an 1842 passage in Jules Michelet's posthumously published *Journal,* where we read of "Albrecht Dürer, by himself, seen frontally, the young Christ of art, a laborious, suffering, sublime workman"; and farther on, "[Dürer] was not, as Michelangelo was, a titan of art, but he was a Christ; he had a passion for art (*Journal,* ed. Paul Viallaneix [Paris, 1959], 1:441 and 452; cited in Ulrich Finke, *Die französische und englische Dürer-Rezension im 19. Jahrhundert,* Renaissance-Vorträge, Stadtgeschichtliche Museen Nürnberg, 4–5 [Nuremberg, 1976]; and in Białostocki, *Dürer and His Critics,* p. 101 [full ref. chap. 1, n. 1]).

29. For example, Pope-Hennessy, *Portrait,* p. 129 (full ref. chap. 1, n. 52).

30. In Plato's *Timaeus, analogia* means "proportion" (*Timaeus,* 37.1). Given that Dürer refers to Plato by name in his writings, and given his probable contact with the *Theologia Platonica* of Marsilio Ficino (Panofsky, *Dürer,* 1:165; Grote, "Die 'Vorder-Stube'"), it is tempting to speculate that the artist replicates specifically the *proportions* of the Holy Face in order to make an argument about analogy per se. Moreover, Dürer's use of geometry to establish and repeat these divine proportions further links him to God, for what sustains the analogy between *deus artifex* and *divina artista* is the common foundation of their works in geometry.

31. "Es ist ein grosse vergleichung zw finden in vngeleichen dingen" (Dürer, *Schriftlicher Nachlaß,* 2:100). Analogy (what Dürer terms *Vergleichung*) is a central concept in Dürer's aesthetics, being the tool whereby individual examples of the beautiful emerge through the discovery of a mean between opposites. The word *Vergleichung* itself is rare, occurring only once in Middle High German in the writings of Meister Eckhardt, where it refers to the relation between earthly things and their prior model in God. See Rupprich's comments, Dürer, 2:102n18; Erwin Panofsky, *Dürers Kunsttheorie vornehmlich in ihrem Verhältnis zur Kunsttheorie der Italiener* (Berlin, 1915), pp. 142ff.

32. Thausing, *Dürer,* p. 363.

33. Thausing, pp. 364–365.

34. The association of the Munich panel with a saint's relic is made explicit in a publication from 1828 celebrating the three hundredth anniversary of Dürer's death. The artist's likeness appears on the title page opposite the book's evocative title: *Reliquen von Albrecht Dürer seinen Verehrern geweiht* (Relics of Albrecht Dürer dedicated to his admirers) (published by Campe in Nuremberg; see Berlin, Staatliche Museen Preussischer Kulturbesitz, *Dürers Gloria. Kunst, Kult, Konsum,* ed. Berthold Hinz, exh. cat. [Berlin, 1971], fig. 68). For further documentation of the nineteenth-century cult of Dürer, see also Nuremberg, Museen der Stadt, *Das Dürer-Stammbuch von 1828,* ed. Matthias Mende and Inge Hebecker, exh. cat. (Nuremberg, 1973).

35. Panofsky, *Dürer,* 1:43; Kehrer regards the 1500 *Self-Portrait* as potentially *Blasphemie* (*Dürers Selbstbildnisse,* p. 39 [full ref. chap. 1, n. 8]); and Winkler writes of the Christ reference: "At Dürer's time it was an unknown, perhaps even heretical thought; but we could trust our artist to be capable of it" (*Albrecht Dürer,* p. 81 [full ref. chap. 1, n. 36]).

36. Panofsky, *Dürer,* 1:43.

37. "Gleich förmig deinem maister Christo" (Dürer, *Schriftlicher Nachlaß,* 1:171).

38. "Aber, Herr, du wilht, ehe du richtest, wie dein sohn Jesus Christus von den priestern sterben must und vom todt erstehn und darnach geng himmel fahren, das es auch also gleichförmig ergeht deinen nachfolger Martino Luther, den der pabst mitt ein geldt verrätherlich wieder gott umb sein leben bringt, den wirstu erquicken"

(Dürer, 1:171; see also Bainton, "Dürer and Luther," pp. 269–272 [full ref. chap. 2, n. 77]).

39. The inscription, "Domine da quod iubes et iube quod vis," echoes a passage in Thomas à Kempis ("Da quid vis, et quantum vis et qn vis," *De imitatione Christi*, 2.16). See London, British Museum, *The Age of Dürer and Holbein: German Drawings, 1400–1550*, ed. John Rowlands, exh. cat. (London, 1988), cat. no. 66b.

40. The best study of the *Self-Portrait* from this perspective remains Franz Winzinger's "Albrecht Dürers Münchener Selbstbildnis," *Zeitschrift für Kunstwissenschaft* 8 (1954): 43–64. New material is given by Fedja Anzelewsky in his *Dürer-Studien. Untersuchungen zu den ikonographischen und geistesgeschichtlichen Grundlagen seiner Werke zwischen den beiden Italienreisen* (Berlin, 1983), pp. 90–100, and by Klaus H. Jürgens in "Neue Forschungen zu dem Münchener Selbstbildnis des Jahres 1500 von Albrecht Dürer," *Kunsthistorisches Jahrbuch Graz* 19–20 (1983–1984): 167–190; 21 (1985): 134–164.

41. "Der schönste aller welt ist" (Dürer, *Schriftlicher Nachlaß*, 2:104).

42. This analogy is current in the North since the revived Neoplatonism of the twelfth century. See Edgar de Bruyne, *Etudes d'esthétique médiévale* [Bruges, 1946], 3:213; Donat de Chapeaurouge, "Theomorphe Porträts der Neuzeit," *Deutsche Vierteljahresschrift für Literatur und Geisteswissenschaft* 42 (1968): 263–265; and Kris and Kurz, *Legend, Myth, and Magic*, pp. 38–60 (full ref. chap. 2, n. 44).

43. Charles Trinkaus, *In Our Image and Likeness: Humanity and Divinity in Italian Renaissance Thought*, 2 vols. (London, 1970).

44. William J. Bouwsma, "Renaissance and Reformation: An Essay in Their Affinities and Connections," in *Luther and the Dawn of the Modern Era*, ed. Heiko Augustinus Oberman, Studies in the History of Christian Thought, 8 (Leiden, 1974), pp. 128–149.

45. Panofsky, *Dürer*, 1:43.

46. For a good introduction to the plurality of pre-Reformation opinions on confession and sermons, see Steven E. Ozment, *The Reformation in the Cities: The Appeal of Protestantism to Sixteenth-Century Germany and Switzerland* (New Haven, 1975), pp. 15–46.

Chapter Five

1. The classic study of the *acheiropoetos* and its legends is still Ernst von Dobschütz, *Christus-*
bilder. Untersuchung zur christlichen Legende, Texte und Untersuchungen zur Geschichte der altchristliche Literatur, 19 (n.s. 3), 2 vols. (Leipzig, 1899). See also Ernst Kitzinger, "The Cult of Images in the Age before Iconoclasm," *Dumbarton Oaks Papers* 8 (1954): 83–149; Walter Felicetti-Liebensfels, *Geschichte der byzantinischen Ikonenmalerei* (Olten and Lausanne, 1956), pp. 20 and 42–48; André Grabar, *L'iconoclasme byzantin. Dossier archéologique* (Paris, 1957), pp. 20–47 and passim; Kurt Bauch, "Imago," in *Studien zur Kunstwissenschaft* (Berlin, 1967), pp. 1–20; Peter Brown, *Society and the Holy in Late Antiquity* (London, 1982), pp. 261–264; and Hans Belting, *Bild und Kult. Eine Geschichte des Bildes vor dem Zeitalter der Kunst* (Munich, 1990), pp. 60–69, 233–252.

2. Dobschütz, *Christusbilder*, 1:41.

3. Dobschütz, 1:102–196; Felicetti-Liebensfels, *Geschichte*, pp. 19–20.

4. According to Syrian accounts of the Abgar image, the likeness of Christ appeared tender to believers and angry to heathens. Its power was apotropaic, like a palladium, driving enemies away through the sight of its fierce visage. Later travelers reported that the mandylion changed its face constantly, transforming from a boy to a thirty-three-year-old man (the age of Christ of the Passion) in the course of every day (Felicetti-Liebensfels, p. 20).

5. Kurt Weitzmann et al., *The Icon* (London, 1982), pp. 12 and 28.

6. On the mandylion in the West, see Comte de Riant, *Exuviae sacrae Constantinopolitanae*, 2 vols. (Geneva, 1875 and 1877), 2:135; Dobschütz, *Christusbilder*, 1:185–187; Steven Runciman, "Some Remarks on the Image of Edessa," *Cambridge Historical Journal* 3 (1931): 251; André Grabar, *La Sainte Face de Laon: Le mandylion dans l'art orthodoxe* (Prague, 1931); and Belting, *Bild und Kult*, p. 246.

7. The best discussion of the sources and transformation of the Veronica legend is Dobschütz, *Christusbilder*, 1:197–262; on the sudarium as image, see Belting's remarkable chapter "Das 'wahre Porträt' Christi. Legenden und Bilder im Wettstreit" (*Bild und Kult*, pp. 246–252), with bibliography. See also S. K. Pearson, *Die Fronica. Ein Beitrag zur Geschichte des Christusbildes im Mittelalter* (Strasbourg, 1887); Karen Gould, *The Psalter and Hours of Yolande of Suissons* (Cambridge, Mass., 1978), pp. 81ff.; and André Chastel, "La Véronique," *Revue de l'art* 40–41 (1978): 71–84. See also Ewa Kuryluk, *Veronica and*

Her Cloth: History, Symbolism and Structure of a "True" Image (Oxford, 1991), which links myths of the sudarium to female piety and sexuality in the Middle Ages.

8. On eleventh- and twelfth-century descriptions of the Veronica by Benedict of Monte Soracte and Petrus Mallius, see Belting, pp. 602–605; also Anton De Wall, "Die antiken Reliquiare der Peterskirche," *Römische Quartalschrift* 7 (1893): 257. The size of the sudarium is known from its extant crystal setting (*Venezia e Bisanzio*, exh. cat. [Venice, 1974], cat. no. 81).

9. The earliest legends of the Veronica tell the story of the punishment of Pilate. Emperor Tiberius, healed by a painted portrait of Christ that Veronica kept as token of her gratitude to Jesus, learns of the Crucifixion, punishes Pilate, and destroys Jerusalem as vengeance against the Jews.

10. Cambridge, Corpus Christi College, Cod. 16, fol. 49ᵛ; Matthew Paris, *Chronica majora*, ed. Henry Richard Luard, Chronicles and Memorials of Great Britain and Ireland during the Middle Ages, 7 vols. (London, 1872–1884), 3:7; Suzanne Lewis, *The Art of Matthew of Paris in the "Chronica Majora*," California Studies in the History of Art, 21 (Berkeley, 1987), pp. 126–127.

11. Excerpted in Belting, *Bild und Kult*, p. 603.

12. For a discussion of this reception, see Hans Belting and Dagmar Eichberger, *Jan van Eyck als Erzähler. Frühe Tafelbilder im Umkreis der New Yorker Doppeltafel* (Worms, 1983), p. 95; also Otto Pächt, "The 'Avignon Diptych' and Its Eastern Ancestry," in *De Artibus Opuscula XL: Essays in Honor of Erwin Panofsky*, ed. Millard Meiss (New York, 1961), 1:402–421.

13. As quoted in André Chastel, *The Sack of Rome, 1527*, trans. Beth Archer (Princeton, 1983), p. 104.

14. Dobschütz, *Christusbilder*, 1:225–226.

15. For example, in new pictorial inflections of the story of St. Luke painting the Madonna (see Dorothee Klein, *St. Lukas als Maler der Maria. Ikonographie der Lukas-Madonna* [Berlin, 1933]; Gisela Kraut, *Lukas malt die Madonna* [Worms, 1986]).

16. André Grabar, *Martyrium: Recherches sur le culte des reliques et l'art chrétien antique* [1946], 2 vols. (Paris, 1972), 2:343–352; see also Belting, *Bild und Kult*, pp. 72–76; and David Freedberg, *The Power of Images: Studies in the History and Theory of Response* (Chicago, 1989), pp. 92–98.

17. Peter Brown, *The Cult of the Saints: Its Rise and Function in Latin Christianity*, Haskell Lectures on History of Religions, n.s. 2 (Chicago, 1980), p. 88.

18. This point is most forcefully made by Belting, *Bild und Kult*, pp. 11–27, 164–184, and passim; see also my review of his book in *Liber* (*Frankfurter Allgemeine Zeitung/L'Indice/Le Monde/El Pais*) 2, 3 (October 1990): 3 and 15.

19. Dobschütz, *Christusbilder*, 1:56. For an extensive account of the relation between icons and the doctrine of the Incarnation, see Christoph von Schoenborn, *L'icône du Christ: Fondements théologiques élaborés entre le Iᵉʳ et le IIᵉ Concile de Nicée (325–787)*, Paradosis, Etudes de littérature et de théologie anciennes (Fribourg, 1976).

20. The literature on the theology of icons is vast. A good recent study, in English and with a useful bibliography, is Jaroslav Pelikan, *Imago Dei: The Byzantine Apologia for Icons*, A. W. Mellon Lectures in the Fine Arts, 1987 (Princeton, 1990). Belting's chapter "Die Kirche und das Bild" is the clearest and most subtle account of the material I know (*Bild und Kult*, pp. 164–185). Texts relating to the iconoclastic controversy are collected, translated, and annotated in Daniel J. Sahas, *Icon and Logos: Sources in Eighth-Century Iconoclasm*, Toronto Medieval Texts and Translations, 4 (Toronto, 1986). Also useful are Gerhard B. Ladner, "The Concept of the Image in the Greek Fathers and the Byzantine Iconoclastic Controversy," *Dumbarton Oaks Papers* 7 (1953): 1–34; Kitzinger, "Cult of Images"; Johannes Kollwitz, "Bild und Bildtheologie im Mittelalter," in *Das Gottesbild im Abendland*, ed. Wolfgang Schöne et al., Glaube und Forschung, 15 (Witten and Berlin, 1959), pp. 125ff.; Hans-Georg Beck, "Von der Fragwürdigkeit der Ikone," *Bayerischen Akademie der Wissenschaften, philosophisch-historisch Klasse, Sitzungsberichte*, 1975, fasc. 7; Leonid Ouspensky and Vladimir Lossky, *The Meaning of Icons*, trans. G. E. H. Palmer and E. Kadloubovsky, rev. ed. (Crestwood, N.Y., 1982), pp. 11–49.

21. George Pisides, *The Battle against the Persians* (622), in *Giorgio di Pisidia Poemi I: Panegirici Epici*, ed. Agostino Pertusi, Studie patristica et byzantina, 7 (Ettal, 1960), pp. 84ff.; excerpted in Belting, *Bild und Kult*, pp. 552–554.

22. St. John of Damascus, *On the Divine Images*, trans. David Anderson (Crestwood, N.Y., 1980), pp. 36 and 91. John of Damascus derives his formulation from St. Basil.

23. Belting, *Bild und Kult*, pp. 173–174; see also Marie-José Baudinet's interesting analysis of the second *Antirrhetic* of Nicephorus ("The Face

of Christ, the Form of the Church," in *Fragments for a History of the Human Body,* vol. 1, ed. Michel Feher, Ramona Naddaff, and Nadia Tazi, Zone, 3 [New York, 1989], pp. 149–159).

24. Dobschütz, *Christusbilder,* 1:38–39.

25. Dobschütz, 1:38; see Michael Camille's remarkable chapter "Fallen Fabrication: Making Images," in *The Gothic Idol: Ideology and Image-Making in Medieval Art,* Cambridge New Art History and Criticism (Cambridge, 1989), pp. 27–49.

26. Dobschütz, 1:53.

27. St. Theodore the Studite, *On the Holy Icons,* trans. Catherine P. Roth (Crestwood, N.Y., 1981), p. 101.

28. For a lengthy discussion of this phrase, see Wuttke, "Dürer und Celtis," p. 85 (full ref. chap. 4, n. 4).

29. Already in 1208, Pope Innocent linked the ostension of the Veronica to the granting of indulgences (*Gesta Innocenti Papae,* excerpted in Dobschütz, *Christusbilder,* 2:291). Hans Belting speculates that subsequent cultivation of the Veronica as the most sacred relic in Rome relates to the transferral of the mandylion from Constantinople to the West. The huge indulgences associated with the Veronica were a means both of elevating the Roman *vera icon* against any Eastern rivals and of placing the power of images under papal jurisdiction (*Bild und Kult,* p. 246).

30. Paris, *Chronica majora,* ed. Luard, 3:7; I have consulted Belting's German translation of the passage (*Bild und Kult,* p. 604).

31. In the *Paradiso,* Dante writes of "one that comes, perhaps, from Croatia to see our Veronica and whose old hunger is never satisfied, but he says to himself, as long as it is shown: 'My Lord Jesus Christ, very God, was this then your true semblance?'" (*Paradiso,* 31.102–108; trans. John D. Sinclair [New York, 1977], p. 451); and Petrarch, in sonnet 16 of the *Canzoniere,* weaves the Roman sudarium as object of pilgrimage and devotion into a poem about a lover's true image of his beloved.

32. Stephan Beissel, *Die Verehrung der Heiligen und ihrer Reliquien in Deutschland im Mittelalter,* Stimmen aus Maria Laach (1890), fasc. 47; (1892), fasc. 54; Horst Appuhn, *Einführung in die Ikonographie der mittelalterlichen Kunst in Deutschland* (Darmstadt, 1985), pp. 111–112.

33. Chastel, "Le Véronique," fig. 11; Wilhelm Ludwig Schreiber, *Handbuch der Holz- und Metallschnitte des XV. Jahrhunderts* (Leipzig, 1902), 4:11.

34. Chastel, "Le Véronique," and idem, *Sack of Rome,* p. 49.

35. Max J. Friedländer, *Early Netherlandish Painting,* trans. Heinz Norden (Leiden, 1967–1976), 7:26, 59, and cat. no. 3; Munich, Bayerische Staatsgemäldesammlung, *Alte Pinakothek München. Erläuterung zu den ausgestellten Gemälden* (Munich, 1983), pp. 310–312.

36. One should not, however, overlook the continuing influence of other Byzantine icons of Christ, which continued to flow into the West well into the fifteenth century. For the impact of icons brought from Constantinople after 1204, see Hans Belting, "Die Reaktion der Kunst des 13. Jahrhunderts auf den Import von Reliquien und Ikonen," in *Acts of the Twenty-fourth International Congress of the History of Art, Bologna, 1979,* vol. 2, *Near East and West in Thirteenth-Century Art,* ed. Hans Belting (Bologne, 1982), pp. 35–53; and more recently, Belting, *Bild und Kult,* pp. 369–390. On the reception of Eastern icons through Prague in the late fourteenth century, see Anton Legner, "Ikon und Portrait," in *Die Parler und der Schöne Stil,* ed. Anton Legner, exh. cat. (Cologne, 1978), 3:217.

37. Edgar Breitenbach, "The Tree of Bigamy and the Veronica Image of St. Peter's," *Museum Studies, the Art Institute of Chicago* 9 (1978): 30–33.

38. Dobschütz, *Christusbilder,* 1:226.

39. London, National Gallery inv. no. 2593.

40. The classic discussion of the *Andachtsbild* is still Panofsky's early essay, "Imago pietatis," pp. 261–308 (full ref. chap. 1, n. 27). See also Hans Belting, *Das Bild und sein Publikum im Mittelalter. Form und Funktion früher Bildtafeln der Passion* (Berlin, 1981), pp. 69–104 and passim, with specific discussion of the *vera icon* within the tradition of the *Andachtsbild.*

41. Munich, *Alte Pinakothek,* pp. 338–339, with bibliography. For the Master of St. Veronica, see Rainer Budde, *Köln und seine Maler, 1300–1500* (Cologne, 1986), pp. 38–49.

42. London, National Gallery inv. no. 687. See Cologne, Wallraf-Richartz-Museum, *Vor Stefan Lochner. Die Kölner Maler von 1300–1430,* exh. cat. (Cologne, 1974), p. 83; F. G. Zehnder, "Salve sancta facies. Zu Christusbildern in der Kölner gotischen Malerei," *Museen der Stadt Köln, Bulletin* 3 (1986): 41–44.

43. For example, the Master of the Holy Kinship, the Master of St. Severin, and the Master of St. Bartholomew, all active around 1500; see Budde, *Köln,* pp. 128–158.

44. See Heinrich Wölfflin's chapter "Gestalt und Umriss" in *Italien und das deutsche Formgefühl* (Munich, 1931), pp. 9–76; Wilhelm Worringer, *Formprobleme der Gotik* (Munich, 1927), pp. 36–47; Theodor Hetzer, *Das deutsche Element in der italienischen Malerei des 16. Jahrhunderts* (1929), republished in *Schriften Theodor Hetzers*, vol. 3, *Das Ornamentale und die Gestalt*, ed. Gertrude Berthold (Stuttgart, 1987), esp. pp. 71–97; Pächt, "Zur deutschen Bildauffassung" (full ref. chap. 1, n. 4); and most recently, Bernhard Rupprecht, "Malerei und Realität. Der Bildanspruch der Vor-Dürerzeit (1460–1500)," in *Albrecht Dürer: Kunst einer Zeitwende*, ed. Herbert Schade (Regensburg, 1971).

45. This is true for Dürer's Nuremberg: for example, the small devotional panel of *The Man of Sorrows with the Virgin and John the Evangelist* in the Church of St. Lorenz in Nuremberg, in which a Holy Face, flanked by donors, decorates the lower register. The sudarium often appears in German altarpieces either in narrative scenes of the Carrying of the Cross or the Crucifixion (where it is usually displayed by Veronica to the left of the cross), or as one of the *arma Christi* in pictures of the Man of Sorrows or the Mass of St. Gregory. It also appears alone as the front or rear predella of retable altarpieces. Some examples: the Nördlingen master Friedrich Herlin's *Sudarium* on the rear predella of his 1466 high altar of the Church of St. Jacob in Rothenburg on the Tauber (fig. 42); the front predella of Friedrich Pacher's *Peter and Paul Altarpiece* of about 1480, originally in the Jöchlturm chapel in Sterzing and now in the Ferdinandeum in Innsbruck (Avraham Ronan, *The Peter and Paul Altarpiece and Friedrich Pacher* [Jerusalem, 1974], pp. 16–17, with bibliography); the c. 1500 predella by Bartholomäus Zeitbom, now in the Museum der Stadt Ulm; the rear predella of Jörg Ratgeb's great 1515 *Herrenberg Altar*, now in the Staatsgalerie in Stuttgart; the predella of an altarpiece in St. George near Tösens, made about 1500 by a Swabian master working in the Tyrol (Erich Egg, *Gotik in Tirol. Die Flügelaltäre*, with Wolfgang Pfauder [Innsbruck, 1985], p. 365); and the predella of an altarpiece in Baselga de Bremiso from 1508 (Egg, p. 402).

46. Pächt, "Zur deutschen Bildauffassung," p. 107.

47. See also the small woodcut *Holy Face* from the *Opus speciale missarum de officiis dominicalibus* (Strasbourg, 1493) attributed to Dürer (Kn. 121) and two sketched Holy Faces, one a sudarium now in the Albertina (W. 608), the other simply a

nimbed Christ head now in Florence (W. 609). In all of his printed Passions, and in several drawings, the scene of the Carrying of the Cross includes the Veronica episode (Kn. 60, 189, and 274). In a drawing in the Uffizi from c. 1520 (W. 793; see also W. 794), Veronica, whose relation to Christ is the scene's central focus, kneels in a pile of dung symbolic of her status as unmarried sinner (see Hans Gerhard Evers, *Dürer bei Memling* [Munich, 1972], pp. 58–68).

48. Heller, *Das Leben und die Werke*, 2:80 (full ref. chap. 2, n. 47).

49. Dürer, *Schriftlicher Nachlaß*, 1:156, 172.

50. The letter was acquired by the Albertina in 1902 and described by Joseph Meder (*Jahrbuch der kunsthistorischen Sammlungen des Allerhöchsten Kaiserhauses* 23 [1902]: 53ff.). It was lost sometime after 1919 (see Anzelewsky, *Dürer*, cat. no. 69ᵛ, pp. 172–173 [full ref. chap. 1, n. 22]).

51. See Belting's discussion of Antoniazzo and the imitation of Byzantine icons in Italy in the fifteenth century (*Bild und Kult*, pp. 382, 492–493).

52. Max Geisberg, *The German Single-Leaf Woodcut: 1500–1550*, rev. and ed. Walter L. Strauss (New York, 1974), 1:167 (original Geisberg no. 192-1). In the early nineteenth century the woodcut itself was regarded as Dürer's and frequently copied (for example, by the art historian and archaeologist Leon de Labord and by the Bamberg sculptor Johann Andreas Kamm). The argument that the print may copy a Dürer original is Thausing's (*Dürer*, pp. 362–363 [full ref. chap. 4, n. 25]).

53. For an account by Dürer of what he took to be a miraculous image, see his description of a "wonder work" (*wunderwerk*) in 1503, when the image of a cross "fell" on people's clothing. One such sign appeared on the "linen cloth" of Dürer's maid's dress, which Dürer renders in watercolor in his *Gedenkbuch* (now in the Kupferstichkabinett in Berlin; Dürer, *Schriftlicher Nachlaß*, 1:36).

54. Giorgio Vasari, *Lives of the Artists*, trans. George Bull, rev. ed. (Harmondsworth, 1987), 1:306. The self-portrait is mentioned in Van Mander (*Dutch and Flemish Painters*, p. 38 [full ref. chap. 2, n. 58]); Sandrart saw the work in the *Kunstkammer* of the Gonzaga in Mantua. It is now lost.

55. "1515 Raffahell de Vrbin der so hoch peim pobst geacht ist gewest, der hat dyse nackette bild gemacht vnd hat sy dem Albrecht Dürer gen Nornberg geschickt, im sein hand zw weisen"

(Dürer, *Schriftlicher Nachlaß*, 1:209). Raphael's drawing, now in the Albertina, comes to us from Dürer's *Nachlaß* through the Imhoff collection. See Panofsky's influential, though flawed, interpretation of this inscription that closes his Dürer monograph (*Dürer*, 1:284). Panofsky attributes the drawing wrongly to Raphael's shop rather than to Raphael himself. For a vindication of Dürer's original attribution (which is now generally accepted), see Alice M. Kaplan, ''Dürer's 'Raphael' Drawing Reconsidered,'' *Art Bulletin* 56 (1974): 50–58.

56. Dürer, *Schriftlicher Nachlaß*, 1:212n35.

57. Vasari's term, *maravigliosa*, recalls the domain of human craftsmanship that medieval writers like Thomas Aquinas termed *mirabilia*. Sometimes describing the ruined glories of Rome, sometimes contemporary mechanical images (aeophiles, heliotropic statues, and other automatons), the word *mirabilia* distinguished works of human artistry, which could make things appear to act contrary to nature through illusionism and other tricks of knowledge, from miraculous images proper. As Michael Camille has argued for the thirteenth century, *mirabilia* as automatons ''involved myths of man as God, creator of humanoid life forms. . . . The idea of the autonomous creator thus has its origins in the automata he was once called upon to construct'' (*Gothic Idol*, pp. 250 and 258).

58. Hans Sedlmayr, *Die Entstehung der Kathedrale* (Zurich, 1950), pp. 103–108; Otto von Simson, *The Gothic Cathedral: Origins of Gothic Architecture and the Medieval Conception of Order* (Princeton, 1956), pp. 8–9; Evers, *Dürer bei Memling*, pp. 68–70.

59. John Shearman, *Art and the Spectator in the Italian Renaissance*, A. W. Mellon Lectures in the Fine Arts, 1988 (Princeton, forthcoming).

60. Quoted in Shearman, *Art and the Spectator;* from Glanville Downey, ''Nikolaus Mesarites: Description of the Church of the Holy Apostles in Constantinople,'' *Transactions of the American Philosophical Society*, n.s., 46 (1957): 855ff.

61. Jan van Eyck's *Holy Face* exists in a number of copies, none of which can be called the ''original'' version. For convenience I refer to the Berlin *Holy Face*, which is the best extant version, as ''by'' Van Eyck himself. For a discussion of the extant panels in Bruges, Berlin, London, and Munich, as well as their various inscriptions, see Friedländer, *Early Netherlandish Painting*, 1:69, and especially Erwin Panofsky, *Early Netherlandish*

Painting: Its Origins and Character (New York, 1953), 1:187n1. Dürer adds certain details from German images of the Veronica: for example, the few locks hanging down over his forehead where his hair parts constitute a detail of Christ's physiognomy that has precedents in Byzantine icons of the twelfth century and that reappears in most German sudaria (see the engraving by the Master of the Playing Cards; fig. 51).

62. Alin Janssens de Bisthoven and R. A. Parmentier, *Le Musée communal de Bruges—Les primitifs Flamands* (Antwerp, 1951), pp. 47–52.

63. Friedländer, *Early Netherlandish Painting*, 1:69.

64. A full account of Jan van Eyck's *en buste* Holy Face would have to situate it, as well, within the tradition of the *thoracicula*, the half-length portrait icon of Eastern origin that Sixten Ringbom describes as the ''devotional image *par excellence*'' (*Icon to Narrative: The Rise of the Dramatic Close-up in Fifteenth-Century Devotional Painting*, 2d rev. ed. [Doornspijk, 1984], p. 37).

65. For the ''new oil technique'' employed by Van Eyck, and for his supposed role as inventor of this technique, see Panofsky, *Early Netherlandish Painting*, 1:151–153.

66. The window motif as a symbol of majesty in *en buste* portraits of holy persons is discussed in Ringbom, *Icon to Narrative*, pp. 42–44.

67. See Munich, Staatliche Graphische Sammlung, *Meister E. S. Ein oberrheinischer Kupferstecher der Spätgothik*, exh. cat. (Munich, 1986), cat. no. 84.

68. Friedländer, *Early Netherlandish Painting*, vol. 2, no. 60.

69. *Llangattock Hours*, fol. 13ᵛ (Malibu, Paul Getty Museum; see R. Schilling, ''Das Llangattock-Stundenbuch. Sein Verhältnis zu van Eyck und dem Vollender des Turin-Milan Stundenbuchs,'' *Wallraf-Richartz Jahrbuch* 23 [1961]: 230), and New York, Pierpont Morgan Library, MS. 421, fol. 13ᵛ. See Belting and Eichberger, *Jan van Eyck als Erzähler*, pp. 95–96. There is an English tradition of short bust representations of the Roman sudarium long before Van Eyck. In Matthew Paris's *Chronica majora* (Cambridge, Corpus Christi College, MS. 16, fol. 49ᵛ, and MS. 26, fol. 283) and other related manuscripts (Westminster Psalter, British Museum, Royal MS. 2 A XXII, fol. 221ᵛ, and a Psalter in the British Museum, Arundel MS. 157, fol. 2), Christ is represented frontally and *en buste,* with hair hanging loose along the neck.

70. Dobschütz discusses the origins, editions, and reception of this text (*Christusbilder*, 2:308–330); see also Paulus Hinz, *Deus Homo. Das Christusbild von seinen Ursprüngen bis zur Gegenwart* (Berlin, 1981), 1:32–33.

71. I have used here the translation in Michael Baxandall, *Painting and Experience in Fifteenth Century Italy: A Primer in the Social History of Pictorial Style* (Oxford, 1972), p. 57.

72. Anna Komnena, *The Alexiad* (c. 1118); *Anna Comnène. Alexiade,* ed. B. Leib, 3 vols. (Paris, 1937–45), 2:110; excerpted in Belting, *Bild und Kult*, p. 572.

73. Alastair Smith, *The National Gallery Schools of Painting: Early Netherlandish and German Paintings* (London, 1985), p. 72.

74. Michael J. Liebmann, "Künstlersignatur im 15.–16. Jahrhundert als Gegenstand soziologischer Untersuchung," in *Lukas Cranach. Künstler und Gesellschaft*, ed. Peter H. Feist et al. (Wittenberg, 1972), p. 129.

75. In the Bruges copy this reddish coloring is particularly marked (Janssens de Bisthoven and Parmentier, *Le Musée Communal de Bruges*, p. 48).

76. "Speciosus inter filios hominum" (see Winzinger, "Albrecht Dürer," p. 54 [full ref. chap. 4, n. 40]). Note the similar inscription on Antoniazzo Romano's *Holy Face* triptych (fig. 47).

77. Kurt Bauch, "Bildnisse des Jan van Eyck," in *Studien zur Kunstwissenschaft*, p. 83. Bauch writes: "The portraits of Jan van Eyck are of such fundamental significance to his art because here appears in pure form something that inhabits all of his art, even his own interpretations of his art" (p. 85). In the Berlin *Holy Face* we encounter synecdochally the whole problem of "realism" in northern religious art as it is invoked by Dürer in the 1500 *Self-Portrait*.

78. For example, the *Portrait of Margaret van Eyck* from 1430 now in Bruges. See Janssens de Bisthoven and Parmentier, *Le Musée communal de Bruges*, pl. 135. Imitation marble and porphyry on frames and backs of panels were common in Italian religious paintings already in the trecento (M. Cämmerer-George, "Ein italienische Wurzel in der Rahmen-Idee Jan van Eycks," in *Kunstgeschichtliche Studien für Kurt Bauch* [Berlin, 1967], pp. 69–76), where it conveyed a message of eternity (the image as a timeless memory of the prototype) and defined the panel as a kind of epitaph (red porphyry was believed to be the material of Christ's tombstone). Van Eyck, who seems to have painted the backs of all his por-

traits in imitation of porphyry, derived the conceit from Italian examples or from similar works from Bohemia (see Dülberg, *Privatporträts*, pp. 116–127 [full ref. chap. 4, n. 16]).

79. Immanuel Kant, *Critique of Judgment* (1790), § 14.

80. See Martin Heidegger's discussion of the foundational *Begriffschema* of Western aesthetics in "Der Ursprung des Kunstwerkes" (1935–1936), in *Holzwege* (Frankfurt, 1950), pp. 11–16; also Jacques Derrida's discussion of the frame in *The Truth in Painting*, trans. Geoff Bennington and Ian McLeod (Chicago, 1987), pp. 22–23, 57–77.

81. Gustav Künstler, "Jan van Eycks Wahlwort 'als ich kan' und das Flügelaltärchen in Dresden," *Wiener Jahrbuch für Kunstgeschichte* 25 (1972): 108. It is interesting that the earliest extant Latin of any kind is the inscription on a brooch from Praeneste (c. 600 B.C.E.), which reads in Greek letters MANIOS MED FHE FHAKED NUMASIOI ("Manius made me for Numerius").

82. On artists' signatures and other labels of authorship in the Middle Ages, see Heinrich Klotz, "Formen der Anonymität und des Individualismus in der Kunst des Mittelalters und der Renaissance," *Gesta: International Center of Medieval Art* 15 (1976): 303–312; Jan Białostocki, "Begegnung mit dem Ich in der Kunst," *Artibus et historiae* 1 (1980): 25–37; Reiner Haussherr, "*Arte nulli secundus*. Eine Notiz zum Künsterlob im Mittelalter," in *Ars auro prior. Studia Ioanni Białostocki sexagenario dicata* (Warsaw, 1981), pp. 43–47; Liebmann, "Künstlersignatur," pp. 129–134; Harold Keller, "Künstlerstolz und Künstlerdemut im Mittelalter," in *Festschrift der Wissenschaftlichen Gesellschaft und der Johann Wolfgang Goethe-Universität, Frankfurt am Main* (Wiesbaden, 1981), 191–219; Peter Strieder, "Schri. kunst. schri. vnd. klag. dich. ser.—Kunst und Künstler an der Wende zum Mittelalter zur Renaissance," *Anzeiger des Germanischen Nationalmuseums*, 1983, pp. 19–26; and Peter Cornelius Claussen, "Künstlerinschriften," in Cologne, Schnütgen Museum, *Ornamenta Ecclesiae. Kunst und Künstler der Romanik*, ed. Anton Legner, exh. cat. (Cologne, 1985), 1:263–276. I am indebted to James Marrow for some of these references.

83. Theophilus, writing in the early twelfth century, advises the novice artist, "Remember that you can do nothing yourself; you reflect that you have or intend nothing unless accorded by God, but by believing, by acknowledging and rendering thanks, you ascribe to the divine com-

passion whatever you know, or are, or are able to be" (*De diversis artibus*, trans. William C. R. Dodwell [London, 1961], p. 63; excerpted in Caccilia Davis-Weyer, *Early Medieval Art, 300–1150*, Medieval Academy Reprints for Teaching, 17 [Toronto, 1986], p. 178). See Camille's discussion of this passage (*Gothic Idol*, p. 31).

84. See Ernst Robert Curtius on "affected modesty" and *humilitas* formulas (*European Literature and the Latin Middle Ages*, trans. by Willard Trask [Princeton, 1973], pp. 83–85, 407–413).

85. R. W. Scheller, "'Als ich can,'" *Oud Holland* 83 (1968): 136.

86. Scheller, p. 137.

87. Bauch, "Imago," p. 10.

88. A century later, about 1525, the Italian painter Ugo da Carpi would fashion an altarpiece for the chapel of St. Veronica in St. Peter's and inscribe it with a text proclaiming that he had made the panel without using a brush (*fata senza penelo*). The thought would have fit well Jan van Eyck's *Holy Face*, but for the Italian painter it misfired, and Vasari and Michelangelo laughed about the all too human, all too handmade self-proposed *non manufactum*. (See Belting, *Bild und Kult*, p. 248; the passage in Vasari appears in Giorgio Vasari, *Le vite de' più eccellenti pittori, sculptori e architettori*, ed. Gaetano Milanesi (Florence, 1880), 5:421.

89. London, National Gallery inv. no. 222; Panofsky, *Early Netherlandish Painting*, 1:198–199.

90. D. G. Carter, "Reflections on Armor in the 'Canon van der Paele Madonna,'" *Art Bulletin* 36 (1954): 60–62.

91. Legner, *Die Parler*, 3:217–235.

92. See, for example, the dedication page in the *Brussels Hours* by Jacquemart de Hesden from c. 1390 (Brussels, Bibliothèque Royale, MS. 11060-1, fols. 10–11). An interesting Nuremberg example of the devotional diptych is the *Löwenstein Diptych* by Hans Pleydenwurff from about 1456. The left panel, now in the Germanisches Nationalmuseum, is a naturalistic portrait of the Bamberg canon and subdeacon George, Count von Löwenstein, holding a prayer book and silhouetted against a deep blue background; the right panel, now in Basel, is an idealized *Man of Sorrows* on a gold ground. The two images represent not only the confrontation between Christ and an individual Christian self, but also the self-conscious pairing of two different pictorial modes: the icon and the portrait (reproduced in New York, *Gothic and Renaissance Art in Nurem-*

berg, pp. 170–171 [full ref. chap. 1, n. 50]). Even stranger is a devotional diptych by the Master of St. Ursula, now split between the Fogg Museum at Harvard and the Johnson Collection in Philadelphia. The sitter, perhaps Ludovico Portinari, appears in an interior setting with a view into a landscape, while the Virgin and child are silhouetted against a cloth of honor and a gold ground (Friedländer, *Early Netherlandish Painting*, vol. 6, nos. 122 and 134).

93. See Anton Legner, "Das Bronnbacher Wanddenkmal im Liebieghaus," in *Kunstgeschichtlische Studien für Kurt Bauch zum 70. Geburtstag*, ed. Margrit Lisner and Rödiger Becksmann (Munich, 1967), pp. 180–182.

94. Friedländer, *Early Netherlandish Painting*, 2:15 and 6a:14. For a discussion of Rogier's Philadelphia diptych and similar works as depictions of visual response, see James H. Marrow, "Symbol and Meaning in Northern European Art of the Late Middle Ages and the Early Renaissance," *Simiolus* 16 (1986): 150–169; also Belting's chapter "Der Dialog mit dem Bild. Die Ära des Privatbildes am Ausgang des Mittelalters," in *Bild und Kult*, pp. 457–509.

95. The manuscript, a French translation from the Latin by Laurent de Premierfait, goes by the name *Des cleres et nobles femmes* (Paris, Bibliothèque Nationale, Fr. 598, fol. 92). See Millard Meiss, *French Painting in the Time of Jean de Berry: The Limburgs and Their Contemporaries* (New York, 1974), 1:287–290. Such an illustration also reflects the increasing prestige of the artist's trade. It is, after all, only in the thirteenth and fourteenth centuries that the arts of painting and sculpture are elevated above the contemptible professions (the *inhonesta mercimonia*, *artes indecorae*, or *vilia officia*); for which see Xénia Muratova, "Vir quidam fallax et falsidicus sed artifex praeelectes: Remarques sur l'image sociale et littéraire de l'artiste au Moyen Age," in *Artistes, artisans, et production artistique au Moyen Age: Colloquium international*, ed. Xavier Barral i Altet, vol. 1, *Les hommes* (Paris, 1986), 53–72; Jacques Le Goff, *Time, Work, and Culture in the Middle Ages*, trans. Arthur Goldhammer (Chicago, 1980), p. 59; and G. Ouitt, Jr., "The Status of the Mechanical Arts in Medieval Classifications of Learning," *Viator* 14 (1983): 91–94, as cited in Camille, *Gothic Idol*, pp. 360–361n19.

96. Related to this image are contemporary representations of St. Catherine, who was believed to have found an icon of the Virgin that

spoke to her (for which see Legner, "Ikon und Portrait," p. 220). St. Catherine often carries as her attribute a mirror, which is both a reminder of the legend of the icon and a symbol of the saint's virginity (the *speculum sine macula* of the Immaculate Conception).

97. Attributed to the Coronation Master and dated a year earlier than Fr. 598 (from before 1403). Paris, Bibliothèque National, Fr. 12420, fol. 101ᵛ. Meiss, *French Painting*, 1:283–287.

98. Meiss, 1:14.

99. That the evaluation of the icon as art should first take place in the work of a French book illuminator is not surprising given the general redefinition of human labor in court culture around 1400; see Martin Warnke, *Hofkünstler. Zur Vorgeschichte des modernen Künstlers* (Cologne, 1985), pp. 52–64 and passim.

100. Paul de Man, "Autobiography as De-facement," p. 70 (full ref. chap. 1, n. 60). On more recent developments in the study of autobiography, see Paul John Eakin's excellent foreword to Philippe Lejeune, *On Autobiography*, trans. Katherine Leary, Theory and History of Literature, 52 (Minneapolis, 1989), pp. vi–xxviii.

101. They are *The Feast of the Rose Garlands*, produced in Venice in 1506 and now in the Narodni Gallery, Prague; *The Martyrdom of the Ten Thousand* (1508), now in Vienna; *The Ascension of the Virgin* (*Heller Altarpiece*), produced in 1509 and destroyed probably in 1729, but known in a good copy by Jobst Harrich now in the Historisches Museum in Frankfurt; and *The Adoration of the Holy Trinity* (*Landauer Altarpiece*), dated 1511 and now in Vienna.

102. The most important Italian examples are Benozzo Gozzoli's self-portrait in his *Journey of the Magi* fresco in the chapel of the Palazzo Medici-Riccardi, Florence, from 1459; Domenico Ghirlandaio's 1485–1490 frescoes in the choir of Sta. Maria Novella, Florence, where the artist appears in the scene of the *Expulsion of Joachim from the Temple*; and Luca Signorelli's self-portrait with his teacher Fra Angelico in the *Preaching of the Antichrist* fresco (Chapel of San Brixio in the Orvieto cathedral), part of an ensemble begun by Fra Angelico in 1447 and completed by Signorelli sometime about 1504. For a review of *in assistenza* self-portraiture in Italy, see L. M. Sleptzoff, *Men or Supermen? The Italian Portrait in the Fifteenth Century* (Jerusalem, 1978), pp. 111–136. A famous northern example is the *Festival of the Archers* by the Master of Frankfurt, now in the Koninklijk

Museum voor Schone Kunsten, Antwerp (Friedländer, *Early Netherlandish Painting*, 7:56 and no. 164). A related northern self-portrait device, of course, is the theme of St. Luke painting the Virgin, in which the evangelist is often portrayed with the artist's features.

103. The novelty of this double self-reference has been emphasized by André Chastel: "In this series of self-portraits 'in assistenza,' Dürer has, on the whole, proved himself to be more original than he is in his individual self-portrait likenesses" ("Zu vier Selbstbildnissen Albrecht Dürers aus den Jahren 1506 bis 1511," in *Albrecht Dürer: Kunst im Aufbruch*, ed. Ernst Ullmann (Leipzig, 1972), p. 46.

104. Friderike Klauner, "Gedanken zu Dürers Allerheiligenbildern," *Jahrbuch der kunsthistorischen Sammlungen in Wien* 75 (1979): 57–92; on the format of the *Landauer Altarpiece* and its tradition, see Jörg Rasmussen, "Die Nürnberger Altarbaukunst der Dürerzeit" (Ph.D. diss., Ludwig-Maximilians-Universität, Munich, 1974), pp. 20–31.

105. Biblioteca Governativa di Lucca, Cod. Lat. 1942; see also the *Wiesbaden Codex* (Wiesbaden, Hauptstaatsarchiv, 3004 Cod. B 10).

106. Quoted in Heinrich Schipperges, *Hildegard von Bingen. Ein Zeichen für unsere Zeit* (Frankfurt, 1981), p. 101.

107. Regine Dölling, "Byzantinische Elemente in der Kunst des 16. Jahrhunderts," in *Aus der byzantinischen Arbeit der Deutschen Demokratischen Republik*, ed. Johannes Irmscher, Deutscher Akademie der Wissenschaften zu Berlin, Berliner Byzantinsche Arbeiten, 6 (Berlin, 1957), pp. 148–185.

108. The specific model of the German *Lukasmadonna* was a thirteenth-century Italo-Byzantine icon from S. Maria del Popolo in Rome, which was itself based on an Eastern icon still extant in the Chiesa del Carmine in Siena. The authenticity of the Marian icon in Rome was proclaimed by Pope Sixtus IV in 1478. See Peter Strieder, "Hans Holbein d. Ä. und die deutschen Wiederholungen des Gnadenbildes von Santa Maria del Popolo," *Zeitschrift für Kunstgeschichte* 22 (1953): 252–267.

109. See Klein, *St. Lukas*, 7–12; Strieder, "Hans Holbein," pp. 252–267; Ouspensky and Lossky, *Meaning of Icons*, pp. 80–103.

110. See Bernhard Decker, *Das Ende des mittelalterlichen Kultbildes und die Plastik Hans Leinbergers*, Bamberger Studien zur Kunstgeschichte und

Denkmalpflege, 3 (Bamberg, 1985), pp. 250–290.

111. London, British Museum, Arundel MS. 128, fol. 62 (see Dürer, *Schriftlicher Nachlaß,* 2:104).

112. For editions of the Lentulus letter in Germany at 1500, see Wuttke, "Dürer and Celtis," pp. 100–101.

113. Dobschütz, *Christusbilder,* 2:328n2.

114. Geisberg, *German Single-Leaf Woodcut,* 2:413 (original Geisberg no. 441). The profile *vera effigies* is a new type, based on the emerald cameo from the Treasury of Constantinople and believed to be of great antiquity, which was given to Pope Innocent VIII by the Sultan Bajazet II (see C. W. King, "The Emerald Vernicle of the Vatican," *Archaeological Journal* 27 [1870]: 181; G. F. Hill, *The Medallic Portraits of Christ* [Oxford, 1920]; and G. Habich, "Zum Medaillen-Porträt Christi," *Archiv für Medaillen- und Plakattenkunde* 2 [1920–1921]: 75). The cameo, which is lost, would have been known to Burgkmair through numerous Italian bronze medals from the fifteenth century; it also served as model both for the profile Christ in the *Miraculous Draught of Fishes* tapestry for the Sistine Chapel, designed by Raphael in 1515 and executed by Pieter van Aelst, and for Michelangelo's Minerva *Christ* (see John Shearman, *Raphael's Cartoons in the Collection of Her Majesty the Queen and the Tapestries for the Sistine Chapel* [London, 1972], p. 50).

115. Dobschütz, *Christusbilder,* 2:308 and 328n2.

116. Dölling, "Byzantinische Elemente," p. 172.

117. Geisberg, *Single-Leaf Woodcuts,* 2:616–617 (old Geisberg nos. 651–652).

118. Ernst Benz, *Wittenberg und Byzanz. Zur Begegnung und Auseinandersetzung der Reformation und der östlich-orthodoxen Kirche* (Marburg, 1949).

119. Werner Schade, *Cranach: A Family of Painters,* trans. Helen Sebba (New York, 1980), pp. 23 and 467.

120. Panofsky, *Dürer,* 1:35.

121. Strieder, *Albrecht Dürer,* p. 92 (full ref. chap. 2, n. 35); the hypothesis of a trip to the Netherlands by the young Dürer has been rejected by many scholars, however, most recently Hutchison, *Dürer,* pp. 36–37 (full ref. chap. 1, n. 59).

122. See Jan Białostocki, "Fifteenth-Century Pictures of the Blessing Christ, Based on Rogier van der Weyden," *Gesta* 15 (1976): 313–320. Disputing my earlier emphasis on the *vera icon* as Dürer's model in the 1500 *Self-Portrait,* James H.

Marrow has proposed this Rogierian type as an alternative source in "The Northern Alternative: Visual Innovation and Artistic Self-Consciousness North of the Alps, Thirteenth–Sixteenth Centuries," Braillard Lectures, Boston Museum of Fine Arts, March 25, 1987.

123. Pächt, "'Avignon Diptych,'" pp. 404–405.

124. Indeed, the first surviving independent portrait in Italy, the 1320 funerary panel of *Archbishop Uberto d'Ormond,* now in Naples, is thus composed (see Ferdinando Bologna, *I pittori alla corte angioina di Napoli, 1266–1414* [Rome, 1969], pp. 126–132 and fig. 41; I am grateful to John Shearman for bringing this example to my attention).

125. On the potential displacement of the viewer in northern painting as demonstrated by the *Van der Paele Madonna,* see Svetlana Alpers, *The Art of Describing: Dutch Art in the Seventeenth Century* (Chicago, 1983), pp. 44–45.

126. Panofsky, *Early Netherlandish Painting,* 1:350–351 and 351n7; see also Larry Silver, "Fountain and Source: A Rediscovered Eyckian Icon," *Pantheon* 41 (1983): 95–104.

127. Jan van Eyck's *Madonna in the Church* is reproduced in Friedländer, *Early Netherlandish Painting,* vol. 1, no. 39; the Bruges Master of 1499's panel is one half of a diptych with Chrétien de Hondt as donor (now in Antwerp; Friedländer, vol. 4, no. 37); Gossaert's diptych *Madonna in a Church, St. Anthony with a Donor* dates from about 1508 and is now in the Palazzo Doria, Rome (Friedländer, vol. 8, no. 3). Hans Belting has discussed the role of "archaism" within the art of Netherlandish Romanists (*Bild und Kult,* pp. 526–533). On the general subject of interpretation and emulation in Renaissance literary theory, see Thomas Greene's magisterial *The Light in Troy: Imitation and Discovery in Renaissance Poetry* (New Haven, 1982), esp. 54–80; also David Quint, *Origin and Originality in Renaissance Literature: Versions of the Source* (New Haven, 1983).

128. See especially the chapter "Retrospektive als Signatur der Epoche," in Decker, *Das Ende,* pp. 170–178, as well as Decker, "Zur geschichtlichen Dimension in Michael Pachers Altären von Gries und St. Wolfgang," *Städel Jahrbuch* 6 (1977): 292–318. The classic account of retrospective tendencies in German sculpture of the period is Theodor Müller, "Frühe Beispiele der Retrospective in der deutschen Plastik," *Bayerische Akademie der Wissenschaften, philosophisch-historische Klasse, Sitzungsberichte,* 1961, fasc. 1.

129. Johannes Butzbach's *Libellus de praeclaris picturae professoribus* exists in one manuscript in the University Library in Bonn; it is published in Latin and German as *Von den berühmten Malern,* ed. and trans. Otto Pelka (Heidelberg, 1925).

130. Published under Butzbach's Latin name Piemontanus (trans. by D. J. Becker as the *Wanderbüchlein* [Leipzig, 1912]).

131. See Julius von Schlosser, *Die Kunstliteratur. Ein Handbuch zur Quellenkunde der neueren Kunstgeschichte* (Vienna, 1924), pp. 180 and 182.

132. Butzbach, *Von den berühmten Malern,* ed. Pelka, pp. 30 and 45. Page numbers refer to Pelka's Latin transcription and German translation of the *Libellus,* respectively.

133. Butzbach, pp. 30 and 45.

134. Białostocki, "Man and Mirror in Painting," p. 65 (full ref. chap. 1, n. 2).

135. Butzbach, pp. 31 and 46.

136. "Dan ist der künstlich mensch frum aws natur, so meidet er das pos vnd würgt das gut. Dortzw dinen dÿ künst, dan sÿ geben zu erkennen gutz und pös" (Dürer, *Schriftlicher Nachlaß,* 2:106).

137. Butzbach, pp. 37 and 53.

138. Butzbach, pp. 34 and 49.

139. Butzbach, pp. 35 and 51.

140. Butzbach, pp. 36 and 52.

141. Butzbach, pp. 37 and 53.

142. Probably composed in 1502 and published in 1505 in Strasbourg. The *Epithoma* has been called "the oldest handbooklet on German history" (see Rupprich's comments in Dürer, *Schriftlicher Nachlaß,* 1:290n1). For Wimpfeling's place as the first national historian of Germany see Joseph Knepper, *Jacob Wimpfeling. Sein Leben und seine Werke,* Erläuterungen und Ergänzungen zu Janssens Geschichte des deutschen Volkes, 3, 2–4 (Freiburg im Breisgau, 1902).

143. Dürer, *Schriftlicher Nachlaß,* 1:290.

Chapter Six

1. A possible relation between Cusanus's *Vision of God* and the 1500 *Self-Portrait* was suggested by Donat de Chapeaurouge ("Theomorphe Porträts," p. 264 [full ref. chap. 4, n. 42]) but has not yet been pursued. For the influence of Cusanus elsewhere in the visual arts, see Eberhard Hempel, "Nicolaus von Cues in seinen Beziehung zur bildenden Kunst," *Berichte über die Verhandlungen der Sächsischen Akademie der Wissenschaften zu Leipzig: Philologisch-historischen Klasse*

100 (1953): fasc. 3; Hermann Beenken, "Figura cuncta videntis," *Kunstchronik* 4 (1951): 266–269; and Alfred Neumeyer, *Der Blick aus dem Bilde* (Berlin, 1964), pp. 40–41. Since the appearance of an early version of my present argument (Koerner, "Albrecht Dürer and the Moment of Self-Portraiture," *Daphnis* 15 [1986]: 409–439), some of my conjectures have found support in Werner Beierwaltes, "Visio-Facialis—Sehen ins Angesicht. Zur Koincidenz des endlichen und unendlichen Blicks bei Cusanus," *Bayerische Akademie der Wissenschaften, philosophisch-historische Klasse, Sitzungsberichte,* 1988, fasc. 1.

2. On the figure of the omnivoyant, see Kurt Rathe, *Die Ausdrucksfunktion extrem verkürtzer Figuren,* Studies of the Warburg Institute, 8 (London, 1938), pp. 19–27, 48–56; Neumeyer, *Der Blick aus dem Bilde,* esp. pp. 39–43; Shearman, *Art and the Spectator,* passim (full ref. chap. 5, n. 59). The Pliny passage is in his *Natural History,* 35.37.120; Jacobus de Voragine's story of the scribe appears at the end of "The Legend of the Finding of the Cross," in *Legenda aurea,* ed. Richard Benz (Jena, 1925), vol. 1, cols. 465–466.

3. Bernard of Angers, *Liber miraculorum S. Fides,* ed. Auguste Bouillet [Paris, 1897]; trans. into French by Bouillet and L. Servières in *Sainte-Foy vierge et martyre* (Rodez, 1900), pp. 441ff. The cult image dates from 983–1013 and is still kept in the abbey treasury in Conques; Belting regards the statue's head as possibly of late antique or Celtic origin, which makes Bernard's initial suspicion of idolatry understandable (*Bild und Kult,* p. 335 [full ref. chap. 5, n. 1]). See also E. Dahl, "Heavenly Images: The Statue of St. Foy at Conques and the Significance of the Medieval 'Cult Image' in the West," *Acta ad archaeologiam et artium historiam pertinenta* 8 (1978): 187–189.

4. Jasper Hopkins, *Nicholas of Cusa's Dialectical Mysticism: Text, Translation and Interpretative Study of De Visione Dei,* 2d ed. (Minneapolis, 1988), p. 111. I have used Hopkins's translation, which includes the complete Latin text on facing pages and is based on eighteen surviving manuscripts of *De visione Dei.* An earlier translation by Emma Gurney Salter (Nicholas of Cusa, *The Vision of God* [London, 1928]) is perhaps more readable than Hopkins but is based on the unreliable 1565 Basel edition. I have also consulted the standard Heidelberg edition of Nikolaus von Cues, *De visione Dei. Von Gottes Sehen,* ed. and trans. E. Bohnenstadt, Schriften des Nicolaus von Cues im Auftrag der Heidelberger Akademie der Wissen-

schaften in deutschen Übersetzung, 4 (Leipzig, 1942).

5. Hopkins, *Nicholas of Cusa's Dialectical Mysticism*, pp. 114–115.

6. Nikolaus von Cues, *Von Gottes Sehen*, pp. 163–164; *De visione Dei* was sometimes referred to by the title *De icona*.

7. Hopkins, p. 115.

8. See Althusser's discussion of the religion in "Ideology and Ideological State Apparatuses," *Lenin and Philosophy*, pp. 178–183 (full ref. chap. 3, n. 15).

9. Hopkins, *Nicholas of Cusa's Dialectical Mysticism*, p. 113. Cusanus also includes in his list "the one of the archer in the forum at Nuremberg" and "the image in my Veronica Chapel in Koblenz," the latter probably part of an altarpiece in the curia where the Cusan was chaplain in 1431–1439.

10. Hans Kauffmann, "Ein Selbstporträt Rogers van der Weyden," *Repertorium für Kunstgeschichte* 39 (1916): 14–30; Erwin Panofsky, "Facies illa Rogeri maximi pictoris," in *Late Classical and Medieval Studies in Honor of Albert M. Friend, Jr.*, ed. Kurt Weitzmann (Princeton, 1955), pp. 392–400.

11. On the tapestry, see Anna Maria Cetto, "Der Berner Traian- und Herkinbald-Teppich," *Jahrbuch des Bernischen Historischen Museums* 43–44 (1963–1964): 3–230; André von Mandach, *Der Trajan- und Herkinbald-Teppich. Die Entdeckung einer internationalen Porträtgalerie des 15. Jahrhunderts* (Bern, 1987).

12. Jeanne Maquet-Tombu, "Les tableaux de justice de Roger van der Weyden à l'hôtel de ville de Bruxelles," *Phoebus* 2 (1949): 178–181.

13. "Vir ipse quod rarum est in Germanis supra opinionem eloquens et Latinus, historias idem omnes non priscas modo, sed mediae tempestatis tum veteres tum recentiores usque ad nostra tempora memoria retinebat" (Giovanni Andrea Bussi, *Prefazioni alle edizioni di Sweynheym e Pannartz prototipografi Romani*, ed. M. Miglio [Milan, 1978], p. 17; see Paul Lehmann, *Vom Mittelalter und von der lateinischen Philologie des Mittelalters* [Munich, 1914], p. 6). On the development of the terms *media aetas*, *medium aevum*, and *media tempestas* from Petrarch and Salutati through Bussi, see Nathan Edelman, "The Early Uses of Medium Aevum, Moyen Age and Moyen Temps," *Romanic Review* 30 (1938): 6; Ernst Cassirer, *The Individual and the Cosmos in Renaissance Philosophy*, ed. Mario Domandi (Philadelphia,

1972), p. 34n35; and Uwe Neddermeyer, *Das Mittelalter in der deutschen Historiographie vom 15. bis zum 18. Jahrhundert. Geschichtsgliederung und Epochenverständnis in der frühen Neuzeit*, Kölner historische Abhandlungen, 34 (Cologne, 1988), pp. 101–104. The term appears also in the Latin edition (1493) of Hartmann Schedel's *Nuremberg Chronicles* and in Faber Stapulensis's preface to his 1514 edition of Cusanus's works (Cassirer, p. 34n35; Ernst Schäfer, "The Emergence of the Concept 'Medieval' in Central European Humanism," *Sixteenth Century Journal* 7 [1976]: 27n23). Note that during the Middle Ages, phrases similar to "medieval" do occur, though with a meaning quite different from that used today. Julian of Toledo, for example, writes of the "middle age" (*tempus medium*) to refer to the period between Christ's Incarnation and Second Coming (*Antikeimenon*, 2.69; also Augustine, *De civitas Dei*, 9.1; quoted in Alister E. McGrath, *Iustitia Dei: A History of the Christian Doctrine of Justification*, vol. 1, *The Beginnings to the Reformation* [Cambridge, 1986], p. 37).

14. Cassirer, *Individual and the Cosmos*, pp. 7–72; Cassirer, *Das Erkenntnisproblem in der Philosophie und Wissenschaft der neueren Zeit* (1921), 4 vols., 3d ed. (Darmstadt, 1974): 1:21–61; Alexander Koyré, *From the Closed World to the Infinite Universe* (Baltimore, 1957); Karl Jaspers, *Anselm and Nicholas of Cusa* (New York, 1974); Blumenberg, *Legitimacy*, pp. 483–547 (full ref. chap. 2, n. 7), and idem, *Die Lesbarkeit der Welt* (Frankfurt, 1981), pp. 58–67; Amos Funkenstein, *Theology and the Scientific Imagination from the Middle Ages to the Seventeenth Century* (Princeton, 1986): 64–68. See also Karl Heinz Volkmann-Schluck, *Nicolaus Cusanus. Die Philosophie im Übergang vom Mittelalter zur Neuzeit* (Frankfurt, 1957). On the continuing controversy over the Cusan's status as threshold figure, see also William Kerrigan and Gordan Braden, *The Idea of the Renaissance* (Baltimore, 1989), pp. 84–86.

15. Blumenberg, *Legitimacy*, p. 484.

16. Hans Rupprich, *Wilibald Pirckheimer und die erste Reise Dürers nach Italian* (Vienna, 1930), p. 3; Arnold Reimann, *Die älteren Pirckheimer: Geschichte eines Patriziergeschlechtes in Zeitalter des Frühhumanismus (bis 1501)*, ed. Hans Rupprich (Leipzig, 1944), pp. 71 and 84. Franz Juraschek has postulated an influence of Cusanus on Dürer through Willibald's father Dr. Johannes Pirckheimer, who in 1495 entered the Franciscan order. See *Das Rätzel in Dürers Gotteschau. Die Holzschnittapoka-*

lypse und Nikolaus von Cues (Salzburg, 1955), pp. 131–132n27.

17. Inventoried as *Opera varia summe Theorie Cardinalis Nicolai de Cusa Episcopi Brixiensis* (Richard Stauber, *Die Schedelsche Bibliothek. Ein Beitrag zur Geschichte der Ausbildung der italienischen Renaissance, des deutschen Humanismus und der medizinischen Literatur,* Studien und Darstellung aus dem Gebiete der Geschichte, 6:2–3 [Freiburg im Breisgau, 1908], p. 130). For a list of extant manuscript copies and early editions of *De visione Dei,* see Hopkins, *Nicholas of Cusa's Dialectical Mysticism,* pp. 101–105.

18. Faber Stapulensis's complete edition (*Nicolae Cusae cardinalis opera*), published in Paris in 1514; see Cassirer, *Individual,* p. 34n35. For the history of Cusanus's works in manuscripts and incunabula, see Hans Gerhard Senger, "Cusanus-Studien, XI. Zur Überlieferung der Werke des Nikolaus von Kues im Mittelalter," *Sitzungsbericht der Heidelberger Akademie der Wissenschaften, philosophisch-historische Klasse,* 1975, fasc. 5.

19. Published by Johann Winterburger in Vienna; Eduard Langer and W. Dolch, eds., *Bibliographie der österreichischen Drucke des xv. und xvi Jahrhunderts* (Trient and Vienna, 1913), 1, 1:101. See also Ulrich Cervinus Origines' letter to Celtis from September 8, 1500, which plays on the title of Celtis's songs (*Saeculare*) and the turn of the half-millennium (Konrad Celtis, *Briefwechsel,* ed. Hans Rupprich, Veröffentlichung der Kommission zur Erforschung der Reformation und Gegenreformation, Humanistenbriefe, 3 [Munich, n.d.], p. 422 and n. 1). On Celtis's publication project, see Wuttke, "Dürer and Celtis" (full ref. chap. 4, n. 4).

20. For a discussion of Cusanus's notion of "play" as an interpretative model distinct from traditional allegory, see Walter Haug, "Das Kugelspiel des Nicolaus Cusanus und die Poetik der Renaissance," *Daphnis* 15 (1986): 356–374.

21. Hopkins, *Nicholas of Cusa's Dialectical Mysticism,* pp. 125–127.

22. On this point, see Ronald Levao, *Renaissance Minds and Their Fictions: Cusanus, Sidney, Shakespeare* (Berkeley, 1985), p. 78.

23. Hopkins, *Nicholas of Cusa's Dialectical Mysticism,* p. 125.

24. Hopkins, p. 117.

25. See Caroline Walker Bynum, *Jesus as Mother: Studies in the Spirituality of the High Middle Ages,* Publications of the Center for Medieval and Renaissance Studies, 16 (Berkeley, 1982), p. 86;

and Levao, *Renaissance Minds,* pp. 78–79. In *De diligendo Deo* (c. 1122), Bernard distinguishes between "man loving himself for his own sake," which is love in the first degree, and "man loving himself for the sake of God," which is the highest degree of love: "To love in this way is to become like a God" (*Selected Works,* trans. G. R. Evans [New York: 1987], p. 196). The idea that self-love plays a primary role in devotion derives ultimately from Augustine, who, as Charles Taylor writes, first preached that the road from lower to higher "passes through attending to ourselves as *inner. . . .* God is to be found in the intimacy of self-presence" (*Sources of Self,* pp. 129, 134 [full ref. chap. 1, n. 42]).

26. Cusanus is anticipated in this by the leaders of the *devotio moderna,* who, while tolerating or even encouraging the use of images in religious devotion, aspired finally to an "imageless ideal" of pure inward contemplation. See Craig Harbison, "Visions and Meditations in early Flemish Painting," *Simiolus* 15 (1985): 87–118.

27. Hopkins, *Nicholas of Cusa's Dialectical Mysticism,* p. 135.

28. On Cusanus's anthropology, see Pauline Moffitt Watts, *Nicolaus Cusanus: A Fifteenth-Century Vision of Man,* Studies in the History of Christian Thought, 30 (Leiden, 1982).

29. Hopkins, *Nicholas of Cusa's Dialectical Mysticism,* p. 137.

30. Hopkins, p. 129; the reference here is to 1 Cor. 13:12.

31. Hopkins, p. 199.

32. Hopkins, p. 127.

33. Pico della Mirandola, *Oration on the Dignity of Man,* in *The Renaissance Philosophy of Man,* ed. and trans. Ernst Cassirer et al. (Chicago, 1948), p. 225.

34. Nicholas of Cusa, *Der Laie über den Geist,* trans. Martin Honecker and Hildigard Menzel-Rogner, Schriften des Nikolaus von Cues im Auftrag der Heidelberger Akademie der Wissenschaften in deutschen Übersetzung, 10 (Hamburg, 1949), p. 78. The notion that man, through his works, completes God's creation, or returns it to its prelapsarian state, is present already in some of the Fathers (e.g., Origen, Basil, Gregory of Nyssa, Ambrose; see Taylor, *Sources of Self,* p. 547n3; on the Renaissance expansion of this idea that nature around us is incomplete and demands the labor of man, see Clarence S. Glacken, *Traces of the Rhodian Shore* [Berkeley, 1976], pp. 466–467).

35. On the emphasis on production in Renaissance thought from Cusanus to Francis Bacon, and on its significance for the emergence of modern identity, see Taylor, pp. 200–201.

36. On this theological motif in Western aesthetics, see Jacques Derrida, "Economimesis," trans. R. Klein, *Diacritics* 11 (1981): 9–10.

37. "Sÿ nütz, wan gott wirt dordurch geert, wo man sicht, das gott einer gkreatur sollich vernunft verleicht, der solliche kunst jn jm hat" (Dürer, *Schriftlicher Nachlaß*, 2:93).

38. "Wir werden durch kunst der gottlichen gepildnis destmer vergleicht" (Dürer, 2:129).

39. For a recent introduction to Nicholas of Flüe, see Walter Nigg, *Nikolaus von Flüe. Eine Begegnung mit Bruder Klaus* (Freiburg im Breisgau, 1976). For the text of the *Pilgrim Tract*, see Werner T. Huber, *Der göttliche Spiegel. Zur Geschichte und Theologie des ältesten Druckwerks über Bruder Klaus und sein Meditationsbild*, Europäische Hochschulschriften, ser. 23, Theologie, 164 (Bern, 1981). For the source of Gundelfingen's theology in writings of Cusanus, see Huber, *Göttliche Spiegel*, pp. 65–108 and passim.

40. The three early editions of the *Pilgrim Tract* are Augsburg: Peter Berger, n.d. [1486–1488]; Nuremberg: Markus Ayrer, 1488; and Nuremberg: Peter Wagner (?), n.d. [1489]; on the publication history of the *Tract*, see Huber, *Göttliche Spiegel*, pp. 9–10. Dürer's authorship of the woodcuts of Ayrer's edition is accepted by Willy Kurth, *The Complete Woodcuts of Albrecht Dürer* [privately published, n.d.], pp. 7–9.

41. Robert Durrer, *Die Kunstdenkmäler des Kanton Unterwalden. Zur Statistik schweizerischer Kunstdenkmäler* (Zurich, 1899–1928), p. 489.

42. As in the crowned Christ of Jan van Eyck's *Ghent Altarpiece* as *Dei testis* (Panofsky, *Early Netherlandish Painting*, 1:220). The general format of the picture (scenes in roundels surrounding a central circular portrait of Christ) is common in medieval art; see, for example, the "Wheel of the Ages of Man" in the *Delisle Psalter* (London, British Museum MS. 83 II, fol. 126v; reproduced and discussed in Wolfgang Kemp, *Sermo Corporeus. Die Erzählung der mittelalterlichen Glasfenster* [Munich, 1987], p. 153).

43. "Das goetliche wesen . . . die ungeteylt gotheyt, darinnen sich alle heyligen erfrewen" (Huber, *Göttliche Spiegel*, p. 18). In Heinrich Gundelfingen's Latin text *Historia Nicolae Underwaldensis Heremite*, the center is referred to explicitly as the Trinity: "Et veluti sua potentia tres personae radiolorum *egrediuntur acumen*" (Huber, p. 18; from a manuscript in the Biblioteca Comunale dell'Archiginnasio di Bologna, Cod. A. 152).

44. The panel shares this device with Hieronymus Bosch's *Tabletop of the Seven Deadly Sins and the Four Last Things* from c. 1485–1500, now in the Prado, a work that has been linked to Cusanus's *De visione Dei* (Walter S. Gibson, *Hieronymus Bosch* [New York, 1973], p. 35).

45. It is assumed that Nicholas of Flüe did not actually produce the Sachseln panel, but he may have invented its iconography, and it is in this sense that he can speak of it as "*my* book" (Huber, *Göttliche Spiegel*, p. 17).

46. "Den . . . gotlichen spiegel secz ich hier nach gestalt eines menschen bild" (Huber, p. 20).

47. "Wie wol es mir nit recht grundtlich wissent ist" (Huber, p. 20).

48. "Yedoch secz ich es also, das der herr sprach: Wir woellen machen einen menschen nach unserm geleichen und bildung, wiewol man das in ander weg brobieren mag. Doch so sprich ich, das got von himel ist gestigen und hat an sich genommen menschliche bildnuß" (Huber, pp. 20–21).

49. In interpreting the *imago* passages in Genesis (1:26–27, 5:1, and 9:6), medieval theology distinguished between Christ fashioned as image of God the father and man made in the image of the son—that is, between *imago Dei* and *ad imaginem Dei* (Bauch, "Imago," p. 14 [full ref. chap. 5, n. 1]).

50. Blumenberg, *Legitimacy*, pp. 527–530.

51. "Daz dy hochferstendigen ein geleichheit zw got hetten als man schriben fint. Dan ein guter maler ist jndwendig voller vigur. Vnd obs müglich wer, daz er ewiglich lebte, so het er aws den jnneren ideen, do van Plato schreibt, albeg etwas news durch die werck aws tzwgissen" (Dürer, *Schriftlicher Nachlaß*, 2:109); Dürer repeats this passage variously throughout his drafts for the *Lehrbuch* (e.g., 2:112 and 113).

52. Dürer, 3:296.

53. Augustine, *De trinitate*, 5; see Thomas Cramer, "*Solus creator est Deus. Der Autor auf dem Weg zum Schöpfertum,*" *Daphnis* 15 (1986): 260; for a historical introduction to the concept of human "creativity" in Western aesthetics, see Blumenberg's "'Nachahmung der Natur,'" pp. 55–103 (full ref. chap. 3, n. 12).

54. Seneca, *Epistolae*, 65.7; Marsilio Ficino, *Libri de vita triplici*, 1.6; as quoted in Erwin Panofsky, *Idea: A Concept in Art Theory*, trans. Joseph

J. S. Peak (New York, 1968), pp. 124–125; see also Dürer, *Schriftlicher Nachlaß*, 2:111n11.

Chapter Seven

1. This hand could also be Dürer's left, posed and pictured without a mirror, as in the Metropolitan *Self-Portrait* (fig. 2).

2. "Also hab man weyter acht, das man fleyssig eynzich die brust, bauch, den rucken vnd hindern, die beyn, füß, arm vnd hend mit allem jrem inhalt, auff das die aller kleinsten dinglein wolgeschickt vnnd auff das best gemacht weren. Vnnd dise ding sollen auch im werck auff das aller reynest vnnd fleyssigst auß gemacht werden, vnd die aller kleynsten runtzelein vnd ertlein nit außgelassen, so vil das müglich ist" (Dürer, *Schriftlicher Nachlaß*, 3:294).

3. From Albrecht Dürer, *De symmetria partium humanorum corporum*, trans. Joachim Camerarius (Nuremberg, 1532), fol. Aija ff. Camerarius's Latin text is given in Dürer, *Schriftlicher Nachlaß*, 1:307; translated into English by Conway in *Writings of Albrecht Dürer*, pp. 136–137 (full ref. chap. 1, n. 5). For a general account of this text, see Peter W. Parshall, "Camerarius on Dürer—Humanist Biography as Art Criticism," in *Joachim Camerarius (1500–1574). Beiträge zur Geschichte des Humanismus im Zeitalter der Reformation*, ed. F. Baron, Humanistische Bibliothek, ser. 1, Abhandlungen, 24 (Munich, 1978), pp. 11–29.

4. Hans Robert Jauss, "Die klassische und die christliche Rechtfertigung des Hässlichen in mittelalterlicher Literatur," in *Die nicht mehr schöne Künste. Grenzphänomene des Ästhetischen*, ed. Hans Robert Jauss, Poetik und Hermeneutik, 3 (Munich, 1968), pp. 143–168.

5. Dürer, *Writings*, p. 137.

6. Bern, Kunstmuseum, *Niklaus Manuel Deutsch. Maler, Dichter, Staatsmann*, ed. Cäsar Menz and Hugo Wagner, exh. cat. (Bern, 1979), cat. no. 198.

7. The main sources are Livy, *Ab urbe condita*, 1.57–60; Ovid, *Fasti*, 2.721–852; and Dio Cassius, *Roman History*, 2.13–20. Other accounts are surveyed in Ian Donaldson, *The Rapes of Lucretia: A Myth and Its Transformations* (Oxford, 1982), pp. 5–6; for German representations of Lucretia, see Kristen Eldyss Sorensen Zapalac, *"In His Image and Likeness": Political Iconography and Religious Change in Regensburg, 1500–1600* (Ithaca, 1990), pp. 119–126; also Mary D. Garrard, *Artemisia Gentileschi: The Myth of the Female Hero in Italian Baroque Art* (Princeton, 1989), pp. 216–239.

8. Dürer, *Writings*, p. 138. The praise of Dürer's skilled "hand" is common in eulogies of the artist written just after his death. See, for example, Hans Sachs's poem accompanying Erhard Schön's (?) c. 1550 woodcut portrait of Dürer ("Behold, if you would like to know / The image reproduced here. / . . . / His hand has far surpassed / All other masters of his time") ("Schaw an, ob dw erkennen wild / Das oben abconterfeit pild. / . . . / Des hant hat ubertroffen weit / All ander maister seiner zeit"; Dürer, *Schriftlicher Nachlaß*, 1:305); and the anecdote of Dürer and Maximilian recounted in a collection of the sayings of Melanchthon edited by Johannes Manlius (*Locorum communium collectanea* [Basel, 1563]; Dürer, 1:326).

9. Vasari, *Lives*, 1:64–65; Kris and Kurz, *Legend, Myth, and Magic*, pp. 96–97 (full ref. chap. 2, n. 44); for Wu Tao-tzu, the eighth-century Chinese master, see the *Record of Famous Painters of All the Dynasties* by Chang Yen-yüan from c. 847, in Susan Bush and Hsio-yen Shih, eds., *Early Chinese Texts on Painting* (Cambridge, Mass., 1985), pp. 61 and 64.

10. Dürer, *Schriftlicher Nachlaß*, 3:293.

11. The *fast freie geübte hand* (Dürer, 2:133).

12. Dürer, 2:113.

13. Parshall, "Camerarius on Dürer," p. 23; Jan Białostocki, "The Renaissance Concept of Nature and Antiquity" (1963), in *The Message of Images: Studies in the History of Art*, Bibliotheca Artibus et Historiae (Vienna, 1988), pp. 64–68.

14. Dürer, *Schriftlicher Nachlaß*, 3:293.

15. Peter Parshall rightly links this value to the Renaissance ideal of "artless art," what Baldassare Castiglione's *Book of the Courtier* calls *sprezzatura* ("Camerarius on Dürer," p. 23). For an analogous aesthetic in another pictorial tradition, see James Cahill, "Quickness and Spontaneity in Chinese Painting: The Rise and Decline of an Ideal" (paper delivered as Faculty Research Lecture, University of California at Berkeley, 1982).

16. James Snyder, *Northern Renaissance Art: Painting, Sculpture, the Graphic Arts from 1350 to 1575* (New York, 1985), p. 262.

17. For an excellent treatment of the effect of the *alla prima* technique in manuscript illumination and its general use in Bosch, see Daniela Hammer-Tugendhat, *Hieronymus Bosch. Ein historische Interpretation seiner Gestaltungsprinzipien*, Theorie und Geschichte der Literatur und der schönen Künste, 58 (Munich, 1981), pp. 55–80 and passim.

18. For a good description of the various

painting techniques being developed in Germany around 1500, see Franz Winzinger, *Albrecht Altdorfer: Die Gemälde* (Munich, 1975), pp. 61–62; also Fritz Burger, *Die deutsche Malerei vom ausgehenden Mittelalter bis zum Ende der Renaissance*, 3 vols., Handbuch der Kunstwissenschaft (Wildpark-Potsdam, 1917), 1:xxx.

19. "Jhr ziecht mich auch wieder an, ich soll euch zugesagt haben, das ich euch machen soll die taffel mit dem allerhöchsten fleiß, so ich kann. Das hab ich freylich nit gethan, ich sey den vnsinnig gewest. Den ich getrauet mirs, sie in meinen ganzen leben kaum zu fertigen. Den mit dem großen fleiß kan ich ain angesicht in ainem halben jahr kaum machen. So hat jr taffel schir 100 angesicht ohne gewandt vnd landschafft vnd ander ding, die daran seindt" (Dürer, *Schriftlicher Nachlaß*, 1:68). The letter dates from November 4, 1508; on the survival of these letters in copies, and on the original circumstances of their composition, see Rupprich's commentary (Dürer, 1:61–64; Hutchison, *Dürer*, pp. 99–105 [full ref. chap. 1, n. 59]).

20. Another example is Dürer's panel *Christ among the Doctors*, produced in Italy in 1506 and now in the Thyssen-Bornemiscza Collection. An inscription in the painting reads: *opus qui[n]que dierum* ("the work of five days"), which might express an ideal of quick execution as well as an analogy to the divine creation of the world in five days. On this painting, and on the value of *Schnellmalerei*, see Jan Białostocki, "'Opus Quinque Dierum': Dürer's 'Christ among the Doctors' and Its Sources," *Journal of the Warburg and Courtauld Institutes* 22 (1959): 17–34; and Franz Winzinger, "Albrecht Dürer in Rom," *Pantheon* 24 (1966): 283–287.

21. Dürer recorded the fact of landscapes drawn or painted outdoors in a sheet, *Alpine Waterwheel*, executed in watercolor and gouache probably about 1495 and kept now in Berlin (W. 103). Dürer includes in his composition the seated figure of an artist sketching from nature. On the sheet's disputed attribution to Dürer, see Strauss, *Complete Drawings of Albrecht Dürer*, vol. 1, no. 1495/39 (full ref. chap. 2, n. 35).

22. Christopher Wood has completed a dissertation on the relation of these media to the rise of landscape painting in Germany ("The Independent Landscapes of Albrecht Altdorfer" [Ph.D. diss., Harvard University, 1991]).

23. Dürer, *Writings*, p. 139.

24. Joachim Camerarius, *Elementa rhetoricae, sive capita exercitiorum studii puerilis et stili, ad comparandam utriusque linguae facultatem* (Basel, 1541); the relevant passage is reprinted in Dürer, *Schriftlicher Nachlaß*, 1:319.

25. Trans. William S. Heckscher, "*Melancholia* (1541): An Essay in the Rhetoric of Description by Joachim Camerarius," in *Joachim Camerarius*, ed. Baron, p. 33.

26. Liège, Archives de l'etat, Fonds de l'abbaye de Stavelot, MS. 341. See F. Rädle, "Abt Wilbald und der Goldschmidt G.," *Mittellateinisches Jahrbuch* 10 (1975): 74–79; Anton Legner, "Illustres Manus," in Cologne, *Ornamenta Ecclesiae*, 1:187 and 261 (full ref. chap. 5, n. 82).

27. One particularly interesting example of this motif occurs in an English (?) miniature from the beginning of the twelfth century showing St. Anselm of Canterbury and Bosso, abbot of Bec, disputing the question, *Cur Deus homo* ("Why God became man"; Cologne, Wallraf-Richartz-Museum, Graphische Sammlung, inv. no. H. 147). God's hand descends from the ring of heaven and is met by the upward-pointing hand of Anselm, suggesting the relation of God and his *imago* that is the subject of the disputatio. The page is reproduced and discussed in Cologne, *Ornamenta Ecclesiae*, 1:80.

28. An early instance is in Giovanni Santi's *Cronica rimata*, written shortly before 1494 (ed. H. Holtzinger [Stuttgart, 1893]), where we read of "Pietro Perugino / Of Pieve, a divine painter" (quoted in Baxandall, *Painting and Experience*, p. 113 [full ref. chap. 5, n. 7]). The term *divino* was used frequently to describe Michelangelo, but mainly after his death in 1564 (the earliest example is from 1532 in Ariosto, *Orlando furioso*, 33.2; for this and other instances, see David Summers, *Michaelangelo and the Language of Art* [Princeton, 1981], p. 528n40).

29. Heckscher, "*Melencolia*," pp. 44–46.

30. Dürer, *Schriftlicher Nachlaß*, 1:298n3.

31. "Nunc iacet informi manus illa infecta colore, / Subdita cui ratio tota coloris erat. / Nunc digiti pallent, qui cum libuisset habebant, / Quas ebori possent inseruisse rosas. / Quis nunc, o Alberte, tuas tetigisse tabellas? / Successor quis erit qui queat esse tibi? / Interitum natura tuum lugere videtur, / Quam poteras docta pene referre manu!" (Helius Eobanus Hessus, *In funere Alberti Dureri Norici, pictorum suae aetatis facile principis*, 11.43–50; the Latin text is given in Dürer, 1:299). The epithet *docta . . . manus* comes from Celtis in his 1500 epigram "Ad Pictorum Albertum Durer Nurnbergensum" (see Wuttke, "Unbekannte Celtis-Epigramme," p. 322 [full ref. chap. 4, n. 13]).

32. The theme of rebirth, or what Dürer calls *widererwaxsung* (Dürer, 2:144), plays throughout the whole epicedium, occurring often at the point where a classical reference combines with a modern name or a neologism: e.g., the word *palingenesis* ("rebirth") in line 118 (Dürer, 1:300). On metaphors of rebirth within the visual arts at Dürer's time, see Rudolf Chadraba, "Albrecht Dürer und die Bedeutung des vegetabilen Elementes in der deutschen Kunst nach 1500," in *Albrecht Dürer: Kunst im Aufbruch*, ed. Ernst Ullmann (Leipzig, 1972), pp. 89–97.

33. A similar ambiguity, whether Dürer's "beauty" is a characteristic of his physical being (a beautiful body) or a faculty of his mind (an ability to *know* beauty), is registered in Willibald Pirckheimer's *Elegia* on the death of Dürer, attached to the first edition of the *Proportionslehre* (1528). There are listed Dürer's "possessions": "inborn talent, beauty, faith, and uprightness" (*ingenium, formam, cum probitate fidem*; Dürer, 1:303).

34. Dresden, Sächsische Landesbibliothek, MS. R-147, fol. 100ʳ; see Walter Strauss, *The Human Figure by Albrecht Dürer: The Complete Dresden Sketchbook* (New York, 1972), no. 121, p. 242. Kurt Gerstenberg identified the hand as Dürer's ("Dürers Hand," *Monatshefte für Kunstwissenschaft* 5 [1912]: 524–526).

35. Winzinger, "Albrecht Dürers Münchner Selbstbildnis," pp. 52–54 (full ref. chap. 4, n. 40).

36. On Dürer's constructed figures and their emergence within his oeuvre, see Ludwig Justi, *Konstruierte Figuren und Koepfe unter den Werken Albrecht Dürers* (Leipzig, 1902).

37. For a brief summary of the categories icon, index, and symbol in Peirce, see Terence Hawkes, *Structuralism and Semiotics* (Berkeley, 1977), pp. 127–130.

38. "Es ist zu mercken das inn der hand kein Finger einen form hat wie die ander. Das besuch ein yglicher bey den menschen so wirdet er das also befindenn. Auch prüff ich so die hand ausgestreckt wirdet das sy nit gantz gerad auff einander steet sondern scheubet sich bei dem kleinen finger auszwertz" (*Vier pucher von menschlicher proportion* [Nuremberg, 1528]; quoted in Gerstenberg, "Dürers Hand," p. 524n3; similar formations appear in Dürer, *Schriftlicher Nachlaß*, vol. 2, no. II C 3c, and vol. 3, no. I D 16).

39. "Dan es lebt als kein schon mensch awff erd, er möcht albeg noch schöner sein. Es lebt awch kein mensch awff erd, der sagen noch ant-
zeigen kan, wÿ dy schönest gestalt des menschen möcht sein" (Dürer, 2:101).

40. "Dann die lügen ist in vnsrer erkantnus, vnd steckt die finsternus so hart in vns, das auch vnser nach dappen felt" (Dürer, 3:293).

41. Panofsky, *Dürers Kunsttheorie*, pp. 127–156 (full ref. chap. 4, n. 31); *Dürer*, 1:275–280.

42. "Waß aber dy schonheit seÿ, daz weis jch nit" (Dürer, 2:100).

43. I am reminded of the unsatisfying and always only partial fit between paintings like Jan van Eyck's *Holy Face* or Dürer's 1500 *Self-Portrait* and subsequent charts of their proportions (e.g., figs. 54 and 79).

44. Erwin Panofsky, "The History of the Theory of Human Proportions as a Reflection of the History of Styles," in *Meaning in the Visual Arts* (Chicago, 1982), p. 56.

45. Dresden, Sächsische Landesbibliothek, MS. R-147, fol. 96ʳ; Strauss, *Human Figure*, no. 122, p. 244.

46. Gerstenberg, "Dürers Hand," p. 524.

47. "Dÿs lang der langen finger ist dyse preit."

48. Winzinger, "Albrecht Dürers Münchener Selbstbildnis," pp. 50–57; Jürgens, "Neue Forschungen," pp. 171–177 and passim (full ref. chap. 4, n. 40). For an example of the search for Dürer's proportional scheme run amok, see Joachim Kromer, *Die Entwicklung der Schlüsselkomposition in der spätmittelalterlichen Kunst um 1500. Meister ES—Schongauer—Grünewald*, Studien zur deutschen Kunstgeschichte, 357 (Baden-Baden, 1979), fig. 14.

Chapter Eight

1. "Darauß ist beschlossen, das kein mensch auß eygnen sinnen nymer mer kein schön bildnuß kün machen, es sey dan sach, das er solchs auß vil abmachen sein gemüt vol gefast. Das ist dann nit mer eygens genant, sunder vberkumen vnd gelernte kunst worden, die sich besambt, erwechst vnnd seins geschlechtz frücht bringt. Darauß wirdet der versamlet heymlich schatz des hertzen offenbar durch das werck vnnd die newe creatur, die einer in seinem hertzen schöpfft inn der gestalt eins dings" (Dürer, *Schriftlicher Nachlaß*, 3:295–296). Jürgen's argument appeared as "Neuer Forschungen zu dem Münchener Selbstbildnis (II–III)," esp. pp. 145–146 (full ref. chap. 5, n. 5). On Dürer's *Philosophia* woodcut and its inscriptions, see Dieter Wuttke, "Humanismus in Nürnberg um 1500," in Nuremberg,

Germanisches Nationalmuseum, *Caritas Pirckhei-mer, 1467–1532,* exh. cat. (Nuremberg, 1982), pp. 128ff. and cat. no. 134.

2. Christoph Scheurl, *Libellus de laudibus Germaniae et ducum Saxoniae,* 2d ed. (Leipzig, 1508), fol. h 5 (43ᵃᵇ); the relevant passage appears in Dürer, *Schriftlicher Nachlaß,* 1:290. The anecdote itself recalls the oft-quoted agon between Parrhasius and Zeuxis described in Pliny, *Natural History,* 35.64–66. Closer still is the anecdote told by Nossis and collected in the *Greek Anthology:* "This is the picture of Thaumareta. Well did the painter render the bearing and the beauty of the gentle-eyed lady! Thy little house-dog would fawn upon thee as if it saw thee here, thinking it looked upon the mistress of its home!" (9.604; trans. W. R. Paton [Cambridge, Mass., 1933], p. 337); for knowledge of the *Greek Anthology* in the North, see James Hutton, *The Greek Anthology in France and the Latin Writers of the Netherlands to the Year 1800,* Cornell Studies in Classical Philology, 28 (Ithaca, 1935); I am grateful to John Shearman for these references. On the northern sources of Dürer's nature studies, see Koreny, *Albrecht Dürer,* pp. 14–15 (full ref. chap. 2, n. 53); on the conventions and function of animal portraiture in the early Renaissance, see Otto Pächt, "Early Italian Nature Studies and the Early Calendar Landscape," *Journal of the Warburg and Courtauld Institutes* 13 (1950): 13–25.

3. Van Mander, *Dutch and Flemish Painters,* p. 40 (full ref. chap. 2, n. 58).

4. See, for example, the famous twelfth-century mandylion from Novgorod, now in the Tretjakov Gallery in Moscow (reproduced in Belting, *Bild und Kult,* p. 242 [full ref. chap. 5, n. 1]).

5. Dürer's "knots" are based on similar images by Leonardo da Vinci. See Ananda K. Coomaraswamy, "The Iconography of Dürer's 'Knots' and Leonardo's 'Concatenation,'" *Art Quarterly* 7 (1944): 109; Joseph Leo Koerner, *Die Suche nach dem Labyrinth: Der Mythos von Dädalus und Ikarus* (Frankfurt, 1983), pp. 76–78.

6. For example, in foreground of the panel *The Vision of St. Bernard,* from the 1487 Augustiner Altarpiece, now in the Germanisches National-museum in Nuremberg (reproduced in Panofsky, *Dürer,* fig. 4).

7. Koreny considers the date "no doubt autographic" (*Albrecht Dürer,* p. 178). In this he concurs with Flechsig (*Dürer,* 2:366 [full ref. chap. 1, n. 16]) and Winkler (*Die Zeichnungen Albrecht Dürers,* 2:67).

8. It is possible that the *Great Turf* expresses a metaphysics of the human relation to visible reality. Blades of grass appear in an important passage of Marsilio Ficino's *Theologia Platonica,* a work evidently known to Dürer (see Fedja Anzelewsky, *Dürer: Werk und Wirkung* [Stuttgart, 1980], pp. 220–226). There we read: "When Apelles looked at a field he tried to paint it with colors on a panel. It was the whole field which showed itself in a single moment to Apelles and aroused this desire in him. This showing and rousing could be described as 'action.' . . . The act of looking and painting done by Apelles is called 'motion' because it proceeds in successive stages. First he looks at one flower then at the next and he paints it in the same way. It is the field which causes in Apelles' mind at one and the same moment both the perception of the field and the desire to paint it. But that Apelles looks at one blade of grass and paints it, and then another, at different and successive moments of time, is not an effect caused by the field, but by the soul of Apelles, whose nature it is to see and do different things one at a time and not simultaneously" (Marsilio Ficino, *Opera omnia* [Basel, 1576], p. 188, as quoted and translated in Ernst Gombrich, *Symbolic Images,* Studies in the Art of the Renaissance, 2 [Chicago, 1972], p. 77). In reducing the visible to the atomism of the graphic mark in the *Turf,* however, Dürer can restore to the narrow perspective of man a new vision of totality.

9. Dürer, *Schriftlicher Nachlaß,* 1:309; Dürer, *Writings,* pp. 138–139 (full ref. chap. 1, n. 5).

10. On Dürer's important distinction between *Brauch* (= practice, as well as manual skill) and *Kunst* (= theoretical knowledge), see Panofsky, *Dürers Kunsttheorie,* pp. 166–180 (full ref. chap. 4, n. 31).

11. Pliny, *Natural History,* 35.81–82; see Alistair Smith, "Dürer and Bellini, Apelles and Protogenes," *Burlington Magazine* 114 (1972): 326–329; Hans van de Waal, "The 'Linea Summae Tenuitatis' of Apelles: Pliny's Phrase and Its Interpreters," *Zeitschrift für Aesthetik* 12 (1967): 5–32.

12. Wuttke, "Unbekannte Celtis-Epigramme," p. 322 (full ref. chap. 4, n. 13); see also Scheurl, *Libellus de laudibus Germaniae,* where Dürer is also called *alter Apelles* (Dürer, *Schriftlicher Nachlaß,* 1:290). See Donald Burton Kuspit, "Dürer and the Northern Critics, 1502–1572" (Ph.D. diss., University of Michigan, 1971), pp. 9–22.

13. Desiderius Erasmus, *Dialogus* (Basel,

1528), p. 68; Dürer, *Schriftlicher Nachlaß*, 1:297; translated into English in Białostocki, *Dürer and His Critics*, p. 31 (full ref. chap. 1, n. 1). See also Erwin Panofsky, "*Nebulae in Pariete*: Notes on Erasmus' Eulogy on Dürer," *Journal of the Warburg and Courtauld Institutes* 14 (1951): 34–41; and idem, "Erasmus and the Visual Arts," *Journal of the Warburg and Courtauld Institutes* 32 (1969): 200–227. Erasmus's praise derives from Pliny's description of Apelles (*Natural History*, 35.96).

14. See extant letters by Dürer's friends, in Dürer, *Schriftlicher Nachlaß*, 1:253, 254, 265; also Waetzoldt, *Dürer*, pp. 37–38 (full ref. chap. 1, n. 9).

15. This reading of the phrase *wild kappen* was suggested by Hans-Joachim Mähl, in Sebastian Brant, *Das Narrenschiff*, trans. H. A. Junghans and ed. H. J. Mähl (Stuttgart, 1964), p. 22n7.

16. Mit schwebel, harz, büffen das har
Dar in schlecht man dan eyer klar
Das es jm schusselkorb werd krusz
Der henckt den kopff zum fenster vsz
Der bleicht es an der sunn vnd für
Dar vnder weden lüse nit dür.

Sebastian Brant, *Das Narrenschyff* (Basel, 1494), chap. 4, lines 9–14.

17. Dürer, 1:245; trans. Panofsky, *Dürer*, 1:117.

18. Białostocki, *Dürer and His Critics*, p. 27; Hutchison, *Dürer*, p. 29 (full ref. chap. 1, n. 59). In Italy in the early sixteenth century, wearing beards becomes the subject of a lively debate. Pope Julius II, believed (erroneously) by his admirers to be the first bearded pope, grew his beard to affect the identity of warrior prince and emperor, and perhaps even to allude to the bearded St. Peter and Christ. And Piero Valeriano, in a popular treatise entitled *Pro sacerdotum barbis* (1529), used Julius's example to defend priestly beards. See Loren Partridge and Randolph Start, *A Renaissance Likeness: Art and Culture in Raphael's "Julius II"* (Berkeley, 1980), pp. 2–3, 43–46, with extensive bibliography; also Mark J. Zucker, "Raphael and the Beard of Pope Julius II," *Art Bulletin* 59 (1977): 524–533.

19. Raymond Firth, *Symbols Public and Private* (Ithaca, 1973), p. 298; see also E. R. Leach's now-classic study, "Magical Hair," *Journal of the Royal Anthropological Institute* 88 (1958): 147–161.

20. Dürer's marked attention to his own body might be interpretable under the category, developed in Stoic thinking and reemergent during the Renaissance, of the *cura sui* (Greek, *epimeleia heau-tou*) or "care of the self," which traditionally included not only introspection but also practical hygiene (Michel Foucault, *The History of Sexuality*, vol. 3, *The Care of the Self*, trans. Robert Hurley [New York, 1986], pp. 37–68 and passim).

21. Hutchison, *Dürer*, pp. 23 and 55. On Spengler's place in Nuremberg society, see Hans von Schubert, *Lazarus Spengler und die Reformation in Nürnberg*, ed. Hajo Holborn, Quellen und Forschungen zur Reformationsgeschichte, 17 (Leipzig, 1934).

22. Pliny, *Natural History*, 35.84; also recounted in Valerius Maximus, *Factorum ac dictorum memorabilium*.

23. Also sag jch auch disem mann,
So er das maler handtwerck kan,
Das er dann beÿ demselben bleib,
Damit mans gspött nit auß im treib.

(Dürer, *Schriftlicher Nachlaß*, 1:130.)

24. See Burckhardt's chapter "Der moderne Spott und Witz," in *Kultur der Renaissance*, pp. 143–157 (full ref. chap. 1, n. 10).

25. Dannoch will ich reimen machen,
Sollt der schreiber [Spengler] noch mehr lachen,
Spricht der haarig partet maler
Zu dem spöttigen schreiber.

(Dürer, *Schriftlicher Nachlaß*, 1:131.) Note that *schreiber* here means both "writer" and "secretary," as in Spengler's title as *Ratsschreiber*. On the back of a lost panel by Dürer, *Minerva and the Muses*, which at 1822 was owned by Hans Albrecht von Derschau and described by Joseph Heller (*Das Leben*, 2:225 [full ref. chap. 2, n. 47]), the following inscription appeared: "Ich will den noch verse machen, / Solt du schreiber noch mehr lachen, / Und der haarig barteg mahler / Wird durch dies gemähl dein zahler."

26. The reconstruction of the original triptych is described in Dülberg, *Privatporträts*, cat. no. 130 (full ref. chap. 4, n. 16).

27. Robert Bernheimer, *Wild Men in the Middle Ages* (Cambridge, Mass., 1952); Timothy Husband, *The Wild Man: Medieval Myth and Symbolism* (New York, 1980).

28. Larry Silver, "Forest Primeval: Albrecht Altdorfer and the German Wilderness Landscape," *Simiolus* 13 (1983): 15–18.

29. See Marie-Christine Pouchelle's brilliant essay, "Des peaux de bêtes et des fourrures. Histoire médiévale d'une fascination," *Le temps de la réflexion* 2 (1981): 403–428. On the medieval fur trade generally, see Robert Delort, *Le commerce des*

fourrures en Occident à la fin du Moyen Âge, 2 vols., Ecole française de Rome (Rome, 1978).

30. Pouchelle, p. 403.

31. Pouchelle, pp. 409–410.

32. For a discussion of Vischer's sheet, with bibliography, see New York, *Gothic and Renaissance Art in Nuremberg,* pp. 393–394 (full ref. chap. 1, n. 50).

33. Ovid, *Metamorphosis,* 8.900–9.740.

34. For the determination of the viewer as specifically male in erotic and quasi-erotic art of the period, see chapter 14 below.

35. "[W]enn ich sage: 'Ich,' *meine* ich mich *als diesen* alle anderen Ausschliessenden; aber was ich sage, Ich, ist eben jeder" (G. W. F. Hegel, *Werke in zwanzig Bände,* vol. 8, *Enzyklopädie der philosophischen Wissenschaften, I* [Frankfurt, 1979], p. 74, § 20); see Paul de Man, "Sign and Symbol in Hegel's *Aesthetics," Critical Inquiry* 8 (1982): 768–769.

36. Jürgens, "Neue Forschungen," p. 175 (full ref. chap. 4, n. 40).

37. Wilhelm Vöge, *Jörg Syrlin der Ältere und seine Bildwerk,* vol. 2, *Stoffkreis und Gestaltung* (Berlin, 1950), p. 103.

38. Weitzmann et al., *Icon,* p. 54 (full ref. chap. 5, n. 5); Wuttke, "Dürer and Celtis," pp. 102–103 (full ref. chap. 4, n. 4). For another version of this type, see the mosaic of Christ in the Museo del Bargello, Florence (Weitzmann et al., p. 64).

39. Felicetti-Liebenfels, *Geschichte,* p. 63 (full ref. chap. 5, n. 1); quoted in Wuttke, "Dürer and Celtis," p. 103.

40. This gesture of self-reference led past scholars to believe (probably falsely) that the bust represents Syrlin himself (e.g., Hans Seifert, *Das Chorgestühl im Ulmer Münster* [Königstein im Taunus, n.d.]). The sitter's gesture, accordingly, would answer the question, Who made this work? Vöge argued against the identification of the bust with Syrlin, proposing instead that the figure represents Virgil (*Jörg Syrlin,* pp. 103–131).

41. For example, Giorgione's *La Vecchia,* c. 1508–1511, Accademia, Venice, and *Il Broccardo,* Museum of Fine Arts, Budapest (reproduced in Boehme, *Bildnis,* pp. 107 and 161 [full ref. chap. 1, n. 13]); and Lotto's *Portrait of a Man with a Claw,* c. 1527, in the Kunsthistorisches Museum, Vienna, and *Andrea Odoni* in Hampton Court palace (Pope-Hennessy, *Portrait,* pp. 230 and 231 [full ref. chap. 1, n. 52]).

42. For the history of this term, see Jaroslav Pelican, *Jesus through the Centuries: His Place in the History of Culture* (New Haven, 1985), p. 146.

43. I accept the date suggested by Strieder, *Dürer,* p. 24 (full ref. chap. 2, n. 35).

44. "Do der gelb fleck ist vnd mit dem finger drawff dewt, do ist mir we."

45. The bronze is reproduced and discussed in Hans R. Weihrauch, *Europäische Bronzstatuetten. 15.–18. Jahrhundert* (Braunschweig, 1967), pp. 284–286; on its relation to the Bremen sheet, see Strieder, *Dürer,* p. 24.

46. The similarities between the bronze *Venus* and Dürer's engraving are too many to be accidental. Also related are Dürer's *Women's Bath,* 1497, now in Bremen (W. 152), and the very early *Nude Woman* in the Musée Bonnat in Bayonne (W. 28).

47. See also the *Man of Sorrows* that Kurt Steinbart attributed to Dürer and dated to 1511. The rounded shape of Christ's hand and its position near the center of the lower portion of the panel perhaps echo Dürer's own gesture in the 1500 *Self-Portrait.* Steinbart believed that Dürer fashioned in this Christ likeness a self-portrait ("Albrecht Dürers Schmerzensmann von 1511 als christomorphes Selbstbildnis," *Zeitschrift für Kunstgeschichte* 14 [1951]: 32–39). The attribution has been disputed by Panofsky in the appendix to his 1955 one-volume edition of *The Life and Art of Albrecht Dürer* (Princeton, 1955), p. 299.

48. E. Sauser, "Wunden Christi," in *Lexikon der christlichen Ikonographie,* ed. Engelbert Kirschbaum (Rome, 1972), 4:540–542; Vladimir Gurewich, "Observations on the Iconography of the Wound on Christ's Side, with Special Reference to Its Position," *Journal of the Warburg and Courtauld Institutes* 20 (1957): 358–362.

49. Devotion to the five wounds of Christ was particularly intense during times of plague and epidemic, working apotropaically against sickness and death (Sauser, "Wunden," p. 540).

50. Early commentators referred to this drawing as an *Ecce Homo;* Emma Voigtländer recognized it as a self-portrait ("Ein Selbstbildnis aus Dürers Spätzeit," *Repertorium für Kunstwissenschaft* 44 [1924]: 282–287); for a summary of the literature, see Strauss, *Complete Drawings,* no. 1522/8 (full ref. chap. 2, n. 35). The drawing was lost in 1945.

51. First noted by Werner Schmidt, curator of drawings in the Staatliche Kunstsammlung, Weimar, in "Autour de l'exposition de Dresden, recherches sur Dürer," in *La gloire de Dürer,* ed.

Richter, pp. 107–116 (full ref. chap. 4, n. 17); and idem, "Die Seitenwunde Christi auf Dürers Weimarer Selbstbildnis," in *Von Macht der Bilder. Beiträge des C.I.H.A.-Kolloquims "Kunst und Reformation,"* ed. Ernst Ullmann (Leipzig, 1983), pp. 216–223.

52. "[W]hen a man ascribes a face to You, he does not seek it outside the human species; for his judgment is contracted within human nature and does not, in judging, go beyond the passion that belongs to this contractedness. Similarly, if a lion were to ascribe to You a face, he would judge it to be only lionlike; an ox would judge it to be only oxlike; an eagle would judge it to be only eagle-like" (Hopkins, *Nicholas of Cusa's Dialectical Mysticism,* p. 137 [full ref. chap. 6, n. 4]). Edgar Wind notes the conflation in this passage of Xenophanes, Ezek. 1:10, and the emblems of the four evangelists (*Pagan Mysteries in the Renaissance,* rev. ed. [Oxford, 1980], p. 220).

53. "Das der mensch von ym selber etwas haltet und wenet, er sey und wisse und vermüg etwas, unnd sich selber and das seyne sucht yn den dingen unnd sich selber lieb hatt und dißen gleich" (*Theologia deutsch,* ed. Hermann Mandel, Quellenschriften zur Geschichte des Protestantismus, 7 [Leipzig, 1908], p. 32).

54. Schipperges, *Garten der Gesundheit,* p. 23 (full ref. chap. 1, n. 43).

55. Blumenberg, *Legitimacy,* p. 547 (full ref. chap. 2, n. 7).

56. "Es ist nit pös, daz der mensch vill lernt wy wol etlich grob darwider sind, dy do sagen, kunst mach hoffertig. Solt daz sein, so wer nÿmant hoffertiger dan got, der alle kunst beschaffen hat" (Dürer, *Schriftlicher Nachlaß,* 2:106; also 2:132). Michael Baxandall discusses the link between Reformation iconoclasm and pre-Reformation charges of the vanity or *Hofart* of elaborate, expensive images (*The Limewood Sculptors of Renaissance Germany* [New Haven, 1980], pp. 82–93).

57. Dürer, *Schriftlicher Nachlaß,* 1:205. I follow the English translation given by Strieder, *Dürer,* p. 30, but refer the reader to the philological work of Dieter Wuttke ("Dürer and Celtis," pp. 82–93). *Effingebam,* translated by Strieder as "painted," suggests specifically something worked or pressed, as in an act of molding; the word resonates with the notions of an "imprint," as implied in the myth of the *acheiropoetos. Effingebam* might best be translated as "fashioned," with its attendant connotations of fiction making and feigning (Levao, *Renaissance Minds,* p. xxiii [full ref. chap. 6, n. 22]). This is the sense conveyed by Conrad Celtis's 1500 epigram that describes Dürer as having depicted himself *ficto . . . ore,* that is, with fashioned or idealized features ("De cane eiusdem," published in Wuttke, "Unbekannte Celtis-Epigramme," p. 323). Related more to sculpture than to painting, Dürer's use of *effingebam* also suggests a *paragone.* This is of interest because it links the Munich panel to a tradition of portraits that I have not discussed and that offers important precedents for Dürer's self-portraits: the sculpted *Baumeisterbildnisse* ("master builder portraits") that appear in German cathedrals throughout the Middle Ages (see Kurt Gerstenberg's very useful *Die deutschen Baumeisterbildnisse des Mittelalters* [Berlin, 1966]). These images, memorials to the special prestige of architects, are another possible model for Dürer's 1500 *Self-Portrait.* For what distinguishes architects from other craftsmen, what raises their work from manual to intellectual labor, is their command of *geometry;* and it is geometry that Dürer demonstrates in idealizing his own body according to the proportions of the *vera icon.*

58. Walter Haug, "Die Zwerge auf den Schultern der Riesen. Epochales und typologisches Geschichtsdenken und das Problem der Interferenzen," in *Epochenschwelle und Epochenbewußtsein,* ed. Reinhart Herzog and Reinhart Koselleck, Poetik und Hermeneutik, 12 (Munich, 1987), p. 175. For a survey of the problem of the epoch within historiography, see Johannes Burkhardt, *Die Entstehung der moderne Jahrhundertrechnung. Ursprung und Ausbildung einer historiographischen Technik von Flacius bis Ranke,* Göppinger Akademische Beiträge, 43 (Göppingen, 1971); the history of the concept of the "modern epoch" is discussed by Reinhart Koselleck in "'Neuzeit': Remarks on the Semantics of the Modern Concepts of Movement," in *Futures Past: On the Semantics of Historical Time,* trans. Keith Tribe (Cambridge, Mass., 1985), pp. 231–246.

59. As discussed earlier, the Jubilees of 1300 and 1350 were the notable moments in the veneration of the Roman Veronica, something that may be recalled in Dürer's new *vera icon* at 1500. On whether the year 1000 was understood at the time as a moment of renewal, see Stephen G. Nichols, Jr., *Romanesque Signs: Early Medieval Narrative and Iconography* (New Haven, 1983), pp. 17–21.

60. Neither the date 1300 nor Dante's age is ever mentioned explicitly in the text; they must

be deduced through various astronomical and historical clues.

61. On Petrarch, see T. E. Mommsen, "Petrarch's Conception of the 'Dark Ages,'" *Speculum* 17 (1942): 224–242. On the Renaissance view of the Middle Ages, see Jürgen Voss, *Das Mittelalter im historischen Denken Frankreichs. Untersuchungen zur Geschichte des Mittelalterbegriffes und der Mittelalterbewertung von der zweiten Hälfte des 16. bis zur Mitte des 19. Jahrhunderts,* Veröffentlichung des historisches Instituts der Universität Mannheim (Munich, 1972); Ludovica Gatto, *Viaggio intorno al concetto di medioevo: Profilo di storia della storiografia medievale,* 2d ed. rev. and expanded, Biblioteca di cultura, 108 (Rome, 1981); and Neddermeyer, *Das Mittelalter* (full ref. chap. 6, n. 13). The literature on the concept of the Renaissance (what Vasari, in 1550, calls *renascità*) is vast. Some important studies are W. K. Ferguson, *The Renaissance in Historical Thought* (Boston, 1948); B. L. Ullmann, "Renaissance: The Word and the Concept," *Studies in Philology* 49 (1952): 105–118; F. Masai, "La notion de Renaissance. Equivoques et malentendus," in C. Parelman, *Les catégories en histoire* (Brussels, 1969), pp. 57–89; and Erwin Panofsky, "'Renaissance'—Self-Definition or Self-Deception," in *Renaissances and Renascences in Western Art* (New York, 1972), pp. 1–41. For the German situation at 1500, see F. J. Worstbrock, "Über das geschichtliche Selbstverständnis des deutschen Humanismus," in *Historizität in Sprach- und Literaturwissenhaft. Vorträge und Berichte der Stuttgarter Germanistentagung 1972,* ed. Walter Müller-Seidel (Munich, 1974); and Klaus Schreiner, "'Diversitas Temporum'. Zeiterfahrung und Epochengliederung im späten Mittelalter," in *Epochenschwelle und Epochenbewußtsein,* ed. Herzog and Koselleck, pp. 381–428 (see n. 58 above).

62. Franco Simone, "Da coscienza della rinascita negli umanisti francesi," *Rivista di letterature moderne* 2 (1947): 236; as quoted in Greene, *Light in Troy,* p. 3 (full ref. chap. 5, n. 127).

63. Wuttke, "Dürer und Celtis," pp. 77–129; this article exists in a number of earlier versions, all with slightly different inflections, including: "Dürer und Celtis. Von der Bedeutung des Jahres 1500 für den deutschen Humanismus," in *Humanismus und Reformation als kulturelle Kräfte in der deutschen Geschichte,* ed. Lewis W. Spitz et al., Veröffentlichung zur Historischen Kommission zu Berlin, 51 (Berlin, 1981), pp. 121–150; and *Aby Warburgs Methode als Anregung und Aufgabe,* 3d ed., Gratia: Bamberger Schriften zur Renais-

sanceforschung, 2 (Göttingen, 1979).

64. The classic analysis of history as secularized eschatology is Karl Löwith, *Meaning in History* (Chicago, 1949), pp. 1–19, 157–159, and 200–207.

65. Wuttke, "Dürer und Celtis," p. 107.

66. A famous case of interpreting and adjusting biographical facts to fit schemes of cosmic history occurred in relation to the birth date of Martin Luther (see Warburg, *Heidnisch-antike Weissagung* [full ref. chap. 1, n. 44]). On the relation of biography to world history, see Hans Blumenberg, *Lebenszeit und Weltzeit* (Frankfurt, 1986).

67. Dürer seems to have represented himself with Celtis at the center of the *Martyrdom of the Ten Thousand* (fig. 67).

68. Wuttke, *Aby Warburgs Methode,* p. 18.

69. Dürer himself uses the phrase *anno domini* in inscriptions on various works, including the *Landauer Altarpiece* and the *Martyrdom of the Ten Thousand.* Note that Dürer's initials were variously punned by his later admirers: as *Apelles Deuthonicus* or German Apelles (by Georg Vischer in his panel *Christ and the Adultress* after the 1500 *Self-Portrait*), and as *Albertus Duro* (Albert of the hard style).

70. The history of autobiography as a literary genre also supports the view that the modern self constructs its identity partly by appropriating the attributes of God. As Hans Robert Jauss writes: "The extent to which man strives toward the goal of his autonomy and begins to ground his true self in his own individuality, rather than finding it in the alien thou of the Creator, is the measure to which aesthetic experience takes possession of the attributes of divine identity and recasts them according to the norms of self-experience, a self-experience that manifests itself in the forms, assumptions, and expectations of modern autobiography" (*Ästhetische Erfahrung und literarische Hermeneutik,* vol. 1 [Munich, 1977], p. 201). Jauss bases his account of autobiography largely on Jean Starobinsky, *Jean-Jacques Rousseau: Transparency and Obstruction,* trans. Arthur Goldhammer [Chicago, 1988]). Part of my strategy has been to read Dürer's 1500 *Self-Portrait* as a pictorial analogue to this process in literary history.

Chapter Nine

1. Francis Bacon, *Essays* (London, 1972), p. 129; the original complete edition of the *Essays*

or Councels Civill and Morall was published in 1625.

2. "Dan einer itlichen muter gefelt ir kint woll doraws kumt das vill moler machen das inen geleich ist"; "Waß aber dy schonheit seÿ, daz weis jch nit" (Dürer, *Writings,* p. 180 and 199 [full ref. chap. 1, n. 5]; Dürer, *Schriftlicher Nachlaß,* 2:100). The autommetic nature of all visual images interested many Renaissance authors. In the *Trattato,* Leonardo da Vinci writes that, just as a man's body conforms to his soul, so too an artist's pictures will mirror his physical appearance. Human judgment, linking body and mind, "also moves the art of the painter and makes him replicate himself, since it appears to that soul that this is indeed the true way of representing a man and that anyone who departs from this is mistaken" (*Treatise on Painting, Codex Urbinas Latinus 1270,* ed. A. P. MacMahan [Princeton, 1956], p. 861; as quoted and translated in Ernst H. Gombrich, *Heritage of Apelles,* Studies in the Art of the Renaissance, 3 [London, 1976], p. 69). Similarly, in one of his sermons Girolamo Savonarola notes, "Every painter paints, as the saying goes, actually himself. Insofar as he is a painter, namely, he paints after his own ideas" (*Prediche sopra Ezechiele,* ed. R. Ridolfi [Rome, 1955], 1:343; excerpted in Belting, *Bild und Kult,* p. 524 [full ref. chap. 5, n. 1]).

3. For the chronology of Dürer's aesthetic theory, see Erwin Panofsky, *Dürers Kunsttheorie,* pp. 127–156 (full ref. chap. 4, n. 31).

4. "Idoch will jch hÿ dÿ schonheit also vür mich nemen: was zw den menschlichen tzeiten van dem meinsten teill schön geacht würt, des soll wir vns fleissen zw machen" (Dürer, 2:100). On beauty as determined by the *commune arbitrium* (a view taken by Leonardo), see Panofsky, *Dürers Kunsttheorie,* 130ff.; this was later rejected by Dürer in his 1528 "Aesthetic Excursus," which renews an emphasis on the value of the unique artistic personality in determining the beautiful.

5. Jaroslav Pelikan, *The Christian Tradition: A History of the Development of Doctrine,* vol. 2, *The Spirit of Eastern Christendom (600–1700)* (Chicago, 1974), pp. 75–90.

6. Donato Acciaiuoli, "Sermon on the Last Supper" (April 13, 1468), as quoted and discussed in Trinkaus, *In Our Image and Likeness,* 2:644–650 (full ref. chap. 4, n. 43).

7. Decker, "Gelingen oder Mißlingen des Fortschritts," pp. 434–439 (full ref. chap. 2, n. 54).

8. Jane Hutchinson's recent biography of Dürer closes with an excellent chapter on this interesting and troubled history of reception ("The Celebrated Albrecht Dürer," in *Dürer,* pp. 187–206 [full ref. chap. 1, n. 59]). See also Lüdecke and Heiland, *Dürer und die Nachwelt* (full ref. chap. 1, n. 21); Białostocki, *Dürer and His Critics* (full ref. chap. 1, n. 1); Nuremberg, Germanisches Nationalmuseum, *Vorbild Dürer. Kupferstiche und Holzschnitte Albrecht Dürers im Spiegel der europäischen Druckgraphik des 16. Jahrhunderts,* exh. cat. (Munich, 1978); Nuremberg, *Das Dürer-Stammbuch von 1828* (full ref. chap. 4, n. 34); Berlin, *Dürers Gloria* (full ref. chap. 4, n. 34). On the 1971 Dürer Year, see *Der Spiegel* 9 (1971): 153–178 (cited in Hutchinson, 221n31); and Hans Ernst Mittig, *Dürers Bauernsäule. Ein Monument des Widerspruchs,* Kunststuck (Frankfurt, 1984), esp. pp. 46–47. Dürer's afterlife can be usefully compared with that of Altdorfer (for which see Reinhild Janzen, *Albrecht Altdorfer: Four Centuries of Criticism,* Studies in the Fine Arts: Criticism, 9 [Ann Arbor, Mich., 1980]) and that of Grünewald (Andrée Hayum, *The Isenheim Altarpiece: God's Medicine and the Painter's Vision* [Princeton, 1989], pp. 118–150).

9. With the exception of his friendship portrait for Raphael; see chap. 5 above.

10. The earliest extant nude constructed on a principle of proportions seems to be the Albertina *Reclining Female Nude* dated 1501 and inscribed by Dürer: *Dz hab ich gfisyrt* (fig. 97; W. 260), see Justi, *Konstruierte Figuren,* pp. 28–31 (full ref. chap. 7, n. 36).

11. Panofsky, *Dürer,* 1:90.

12. First told in Xenophon, *Memorabilia,* 3.10.1–4, and repeated in Pliny, *Natural History,* 35.64–66; Cicero, *De inventione,* 2.1.3–4; Dionysius Halicarnassus, *De imitatio,* 6.1; Valerius Maximilus, 3.7; Ailianos, *Varia historia,* 4.12 and 14.47; Plutarch, *Fragmenta,* 134. As Kris and Kurz (*Legend, Myth, and Magic,* p. 44 [full ref. chap. 2, n. 44]) and Baxandall (*Giotto,* pp. 35–37 [same note]) have shown, this story became a permanent feature of artists' biographies and self-understanding during the Renaissance.

13. "Item aws fill stucken geklawbt, aws vill schöner menschen, mag etwas gutz gemacht werden" (Dürer, *Schriftlicher Nachlaß,* 2:101); "Wiltw ein schön menschlich bild machen, so thut not, das dw dÿ art vnd glidmas jn vill menschen ersuchest, do fan eim daz hawbt, van eim anderen dy prust, arm, pein, also durch alle gelid des leibs foren vnd hinden, nichtz aws genumen" (2:118).

14. See examples of similar shield-bearing nudes in Camille, *Gothic Idol*, p. 20 and passim (full ref. chap. 5, n. 25).

15. "Einen man Jacobus genent van venedig geporn ein liblicher moler. Der wies mir, man vnd weib dÿ er aws der mas gemacht het das ich awff dÿse zeit libr sehen wold was sein mainung wer gewest dan ein new kunigreich, vnd wen ichs hett so wolt ich ims zu eren in trug pringen gemeinem nutz zw gut" (British Museum MS. 2:43; Dürer, *Writings*, p. 254). *Mainung* here does not denote "meaning," as Conway translates it, but rather means "method," as when Dürer, in his writings on perspective, describes "ein andre meynung" of perspectival drawing (Dürer, *Schriftlicher Nachlaß*, 2:385). The emphasis on Jacopo de' Barbari as the starting point for Dürer's theoretical work is general in the literature since Thausing. For specific parallels between the Italian artist and Dürer, see Justi, *Konstruierte Figuren*, especially pp. 59–63.

16. The *Apollo Belvedere* (Museo Pio-Clementino, Cortile Ottagono, inv. no. 1015), dating from 130–140 C.E. and replicating a Greek work of the mid-fourth century B.C.E., stood in the garden of San Pietro in Vincoli at the end of the fifteenth century. By 1509 it was placed in the sculpture court of the Belvedere (see Vatican Museums, *The Vatican Collections: The Papacy and Art*, exh. cat. [New York, 1982], p. 63). Dürer could have known of the *Apollo* from Italian drawings, such as those in the *Codex Escurialensis* (fol. 53); see Aby Warburg, "Dürer und die italienische Antike" (1906), in *Ausgewählte Schriften und Würdigungen*, ed. Dieter Wuttke, 2d rev. ed., Saecula Spiritalia, 1 (Baden-Baden, 1980), pp. 125–135; and Erwin Panofsky, "Albrecht Dürer and Classical Antiquity," in *Meaning in the Visual Arts* (Chicago, 1955), pp. 249–265.

17. K. T. Parker, "Eine neugefundene Apollozeichnung Albrecht Dürers," *Jahrbuch der preussischen Kunstsammlungen* 46 (1925): 248–254; Erwin Panofsky, "Dürers Darstellungen des Apollo und ihr Verhältnis zu Barbari," *Jahrbuch der preussischen Kunstsammlungen* 41 (1920): 359ff.

18. At this point, Dürer's contact with Vitruvius would have been through his humanist friends in Germany; see Panofsky, "Albrecht Dürer and Classical Antiquity," p. 250.

19. Justi, *Konstruierte Figuren*, p. 10.

20. "Dan zw gleicher weis, wÿ sÿ dy schönsten gestalt eines menschen haben zw gemessen jrem abgot Abblo, also wollen wÿr dy selb

mos prawchen zw Crÿsto dem herren, der schönste aller welt ist" (Dürer, *Schriftlicher Nachlaß*, 2:104). At about the same time a more radical version of this ecumenicalism was expressed by the Strasbourg humanist Mutianus Rufus: "There is but one god and one goddess, but many are their powers and names: Jupiter, Sol, Apollo, Moses, Christ, Luna, Ceres, Proserpina, Tellus, Maria. But have a care in speaking these things. They should be hidden in silence as are the Eleusinian mysteries; sacred things must needs be wrapped in fable and enigma" (quoted and discussed in Jean Seznec, *Survival of the Pagan Gods: The Mythological Tradition and Its Place in Renaissance Humanism and Art*, trans. Barbara F. Sessions [Princeton, 1972], p. 99).

21. "Einmall hat der schopfer dÿe Menschen gemacht, wie sie müsen sein" (Dürer, 3:272).

22. Including W. 265, 333, 334, 335, 336, 411, 412, and 424.

23. Wölfflin, *Die Kunst Albrecht Dürers*, p. 129 (full ref. chap. 1, n. 9).

24. "Vnder dem haüffen aller menschen begriffen" (Dürer, *Schriftlicher Nachlaß*, 3:272).

25. "Dann ein moll müs die menschliche gestalt beleiben ab geschiden van andern creaturn" (Dürer, 3:272). See Rupprich's comments on the term *ab geschiden* as it relates to Cicero's notion of *separatio*—as opposed to *comparatio*, Plato's *analogia*—and to the language of German mystics—Meister Eckhart's *abgescheidenheit* as the fundamental condition of the soul (3:272n7).

26. Mikhail Bakhtin, *Rabelais and His World*, trans. Hélène Iswolsky (Bloomington, Ind., 1984), pp. 24 and 29.

27. For bibliography, see New York, *Gothic and Renaissance Art in Nuremberg*, pp. 116–118 (full ref. chap. 1, n. 50).

28. Bakhtin, *Rabelais*, p. 29.

29. Panofsky, *Idea*, pp. 26–29 (full ref. chap. 6, n. 54).

30. Panofsky, *Dürer*, 1:85.

31. St. Augustine's paraphrase of Ps. 49:12, in *De civitate Dei* 13.3; trans. Henry Bettenson, *Concerning the City of God against the Pagans* (Harmondsworth, 1972), p. 512.

32. "Angelus hos cernens miratus dixit, ab horto / Non ita formosos uos ego depuleram" (*Poematum libri quinque* [Basel, 1522], fol. u¹; reprinted in Dürer, *Schriftlicher Nachlaß*, 1:296). Which of Dürer's images of the Fall Velius refers to here is still open to debate; Lüdecke and Heiland argue for the 1504 engraving (*Dürer und die*

Nachwelt, p. 252); Rupprich points to a group of works, including the panels *Adam* and *Eve* in Madrid as well as the woodcut *Fall* (Kn. 256) and *Expulsion* (Kn. 257) from the *Small Passion* (Dürer, 1:296n3).

33. For example, Antonio Pollaiuolo's so-called *Ten Nudes*, with its tablet inscribed *Opvs Antonii Pollaioli Florenttini* (see Panofsky, *Dürer*, 1:87).

34. Christoph Scheurl, *Oratio attingens litterarum praestantiam nec non laudem ecclesiae collegiatae Vittenburgensis* (Leipzig, 1509) following Pliny, *Natural History*, Praef. 26. The dedicatory letter was addressed to Lucas Cranach the Elder (reprinted in Dürer, *Schriftlicher Nachlaß*, 1:292). Words for "make" in the imperfect appear also in Dürer's 1500 *Self-Portrait* and the *Martyrdom of the Ten Thousand*.

Chapter Ten

1. See Liebmann, "Die Künstlersignatur," pp. 129–134 (full ref. chap. 5, n. 74); Werner Schultheiss, "Albrecht Dürers Beziehungen zum Recht," in *Albrecht Dürers Umwelt. Festschrift zum 500. Geburtstag Albrecht Dürers*, Nürnberger Forschungen, 15 (Nuremberg, 1971), pp. 220–254; Thomas Würtenberger, *Albrecht Dürer. Künstler, Recht, Gerechtigkeit* (Frankfurt, 1971), pp. 43–65.

2. For a recent discussion of the transformation of law, diplomacy, and feudalism through writing in the twelfth century, see Brian Stock, *The Implications of Literacy: Written Language and Models of Interpretation in the Eleventh and Twelfth Centuries* (Princeton, 1983), pp. 42–59 and passim.

3. See Max Geisberg, *Die Anfänge des deutschen Kuperferstiches und der Meister E. S.*, Meister der Graphik, 2 (Leipzig, 1910), pp. 15ff.; Max Lehrs, *Geschichte und kritischer Katalog des deutschen, niederländischen und französischen Kupferstichs im xv. Jahrhundert*, 9 vols. (Vienna, 1908–1934), 1:19–22; Pauli, "Dürers Monogramm," pp. 34–40 (full ref. chap. 2, n. 17). On Schongauer's crosier, see Lehrs, cat. no. 105, and most recently, Berlin, Kupferstichkabinett, *Martin Schongauer, Druckgraphik im Berliner Kupferstichkabinett*, ed. Hartmut Krohm and Jan Nicolaisen, exh. cat. (Berlin, 1991), cat. no. 30. The prints of Cranach the Elder represent a special case of artistic self-denomination. From about 1506 on, the artist's initials appear on tablets within the represented scene together with the coats of arms of Cranach's patrons, the dukes of Saxony, which often appear as

shields dangling from the boughs of trees. These armorials derive from the *Hofmarke* and denote possession. Although Cranach's prints were, like Dürer's, sold on the open market, they still proclaim themselves the product both of a specific workshop and of a specific patron.

4. Indeed, Dürer's practice of monogramming his sketches is without clear precedent in Western art and, except for his immediate epigones in Germany, without significant followers until the more recent past. Dürer's first extant monogrammed drawing seems to be the *Enthroned Virgin and Child Flanked by Musical Angels* (W. 4) dated 1485, now in Berlin.

5. *Albrecht Dürer von Nörmergk* appears on the back of the woodblock of Dürer's earliest undisputed print, the frontispiece of an edition of the letters of St. Jerome, published by Nicolaus Keszler (*Liber epistilare Sancti Hieronymi* [Basel, 1492]; Kn. 108). Some fifteenth-century book illustrations are marked with initials probably identifying the cutter (see W. L. Schreiber, *Handbuch der Holz- und Metallschnitte des xv. Jahrhunderts*, 8 vols. [Leipzig, 1926–1930], 7:40–43; Arthur M. Hind, *An Introduction to the History of Woodcut*, 2 vols. [New York, 1935], 2:467–469).

6. Panofsky, *Dürer*, 1:19.

7. Stephan Fridolin, *Schatzbehalter oder Schrein der waren reichtümer des heils vnnd ewyger seligkeit* (Nuremberg, 1491), and Hartmann Schedel, *Liber Chronicarum* (Nuremberg, 1493). Both were financed by two local merchants, Sebald Schreyer and Sebastian Kammermeister.

8. Werner Schultheiss, "Ein Vertrag Albrecht Dürers über den Vertrieb seiner graphischen Kunstwerke," *Scripta Mercaturae* 1 (1969): 79. Some scholars believe that Dürer also cut the blocks for his early woodcuts, only later employing a professional block cutter or *Formschneider* (e.g., Hieronymus Andreae, documented after 1515). This has been disputed by Hutchison, who intriguingly suggests a limewood sculptor, perhaps the great Veit Stoss himself, as the cutter of the *Apocalypse* (*Dürer*, pp. 59–60 [full ref. chap. 1, n. 59]).

9. See Michael Baxandall's remarks on the "integrating monopoly" in the production of retable altarpieces, in *Limewood Sculptors*, pp. 116–122 (full ref. chap. 8, n. 56).

10. For introductions to this central object of late medieval art in Germany, see Walter Paatz, *Süddeutsche Schnitzaltäre der Spätgotik* (Heidelberg, 1963); Herbert Schindler, *Der Schnitzaltar. Meister-*

werke und Meister in Süddeutschland, Österreich und Südtirol (Regensburg, 1978); and Baxandall, *Lime-wood Sculptors,* esp. pp. 62–69.

11. "Aber ich viel von seinen knechten mich leiden muste" (Dürer, *Schriftlicher Nachlaß,* 1:31).

12. For example, Hans Süss von Kulmbach's 1510 altarpiece of St. Anne in the Lorenzkirche, as well as the three altars he delivered to Cracow; Hans Baldung Grien's retable for the high altar in Freiburg, completed in 1516; and of course Grünewald's *Isenheim Altarpiece,* 1513–1515.

13. For an excellent discussion of the uniqueness of Dürer's "altarpieces," from the *Dresden Triptych* of 1496 to the *Landauer Altarpiece,* see Rasmussen's "Die Nürnberger Altarbaukunst der Dürerzeit," pp. 7–41 (full ref. chap. 5, n. 104); for the general situation of the retable at 1500, see Ute-Nortrud Kaiser, "Der skulptierte Altar der Frührenaissance in Deutschland," 2 vols. (Ph.D. diss., Frankfurt am Main, 1978), and Decker, *Das Ende,* pp. 15–32 and 224–229 (full ref. chap. 5, n. 110).

14. The original frame is now in the Germanisches Nationalmuseum, Nuremberg; Dürer's sketch for the frame is preserved in the Musée Condé in Chantilly (W. 445).

15. "Es wäre auch nie erhört worden, auf einen altar solch ding zu machen. Wer wolt es sehen?" (Dürer, *Schriftlicher Nachlaß,* 1:68).

16. Scholars estimate that the original editions of early German woodcuts and broadsheets were about a thousand copies (Bruno Weber, *Wunderzeichen und Winckeldrucker, 1543–1586. Einblattdrucke aus der Sammlung Wikiana in der Zentralbibliothek Zürich* [Zurich, 1972], p. 27; Gisela Ecker, *Einblattdrucke von den Anfängen bis 1555. Untersuchungen zu einer Publikationsform literarischer Texte,* 2 vols. [Göppingen, 1981], p. 20). Editions of engravings were much smaller. On the early print collecting in Nuremberg, see Wilhelm Schwemmer, "Aus der Geschichte der Kunstsammlungen der Stadt Nürnberg," *Mitteilungen des Vereins für Geschichte der Stadt Nürnberg* 40 (1949): 97–133; Jeffrey Chipps Smith, "The Transformation of Patrician Tastes in Renaissance Nuremberg," in *New Perspectives,* ed. Smith, pp. 83–100 (full ref. chap. 1, n. 37); Stephen Goddard, "The Use and Heritage of the Small Engraving in Renaissance Germany," in Lawrence, Kansas, Spencer Museum of Art, *The World in Miniature: Engravings by the German Little Masters, 1500–1550,* ed. Stephen Goddard, exh. cat. (Lawrence, 1988), pp. 13–29; and Keith

Moxey, *Peasants, Warriors, and Wives* (Chicago, 1989), pp. 22–23.

17. "Den gmaine gmäll will ich ain jahr ain hauffen machen, das niemandt glaubte, das möglich were, das ain man thun möchte. An solchen mag man etwas gewinnen. Aber das fleisig kleiblen gehet nit von statten. Darumb will ich meines stechens auß warten. Vnd hette ichs bißhero gethan, so wollte ich vf den heitigen tag 1000 fl. reicher sein" (Dürer, *Schriftlicher Nachlaß,* 1:72). See Decker's reading of this passage in "Dürer—Konstruktion eines Vorbildes," in Beck and Decker, *Dürers Verwandlung,* pp. 423–424 (full ref. chap. 2, n. 54).

18. "500 jahr sauber vnd frisch" (Dürer, 1:72).

19. Stadtarchiv Nürnberg, Stadtgericht, Schuldverbriefungsbuch K, fol. 132ᵛ; first discovered by Karl-Heinz Goldmann, "Dürer-Funde im Stadtarchiv Nürnberg," *Amtsblatt der Stadt Nürnberg,* August 22, 1962; reprinted and discussed in Schultheiss, "Ein Vertrag," pp. 78–79.

20. "In den stetten und orten, do ine nutz und gut sein beduncken wurd, veyl haben und auf das hochst und teurst, so er mag verfeylssen, verkauffen und von stat und gegend zu der anderen damit ziehen, dieselben veyllhaben und sich die zu verkauffen nichtztzit doran weder spil noch ander leichtfertig hendel verhindern lassen woll und das gelt, so er daraus loesen wurd, dem genanten Dürer fuderlich zusenden" (quoted in Schultheiss, "Ein Vertrag," p. 79).

21. Stadtarchiv Nürnberg, Gerichtsbuch Conservatorium, vol. 3, fol. 53b; represented in Dürer, *Schriftlicher Nachlaß,* 1:244.

22. On the general structure of the book trade, see Lucien Febvre and Henri-Jean Martin, *The Coming of the Book: The Impact of Printing, 1450–1800,* trans. David Gerard (London, 1976), pp. 216–247.

23. "Des gleichen mit knechten, dy nit rechnung thetten. Awch mir einer zw Rom gestorben mit verlustigung meins gut. Des halben, do jch jm 13. jor jn meiner e pin gewest, hab jch grosse schult beczalt, dy jch zw Fenedig gewunen hab" (Dürer, *Schriftlicher Nachlaß,* 1:36).

24. Waetzoldt, *Dürer,* p. 20.

25. Schultheiss, "Ein Vertrag," p. 80. Hutchison rightly points out that "Dürer's wife and mother, like other Nuremberg women of their social class, would have been accustomed to handling his sales even when he was at home, since in Nuremberg it was the custom to regard retail sales as women's work" (*Dürer,* 83; see also

Merry E. Wiesner, *Working Women in Renaissance Germany* [New Brunswick, N.J., 1986], pp. 170–171). Carel van Mander, in his life of the painter Jan of Hollanda, writes that Jan's wife sold paintings in the markets of Brabant and Flanders while Jan stayed at home.

26. See Dürer, *Schriftlicher Nachlaß*, 1:238; Lüdecke and Heiland, *Dürer und die Nachwelt*, pp. 31–34 (full ref. chap. 1, n. 21); and Decker's interesting remarks on "Dürer und das Geld," in "Dürer—Konstruktion eines Vorbildes," pp. 425–431.

27. For a discussion of the "destruction of the sense of a definable relationship between man and ultimate realities" through the self-determination of individuals within a commercial economy, see Bouwsma, "Renaissance and Reformation," pp. 129–135 (full ref. chap. 4, n. 44); also Jacques Le Goff, *Marchands et banquiers du Moyen Age* (Paris, 1956).

28. Summed up in the title of Ludwig Grote's 1964 essay "Vom Handwerker zum Künstler. Das gesellschaftliche Ansehen Albrecht Dürers" (full ref. chap. 2, n. 22).

29. Gerald Strauss, *Nuremberg in the Sixteenth Century* (Ann Arbor, Mich., 1976), pp. 58–64.

30. Schultheiss, "Albrecht Dürers," pp. 229–233; for the relevant documents, see Theodor Hampe, *Nürnberger Ratsverlässe über Kunst und Künstler in Zeitalter der Spätgotik und Renaissance, 1474–1618*, 2 vols. (Vienna, 1904), especially vol. 2, nos. 37, 56.

31. For a brief introduction, in English, to the economic situation of the imperial city of Nuremberg, see Jeffrey Chipps Smith, *Nuremberg: A Renaissance City, 1500–1618* (Austin, 1983), pp. 17–22; the classic study of the German imperial city at the eve of the Reformation remains Bernd Moeller, *Imperial Cities and the Reformation: Three Essays*, trans. H. C. Erik Midelfort and Mark U. Edwards, Jr. (Philadelphia, 1972), pp. 14–115; see also Strauss, *Nuremberg in the Sixteenth Century.*

32. It was in 1596 that the council finally demanded from painters working in Nuremberg the traditional requirement for admission to a guild: the *Meisterwerk* (Schultheiss, "Albrecht Dürers," p. 230).

33. Vasari, *Le vite*, ed. Milanesi, 5:398–409 (full ref. chap. 5, n. 88). Marcantonio executed his copies almost immediately after Dürer released the first seventeen of twenty woodcuts of the

Marienleben; his engraved copies of Dürer's *Small Passion* were produced about 1511, thus postdating Dürer's stay in Venice. For recent accounts of this episode, see Thomas Würtenberger, *Albrecht Dürer*, pp. 60–62, and idem, "Albrecht Dürer und das Strafrecht der Stadt Nürnberg," *Zeitschrift für die gesamte Strafrechtswissenschaft* 61 (1942): 139–165. Other early Italian copyists of Dürer include Giulio Campagnola, Giovanni Antonio da Brescia, Agostino Veneziano, Nicoletta Rosex da Modena, and Giovanni Battista Palumba.

34. "Awch sind mir jr vill feind vnd machen mein ding in kirchen ab vnd wo sy es mügen bekumen" (Dürer, *Schriftlicher Nachlaß*, 1:43–44).

35. "Dem frembden, so under dem rathaus kunstbrief fayl hat und unnder denselben etlich, so Albrecht Dürers hanndzaichen haben, so im betrüglich nachgemacht sind, soll man in pflicht nemen, dieselben zaichen alle abzethun und der kaine hie fail ze haben, oder, wo er sich des widere, soll man im dieselben brief alle als ain falsch auffheben und zu ains rats hannden nemen" (*Ratsprotokoll* of January 2, 1512; Dürer, *Schriftlicher Nachlaß*, 1:241).

36. The original drawing (W. 9), now in the Stadtmuseum in Gdánsk, bears the inscription (in Dürer's hand): "This Wolfgang Pewrer made in the year 1484" (*Dz hat Wolfgang Pewrer gemacht jm 1484 jor*). Dürer's engravings after it are (mis)-named the *Great Courier* (c. 1494; Kn. 1) and the *Small Courier* (c. 1496; Kn. 10). On the relation between Peurer's drawing and Dürer's prints, see V. M. Strock, "Albrecht Dürer—Wolfgang Peurer," *Argos. Festschrift für Kurt Badt* (Cologne, 1970), pp. 249–260.

37. Waetzoldt, *Dürer*, 20 (full ref. chap. 1, n. 9); Schultheiss, "Albrecht Dürer," p. 242; Nuremberg, *Vorbild Dürer*, passim (full ref. chap. 9, n. 8). The title page of Graff's pirated *Apocalypse* reads "printed at Strasbourg by Hieronymus Graff, the painter" (see Charles G. A. Schmidt, *Répertoire bibliographique strasbourgeois jusqu'à vers 1530* [Strasbourg, 1894], 4:15).

38. See, for example, the case of the sculptor Veit Stoss, who was convicted of forging a document in 1503; Michael J. Liebmann, *Die deutsche Plastik, 1350–1550*, trans. Hans Störel (Leipzig, 1982), pp. 350–351; R. Stammler, "Veit Stoß und das Recht," *Deutsches Rechtsleben in alter und neuer Zeit* 1 (1928): 40ff.

39. For a brief study of *der Falsch* in medieval law, see Karl Elben, *Zur Lehre von der Warenfäl-*

schung—hauptsächlich in geschichtlicher Hinsicht (Freiburg and Tübingen, 1881), pp. 2–30 and passim.

40. Thomas Würtenberger, "Recht und Gerechtigkeit in der Kunst Albrecht Dürers," in *Kunst und Recht. Festgabe für Hans Fehr*, Arbeiten zur Rechtssoziologie und Rechtsgeschichte, 1 (Karlsruhe, 1948), pp. 221ff.

41. Elben, *Zur Lehre*, p. 21.

42. On the history of copyright, particularly in the German context, I found useful Ludwig Gieseke, *Die geschichtliche Entwicklung des deutschen Urheberrechts*, Göttinger Rechtswissenschaftliche Studien, 22 (Göttingen, 1957); Walter Bappart, *Wege zum Urheberrecht. Die geschichtliche Entwicklung des Urhebergedankes* (Frankfurt, 1962), p. 91; Thomas Würtenberger, *Das Kunstfälschertum*, 2d ed. (Leipzig, 1970), pp. 187ff. and 232ff.; and Martin Vogel, "Deutsche Urheber- und Verlagsrechtsgeschichte zwischen 1450 und 1850," *Archiv für Geschichte des Buchwesens* 9 (1978), cols. 1–190. An interesting account of literary property from a philosophical perspective is Bernard Edelman, *La propriété littéraire et artistique* (Paris, 1989); I am grateful to Lindsay Waters for this reference.

43. Gieseke, *Geschichtliche Entwicklung*, p. 19. On ideas of authorship during the Middle Ages, see A. J. Minnis, *Medieval Theory of Authorship*, 2d ed. (Philadelphia, 1988).

44. Bappart, *Wege zum Urheberrecht*, p. 91.

45. Bappart, p. 21.

46. Thus the thirteenth-century German poet Eike von Repgow writes in his *Sachsenspiegel* of about 1230: "Great worry vexes me; I fear that someone will multiply this book and start to pervert it and blame it on me" ("Grôz angest gêt mich an: / ich vorchte, daz manig man dicz bûch wolle mêren / und beginne recht zu verkêeren unde zcîhe des an mich"; qutoed in Bappert, p. 87).

47. In 1481 the duke of Milan granted the publisher Andrea de Bosiis a privilege for Jean Simoneta's *Sforziade*; in 1486 the Venetian Senate granted one to Sabellicus for his history of Venice; and again in 1492, the Senate issued Petrus Franciscus of Ravenna a privilege for his *Foenix*. Gieseke, *Geschichtliche Entwicklung*, pp. 23–30; Febvre and Martin, *Coming of the Book*, p. 241.

48. Gieseke, pp. 27–28.

49. Friedrich Lehne, "Zur Rechtsgeschichte der kaiserlichen Druckprivilegien. Ihre Bedeutung für die Geschichte des Urheberrechts,"

Mitteilungen des Österreichischen Institut für Geschichtsforschung 53 (1939): 343ff.

50. Febvre and Martin, *Coming of the Book*, p. 241. On censorship in sixteenth-century Nuremberg, see August Jegel, "Altnürnberger Zensur vor allem des 16. Jahrhunderts," in *Festschrift Eugen Stollreiter*, ed. Fritz Redenbacher (Erlangen, 1950), pp. 54–64; Arndt Müller, "Zensurpolitik der Reichstadt Nürnberg," *Mitteilungen des Vereins für Geschichte der Stadt Nürnberg* 49 (1959): 66–619; Moxey, *Peasants, Warriors, and Wives*, pp. 24–26.

51. Dürer, *Schriftlicher Nachlaß*, 1:241. See also Martin Luther's "Mandat wider die Drucker," where the Reformer refers to pirated editions as *Diebstahl* ("theft") and *Raub* ("robbery"); see Würtenberger, *Das Kunstfälschertum*, p. 179.

52. Gieseke, *Geschichtliche Entwicklung*, pp. 33–35.

53. In a privilege granted to the *Proportionslehre* and upheld posthumously in 1532, Dürer was protected both as publisher and as author. That these early copyrights protected only Dürer's *hanndzaichen* might help to explain the actual form of the monogram. In a work like Dürer's 1504 *Fall* (fig. 98) and, more obviously, in various prints by Baldung, such as the 1519 woodcut *Fall* (fig. 145) and the *Wild Horses* woodcut series (figs. 204, 207, 208), the monogram appears inseparable from the print's structure and meaning. Inscribed on a tablet that is part of the represented world and plays an important role in the story depicted, the monogram cannot be elided by a copyist without altering the original image's fundamental message. The embedding and emplotment of the monogram that we observe in these works might be, in part, a tactic for cementing the bond between artist and artwork.

54. "Heus, tu insidiator ac alieni laboris et ingenii surreptor, ne manus temerarias his nostris operibus inicias, cave! Scias enim a gloriosissimo Romanorum imperatore Maximiliano nobis concessum esse, ne quis suppositiis formis has imagines imprimere, seu impressas per imperii limites vendere audeat" (Dürer, *Schriftlicher Nachlaß*, 1:76). Other privileges Dürer received from the emperor were in 1525, for *Unterweisung der Messung*, and in 1528, for the *Proportionslehre*.

55. Quintilian, *Institutio oratio*, 2.14.5; 10.2.12; as quoted and discussed in Baxandall, *Giotto*, p. 15 (full ref. chap. 2, n. 44). On antique notions of genius, see Penelope Murray, "Poetic Genius

and Its Classical Origins," in *Genius: The History of an Idea*, ed. Penelope Murray (New York, 1989), pp. 9–29; the classic study is still Edgar Zilsel, *Die Entstehung des Geniebegriffes. Ein Beitrag zur Ideengeschichte der Antike und des Frühkapitalismus* (Tübingen, 1926).

56. See most recently Martin Kemp, "The 'Super-Artist' as Genius: The Sixteenth-Century View," in *Genius*, ed. Murray, pp. 44–42; also Panofsky, *Dürers Kunsttheorie*, pp. 166ff. (full ref. chap. 4, n. 31); Hermann Beenken, "Dürers Kunsturteil und die Struktur des Renaissance-Individualismus," in *Festschrift Heinrich Wölfflin* (Munich, 1924), pp. 183–193; and Jan Białostocki, "Vernunft und Ingenium in Dürers kunsttheoretischem Denken," *Zeitschrift des deutschen Vereins für Kunstwissenschaft* 25 (1971): 107–114. For the words *Gewalt* and *walten* in the sixteenth century, see Jacob Grimm and Wilhelm Grimm, *Deutsches Wörterbuch*, 16 vols. in 42 (Leipzig, 1854–1972), vol. 4, cols. 4910–5094; and Friedrich Kluge and Alfred Götze, *Etymologisches Wörterbuch der deutschen Sprache*, 15th ed. (Berlin, 1951), pp. 264 and 853. In the *Bauernkrieg* of 1525, *gewalt* means something like "freedom" and is often what the rebelling peasants demand (Alfred Götze and L. E. Schmitt, eds., *Aus dem sozialen und politischen Kampf. Die zwölf Artikel der Bauern 1525. Hans Hergot, Von der neuen Wandlung 1527*, Neudrucke deutscher Literaturwerke des 16. und 17. Jahrhunderts, Flugschriften aus der Reformationszeit, 20 [Halle, 1953]).

57. "Aber darbey ist zu melden, das ein verstendiger geübter künstner in grober bewrischer gestalt sein grossen gwalt vnd kunst mer erzeygen kan, etwan in geringen dingen, dann mancher in seinem grossen werck. Dise seltzame red werden allein die gewaltzamen künstner mögen vernemen, das ich war red. Darauß kumbt, das manicher etwas mit der federn in eim tag auff ein halben bogen bapirs reyst oder mit seim eysellein etwas in ein klein höltzlein versticht, daz würt künstlicher vnd besser dann eins andern grosses werck, daran der selb ein gantz jar mit höchstem fleyß macht. Vnd dise gab ist wunderlich. Dann Got gybt offt einen zu lernen vnd verstand, etwas gutz zu machen, des gleichen jm zu seinen zeytten keiner gleich erfunden wirdet vnd etwan lang keiner for jm gewest vnd nach jm nit bald einer kumbt. Des sehen wir exempel bey der Römer zeyten, da sie in jrem bracht waren, was bey jnen gemacht ist worden, der drümer wir noch sehen, der gleychen von kunst in vnsern

wercken yetz wenig erfunden wirdet" (Dürer, *Schriftlicher Nachlaß*, 3:293).

58. For records of these cases (*Ratsprotokoll*, May 2, 1532, and October 1, 1532), and for the imperial privilege Agnes was granted by Charles V, see Dürer, 1:237, 243–244, and *Archiv für Geschichte des Buchhandels* 2 (1962): 237ff. Joseph Kurthen demonstrated that Beham's system of proportions (*Kunst und Lehrbüchlein. Malen und Reissen zulernen nach rechter Proportion Mass und austeylung des Circkels. Angehenden Malern und Kunstbaren Werkleuten dienlich* [1546]) was different from Dürer's and that what was protected was the very *idea* of a book on proportions ("Zum Problem der dürerschen Pferdekonstruktion. Ein Beitrag zur Dürer und Behamforschung," *Repertorium für Kunstwissenschaft* 44 [1924]: 77–99).

59. Würtenberger sees a direct connection between Dürer's suit against Raimondi in Venice and the Nuremberg Rat's 1512 decree on unauthorized copies of Dürer's woodcuts, citing the traditional influence of Italian law on the city (*Albrecht Dürer*, p. 80n300); see also Hans Liermann, "Nürnberg als Mittelpunkt deutschen Rechtslebens," *Jahrbuch für fränkische Landesforschung* 2 (1936): pp. 7ff.; and Strauss, *Nuremberg*, pp. 218–230.

60. The literature on the reception of Roman law in Germany is vast. For a recent discussion in English, with an extensive bibliography, see Gerald Strauss, *Law, Resistance, and the State: The Opposition to Roman Law in Reformation Germany* (Princeton, 1986), especially pp. 56–95.

61. The text of the proceedings, along with an informative commentary, is given in Altona, "Aus den Akten des Reichskammergerichts," *Zeitschrift für die gesamte Strafrechtwissenschaft* 12 (1892): 898–912; reference to the case appears also in Würtenberger, *Albrecht Dürer*, p. 77n235. For an introduction to the founding and jurisdiction of the Reichskammergericht, see Holborn, *History of Modern Germany*, pp. 43–44 (full ref. chap. 4, n. 6).

62. "Nach löblicher art aus künstlicher warnemung ihres alters, krauts, bletter, samen, Steudlein und wurtzeln nun lange zeit vilch jare her bis in das fünfft mit großer mühe, kosten und arbeit abconterfeit, als ein neu werk vormals im truck nit gesehen, dazu wieder auch vil contrafeyisch figuren haben nachreißen und nachschneiden lassen, von Stich zu Stich verjüngen lassen" (Altona, "Aus den Akten," p. 900).

63. Miriam Usher Chrisman, *Lay Culture,*

Learned Culture: Books and Social Change in Strasbourg, 1480–1599 (New Haven, 1982), pp. 175–178; on Brunfels, see P. W. E. Roth, "Otto Brunfels, nach seinem Leben und literarischen Werken," *Zeitschrift für die Geschichte des Oberrheins*, n.s., 9 (1864): 284–381. Hans Weiditz's place within the history of book illustration is described by William M. Ivins, Jr., *Prints and Visual Communication* (London, 1953), pp. 2–20 and 33–46; see also James Ackerman, "The Involvement of Artists in Renaissance Science," in *Science and the Arts in the Renaissance*, ed. John W. Shirley and F. David Hoeniger, Folger Institute Symposia (Washington, D.C., 1985), pp. 113ff.; and F. David Hoeniger, "How Plants and Animals Were Studied in the Mid-Sixteenth Century," in Shirley and Hoeniger, *Science and the Arts*, pp. 131–134.

64. Altona points out how Egenolf's defense, in both its structure and its citations (Ulpian, Papinian, Justinian, and the *Corpus juris*), is saturated with Roman law ("Aus den Akten," p. 899).

65. "Und wan gleich die Kreuther unter ei nander sich ein wenig vergleichen, so wolle doch Ew. Gnaden erwegen, daß man Rosmarin Affodillis oder ander Krauth nie kann in einer anderen formb oder gestalt mallen oder conterfeyen, dann es an im selbst ist . . . Es wäre ja ein *absurdum*, daß Kay. Privileg also sollte verstanden werden, daß dieweyl Hannes Schott hatte das Kreutherbuch getruckt, daß derhalben man müßte ein Krauth, das kleine schmahle blettlein hatt, mit langen breiten Blettern und contra drucken wider Arth gestalt formb und natur der kreuther; etwas unförmblichs nit gesehen, denn wiewol Albrecht Dürer Jacob Meller zu Wittenberg und andere Priviligien haben, daß niemandt ihre gemälte nachmallen darff, so folgt doch derhalben nit, das dieweyllen dieselben einen *Adam et Evam Acteonem Achillem pinxissent*, daß derohalb khein anderer maller auch dergleichen fabbeln nit malen dürfft" (Altona, "Aus den Akten," p. 901).

66. Although named in the court proceedings, Weiditz is mentioned in the book itself only in some verses of praise in the first edition of the first volume of the *Herbarium*, suggesting the preeminence of publishers and authors over illustrators in the sixteenth-century book industry. In the next great German herbal, Fuchs's *De stirpium historia*, published in Basel in 1542, the illustrators are more prominently named and their contribution is defined. At the end of the volume appear the names, occupations, and portraits of the artist who drew the plants (Albert Mayer), the artist who transferred Mayer's drawing to the blocks (Heinrich Fullmaurer), and the block cutter (Rudolph Speckle). Ivins notes that this is "the first time that a set of illustrations, although based on drawings specifically made for the purpose of illustrating a text, were, as actually printed, second-hand and not first-hand reports" (*Prints and Visual Communication*, p. 44). It suggests, among other things, that the relation between artist and image was becoming increasingly diversified in this period.

67. Justi, *Konstruierte Figuren*, pp. 29–30 (full ref. chap. 7, n. 36).

68. See *visieren* in Alfred Götze, *Frühneuhochdeutsches Glossar*, 7th ed. rev. and exp., Kleine Texte für Vorlesungen und Übungen, 101 (Berlin, 1967).

69. Justi, *Konstruierte Figuren*, pp. 30–31.

70. Anton Springer, "Inventare der Imhoff'-schen Kunstkammer," p. 352 (full ref. chap. 2, n. 47).

71. Before Dürer, copyists almost never include the monogram of the original artist, signing their copy instead with a monogram of their own.

72. Lisa Oehler, "Das 'geschleuderte' Dürer-Monogramm," *Marburger Jahrbuch für Kunstwissenschaft* 17 (1959): 57–192; and "Das Dürermonogramm auf Werken der Dürerschule," *Städel-Jahrbuch*, n.s., 4 (1973): 37–80. I am not in agreement with many of Oehler's specific attributions; see Koerner, "Albrecht Dürer's *Pleasures of the World*," pp. 180–216 (full ref. preface, n. 13).

73. Lisa Oehler, "Das Dürermonogramm auf Werken der Dürerzeit," *Städel-Jahrbuch*, n.s., 3 (1971): 78–108. Similar monograms appear in the works of Hans Schäufelein, Jörg Breu the Elder, Wolf Huber, Hans Leu the Younger, Virgil Solis, and Melchior Lorich.

74. A full analysis of the historical course of Dürer's notion of himself as example should extend beyond his century to examine the eighteenth-century reception of Dürer within the category of "characteristic," as formulated by the earl of Shaftesbury, Goethe (*Von deutscher Baukunst*, 1772), and Johann Christian Lavater (Białostocki, *Dürer and His Critics*, especially pp. 73–143 [full ref. chap. 1, n. 1]).

75. As transcribed and interpolated by Strauss, *Complete Drawings*, 2:1503/16 (full ref. chap. 2, n. 35); the second drawing referred to in the inscription is probably the *Head of Suffering Man*, also in charcoal on identically sized paper (310 × 221 cm), and also now in the British Museum (W. 271).

76. *Odnojazycie,* translated variously as monoglossia, the monologic, or monologism. See Mikhail Bakhtin's essays "Discourse and the Novel" and "From the Prehistory of Novelistic Discourse," in *The Dialogic Imagination: Four Essays,* ed. Michael Holquist and trans. Caryl Emerson and Michael Holquist (Austin, 1981), especially pp. 51–68 and 260–274; see also his late essay, "Towards a Methodology for the Human Sciences," in *Speech Genres and Other Late Essays,* pp. 159–172 (full ref. preface, n. 6). For a good, short introduction to monologism and dialogism, see Renate Lachmann, "Vorwort" to Mikhail Bakhtin, *Rabelais und seine Welt—Volkskultur als Gegenkultur,* ed. Lachmann and trans. Gabriele Leupold (Frankfurt, 1987), pp. 33–40.

77. I am indebted to Marjorie Cohn, curator of prints at the Harvard Art Museums, for this observation. William M. Ivins, Jr., observes that in early impressions of the etched *Sudarium,* Dürer heightened color and contrast by wiping the inked plate unevenly (*How Prints Look,* rev. ed., ed. Marjorie B. Cohn [Boston, 1987], p. 81).

Chapter Eleven

1. An early version of this chapter was presented at the 1989 annual meeting of the Medieval Academy of America (Madison, Wisconsin), in the session "Patronage, Production, and Public," organized by Sandra Hindman and O. K. Werckmeister.

2. Staatsbibliothek, Munich, L. impr. membr. 64. The best facsimile edition of the *Prayer Book* remains the rather rare volume, Karl Giehlow, ed., *Kaiser Maximilians I. Gebetbuch mit Zeichnungen von Albrecht Dürer und anderen Künstler* (Vienna and Munich, 1907); Walter L. Strauss, *The Book of Hours of the Emperor Maximilian the First* (New York, 1974), is less satisfactory but does contain useful annotations and bibliography; see also the more recent *Das Gebetbuch Kaiser Maximilians: Der Münchner Teil mit den Randzeichnungen von Albrecht Dürer und Lucas Cranach der Altere,* with commentary by Hinrich Sieveking (Munich, 1987). Illuminations by Altdorfer and Cranach are well reproduced on imitation vellum in Jacqueline Guillard and Maurice Guillard, *Altdorfer and Fantastic Realism in German Art,* exh. cat. Centre Culturel du Marais (Paris, 1984), pp. 277–344. For a history of the *Prayer Book*'s discovery and early reception, see Karl Giehlow, "Beiträge zur Entstehungsgeschichte des Gebetbuchs Kaisers Maxi-

milians I.," *Jahrbuch der Kunsthistorischen Sammlungen des allerhöchsten Kaiserhauses* 20 (1899): 30–112.

3. Ernst H. Kantorowicz, "The Sovereignty of the Artist: A Note on Legal Maxims and Renaissance Theories of Art," in *Selected Studies,* ed. Michael Cherniavsky and Ralph E. Giesey (Locust Valley, N.Y., 1965), pp. 352–365.

4. On Peutinger, see Theodor Herberger, *Conrad Peutinger in seinem Verhältnis zum Kaiser Maximilian I.,* Jahresbericht des historischen Vereins für den Reg. Bez. Schwaben und Neuburg 1849 und 1850 (Augsburg, 1851); Erich König, *Peutingerstudien* (Freiburg, 1919); J. Bellot, "Konrad Peutinger und die literarisch-künstlerische Unternehmung Kaiser Maximilians," *Philobiblon* 11 (1967): 171–190. For an excellent summary, in English, of the Maximilian's projects, see Larry Silver, "Prints for a Prince: Maximilian, Nuremberg, and the Woodcut," in Smith, *New Perspectives,* pp. 7–21 (full ref. chap. 1, n. 37).

5. The Fraktur script, designed by Leonhard Wagner, was cut and printed by Johannes Schoensperger on New Year's Day, 1514.

6. Geisberg, *German Single-leaf Woodcut,* 2:437, old Geisberg no. 466 (full ref. chap. 5, n. 52); see Walter L. Strauss, "History of the Prayer Book," in his *Book of Hours,* pp. 320–322. See also Tilman Falk, *Hans Burgkmair. Studien zu Leben und Werk des Augsburger Malers,* Bruckmanns Beiträge zur Kunstwissenschaft (Munich, 1968), pp. 70 and 107n440.

7. For a survey of this material, see Friedrich Winkler, *Die flämische Buchmalerei des XV. und XVI. Jahrhunderts* (Leipzig, 1925); Otto Pächt, *The Master of Mary of Burgundy* (London, 1947); Vienna, Österreichische Nationalbibliothek, *Flämische Buchmalerei. Handschriftenschätze aus dem Burgunderreich,* ed. Dagmar Thoss, exh. cat. (Graz, 1987).

8. Dürer's technique and its antecedents are discussed in Erwin Panofsky, "Über das Zeichnung mit farbiger Feder. Bemerkungen zu einigen Blättern des Virgilius Solis und zu den Randzeichnungen im Gebetbuch Maximilians I," *Monatshefte für Kunstwissenschaft* 8 (1915): 166–169.

9. The argument that the *Prayer Book* sketches are models for woodcuts is most fully articulated by Giehlow, "Beiträge zur Entstehungsgeschichte," pp. 68–73; see also Panofsky, *Dürer,* 1:184–187; Strauss, "History of the Prayer Book," pp. 322–323; and Hutchison, *Dürer,* 115 (full ref. chap. 1, n. 59).

10. For example, the scene of a peasant dance, repeated a number of times in the Pigouchet *Hours*, resembles Dürer's sketch on folio 56ᵛ. On the Pigouchet *Hours* generally, see Hugh William Davies, comp., *Catalogue of a Collection of Early French Books in the Library of Charles Fairfax Murray*, 2 vols. (London, 1910), 1:265ff.; on Dürer's possible use of it in his *Landauer Altarpiece*, see Panofsky, *Dürer*, 1:126–127. I am indebted to Anne Anninger and Alex Nagel for information on Philippe Pigouchet.

11. For an example of this identification of printing with the "nation" of Germany, see Johann Fischert's polemic against Vasari in the preface to his translation of *Accuratae effigies pontificum maximorum* of 1576 (relevant passages given in Lüdecke and Heiland, *Dürer und die Nachwelt*, pp. 281–282 [full ref. chap. 1, n. 21]; also Friedrich Thöne, "Johannes Fischart als Verteidiger deutscher Kunst," *Zeitschrift der Deutschen Verein für Kunstwissenschaft* 9 [1934]: 127).

12. A history of conceptions of the book as object is given in Curtius, *European Literature*, pp. 303–338 (full ref. chap. 5, n. 84); for the image of the book in art, see Jan Białostocki, *Bücher der Weisheit und Bücher der Vergangenheit: Zur Symbolik des Buches in der Kunst*, Abhandlungen der Heidelberger Akademie der Wissenschaft, Philosophisch-historische Klasse, 5 (Heidelberg, 1984).

13. Jan-Dirk Müller, *Gedechtnus. Literatur und Hofgesellschaft um Maximilian I.*, Forschungen zur Geschichte der älteren deutschen Literatur, 2 (Munich, 1982).

14. For example, Anastasius Grün, *Der letzte Ritter*, 3d ed. (Leipzig, 1844).

15. See Norbert Elias, *The Civilizing Process*, vol. 2, *Power and Civility*, trans. Edmund Jephcott (New York, 1982), pp. 91–225; and idem, *Court Society*, trans. Edmund Jephcott (New York, 1983).

16. Müller, *Gedechtnus*, pp. 11–79.

17. Silver, "Prints for a Prince," p. 15.

18. Karl Giehlow, "Urkundenexegese zur Ehrenpforte Maximilians I," in *Beiträge zur Kunstgeschichte Franz Wickhoff gewidmet* (Vienna, 1907), pp. 91–110; and idem, "Die Hieroglyphenkunde des Humanismus in der Allegorie der Renaissance besonders der Ehrenpforte Kaiser Maximilian I," *Jahrbuch der kunsthistorischen Sammlungen des Allerhöchsten Kaiserhauses* 32 (1915), 1ff.; Panofsky, *Dürer*, 1:172–182; Peter Strieder, "Zur Entstehungsgeschichte von Dürers Ehrenpforte für Kaiser Maximilian," *Anzeiger der Germanischen*

Nationalmuseum, 1954–1959, pp. 128–142; Müller, *Gedechtnus*, pp. 148–158 and bibliography.

19. Walter Benjamin, "Das Kunstwerk im Zeitalter seiner technischen Reproduzierbarkeit 'Zweiter Fassung,'" in *Gesammelte Schriften*, 1:475 (full ref. chap. 1, n. 39).

20. It is interesting that the first book of importance produced by lithography was an edition of Dürer's illustrations for the *Prayer Book*. The sketches were meticulously copied by Johann Nepomuk Strixner and published by the Aretin-Senefelder Verlag (*Albrecht Dürers christlich mythologische Handzeichnungen* [Nuremberg, 1808]).

21. Benjamin, "Das Kunstwerk," p. 480.

22. On luxury manuscripts as gifts in the court culture of fourteenth-century France and Burgundy, see Millard Meiss, *French Painting in the Time of Jean de Berry: The Late Fourteenth Century and the Patronage of the Duke*, 2 vols., National Gallery of Art, Kress Foundation, Studies in the History of European Art, 2 (New York, 1967), pp. 40–52.

23. When Maximilian discovered that impressions of his *Triumphal Procession* were being sold on the open market in territory controlled by Nuremberg, he declared their sale illegal, and the city council had to apologize to the emperor. See Moxey, *Peasants, Warriors, and Wives*, p. 22, with references (full ref. chap. 10, n. 16).

24. Theodor Hetzer, "Über Dürers Randzeichnungen im Gebetbuch Kaiser Maximilians" (1941), in *Schriften Theodor Hetzers*, vol. 2, *Die Bildkunst Dürers*, ed. Gertrude Bertold (Mittenwald and Stuttgart, 1982), pp. 273–314.

25. The main interpretations of the image are Karl Giehlow, "Dürers Hieroglyphen im Gebetbuch Kaiser Maximilians," *Sitzungsberichte der Kunstgeschichtlichen Gesellschaft* 2 (1908): 21; Karlheinz Reissinger, "Studien zu Albrecht Dürers Randzeichnungen im Gebetbuch Kaiser Maximilians I." (Ph.D. diss., Würzburg, 1938), pp. 62–63; Maria Gräfin Lanckorońska, *Die christlich-humanistische Symbolsprache und deren Bedeutung in zwei Gebetbüchern des frühen 16. Jahrhunderts. Gebetbuch Kaiser Maximilians und Breviarium Grimani*, Studien zur deutschen Kunstgeschichte, 319 (Baden-Baden and Strasbourg, 1958), pp. 60–62; Hans Christoph Tavel, "Die Randzeichnungen Albrecht Dürers zum Gebetbuch Kaiser Maximilians," *Münchner Jahrbuch der bildenden Kunst*, ser. 3, 16 (1965): 68–69 and 115–116; Ewald M. Vetter and Christoph Brockhaus, "Das Verhältnis von Text

und Bild in Dürers Randzeichnungen zum Gebetbuch Kaiser Maximilians," *Anzeiger des germanischen Nationalmuseums* (1971–1972): 82–83. See also Gerhart von Graevenitz, *Das Ich am Rande. Zur Topik der Selbstdarstellung bei Dürer, Montaigne und Goethe,* Konstanzer Universitätsreden, 172 (Constance, 1989), pp. 9–11; von Graevenitz rightly stresses the paradox of "elevation" in text and image in the Prayer Book.

26. Panofsky, *Dürer,* 1:189.

27. The format and sources for Dürer's *grotteschi* in the *Prayer Book* are reviewed briefly in Panofsky, *Dürer,* 1:185; for the Italian reception of antique "grotesques" through the excavation of Nero's Domus Aurea in 1480, see Nicole Dacos, *Le découverte de la Domus Area et la formation des grotesques à la Renaissance,* Studies of the Warburg Institute, 31 (London, 1969).

28. For an ingenious interpretation of this object as the *philosophisches Ei* of alchemy, see G. F. Hartlaub, "Albrecht Dürers 'Aberglaube'. Zu einigen Handzeichnungen und graphischen Blättern," *Zeitschrift des Deutschen Vereins für Kunstwissenschaft* 5 (1940): 184.

29. Vetter and Brockhaus, "Das Verhältnis von Text und Bild," p. 82.

30. See, for example, Quinus Septimus Florens Tertullianus, *De corona,* as quoted in Vetter and Brockhaus, p. 188n81.

31. Vetter and Brockhaus, "Das Verhältnis von Text und Bild," p. 82.

32. Rudolf Berliner, "Arma Christi," *Münchener Jahrbuch der bildenden Kunst,* ser. 3, 6 (1955): 157–238; Robert Suckale, "Arma Christi. Überlegungen zur Zeichenhaftigkeit mittelalterlicher Andachtsbilder," *Städel Jahrbuch* 6 (1977): 183–185.

33. Erich Auerbach, "*Sermo humilis,*" in *Literatursprache und Publikum in der lateinischen Spätantike und Mittelalter* (Bern, 1958): 36; Jauss, "Klassische und christliche Rechtfertigung," p. 157 (full ref. chap. 7, n. 4).

34. Other examples of sudaria at the base of pages in illuminated manuscripts and books are Bertold Furtmeyr's *Crucifixion* from about 1485, added to the *Missal of Petrus Krüger,* dated 1406 (Munich, Bayerische Staatsbibliothek, Clm. 14045, fol. 32ᵛ; reproduced in Florentine Mütherich and Karl Dachs, eds., *Regensburger Buchmalerei. Von frühkarolingischer Zeit bis zum Ausgang des Mittelalters,* exh. cat. [Munich, 1987], cat. no. 107); Jacob Elsner's *Kress Missal,* now in Germanisches Nationalmuseum in Nuremberg (Tavel, "Rand-

zeichnungen," p. 71); and several pages of the Pigouchet *Hours.*

35. See, most recently, Stephen Greenblatt, "Murdering Peasants: Status, Genre, and the Representation of Rebellion," *Representations* 1 (1983): 1–29; Mittig, *Dürers Bauernsäule* (full ref. chap. 9, n. 8).

36. The problem is raised already in Goethe's review of the lithograph reproduction of the *Prayer Book* from 1808 (*Jena Allgemeine Literatur-Zeitung* 1:67 [March 9, 1808], cols. 529–543). See Giehlow, *Kaiser Maximilians I. Gebetbuch,* pp. 22–24.

37. Such exegetical optimism is clearest in Vetter and Brockhaus, "Das Verhältnis."

38. Lilian M. C. Randall, *Images in the Margins of Gothic Manuscripts,* California Studies in the History of Art, 4 (Berkeley, 1966); and Meyer Schapiro's review of Randall reprinted in his *Late Antique, Early Christian and Mediaeval Art* (New York, 1979), pp. 197–198. For the critical terminus, the "grotesque," see Bakhtin, *Rabelais,* pp. 1–58, 303–336, and passim (full ref. chap. 10, n. 76); Frances Barasch, *The Grotesque: A Study in Meanings* (The Hague, 1971); Philip Thomson, *The Grotesque* (London, 1972); Geoffrey Galt Harpham, *On the Grotesque: Strategies of Contradiction in Art and Literature* (Princeton, 1982), pp. 3–76.

39. For a lively modern account of this theology, see Harvey Cox, *The Feast of Fools: A Theological Essay on Festivity and Fantasy* (Cambridge, 1969).

40. Dürer's technique here has precedents in the tradition of "filigree" sketches in border illumination of the Middle Ages; see Tavel, "Randzeichungen," p. 119n79 with references.

41. Hetzer, "Dürers Randzeichungen," p. 296.

42. Jacques Derrida, "Signature Event Context," in *Margins of Philosophy,* trans. Alan Bass (Chicago, 1982), p. 328.

43. The earliest possible comparison I know of is Egon Schiele's 1910 *Nude Self-Portrait,* executed in colored chalk and now in the collection of Rudolf Leopold in Vienna, in which the artist represents himself similarly in three-quarters, with his arms left unfinished (reproduced in Vienna, Historisches Museum, *Traum und Wirklichkeit. Wien, 1870–1930,* exh. cat. [Vienna, 1985], p. 518, cat. no. 15/8/32). Heinrich Schwarz has suggested a direct link between Schiele's nude self-portrait and the Weimar drawing ("Schiele, Dürer, and the Mirror," *Art Quarterly* 30 [1967]: 210–223). Franz Roh was the first to publish Dürer's sketch

as a self portrait ("Ein neues Selbstbildnis Dürers," *Repertorium für Kunstwissenschaft* 39 [1916]: 10–15), although the idea had already been suggested by Rudolf Wustmann, *Albrecht Dürer* (Leipzig, 1906), pp. 11–12.

44. In dating the *Nude Self-Portrait* to 1503, I follow Panofsky's sensible discussion of the sketch and its relation to the British Museum *Dead Christ* sketch of the same year, which I shall discuss below (*Dürer*, 1:90).

45. Panofsky, *Dürer*, 1:90. The suggestion that the *Self-Portrait* represents Dürer during or after a sickness was made first by Flechsig, *Albrecht Dürer*, 2:306 (full ref. chap. 1, n. 16).

46. Werner Schmidt, "Autour de l'exposition de Dresden," pp. 107–116; and idem, "Die Seitenwunde Christi auf Dürers Weimarer Selbstbildnis," pp. 216–223 (full refs. chap. 8, n. 51).

47. "Wie eine offene Wunde," (Sigmund Freud, "Trauer und Melancholie" [1917], in *Studienausgabe*, vol. 3, *Psychologie des Unbewußten*, ed. Alexander Mitscherlich et al. [Frankfurt, 1975], p. 206. I am grateful to members of the graduate program in the Theory of Literature, University of Constance (1991–1992), and in particular Miltos Pechlivanos, for suggesting to me a Freudian reading of Dürer's 1504 *Fall* as a melancholic's fantasy of deferred punishment.

48. Michel de Montaigne, *The Complete Essays of Montaigne*, trans. Donald M. Frame (Stanford, 1965), p. 2; see also Jean Starobinsky's interpretation of this passage in *Montaigne in Motion*, trans. Arthur Goldhammer (Chicago, 1985), pp. 138–141.

49. Montaigne, *Complete Essays*, p. 643.

50. Dürer's was possibly helped in his task by a new technology in the production of mirrors. Only after 1500 was it possible, through a new tin and mercury amalgam developed, interestingly, in Venice and in Nuremberg, to make flat rather than convex mirrors, thus allowing the artist to see his whole body from a reasonable distance (see Schwarz, "Schiele, Dürer, and the Mirror," pp. 210–214).

51. See Camille's chapter "The Fallen Body," in *Gothic Idol*, esp. pp. 87–101 (full ref. chap. 5, n. 25).

52. Geoffrey H. Hartman, "Toward Literary History," in *Beyond Formalism: Literary Essays, 1958–1970* (New Haven, 1970), p. 373n18.

53. "Serpens autum est ipsa sensualitas quae serpit in terrenis, caducis, infimis et carnalibus. Hinc itaq; serpens, per concupiscentiam sensi-

bilium, tentauit Euam, rationem scilicet, quae acquiescens serpenti, ipsis puta sensuum illecebris, decepta est" (Heinrich Cornelius Agrippa, "De originali peccato," [1529], in *Opera* [Lyons, {c. 1600}; reprinted Hildesheim, 1970], p. 552).

Chapter Twelve

1. "Quicquid Alberti Dureri mortale fuit, sub hoc conditur tumulo" (Dürer, *Schriftlicher Nachlaß*, 1:304; trans. Panofsky, *Dürer*, 1:10).

2. The episode is recounted in Christoph Scheurl's 1542 *Beschreibung des Erber geschlechts der Zingel, Irer geburt, Heuraten, sterbens vnnd Begrebnussen* (Nüremberg, Germanischen Nationalmuseum, MS. IV and 35 Bll, fol. 4ᵛ), as well as in an unidentified manuscript quoted in Dürer, *Schriftlicher Nachlaß*, 1:298.

3. On the debate over the nature of Dürer's exhumation, see Theodor Hampe, "Düreranekdote," *Fränkische Monatshefte* 7 (1928): 168.

4. Decker, "Gelingen oder Mißlingen," pp. 445–446 (full ref. chap. 2, n. 54).

5. Goldberg, "Zur Ausprägung der Dürer-Renaissance," pp. 136–137 (full ref. chap. 4, n. 23); Decker, p. 446.

6. The hair was kept in various containers over the years, from an urn-shaped box decorated with a carved profile portrait of Dürer to its present setting fashioned by Edward Steinle in 1871 (Lüdecke and Heiland, *Dürer*, p. 67n93 [full ref. chap. 1, n. 21]). The history of Dürer's lock of hair, with all the relevant texts, is chronicled in Lüdecke and Heiland, pp. 66–68 and 285–286. See also Matthias Mende, "Dürer, der zweite Apelles," in *Dürer heute*, ed. Willi Bongard and Matthias Mende (Munich, 1971), p. 33; and Białostocki, *Dürer and His Critics*, p. 103 (full ref. chap. 1, n. 1).

7. "Die einzige körperliche Überreste eines alten verdienstvollen Teutschen" (Heinrich Sebastian Hüsgen, in 1798; see Lüdecke and Heiland, p. 67).

8. "Hierinn ligt oder jst das haar, welches man dem kunstreichen vnd weittberüembten moler, namblichen hern Albrecht Deürer zu Nüerenberg nach seinem todt anno 1528 den 8 ten tag Aprilen hatt abgeschnitten zu einer gedechtnus. Solches ist nachmals dem kunstreichen moler, herrn Hans Balldung burger alhie zu Straßburg worden" ("Beglaubigung der Echtheit einer Haarlocke, die Dürer am zweiten Tag nach seinem Tod

vom Haupte abgeschnitten wurde" [1553]; reprinted in Dürer, *Schriftlicher Nachlaß*, 1:251).

9. Baldung's participation in Dürer's shop has been deduced from a number of surviving prints, glass paintings, and panel paintings produced in and around Nuremberg at 1503–1506 and attributed to Baldung. The only documentary evidence of this association consists of a passage in Dürer's Netherlandish diary and the anecdote about Dürer's lock of hair. Baldung's exact status in Dürer's shop is the subject of some debate. Although probably already a trained painter by the time he reached Nuremberg, Baldung worked in Dürer's shop as an apprentice, because that was the only status permitted to an unmarried male in a master's household. For an excellent short account of Baldung's life and art in English, see Alan Shestack, "An Introduction to Hans Baldung Grien," in New Haven, Yale University Art Gallery, *Hans Baldung Grien: Prints and Drawings*, ed. James H. Marrow and Alan Shestack, exh. cat. (New Haven, 1981), pp. 3–18. The most comprehensive biography is still Carl Koch, "Hans Baldung Grien, 1484/85–1545," in *Die grosse deutsche Biographie* (Berlin, 1956), 1:401–417, which should be supplemented by the recent article by Thomas A. Brady on the artist's commercial activities in Strasbourg ("The Social Place of a German Renaissance Artist: Hans Baldung Grien (1484/5–1545)," *Central European History* 8 [1975]: 295–315). For a bibliography of Baldung literature before 1915, see Mela Escherich, *Hans Baldung Grien, Bibliographie, 1509–1915* (Strasbourg, 1916); more recent studies are listed in Karlsruhe, Staatliche Kunsthalle, *Hans Baldung Grien*, exh. cat. (Karlsruhe, 1959), pp. 27–32; Mende, *Dürer-Bibliographie*, Lit. 21 (full ref. chap. 1, n. 1); and Matthias Mende, *Hans Baldung Grien: Das graphische Werk* (Unterschneidheim, 1978), pp. 35–37. Lucas Würthrich has summarized new directions in Baldung scholarship in a short piece introducing a series of essays on the artist ("Probleme der Baldung-Forschung. Kolloquium im Kunstmuseum Basel, 30. Juni 1978," *Zeitschrift für Schweizerische Archäologie und Kunstgeschichte* 35 [1978]: 205). The relationship between Dürer and Baldung has been studied by Karl Oettinger and Karl-Adolf Knappe (*Hans Baldung Grien und Albrecht Dürer in Nürnberg* [Nuremberg, 1963]) and, more recently, by Linda A. Hults-Boudreau in "Hans Baldung Grien and Albrecht Dürer: A Problem of Northern Mannerism" (Ph.D. diss., University of North

Carolina, Chapel Hill, 1978). On Dürer's shop in general, see Nuremberg, Germanisches National-Museum, *Meister um Albrecht Dürer*, exh. cat. (Nuremberg, 1961), pp. 11–16.

10. The story of Baldung's activities in Nuremberg is given in Oettinger and Knappe, *Hans Baldung Grien*, pp. 7–8 and passim.

11. *Die Matrikel der Universität Heidelberg, 1386–1662*, ed. Gustav Toepke, 3 vols. (Heidelberg, 1884–1893), 1:276; Brady, "Social Place," 292.

12. Brady, pp. 298–303.

13. "Mehr hab ich für I gulden hans grun verkauft" (Dürer, *Schiftlicher Nachlaß*, 1:270–271).

14. For a good collection of portraits and effigies of Dürer from the nineteenth century, see Berlin, *Dürers Gloria* (full ref. chap. 4, n. 34). Sixteenth-century material is given in Matthias Mende, *Dürer-Medaillen. Münzen, Medaillen, Plaketten von Dürer, auf Dürer, nach Dürer*, exh. cat. (Nuremberg, 1983).

15. Carl Koch, *Die Zeichnungen Hans Baldung Griens* (Berlin, 1941), henceforth referred to as "K." For the dating of the sketch, see Karlsruhe, *Hans Baldung Grien*, cat. no. 110; Tilman Falk, "Die Zeichnungen," in *Hans Baldung Grien in Kunstmuseum Basel*, exh. cat. (Basel, 1978), cat. no. 13, p. 50; New Haven, *Hans Baldung Grien*, cat. no. 13. Oettinger and Knappe date the drawing to 1504–1505 (*Hans Baldung Grien and Albrecht Dürer*, pp. 7–8), which seems too early given the quality of Baldung's other works from those years (e.g., the *Banner Carrier* of c. 1504, in private hands, reproduced in Marianne Bernhard, ed., *Hans Baldung Grien. Handzeichnungen—Druckgraphik* [Munich, 1978], p. 100, and *Death and a Landsknecht* [fig. 134; K. 2]).

16. For a history of this term, see Kathleen Cohen, *Metamorphosis of a Death Symbol: The Transi Tomb in the Late Middle Ages and the Renaissance* (Berkeley, 1973), pp. 9–11; also Erwin Panofsky, *Tomb Sculpture: Four Lectures on Its Changing Aspect from Ancient Egypt to Bernini*, ed. H. W. Janson (New York, 1964), p. 67 and passim.

17. The allusion, along with its theological meaning, is noted in New Haven, *Hans Baldung Grien*, p. 97.

18. Oettinger and Knappe, *Hans Baldung Grien*, cat. no. 26.

19. Georg Bussmann, *Manierismus im Spätwerk Hans Baldung Griens. Die Gemälde der zweiten Strassburger Zeit* (Heidelberg, 1966), pp. 166–180 and passim.

20. Oettinger and Knappe regard the sketch "als erstes Zeugnis der Teilnahme des Gesellen an den Proportionsstudien des Meisters" (p. 17); see also New Haven, *Hans Baldung Grien*, pp. 94–95.

21. Gert von der Osten, *Hans Baldung Grien: Gemälde und Dokumente* (Berlin, 1983); henceforth referred to in the text as "O."

22. Panofsky, *Dürer*, vol. 2, cat. no. 1.

23. See Konrad Hoffmann's discussion of Dürer's *Fountain Nymph* of c. 1515 (W. 663), in "Antikenrezeption und Zivilisationsprozess im erotischen Bilderkreis der frühen Neuzeit," *Antike und Abendland* 24 (1978): 146–158.

24. The most reliable introduction to the dance of death is Hellmut Rosenfeld, *Der Mittelalterliche Totentanz. Entstehung—Entwicklung—Bedeutung*, 3d ed., Beihefte zum Archiv für Kulturgeschichte, 3 (Cologne, 1974); less trustworthy, but still useful, is Stephan Cosacchi, *Makabretanz. Der Totentanz in Kunst, Poesie und Brauchtum des Mittelalters* (Meisenheim am Glan, 1965). Texts and images of the German dance of death are assembled in Gert Kaiser, ed., *Der tanzende Tod*, (Frankfurt, 1982).

25. I follow here Harold Bloom's reading of Milton, variously worked out in *Map of Misreading* (New York, 1975), pp. 125–141, and *Ruin the Sacred Truths: Poetry and Belief from the Bible to the Present*, Charles Eliot Norton Lectures, 1987 (Cambridge, Mass., 1989), pp. 102–113. See also Koerner, *Die Suche nach dem Labyrinth*, pp. 141–155 (full ref. chap. 8, n. 5).

26. Marsilio Ficino, *Sopra lo amore o ver convito di Platone*, 5.6; trans. Victor A. Velen (published as appendix 1 in Panofsky, *Idea*, p. 137 [full ref. chap. 6, n. 54]).

27. St. Bonaventura, *Collationes*, in *Hexameron*, 13.12; as quoted in Hans Blumenberg, *Die Lesbarkeit der Welt* (Frankfurt, 1981), pp. 53–54.

28. Compare this with Denis Diderot's warning against representing the beholder within a painting: "Le spectateur n'est jamais du sujet" (in *Salons*, ed. Jean Seznec and Jean Adhémar [Oxford, 1963], 2:66; as quoted and discussed in Michael Fried, *Theatricality and Absorption: Painting and Beholder in the Age of Diderot* [Berkeley, 1980], p. 97).

29. Bakhtin, *Rabelais*, p. 317.

30. As Mary Douglas writes, "Just as the focus of all pollution symbolism is the body, the final problem to which the perspective of pollution leads is bodily disintegration" (*Purity and Danger: An Analysis of the Concepts of Pollution and Taboo* [London, 1966], p. 173).

31. Julia Kristeva, The Powers of Horror: An Essay on Abjection, trans. Leon S. Roudiez (New York, 1982), pp. 3–4.

32. The earliest dated work of Baldung is the sketch *Aristotle and Phyllis* from 1503, now in the Louvre (K. 1).

33. Oettinger and Knappe, *Hans Baldung Grien*, pp. 6–7.

34. Eduard Syndikus, "Hochzeit und Tod—ein wiederentdecktes Bild," *Zeitschrift für Kunstwissenschaft* 6 (1952): 47–56; Buchner, *Das deutsche Bildnis*, pp. 173–175 and cat. no. 197 (full ref. chap. 1, n. 55). The artist of these panels used to be called Master of the Aachen Cabinet Doors; more recently he has become Master of the Aachen Life of the Virgin (for which see Hans M. Schmidt, *Der Meister des Marienlebens und sein Kreis* [Düsseldorf, 1978]; I am grateful to Dr. Schmidt for this correction).

35. The work was formerly regarded as a self-portrait of Burgkmair until the discovery of Furtenagel's signature in 1933. Some scholars still believe that the portrait is by Burgkmair and that Furtenagel was responsible only for finishing the work (Tilman Falk, *Hans Burgkmair: Studien zu Leben und Werk des Augsburger Malers*, Bruckmanns Beiträge zur Kunstwissenschaft [Munich, 1968], pp. 53 and 101–102n321; Berthold Hinz, "Studien zur Geschichte des Ehepaarbildnisses," *Marburger Jahrbuch für Kunstwissenschaft* 19 [1974]: 167–171; James H. Marrow, "'In desen Speigell': A New Form of 'Memento Mori' in Fifteenth-Century Netherlandish Art," in *Essays in Northern European Art Presented to Egbert Haverkamp-Begemann on His Sixtieth Birthday* [Doornspijk, 1983], pp. 154–163).

36. Kristeva, *Powers of Horror*, pp. 14–15.

37. See Bakhtin remarks on parody in "From the Prehistory of Novelistic Discourse," p. 76 (full ref. chap. 10, n. 76).

38. See my discussion of Baldung's 1519 woodcut *Fall* below.

39. Indeed, the play between literal and figurative disfiguration (as physical putrefaction and as rhetorical subversion) underscores the interpretative predicament that Baldung stages for us: that is, the impossibility of fixing the referential status of a figure. See Paul de Man, "Shelley Disfigured," in *Rhetoric of Romanticism*, pp. 99–101

(full ref. chap. 1, n. 60); Chase, *Decomposing Figures*, p. 6 (full ref. chap. 1, n. 60).

Chapter Thirteen

1. Wilhelm Dilthey, *Das Erlebnis und die Dichtung: Lessing, Goethe, Novalis, Hölderlin,* 8th ed. (Leipzig, 1922), p. 230.

2. See Martin Heidegger's account of the role of death in any hermeneutic act in the chapter "Das mögliche Ganzsein des Daseins und das Sein zum Tode," in *Sein und Zeit,* 14th ed. (Tübingen, 1977), pp. 235–267, especially the historical note, p. 249n1.

3. St. John Chrysostom, "Homily on the Transferral of Martyrs' Relics," in *Texte der Kirchenväter,* ed. Alfons Heilman (Munich, 1964), 4:426; see also Chrysostom's treatise *On Patience,* subtitled *The Dead Must Not Be Bitterly Mourned* (in *Patrologiae cursus completus series Graeca,* ed. J.-P. Migne, 162 vols. [Paris, 1857–1866], vol. 60, col. 727). Chrysostom's thought is an early and intense instance of the Christian obsession with death that culminates in the monastic culture of the later Middle Ages.

4. According to Peter Comestor's *Historia scholastica,* Adam and Eve mourned Abel for one hundred years, a scene frequently depicted in illustrations of the *Speculum humanae salvationis.* See, for example, the image labeled "Prothoplansti luxerunt necem abel" in the block book *Speculum* (first edition published about 1468 in the northern Low Countries), reproduced in Adrian Wilson and Joyce Lancaster Wilson, *A Medieval Mirror: "Speculum humanae salvationis," 1324–1500* (Berkeley, 1984), p. 191.

5. Chrysostom, "Homily," p. 428.

6. Chrysostom, p. 427.

7. "Spectacle horrible, miraige detestable, / Vision fiere, object tres redoubtable, / Mortel signacle, o tres vif exemplaire, / Tu es ung monstre impossible et contraire" (Jean Molinet, *Faits et dictz,* ed. Noël Dupire [Paris, 1934], 2:670; quoted in Jean Delumeau, *Le péché et la peur. La culpabilisation en Occident XIIIᵉ–XVIIIᵉ siècles* [Paris, 1983], p. 50).

8. See Hans Rolf, *Der Tod in mittelhochdeutscher Dichtung. Untersuchungen zum "St. Trudpeter Hohenlied" und zu Gottfrieds von Strassburg "Tristan und Isolde"* (Munich, 1974), pp. 68–69.

9. Johan Huizinga, *The Waning of the Middle Ages: A Study of Life, Thought and Art in France and the Netherlands in the Fourteenth and Fifteenth Centuries,* trans. F. Hopman (New York, 1954), pp. 138–140.

10. The history of death imagery is extraordinarily complex and varied and encompasses a number of different expressions such as the *transi* tomb, the macabre double portrait, the Triumph of Death, the Legend of the Three Living and Three Dead, the dance of death, and the *anatomie moralisée.* The literature on the subject is immense. For introductions to the visual tradition, see Emile Mâle, *L'art religieux de la fin du Moyen Age en France* (Paris, 1925), and Jan Białostocki, "Kunst und Vanitas," in *Stil und Ikonographie: Studien zur Kunstwissenschaft* (Cologne, 1966), pp. 269–317. Useful visual material has been gathered in Philippe Ariès, *Images of Man and Death,* trans. Janet Lloyd (Cambridge, 1985), which should be supplemented by Ariès's two important studies on the subject: *The Hour of Our Death,* trans. Helen Weaver (New York, 1981), and the shorter *Western Attitudes toward Death: From the Middle Ages to the Present,* trans. Patricia M. Ranum (Baltimore, 1979). A good summary of recent historical literature before and after Ariès is Delumeau's *Le péché et la peur,* pp. 44–128. More specialized studies of the subject are Alberto Tenenti, *La vie et la mort à travers l'art du XVᵉ siècle,* Cahiers des Annales, 8 (Paris, 1952); idem, *Il senso della mort e l'amore della vita nel Rinascimento* (Turin, 1957); and Jean Wirth, *La jeune fille et la mort: Recherches sur les thèmes macabre dans l'art germanique,* Hautes études médiéveles et modernes, 36 (Geneva, 1979). Interestingly, the earliest critical study of death symbolism, Gotthold Ephraim Lessing's *Wie die alten den Tod gebildet* (Berlin, 1769), marks the beginning of all modern "iconographic" scholarship. Perhaps the study of the macabre represents the final horizon of any historical analysis of the symbol per se. As Paul Ricoeur has written, "The history of death may not be just the farthest point reached by serial history, but perhaps by all history" (*Time and Narrative,* trans. Kathleen McLaughlin and David Pellaver [Chicago, 1984], 1:111).

11. Theological contexts for grotesque realism in images and narratives of the Passion have been explored by Auerbach, "*Sermo humilis,*" pp. 25–81 (full ref. chap. 11, n. 33), and Jauss, "Die klassische und die christliche Rechtfertigung des Hässlichen," pp. 156–168 (full ref. chap. 7, n. 4). Specifically German examples are discussed by F. P. Pickering, *Literature and Art in the Middle Ages* (London, 1970); idem, "The Gothic Image of

Christ: The Sources of Medieval Representations of the Crucifixion," in *Essays on Medieval German Literature and Iconography,* Anglica Germanica, 2 (Cambridge, 1980), pp. 3–30; Paul Michel, "*Formosa deformitas.*" *Bewältigungsformen des Hässlichen in Mittelalterlicher Literatur,* Studien zur Germanistik, Anglistik und Komparatistik, 57 (Bonn, 1976), pp. 233–320; and James H. Marrow, *Passion Iconography in Northern European Art of the Late Middle Ages and Early Renaissance: A Study of the Transformation of Sacred Metaphor into Descriptive Narrative,* Ars Neerlandica, 1 (Kortrijk, 1979).

12. On the plague's effects on the European mentality, see Philip Ziegler, *The Black Death* (New York, 1969), esp. pp. 259–289. The classic study of the relation between the plague and developments in the visual arts is Millard Meiss, *Painting in Florence and Siena after the Black Death: The Arts, Religion and Society in the Mid-Fourteenth Century* (Princeton, 1951). The history of the fourteenth century as a series of calamities was popularized by Barbara Tuchman in *A Distant Mirror: The Calamitous Fourteenth Century* (New York, 1978).

13. In Germany, for example, in 1481–1482, 1501–1502, 1529–1530.

14. Delumeau, *Le péché,* pp. 110–111. On transformation of warfare and its effects on contemporary mentality, see Steven Ozment, *The Age of Reform, 1250–1550: An Intellectual and Religious History of Late Medieval and Reformation Europe* (New Haven, 1980), p. 8; relevant texts are translated and assembled in Gerald Strauss, ed., *Manifestations of Discontent in Germany on the Eve of the Reformation* (Bloomington, Ind., 1971), pp. 144–169. Against arguments about the macabre's arising from an empirical presence of death in 1350–1550, John Helgeland, following Mary Douglas, has proposed that since the body is a natural symbol for describing social groups and institutions, the decomposing corpse served to symbolize the disintegration of medieval institutions and the transition to the early modern period in Europe ("The Symbolism of Death in the Later Middle Ages," *Omega* 15 [1984–1985]: 145–160).

15. Mâle (*L'art religieux*), Huizinga (*Waning of the Middle Ages*), Tenenti (*La vie et la mort* and *Il senso della morte*), and Wirth (*Le jeune fille*). See also J. Sagnieux, *Les danses macabre de France et d'Espagne et leurs prolongements littéraires* (Paris, 1972), esp. pp. 97–118; and A. Corvisier, "La danse macabre de Meslay-le-Grenet," *Bulletin des*

Sociétés archéologiques d'Eure-et-Loir, 1969–1970, 40–45.

16. Delumeau, *Le péché,* p. 127.

17. Michael Baxandall gives an excellent account of the problem description poses to the historical explanation of pictures in *Patterns of Intention* (New Haven, 1985), pp. 1–11.

18. Inv. no. 3369; first published by John Rowlands, review of *Hans Baldung Grien: Das graphische Werk* by Matthias Mende, *Burlington Magazine* 12 (1979): 590–591.

19. *Death Overtaking a Knight* measures 251 × 384 mm against the *Apocalypse*'s 395 × 285 mm.

20. For one thing, the monogram HB at the bottom left, written as if inscribed on the rock in front of the knight's horse, does not include the "G" that Baldung consistently uses in his signature from about 1512 on (with the exception of the much later *Bewitched Stable Groom* of 1544, Mende 76; see Rowlands, rev. of *Baldung,* p. 591). Moreover, the years 1509 to 1512 were a time when Baldung became interested in themes of the supernatural and the macabre, themes that were to become the hallmark of his art in the next decade (see Shestack, "An Introduction to Hans Baldung Grien," p. 9 [full ref. chap. 12, n. 9]). Finally, in its confident use of hatching, its rather loose organization, its open spaces, its lack of a gray middle tone (stylistic features of Baldung's prints before 1512; see Helmut Perseke, *Hans Baldungs Schaffen in Freiburg* [Freiburg im Bresgau, 1941], p. 155), and in its relative lack of interest in volume as such (Baldung's so-called *Flächenmanier;* see Ludwig Baldass, "Der Stilwandel im Werke Hans Baldung," *Münchener Jahrbuch der bildenden Kunst,* n.s., 3 [1926]: 5–44), *Death Overtaking a Knight* belongs stylistically to the works that date from 1510 to 1512.

21. Mende, *Hans Baldung Grien. Das graphische Werk;* henceforth referred to as "M." (full ref. chap. 12, n. 9).

22. This instrument plays a pivotal role in the central panel of Hieronymus Bosch's *Haywain* triptych, where it is silhouetted against a stack of hay carted through the landscape. Playing on the words of Isaiah, "All flesh is grass" (see José de Sigüenza's early defense and explication of Bosch according to this saying, in *Historia de la orden de San Jeronimo* [1603], trans. Wolfgang Stechow in *Northern Renaissance Art, 1400–1600: Sources and Documents* [Englewood Cliffs, N.J., 1966], p. 24), and on contemporary Netherlandish proverbs that invoke hay as a *vanitas* symbol (Walter S.

Gibson, *Hieronymus Bosch* [Oxford, 1973], pp. 70–71), the pitchfork stands for a desire for earthly things that is blind to the reality of death and damnation.

23. See G. F. Hartlaub, *Hans Baldung Grien: Hexenbilder* (Stuttgart, 1961), pp. 12ff.; also Osten, *Baldung*, pp. 52–53; see my discussion of the self-portrait in chapter 17 below.

24. O. 44.

25. In this vein Dürer published a woodcut *Death and the Mercenary* (1510; Kn. 292) accompanied by a poem he had composed.

26. In the Dutch morality play *Elckerlijc*, composed about 1490, Death's opening address to Everyman comments upon the vanity of his clothing: "Everyman, what bringeth thee here / So foppishly dressed? Hast forgotten God?" (*The Mirror of Salvation*, trans. Adriaan J. Barnouw, Bibliotheca Meerlandica Extra Muros, 2 [The Hague, 1971], lines 70–71).

27. Rudolf Chadraba, *Dürers Apokalypse. Eine ikonographische Deutung*, Tschechoslowakische Akademie der Wissenschaften, Institut für Theorie und Geschichte der Kunst (Prague, 1964), p. 100.

28. This situation is repeated in Holbein's image of a knight in the *Dance of Death* (fol. Fiii^v), where it is accompanied by the motto from Job 34:20: "In a moment shall they die, and the people shall be troubled at midnight and pass away: and the mighty shall be taken away without hand." See also Dürer's *bas-de-page* illustration for folio 37^v of the *Prayer Book of Maximilian*, in which a knight is pursued by Death, an image that depends, perhaps, on Baldung's print. The confrontation of a mounted knight and an animated corpse has numerous pictorial precedents, such as the woodcut illustration of a knight in Olivier de la Marche's *Chevalier délibéré*, published in Gouda about 1486. The mock joust was an integral part of the late medieval popular festive tradition; it is invoked, for example, in the battle between Carnival and Lent in Pieter Bruegel the Elder's famous panel in Vienna.

29. See the discussion of this literature in Rosenfeld, *Der mittelalterliche Totentanz*, pp. 34–45 (full ref. chap. 12, n. 24).

30. Quoted in Heinz Lüdecke, "Drei gesellschaftliche Dürer-Zeichnungen," *Bildende Kunst*, 1971, pp. 501.

31. Jean Wirth is right to point out that this meeting of the young man and Death cannot be translated into a text but remains an independent, irreducible visual drama, endowed with more complexity than anything in the literature of the time (*La jeune fille et la mort*, p. 19; see also Amsterdam, Rijksmuseum, *Vom Leben im späten Mittelalter*, ed. J. P. Filedt Kok, exh. cat. [Amsterdam, 1985], cat. no. 58). Interestingly, Dürer uses this young man from the Housebook Master's drypoint for his own early (1492–1493) sketch, *Young Couple Walking* (W. 56). Produced about the time of the artist's marriage to Agnes Frey, and endowing the youth with a face resembling the artist's own, Dürer's drawing forms the basis of the c. 1498 *Promenade* engraving (Kn. 19), in which an "unequal couple" is threatened by the figure of Death lurking behind a tree. Projecting himself and his personal situation into this macabre domain, Dürer presages the concatenation of self-portrait, animated corpse, and alluring/repugnant woman that will be one of Baldung's central themes (e.g., figs. 135, 145, 146, 151).

32. Walter Hermann Ryff, *Des aller fürtrefflichsten . . . gschöpffs aller Creaturen . . . beschreibung oder Anatomi* (Strasbourg, 1541), fol. A; see André Chastel's interesting discussion of the *anatomie moralisée* and its relation to the development of print culture in "La baroque et la mort," in *Fables, formes, figures* (Paris, 1978), 1:206–226.

33. For a brief description of metonymy as "substitution of cause for effect and effect for cause," see Richard A. Lanham, *A Handlist of Rhetorical Terms* (Berkeley, 1961), p. 67. Kenneth Burke writes: "'Metonymy' is a device of 'poetic realism.' . . . For the poet spontaneously knows that 'beauty *is* as beauty *does*' (that the 'state' must be 'embodied' in an actualization). He knows that human relations require actions, which are *dramatizations*, and that the essential medium of drama is the posturing, tonalizing body placed in a material scene" (*A Grammar of Motives* [Berkeley, 1969], p. 507).

34. Willy Rotzler, *Die Begegung der drei Lebenden und der drei Toten* (Winterthur, 1961).

35. Ludwig Heinrich Heydenreich, "Der Apokalypsen-Zyklus im Athosgebiet und seine Beziehung zur deutschen Bibel-Illustrationen der Reformation," *Zeitschrift für Kunstgeschichte* 8 (1939): 25ff.

36. Baldung's is more conventional, whereas Dürer's suggests the image of the wild man, as in his 1495 engraving *Young Woman Attacked by Death* (Kn. 3) and the *Coat of Arms of Death* from 1503 (Kn. 41; see Wirth, *La jeune fille*, pp. 35–37).

37. The only two later examples I know in

which Death wields a pitchfork are the woodcut of the "Four Horsemen of the Apocalypse" in the September Bible (1522) illustrated by Hans Burgkmair, and Jean Duvet's engraving *St. John Sees the Four Horsemen* from his *Apocalypse* series completed in 1555—both works that imitate Dürer's original. One interesting early example of the pitchfork as weapon occurs in an Alsatian tapestry from about 1400 (reproduced in Husband, *Wild Man*, fig. 88 [full ref. chap. 8, n. 27]). Two wild men, mounted on a dog and on a lion, joust with pitchforks. Often regarded as antitheses of the Christian knight, wild men appear in such parodic joust scenes from the late fourteenth to the early sixteenth century. If it is true that the mounted figure of Death in Dürer's *Apocalypse* is, in its physiognomy, related to the motif of the wild man, then perhaps Baldung's macabre parody of a joust in *Death Overtaking a Knight* has roots in this tradition as well.

38. Panofsky, *Dürer*, 1:59.

39. Osten, *Baldung*, p. 224.

40. As I suggested in regard to Dürer's Munich *Self-Portrait*, this chiliasm gave way to—or coexisted with—the Renaissance hope for a new golden age to be established in this world through human effort.

41. Max Dvořák, "Dürers Apokalypse," in *Kunstgeschichte als Geistesgeschichte. Studien zur abendländischen Kunstentwicklung* (Munich, 1928), p. 201.

42. This conceit of Death's earthliness as physical weight is nicely illustrated in Baldung's early *Death and the Maiden* panel in Vienna (fig. 153; O. 10). Although the young woman's feet do not disturb the pattern of plants that decorate the ground, this ground and the life it bears can be seen to give under the weight of Death's feet.

43. In chivalric literature from Chrétien de Troyes to Spenser, the castle and forest, temple and labyrinth, are the opposed structures that make up the world or *mundus*. See Angus Fletcher, *The Prophetic Moment: An Essay on Spenser* (Chicago, 1971), pp. 12ff.

44. For example, M. 17 and 18.

45. On the iconography of this city, see Heinrich Theissing, *Dürers Ritter, Tod und Teufel. Sinnbild und Bildsinn* (Berlin, 1978), p. 112.

46. It is perhaps no coincidence that the only other prints by Baldung in an oblong format are the *Wild Horses* series from 1534 (M. 77–79; figs. 204, 207, 208). These disturbing scenes of a sexualized animal world are Baldung's darkest vi-

sion of fallen nature, where all redemption, indeed all humanity, has been banished. See the discussion of these prints in chapter 17 below.

47. Xavier Léon Dufour, *Face à la mort: Jésus et Paul* (Paris, 1979), pp. 293–302; Delumeau, *Le péché*, p. 104.

48. On the origins of the idea of purgatory, see Jacques Le Goff, *The Birth of Purgatory*, trans. Arthur Goldhammer (Chicago, 1984); on the individualizing effect of the doctrine of judgment at death, see Rosenfeld, *Der mittelalterliche Totentanz*, pp. 44–45, and John Bossy, *Christianity and the West, 1400–1700* (Oxford, 1985), pp. 26–27.

49. This interpretation was first proposed by Pierre Chaunu in his account of the *transi* (*La mort à Paris, XVIe, XVIIe, XVIIIe siècles* [Paris, 1978], esp. pp. 246–249).

50. Ariès, *Hour of Our Death*, p. 107; see also his *Western Attitudes toward Death*, pp. 28–38.

51. There exist over 234 manuscript copies of the *Ars moriendi*, making it—after the Bible, Thomas à Kempis's *Imitatio Christi*, Giles of Rome's *De regimine principum*, and the *Romance of the Rose*—the most frequently copied text of the Middle Ages. With the advent of printing, its popularity only increased, producing at least seventy-seven incunabula editions (second only to Thomas's text). See M. C. O'Connor, *The Art of Dying Well: The Development of the Ars Moriendi* (New York, 1942), pp. 61–112; Tenenti, *La vie et la mort*, pp. 48ff.; R. Chartier, "Les arts de mourir, 1450–1600," *Annales E.S.C.*, 1976, 51–75, with a good recent bibliography.

52. The main revisionist here is the Soviet historian of the Middle Ages, Aaron J. Gurjewitsch, in "Conscience individuelle et image de l'audelà," *Annales E.S.C.*, 1982, pp. 255–275, and idem, *Mittelalterliche Volkskultur*, German trans. Matthias Springer (Munich, 1987); see also Le Goff, *Birth of Purgatory*, pp. 369–370; Delameau, *La péché*, pp. 102–103.

53. St. John Chrysostom, "Sermon concerning the Earthquake," 5, in *Texte der Kirchenväter*, ed. Heilman, 4:412.

54. Chrysostom, 4:413.

55. On the Christian conception of history's legibility, see Blumenberg, *Die Lesbarkeit der Welt*, pp. 31ff. (full ref. chap. 6, n. 14).

56. As quoted in Walther Rehm, *Der Todesgedanke in der deutschen Dichtung von Mittelalter bis zu Romantik* (Halle, 1928), p. 141.

57. Bouwsma, "Renaissance and Reformation," pp. 129–145 (full ref. chap. 4, n. 44).

58. As Johannes Geffcken, obviously betraying his Protestant perspective, remarked of the late medieval conceptions of sin, confession, and penance at the eve of the Reformation: "It appears that the righteousness of the law, with its hundred thousand, partly unfulfillable demands, had first to reach its climax before people awoke to the proper, irresistible longing for the righteousness of faith" (*Der Bildercatechismus des funfzehnten Jahrhunderts und die catechetischen Hauptstücke in dieser Zeit bis auf Luther* [Leipzig, 1855], p. vii). For the whole subject of confession in the late Middle Ages, see Thomas N. Tentler, *Sin and Confession on the Eve of the Reformation* (Princeton, 1977), and Ozment's excellent summary of the literature in *Reformation in the Cities*, pp. 17ff. (full ref. chap. 4, n. 46).

59. The close of Cervantes' *Don Quixote* expresses most eloquently this new isolation, as well as the sense, sustained in Baldung, that death is the real harbinger of meaning. Quixote's friends and companions gather around his sickbed and recognize that he will die: "One of the signs that led them to think he was dying was the quick return from madness to sanity" (trans. Samuel Putnam [New York, 1949], 2:985; see Frank Schirrmacher's important remarks on this passage in "Verteidigung der Schrift," in *Verteidigung der Schrift. Kafkas "Process"* [Frankfurt, 1987], pp. 138–141). In this closing deathbed scene (a secularized version of the *ars moriendi*, purged of angels, devils, and the trappings of definitive redemption), death brings reason and reveals the true state of affairs: "I was mad and now I am sane," says the hero; "I was Don Quixote de la Mancha, and now I am, as I have said, Alonso Qijano the good." Only the confrontation with death (which is also his story's end) enables Quixote's *conversio* to sanity. Even the friends who gather around his bed refuse to believe Quixote's turn to reason; like Cervantes' readers, they want him to die with his fiction intact. With no one to guide him and with no spectacle of the Second Coming to reveal how things really are, the hero must insist on his sanity as vigorously as he had upheld his delusions. It is as if by the mid-sixteenth century, it takes a madman assisted by Death to make sense of the world.

Chapter Fourteen

1. For which see Richard Bellm, *Wolgemuts Skizzenbuch in Berliner Kupferstichkabinett. Ein Beitrag zur Erforschung des graphischen Werkes von Michael Wolgemut und Wilhelm Pleydenwurff*, Studien zur deutschen Kunstgeschichte, 322 (Baden-Baden and Strasbourg, 1959).

2. The dance of death illustrating pages of the *Heures à l'usage de Rome*, published in 1498 by Philippe Pigouchet for Simon Vostre, includes a scene of the Fall, as does the mid-fifteenth-century poem *Le mors de la pomme* (ed. L. P. Kurtz [New York, 1957]; see A. Monteverdi, "Le mors de la pomme," *Archivum romanicum*, 1921, pp. 110–134). Niklaus Manuel Deutsch's cycle *Dance of Death* (1516–1519), which decorated the church of the Dominican monastery in Bern, begins with the scene of the Expulsion (see Paul Zinsli, *Der Berner Totentanz des Niklaus Manuel*, Berner Heimatbücher, 54–55 [Bern, 1953], pl. 1). And Hans Holbein the Younger's great woodcut *Dance of Death* begins with the scenes of the causes of death: the creation of Eve, the Fall, and the Expulsion (*Les simulacres et historices faces de la mort* [Lyons, 1538]; the *Simulacres* illustrations were designed by Holbein about 1523–1526, translated into woodcuts by the block cutter Hans Lützelburger, and published by Melchior and Gaspar Treschel).

3. "Das unser tod und sterben . . . eine Frucht und straffe ist der sunde unsers Vaters Adam, welcher hat sich so hoch vergriffen an der hohen maiestet, das er und alles, was von im kompt und auff erden geborn wird, mus ewiglich des todes sein und niemand auff erden dem unglück entgehen noch wehren kan" (Martin Luther, *Werke. Kritische Gesamtausgabe*, 94 vols. in 109 [Weimar, 1883–1980], 36:557).

4. "Der meiste hauffe dencket, es geschehe on gefehr also, das wir sterben wie das Vieh, . . . hie leret uns die Schrift, das der Tod herkompt erstlich aus dem Paradis, von dem biss der verboten frucht" (Luther, *Werke*, 22:284).

5. For a good general account of this painting, see Dieter Koepplin, "Baldungs Basler Bilder des Todes mit dem nackten Mädchen," *Zeitschrift für schweizerische Archäologie und Kunstgeschichte* 35 (1978): 234–241. Technical aspects of the panel are presented in Paolo Cadorin, "Ergebnisse der wissenschaftlichen Untersuchung der beiden Holztafeln 'Der Tod und das Mädchen' und 'Der Tod und die Frau' von Hans Baldung Grien," *Zeitschrift für Schweizerische Archäologie und Kunstgeschichte* 35 (1978): 241–243.

6. Of course, "full sexuality" is precisely what is problematized in this image. Baldung's art does

not propose that, were the woman's vagina to be revealed, the eye and therefore desire would be fulfilled. Sexuality is defined not in terms of activity but in terms of desire, and the object of this desire is precisely what is withheld from representation and appears only as a promise. On the definition of sexuality in terms of desire rather than act, see Victor J. Seidler, "Reason, Desire, and Male Sexuality," in *The Cultural Construction of Sexuality,* ed. Pat Caplan (London, 1987), p. 92; and Michel Foucault and R. Sennett, "Sexuality and Solitude," in *Anthology 1* (London, 1981).

7. The sexuality that Baldung thus stages before his work, the response his image is fashioned to elicit, is specifically male heterosexual desire. In referring to the viewer as "he," I therefore signal only the *implied* viewer of Baldung's art (see my discussion of Baldung's viewers and of his gendered model of sexuality in chapter 15 below). On the construction of the woman as object for the male gaze, see Laura Mulvey's classic 1975 essay, "Visual Pleasure and Narrative Cinema," reprinted in *Feminism and Film Theory,* ed. Constance Penley (New York, 1988), pp. 57–68.

8. In this painting Baldung treads a thin line between representing a multivalent human action and constructing a wholly didactic emblem of desire and its consequences. From this perspective the Basel panel under discussion marks an advance over Baldung's earlier *Death and the Maiden* panel, dated 1517 and also in Basel (O. 44), where the gestures of the cadaver and its victim are more theatrical and the implication of the viewer in the picture's plot is less marked. In that panel, moreover, the picture's normative message is already spelled out for us in the inscription at the top of the picture: *Hie müst dv yn.*

9. *De civitate Dei,* 13.13; trans. Bettenson, pp. 522–523 (full ref. chap. 9, n. 31).

10. Erasmus, *The Enchiridion,* trans. Raymond Himelick (Gloucester, 1970), p. 67.

11. Represented, for example, in a chiaroscuro drawing in the Albertina variously attributed to Dürer and to Baldung (W. 162; see discussion in Osten, *Baldung,* pp. 15–17 and cat. no. 1) and in a drypoint by the Housebook Master (see Amsterdam, *Vom Leben im späten Mittelalter,* p. 138 (full ref. chap. 13, n. 31; W. Rotzler, *Die Begegnung der drei Lebenden und der drei Toten* [Winterthur, 1961]).

12. Baldung had already established this arrangement well before the Basel panel or the 1519 *Fall* in his chiaroscuro *Fall* of 1511 (fig. 147).

13. This echo has been noted by Marrow and Shestack in New Haven, *Baldung,* p. 54 (full ref. chap. 12, n. 9).

14. Reviewing pagan and Christian objections to such transparent veils, Leo Steinberg notes: "The stated objection is not so much to undress, as to the falsehood of fabrics that pretend otherwise. Transparent weaves over bare skin strike ancient censors as instruments of deceit and seduction" (*The Sexuality of Christ in Renaissance Art and in Modern Oblivion* [New York, 1983], p. 147).

15. See the discussion of the Augsburg city ordinance on this issue in Heinrich Kohlhaussen, *Minnekästchen im Mittelalter* (Munich, 1928), p. 45.

16. See also the *Blick aus dem Bilde* in Baldung's 1510 sketch *Eve and the Serpent,* now in Hamburg, fashioned after Dürer's 1504 engraved *Fall* (fig. 131).

17. In Gerald of Wales's *Gemma ecclesiastica,* written about 1200, men are advised to avoid both staring at women and being stared at by women: "Even if your eyes should fall upon a woman you must never fix your gaze." Gerald links the sin of seeing to the Fall: "Eve would not have touched the tree unless she had first gazed upon it heedlessly. We who lead mortal lives much wonder, therefore, how much we ought to guard our sight against illicit object" (*The Jewel of the Church: A Translation of "Gemma Ecclesiastica" by Giraldus Cembrensis,* ed. J. J. Hagen, Davis Medieval Texts and Studies [Leiden, 1979], pp. 182–183; quoted and discussed in Camille, *Gothic Idol,* pp. 304–305 [full ref. chap. 5, n. 25]).

18. New Haven, *Baldung,* p. 121; E. M. Vetter, "Necessarium adae peccatum," *Ruperto-Carola* 18 (1966): 153–154; for similar trends in Netherlandish painting, see also Larry Silver and Susan Smith, "Carnal Knowledge: The Late Engravings of Lucas van Leyden," *Nederlands kunsthistorisch jaarboek* 29 (1978): 239–298; and Larry Silver, "*Figure Nude, Historie e Poesie:* Jan Gossaert and the Renaissance Nude in the Netherlands," *Nederlands kunsthistorisch jaarboek* 37 (1986): 1–40.

19. The closest precedent in Dürer's oeuvre for Baldung's outward-turned Adams is, importantly, the Weimar *Nude Self-Portrait* (fig. 120). The movement from master to student becomes, then, a shift from narcissism, staged as an artist's self-portrait, to heterosexual desire, staged as a plot about the viewer.

20. The satyr reference was first noted by Hans Curjel, *Hans Baldung Grien* (Munich, 1923),

p. 114. In a drawing probably copying a lost painting by Baldung, such satyr's horns are even more in evidence. The sketch, clumsily executed in pen and ink and gray wash, depicts a nude couple posed like Adam and Eve in Baldung's Lugano panel; the man's hair curls in two very obvious tufts (Berlin, Kupferstichkabinett, inv. no. 4992; Bock and Friedländer, *Die Zeichnungen alter Meister im Kupferstichkabinett,* p. 12 [full ref. chap. 1, n. 7]; Bock entitles the drawing, erroneously, "Death and a Nude Woman").

21. *Leien Bibel, in deren fleissig zu samen bracht sind Die Fürnemeren Historien beder Testament mit jren über gesetzten Summarien* (Strasbourg, 1540), fol. A3ᵛ.

22. Sigmund Freud, *Three Essays on the Theory of Sexuality,* trans. and rev. James Strachey and introduced by Steven Marcus (New York, 1975), p. 19.

23. On the postures of Baldung's nudes and their relation to the conventions of mannerism, see Bussmann, *Manierismus im Spätwerk,* pp. 24–25 (full ref. chap. 12, n. 19).

24. See, for example, Hugh of St. Victor, *Didascalion,* ed. J. Taylor (New York, 1961), p. 55; quoted in Camille, *Gothic Idol,* p. 40.

25. Conrad Braun, *De imaginibus . . . adversus Iconoclastas,* in *D. Conradi Bruni opera tria nunc primum aedita* (Mainz, 1548), p. 51; quoted and translated in Steinberg, *Sexuality of Christ,* p. 17n17.

26. Lucas Cranach the Elder's various twin panels of Adam and Eve modeled after the Madrid *Adam* and *Eve* also follow the Dürerian conceit of represented innocence (for example, the *Adam* and *Eve* panels from 1530 in the Norton-Simon Museum in Pasadena).

27. New Haven, *Baldung,* p. 54.

28. For a very similar situation, see Stanley Fish's early and brilliant work of reader-oriented criticism, *Surprised by Sin: The Reader in Paradise Lost* (London, 1967).

29. Quoted in Camille, *Gothic Idol,* p. 304.

30. Ovid, *Metamorphoses,* 15.234–237; trans. Frank Justus Miller (London, 1916).

31. "Der Tod machte sich an Christum, wolt ein mal ein niedlich Bislin verschlingen sperret seinen Rachen weit auff, fras in auch hinein wie alle andere Menschen" (Luther, *Werke,* 23:714).

32. Luther, 12:685.

33. Published in *Archives für deutsche Studien der neueren Sprachen* 167 (1935): 30–35; as quoted in Cohen, *Metamorphosis of a Death Symbol,* p. 30 (full ref. chap. 12, n. 16).

34. In the *Meditation de humana conditione* of Pseudo-Bernard, a text probably composed about 1150 by Hugh of St. Victor and of influence on Pope Innocent III's important diatribe against pride, we read that "man is nothing but fetid sperm, a bag of excrement, and food for worms (see J. P. Migne, *Patrologia cursus completus series Latina,* 221 vols. [Paris, 1844–1864], vol. 184, cols. 485–508; F. Lazzari, "Le *contemptus mundi* chez saint Bernard," *Revue d'ascétique et de mystique* 41 [1965]: 291–304; the passage is quoted and discussed in Delumeau, *Le péché,* pp. 55–56 [full ref. chap. 13, n. 7]). In this text, contempt for the world involves a special repugnance for the act of copulation, and sperm is regarded as a corruption within us akin to excrement and to the festering flesh of the cadaver. These are ideas that inform not only Baldung's images of the corpse, but also his *Death Overtaking the Knight,* where Death attacks with a *Mistgabel,* and his late woodcut *Ejaculating Stallion* (fig. 206).

35. Ernst Guldan *Eva und Maria. Eine Antithese als Bildmotiv* (Graz and Cologne, 1966), p. 115; see also Paul H. Boerlin et al., *Hans Baldung Grien im Kunstmuseum Basel,* exh. cat., Schriften des Vereins der Freunde des Kunstmuseums Basel, 2 (Basel, 1978), p. 16. A different vicissitude of the bitten apple is cheerfully visualized by Martin Schongauer in his print *Christ in Limbo* from the *Engraved Passion* (c. 1470–1475; Lehrs, no. 29 [full ref. chap. 10, n. 3]; also Berlin, Kupferstichkabinett, *Martin Schongauer,* cat. no. 12–11 [full ref. chap. 10, n. 3]): Eve emerges from hell bearing an apple with teeth marks clearly represented on its surface.

36. Osten, *Baldung,* p. 80.

37. Walter Benjamin, *The Origins of German Tragic Drama,* trans. John Osborne (London, 1977), p. 175.

38. *Patrologia Graeca,* vol. 60, col. 727 (full ref. chap. 13, n. 3), as quoted in Delumeau, *Le péché,* p. 50.

39. The metaphor of self-consumption is Stanley Fish's; see his *Self-Consuming Artifacts: The Experience of Seventeenth-Century Literature* (Berkeley, 1972).

40. Benjamin, *Origins,* p. 166.

41. See, for example, Wirth, *La jeune fille,* pp. 61–75 (full ref. chap. 13, n. 10); Osten, *Baldung,* pp. 59–62.

42. Maurice Blanchot, "Two Versions of the Imaginary," originally published in *L'espace littéraire* (1955); trans. Lydia Davis in *The Gaze of Orpheus* (Barrytown, N.Y., 1981), p. 81.

43. Technical studies of the panel are summa-

rized in Robert A. Koch, *Hans Baldung Grien: Eve, the Serpent and Death,* Masterpieces of the National Gallery of Canada, 2 (Ottawa, 1974); more recent interpretations include Wolfgang Hartmann, "Hans Baldungs 'Eva, Schlange und Tod' in Ottawa," *Jahrbuch der Staatlichen Kunstsammlungen in Baden-Würtemberg* 15 (1978): 7–20; A. Kent Hieatt, "Eve as Reason in a Tradition of Allegorical Interpretation of the Fall," *Journal of the Warburg and Courtauld Institutes* 43 (1980): 221–226; and idem, "Hans Baldung Grien's Ottawa *Eve* and Its Context," *Art Bulletin* 65 (1983): 290–304.

44. Hults-Boudreau, "Hans Baldung Grien and Albrecht Dürer," p. 109 (full ref. chap. 12, n. 9).

45. In his study of the Ottawa panel, Hieatt suggests that the theme of metamorphosis, central to the art and self-understanding of the Renaissance, finds here a bizarre expression. Adam becomes Death through the changes of male sexual arousal: "Coincidentally with Eve's manipulation of the [snake's] tail, which emerges suggestively from the direction of Adam's masked midriff, the aroused serpent viciously bites Adam's wrist so as to infect him with the poison of death of which a necessary aspect is arousal of sinful desire" ("Hans Baldung Grien's Ottawa *Eve,*" p. 298).

46. See Augustine, *Contra Julianum,* 4.8.49, discussed in Peter Brown, *The Body and Society: Men, Women, and Sexual Renunciation in Early Christianity* (New York, 1988), p. 408.

47. Erwin Panofsky, *Studies in Iconography: Humanistic Themes in the Art of the Renaissance* (New York, 1972), pp. 72–78; Aby Warburg, *Heidnischantike Weissagung,* pp. 221–231 (full ref. chap. 1, n. 44). See also the wild man with a crutch in Dürer's *Coat of Arms of Death* (Kn. 41).

48. Geisberg, *German Single-Leaf Woodcut,* 2:461; old Geisberg no. 490 (full ref. chap. 5, n. 52).

49. Wirth, *La jeune fille,* pp. 68–70.

50. Wirth, pp. 158–167.

51. Wirth, pp. 151ff.; on Nicodemism, see Theodore Beza, *John Calvin, Tracts and Treatises,* 3 vols. (Edinburgh, 1851), 1:lxxxvii ff.; Carlo Ginsburg, *Il Nicodemismo* (Turin, 1970); Carlos M. N. Eire, "Calvin and Nicodemism: A Reappraisal," *Sixteenth Century Journal* 10 (1979): 45–69; and idem, *War against the Idols: The Reformation of Worship from Erasmus to Calvin* (Cambridge, 1986), pp. 234–275.

52. For which, see Herbert Zschelletzschky, *Die "Drei gottlosen Maler" von Nürnberg—Sebald Beham, Barthel Beham und George Pencz. Historische Grundlagen und ikonologische Probleme ihrer Graphik zu Reformations- und Bauernkreigszeit* (Leipzig, 1971).

53. See Jean Wirth, "Hans Baldung Grien et les dissidents strasbourgeois," in *Croyants et sceptiques au XVI^e siècle: Le dossier des "Epicuriens,"* ed. Marc Lienhard (Strasbourg, 1981), p. 136.

54. Lucien Febvre, *The Problem of Unbelief in the Sixteenth Century: The Religion of Rabelais,* trans. Beatrice Gottlieb (Cambridge, 1982).

55. Delumeau, *Le péché,* p. 124.

56. I am reminded here of a remark by Erasmus concerning the false allure of arcane learning: "How is it that people give themselves so much trouble about the details of all sorts of remote philosophical systems and neglect to go to the sources of Christianity itself?" quoted in Johan Huizinger, *Erasmus and the Ages of Reform,* trans. F. Hopman [Princeton, 1984]).

57. In both his 1512 Berlin *Crucifixion* (O. 16) and the *Crucifixion* on the rear of his great 1516 *Freiburg Altarpiece* (O. 26h), Baldung displays the skull of Adam prominently in the foreground and tilts it so that its eye sockets seem to gaze up at the downturned face of Christ. And in the Basel *Crucifixion* of 1512 (O. 17) Adam's skull, upon which sits a trompe l'oeil fly, appears at the base of the cross and just below a *cartellino* with Baldung's name, monogram, and the picture's date.

Chapter Fifteen

1. Adam's gaze is, however, curiously akin to Dürer's in the Weimar *Nude Self-Portrait,* that uncanny bridge between the two artists.

2. Baldung's desire for originality is not only a legacy of Dürer. When the painters' guild of Baldung's native Strasbourg proposed new statutes for itself in 1516, it attempted to stipulate that the masterpiece, required for master status in the guild, be not only skillfully made, but also original: "Item, the candidate shall make his masterpiece an independently designed one, without using any model pattern, but rather out of his own intelligence and skill; for such a one as makes the masterpiece in this way is one who can also make others after it, which may then be proper to him" (Hans Rott, *Quellen und Forschungen zur südwestdeutschen und schweizerischen Kunstgeschichte im 15. und 16. Jahrhundert,* vol. 3, *Oberrhein* [Stuttgart, 1938], Quellen 2, pp. 221–222; cited and trans. in Baxandall, *Limewood Sculptors,* p. 123 [full ref. chap. 8, n. 56]). Not all guild

members agreed with this clause. They argued that there was nothing wrong with copying and emulating the art of the "forefathers." Baxandall has usefully distinguished the terms of this artisanal debate from those of "humanist neo-classical art criticism" such as we find in Dürer (*Limewood*, p. 124; and idem, "Rudolf Agricola and the Visual Arts," in *Intuition und Kunstwissenschaft. Festschrift für Hanns Swarzenski* [Berlin, 1973], pp. 409–419). Yet the 1516 debate, carried out while Baldung was absent from Strasbourg, signals a broad-based awareness of the notion of an original.

3. The identification of the Basel panel as a scene of *Der Tod und die Wollust*, occurs already in Erwin Panofsky, *Herkules am Scheidewege und andere antike Bildstoffe in der neueren Kunst*, Studien der Bibliothek Warburg, 18 (Leipzig, 1930), p. 55n3; see also C. Cieri Via, "Il tema della vanitas nell'opera di Hans Baldung Grien," *Annuario dell'Istituto de storia dell'arte*, 1974–1976, pp. 125–144; Osten, *Baldung*, p. 151.

4. Jacob Locher, *Stultifera Navis* (Basel, 1497), fol. 131. Brant's German text refers only to a choice between the paths of virtue and of vice; Locher adds the story of Hercules, known to him mainly from Xenophon (*Memorabilia*, 2.1.21ff.) and Prodikos, which he entitles "Concertatio virtutis cum voluptate." See Friedrich Zarnecke, ed., *Sebastian Brants Narrenschiff* (Leipzig, 1854), pp. 213 and 454.

5. Brant's German text reads: "Die eyn was aller wollust vol / Vnd hübsch geziert, mit reden süsz / Grosz lust vnd freüd sie jm verghiesz / Der end doch wer der dot mit we / Dar noch keyn freüd, noch wollust me" (*Narrenschiff*, 107, lines 24–28). Note that in the illustration the corpse is visible to the viewer but out of Hercules' line of sight.

6. Panofsky, *Herkules am Scheidewege*, pp. 39–42 and passim; see also Dieter Wuttke, *Die "Histori Herculis" des Nürnberger Humanisten und Freundes des Gebrüder Vischer, Pangratz Bernhaubt gen. Schwenter. Materien zur Erforschung des deutschen Humanismus um 1500*, Beihefte zum Archiv für Kulturgeschichte, 7 (Cologne, 1964), pp. 130–132.

7. Geiler's *Narrenschiff* sermons, delivered each Sunday (and daily from Ash Wednesday to Easter Sunday) between February 28, 1498, and April 21, 1499, were well attended and enormously influential. They depended on the 1494 Strasbourg edition, published by Johann Grüninger, and on Locher's Latin translation (see Zarncke, *Sebastian*

Brants Narrenschiff, pp. lxxviii–lxxix, 250–254, 454; a Latin version of these sermons, edited by Jacob Otther, was published by Matthias Schürer under the title *Nauicula seu speculum fatuorum* [Strasbourg, 1510]).

8. Paul Ricoeur, "'Original Sin': A Study in Meaning," in *The Conflict of Interpretations: Essays in Hermeneutics*, trans. Peter McCormick and ed. Don Ihde, Northwestern University Studies in Phenomenology and Existential Philosophy (Evanston, Ill., 1974), p. 273. See also Ricoeur's remarkable account of the "Adamic" myth in *The Symbolism of Evil*, trans. Emerson Buchanan (Boston, 1967).

9. Ricoeur, "'Original Sin,'" p. 278.

10. Ricoeur, p. 284.

11. Iser, *Act of Reading*, p. 34 (full ref. preface, n. 4); see also idem, *The Implied Reader: Patterns of Communication in Prose Fiction from Bunyan to Beckett* (Baltimore, 1974). Iser's *Wirkungstheorie* helps to redirect interpretation from an analysis of what images or texts mean to how they mean, yet it does not adequately ground its material in history. The changing status of interpretation, which is the underlying theme of this chapter, is an expression of what Hans-Georg Gadamer termed the "historicity of understanding"—that is, the fact that the conception of meaning and interpretation per se undergoes historical change (*Wahrheit und Methode*, pp. 250–290 (full ref. preface, n. 4); the origin of this position is Heidegger, *Sein und Zeit*, pp. 335–338 [full ref. chap. 13, n. 2]).

12. Paul de Man wrote usefully of the reader "in" the text: "The necessary presence of the moment of utterance and of the interpretative moment of understanding has nothing to do with the empirical situation naïvely represented in this scene: the notions of audience and of narrator that are part of any narrative are only the misleading figuration of a linguistic structure. And just as the indeterminacy of reference also generates the illusion of a subject, a narrator, and a reader, it also generates the metaphor of temporality. A narrative endlessly tells the story of its own denominational aberration and it can only repeat this aberration on various levels of rhetorical complexity. Texts engender texts as a result of their necessary aberrant semantic structure; hence the fact that they consist of a series of repetitive reversals that engenders the semblance of a temporal sequence" (*Allegories of Reading: Figural Language in Rousseau, Nietzsche, Rilke, and Proust* [New Haven, 1979], p. 162). The move-

ment from Dürer to Baldung, observed as a transformation of the self-portrait of the artist into the figure of the viewer, reflects a "repetitive reversal" of the specular, rather than linguistic, structure of images.

13. See Jacques Lacan's reading of the icon of Christ, in *The Four Fundamental Concepts of Psychoanalysis*, ed. Jacques-Alain Miller and trans. Alan Sheridan (Harmondsworth, 1977), p. 113.

14. Wilhelm Pinder, *Vom Wesen und Werden deutscher Form*, vol. 2, *Die Kunst der ersten Bürgerzeit* (Leipzig, 1937), pp. 199–205; Ernst Michalski, *Die Bedeutung der ästhetischen Grenze für die Methode der Kunstgeschichte* (Berlin, 1932), as discussed in Kemp, *Anteil des Betrachters*, pp. 24–26 (full ref. preface, n. 11); Fried, *Theatricality and Absorption* (full ref. chap. 12, n. 28); Belting, *Bild und Kult*, pp. 457–509 (full ref. chap. 5, n. 1).

15. Baldung became master in the guild Zur Steltz (the guild of goldsmiths, printers, painters, and glaziers) sometime between April 17, 1509, when he was granted citizenship in Strasbourg, and October 31, 1510, when he is mentioned in a document as "Meister Hans Baldung" (Osten, *Baldung*, p. 289; doc. nos. 1–2). The best treatments of Baldung's witches are Gustav Radbruch, "Hans Baldungs Hexenbilder," in *Elegantiae juris criminalis*, 2d ed. (Basel, 1950), pp. 30–48; Hartlaub, *Hans Baldung Grien. Hexenbilder* (full ref. chap. 13, n. 23); Sigrid Schade, *Schadenzauber und die Magie des Körpers. Hexenbilder der frühen Neuzeit* (Worms, 1983); and Linda C. Hults, "Baldung and the Witches of Freiburg: The Evidence of Images," *Journal of Interdisciplinary History*, 1987, pp. 249–276. The literature on witches and witchhunting in early modern Germany is vast and contentious. Guidance and useful bibliographies are given by H. C. Erik Midelfort, "Recent Witch Hunting Research, or Where Do We Go from Here?" *Papers of the Bibliographical Society of America* 62 (1968): 373–420; and idem, "Witchcraft, Magic, and the Occult," in *Reformation Europe: A Guide to Research*, ed. Steven E. Ozment (St. Louis, 1982), pp. 183–210. The classic modern work on witchcraft is still Julio Caro Baroja, *The World of the Witches*, trans. O. N. V. Glendenning (Chicago, 1965); a more up-to-date and very readable introduction is Brian P. Levack, *The Witch-Hunt in Early Modern Europe* (London, 1987).

16. Baldung's earlier uses of a monogram are on the *St. Sebastian Altarpiece* of 1506–1507, signed HG on the ground below the saint (fig. 141),

and an *Unequal Couple* engraving, dated 1507 and also signed HG (M. 547).

17. New Haven, *Baldung*, cat. no. 18 (full ref. chap. 12, n. 9).

18. Baldung could have also learned this technique from Lucas Cranach the Elder, who used it by 1509, if not earlier. On the origins of the chiaroscuro woodcut, see Anton Reichel, *Die Clair-obscur-Schnitte des xvi, xvii und xviii Jahrhunderts* (Zurich, Leipzig, and Vienna, 1926); Hind, *Introduction to a History of Woodcut*, 1:23, 49–51 (full ref. chap. 10, n. 5); Walter Strauss, *Chiaroscuro: The Clair-Obscur Woodcuts by the German and Netherlandish Masters of the XVIth and XVIIth Centuries* (New York, 1975).

19. "Was sagstu uns aber von den weibern, die zu nacht faren und so si zusamen kumen? . . . Nun zum ersten sprich ich, das sie hin und her faren und bliben doch an einer stat, aber sie wenen sie faren, wan der teuffel kan inen ein schein also in kopff machen und also ein fantasey, das die nit anders wenen, dan sie faren allenthalben, und wenen sie geen beieinander und bei anderen frauwen und tantzen und springen und essen" (Joseph Hansen, *Quellen und Untersuchungen zur Geschichte des Hexenwahns und der Hexenverfolgung im Mittelalter* [Bonn, 1901], pp. 284–285, no. 58; Johann Geiler von Kayserberg's 1508 Lenten sermons were published by Johann Grieninger as *Die Emeis. Dies ist das buch von der Omeissen* [Strasbourg, 1516]). In the 1516 Strasbourg edition of the *Emeis*, this passage on the reality of witches' flight is illustrated by a woodcut of witches probably executed in Baldung's shop (fol. 37; Hansen 284n2). Baldung designed woodcut illustrations for a number of Geiler's works; see Maria Consuelo Oldenbourg, *Die Buchholzschnitte des Hans Baldung Grien. Ein bibliographisches Verzeichnis ihrer Verwendung*, Studien zur deutschen Kunstgeschichte, 335 (Baden-Baden, 1962), L. 16, 24, 78, and 120.

20. Hansen, pp. 287–288. On the history of the belief in witches' flight, see Norman Cohn, *Europe's Inner Demons: An Enquiry Inspired by the Great Witch Hunt* (New York, 1975), pp. 210–219.

21. The most succinct account of this "systematic mythology of Satan's kingdom and Satan's accomplices [built] out of the mental rubbish of peasant credulity and feminine hysteria [*sic*]" is H. R. Trevor-Roper, *The European Witch-Craze of the Sixteenth and Seventeenth Centuries and Other Essays* (New York, 1969), pp. 93–97, 116–118.

22. The historians most responsible for this

understanding of witchcraft are Cohn (*Europe's Inner Demons*) and Richard Kieckhefer, *European Witch Trials: Their Foundations in Popular and Learned Culture, 1300–1500* (London, 1976).

23. Joseph Hansen, *Zauberwahn, Inquisition und Hexenprozeß im Mittelalter und die Entstehung der großen Hexenverfolgerung* (Munich and Leipzig, 1900), p. v.

24. On the effect of torture on the documentary record, see Trevor-Roper, *European Witch-Craze*, pp. 118–128 and passim.

25. See the review of this literature in Midelfort, "Recent Witch Hunting Research." A recent revival of this position is Jeffrey B. Russel, *Witchcraft in the Middle Ages* (Ithaca, 1972).

26. Margaret A. Murray, *The Witch Cult in Western Europe* (Oxford, 1921), *The God of the Witches* (London, 1933), and *The Divine King of England* (London, 1954). The work of Carlo Ginzburg has lent some support to Murray's contention that witchcraft had its roots in an ancient fertility cult. However, Ginzburg modifies her thesis "that the sabbat described in witchcraft trials referred to gatherings which had actually taken place" (*The Night Battles: Witchcraft and Agrarian Cults in the Sixteenth and Seventeenth Centuries*, trans. John Tedeschi and Anne Tedeschi [London, 1983], p. xiii; see also Ginzburg's more recent study, *Ecstasies: Deciphering the Witches' Sabbath*, trans. Raymond Rosenthal [New York, 1991]).

27. For example, Elliot Rose, *A Razor for a Goat* (Toronto, 1962), and many of the essays collected by Claudia Honecker in *Die Hexen der Neuzeit* (Frankfurt, 1978). See Gerhard Schormann's criticism of Honecker in *Hexenprozesse in Deutschland*, Kleine Vandenhoeck-Riehe, 1470 (Göttingen, 1981), pp. 116–122.

28. Levack, *Witch-Hunt*, pp. 13 and 17; Kieckhofer, *European Witch Trials*, chaps. 3 and 5.

29. This point is made by Ginzburg, *Night Battles*, p. xvi.

30. Mariam Usher Chrisman, *Bibliography of Strasbourg Imprints, 1480–1599* (New Haven, 1982), C3.2.1–31; C5.1.11–12.

31. Thomas Murner, *Tractatus de phitonico contractu* (Freiburg im Breisgau, 1499); Hansen, *Quellen*, p. 254, no. 49.

32. Schade, *Schadenzauber*, p. 53.

33. Heinrich Kramer or Institoris (his Latin name) and Jacob Sprenger had been inquisitors in southern Germany and the Rhineland since the early 1470s. When their efforts to prosecute witches met resistance from local ecclesiastical and secular authorities, they obtained a bull from Pope Innocent VIII in 1484 authorizing them to proceed. On the *Malleus maleficarum* and its authors, see Hansen, *Quellen*, pp. 360–407; Sydney Anglo, "Evident Authority and Authoritative Evidence: The *Malleus Maleficarum*," in *The Damned Art: Essays in the Literature of Witchcraft*, ed. Sydney Anglo (London, 1977), pp. 1–31. The *Malleus maleficarum* has been translated into English by Montague Summers (London, 1928); all my quotations from the *Malleus* are from this translation.

34. Hansen, pp. 243–246, no. 47; discussed in Schade, *Schadenzauber*, pp. 25–32.

35. The *Witches' Sabbath*, monogrammed and dated 1506, now in the Louvre (Inv. no. 18.867); see New Haven, *Baldung*, p. 115.

36. Brady, "Social Place," p. 303 (full ref. chap. 12, n. 9).

37. Brady, p. 303.

38. The role of the universities in developing the mentality of the witch craze is stressed by Schormann, *Hexenprozesse*, pp. 34–51 and passim.

39. The evidence is assembled in Kieckhofer, *European Witch Trials*, pp. 18–26. The "climax of the European witch-craze" was the 1620s (Trevor-Roper, *European Witch-Craze*, p. 83).

40. For example, the case of Hans Schoch, executed for weather sorcery in 1451; in August Stöber, "Die Hexenprozesse in Elsaß, besonders im 16. und im Anfange des 17. Jahrhunderts," *Alsatia, Jahrbuch für elsässische Geschichte, Sage, Sitte und Sprache*, 1856–1857, p. 306.

41. Philippe Dollinger, "La tolérance à Strasbourg au XVIe siècle," in *Hommage à Lucien Febvre. Eventail de l'histoire vivante* (Paris, 1953), pp. 246ff.; Schade, *Schadenzauber*, p. 53.

42. Chrisman, *Lay Culture and Learned Culture*, p. xxiii (full ref. chap. 10, n. 63).

43. Hansen, *Quellen*, p. 608, no. 215; and Stöber, "Die Hexenprozesse," p. 305. Stöber cites Theiler, "Notices sur les procédures criminalles etc. dans l'évêché de Strasbourg," in *Hinterlassene Schriften*, p. 77; I have been unable to track down this source.

44. "Daz, das die hexen oder unholden thuon, dasselbig ist nit ein anfenklich wirklich ursach desselben, daz da geschicht; es ist nit me denn ein zeichen; wen der teufel das zeichen sicht und die wort hört, so weisz er, was sie gern hetten; der thut denn dazselbig, und der teuffel thut es, und nit sie" (Hansen, *Quellen*, p. 287; quoted also in Schade, *Schadenzauber*, p. 60).

45. Schade, *Schadenzauber*, pp. 59–62.

46. Kramer and Sprenger, *Malleus maleficarum*, pp. 41–48.

47. Hansen, *Quellen*, p. 288.

48. Christina Larner, *Enemies of God: The Witch-Hunt in Scotland* (London, 1981), pp. 89–102. The much higher estimates of as many as nine million executions (e.g., Andrea Dworkin, *Woman Hating* [New York, 1974], p. 130, and Wanda von Bayer-Katte, "Die historische Hexenprozesse. Der verbürokratisierte Massenwahn," in *Massenwahn in Geschichte und Gegenwart*, ed. W. Bitter [Stuttgart, 1965], p. 222), have been rejected by most scholars; see Levack, *Witch-Hunt*, pp. 19–22.

49. Cohn, *Europe's Inner Demons*, p. 248.

50. Dürer, in the Netherlands Diary, refers to Baldung both as "Hans Grun" and as "Grünhans" (Dürer, *Schriftlicher Nachlaß*, 1:167, 175). One likely origin of the nickname lies in the circumstances of Dürer's shop. In the years of Baldung's apprenticeship (1503–1507), there were at least four people in Dürer's house with the same name: Dürer's brother Hans, Hans Schäufelein, Hans Süss von Kulmbach, and Hans Baldung. However we interpret its meaning, the appendage "Grien" or "Grün" would have been useful in this situation.

51. Radbruch, "Hans Baldungs Hexenbilder," p. 44n51.

52. On the basis of its slightly stiff draftsmanship, Carl Koch, following Otto Benesch (Vienna, Albertina, *Hans Baldung-Grien. Gedächtnisausstellung zur 450. Wiederkehr seines Geburtsjahres*, exh. cat. [Vienna, 1935]), regards the Albertina drawing as a workshop copy of a lost Baldung original (Koch, *Die Zeichnungen*, p. 100). From Urs Graf's Albertina version of an original in the Louvre (K. A 16 and K. 63), we know that Baldung's chiaroscuro witch drawings were already being copied during the mid-1510s and that these copies could be quite faithful to the original. I tend to agree with the attribution of this drawing to Baldung's shop. While emphasizing the speed and agility of an individual artist's hand, color ground drawings were often faithfully replicated, sometimes by their "original" producer; see, for example, the two almost identical versions of *Samson and the Lion*, both executed by Albrecht Altdorfer in black and white ink on greenish-brown ground (both are now in the Kupferstichkabinett in Berlin [inv. 86 and 87]).

53. Kramer and Sprenger, *Malleus maleficarum*, pp. 225 and 228. For a discussion of the evil eye or *fascinum* in the popular lore of witches, see Baroja, *World of the Witches*, p. 38.

54. In the Albertina sheet, the line is somewhat less fluid and diverse than in the chiaroscuro sketches solidly attributed to Baldung's own hand, particularly in the hatching. Yet the remarkable quality of the drawing suggests that, if indeed it is a shop copy, Baldung's assistants have been well trained in their master's personal style.

55. See my discussion of Manuel in chapter 16; on Urs Graf, see Christian Andersson, *Dirnen—Krieger—Narren: Ausgewählte Zeichnungen von Urs Graf* (Basel, 1978).

56. According to the *Malleus*, the devil himself made a clear distinction between a witch who is old and sterile and one who is not. With the former, his carnal embraces are "without the injection of semen, since it would be of no use"; with the latter "he approaches her in the way of carnal delectation . . . [and] for the sake of infecting her progeny" (Kramer and Sprenger, *Malleus maleficarum*, p. 112).

57. An interesting precedent for such a frank display of the female genitals is the so-called *Sheela-na-Gig*, common in medieval sculpture of the British Isles (for which see Jørgen Andersen, *The Witch on the Wall* [Copenhagen and London, 1977]).

58. Sigrid Schade has noted that images of female witches often suggest male fantasies of female autoeroticism (*Schadenzauber*, p. 74). I am grateful to Rachel Perry for her well-argued insistence on this reading of Baldung's sheet.

59. "Ein mensche wirt in sunden enpfangen, mit vnreinem, vngenantem vnflat in muterlichem leibe generet . . . ein ganzer vnlust, ein kotfass, ein vnreine speise, ein stankhaus, ein vnlustiger spulzuber, ein faules as, ein schimelkaste, ein bodenloser sack, . . . ein vbelriechender harnkrug, ein vbelsmeckender eimer" (Konrad Burdach, *Vom Mittelalter zur Reformation*, vol. 3, *Der Ackermann aus Böhmen. Einleitung, Kritischer Texts, Vollständiger Leseartenapparat, Glossar, Kommentar*, ed. Alois Bernt and Konrad Burdach [Berlin, 1917], 1:55). On attitudes toward women in the Renaissance generally, see Ian Maclean, *The Renaissance Notion of Woman: A Study in the Fortunes of Scholasticism and Medical Sciences in European Intellectual Life* (Cambridge, 1980); recent literature is summarized in Joyce Irwin, "Society and the Sexes," in Ozment, *Reformation Europe*, pp. 343–359 (full ref. chap. 4, n. 46).

60. Leonhard Culman, *Ein schön weltlich spil / von der schönen Pandora / auß Hesiodo dem kriecheschen Poeten gezogen,* discussed in G. Vogel, "Der Mythos von Pandora. Die Rezeption eines griechischen Sinnbildes in der deutschen Literatur" (Ph.D. diss., University of Hamburg, 1972), pp. 34–35; cited in Schade, *Schadenzauber,* pp. 98–99. According to Erwin and Dora Panofsky, it was Erasmus (*Adagiorum chiliades tres* [Venice, 1508], 1.233) who replaced the large jar or *pithos,* mentioned in Hesiod's account of Pandora, with a box or *pyxis* (*Pandora's Box: The Changing Aspects of a Mythical Symbol,* 2d ed. rev. and exp. [New York, 1962], pp. 14–26). The older image of the jar survived longer in Italy (it appears, for example, in Lorenzo de' Medici's poem "Selve d'amore"; see Vogel, pp. 21ff.; Schade, p. 99), but seems to have been known to Baldung. The allegorization of woman as Pandora is, of course, just a variant of the identification of woman with flesh. As Erasmus writes in the *Enchiridion,* "Keep in mind that 'woman' is man's sensual part: she is our Eve, through whom that wiliest of serpents lures our passions into deadly pleasure"—the serpent being at once lust and the uncontrollable member, the penis (*Enchiridion,* 2; trans. Himelick, p. 39 [full ref. chap. 14, n. 10]).

61. Panofsky and Panofsky, pp. 11–13.

62. The legend originated in the East and became associated with Virgil in the thirteenth century. See Domenico Comparetti, *Vergil in the Middle Ages,* trans. E. F. M. Benecke (London, 1895); E. Müntz, "Etudes iconographiques. La légende du sorcier Vérgile dans l'art des 14e, 15e et 16e siècles," *Monatsberichte über Kunstwissenschaft und Kunsthandel,* 1902, pp. 85ff.; J. W. Spago, *Virgil the Necromancer,* Harvard Studies in Comparative Literature, 10 (Cambridge, 1934); David Ross, "Allegory and Romance in a Medieval French Marriage Casket," *Journal of the Warburg and Courtault Institutes* 11 (1948): 120–125; Schade, *Schadenzauber,* pp. 102–107.

63. Schade, pp. 106 and 151n483. Urs Graf's *Witches' Sabbath* copy after Baldung is now in the Albertina in Vienna (K. A 16). Interestingly, on the water bottle at the far left of the sheet, Graf replaces Baldung's Freiburg coat of arms with the coat of arms of Basel. Both artists' local allegiances are thus inscribed on the witches' equipment.

64. Kramer and Sprenger, *Malleus maleficarum,* pp. 121–122.

65. This case is discussed in the thirteenth-century *Summa confessorum* of Thomas Chobham (ed. F. Broomfield [Leuven and Paris, 1968], as cited in Marie-Christine Pouchelle, *Body and Surgery in the Middle Ages* [London, 1990], p. 195).

66. Cohn, *Europe's Inner Demons,* p. 240.

67. E. Hoffmann-Krayer, "Luzerner Akten zum Hexen- und Zauberwisen," *Schweizerisches Archiv für Volkskunde* 3 (1899): 117–121; translated and discussed in Cohn, p. 240.

68. Pouchelle, *Body and Surgery,* pp. 180–191 and passim. On the long history of the androcentric, one-sex body, in which women's anatomy is modeled as that of an inverted man and therefore as a lower expression of the normative male facies, see Thomas Laqueur's *Making Sex: Body and Gender from the Greeks to Freud* (Cambridge, Mass., 1990).

69. Pouchelle, p. 191.

70. Robert Stiassny, "Baldung Griens Zeichnungen," *Zeitschrift für bildende Kunst,* n.s., 9 (1897–1898): 54; Radbruch, "Hans Baldungs Hexenbilder," p. 44; Koch, *Die Zeichungen,* p. 102; Karlsruhe, *Hans Baldung Grien,* cat no. 144 (full ref. chap. 12, n. 9.)

71. Pliny, *Natural History,* 7.15.46–65; trans. H. Rackham (Cambridge, Mass., 1942), 2:549.

72. Larner, *Enemies of God,* p. 93; Larner quotes a sixteenth-century English translation of the *Natural History* cited in P. Shuttle and P. Redgrove, *The Wise Wound* (London, 1978), pp. 221–222.

73. Laqueur, *Making Sex,* p. 40.

74. Pouchelle, "Des peaux de bêtes," pp. 417–418 (full ref. chap. 8, n. 29); idem, *Body and Surgery,* pp. 166–167.

75. Kramer and Sprenger, *Malleus maleficarum,* p. 228; discussed in Hartlaub, *Hans Baldung Grien,* p. 16.

76. For example, roughly one-half of the witchcraft cases heard on appeal at the Parlement of Paris involved accusations of magical healing (A. F. Soman, "The Parlement of Paris and the Great Witch Hunt (1565–1640)," *Sixteenth Century Journal* 9 [1978]: 43). A similar proportion is evidenced in Switzerland, Austria, Schleswig-Holstein, and elsewhere (Levack, *Witch-Hunt,* pp. 126–128). Larner usefully describes the division between professional medicine and "folk" healing as a split between the official and the unofficial: "Official healing was that sanctioned by the emergent professional associations and taught in the universities. Official healing was "scientific." This is not to say that official healers had got their

facts right in terms of twentieth-century positivist science; it is merely to say that scientific healing in this period was based upon current physical knowledge and was susceptible to intellectual discussion and experiment within the current paradigm" (*Enemies of God,* p. 139).

77. Kramer and Sprenger, *Malleus maleficarum,* p. 99.

78. As Thomas Laqueur writes of the woodcut illustrations to Ryff's *Anatomi,* "The history of the representation of the anatomical differences between man and woman is thus extraordinarily independent of the actual structures of these organs or of what was known about them. Ideology, not accuracy of observation, determined how they were seen and which differences would matter" (*Making Sex,* p. 88).

79. Kramer and Sprenger, *Malleus maleficarum,* p. 44.

80. Kramer and Sprenger, p. 47.

81. Kramer and Sprenger, p. 114.

82. That there exist several faithful copies of Baldung's chiaroscuro witch drawings—including, perhaps, the 1514 Albertina sheet (fig. 159)—testifies to the demand for these precious handmade objects. As with Dürer, a valorization of the unique "original" can elicit simultaneously an industry of perfect handmade copies.

83. I take this phrase from the 1522 *Sendschreiben,* in which Franz von Sickingen notes the distracting nature of images in Christian worship and advises that they be placed instead *in schönen Gemächern und zur Zierde* (quoted in Martin Warnke, "Durchbrochene Geschichte? Die Bilderstürme der Wiedertäufer in Münster," in *Bildersturm. Die Zerstörung des Kunstwerks,* ed. Martin Warnke [Munich, 1973], p. 73).

84. The Albertina sheet's inscription suggests it was a personal gift from Baldung to the cleric.

85. Two years earlier, just after his arrival in Freiburg in 1512, Baldung created a more orthodox New Year's greeting. The chiaroscuro drawing *Christ and Doubting Thomas,* now in Strasbourg, bears the inscription "HBG 1512 EIN GUT NW JAR" and probably refers to St. Thomas's Day (December 21), before Christmas, at the end of the ecclesiastical year (K. 30).

86. As Sigrid Schade maintains (*Schadenzauber,* p. 114).

87. On the Feast of Fools, see Sedlmayr, *Die Entstehung der Kathedrale,* pp. 44–45 (full ref. chap. 5, n. 58); Peter Burke, *Popular Culture in Early Modern Europe* (New York, 1978), p. 192; and

Bakhtin, *Rabelais,* pp. 74–75 (full ref. chap. 9, n. 26). The literature on carnival and on its inversions of official culture and hierarchy is large. In addition to Bakhtin and the growing critical literature on his work, some starting points are Roger Caillois, *Man and the Sacred,* trans. Meyer Barasch (Glencoe, Ill., 1959); Jean Duvignaud, *Le don du rien: Essai d'anthropologie de la fête* (Paris, 1977); and Burke, pp. 178–204. Maria Corti's "Models and Antimodels in Medieval Culture" (*New Literary History* 10 [1979]: 339–366) applies, with great success, the Marxist semiotics of Jurij Lotman to link medieval parody and inversion to social modeling. The most exciting and useful attempt to make carnival into a key term for cultural poetics is Peter Stallybrass and Allon White, *The Politics and Poetics of Transgression* (London, 1986). I would note that, in his original colophon to the *Ship of Fools,* Brant linked his work's publication to a festive calendar date: "Printed in Basel on Shrovetide, which is called the fools' church holiday, in the year after Christ's birth thousand four hundred and ninety-four. 1.4.9.4" (*Gedruckt zu Basel vff die Vasenaht / die man der narren kirchwich nennet / Im jor noch Christi geburt Tusent vierhundert vier vnd nüntzig / .1.4.9.4*).

88. See Curtius, *European Literature,* pp. 94–98 (full ref. chap. 5, n. 84); and Barbara A. Babcock, ed. *The Reversible World: Symbolic Inversion in Art and Society* (Ithaca, N.Y., 1978), especially Babcock's "Introduction" and the essay by David Kunzle, "World Upside Down: The Iconography of a European Broadsheet Type," pp. 39–94.

89. Paul Heitz, *Neujahrswünsche des xv. Jahrhunderts,* Drucke und Holzschnitte des xv. und xvi. Jahrhunderts in getreuer Nachbildung, 3 (Strasbourg, 1900). The practice of giving gifts to family, friends, and members of the church is very old; most of the duc de Berry's fabulous *joyaux* and manuscripts were New Year's gifts (see Meiss, *French Painting in the time of Jean de Berry,* pp. 48–50 (full ref. chap. 5, n. 95).

90. Bakhtin, *Rabelais,* pp. 13 and 85. Also Paul Lehmann, *Die Parodie im Mittelalter,* 2d ed. (Stuttgart, 1963); Sander L. Gilman, *The Parodic Sermon in European Perspective: Aspects of Liturgical Parody from the Middle Ages to the Twentieth Century,* Beiträge zur Literatur des XV. bis XVIII. Jahrhunderts, 6 (Wiesbaden, 1974).

91. See the 1482 German calendar illustration showing a couple in a garden of love reproduced in Heitz, *Neujahrswünsche,* cat. no. 28. On New Year's poems, see J. A. Schmeller, *Das Bayerische*

Wörterbuch, 2d ed., ed. K. Frommann (Munich, 1872), cited in Heitz, p. 8.

92. Dürer's topsy-turvy putto (possibly inspired by the Housebook Master's drypoint *Coat of Arms with a Peasant Standing on His Head* as well as the Master b x g's *Two Playing Children* [both reproduced in Amsterdam, *Von Leben im späten Mittelalter,* cat. no. 88 and cat. no. 61 figure c 1; full ref. chap. 13, n. 31]) also appears in the foreground of Baldung's *Madonna and Child with Angels in a Landscape* from 1511 (M. 20) and, earlier, in the Basel drawing *Virgin with Child and a Putto* from 1504 (K. 4). For a good discussion of the iconography of Dürer's engraved *Witch,* see Anzelewsky, *Dürer-Studien,* pp. 101–116 (full ref. chap. 4, n. 40).

93. The iconography of this motif is studied in Ruth Mellinkoff, "Riding Backwards: Theme of Humiliation and Symbol of Evil," *Viator* 4 (1973): 153–176.

94. On this theme and its relation to the topsy-turvy world of carnival, see Natalie Zemon Davis, *Society and Culture in Early Modern France* (Stanford, 1975), pp. 124–151.

95. Radbruch, "Hans Baldungs Hexenbilder," p. 44.

96. Bernt Moeller, "Frömmigkeit in Deutschland um 1500," *Archiv für Reformationsgeschichte* 56 (1965): 5–31; Schade, *Schadenzauber,* pp. 112–118.

97. Taylor, *Sources of Self,* pp. 216–217 (full ref. chap. 1, n. 42).

98. For example, the affair between a prior named Hieronymus Tetzel and a nun of the Dominican cloister in Engelthal (Schubert, *Lazarus Spenger,* pp. 132–134 [full ref. chap. 8, n. 21]; Ozment, *Reformation in the Cities,* pp. 59–61; Miriam Usher Chrisman, *Strasbourg and the Reform: A Study of the Process of Change,* Yale Historical Publications, Miscellany 87 [New Haven, 1967], p. 69), and the scandal concerning Johannes Hänlein and Barbara Schleiffer (Hutchison, *Dürer,* p. 117 [full ref. chap. 1, 59]).

99. See François Wendel, *Le mariage à Strasbourg à l'époque de la réforme, 1520–1692,* Collection d'études sur l'histoire du droit et des institutions de l'Alsace, 4 (Strasbourg, 1928), pp. 22–23; Chrisman, *Strasbourg,* pp. 131–133.

100. Strasbourg was pivotal in the struggle over whether married priests should preach to the laity and administer the sacraments. The city's key reformer, Martin Bucer, was married before he reached Strasbourg in 1523; and Anton Firn, preacher at Strasbourg, announced his marriage from the pulpit of St. Thomas's in 1523 (Chrisman, *Strasbourg,* pp. 132–133; Adolf Baum, *Magistrate und Reformation in Straßburg bis 1529* [Strasbourg, Heitz, 1887], pp. 34–36; for the general question of Reformation attitudes toward marriage see Waldemar Kawerau, *Die Reformation und die Ehe. Ein Beitrag zur Kulturgeschichte des 16. Jahrhunderts* [Halle, 1892]); Olavi Lähteenmäki, *Sexus und Ehe bei Luther* (Turku, 1955); Klaus Suppan, *Die Ehelehre Martin Luthers* (Salzburg, 1971); Steven Ozment, *When Fathers Ruled: Family Life in Reformation Europe* (Cambridge, Mass., 1983), pp. 1–99; and Moxey, *Peasants,* pp. 122–124 (full ref. chap. 10, n. 16).

101. See I. A. Richards's still-useful remarks in *Practical Criticism: A Study in Judgment* (London, 1929), pp. 182–184. German satirical literature of the sixteenth century is usefully introduced, with up-to-date bibliographies, by Barbara Könneker, *Satire im 16. Jahrhundert. Epoche—Werke—Wirkung,* Arbeitsbücher zur Literaturgeschichte (Munich, 1991).

102. On the Master E. S.'s *Figure Alphabet,* see Munich, *Meister E. S.,* pp. 90–94 (full ref. chap. 5, n. 67); on its medieval precedents, see Otto Pächt, *Book Illumination in the Middle Ages: An Introduction,* trans. Kay Davenport (New York and London, 1986), pp. 45–95, cat. no. 122. The letters *g* and *m* also satirize monks and nuns.

103. See Keith P. F. Moxey, "Master E. S. and the Folly of Love," *Simiolus* 11 (1980): 125–148; T. Vignau-Wilberg, "Höfische Minne und Bürgermoral in der Graphik um 1500," in *Wort und Bild in der niederländischen Kunst und Literatur des 16. und 17. Jahrhunderts* (Erfstadt, 1984), pp. 43–52; Munich, *Meister E. S.,* pp. 83–84, cat. no. 98.

104. Moxey, "Master E. S.," p. 148.

105. Werner Lenk, *Das Nürnberger Fastnachtspiel des 15. Jahrhunderts. Ein Beitrag zur Theorie und zur Interpretation des Fastnachtspiels als Dichtung,* Deutsche Akademie der Wissenschaften zu Berlin, ser. C, Beiträge zur Literaturwissenschaft, 33 (Berlin, 1966), pp. 52–74. For an extensive bibliography on the *Fastnachtspiel* and a critical overview of the literature, see Walter Wuttke and Dieter Wuttke, eds., *Fastnachtspiele des 15. und 16. Jahrhunderts,* 2d ed. rev. and exp. (Stuttgart, 1978).

106. *Der Ritter vom Turn. Von den Exempeln der Gotsfurcht und Erberkeit* was translated into German by Marquart vom Steyn and published by Michael Furter. The original French text, dating from 1370–1372 and popular throughout the fif-

teenth century, was composed by Geoffroy de la Tour Landry "for the education of his daughter." All the woodcuts are reproduced and discussed in R. Kautzsch, *Die Holzschnitte zum Ritter vom Turn,* Studien zur deutschen Kunstgeschichte, 44 (Strasbourg, 1903); see also Kurt Pfister, *Der Ritter vom Turn* (Munich, 1912).

107. Francesco Maria Guazzo, *Compendium maleficarum,* ed. Montague Summers and trans. E. A. Ashwin (London, 1929), p. 30. In the late fifteenth century, *Champion des Dames,* by Martin Le Franc, similarly describes old women "readily kissing the devil's ass as a sign of obedience" (quoted and discussed in Baroja, *World of the Witches,* p. 90).

108. In the case of *Ritter vom Turn,* which was written for the education of a daughter and is about good and evil women, the reader-viewer is, at least notionally, a woman.

109. Alternatively, the illustrations are given to some anonymous talent akin to Dürer—what the literature sometimes calls Dürer's doppelgänger. See Wilhelm Worringer, *Die altdeutsche Buchillustration* (Munich, 1912), pp. 82–91; Friedrich Winkler, *Dürer und die Illustrationen zum Narrenschiff* (Berlin, 1941); Panofsky, *Dürer,* 1:29; Kurth, *Complete Woodcuts,* nos. 36–48 (full ref. chap. 6, n. 40); and Wolfgang Hütt, *Albrecht Dürer 1471 bis 1528. Das gesamte graphische Werk* (Herrsching, n.d.), 2:1290.

110. Michel Foucault, "Technologies of Self," p. 46 (full ref. chap. 3, n. 3).

111. Foucault, p. 46; see also idem, *The History of Sexuality,* vol. 1, *An Introduction,* trans. Robert Hurley (New York, 1978), pp. 53–73. The essay "Technologies of Self" records Foucault's 1982 faculty seminar at the University of Vermont.

112. Max Weber, *The Protestant Ethic and the Spirit of Capitalism,* trans. Talcott Parsons (London, 1985), pp. 36–37.

113. The pivotal event in the history of confession is the Fourth Lateran Council's *Omnis utriusque sexus* (1215), which demands that each Christian confess once a year to a local priest or face excommunication. See Tentler, *Sin and Confession* (full ref. chap. 13, n. 58); earlier developments are treated by Pierre J. Payer, *Sex and the Penitentials: The Development of a Sexual Code, 550–1150* (Toronto, 1984), and James A. Brundage, *Law, Sex, and Christian Society in Medieval Europe* (Chicago, 1987). The pioneer of the reading of late medieval piety as intensely scrupulous in its spiritual demands was the Catholic histo-

rian Nicolaus Paulus; see Ozment, *Reformation in the Cities,* pp. 22–32 and 49–56.

114. Johannes Oecolampadius, *Quod non sit onerosa christianis confessio, paradoxon* (Basel, 1521), pp. B 1 a, B 4 a; cited and discussed in Ozment, *Reformation,* p. 51.

115. Jacob Strauss, *Ein neüw wunderbarlich Beychtbeüchlin / in dem die warhafftig Gerecht beycht und bussfertigkeit Christlichen gelert und angezwygt wirt* (Augsburg, 1523), p. B 1 b; quoted in Ozment, *Reformation,* pp. 52–53.

116. Tentler, *Sin and Confession,* p. 88.

117. See Jean Gerson, *Opera omnia,* ed. Ellies Du Pin, 7 vols. (Anvers, 1706), 2:453–455; also idem, *Oeuvres complètes,* ed. Palemon Glorieux (Paris, 1971), 8:71–75. *De confessione mollitiei* is discussed in Tentler, pp. 90ff.

118. On the macabre as an outgrowth of late medieval strategies of self-examination and repentance, see Delumeau, *Le péché,* pp. 53–54 [full ref. chap. 13, n. 7]).

119. The difference between Cranach's secular panels and Baldung's recalls Stanley Fish's useful distinction between "rhetorical" and "dialectical" texts: "A presentation is rhetorical if it satisfies the needs of its readers. The word 'satisfies' is meant literally here; for it is characteristic of a rhetorical form to mirror and present for approval the opinions its readers already hold. . . . A dialectical presentation, on the other hand, is disturbing, for it requires of its readers a searching and rigorous scrutiny of everything they believe and live by . . . it does not preach the truth, but asks that its readers discover the truth for themselves, and this discovery is often made at the expense not only of a reader's opinions and values, but of his self-esteem. If the experience of a rhetorical form is flattering, the experience of a dialectical form is humiliating" (*Self-Consuming Artifacts,* pp. 1–2 [full ref. chap. 14, n. 39]).

120. Kramer and Sprenger, *Malleus maleficarum,* p. xxx.

121. Dürer, *Schriftlicher Nachlaß,* 3:293.

122. The best introductions to Strasbourg history during this period are Willy Andreas, *Straßburg an der Wende vom Mittelalter zur Neuzeit* (Leipzig, 1940), and Chrisman, *Strasbourg.* Standard studies on the city's intellectual life are Francis Rapp, *Réformes et réformation à Strasbourg: Eglise et société dans le diocèse de Strasbourg (1450–1525),* Association des publications près les Universités Strasbourg, Collection de l'Institut des hautes études alsaciennes, 23 (Paris, 1974),

which should be supplemented by Rapp's more recent essay, "L'humanisme et le problème de l'église," in *Strasbourg au coeur religieux du XVI^e siècle. Hommage à Lucien Febvre*, ed. Georges Livet and Francis Rapp (Strasbourg, 1977), pp. 45–49. Political and social conditions are detailed in Thomas A. Brady, Jr., *Ruling Class, Regime, and Reformation at Strasbourg, 1520–1555*, Studies in Medieval and Reformation Thought, 22 (Leiden, 1978). Miriam Chrisman's recent book, *Lay Culture, Learned Culture*, discusses usefully the different kinds of readers addressed by publications printed on Strasbourg presses in the sixteenth century (full ref. chap. 10, n. 63).

123. A list of the humanists, theologians, scholars, scientists, and popular authors in Strasbourg in the sixteenth century is given in Chrisman, *Lay Culture, Learned Culture*, p. 34, table 7. On the *sodalitas* and its membership, see Charles G. A. Schmidt, *Histoire littéraire de l'Alsace à la fin du XV^e et au commencement du XVI^e siècle*, 2 vols. (Paris, 1879), 2:174ff. and passim.

124. See Percy Stafford Allen, ed., *Opus epistolarum Des. Erasmi Roterdami*, 12 vols. (Oxford, 1905–1909), 2:7–9; Chrisman, *Lay Culture, Learned Culture*, pp. 92–93.

125. Chrisman, *Strasbourg*, pp. 51ff.; Chrisman, *Lay Culture, Learned Culture*, pp. 44–45; and for a general account of Wimpfeling and his circle, see Joseph Knepper, *Jacob Wimpfeling. Sein Leben und seine Werke*, Erläuterungen und Ergänzungen zu Janssens Geschichte des deutschen Volkes, 3, 2–4 (Freiburg im Breisgau, 1902). On the Nuremberg *sodalitas*, see Ludwig Grote's excellent article, "Die 'Vorder-Stube' des Sebald Schreyer. Ein Beitrag zur Rezeption der Renaissance in Nürnberg," *Anzeiger des Germanischen Nationalmuseum*, 1954–1959, 43–67.

126. The isolated character of the humanists in Strasbourg is stressed in Chrisman's account of the different publishers and their distinct audiences (*Lay Culture, Learned Culture*, pp. 37–58).

127. Brady, "Social Place of a German Renaissance Artist," pp. 295–300.

128. Johannes Ficker and Otto Winckelmann, *Handschriftproben des 16. Jahrhunderts nach Strassburger Originalen*, 2 pts. (Strasbourg, 1902–1905), 1:2, cited in Brady, "Social Place," pp. 304 and 314.

129. Brady, pp. 298–303.

130. In 1525 Strasbourg's painters and sculptors presented the city with a petition humbly begging for work to make up for their lost income (Rott, *Quellen*, vol. 3, *Oberrhein, Quellen* 1, pp. 304–305; *Quellen* 2, pp. 263–264; Brady, p. 312).

131. Joël Lefebvre, *Les fols et la folie. Etude sur les genres du comique et la création littéraire en Allemagne pendant la Renaissance* (Paris, 1968), pp. 110–116.

132. Chrisman, *Lay Culture, Learned Culture*, p. 93. For the reception of Erasmus in Strasbourg, see Jean Rott, "Erasme et les reformateurs de Strasbourg," in *Erasme, l'Alsace et son temps*, Publications de la Société savante d'Alsace et des régions de l'est, Collections Recherches et Documents, 8 (Strasbourg, 1970), pp. 49–56. This was also the generation of Sebastian Locher, the celebrated translator of the *Narrenschiff* into Latin (1497), and Celtis's successor in Ingolstadt. Celebrating the divine origins and theological wisdom of poetry, and satirizing the theology of Scholasticism as a sterile mule, Locher was disowned by Brant and, in 1507, condemned by Wimpfeling (Knepper, *Wimpfeling*, pp. 213–226; Joseph Schlecht, "Zu Wimpfelings Fehden mit Jakob Locher und Paul Lang," in *Festgabe für K. Th. von Heigel* [Munich, 1903], pp. 236–265; Lefebvre, *Les fols et la folie*, pp. 150–151).

133. Renaissance philology, which developed first in Italy, encompassed the search for old manuscripts, the renovation and reconstruction of ancient texts, and the preparation of standard "editions" of texts and authors for printing as books. On Renaissance philology in a specifically German context, see John D'Amico, *Theory and Practice in Renaissance Textual Criticism: Beatus Rhenanus between Conjecture and History* (Berkeley, 1988).

134. Wilhelm Dilthey, *Die Entstehung der Hermeneutik*, in *Gesammelte Schriften* (Stuttgart, 1960), 3:317–338.

135. Gadamer, *Wahrheit und Methode*, p. 163 (full ref. preface, n. 4). The idea that religious authority should be based on Scripture alone was first institutionalized for the Reformation in the Zurich Disputation of January 29, 1523, in which the *Bürgermeister* and city council tested the validity of Zwingli's teachings from the perspective of Scripture alone. In this they followed Luther, who had established this same principle already in his Leipzig debate (1519), writing: "Per sese certissima, facillima, apertissima, sui ipsius interpres, omnium omnia probans, iudicans et illuminans" (*Werke*, 7:97; see Ozment, *Reformation in the Cities*, p. 220). For an account of the *sola*

scriptura before Luther, see Heiko Augustinus Oberman, *Harvest of Medieval Theology: Gabriel Biel and the Medieval Nominalism* (Cambridge, 1963), pp. 363–365.

136. For a good summary of this dilemma, see Roland H. Bainton, "The Problem of Authority in the Age of the Reformation," in *Luther, Erasmus, and the Reformation*, ed. John C. Olin, James D. Smart, and Robert E. McNally (New York, 1969), pp. 14–25.

137. "All land syndt yetz voll heylger geschrifft / Vnd was der selen heyl antrifft / Bibel, der heylgen vätter ler / Vnd ander der glich bücher mer."

138. "All strassen, gassen, sindt voll narren / Die nüt dann mit dorheit umbgan."

139. One interesting case study of the crisis of interpretation would be the sixteenth-century reception of, and learned commentary on, the *Praise of Folly* itself. A step in this direction has been taken by Günter Hess, "Kommentarstruktur und Leser. Das 'Lob der Torheit' des Erasmus von Rotterdam, kommentiert von Gerardus Listrius und Sebastian Franck," in *Der Kommentar in der Renaissance*, ed. August Buck and Otto Herding, Kommission für Humanismusforschung, 1 (Bonn, 1975), pp. 141–165.

140. Dilthey, *Auffassung und Analyse des Menschen im 15. und 16. Jahrhundert*, in *Gesammelte Schriften*, 11:59 (full ref. chap. 15, n. 134).

141. "Ibi continuo alia mihi facies totius scripturae apparuit" (Luther, *Werke*, 54:186). This "reformational breakthrough" is brilliantly analyzed in Gerhard Ebeling, *Luther. Einführung in sein Denken*, 4th ed. (Tübingen, 1981), pp. 33–36.

142. "Ut opus Dei, id est, quod operatur in nobis Deus, virtus Dei, qua nos potentes facit, sapientia Dei, qua nos sapientes facit, fortitudo Dei, salus Die, gloria Dei."

143. As Jürgen Habermas writes of the medical usage of this word: "The crisis cannot be separated from the viewpoint of the one who is undergoing it—the patient experiences his powerlessness *vis-à-vis* the objectivity of the illness only because he is a subject condemned to passivity and temporarily deprived of the possibility of being a subject in full possession of his powers. We therefore associate with crises the idea of an objective force that deprives a subject of some part of his normal sovereignty" (*Legitimation Crisis*, trans. Thomas McCarthy [Boston, 1973], p. 1). For a discussion of the historical status of the notion of "crisis," see Reinhart Koselleck, *Critique*

and Crisis: Enlightenment and the Pathogenesis of Modern Society, Studies in Contemporary German Social Thought (Cambridge, 1988), pp. 158–186.

Chapter Sixteen

1. "Erzeigen solt mir gar kein Ehr, / Ich bin ain Bild und sonst nicht mehr / Kan dir die wenigst Hülff nicht schaffen / Drumb dich an mir thu nicht vergaffen." The following chapter is a revised and abridged version of part 3 of my University of California at Berkeley dissertation, "Self Portraiture and the Crisis of Interpretation." I summarized my argument in a talk entitled *"Homo Interpres in Bivio:* The Iconography of Choice in Lucas Cranach," delivered at Iconography at the Crossroads, a conference sponsored by the Index of Christian Art and held at Princeton University in March 1990.

2. C. Bürckstürmer, *Die Geschichte der Reformation und Gegenreformation in der ehem. Freien Reichsstadt Dinkelsbühl* (Dinkelsbühl, 1914), 1:65ff.; Nuremberg, Germanisches Nationalmuseum, *Martin Luther und die Reformation in Deutschland*, exh. cat. (Nuremberg, 1983), cat. no. 540.

3. The best accounts of Luther's image theology are Hans Preuss, *Martin Luther der Künstler* (Gütersloh, 1931); Margarete Stirm, *Die Bilderfrage der Reformation*, Quellen und Forschungen zur Reformationsgeschichte, 45 (Gütersloh, 1977); Carlos M. N. Eire, *War against the Idols: The Reformation of Worship from Erasmus to Calvin* (Cambridge, 1986); and, most notably, Sergiusz Michalski, *Protestanci a sztuka. Spór o obrazy w Europie Nowożytnej*, Idee i sztuka: Studia z dziejów sztuki i doktryn artystycznych (Warsaw, 1989), forthcoming in English as *Images and Iconoclasts: The Protestant Image Question in Western and Eastern Europe*, trans. Chester Kisiel (Cambridge). I am grateful to Dr. Michalski for making both the Polish edition and the English manuscript version available to me. Andreas Bodenstein von Karlstadt's iconoclastic treatise, first printed in Wittenberg in 1522 on the press of Nikell Schytlentz, has appeared in a good modern edition as *Von Abtuhung der Bylder Vnd das keyn Betdler unther den Christen seyn soll*, ed. Hans Leitzmann, Kleine Texte für theologische und philologische Vorlesungen und Übungen, 74 (Bonn, 1911). Luther formulated his response first in the "Invocabit" sermon of March 1522 (*Werke*, 10, pt. 3:31ff.) and then, in 1525, in the treatise *Wider die himmlischen*

Propheten (*Werke,* 18:62ff.) and the sermon on the Second Book of Moses (*Werke,* 16:437ff.).

4. Martin Luther, *Werke,* 28:554; as quoted in Stirm, *Die Bilderfrage,* p. 47; Luther's position here agrees with that of Hugo of St. Victor, who wrote: *Idolum nihil est* (*Patrologia Latina,* vol. 175, col. 527).

5. Hamburg, Kunsthalle, *Luther und die Folgen für die Kunst,* ed. Werner Hofmann, exh. cat. (Munich, 1983), cat. no. 1; Baxandall, *Limewood Sculptors,* pp. 79ff. (full ref. chap. 8, n. 56); Belting, *Bild und Kult,* p. 517 (full ref. chap. 5, n. 1).

6. The best short introduction to Cranach is Max Friedländer's introductory essay in Max J. Friedländer and Jacob Rosenberg, *The Paintings of Lucas Cranach,* rev. ed. (Ithaca, 1978), henceforth referred to as "FR." Relevant documents are collected in Heinz Lüdecke, *Lucas Cranach der Ältere im Spiegel seiner Zeit. Aus Urkunden, Chroniken, Briefen, Reden und Gedichte* (Berlin, 1953); see also the excellent catalog of the 1974 Cranach exhibition in Basel (Basel, Kunsthalle, *Lukas Cranach. Gemälde, Zeichnungen, und Druckgraphik,* ed. Dieter Koepplin and Tielman Falk, exh. cat., 2 vols. [Basel, 1974 and 1976]). The definition of a distinctly Lutheran art has vexed art historians for generations. Dürer's Netherlandish diary and *Apostles* panels suggest he was sympathetic toward Luther, yet his 1528 death makes his status as a genuinely Reformation artist nebulous (see the recent discussion in Hutchinson, *Dürer,* pp. 157–169 [full ref. chap. 1, n. 59]). Younger German and Swiss artists of the period had mixed relations to the Lutheran cause. Baldung's art, I believe, stands closer to Erasmus than to Luther (for Baldung's relation to the Reformation, see Alexander Rüstow, "*Lutherana Tragoedia Artis.* Zur geistesgeschichtlichen Einordnung von Hans Baldung Grien angesichts der erstmaligen Ausstellung seines Gesamtwerkes in Karlsruhe," *Schweizer Monatshefte* 39 [1959]: 891–906; Brady, "Social Place," 307–311 [full ref. chap. 12, n. 9]). Niklaus Manuel Deutsch took an active role in the Reformation in Bern yet gave up his profession as artist. The brothers Hans Sebald and Barthel Beham, temporarily exiled from Nuremberg on charges of being "godless," may have been radical protestants, but they became favored painters of Catholics like Cardinal Albrecht of Brandenburg and Johann Eck. Matthias Gerung produced both virulent antipapal propaganda and religious works for Catholic donors. Altdorfer's images promoted the popular cult of the "Schöne Maria"

in Regensburg, which scandalized the reformers because of its idolatrous nature. Holbein, under Erasmus's guidance, produced a satirical broadsheet of Luther as "Hercules Germanicus." And even Cranach did work for Catholic patrons throughout his career (for example, his woodcuts illustrated both Luther's Bible and Hieronymus Emser's Catholic Bible; see Peter-Klaus Schuster, "Abstraktion, Agitation und Einfühlung: Formen protestantischer Kunst im 16. Jahrhundert," in Hamburg, *Luther und die Folgen für die Kunst,* p. 115). Such contradictions do not necessarily reflect artists' lack of commitment to the Lutheran cause. The full sense of the Reformation as an ecclesiastical founding emerged slowly in the sixteenth century, and economic relations between the factions were affected rather little. For an extensive bibliography of the relation between art and the German Reformation, see Linda B. Parshall and Peter W. Parshall, *Art and the Reformation: An Annotated Bibliography* (Boston, 1986).

7. Elfriede Starke, "Luthers Beziehung zu Kunst und Künstlern," in *Leben und Werk Martin Luthers von 1526 bis 1546: Festausgabe zu seinem 500. Geburtstag,* ed. Helmar Junghans (Göttingen, 1983), p. 537.

8. Martin Luther, *Passional Christi und Antichristi* (Wittenberg, 1521); Johannes Jahn, ed., *1472–1553 Lucas Cranach der Ältere: Das gesamte graphische Werk* (Herrsching, 1972), pp. 555–583, henceforth referred to as "J."

9. See Oskar Thulin, *Cranach-Altäre der Reformation* (Berlin, 1955).

10. Thulin, p. 8; see also Warnke, *Cranachs Luther,* pp. 24–25 (full ref. chap. 4, n. 9). Several original impressions of Cranach's engraving (e.g., Berlin, Kupferstichkabinett, inv. no. 562-2 and 565-2) still show traces of the profile after it had been scratched from the plate.

11. Starke, "Luthers Beziehung," p. 535. In a Latin obituary by Mathäus Gunderam, tutor to Cranach the Younger's children 1546–1556, Cranach the Elder is described as having been "loved by Dr. Luther his whole life and bound to him by bonds of intimate friendship and sponsorship" (cited in Christian Schuchardt, *Lukas Cranach. Leben und Werke* [Leipzig, 1851], 1:20).

12. For discussions of the collaboration of Cranach and Luther and an assessment of its importance, see Carl C. Christensen, *Art and the Reformation in Germany* (Athens, Ohio, 1979), pp. 124–125; and Jean Wirth, "Le dogme en image: Luther et l'iconographie," *Revue de l'art* 52 (1981):

13. A sizable literature has developed around Cranach's composition. See, for example, Thulin, *Cranach-Altäre*, pp. 54–74 and 126–149; Martin Scharfe, *Evangelische Andachtsbilder. Studien zu Intention und Funktion des Bildes in der Frömmigkeitsgeschichte vornehmlich des schwäbischen Raumes*, Veröffentlichung des staatlichen Amtes für Denkmalpflege Stuttgart, ser. C, Volkskunde, 5 (Stuttgart, 1968); Basel, *Lukas Cranach*, 2:506–510; Wanda Drecka, "'Allégorie de la rédemption' de Lucas Cranach, le vieux," *Bulletin du Musée national de Varsovie* 4 (1963): 1–13; Donald L. Ehresmann, "The Brazen Serpent: A Reformation Motif in the Words of Lucas Cranach the Elder and His Workshop," *Marsyas* 13 (1966–1967): 32–47; Hans Carl von Haebler, *Das Bild in der evangelischen Kirche* (Berlin, 1957), pp. 17–18; Craig Harbison, *The Last Judgment in Sixteenth-Century Northern Europe: A Study of the Relation between Art and the Reformation* (New York, 1976): 94–102; and Friedrich Ohly, *Gesetz und Evangelium. Zur Typologie bei Luther und Lucas Cranach. Zum Blutstrahl der Gnade in der Kunst*, Schriftenreihe der Westfälischen Wilhelms-Universität Münster, n.s. 1 (Münster, 1985), especially pp. 16–48 and 94–99.

13. For example, Hans Holbein the Younger's *The Law and the Gospels* in National Galleries of Scotland (for which see F. Grossmann, "A Religious Allegory by Hans Holbein the Younger," *Burlington Magazine* 103 [1961]: 491–494; John Rowlands, *Holbein* [Boston, 1985], pp. 93–94 and cat. no. 56), Franz Timmermann's panels in the Hamburg Kunsthalle and in the University Art Museum in Liège (reproduced in Hamburg, *Luther und die Folgen*, p. 214), Erhard Altdorfer's woodcut title page to Luther's *Low German Bible* of 1533 (fig. 185, see discussion below), Georg Lemberger's panel in the Germanisches Nationalmuseum, Nuremberg, and Geoffroy Tory's early single-leaf woodcut from about 1535 (fig. 186; Anna Maria Göransson argues that it was Tory, rather than Cranach, who originated the composition of the law and the gospel; see "Livsträdet och Geofroy Tory," *Tidskrift för Konstvetenskap* 30 [1957]: 59–85; see, though, Hamburg, *Luther und die Folgen*, p. 212).

14. Karl Ernst Meier, "Fortleben der religiösdogmatischen Kompositionen Cranachs in der Kunst des Protestantismus," *Repertorium für Kunstgeschichte* 30 (1909): 415–435; Richard Foerster, "Die Bildnisse von Johann Hess und Cranachs 'Gesetz und Gnade,'" *Jahrbuch des Schlesischen Museums für Kunstgewerbe und Altertümer* 5 (1909):

117–143; Ernst Grohne, "Die bremischen Truhen mit reformatorischen Darstellungen und der Ursprung ihrer Motive," *Abhandlungen und Vorträge der Bremer Wissenschaftlichen Gesellschaft* 10, 2 (1936); Thulin, *Cranach-Altäre*, pp. 136–140; Peter Poscharsky, *Die Kanzel. Erscheinungsform im Protestantismus bis zum Ende des Barocks*, Schriftenreihe des Instituts für Kirchenbau und kirchliche Kunst der Gegenwart, 1 (Gütersloh, 1963), pp. 162ff.; Worcester, Iris and B. Gerald Cantor Art Gallery, *Northern Renaissance Stained Glass: Continuity and Transformation*, ed. Virginia Chieffo Raguin, exh. cat. (Worcester, 1987), cat. no. 27.

15. See Sergiusz Michalski's interesting analysis of writing in Reformation art, "'Widzialne słowa' sztuki protestanckiej," pp. 171–208 (full ref. chap. 4, n. 7). In the title of a woodcut version of the law and the gospel, Cranach the Younger formulated the link between word and image thus: "A beautiful figure of the Old and New Testaments, in which it is clearly denoted and obviously represented what is taught and done by all the prophets and apostles, as is written and explained in the text below" (*Eine schöne Figur des Alten vnd newen Testaments, darin klerlich angezaigt und augenscheinlich vorgebildet wirdt, was in einem yeden, durch die Propheten vnd Aposteln gelehrt und gehandelt sey worden, wie in der Schrifft vnten deutlich verfasset vnd erkleret ist*; quoted in Poscharsky, *Die Kanzel*, pp. 153–54).

16. On the *Weimar Altarpiece*'s place within the history of the Reformation, see Schade, *Cranach*, p. 92 (full ref. chap. 5, n. 119); the most extensive reading of the painting is Ohly, *Gesetz und Evangelium*. The Church of Saints Peter and Paul (also called the City Church) has been renamed the Herder Church.

17. Although the elder Cranach's likeness was completed by his son, the idea for such an *in assistenza* portrait probably goes back to the father's initial design for the altarpiece. Cranach's likeness, placed within an altarpiece also functioning as an epitaph for Duke Johann Friedrich of Saxony, thus lies somewhere between a self-portrait and a funeral effigy.

18. Gerhard Ebeling has called the law and the gospel "the foundational formula of theological understanding" in the Reformation; see his "Luther: Theologie," in *Die Religion in Geschichte und Gegenwart*, ed. Kurt Galling, 3d rev. ed., 6 vols. (Tübingen, 1956–1962), 4:507. The most thorough account I know of Luther's conception of the law and the gospel as it relates to his theology

of justification, and as it differs from earlier conceptions, is Otto Herman Pesch, *Theologie der Rechtfertigung bei Martin Luther und Thomas Aquin: Versuch eines systematisch-theologischen Dialogs,* Walberger Studien der Albertus-Magnus-Akademie, Theologische Reihe, 4 (Mainz, 1967); on earlier doctrines of justification, see Alister E. McGrath's excellent *Iustitia Dei* (full ref. chap. 6, n. 13); also Charles P. Carlson, *Justification in Earlier Medieval Theology* (The Hague, 1975), and E. Jane Dempsey Douglas, *Justification in Late Medieval Preaching: A Study of John Geiler of Keisersberg,* Studies in Medieval and Reformation Thought, 1 (Leiden, 1966).

19. "Quando autem pene universa scriptura totiusque Theologiae cognitio pendet in recta cognitione legis et Euangelii," Luther, *Werke,* 7:502; quoted in Pesch, *Theologie,* p. 31.

20. "Audistis autem iam saepe, meliorem rationem tradendi et conservandi puram doctrinam non esse, quam ut istam methodum sequamur, nempe ut dividamus doctrinam christianam in duas partes, scilicet in legem et evangelium," Luther, *Werke,* 39, pt. 1:361; quoted in Pesch, *Theologie,* p. 31.

21. "Die höchste kunst jnn der Christenheit" (Luther, *Werke,* 36:9).

22. In the Middle Ages, Scripture was regarded as *difficultas ornatus,* a text whose figurative obscurity invites close attention and puts the reader in the proper ascetic frame of mind. The reward for such exegetical labor, according to St. Augustine and others, is the mixture of delight and awe attendant on the difficult unveiling of the sacred (see Angus Fletcher, *Allegory: The Theory of a Symbolic Mode* [Ithaca, 1964], pp. 234–236).

23. The best introduction to the question of typology in Christian thought is still Erich Auerbach's 1944 essay "'Figura,'" translated by Ralph Mannheim in *Scenes from the Drama of European Literature,* Theory and History of Literature, 9 (Minneapolis, 1984), pp. 11–76; for a history of typological exegesis, see James Samuel Preuss, *From Shadow to Promise: Old Testament Interpretation from Augustine to the Young Luther* (Cambridge, 1969).

24. See Ohly, *Gesetz und Evangelium,* p. 44. The representation of Luther as Moses' antitype must be considered in light of earlier figurative interpretations of the Reformer, such as Baldung's banned engraving of *Luther as Saint* and Dürer's project drawing for the *Large Crucifixion* of about

1523, in which John the Baptist has the facial features of Luther (Hamburg, *Luther und die Folgen für die Kunst,* cat. no. 95).

25. Luther, *Lectures on Romans,* trans. Wilhelm Pauck (Philadelphia, 1961); the lectures were first published in 1908 (Johannes Ficker, *Luthers Vorlesung über den Römerbrief 1515/1516* [Leipzig, 1908]) and appeared in 1938 in the Weimar Edition (Luther, *Werke,* vol. 56).

26. Luther, *Werke,* 56:233; quoted in Wilhelm Pauck's "General Introduction" to Luther, *Lectures on Romans,* p. lxvi.

27. The woodcut impressions are in the Weimar Schloßmuseum and the British Museum. The panel in Gotha gives the name "Gotha type" to all representations of the law and the gospel that show a damned sinner driven into hell in the "law" scene and a praying Christian directed by John the Baptist toward Christ in the "gospel" scene; the alternative arrangement is called the "Prague type," after Cranach's panel in the Prague National Gallery (fig. 178; see discussion below). For a comparison of the different versions of Cranach's compositions according to their motifs and arrangement, see Poscharsky, *Die Kanzel,* pp. 155–157.

28. What Dante called the *selva obscura* (*Inferno,* 1.2).

29. In a project drawing for his composition, now in Frankfurt, Cranach places the Expulsion in the background of the law and leaves the sinner standing somewhat awkwardly between Death and the Old Testament prophets (fig. 175). This arrangement is repeated in an epitaph panel of about 1560 by an anonymous German artist working under Cranach's influence. In this panel, now in the Evangelisch-Lutherische Pfarrkirche in Heilbrunn, Adam and Eve's expulsion stand in the place of Cranach's naked sinner driven by death into hell (see Nuremberg, Germanisches Nationalmuseum, *Reformation in Nürnberg: Umbruch und Bewahrung,* exh. cat. [Nuremberg, 1979], p. 135).

30. Luther, *Lectures on Romans,* p. 193.

31. Luther, *Lectures,* pp. 193–194.

32. The notion that Christ's fulfillment of the law reorients scriptural meaning is a central assumption of Christian typology. As St. Augustine writes in the *City of God,* "The Old Testament is nothing but the New covered with a veil, and the New is nothing but the Old revealed (16.26, as quoted in Emile Mâle, *The Gothic Image: Religious Art in France of the Thirteenth Century,* trans. Dora

Nussey [New York, 1958], p. 136). On Luther's revision of the *function* of typological exegesis, see Gerhard Ebeling, "Die Anfänge von Luthers Hermeneutik," in *Lutherstudien* (Tübingen, 1971), 1:42–51.

33. Meier, "Fortleben," p. 417.

34. Robert W. Scribner, *For the Sake of Simple Folk: Popular Propaganda for the German Reformation*, Cambridge Studies in Oral and Literate Culture, 2 (Cambridge, 1981), pp. 210–220.

35. Basel, *Cranach*, 2:507.

36. See Luther, *Lectures*, pp. 201–203, where he refers to 1 Cor. 2:14 and Rom. 7:14.

37. For the Law as *Geschehen* in Luther, see Gerhard Ebeling, "Reflections on the Doctrine of the Law," in *Word and Faith*, trans. James W. Leitch (London, 1963), pp. 278ff.

38. McGrath, *Iustitia Dei*, p. 2.

39. On the relation of parataxis to allegory, see Fletcher, *Allegory*, pp. 102, 171–172; on the relation between parataxis and self, see Theodor W. Adorno, "Parataxis. Zur späten Lyrik Hölderlin," in *Note zur Literatur*, ed. Rolf Tiedemann (Frankfurt, 1974), pp. 447–491.

40. See Kurt Glaser on Cranach's development of an *einheitlichen Schauplatz* in his works from 1502 to 1504 (*Lukas Cranach* [Leipzig, 1923], p. 160).

41. Fletcher, *Allegory*, p. 107.

42. Ebeling, *Lutherstudien*, 1:50.

43. Martin Luther, *In primum librum Mose enarrationes*; Luther, *Werke*, 42:174; as quoted in Guldan, *Eva und Maria*, p. 140 (full ref. chap. 14, n. 35).

44. Guldan, p. 136.

45. Luther regarded the brazen serpent, which appears in virtually every one of Cranach's images of the law and the gospel, as a vivid emblem of justification. Just as the cure for the poison serpents was another serpent—the brazen one Moses wrought for the stricken Israelites—so too God became flesh to redeem man's carnal sin (Ehresmann, "Brazen Serpent," pp. 32–47). Cranach's unprecedented placement of this Old Testament episode in the gospel scene, I suggest, visualizes the close proximity between disease and cure that Luther reads into the brazen serpent story itself. A Christian reading can so transform the Old Testament's very essence that, granted a new, redeemed semantic valence, it can actually appear among the scenes original to the gospel.

46. From the five-volume *Salzburg Missal*, produced between about 1487 and 1489, Staatsbibliothek, Munich, Clm. 15708–15712; this page is 15710, fol. 60ᵛ, and is reproduced and discussed in Munich, *Regensburger Buchmalerei*, cat. no. 106. Note that Cranach's own 1509 woodcut *Fall* displays Adam seated below the tree (J. 292), as does the related woodcut of paradise by Erhart Altdorfer in the Lübeck Bible of 1533–1534 (reproduced in Walther Jürgens, *Erhard Altdorfer. Seine Werke und seine Bedeutung für die Bibelillustration des 16. Jahrhunderts* [Lübeck, 1931], ill. 16). In one abbreviated version of the formula "the law and the gospel," the tree is actually depicted as a crucifix. On the corpus of the 1555 pulpit in the Jacobikirche, Freiberg in Saxony, the painted scenes of Moses receiving the law and of Christ sending forth the apostles (Mark 16:15) are separated by a bare and leafy tree to which is attached an actual sculpted crucifix.

47. The classic account of northern "realism" is Panofsky's chapter "Reality and Symbol in Early Flemish Painting: 'Spiritualia sub metaphoris corporalium'" (*Early Netherlandish Painting*, pp. 131–148). It was this notion of mimesis, we recall, that motivated the artist's signature in the Eyckian portrait panels of Christ and thus helped to originate the demand for self-portraiture as it emerges finally in Dürer. While it seems to mirror reality, northern "realism" also links painting to its human source in the personal talent and quasi-divine artifice, thus implying a double conception of the image's model: as representer and as represented world. I take the term "signlike" from Robert Suckale's remarkable essay, "Arma Christi" (full ref. chap. 11, n. 32).

48. A phenomenology of symmetry has yet to be written. Discussing symmetry in ornament, E. H. Gombrich has suggested how closely our very notion of objects depends on a perception of symmetry: "Symmetry . . . implies cohesion. The whole shape or field must be ruled by one inherent principle or law, and it is this instinctive conviction which makes the ordered shape stand out for scrutiny. Since it is unlikely to have come about by a mere accidental shuffling of shapes and colors, it must be classified as an object in its own right, and as such we must be able to give it a meaning and a name" (*The Sense of Order: A Study of the Psychology of Decorative Art*, Wrightsman Lectures, 9 [Ithaca, 1979], p. 158). On symmetry as possessing a specific semantic function in medieval art, see Madeline H. Caviness, "Images of Divine Order and the Third Mode of Seeing," *Gesta* 22 (1983): 99–120; on symmetry in

Renaissance art, see David Summers, "*Figure Come Fratelli:* A Transformation of Symmetry in Renaissance Painting," *Art Quarterly*, n.s., 1 (1977): 59–88.

49. See Fletcher's remarks on allegory and magic (*Allegory*, pp. 188–190).

50. Geisberg, *German Single-Leaf Woodcut*, 3:860; old Geisberg no. 926 (full ref. chap. 5, n. 52).

51. Wilhelm Worringer, *Lukas Cranach* (Munich, 1908), p. 118; a similar judgment is expressed in Glaser, *Lukas Cranach*, pp. 158–160 (full ref. chap. 16, n. 40).

52. *Abgöttisch* (Luther, *Werke*, 28:677); quoted in Walter Tappolet, ed., *Das Marienlob der Reformation: Martin Luther, Johannes Calvin, Huldrich Zwingli, Heinrich Bullinger* (Tübingen, 1962), p. 147.

53. "Die Groschen Bilder betet man . . . nicht an, man setzet kein vertrawen drauff, sondern es sind Merckbilde. . . . [D]ie verwerffen wir nicht" (Luther, *Werke*, 28:677).

54. "Damit man Gottes werck und wort allen enden ymer fur augen hette, and dran furcht und glauben gegen Gott ubet" (Luther, *Werke*, 10, pt. 2:458).

55. "Wir . . . müssen alle ding, die wir nicht kennen und wissen, durch bilde fassen, ob sie gleich nicht so eben zutreffen odder jnn der warheit also ist, wie mans malet" (Luther, 37:66).

56. "Die lere von Göttlichen sachen durch grobe, eusserliche bilde. . . . Wie Christus selbs allenthalben im Euangelio dem volck das geheimnis des himelreichs durch sichtige bild und gleichnis fur hellt" (Luther, 37:64).

57. Luther reiterates this list in his writings throughout his career; see Stirm, *Die Bilderfrage*, pp. 94–95. Interestingly, the image of John the Baptist pointing to the lamb of God was already the subject of controversy in the seventh century. In a council of 692, this image was interpreted as St. John's own metaphor for Christ but not an appropriate subject for painting. Representing Christ as a lamb, it was argued, insulted his humanity and undermined his visibility as flesh (Belting, *Bild und Kult*, p. 162; Belting cites Kathleen Corrigan, "The Witness of John the Baptist on an Early Byzantine Icon in Kiev," *Dumbarton Oaks Papers* 42 [1988]: 1–11).

58. "Unser hertz und gedanken an die wort das Glaubens, Welcher sagt: Ich gleube an den HERREN Christum, Gottes Son, gestorben, begraben, und zur Helle gefaren . . . von der Jungfrawen geboren" (Luther, *Werke*, 37:65).

59. Ehresmann has argued that the brazen serpent, for Luther an emblem of the Scripture, differs from its antithesis, the poison serpent, only through God's word, which commands it to be so, and through the Israelites' faith in the promise of that word. As Luther writes, "The word clings to the serpent, and the serpent worked in the power of the word" ("Dis wort klebt an der schlangen, und ynn krafft des worts halff die schlange" [*Werke*, 20:430]; see Ehresmann, "Brazen Serpent," pp. 44–46).

60. "Man mus doch dem groben volck kindlich und einfeltiglich fürbilden, als man imer kan, Sonst folget der zweyer eines, das sie entweder nichts da von lernen noch verstehen, odder wo sie auch wollen klug sein und mit vernunfft jnn die hohen gedancken geraten, das sie gar vom glauben komen. Das rede ich darumb, weil ich sehe, das die wellt itzt wil klug sein jnns Teuffels namen" (Luther, *Werke*, 37:64).

61. Margarete Stirm writes of this doctrine, "In their crudeness, which no one can take directly they [images] lead themselves in their representations *ad absurdum*, and thereby resist every useless speculation" (*Bilderfrage*, p. 91). I suggest that Luther comes close to Pseudo-Dionysius here, who in his early sixth-century treatise *On the Celestial Hierarchies* wrote of revealing God in "unlike images" (*anaplaseis*) as a way of expressing the infinite disparity between matter and divinity (G. Heil and M. de Gandillac, eds., *Denys l'Aréopagite. La hiérarchie céleste*, 2d ed., Sources chrétiennes [Paris, 1970], 58:80; excerpted in Belting, *Bild und Kult*, p. 550).

62. Worringer, *Cranach*, p. 116.

63. In a panel of *The Law and the Gospel* now in the Schloßmuseum in Weimar, Cranach inscribes above the bare and leafy tree the words "The Lord himself will give a sign, a virgin" (*Der Herr wird selbst ein zeichen geben, ein jungfrau*), abbreviating Isa. 7:14; similarly, in Hans Holbein the Younger's *The Law and the Gospel* from the mid-1530s, now in Edinburgh, the prophet addresses the nude man (here labeled "HOMO") with the words "Ecce virgo concipiet filium."

64. The most complete account of Luther's anthropology is Gerhart Ebeling's still unfinished *Lutherstudien*, vol. 2, *Disputatio de Homine I. Text und Traditionshintergrund*, and *Disputatio de Homine II. Die philosophische Definition des Menschen*, 2 vols. (Tübingen, 1977–1982). Ebeling's point of reference is Luther's 1536 *Disputatio* concerning "man" in Rom. 3:28—a passage that, inciden-

tally, appears among the biblical quotations at the base of Cranach's Gotha panel of *The Law and the Gospel* (fig. 172).

65. I quote here from Wilhelm Pauck's translation of Luther's *Lectures on Romans*, which renders biblical passages from the Vulgate, though modified to reflect Luther's usage (*Lectures*, pp. xiv and 199–200).

66. Luther, *Lectures*, p. 208.

67. Luther, *Lectures*, p. 207.

68. The presence of the Hercules motif in Cranach's picture was first noted by Anna Maria Göransson ("Livsträdet och Geofroy Tory") but has received little critical attention. Only Jean Wirth ("Le dogme," p. 18) and Peter-Klaus Schuster ("Abstraktion," pp. 118–119) have addressed this curious allusion, although I disagree with their conclusions. On the reception of the story of Hercules at the Crossroads in the Renaissance, see Panofsky, *Herkules am Scheidewege*, pp. 37–68 (full ref. chap. 15, n. 3); Markus Reiterer, "Die Herkulesentscheidung von Prodikos und ihre frühhumanistische Rezeption der *Voluptatis cum Virtute disceptatio* des Benedictus Chelidonius" (Ph.D. diss., Vienna, 1952); and Wuttke, *Die "Histori Herculis"* (full ref. chap. 15, n. 6), especially the bibliography, p. 118n14.

69. See Schade, *Cranach*, p. 91; strikingly similar in composition is Peter Vischer the Younger's drawing *The Dream of Hercules*, in the manuscript of the Histori Herculis by Pangraz Schwenter (Nuremberg, Stadtsbibliothek Amb 245 2°, fol. 4ᵃ; reproduced and discussed in Wuttke, "Histori Herculis," pl. 1).

70. Basel, *Cranach*, 2:615.

71. In Christian thought, *homo viator* can metaphorize both man's alienation from God through evil and man's pious repudiation of the world for God; see Gerhart B. Ladner, "*Homo Viator*: Mediaeval Ideas on Alienation and Order," *Speculum* 42 (1967): 233–259. On the metaphoricity of the "path," see Wolfgang Harms, *Homo Viator in Bivio: Studien zur Bildlichkeit des Weges*, Medium Aevum: Philologischen Studien, 21 (Munich, 1970), pp. 11ff. and passim.

72. In the performance of Ben Jonson's court masque *Pleasure Reconcild to Vertue*, the story of Hercules at the Crossroads was staged with the young Charles, future king of England, playing the role of Hercules; the masque celebrated the prince's actual coming of age (Jonson, *Works*, ed. C. H. Herford and Evelyn and Percy Simpson [Oxford, 1952], vol. 8; see Koerner, *Die Suche nach*

dem Labyrinth, pp. 84–104 (full ref. chap. 8, n. 5).

73. Anzelewsky, *Dürer-Studien*, pp. 84–89 (full ref. chap. 4, n. 40). Valla's *De voluptate*, later titled *De vero falsoque bono*, dates to about 1450; on the text, see Lotizia A. Panizza, "Lorenzo Valla's *De Vero Falsoque Bono*, Lactantius and Oratorial Scepticism," *Journal of the Warburg and Courtauld Institutes* 41 (1978): 76–107.

74. Cassirer, *Individual and the Cosmos*, p. 80 (full ref. chap. 6, n. 13).

75. Cassirer, p. 74; see also Francis A. Yates, *Giordano Bruno and the Hermetic Tradition* (Chicago, 1964), pp. 192–199.

76. Cassirer, *Individual*, p. 121.

77. The painting's title as it appears in London, National Gallery, *National Gallery Illustrations: Italian Schools* (London, 1937), inv. no. 213, is *Vision of a Knight*; Panofsky's title, *The Dream of Scipio*, is probably more correct (*Herkules am Scheidewege*, pp. 82–83 and passim).

78. Panofsky, *Herkules*, pp. 82–83.

79. Cassirer, *Individual*, p. 79.

80. On this point, see Adrian Stokes's marvelous account of this painting in *Raphael, 1483–1520*, reprinted in *The Critical Writings of Adrian Stokes*, ed. Lawrence Gowing (London, 1978), 2:282.

81. Wirth, "Le dogme," pp. 19–20.

82. Jürgens, *Erhard Altdorfer*, pp. 33–54. Luther's 1533 Low German *New Testament*, which I illustrate, uses the identical title-page border as *De Biblie*.

83. Warburg, *Heidnisch-antike Weissagung* (full ref. chap. 1, n. 44).

84. As Hans Blumenberg writes in *The Legitimacy of the Modern Age*, "On the question of human freedom and its significance for salvation, the Middle Ages disintegrates—its dissociation is effected—into radical self-disempowering, on the one hand, and equally resolute self-empowerment, epitomized in the zone of what will be called the 'Renaissance,' on the other hand" (*Legitimacy*, p. 541 [full ref. chap. 2, n. 7]).

85. G. W. F. Hegel, *Vorlesungen über die Geschichte der Philosophie*, in *Sämtliche Werke*, ed. H. Glockner (Stuttgart, 1958), 19:262.

86. "Daß der freie Wille nichts sei"; this was the title Justus Jonas gave to the 1526 edition of *De servo arbitrio*; see Gerhard Ebeling, "Frei aus Glauben: Das Vermächtnis der Reformation," in *Lutherstudien*, 1:318n.

87. Ernst F. Winkler, "Introduction," *Erasmus—Luther: Discourse on Free Will*, trans. and ed. Ernst F. Winkler (New York, 1961), p. v.

88. "Proponit praemium, si velit eligere, quod pium est, proponit paenum, si malit sequi diversum"; Desiderius Erasmus, *De libero arbitrio* in *Ausgewählte Schriften*, ed. Werner Welzig (Darmstadt, 1969), 4:60. My translations of Erasmus have been aided by the parallel German of Welzig and by Winkler, *Erasmus—Luther.*

89. "Posui ante faciem tuam viam vitae et viam mortis. Elige, quod bonum est, et incede com eo."

90. "Ridicule siquidem diceretur: elige, cui non adesset potestas semet huc et illuc applicandi, perinde quasi quis in bivio consistenti dicat: Vides duplicem viam, utra voles ingreditor, cum altera tantum pateret."

91. I have used here Philip S. Watson's translation of *De servo arbitrio*, from *Luther's Works* (Philadelphia, 1972), 33:126.

92. In a broadsheet by the Monogrammist NG, reproduced and discussed by Scribner in *For the Sake of Simple Folk*, pp. 208–210, the conflict between reason and the teachings of Christ is depicted as a version of Hercules at the Crossroads. A figure labeled *Mensch* stands between Christ and a woman representing Reason.

93. Luther, *De servo arbitrio*, trans. Watson, 30:127.

94. Cf. Hamburg, *Luther und die Folgen für die Kunst*, pp. 212–216.

95. On the dating of this print, see Hamburg, *Luther und die Folgen für die Kunst*, p. 212. One aspect of Tory's woodcut that has received no attention is his placement of Sarah and Isaac in the "gospel" scene, and of Hagar and Ishmael in the "law" scene. The relevant biblical passage for this conceit is Gal. 4:21–31, which allegorizes the Old Testament story of Abraham's sons as a message about the relationship between the law and the gospel. "He [Ishmael] of the bondwoman [Hagar] was born after the flesh; but he [Isaac] of the freewoman [Sarah] was by promise. Which things are an allegory: for these are the two covenants" (Gal. 4:23–24). The story of Ishmael and Isaac is appropriate to Tory's woodcut not only because it juxtaposes the messages of the two covenants, but because, through its evocation in the New Testament, it validates typology generally. Paul reads the story as proof that the Old Testament predicts its own relationship to the New ("Tell me, ye that desire to be under the law, do ye not hear the law" [Gal. 4:21]); he thus allegorizes the Mosaic text as a prophecy of his own faith. The church fathers, and St. Augustine in particular, regarded this allegorization, together with John

3:14, as the biblical justification for typology (on this point, see Mâle, *Gothic Image*, p. 136).

96. See Pesch's account of Thomas Aquinas's theology of justification as it relates to Luther's (*Theologie*, pp. 401–463).

97. Martin Luther, *Luther's Works*, ed. Milton C. Oswald and trans. Herbert J. A. Bouman (St. Louis, 1976), 11:494; original text in Luther, *Werke*, 4:362–363. Earlier in his lectures on the Psalms, Luther calls the Galileans "wanderers, strangers of the world, and wayfarers, for whom the world is not a dwelling place but a desert, Egypt, captivity, road, way, *crossing*, guest lodging" (emphasis added; *Works*, 11:146; *Werke*, 3:649).

98. Wolfgang Capito, *Entschuldigung an der hoch würdigen fürsten unseren herren Wilhelmen Bischoffen zu Strassburg* (Augsburg, 1524); as quoted in Chrisman, *Strasbourg and the Reform*, p. 111 (full ref. p. 15, n. 98).

99. Karl Barth, "Reformation as Decision," trans. Lewis W. Spitz, in *The Reformation: Basic Interpretations*, ed. Lewis W. Spitz, 2d ed. (Lexington, Mass., 1972), pp. 162–163.

100. "Unter dem Bapstumb hat der Bapst mit alle seinen gelerten, Cardineln, Bisschoffen und hohen schulen noch nie gewust, . . . was das Euangelion gegen dem gesetz . . . unterschiedlich sey, Darumb ist jr glaube ein lauter Turcken glauben von den gesetzen, welcher allein gleubt: Du solt nicht stelen, nicht tödten u[nd soweiter], wenn sie auch auffs höchste komen, Aber es ist nichts geredt, wie man Christen werden sol" (Luther, *Werke*, 36:10).

101. See Ebeling on Luther's notion of the *verbum hominis* and *traditiones huius mundi* as the bane of the church and the papacy, in "Reflections on the Doctrine of the Law," pp. 268–270.

102. Lügend ir nun, dass ir gschickt syen
Und predgend allweg das geistlich recht!
So sind wir herren und die leien knecht;
Und tragend herzü bi der schwere,
Das sunst alles verderbt wäre,
Wo ir das euangelium seitind
Un nach sim inhalt recht usleitind.
(Niklaus Manuel Deutsch, *Ein Faß nacht spyl . . . vom Babst vn[d] siner priesterschafft*, lines 62–68; in Jakob Baechtold, ed., *Nikolaus Manuel*, Bibliothek älterer Schriftwerke der deutschen Schweiz und ihres Grenzgebietes, ser. 1, 2 [Frauenfeld, 1878], pp. 33–34.) On the place of Manuel's play in the early Reformation, see Ozment, *Reformation in the Cities*, pp. 111–116 (full ref. chap. 4, n. 46).

103. Wirth, "Le dogme," p. 15.

104. Curtius, *European Literature*, pp. 153–154 (full ref. chap. 5, n. 84).

105. On Reformation conceptions of theological novelty, see Hans-Georg Hofacker, "'Vom alten und nüen Gott, Glauben und Ler'. Untersuchungen zum Geschichtsverständnis und Epochenbewußtsein einer anonymen reformatorischen Flugschrift," in *Kontinuität und Umbruch. Theologie und Frömmigkeit in Flugschriften und Kleinliteratur an der Wende vom 15. zum 16. Jahrhundert*, ed. Josef Notle, Hella Tompert, and Christof Windhorst, Spätmittelalter und Frühe Neuzeit, Tübinger Beiträge zur Geschichtsforschung, 2 (Stuttgart, 1978), pp. 145–177. On Luther's "modernity" in historiography since the nineteenth century see Gerhart Ebeling, "Luther and the Beginnings of the Modern Age," in *Luther and the Dawn of the Modern Era*, ed. Heiko Augustinus Oberman, Studies in the History of Christian Thought, 8 [Leiden, 1974], pp. 11–39).

106. *Der deuchleüchtigisten hochgepornen Fursten und Herren . . . endtliche Protestation auf dem Reichstage zu Speyr* (n.p., 1529), p. B 1 b; quoted and discussed in Ozment, *Reformation in the Cities*, p. 150.

107. Joseph Lortz, *Die Reformation in Deutschland*, 2d ed., 2 vols. (Freiburg im Breisgau, 1941), 2:51.

108. Konrad Hoffmann, "Typologie, Exemplarik und reformatorische Bildsatire," in *Kontinuität und Umbruch*, ed. Notle, Tompert, and Windhorst, pp. 189–210 (full ref. chap. 16, n. 105); and Scribner, *For the Sake of Simple Folk*, esp. pp. 196–206.

109. In a letter of March 7, 1521, to Georg Spalatin, Luther used the word "antithesis" to describe the method of his and Cranach's *Passional Christi und Antichristi*, published in Wittenberg in 1521 (Gerald Fleming, "On the Origin of the *Passional Christi und Antichristi* and Lucas Cranach the Elder's Contribution to Reformation Polemics in the Iconography of the *Passional*," *Gutenberg Jahrbuch*, 1973, 351–368; cited in Burke, *Popular Culture*, p. 309n49 [full ref. chap. 15, n. 87]).

110. "Also machen sie aus Christo nichts denn einen strengen, zornigen Richter fur dem man sich furchten musse als [vor einem], der uns wolle inn die helle stossen, Wie man jn gemalt hat auff dem Regenbogen zu gericht sitzend und seine Mutter Maria und Johannes den Teuffer zu beiden seiten als furbitter gegen seinem schrecklichen Zorn" (Luther, *Werke*, 46:8). The legitimacy of such images of the Last Judgment with the "double intercession" of the Virgin and John

was already a point of conflict between Luther and the Catholic theologian Johann Eck (Rowlands, *Holbein*, p. 94).

111. On this point, see Barth, "Reformation," pp. 162–163.

112. I take this term from J. H. van den Berg, *The Changing Nature of Man: Introduction to a Historical Psychology*, trans. H. F. Croes (New York, 1961), pp. 228–236.

113. Georg Simmel, "Soziologische Ästhetik," in *Brücke und Tür: Essays des Philosophischen zur Geschichte, Religion, Kunst, und Gesellschaft* (Stuttgart, 1957), pp. 200–201, 205.

114. This play between immediacy and distance effected by the represented human subject has, I believe, a distant heir in the so-called *Rückenfigur* that appears in so many landscapes of that most Protestant of romantic painters, Caspar David Friedrich.

115. Ohly, *Gesetz und Evangelium*, pp. 48–81.

116. See the discussion of the origins of the retable altar in Decker, *Das Ende des mittelalterlichen Kultbildes*, pp. 61–113 (full ref. chap. 5, n. 110).

117. Cologne, *Ornamenta ecclesiae*, cat. no. F46 (full ref. chap. 5, n. 82); Ohly, *Gesetz und Evangelium*, pp. 64–65.

Chapter Seventeen

1. Kleist, *Sämtliche Werke und Briefe*, ed. Helmut Sembdner, 2d rev. ed. (Munich, 1961), 2:343–345.

2. See Paul de Man, "Aesthetic Formalization in Kleist's *Über das Marionettentheater*," in *Rhetoric of Romanticism*, p. 267 (full ref. chap. 1, n. 60); for overviews of Kleist's text and its interpretations, see Helmut Sembdner, ed., *Kleists Aufsatz über das Marionettentheater, Studien und Interpretationen* (Berlin, 1967), and William Ray, "Suspended in the Mirror: Language and the Self in Kleist's 'Über das Marionettentheater,'" *Studies in Romanticism* 18 (1979): 521–546.

3. "Mann spricht: darumb, das Adam den Apffel aß, wer er verloren oder gefallen. Ich sprich: es was umb seyn annemen und umb syn ich, meyn, myr, mich, und umb das gleich" (*Theologia Deutsch*, vol. 3, ed. Mandel, p. 11 [full ref. chap. 8, n. 53]).

4. In the *Theologia*, "true obedience" involves an ascesis of "selfhood and I-hood" (*selbheit und icheit*): a man must act "as if he were nothing, and feel his self to be as nothing, and regard as small things of himself and what are his, as if he were nothing and the least of all creatures" ("als ob er

nit were noch sein selbs als wenig enpfinden und von ym selber und dem seinen als kleyn halten, als er nit were und als wenig von allen creaturen"; ed. Mandel, p. 31). In the 1494 edition of the *Theologia*, the phrase "selbheit und icheit" appears as "mir mîn, mich und das glîchen." Luther calls this selfhood the state of being "curved in on oneself." For an introduction to the relation between the *Theologia* and Luther, see Steven E. Ozment, *Mysticism and Dissent: Religious Ideology and Social Protest in the Sixteenth Century* (New Haven, 1973), pp. 14–69; *The Theologia Germanica of Martin Luther*, trans. Bengt Hoffman (New York, 1980), pp. 1–50, 171n73.

5. Kleist, *Werke*, 2:342.

6. Kleist, 2:345.

7. On Dürer as originator of the sculpted atelier mannequin in the North, see Decker, "Gelingen oder Mißlingen des Fortschritts," pp. 471–475 (full ref. chap. 2, n. 54); A. Weixlgärtner, "Dürer und die Gliederpuppe," in *Beiträge zur Kunstgeschichte Franz Wickhoff gewidmet* (Vienna, 1903), pp. 80ff.

8. "*Ist . . . ungehorsam und selbheyt und icheyt und das gleich*" (*Theologia Deutsch*, ed. Mandel, p. 33).

9. Thus is it called in Sylvester Prierias Mazzolini's *Summa summarium* (Bologna, 1515). Like intercourse in improper orifices (*non in debito vase*), the *a tergo* position was *indebitus modus* and therefore was condemned by everyone from penitentials of the early Middle Ages to Albertus Magnus, Burchard of Worms, and Berthold of Freiburg. Berthold writes that performing the act from behind like irrational beasts *waer alles ein todsuende* ("Von dem seelichen werccken," in *Summa Johannis, deutsch* [Augsburg, 1472], Q. 177); Bartholomaeus de Chaimis concludes that it is a mortal sin for a woman to be on top or for a man to enter from behind if it is done for pleasure (*Interrogatorium*, 3.3); and the *Tractatus de instructionibus confessorum*, vol. 2 ("De luxuria," A6a–A7a), notes that the interdict against the *a tergo* position is meant especially for married couples, since such lewd embraces were deemed more damnable when performed by a wife than by a prostitute. The relevant texts are assembled in Tentler, *Sin and Confession*, pp. 189–204 and 204n58 (full ref. chap. 13, n. 58); as well as Brundage, *Law, Sex, and Christian Society*, pp. 161,·286, 367, and 452 (full ref. chap. 15, n. 113).

10. Although most late medieval theologians agreed that sexual desire was a symptom of fal-

lenness, they differed in their opinion on the exact relation between original sin and sexuality. One school, represented by Peter of Lombard and dependent on a reading of Augustine, regarded concupiscence as the cause of the trespass in the garden, original sin being a *qualitas morbida anime, vitium scilicit concupiscentie* (see Gabriel Biel's commentaries on the *Sentences* [II *Sent.*, d. 30, q. 2, art. 1]). Against this interpretation stood Anselm of Canterbury, Duns Scotus, William of Occam, and Gregory of Rimini. They argued that the main characteristic of original sin is the absence of righteousness, resulting in concupiscence as God's punishment of man (Oberman, *Harvest of Medieval Theology*, pp. 122–128, full ref. chap. 15, n. 135). For historical accounts of the doctrine of original sin, see Johannes N. Espenberger, *Die Elemente der Erbsünde nach Augustin und der Frühscholastik* (Mainz, 1905); Raymond M. Martin, *La controverse sur le péché originel au début du XIVᵉ siècle* (Louvain, 1930); and on early developments, Elaine Pagels, *Adam, Eve, and the Serpent* (New York, 1988). Baldung, it seems, belongs clearly within a neo-Augustinian tradition.

11. New Haven, *Hans Baldung Grien*, p. 244 (full ref. chap. 12, n. 9).

12. See Jean Wirth's introduction to *Diables et diableries: La représentation du diable dans la gravure des XVᵉ et XVIᵉ siècles*, exh. cat. (Geneva, 1976), pp. 9–10.

13. Erasmus, *Enchiridion*, 7; trans. Himelick, p. 75 (full ref. chap. 14, n. 10).

14. Baldung is perhaps not unique in visualizing this analogy. There exists, in Renaissance art, a strain of self-portraiture *in malo*, in which the picture's villain (Holofernes, Goliath, Marsyas, etc.) has the features of the artist, or in which the artist appears *in assistenza*, but among the scoundrels (e.g., Dürer and Celtis walking through the tortures in *Martyrdom of the Ten Thousand* (fig. 67). See John Shearman, "Cristofano Allori's 'Judith,'" *Burlington Magazine* 121 (1979): 3–10; also Victor Stoichita, *Le prémoderne. Métapeinture au xviᵉ et au xviiᵉ siècles* (Paris, 1991).

15. "Wen das volkommen kumpt, das ist: wenn es bekant wirt, ßo wird das geteilt, das ist: creaturlicheyt, geschaffenheyt, icheyt, selbheyt, meinheyt, alles verschmecht und fur nichtz nit gehalten" (*Theologia Deutsch*, ed. Mandel, p. 9).

16. Dürer did not simply forget to take into account the reversal introduced by the medium of printing. If anything he thematizes here the distortion occurring in every printed image, where

what the artist fashions on the plate or wood-block is never the same as what the finished work finally shows (see Dürer's remarks on *vnderschyd* in printing and casting, *Schriftlicher Nachlaß*, 3:292).

17. Hans Christoph Tavel, "Hans Baldung und die Anfänge Niklaus Manuels," *Zeitschrift für Schweizerische Archäologie und Kunstgeschichte* 35 (1978): 224–233.

18. The practice of signing works with a personal device may have come to Manuel both from Dürer (and Baldung) and from his native tradition in Bern, where it was established by the anonymous Coronation Master. Manuel's *Schweizerdolch* appears not only in his paintings, but also in his poems and *Fastnachtspiele,* where it frequently "signs" the work as the text's final line. For example, the concluding lines of his Shrovetide farce *Von Papsts und Christi Gegensatz,* discussed earlier, read, "Wenn sie mich nun me beschissen, / So sönd die mir's ouch verwissen, / Des hab ich mich ganz eigenlich verwegen, / Und sött es mich costen min schwytzertegen" (Baechtold, *Niklaus Manuel,* p. 111 [full ref. chap. 16, n. 102]; see also pp. 102, 132, and 202 in this complete edition of his writings for similar uses of the *Schweizerdolch*).

19. See the discussion of this drawing in Bern, *Niklaus Manuel Deutsch,* cat. no. 159 (full ref. chap. 7, n. 6).

20. Radolfus's text is given in W. Wattenbach, "Geistliche Scherze des Mittelalters," *Anzeiger für Kunde der deutschen Vorzeit* 14 (1867): 342–344. The specific source of the Nemo sermons seems to have been a point of medieval Scholastic disputation, which is found in Heinrich von Neumünster's work: "Cum nihil ex nihilo, sed sit res omnes ab ente" (Gilman, *Parodic Sermon,* pp. 12–13 and 148n7 [full ref. chap. 15, n. 90]).

21. In 1520, for example, Jörg Schau Scherer of Strasbourg published a verse broadside entitled "Niemanis hais ich, was iederman tut das zucht man mich" (Gilman, p. 13).

22. Bakhtin, *Rabelais,* p. 413 (full ref. chap. 10, n. 76).

23. The best account of Manuel's career is still Conrad André Beerli, *Le peintre poète Nicolas Manuel et l'évolution social de son temps,* Travaux d'humanisme et renaissance, 4 (Geneva, 1953).

24. Manuel's penchant for word games is evident not only in the numerous mottoes on his pictures, many of which have not yet been decoded, but also in his plays, which often use pun-

ning names for their characters (e.g., the figure "Adam Niemergnûg" in *Vom Babst vnd siner priesterschafft*). Manuel's motto, moreover, is sometimes linked directly to the form of his name, as in his drawing of a "Cuckold" signed both "NKAW VB" (i.e., *Niemand kann alles wissen, von Bern*) and "NMD VB" (Niklaus Manuel Deutsch von Bern). Note too that Manuel sometimes signed his final name (Deutsch) as "Alleman," which suggests not only "German" but also "Everyman"; that is, the inversion of Nobody.

25. A more broad-based account of Baldung's contribution would have to compare his art not only with that of Manuel, but with that of Hans Leu the Younger (for which see Walter Hugelshofer, "Überlegungen zu Hans Baldung," *Zeitschrift für Schweizerische Archäologie und Kunstgeschichte* 35 [1978]: 263–269), Urs Graf, and the Nuremberg *Kleinmeistern.* What might be discovered is a version of what Wilhelm Pinder termed "the problem of generations," in which the productions of the epigones of an achieved classicism are constricted in the range of their responses (see Pinder, *Das Problem der Generation in der Kunstgeschichte Europas* [Munich, 1961]).

26. For a summary of Baldung's critical fate in this century, see Matthias Mende, "Zum Holzschnittwerk des Hans Baldung Grien," in his *Hans Baldung Grien,* pp. 11ff.

27. Walter Hugelshofer, "Zu Hans Baldung Grien," *Pantheon* 11 (1933): 177.

28. See the discussion of the panel in New York, *Gothic and Renaissance Art in Nuremberg,* cat. no. 178 (full ref. chap. 1, n. 50).

29. Brant, *Narrenschiff,* 13, "Von buolschafft"; Winkler attributes to Dürer 75 of the 116 woodcut illustrations in the 1494 Basel edition (Friedrich Winkler, *Dürer und die Illustrationen zum Narrenschiff* [Berlin, 1941]).

30. Fols. 6v and 42v; see Tavel, "Randzeichnungen," p. 97 (full ref. chap. 11, n. 25); Panofsky, *Dürer,* 1:189. On the association of the ape with lust, see H. W. Janson, *Apes and Ape Lore in the Middle Ages and the Renaissance,* Studies of the Warburg Institute, 20 (London, 1952), pp. 107–136 and 261–276.

31. As G. F. Hartlaub writes, "The ape refers above all to the artist's trade as *simia naturae;* but it also, through its shamelessness, always designates the emblem of the base nature of man" ("Der Todestraum des Hans Baldung Grien," *Antaios* 2 [1960]: 23).

32. From Sixtus Dittrich's *Epicedion Thomae*

Sporeri musicorum principis, Modulis musicis a Sixto Dittricho illustratum. Tenor (Strasbourg, 1534).

33. Schade, *Schadenzauber*, pp. 80–85 (full ref. chap. 15, n. 15). This sequence, and even the idea that the three woodcuts belong to a "series," is only a surmise: I know of no record of how these works were originally displayed, and the woodcuts themselves contain only internal clues as to a possible connecting narrative. Their similar size, composition, and oblong format, however, together with their unusual subject, argue for the unity of the three sheets. The most controversial aspect of Schade's sequence is her placing the *Fighting Horses* last; most previous scholars (including Marrow and Shestack in New Haven, *Hans Baldung Grien*, pp. 264–266, and Mende, *Hans Baldung Grien*, cat. nos. 77–79) regard it as not directly related to the other two sheets and as slightly earlier in date. I, however, am convinced by Schade's account.

34. See Jay A. Levenson's excellent catalog entry on the *Wild Horses* series (New Haven, *Hans Baldung Grien*, pp. 264–266). On the existence of a "sacred grove" in Hagenau near Baldung's Strasbourg where the artist could have observed herds of wild horses, see Lilli Fischel, "Hans Baldung Grien: The Flesh and the Devil," *Art News* 58, 6 (1959): 54.

35. Lucius Junius Moderatus Columella, *On Agriculture II*, 6.27, trans. E. S. Forster and Edward H. Heffner (Cambridge, Mass., 1954), pp. 191–193; also Virgil, *Georgics*, 3, for a similar passage; both cited in New Haven, *Hans Baldung Grien*, p. 265.

36. Marcus Terentius Varro, *On Agriculture*, 2.7, trans. William Davis Hooper (Cambridge, Mass., 1934), p. 387; New Haven, *Hans Baldung Grien*, p. 265.

37. Panofsky, *Dürer*, 1:88.

38. Note that this very torch, passing out of the view framed by the archway, reappears in Baldung's *New Year's Sheet* of 1514 (fig. 159), but now taking on a wholly demonic, antirational character.

39. And *vngezempten ross* (Dürer, *Schriftlicher Nachlaß*, 1:75).

40. Spengler's own *Tugendbüchlein* of 1519, dedicated to Dürer, represents such a compilation (see Schubert, *Lazarus Spengler*, pp. 114–115 [full ref. chap. 8, n. 21]).

41. Erasmus, *Enchiridion*, 6; trans. Himelick, p. 69.

42. See Panofsky's interpretation of *Knight, Death, and the Devil* as a reception of Erasmus's *Enchiridion* (*Dürer*, 1:151–154); see also Nietzsche's allegorization of Dürer's knight as a primal image of the individual (*Geburt der Tragödie* [1872], in *Sämtliche Werke*, ed. Giorgio Colli and Mazzino Montinari, 15 vols. [Berlin, 1980], 1:131). Ernst Bertram's Nietzsche book centers on this print and its meaning for German spirituality (*Nietzsche*, pp. 50–71 [full ref. chap. 3, n. 4]).

43. Note that for Baldung as he appears in the self-portrait, this horse faces left, like Dürer's original engraving. The pastiche character of Baldung's *Horses* woodcuts is brought forth in one of its later receptions. The Nuremberg artist Jost Amman (1539–1591) used Baldung's *Ejaculating Stallion* as the model for one of his 293 woodcut illustrations for the *Kunstbüchlin*, published in Frankfurt in 1599 (fol. 106v; reproduced in *The Illustrated Bartsch*, vol. 20, pt. 2, *German Masters of the Sixteenth Century. Jost Amman: Woodcuts*, ed. Jane S. Peters (New York, 1985), no. 4.212. Amman, interested in providing other artists and craftsmen with graphic models, transforms Baldung's complex image into a loose assemblage of differently postured horses seen from various points of view.

44. Reproduced in Danielle Régnier-Bohler, "Imagining the Self," in *A History of Private Life*, vol. 2, *Revelations of the Medieval World*, ed. Philippe Ariès and George Duby and trans. Arthur Goldhammer (Cambridge, Mass., 1988), p. 347.

45. See Philippus Aureolus Paracelsus, *Sämtliche Werke*, ed. Karl Sudhoff, 14 vols. (Munich, 1922–1933), 1:254; excerpted in Paracelsus, *Von Licht der Natur und des Geistes*, ed. Kurt Goldhammer (Stuttgart, 1970), p. 148.

46. Baldung's *Horses* woodcuts would be usefully contextualized in period attitudes toward coitus interruptus and masturbation. On coitus interruptus, see Petrus de Palude's proscription as discussed in Tentler, *Sin and Confession*, p. 205; the standard work on the subject is John T. Noonan, *Contraception: A History of Its Treatment by the Catholic Theologians and Canonists* (Cambridge, Mass., 1965); Daniella Jacquart and Claude Thomasset have written a fascinating account of coitus interruptus in the literature of medicine and of courtly love during the Middle Ages (*Sexualité et savoir médical au Moyen Age* [Paris, 1985], pp. 120–192). On masturbation see, for example, that most complete program of interro-

gation in the whole confessional literature: Jean Gerson's *De confessione mollitiei* (*Opera omnia*, 2:453–455 [full ref. chap. 15, n. 117]); the subject is discussed in Tentler, pp. 90–95, and in Brundage, *Law, Sex, and Christian Society,* passim.

47. I follow the date proposed by Marrow and Shestack (New Haven, *Hans Baldung Grien,* pp. 273–275) rather than the date of 1534 postulated by Mende.

48. The most ingenious of these interpretations is Charmian A. Mesenzeva, "'Der behexte Stallknecht' des Hans Baldung Griens," *Zeitschrift für Kunstgeschichte* 44 (1981): 57–61, who sees it as an illustration of the popular legend of "Junker Rechenberger." Mesenzeva's strategy of combining motifs from many different versions of the legend (and from other, rather distantly related legends) to link it to Baldung's print has been criticized by Dale Hoak ("Art, Culture, and Mentality in Renaissance Society: The Meaning of Hans Baldung Grien's *Bewitched Groom* [1544]," *Renaissance Quarterly* 38 [1985]: 488–509). Following Gabriel von Térey's very early suggestion (*Verzeichnis des Gemälde des Hans Baldung genannt Grien* [Strasbourg, 1894], 1:x), Hoak links the work instead to the Alsatian tale of "The Witch in the Guise of a Horse." Both analyses suffer, I believe, from an unproven and, for this artist's oeuvre, untenable assumption that Baldung's images are necessarily related to one particular story or text. Both are correct, however, in focusing their source hunting not on classical myths, humanist allegories, and "high" literature, as would be appropriate for Dürer's secular prints, but on popular culture. This strategy is already established in Gustav Radbruch's excellent folkloristic reading of the print ("Hans Baldung's Hexenbilder," pp. 30ff. [full ref. chap. 15, n. 15]).

49. The best interpretation along these lines is still Hartlaub, "Der Todestraum des Hans Baldung Grien," 13–24; see also Linda A. Hults, "Baldung's *Bewitched Groom* Revisited: Artistic Temperament, Fantasy, and the 'Dream of Reason,'" *Sixteenth Century Journal* 15 (1984): 259–279. Radbruch, too, sees the print as expressive of a "very powerful . . . *personal* experience" ("Hans Baldungs Hexenbilder," p. 39); and before that, Hans Curjel calls the print "the uncanny swan song of the master as he is touched by death" (*Hans Baldung Grien,* p. 132 [full ref. chap. 14, n. 20]).

50. First suggested by Curjel, *Hans Baldung*

Grien, p. 132, and accepted by Hartlaub, who writes that "it is entirely *possible* (even though not quite provable), that Baldung was struck by such a resemblance between himself and his vision that this vision made him stunned" ("Todestraum," p. 20).

51. Radbruch, "Hans Baldungs Hexenbilder," p. 44n51.

52. On radically foreshortened figures in Renaissance art, see H. Jantzen, "Mantegnas Cristo in scurto," in *Über den gotischen Kirchenraum und andere Aufsätze* (Berlin, 1951); Hubert Schade, "Über Mantegnas Cristo in scurto und verwandte Darstellungen," *Neue Heidelberger Jahrbücher,* n.s., 1930, pp. 75–111; and especially Rathe, *Die Ausdrucksfunktion extrem verkürzter Figuren,* pp. 10–16 (full ref. chap. 6, n. 2); I am indebted to John Shearman for these references. Erhart Schön's *Unterweysung der Proportion und Stellung der Possen, ligent und stehent, abgestolen, wi man das vor Augen sihet* (Nuremberg, 1538) contains two woodcut illustrations of a receding ground plane ruled off in squares, upon which lie various geometricized supine figures, rather like tossed atelier mannequins in a perspective machine (figs. 13 and 14). I would note, too, that the earliest German imitation of Dürer's theoretical writings, Hans Sebald Beham's *Kunst und Lehrbüchlein,* was blocked from publication in 1532 by a plagiarism suit by Agnes Dürer (see my discussion in chapter 10). Beham's work offered, among other things, a system of proportions for constructing horses; it would be interesting to study Baldung's travesties of Dürer's horses as a farcical response to this very specific, but thwarted, Dürer reception by another epigone.

53. Baldung models his Christ after Dürer's charcoal sketch *Dead Christ on a Shroud* from 1515, now in Lwow (W. 378); see also Baldung's pen drawing *Lamentation,* now in Basel (K. 34). Useful in this regard is Millard Meiss's interpretation of the "Madonna of Humility" (in *Painting in Florence and Siena,* pp. 132–156 [full ref. chap. 13, n. 12]), as well as Donat de Chapeaurouge, "Zur Symbolik des Erdbodens in der Kunst des Spätmittelalters," *Der Munster* 17 (1964): 38–58.

54. Fols. 71 and 73ᵛ, respectively (see also Baldung's woodcut *Drunken Bacchus* from 1520 [M. 75], and the chiaroscuro sketch of the same subject from 1520, now in Berlin [K. 104]). I can think of few conceits more characteristic of Baldung's

art than this bizarre pairing of the dead Christ and the drunken Bacchus. Far more than Dürer's sketches for the *Prayer Book*, Baldung recaptures the traditional grotesque tone of marginal illumination, infusing it with a heightened sense of the demonic.

55. Geisberg, *German Single-Leaf Woodcut*, 3:794; old Geisberg no. 829 (full ref. chap. 5, n. 52); see Franzsepp Würtenberger's interesting discussion of this foreshortened, supine figure in *Peter Bruegel d. A. und die deutsche Kunst* (Wiesbaden, 1957). Of course, Baldung's images of witches' sabbaths, with their arrangement of nude bodies seated on the ground in various positions, belong also to this figurative domain.

56. Ursula Hoff, "The Sources of 'Hercules and Antaeus' by Rubens," in *In Honor of Daryl Lindsay: Essays and Studies,* ed. Franz Philipp and June Stewart (Melbourne, 1964), pp. 67–69; for an excellent discussion of the Hercules story as moral allegory in the German Renaissance, see Dieter Wuttke's commentary on the *Histori Herculis* by Pangratz Bernhaubt from 1515 (*Die "Histori Herculis"* [full ref. chap. 15, n. 6]).

57. This visual allusion is pointed out by Hieatt, "Hans Baldung Grien's Ottawa *Eve*," p. 297 (full ref. chap. 14, n. 43).

58. Wer beÿ schön frawen nackent leidt,
 Vnd überwinndt sich selbst mit streit,
 Daz sein hertz kein bewegnus geidt . . .
 Der hat eins frommen mannes mueth.
("Von der bösen welt" [1510]; Dürer, *Schriftlicher Nachlaß*, 1:134.)

59. Max Horkheimer and Theodor W. Adorno, *Dialectic of Enlightenment*, trans. John Cumming (New York, 1987), p. 249.

Photographic Credits

Jörg P. Anders: 3, 6, 33, 52, 102, 122, 130, 196; Art Resource: 124; Berlin-Dahlem, Foto Steinkopf: 46; Constantin Beyer: 28, by permission of the British Library: 24; Johannes Pötzsch Buch a.W.: 42; John F. Cook: 13, 17, 27, 29, 30, 31, 34, 37, 43, 44, 48, 50, 54, 57, 58, 60, 62, 63, 65, 70, 73, 75, 79, 83, 92, 99, 106, 108, 111, 112, 115, 117, 118, 128, 129, 132, 136, 143, 145, 147, 150, 156, 157, 158, 161, 163, 164, 165, 166, 167, 168, 177, 179, 181, 185, 186, 187, 188, 190, 199, 201, 204, 205, 206, 207, 208, 209, 210, 211, 212, 214, 215, 217, 220, 222, 223, 224; courtesy of the Fogg Art Museum, Harvard University, Cambridge, Massachusetts, gift of William Gray from the Francis Calley Gray Collection of Engravings: 14, 98, 144; Gray Collection of Engravings Fund: 110, 94; gift of the heirs of Mrs. Mary Hemenway: 109; Germanisches Nationalmuseum, Nuremberg: 107; by permission of the Houghton Library, Harvard University: 77; H. Lilienthal: 138; the Metropolitan Museum of Art, Robert Lehman Collection, 1975 (1975.1.862): 2, 5; Ursula Edelmann: 53, 56; reproduced through the courtesy of the Michigan-Princeton-Alexandria Expedition to Mount Sinai: 36; Yves Petit: 119, 218, 219; Réunion des Musées Nationaux: 18, 66, 160, 216; Rheinisches Bildarchiv: 95; Vatican Museums: 100.

Index

Note: Page numbers are given in roman type, illustration numbers in *italic* type.